Colors
of
Enchantment

Colors *of* Enchantment

Theater, Dance, Music, and
the Visual Arts of the Middle East

Edited by
Sherifa Zuhur

The American University in Cairo Press
Cairo New York

This volume is dedicated
to the memory of my father.

Dar el Kutub No. 9226/00
ISBN 977 424 607 1

Designed by the AUC Press Design Center/Kevin B. Havener

Contents

Theaters of Enchantment

Visual Images

Acknowledgments

I want to thank the staff of the American University in Cairo Press for their work on this volume and the Director of the Press, Mark Linz, for his support. Special thanks are due to Pauline Wickham, the senior editor at the Press who encouraged me to compile a second volume of this project on the contemporary arts, and to Neil Hewison, managing editor of the Press. I would also like to thank Frank Bradley and Kay Hardy Campbell for their careful reading, comments, and suggestions, and James Schevill, poet/playwright, and my stepfather for sharing insights on the purpose of theater with me. Kristina Nelson, Samia Mehrez, Najwa Adra, and Selim Sednaoui understood my aims in this work and made some valuable suggestions regarding inclusions to the volume.

I would like to thank my mother and stepfather for their support during the months of this book's preparation.

Events underway during the work on this volume have caused me to believe ever more strongly in John Stuart Mill's injunctions to speak, discuss, and publish freely, particularly in, of, and for the Middle East. To my dear friends, colleagues, and students, your companionship and support of such sentiments is more valuable than you know.

Contributors

Najwa Adra is outreach coordinator at the New York Foundation for the Arts. She received her Ph.D. in anthropology from Temple University in 1982. She has conducted ethnographic fieldwork in Yemen and has consulted on several development projects. In 2001 she will conduct pilot research in Yemen that is designed to test the efficacy of incorporating expressive culture in development. This project, funded by the World Bank, will focus on teaching literacy to rural Yemeni women using their own poetry. Her previous publications include contributions on the Middle East and Yemen in the *International Encylopedia of Dance* (Oxford University Press, 1998).

Wijdan Ali is a painter, art historian, and lecturer on Islamic civilization. A graduate of the School of Oriental and African Studies (University of London), she was the first woman to enter the Ministry of Foreign Affairs in Jordan in 1962. In 1979 she founded the Royal Society of fine Arts that established the Jordan National Gallery of fine Arts in 1980. She has written a number of publications in Arabic and English on contemporary and classical Islamic art and is a member of several national and international cultural organizations. Her paintings are in major museum collections including the National Museum of Women in the Arts in Washington, DC; the International Museum of Twentieth-Century Art (TIMOTCA); the Ashmolean Museum in Oxford; the British Museum in London; the Jordan National Gallery of Fine Arts; Centre d'Art Vivant de la Ville de Tunis in Tunisia; Musée d'Asillah in Morocco; and the National Art Gallery in Islamabad, Pakistan. Currently she is vice-president and dean of academic research at the Jordan Institute of Diplomacy.

Sami Asmar is a planetary physicist with the National Aeronautics and Space Administration. He performs and writes extensively about Arab music. He founded Turath.org, an organization that promotes Arab music through fellowships, and cofounded a traditional Arab music ensemble in California.

Clarissa Burt is an assistant professor of Arabic literature at the American University in Cairo, where she has taught since 1997. While primarily concerned with classical poetry, she has published on contem-

porary poetry, as well, and is working on a monograph dealing with the story of Harb al-Basus in different genres across the ages.

Michael Frishkopf, assistant professor of music at the University of Alberta, is a graduate of Yale College (B.S., Mathematics, 1984), Tufts University (M.A., Ethnomusicology, 1989), and the University of California, Los Angeles (Ph.D., Music, 1999). Dr. Frishkopf's research interests include musics of the Arab world, ritual and performance in Islam, music and emotion, social systems theory, and music perception.

Tori Haring-Smith has been the artistic director of the English language theater in Cairo Egypt and chair of the performing and visual arts department at the American University there (1996–99). Now back in the United States, she is currently on leave from her position as a professor of English and theater at Brown University so that she can serve for two years as the Executive Director of Thomas J. Watson Foundation. She has directed for several years in Egypt and throughout the northeastern United States. In New York, she assisted Joseph Chaikin with Susan Yankowitz's *Night Sky* and directed *The Country Wife* at the Jean Cocteau Repertory Theatre. Her translation/adaptation of Eduardo de Filippo's *Napoli Milionaria* premiered at the Cocteau in 1995, and her translations of Chekhov's *Seagull* and Molière's *Miser* premiered at Trinity Repertory Company in Providence, Rhode Island. Olympia Dukakis directed her *Seagull* at Arizona Theatre Company in 1994. From 1991–96, she was the dramaturge at Trinity. She has published several books and articles on writing, teaching, and theater, including *From Farce to Metadrama: A Stage History of the Taming of the Shrew*, 1594–1983 (Westport, CH: Greenwood, 1985), *Writing Together* (New York: HarperCollins, 1994), and *Monologues for Women by Women* (Portsmouth, NH: Heinemann, 1994).

Kathleen Hood is a Ph.D. candidate in ethnomusicology at the University of California, Los Angeles. Specializing in Arab music, she recently completed field research in Syria. She is also a cellist and a member of the Long Beach Symphony.

M. R. Ghanoonparvar is professor of Persian and comparative literature at the University of Texas at Austin. His books include *Translating the Garden* (Austin: University of Texas Press, 2001), *In a Persian Mirror: Images of the West and Westerners in Iranian fiction* (Austin: University of Texas Press, 1993), and *Prophets of Doom: Literature as*

a Socio-Political Phenomenon in Modern Iran (Lanham, MD: University Press of America, 1984). He is the co-editor (with John Green) of *Iranian Drama: An Anthology* (Costa Mesa, CA: Mazda, 1989) and *In Transition: Essays on Culture and Identity in Middle Eastern Societies.* He has translated numerous plays, novels, short stories and poems from Persian including Gholamhoseyn Sa'edi's *Othello in Wonderland* and *Mirror-Polishing Storytellers*, Parviz Sayyad's *Cinema Rex Trial*, Jalal Al-e Ahmad's *By the Pen*, Sadeq Chubak's *Patient Stone*, and Simin Daneshvar's *Savushun*.

Deborah Kapchan is an associate professor of anthropology at the University of Texas at Austin, and is the former director of the Center for Intercultural Studies in Folklore and Ethnomusicology. Her first book, *Gender on the Market: Moroccan Women and the Revoicing of Tradition* (Philadelphia: University of Pennsylvania Press, 1996), examined how women use performance genres to create new identities for themselves in the public domain. She is currently working on a narrative ethnography about the Gnawa subculture in Morocco.

Neil van der Linden, who holds a degree in medicine and law, is a Dutch music researcher and journalist. He became involved with Middle Eastern music in Iraq, at first through contact with Munir Bashir. Since then he has developed several exchange projects for music, as well as for theater, film, and visual arts, between the Netherlands and Mashriq countries. Currently he is working on a project with the Lebanese singer Feiruz, Ziad Rahbani, and the Rotterdam Philharmonic Orchestra. He is also preparing a documentary on Iraqi female singers of the past. He is a regular guest on Dutch radio with programs about Middle Eastern music.

Samia Mehrez is associate professor of Arabic literature at the American University in Cairo. She is the author of *Egyptian Writers between History and fiction: Essays on Naguib Mahfouz, Sonallah Ibrahim and Gamal al-Ghitani* (Cairo: AUC Press, 1994). Her articles on Francophone and modern Arabic literature have appeared in *The Bounds of Race* (Ithaca, NY: Cornell University Press, 1991), *Rethinking Translation* (New York: Routledge, 1992), *Yale French Studies*, and *Alif*, among others.

Mona N. Mikhail is a professor of modern Arabic literature and women's studies in the department of Middle East studies, at New York University.

She has published extensively on the different genres of Arabic literature and especially on the image of women in Arab societies. Her most recent work, a video documentary *Live on Stage: A Century and a Half of Theater in Egypt*, investigates the rich legacy of the theater and explores timely issues such as censorship and the role of women.

Sami A. Ofeish is associate professor of political science and acting dean of the College of Arts and Social Sciences at the University of Balamand, Lebanon. He writes and lectures on politics and culture of Lebanon. Currently, he is revising a book manuscript on sectarianism and change in Lebanon, 1943–75.

Eve Troutt Powell is an assistant professor at the University of Georgia, where she teaches the history of the modern Middle East.

'Ali Jihad Racy is a professor of ethnomusicology in the department of ethnomusicology at the University of California, Los Angeles. Born in the village of Ibl al-Saqi, Lebanon, he perfomed as a teenager on national television and developed a program on world folk music on Lebanese radio in the 1960s. His undergraduate degree is from the American University in Beirut, and he earned his graduate degrees at the University of Illinois, Urbana. His master's work was on the funereal music of the Druze, and his doctoral research documented the early recording industry of Cairo. He has written extensively on various genres of Arabic music and *tarab*, and his compositions have been performed by major ensembles, such as the Kronos Quartet. He performs on many instruments, but is particularly memorable on the *nai*, the *buzuq*, and the *mijwiz*.

Rashad Rida taught contemporary literature at the University of Victoria in Canada and at Oakland University until his retirement in 1996.

Tonia Rifaey is a doctoral candidate in the department of sociology at the University of Surrey, England. She is working on aspects of gender and Islam. She earned her Master's degree in Middle Eastern History in the Department of Arabic Studies at the American University in Cairo.

Edward W. Said is University Professor of English and Comparative Literature at Columbia University in New York. He is the author of over twenty books on literature, culture and the Middle East, including *Orientalism* (New York: Penguin, 1995), *Out of Place: A Memoir* (New

York: Knopf, 1999), and *Reflections on Exile and Other Essays* (Cambridge, MA: Harvard University Press, 2001).

Lori Anne Salem completed her doctoral degree in dance at Temple University, where she was awarded the Russell Conwell Fellowship for Graduate Research and a dissertation fellowship. She has published her work in *Dance Research Journal* and in *Arabs in America: Building a New Future* (Philadelphia: Temple University Press, 1999), edited by Michael W. Suleiman. She is currently the director of the Writing Center at Temple and the book review editor for *Dance Research Journal*.

Philip D. Schuyler is an associate professor of music and head of the division of ethnomusicology at the University of Washington in Seattle. He received his undergraduate degree from Yale and his Ph.D. from the University of Washington. An ethnomusicologist who specializes in North Africa and the Middle East, his research interests include the ethnography of performance and the inter-relationship of the arts. His work in Morocco and Yemen has resulted in numerous articles, field recordings, and an ethnographic film.

Selim Sednaoui studied piano in Egypt, Italy, and Switzerland. He has presented concerts in Egypt, Lebanon, France, Belgium, and the United States, where he also lectured on contemporary Egyptian composers. He was vice president of Jeunesse Musicale du Liban from 1959 to 1975, has taught music appreciation at the Lebanese University, and presented music programs on ORTF radio, Beirut. He regularly writes on music for the French-language Egyptian weekly, *Al-Ahram Hebdo*, and has published articles in the French *Piano* magazine.

James Stone is assistant professor of English and comparative literature at the American University in Cairo. He is completing a book entitled *Crossing the Mirror: Shakespeare's Androgyny*.

Reuven Snir is professor of Arabic literature, chair of the department of Arabic language and literature at the University of Haifa, and associate editor of *Al-Karmil–Studies in Arabic Language and Literature*. He has published extensively in English, Arabic, Italian, and Hebrew on various aspects of Arabic prose, poetry, and theatre, as well as on Arabic literature written by Jews and Hebrew literature written by Arabs. He is also a translator of Arabic poetry into Hebrew and Hebrew poetry into Arabic.

Sherifa Zuhur is a visiting research scholar at the Center for Middle Eastern Studies at the University of California, Berkeley, and will be a senior research fellow at the Chaim Herzog Center for Middle East Studies and Diplomacy at Ben Gurion University in the Negev during 2001–02. She was formerly associate professor of history at the American University in Cairo. Her publications include: *Revealing Reveiling, Islamist Gender Ideology in Contemporary Egypt* (Albany, NY: State University of New York Press, 1992) and *Asmahan's Secrets: Woman, War and Song* (Austin: University of Texas Press, 2001), and she was contributing editor of *Images of Enchantment: Visual and Performing Arts of the Middle East* (AUC Press, 1998). She has performed since the age of fourteen in both Western classical and Arabic instrumental, vocal, and dance traditions.

Introduction

Sherifa Zuhur

Colors of Enchantment explores aspects of contemporary visual and performing arts of the modern Middle East. This volume continues the project initiated in an earlier volume, *Images of Enchantment: Visual and Performing Arts of the Middle East* (1998), to provide descriptive and analytical materials on the contemporary arts that have developed in the region. The overall project was generated as a response to what seemed to me an overabundant output concerning violence and terrorism, the development or suppression of democracy, and other, chiefly negative juxtapositions of the West and the Middle East. It was, secondly, a reaction to a romantic, or nostalgic, approach to traditional arts and production in the Middle East that seemed to have taken precedence over explorations of contemporary cultural issues and art forms.

Thirdly, I aimed to convey the exciting process of synthesis and hybridity in the arts whatever its genesis—travel, colonialism, publications and print media, mass media, and globalization of contemporary art forms, especially the conceptual. And fourthly, I wanted to present the work of various authors and performers whose explorations of visual and performing art add to our understanding of *tarab* ("enchantment"), an aesthetic quality that causes enjoyment, reciprocation of emotion and communication between the performers and their audiences in Arabic music—here extended to include other genres of creative expression and entertainment. The range of topics, cases, and authors should also suggest and celebrate the amazing diversity of artistic expression in and of the region.

Dance, music, painting, and cinema made up four sections of that companion volume, *Images of Enchantment*, ranging from aspects of popular as well as "high" culture. This volume continues to survey the arts from this broad perspective and explores additional linkages between the art forms of theater, other forms of public performance and spectacle, cartoons, Arabic "art," "folkloric" and Sufi music, vernacular poetry, tribal dance, and ideas, aesthetics, social critique, and language. The frustrating and fascinating wealth of material precluded inclusion of a great many of my interests: arabesk in Turkey, *rai* music in North Africa, the use of photography as art in the region, considerations of weaving, sculpture, and architecture, and numerous performers of vari-

ous genres in order to present a substantial section on theater.

Certain themes link the included essays or interviews. One has to do with the role of the artist/actor/performer in providing new vistas and modes of vision to their audiences or spectators. I believe this function to be connected with that of the fool, Karagoz, a clown, Goha (Juha Nasrudin) the Fool (Lavie, 1990, particularly pp. 221–239), or madman figure of the Mzeina Bedouin of the Sinai (ibid., pp. 125–150), the poet, and the playwright (as in 'Ali Salim, *Al-Bufih*, 1976). Naturally, the content and "voice" of social critique from an insider-turned–eloquent outcast varies from a tribal community's perspective to those generated from disparate contemporary urban environs.

The artist as the fashioner of taste or voice of conscience (or even ethics) has lengthy historical roots, springing from patrons' esteem for his/her power in eliciting *tarab*. Ziryab, the medieval musician, student of Ibrahim al-Mawsuli who traveled to al-Andalus and established himself there, set the fashions and even the cuisine of the court. In the mid-twentieth century a new model for male stars was promoted by Farid al-Atrash, who sought to modernize and professionalize the image of the male musical and cinematic star (Zuhur, 2001). We should also take note of the influence of the esteemed writer Edward Said and musician/conductor Daniel Barenboim, who have explored a friendship across cultures (Said, 2000, pp. 43, 56) and who seek to unite young musicians of both Arab and Israeli backgrounds through performance.

The artist's ability to influence his/her environment may or may not be actualized, but critique, satire, repositioning (reframing), and transformation are other key artistic activities. Note the sharp vision of early political cartoons, the specific concepts of nationality and race injected by performer 'Ali al-Kassar, or the political role of the clown or clownlike figure in certain plays of Yusuf Idris (see chs. 21, 2, and 3 respectively). But Idris's clown, who can eloquently define his social role, cannot even save his own job! (see ch. 3). The artist or performer may be subjected to demeaning or denigrating language as discussed by Racy, or may recast art as trade (see ch. 17).

These art forms also lend themselves to the expression of romance, or they may adopt elements of experimentation or allude to a great body of traditional culture as in the Sufi *inshad*, the El-Warsha theater's use of epic tale, or the Moroccan poets' performance of *zajal*, a colloquial genre.

Essays were deliberately chosen for this volume, as with its companion, for their scholarship and their inclusion of observations by those personally engaged in contemporary art forms. 'Ali Jihad Racy, Michael Frishkopf, Sami Asmar, and I all perform Arabic music, although Asmar

is a scientist and I, a historian. The artist Huda Lutfi is a historian specializing in the Mamluk era. Edward Said is a literary scholar and critic, as well as an accomplished pianist; Wijdan Ali is both art historian and contemporary painter; likewise, Clarissa Burt, who writes on poetry and dramatic literature, paints. Selim Sednaoui is a concert pianist and music critic who studies philosophy. Tori Haring-Smith, a scholar, has been a dramaturge and theatrical director, and Rashid al-Rida is a director and instructor of theater. Najwa Adra, an anthropologist, oversees a program on the arts for the State of New York. Our dual or multiple roles demonstrate that those who perform or create visual art may be deeply concerned with the development and historical or sociopolitical implications of their chosen form of expression. They also serve to illustrate my belief that the balance suggested in the expression "renaissance man (or woman)" is a condition that is being abandoned by modern education with its contemporary professional specializations and compartmentalizations. Moreover, the presence of both performance or artistic training and experience and the ability to analyze artistic production allows scholars to take a middle ground in what is known in the academy as the *etic* vs. the *emic* debate over the proper approach to observation or knowledge (see ch. 13).

Whereas in *Images* I chose to focus on the nontextual aspects of the four art forms dance, music, painting, and cinema, this volume allows for exploration of certain relations among words, texts, and ideas expressed by or about the arts. For example, 'Ali Jihad Racy explains that in the parlance of musicians, "the verb *yighanni* ("s/he sings") is characteristically avoided in favor of *yiqul* ("s/he says/speaks") and that "this implicit correlation between music and speech seems to bring closer the notions of poet and singer and to portray the musician as a type of orator and conveyor of a revered text" (see ch. 17). Michael Frishkopf elaborates on this melding of performance functions in his exploration of the relationship between the Sufi singer and the Sufi poet—the former being able through his acute judgment of the *hal* ("condition") of his audience to tap into the spiritual reservoirs of the poet's *tarab* (ability to enchant). This ability is also explored in Deborah Kapchan's essay that points to many layers of aesthetics in the translation of emotion, such as the notion of "depth" and the absence of boundaries of time (see ch. 7).

Some of the linguistic distinctions point to matters of honor or respectability, as Najwa Adra indicates in her discussion of the terms used for dance in the Yemeni highlands, which distinguish *bara'* (dances performed by the highlanders to identify themselves by tribe), from *lu'b*, a dance they may also perform that is considered to be

raqs—the actual word for *dance*, which has a connotation of frivolity (see ch. 10). As we have seen before, "the appropriate contexts of performance of all genres of *raqs* are clearly delimited. To perform *raqs* outside these contexts is disapproved of (see Adra, 1998b), yet perfectly licit within them, as in Kay Campbell's discussion of appropriate performance in all-women parties in Saudi Arabia[1] and in William Young's exploration of dance in Rashidi weddings.[2] It is the professionalization of *raqs* in the context of cabarets, clubs, or other public venues, that causes them to be linked with illicit display, even when performed by "masters" like Samia Gamal or Tahia Carioca (see ch. 12). Another way that licit displays become contextually illicit is described by Lori Salem, and that has much to do with the colonial project, in which "American beliefs about the Arab's body and sexuality were imposed on Arabs" (p. 227 of this book). Hence, cross-cultural identifications used to build an Other were as important as professionalizations that delineated particular Selves in physical performances.

Here, it is appropriate to make some general observations about the nature of theater, dance, visual art, and music of the Middle East.

Topical Background: Theater

Traditional modes of theatrical performance derive from shadow plays and puppetry forms that were known into this century (the *karagoz* or *karakoz*). The aesthetics of dramatic performance were also created in various forms of poetic recitation and the public storytelling or readings of the *hakawati* ("storyteller"). While the *hakawati*'s craft ranged from pure storytelling to the more recent "reading" of actual texts to the illiterate, the poetic recitations found in North Africa and many areas of the Arab East could be set to instrumental accompaniment. Such forms also produced the colloquial poetry known as *zajal* of Morocco or the rhymed and eventually staged and sung Lebanese *zajal* (something like the rhyming "dozens" of the African-American community in the United States).

Among Bedouin groups throughout the Middle East, storytelling, whether in traditional forms (i.e., *kan ya makan*, literally, "there was and there was not," the formula that corresponds to "once upon a time"), or in contemporary tales of surreal tourist Bedouin interactions, holds both dramatic and interpretive content. In Iran, the passion plays known as

1 Kay Hardy Campbell, "Folk Music and Dance in the Arabian Gulf and Saudi Arabia," in Zuhur, ed. (1998), pp. 57–69.
2 William C. Young, "Women's Performance in Ritual Context: Weddings among the Rashayda of the Sudan," in Zuhur, ed. (1998), pp. 37–55.

ta'iziye, which told the story of Hussain and his death at the hands of the 'Ummayads, were enacted yearly (and in southern Lebanon, the occasion is marked by processions, self-flagellation, and even self-stabbing and grief). Other early forms of Iranian dramatic performance (e.g., *ruhowze* or *takhthowze* and *siyahbaze*) took place, for example, at weddings.

However, the actual development of theater per se was introduced in both the Arabic-speaking and Iranian worlds through direct contact with the West, as with the introduction of theater to entertain the Napoleonic troops (see ch. 1) and the subsequent development of indigenous satirists, dramatists, and playwrights in the nineteenth century during which composition or staging of satire and short and later full-length plays was introduced into the Middle East by writers who had read, seen, or translated Western works and who developed specific moral or political goals for theater.

In Egypt, the early ventures into theater are usually attributed to Ya'qub al-Sanu'a (1839–1912) who wrote satirical plays performed in colloquial Arabic that mocked the elite and the khedive. He also produced works that included other forms of satire as in political cartoons (Moosa, 1974; Landau, 1958; Marsot, 1971, p. 7; and see ch. 21). There were other early experimentations, as in the work of 'Uthman Galal (see ch. 1). Intriguingly, the prescriptive and educational benefits of dramatic dialogues were used by Abdullah Nadim in response to the corrupting influence of the West, which he detected in many venues including in performances then staged in Cairo for tourists ('Uthman, 1979, p. 77, cited in chapter 11, infra; see also chapter 21).

Najib al-Rihani (1892–1949) continued the development of drama with his theatrical troupe. He was closely identified with one of his characters, Kishkish Bey, the *'umda*, or headman of a rural village (Abou Saif, 1973), who was part of a comedic trend lampooning country folk. 'Ali al-Kassar was similarly identified with one of his characters, in blackface as Osman 'Abd al-Basit, *Barbari Masr al-Wahid* ("the one and only Nubian of Egypt") (see ch. 2). Bishara Wakim, an early character actor in cinema frequently played a *shami* ("Eastern") scoundrel, and Durayd Lahham, a Syrian comedian, was similarly tied to his character Ghawwar (see ch. 6), just as Farid al-Atrash, who will be discussed in this volume primarily in his musical capacity, was identified with his screen persona, Wahid[3] (see ch. 14). Through the establishment of stock characters or representational conventions, these actors/performers

3 Sherifa Zuhur, "Romanticism, Masculinity, Iconicity: Farid al-Atrash, His Life and Work." Guest lecture delivered at Harvard University, Cambridge, Mass., November 18, 1999.

continued a theatrical tradition of social critique.

Certain conservative religious scholars deplored the introduction of theater. For example, in 1911 a group of Damascene *'ulama*, including the preacher of the 'Ummayad mosque, Shaykh Hasan al-Ustuwani, censured a theatrical performance at a local high school arguing that theater, involving as it does a story, or fantasy, equated, as David Commins explained, "the fictional depiction of characters with intentional lies" and was therefore forbidden in Islam (Commins, 1991, p. 122[4]). The conservative objection to cinema that developed some years later was similarly due to its promotion of fantasy and use of visual imagery. As with the public performance of music and dance, as well as filmed scenarios, conservatives opposed women's participation on the ground that they were engaging in *tabarruj* (displaying their bodies and providing sexual temptation). These attitudes did not prevent members of the elite from entering the theatrical profession, for example, the actor and producer Anwar Wagdi in Egypt, or those of middle-class backgrounds, such as Wadi' al-Safi or Fairuz, but religious suspicion of entertainment venues remained.

Readers will note that the first part of our coverage of theater relates to Egypt. Here, a giant of the genre, Tawfiq al-Hakim, a playwright with an extreme sensitivity to language and ideas (Allen, 1979, pp. 99–100), should be mentioned. As he is well discussed elsewhere, we venture here into different topics on Egyptian theater, before exploring some aspects of theater in Iran, Palestine, and Syria. Finally, we take a look at the early Arabic theater in America and a contemporary Arab playwright in the United States and Canada.

Those unfamiliar with Iranian theater may become acquainted with certain key names in that genre, discussed by Mahmoud Ghanoonparvar from Mirza Fath 'Ali Akhundzadeh (1812–78) to Gholamhoseyn Sa'edi (1935–85) to Bahram Beyza'i (b. 1938) and writers in exile like Parviz Sayyad and Mohsen Yalfani, or those in Iran like Salman Farsi Salehzehi. Readers should consider the interesting parallels to the sociopolitical content of Arab theatrical work (see ch. 5).

Theater in the Middle East and the visual arts have been highly responsive to political circumstances. In fact, theater's ability to continue to sharpen social consciousness or point out the abuses of political power seems to be the yardstick by which its vitality has been measured. The technical success of performances, subtlety of character development, allusions to other ideas current in theater and/or considerations of dramatic language are also criteria applied to a theater that is predominant-

4 See also note 24 infra.

ly one of ideas, perhaps harshly so, when measured against theaters of Western Europe.

In Egypt following the 1952 revolution, in Iran after the 1979 Islamic Revolution, in Syria after the rise of Asad, and in certain other Arab country cases, the public sector came to govern much of artistic production and training. This pertained at least to the formal arts—the "high" arts described in this volume. Due to state control, restrictions, and the overall direction of ideology and social critique, it should be noted that the theater (and sometimes, art and cinema) thus pursued topics of social realism or critique. Such themes were sometimes found in "fringe" or "off-off Broadway" productions in the West where nationally funded theater may not operate. Now, the question was whether the issues of social realism in Middle Eastern theater would be kidnapped, so to speak, by their sponsors, in messages of anti-imperialism, and portrayals of class conflict or whether they would break free into new spaces for critique of social and political ills or exploration of universal human experience. And how would such theater measure up artistically? This is a debate that extends as well to the political novel in Arabic literature. Some critics despaired of the aesthetics of such theater and its stagecraft or pointed to the incomplete development of characters in politically grounded plots. The theater in Egypt following the 1952 revolution has been studied and dramatic works of the 1960s and early 1970s have now become classics. But debates about the standards, aesthetics, and weight of cross-national and cross-cultural influences in theater continue, thanks to a very lively experimental theater festival held annually in Cairo (see ch. 1) and to a great deal of similarly spirited activity in Beirut, Tunis, and elsewhere in the Middle East.

A commercial theater in many Arab states (but not in Iran) and elsewhere in the Middle East (referred to in various places in this volume as the *habit* ["decadent theater"] in Egypt) has also continued its development, especially since the outset of open-door economics. It remains, along, with cinema and television, the rival of the "serious" or experimental public or private-sector theater.

Serious and political themes could not be avoided in the growth of a Palestinian theater (see ch. 6). Brechtian, surreal, and experimental elements have also been significantly explored there, as well as in Lebanon, Syria, Tunisia, and Jordan.

Theater has proven to be an especially fertile ground for questions concerning the artist as social commentator and how s/he may be manipulated by or respond to productive considerations, social forces, or even anarchy. 'Ali Salim, an Egyptian playwright, who wrote during the Arab

socialist era, portrayed many of the frustrations of his nation and era. We may note the battles among creators and expositors of art in this dialogue from his play, *The Buffet*:

> Director: Why do you do that?
> Writer: Because I am an artist.
> Director: What do you mean "an artist"?
> Writer: I mean that I am entitled to say anything.
> Director: Then it's chaos when everybody can say anything.
> Writer: No, not anybody, just the artist, and I only say what I
> mean. ('Ali Salim, 1976, p. 141)

Yet, after this idealistic expression of the artist's *raison d'être*, so like that of the clown as described by Yusuf Idris, who has a right—no, a duty—to mock and illuminate (see ch. 3), 'Ali Salim explains that the Director constrains the Writer's freedom, forcing him to delete phrases, add songs and a chorus to his production, and worst of all, agree with the Director ('Ali Salim, 1976, p. 141).

This dismal role for the writer (playwright), whose work lives only on paper if it is not produced, may be contrasted with Sa'dallah Wannus' vision of theater as a continuing social challenge, one that could wield historical allusions (see ch. 8) to suggest contemporary issues, or with Rashad Rida's explanation of Egyptian playwright Karim Alrawi's discoveries of other cultural voices—e.g., Canadian, Chinese, Bosnian. Theater may yet prove the ground for unification of emotional themes of culture, even if historical references create particularities or special "colors."

Middle Eastern Dance

A background to Middle Eastern dance is more fully described in the companion volume. A few of its features bear repeating: the dance's intense musicality, perceived sensuality, and its role in cultural symbolism.

Middle Eastern dance, whether performed informally or staged possesses its own special movement vocabulary, typically involving many movements of the torso including isolations of the hips, shoulders, rib cage, the head, and even the muscles of the abdomen in *raqs sharqi*, solo Oriental dance. In both folk and cabaret dance genres, the feet step, sometimes in patterns, pivot, and are used to afford lateral movements of the hips; kicking and leg extensions are not common, except in contemporary staged forms of (Lebanese, Syrian, Palestinian, Jordanian) *dabka* thanks in part to the influence of Eastern European choreographers.

For centuries dance existed in tribal groupings for the expression of

tribal identity, for courtship, and for the celebration of certain holidays and rites of passage. The tribal basis of the Yemeni state (like that of Saudi Arabia) has served to maintain its social traditions. Yemeni tribal dance and music constitute a special expression of romantic and poetic traditions as well as a recognizable national identity through sound and movement. Dancers may, as in the northern Sudan, perform significant ritual work,[5] providing symbols essential to the wedding process, for example, or as in Yemen, celebrate other ritual occasions. They are thus exempt from the sinful connotations of dance when it is performed in a commercial setting or in solo form.

A historical dispute has ensued over the origins of solo dance performance converted through a lengthy process into the cabaret forms of *raqs sharqi* ("Eastern, or Oriental, dance") or belly dance in the United States and Europe, which is the subject of the essay by Edward Said and Lori Salem's larger work. We can say with some certainty that dance acquired an association with prostitution in the nineteenth century, but not in all contexts, and that dancers developed their own class, terminology, and status as a trade—as have musicians (Nieuwkerk, 1995). We must also note a bewildering set of cultural influences on the dance forms of the region. Some Iranian and Turkish dance forms share considerable movement vocabulary (although more elaborate arm and hand movements exist in certain Persian dances).

The chapters by Najwa Adra, Lori Salem and Edward Said provide very different insights into the issues of dance performance aesthetics, the social status of performance, and the dance's influence on the self-image of the Middle East (or individual groups, e.g., Yemeni highlanders) or its image in the eyes of American or other foreign audiences. This leads us to the question of the local vs. interactive creation of aesthetics and the way in which the spectacle of a culture "dancing" may transmit meaning (see ch. 10).

Contemporary dance in Cairo has a specific social history, wrote Karin van Nieuwkerk (see also Henni-Chebra and Pôche, 1996; Nieuwkerk, 1995), featuring links to the art and function of the *'awalim* (the *almeh*), who danced for women in the harem, taught music and dance, and sang for, but were unseen by, men. As time progressed, performances for men emerged, but in transitional spaces—the club or music hall—thus lowering the status of these performers.

Lori Salem has explored an East-West crossing in history—dramatic American portraits of Circassian slave women whose performances (or

5 Young, "Women's Performance" (supra, n. 2).

depictions in art) served to underscore the depravity of the Oriental "Mussulmans." When brought across the sea to New York and Boston, Circassian waiter girls conveyed sensuality, as did dervish performances for tourists in Cairo in these colonialist years (see ch. 11).

Dance fulfilled new functions as it became a common element in film, writes Marjorie Franken, a métier that allows for the re-examination of performance.[6] Tahia Carioca was a tremendous entertainer in live performance, and although later in life she became a character actress and a comic figure, during the heyday of her career she was the very personification of *tarab*, if we apply the concept to Oriental dance. While Samia Gamal insinuated a delicate sensuality, Carioca's performance was earthy and unmistakably erotic (as Edward Said, 1999, p. 193, remembered). She toured the region with Farid al-Atrash and other performers and also made film appearances.

There has not been much systematic discussion of the transformations in *raqs sharqi* that have taken place since the 1940s. These involve the addition of certain movements, and in some cases, the loss of accurate hip work and the influence of folkloric movement like that of Mahmud Reda, Eastern European choreographers, and in recent years, immigrants working in dance in Egypt. Dance videos have proliferated and promote a screen spectacle rather than the close interaction with a live audience. As with visual art, music and theater, aspects of the market for dance, its consumers, and the new venues presented through the development of technology have profoundly affected it.

Music in the Middle East

Middle Eastern music is made up of Arab, Persian, Turkic, Berber, Hellenic, and other musical elements. Music is not entirely secular as is demonstrated in our inclusion of a chapter on Sufi *inshad*. Other religious uses of music (or vocal tonality) include the *tajwid* of the Qur'an, the *adhan* (the call to prayer), the music for the Prophet's and saint's birthdays (*mawalid*) and Ramadan, the eulogies for the Prophet (*mada'ih*), the music for other forms of the Sufi *dhikr* (Touma, 1996, pp. 152–167; Jones, 1977; Nelson, 1985), and songs composed about the hajj to Mecca.

In the contemporary Middle East, the various musical forms have undergone processes of separation and refinement, as well as blending or interaction. The focus of contributions to this volume is firstly on *al-jadid* (the "new"), the Egyptian term for post-1920/30 Arabic music in Egypt and Lebanon, folk music in Lebanon, opera in Yemen, the continuation

6 Marjorie Franken, "Farida Fahmy and the Dancer's Image in Egyptian Film," in Zuhur ed. (1998), pp. 265–281.

of the Iraqi *maqamat*, the *inshad* in Egypt, and the performance and composition of Western music by Middle Eastern performers.

Arabic (and Persian) music is built on modes rather than scales and is monophonic, which means that a single melodic line is the basis of the music. The modal structures, the *maqamat* (similar in some ways to the *raga* system in Indian music) must be represented in Arabic music; the melodies should be composed either entirely in these *maqamat*, which contain microtones, or modulate away from a main *maqam* and return to it. In folk music, a portion (e.g., four or five notes) of the *maqam* may be used instead. The use of improvisation,[7] as well as composed musical texts, and rhythms that do not exist in Western music together with the *maqamat* make up the distinctive elements of all Arabic music played on instruments that either originated in the Middle East or were adapted to musical use here. The important indigenous instruments are: the *'ud* (a lute), the *buzuq*, and the *nash'at kar* (with longer necks and smaller bodies than the *'ud* and with metal pegs); the *qanun* (a zither, with 144 strings) and the *simsimiya* or *tanbura* (a Red Sea coast, Sinai, and Nubian-based lyre); the *nai* (a wooden flute, the *salamiya* is a soprano version and the *kawala* has a deeper voice) and the *mizmar* or *arghul* (a reeded pipe or double pipe played with circular breathing); the *rabab* (a one- or two-stringed, bowed instrument) and the *kamanja* (a bowed and spiked stringed instrument, and today, meaning a violin); the *tabla* or *darbukka* (a clay or metal drum played with the palms), the Lebanese *tabl* (a giant drum played with sticks) the *daff* or *mazhar* (frame drums or tambourines, with or without cymbals), and the *sagat* (metal finger cymbals). In Iraq, the *santur* is played in place of the *qanun*, along with the *djoze*, the four-stringed *rebab*.

In the modern music composed by Farid al-Atrash and sung by the Lebanese Fairuz (see chs. 14 and 15), imported and adapted instruments may be heard, including the European violin, which replaced the *kamanja* in urban music from the late Ottoman period onward, the viola, the cello, the double bass, various wind instruments, the guitar, castanets, and specially adapted brass and keyboard instruments, such as the saxophone, accordion, organ, and even the quarter-tone piano.

In the twentieth century, Arabic musicians and vocalists developed and transformed their repertoires, which had been heavily affected by Ottoman musical forms and their performance styles; the recording and cinema industries contributed to the fame of performers beyond their local audiences. The small orchestra, known as the *takht* (for the raised

7 Habib Hassan Touma, "The Maqam Phenomenon," in Touma, 1996; see also 'Ali Jihad Racy, "Music," in Hayes, 1983, pp. 136–141.

platform on which it performed) and its Ottoman-Arab repertoire formed the basic musical vocabulary to be learned by performers, composers, and singers. The introduction of folk traditions, as in some of the songs of Farid al-Atrash, the work of Fairuz, the Rahbani brothers, Wadi' al-Safi, and many others, altered that classical repertoire, as did the influence of great early performers and innovative composers like Muhammad Abd al-Wahhab and Umm Kulthum.

The introduction of musical theater, the establishment of music halls and clubs, the growth of the recording industry, the addition of sound to cinema (thus the creation of musical films), and the introduction of many Western instruments and compositional forms were all factors that transformed music over the century. The blending of regional with urban musical elements as well as the continuity of regional music represent other trends.

Singing stars were an advent of this century. I have written on the singer Asmahan, and here, on her brother, Farid al-Atrash. Sami Asmar discusses four figures who became famous in the third quarter of the twentieth century, singers Fairuz and 'Abd al-Halim Hafiz and 'ud performer Munir Bashir, and with Kathleen Hood, writes on Wadi' al-Safi. Neil van der Linden discusses the singers of Iraqi *maqam* (see ch. 16). Our interests are in their specific place in the industry, the sources of their *tarab* and popular appeal, and to provide discographies for novice readers.

Ethnomusicologist 'Ali Jihad Racy was interested in the particular attitudes toward performance and performers as expressed in Lebanese colloquial terms during the period preceding the civil war. These indicated an ambivalence toward the musician and his craft that reflected the multiplicity of musics and audiences during those years from the more elite (read, more Westernized) to the least respected (the gypsy street musician).

The role of the musician is both vital and sometimes degraded. It is circumscribed through social practice, and over time the musician, like the Iraqi *maqam* singers, may become something close to a cultural guardian. Music may come under attack whether, as in the Arab world through the pressures of Western pop recordings, or as in Iran, through the ban on both pop and Persian classical music imposed at the outset of the Iranian Islamic Revolution. It seems that classical Persian music has been resuscitated, although women were not allowed to perform and teach for many years. Singers like Fatemeh Vaezi, known as Parisa, and the singers Hengameh Akhavan and Bima Bima have been permitted to perform for female audiences, accompanied by women musicians. The Kurdish singer Ghashang Kamkar performs with her family members and the Armenian conductor Gorgin Mousissian has established a large

female choir in Iran.[8]

I have included several shorter selections in this section. The work of Philip Schuyler, a respected ethnomusicologist who has studied and encouraged the further study of a wide variety of issues affecting Middle Eastern music is here represented by a short sample on an operetta, composed and performed to elicit awe at the power of history and nation in Yemen (see ch. 18). This experiment allows us to see another side to the projects of culture and identity that contrasts with the issues that Najwa Adra has explored.

Western classical music is studied and performed in much of the Middle East, and some of its features have been explored in an earlier short essay by Selim Sednaoui.[9] In this volume, Sednaoui describes an experiment launched by Daniel Barenboim and Edward Said that he attended in the summer of 1999, which was designed to provide a special experience for young Middle Eastern performers, but also demonstrated the presence of a large number of talented youth in an area that is debatably universal or particular.

Painting and Visual Arts

Painting is in some ways a truly contemporary art in the Middle East. In other ways, we see its alter ego in the hajj paintings on buildings of Upper Egypt (Parker and Neal, 1995) and in the brilliant pastels brightening the myriad concrete rectangular apartment buildings springing up in the formerly desert suburbs of Cairo.

This leads us to a distinction between work that has been dubbed, perhaps erroneously as mere folk art and décor, on the one hand, and studio art, on the other, with its new techniques and state-sponsored introduction (Ali, 1994, pp. 73–74). Folk arts are considered crafts, despite their often brilliant execution of design, as in rugs, the Druze round straw mats of southern Syria, the Syrian embroidered cushions and hangings, and Egyptian tentmakers' products.

Just as Western artistic and cinematic techniques strongly influenced the establishment of cinema in Egypt, Syria, Algeria, and throughout the Arab countries by the 1960s, the development of art education in the Middle East involved an international dimension. Governments sent artists to train in Western academies, or native artists returned from their own self-launched foreign careers to train others. In some cases, as in

8 Maryam Habibian, "Under Wraps on the Stage: Women in the Performing Arts in Post-revolutionary Iran." Paper presented to the Middle East Studies Association annual meeting Washington, D.C. Nov. 19–22 1999.
9 Selim Sednaoui, "Western Classical Music in Umm Kulthum's Country," in Zuhur, ed. (1998), pp. 123–134.

Iraq, local and Western artists directly influenced Middle Eastern artists, first by officers trained in military college in Istanbul, and later by Polish artists in the military who came to Baghdad during World War II (Ali, 1994, pp. 87–88).

According to Wijdan Ali, nearly all Arab artists passed through a stage in which European traditions and aesthetics in art were taught, followed by a period of self-discovery during which they chose "local subjects and themes." When they then entered a "search for identity" phase (Ali, 1994, p. 73), many investigated their own visual heritage. That heritage involves many aspects of visual art, not only painting. The decoration of various surfaces (architectural elements, objects, tiles, etc.), textile production, architecture, and garden design have as lengthy a history as the other art forms discussed in these volumes.

Space precludes the addition of an essay that compares the contemporary work in the visual arts in Beirut with that in Cairo. Yet the vitality and breadth of contemporary métiers and approaches in these two cosmopolitan centers nevertheless demand one's attention. Artists in Beirut are experimenting with painting within old wooden window frames, just as Omar Fayyoumi of Cairo has in a slightly larger scale. Artists are also painting murals, as in Muhammad Abla's image of Kum Ghourab, on a traditional mud-brick building.[10] Another Cairene artist, Anna Boghiguian, has created an entire experience of color in the foyer of the AUC Press building, depicting the street settings of Cairo's literati and utilizing the architectural features of the space in amusing ways.

New concepts of art "for the city" were apparent in Lebanese sculptor Nadim Karam's eleven huge and whimsical pieces that moved through the downtown Beirut area in 1998. The late Michel Basbous created richly warm wood sculptures, and his son Anachar is interested in redeeming buildings with mosaics. While the theme of resurrection and rebuilding can hardly be avoided in postwar Beirut (Gauche, 1998, pp. 2–5), small galleries in Cairo organize work around other themes, as in the Mashrabiyya Gallery's fall 1999 exhibit on the color blue including two small gems by Effat Nagui, striking tongue-in-cheek photographs by Chant Avedissian, and Hihi's brilliantly blue creatures with an ET-like appeal. Other favorites include Gazbia Sirry's continuing interest in "pure" lines with local inspiration, and the movement of a younger painter, Mahir Ali, from semi-Cubist portrai-

10 Muhammad Abla, "Kum Ghourab," still from Cairo Video Visions 2, an exhibition sponsored by the Arts Council of Switzerland, Pro Helvetia Cairo at the Hanagir Gallery. Also in Alyaa El-Giredi and Sameh El-Halawani's work in the Mar Girgis neighborhood.

ture to a somewhat festive surreal style.

An annual Youth Salon for artists under age 35 is sponsored by the Egyptian Ministry of Culture, since normally they are forced to compete with established artists and artist-academics (El-Jesri, 1998, pp. 72–79). In the work of these young artists, an exhibit entitled "Alexandrian Inspirations," and in Margo Veillion's 2000 exhibit, the question of cultural references perennially arises—or those of gender and class, as in the work of Mariam Abdel Aleem.

In Beirut in early 2000, one could move from a display of Gibran Kahlil Gibran's spiritualist paintings to a vast array of approaches in private galleries, some of which included intriguing similarities to certain installations to be found in Cairo's first privately sponsored arts festival, called *al-Nitaq* and held downtown, and which sought heightened interaction between ordinary people and galleries.[11]

Economics intrude into the art world. In various Arab countries, artists, like playwrights and musicians, suffer from the higher valuation accorded to Western products (whether artistic or not). The inter-Arab or Middle Eastern art market is narrow, as there is not much exposure to artists of other Arab countries. The artists of Cairo by and large do not know the artists of Beirut, Amman, Jerusalem, or Gaza. Nor do their buyers. Hence, some must produce other varieties of art products for sale to tourists, foreigners, or locals with special tastes. For example, a Sudanese painter of primarily abstract work, Hussein Sheriffe also provided the designs for boldly printed black and beige gift-wrapping paper. Artists may produce designs for household objects like candle holders with Muski glass instead of "pure" sculpture. The importance of the tourist sector in the Middle East affects artistic production in that visitors are attracted and directed to visions of the ancient past and prefer papyri or copies of pharaonic statuary (in Egypt) or Roman/Nabataean designs or fossil fish (in Lebanon) to any contemporary *objets d'art*.

The tensions between the individual and the national framing of art are intensely experienced in the visual arts, and have to some degree displaced the earlier focus on tradition versus modernity. Can one be an Egyptian artist without referring to symbols evoking the land or nation (e.g., Muhammad Abla's fish, frogs, and birds in his Nile series[12])? Or even more directly in Salah Enani's, Attia Hussein's, or Said Hedaya's work? The Lebanese artists may no longer allude to the terrible *hawadith* ("civil

11 Featuring works by many artists including Hisham Nawar, Shady al-Noshakaty, David D'Agostino, Natheer El-Tanbouli, Muhammad Abou El Naga, Sherif and Silvie Defraoui, and Khaled Hafez. See "Contemporary Voices—Cairo's First Art Festival, al-Nitaq" and Nabil Ali, "In Two Words," *Medina*, 12, March–April, 2000, pp. 84–88.
12 *Mohamad Abla, Der Nil 1998*. Exhibit catalogue. Cairo: Goethe Institute, 1998.

war"), as in Ginane Bacho's "Image of the Word: The Image of the Picture" (1985 and included in *Images of Enchantment*), but can they attract buyers without specific social and historical allusions?

One motif that Wijdan Ali has explored and discussed elsewhere is the use of calligraphy as a graphic form in art. She uses calligraphy boldly in her own work, as do many other artists, including Huda Lutfi. Lutfi began her interest in making art through looking and practicing calligraphy; she comments, "When I relaxed through calligraphy, my mind became empty; it was an act of cleansing thoughts, an act of meditation" (see ch. 20). Calligraphy is not a neutral symbol or design motif, however—it evokes the Islamic past.

I noted in *Images* that a large number of contemporary Arab artists introduced female images to create metaphors for the loss of individualism, national rights, political suppression. This imagery is related to our discussion of political cartoons and the symbolic casting of Egypt as a woman (see ch. 21). Lutfi's work introduces female Coptic-doll figures that are encased in brilliant red and turquoise bars. This differs from the earlier treatment of women's figures by Inji Efflatoun, or Mahmud Said's elegant yet rounded "Dancer with Takht" (1949) or "Banat Bahari" (1937).

Lutfi has some important contributions to make to the debate over the utility of art. Viewing art as meditation or as a means of exploring history and as education for the soul are three different and important themes mentioned in the interview we have included (see ch. 22). Education for the soul, or training in creativity, seems to me the most important aspect, and one that Lutfi has shared with children in Cairo. Children make art for commercial purposes as well, as in the weaving projects (or rug factories) of the outer Giza villages, in the Bedouin work produced near El-Arish, yet the matter of child labor poses a delicate question that can perhaps be balanced with the ideas that artists provide of play and exploration through art.

Artists like playwrights, composers, and other performers have struggled to shape their own identities in nation-states that have iterated the battle for autonomy from the West in ways that may be incongruent with artists' views or interests. The particular form of the state in the Middle East, with its centralized and nationalist content has perhaps fostered the arts far more generously than artists in America, for example, can expect. Yet the special debates concerning the nature of art, the artist, the performer and art's role in cultural production are subject to market forces as explained above and could benefit from more exposure.

Theaters of Enchantment

1 Revisiting the Theater in Egypt: An Overview
Mona Mikhail

It is necessary to look back into the past before making a proper assessment of the state of the art of the Egyptian theater and situating it within a broader cultural framework. From the outset, a strong relationship has existed between the Egyptian government and cultural life. This relationship continues to undergo significant changes. Along with a re-evaluation of government involvement in the management of the economic infrastructure, there have been heated debates that aim to develop a critical and creative response to the new realities of the new millennium. Today there is no possible discussion of cultural forms without some consideration of the new media and communications technologies, which are presenting the government with distinct challenges to various policies, yet also offering novel means of responding to earlier demands for cultural access and entitlement.

Egyptians first encountered the modern theater in the Napoleonic era, following that leader's expedition to Egypt in 1798. Napoleon had brought along two well-known musicians, Filot and Rigel. He had also written a message to the government of the Directoire and asked it to transport a troupe of actors to Egypt. When that troupe arrived, it performed in the home of Karim Bey in Bulaq.

The first theater erected in Egypt was known as *Masrah al-Jumhuriya wa al-Funun* ("Theater of the Republic and the Arts"), according to Muhammad Sayyid Kilani (1958, p. 108) in his study of the era. Napoleon founded a huge theater facing the pond of 'Azbakiya where plays were performed in French as entertainment for the soldiers. However, this theater was destroyed during the 1799 uprising. Subsequently, General Minou rebuilt it and it was then named *Masrah al-Jumhuriya* ("Theater of the Republic"). Two of the plays performed there—*Al-Tahanin* ("The Bakers") and "Zeus and Fauclair"—concerned Bonaparte in Cairo. We are told that many of the actors were drawn from the scholars accompanying the expedition. Some of these facts were recorded in the French papers, such as *Courier de l'Égypte*, one of the earliest French publications in Egypt, printed to entertain the Napoleonic troops. Periodically it published advertisements of social clubs, so for instance in its thirteenth number, published in 1799, we

find an advertisement for a social club in Cairo stating:

> Since the French present now in Cairo feel the need to meet in a
> gathering place where they can find some rest and entertainment
> during the long winter nights, therefore Citizen Dargeavel took on
> the task of establishing a private club to provide them with all the
> amenities of society, after obtaining permission from the
> Commander General. He chose a large mansion with a garden in
> the 'Azbakiya quarter, where the French can enjoy themselves.
> This may be a means of drawing the inhabitants of the country
> (Egyptians) and their women to enter our society, and teach them
> in this indirect way some of our customs and traditions.[13]

The *Courier de l'Égypte* published numerous advertisements about
similar artistic activities, such as the establishment of an acting society
that on the thirtieth of Frémier of the eighth year of the Republic
(December 20, 1800) presented a play by Voltaire and another by
Molière. At about this time, the earliest mention in Arab/Egyptian
sources of the theater appears in al-Jabarti's chronicle; regarding events
of Shaban 11, 1215 A.H. (December 29, 1800), he wrote:

> The place they erected was completed at the 'Azbakiya known as
> *Bab al-hawa* ("the gate of air"), known in their language as
> "comédie," and it consisted of a place where they meet once every
> 10 days to watch for one night *mala'ib* ("dramatized," "played")
> actions performed by some of them for the sake of their enter-
> tainment, which lasts for about four hours of the night, and in
> their language. No one enters without a "pass" or special paper
> (al-Jabarti, 1986, p. 202).

The chronicler al-Jabarti, as reported by the *Courier de l'Égypte*,
wrote in great detail about the performances, for instance, of two plays
Le Sourd and *Le Dragon de Thionville*. He commented that there were
plans to expand the theater hall to double its capacity and he added that
he would have liked to elaborate on the architectural beauty of the the-
ater itself, which was developed by an engineer named Fauvé.

The *Courier*, an excellent source of information concerning the ori-

13 Mahmud Naguib Abu al-Lail, *Al-Sihafa al-faransiya fi Misr mundhu nash'atiha hatta
nihayat al-thawra al-'arabiya*, (1953), pp. 77–78, cited by Sayyid 'Ali Isma'il, *Tarikh
al-masrah fi Misr fi al-qarn al-tas'i 'ashar*. Cairo: General Egyptian Book
Organization, 1998, p. 12.

gins of the theater, also describes the plays *L'Avocat Patelin* and *Les Deux Meuniers* in detail. These small operettas were written by Citizen Balzac, a member of the arts committee. The musical score was composed by Citizen Rigel, a member of the French Academy. The story is about an intentional misunderstanding used by a rival to break up a couple in love. The story ends happily when the young lover wins over his beloved, the daughter of the baker, and the attempts of the elderly, conniving gentleman are foiled. The naïve plot of the triumph of love and the return to equality is symptomatic of the tastes of the day. The *Courier* points out that this kind of play was bound to please the audience. It also reported that many of the elite and socialites of the Turkish/Ottoman society attended as well as many of the Christians and Europeans.

Al-Tahtawi, in a chapter on Parisian leisure spots in his celebrated *Talkhis al-Ibris, fi Talkhis Baris* ("Manners and Customs of Modern Parisians"), notes:

Their [the Parisians'] places of leisure are known as *Theater* and *Spectacle*. These are places where plays are performed; in reality, these are interpretations of serious matters in a form of entertainment and humor. People can draw from these plays great and strange morals, for they see in them all good and evil acts, while they praise the first (the good) and denounce the latter (the evil). The French believe this makes for good behavior, for if it encompasses much satire and humor, it also induces tears and sorrow.... These theaters are beautiful homes with wonderful domes. They comprise many stories and in each story there are rooms (*baignoires*) placed round the dome on the inside. In one of the corners of the theater is a wide seat (*stage*), which is visible from all those aforementioned rooms. All the action on the stage is visible as it is lit by splendid chandeliers. Right under the stage is a place for the instrumentalists (*orchestra*). The stage is connected with the backstage areas that house all the instruments relevant to the plays as well as all the props and all matters connected with the plays, including a place for all the actors, both men and women.

So if, for instance, they wish to portray a sultan and his actions, they would transform the stage into a palace (*décor*) and portray him by singing or using his very words, etc.... During the intermission, the stage is reset behind the curtains so that no one from the audience can see what is occurring. After the *entr'acte* (intermission), the curtains rise and they resume their play. As for the women "players" (*actresses*) and the men, they are simi-

lar to the *'awalim* (dancers and singers) in Egypt. What is quite extraordinary is that they sometimes can speak of very serious and scientific matters and they get quite involved in what they are doing while performing to the extent that one may think they are true scholars.

In continuing he gives information about the manner in which they publicized these plays:

The play is advertised on papers that are placed on the walls of the city, and it is publicized for the elite as well as the general public. In short, one can say that the theater for them is like a public school where both the learned and the ignorant can learn. The greatest of the *spectacles* in the city of Paris is known as the *Opera*. The greatest instrumentalists and dancers perform there. Singers are accompanied by pantomimes in silent movement that relates strange happenings. There is a theater named *comique* where happy poems are sung, and another theater known as the *Italian* which includes work by the greatest musicians, where poetry in Italian is sung (al-Tahtawi, 1993, pp. 207–240).

The travel literature is replete with references to the earliest of theatrical performances in Egypt. Edward Lane's reports, as found in Jacob Landau's seminal work on the origins of cinema and theater, are enlightening concerning these early attempts (Landau, 1958, p. 51). Lane's recording of the very first play by the well-known *mihabazatiya* troupes is important in that it is the first time such a text was recorded (Lane, 1836 [1978], pp. 384–386).

Lane indicated that the Egyptians are greatly amused and entertained by the plays presented by what he called *mohabbazeen*, "players of low farces." They usually performed during celebrations of weddings and circumcisions, festivities usually held in the homes of the elite. The actors were solely boys and men; women's roles were performed by disguised boys or men. A typical play would include stock characters such as *shaykh al-balad* ("chief man of the town") and his servant, a custodian, a Coptic scribe, a peasant indebted to the government and his wife, and five other persons, two of whom would serve as drummers, the third would play the flute, and the other two would dance.

We may also look to Shaykh Sayyid 'Ali Isma'il's rich contribution to the history of the theater in the nineteenth century. His book is drawn from several as yet untapped sources; for instance, his research in the

well-known periodical *Wadi al-Nil* has produced valuable information, especially concerning the censored plays of the day. He informs us that the Khedive Isma'il established a circus in the 'Azbakiya quarter (where the national theater, *Al-Qawmi*, stands today). We are told that in 1869 the art of pantomime was practiced in that circus, which inspired the foundation of other circuses (Isma'il, 1998, pp. 22–23). In 1889 *Cirque al-Hilw* was established and continued in existence until the mid-1950s. It has been revived recently and is performing to enthusiastic crowds in the Balloon Theater (in 'Aguza) since January, 2000.

'Uthman Galal spearheaded a movement of Arabicization of the French theater when he wrote his play *Al-Shaykh al-Matlouf*, a take on Molière's *Tartuffe* in 1873. There is further evidence that Galal translated several other plays in 1870, which could help reassess the pioneering role of Ya'qub Sanu'a, who has been credited thus far as the founding father of Egyptian theater.

If we move from these early days to observations of the contemporary scene, we see that the phenomenal growth of the theater in Egypt in the past couple of decades and the prospects for its growth in the twenty-first century hold great promise. Whether we look at the state-subsidized institutions or the lucrative commercial sector, we must note how the theater in Egypt has grown and developed in most interesting ways in the so-called post–open door era. The rich and varied productions that are seasonally produced by both the commercial sector and the state-sponsored theater, mainly al-Qawmi (the National Theater) as well as the widely successful al-Hanagir experimental theater, are ample proof of the vitality of this understudied domain of Egyptian culture. The experimentation of dozens of independent troupes, alongside the lucrative success of the *masrah al-habit* ("decadent" theater, pejorative term for the commercial theater) is evidence of an ever-growing audience who are eager for entertainment. The hope is that with time, theatrical tastes will become more sophisticated and demanding and that larger audiences will grow to further appreciate the avant garde and the Tajribi ("experimental") Theater Festival, held annually in early September.

Indeed, the Tajribi Festival, which celebrated its twelfth season in 2000, is a much anticipated cultural event that sparks great interest in the press, often laced with heated controversy. No matter, its events are by now well ensconced in the theatrical milieu as a source of inspiration—experimentation being the first stage on the road to innovative and distinguished theater. It is undoubtedly a vehicle for the presentation of new aesthetics, as it were, that dare to venture into uncharted domains. The Ministry of Culture in Egypt, the prime mover for this event, has

adopted and supported this experiment as a fundamental aspect of its overall project to revive an atmosphere of enlightenment that harks back to the early decades of this century, the *asr al-tanwir* ("age of flowering," "enlightenment"), when the theater took root and began its long-flourishing development.

Before delving more specifically into the definition of the role and influence of the Tajribi Festival, it is appropriate to survey some aspects of the theater in general in Egypt. It is interesting to note that the Ministry of Culture has instituted a special day called *yawm al-masrah* ("theater day"), dedicated to officially celebrate the presence of the theater within society. That occasion often coincides with the publication of books and monographs that underline the loyalty to and recognition of the founding mothers and fathers of this art form. Writers, dramatists, and actors are celebrated. Names that resonate with both an appreciative readership and avid audiences are included. These range from Ahmad Shawqi, the prince of poets and author of some of the most enduring poetic dramas, to Tawfiq al-Hakim, father of the modern Egyptian theater, to Naguib Rihani, a school for comedians unto himself; Badi' Khairy, Rihani's worth successor; and Zaki Tulimat and Ahmad Bakthir, who have left indelible imprints on the theater.

The major, well-established troupes who participate in this event and in productions during the rest of the year are *Al-Qawmi* (the National Theater), *Al-Hadith* ("the Modern Theater"), *Al-Masrah al-Kumedi* ("the Comedy Theater"), *Al-Tal'ia* (avant-garde), *Masrah al-Shabab* ("Youth Theater"), the Puppet Theater, the National Theater of the Child, and the Hanagir Theater and Art Center.

A brief survey of the activities of any given year can give us an insight into the variety and versatility of the productions presented to the Cairene audiences as well as the audiences in some of the governorates in the Delta. If we look at the 1996 season as an example, we may note the remarkable array of works by both Egyptian and international writers.

There was a very successful revival of *Al-Sitt Hoda* ("Lady Hoda"), Ahmad Shawqi's last and only poetic comedy directed by the well-known and respected Samir al-'Asfoury at two theaters, the Sayyid Darwish and the George Abyad (both houses are named after giants of the artistic world). Ticket sales exceeded six thousand.

Alfred Farag's innovative comedy *Gharamiyat 'Attwa Abu Matwa* ("The Loves of 'Attwa Abu Matwa") played to over 20,000 spectators for a run of little over a month. Harold Pinter's *Guard*, directed by Muhammad 'Abd al-Hady had a respectable 2,000 viewers for its rela-

tively short run of three weeks. The controversial, timely play of Muhammad Salmawy, *Al-Ganzir* ("The Chain") which deals with the Islamist dilemma in contemporary society, had a whopping 55,000 viewers and played for close to a year at the Salam Theater.

The perennially popular Puppet Theater presented *Al-Faris al-Asmar* ("The Handsome Dark Knight"), directed by Muhammed Shakir to close to 20,000 enthusiasts. Imprecise though they may be, these statistics, gleaned from a publication of the Ministry of Culture, do shed light on the growing interest in serious theater. This profile naturally pales when compared with the sold-out plays and the outrageously expensive tickets of the commercial, or *habit*, theater.

Another trend that betrays a growing interest in serious theater can be seen in the list of presentations at al-Hanagir. Surveying a year's worth of presentations reveals that this theater is in many ways a great experimental forum. It is under the dynamic and capable direction of Dr. Hoda Wasfy, a scholar in the department of French literature at 'Ain Shams University in Cairo who has written extensively on such founding fathers of the theater as 'Uthman Galal. A cursory look at the presentations at al-Hanagir in one season may also give us a hint of its vitality and diversity. It hosted the Ishraqa group, which presented *Island of Slaves* by Marivaux, while the al-Daw' troupe presented the famous Japanese masterpiece *Rashomon*, by Okatagawa, whose action is set in the ancient city of Kyoto. The producer Tariq Sa'id chose this work for several stated reasons. First, he said it had not been presented in Egypt since 1961, when the Pocket Theater ventured to produce it. Secondly, he claimed the text was an exceptionally rich one that presented totally novel references that would be interesting to Egyptian audiences because of their unfamiliarity, such as allusions to torrential rains, thunder, and winds. More importantly, the director and his troupe felt that the play encapsulated truths that are in themselves multifaceted. Thematic elements also justified Tariq Sa'id's choice of this classic. For example, the "other" is not to be rejected merely for holding different views—a theme that resonates poignantly in a beleaguered society where fringe groups attempt to impose their extremist views. Such an ideological choice on the part of a director is actually very much within a long tradition of theater in Egypt. Consider the theater and its progression from its earliest experimentations of adaptations of purely Western plays, particularly the French and Italian theaters of the early 1920s.

The 1960s were also great years of experimentation. For instance, the central role that Berthold Brecht played in many parts of the Arab world

is significant. Rashid Bu Sha'ir devotes an entire study to the impact of Brecht on the theater of the Arab East (Bu Sha'ir, 1996). His popularity in Syria, Iraq, and Egypt coincided with the then-growing interest in socialist ideologies among intellectuals and literati. Brecht theorized that the theater can play a pivotal role in directing and changing a viewer's consciousness, and thereby can manipulate society. Bu Sha'ir sees this Brechtian impulse, for example, in the work of the late Sa'dallah Wannus of Syria who articulated a search for an Arab theater as a theater of struggle and change.

Today writers and directors may be wavering between traditional Aristotelian criteria and a theory of commitment in Brechtian terms. The politicization of the theater is a subject of great debate as it has been for decades, responsibly treated by such critics as Louis Awad, Muhammad Mandur, and Mahmud Amin al-'Alim among others. The question was, as Wannus put it in an interview with *Al-Ahram* in 1995, was to make a distinction between "a theater that is interested directly in politics and a theater that conducts politics."

From this perspective, then, we can see the importance of the choices that are made on a daily basis, be it for the regular annual repertoire or for special productions within the Tajribi Festival. In 1996 the eighth Tajribi Theater Festival hosted 45 foreign troupes with a total of 900 performances (see **figures** 1 and 2). That year Egypt won the first prize for direction for an adaptation of al-Tahir 'Abdallah's poignant tale of mythical parameters, *Al-Tawq wa al-Iswirra* ("The Neckring and the Bracelet"). The play was also made into a very successful feature film starring the actress Sharihan.

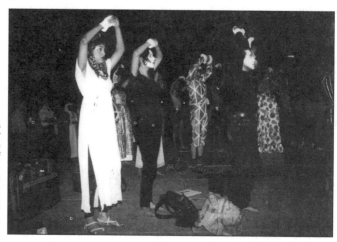

Figure 1. A view of "Under the Doorstep in Search of Identity," performed at the Tajribi ("experimental") Theater Festival in Cairo, 1996.

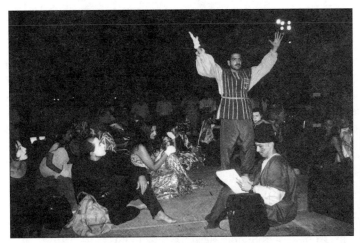

Figure 2. In this second view of "Under the Doorstep," audience members need to stand to experience the action of the performers.

The annual Tajribi Festival publishes a daily bilingual English/Arabic newsletter to keep the participating contestants and the public abreast of the various activities, and it gives an approximate idea of the diversity of this extraordinary multicultural event. For instance, the newsletter of September 5, 1996, reported that on that day alone the public had the luxury of choosing among troupes from Romania, Lebanon, Switzerland, Palestine, Portugal, Brazil, South Africa, the Ukraine, Jordan, Italy, the Czech Republic, and the Netherlands. Every year there is a focus of parallel publications that highlight a specific theatrical tradition; these are chosen and then translated into Arabic. In 1996, for instance, Latin American theater was thus honored.

Equally interesting is the criticism that some of these productions elicit. Often some productions give rise to heated debates in the press, sometimes concerning some of the taboos that certain plays and productions challenge. The Syrian Sa'dallah Wannus' highly acclaimed work, *Tuqus al-Isharat wa al-Tahawalat* ("Rituals of Signs and Transformations"; see ch. 8) received both rave reviews and equally vicious attacks in the general press. The daring, innovative direction of Hassan al-Wazir and the performances of Sawsan Badr and Hamdi al-Wazir in this play were highly acclaimed by both supporters and detractors.

The works chosen for the Tajribi Festival intentionally vary in style and range. Whether classic dramas or action-driven Broadway-type shows, they mostly have a reinvigorating effect on the theater milieu in Egypt and the Arab world. As mentioned earlier, all the shows are not uncritically accepted. In fact, one comes across comments such as this

one by Medhat Abu Bakr in the Tajribi newsletter in September, 1996:

> Some understand the experimental in a very wrong light
> Experimentation is not merely a 'painted' face of one seated under
> a chair utters occasionally the word 'boo' once in a loud voice and
> once whispering. Or someone playing with matches in a dark
> space. Or again, someone standing with his back to the audience
> for three quarters of an hour and suddenly turns to us howling.
> Experimentation in the theater is rather wide spaces of 'beautiful'
> creativity performed in total freedom without booing or howling."

The reemergence of traditional forms of the theater that retell classic
tales and reenact epic battles such as *khayal al-zill* ("the shadow the-
ater"), which was threatened with extinction, has also been influenced
by ideas from experimental theater. This fantasy of shadow, popular
throughout the Middle East, has been performed in Egypt since Mamluk
times. The simple tools, a white cloth screen, lit from the rear, and one-
dimensional puppets with movable body parts manipulated by the deft
hands of the puppeteer enchant both young and old. The minstrels/pup-
peteers of this theater used to crisscross the country, entertaining hordes
of enthusiastic viewers, especially at *mawalid*, festivals of holy men and
women. This local form of Turkish *karagoz* has in recent years been prac-
ticed by Ahmad al-Komi, who manages a small troupe of musicians and
entertainers, and has been featured in Hassan al-Geretly's version of
Dayrin Dayr ("All Around"), an avant garde production of the El-Warsha
theater (see ch. 4).

The Tajribi Theater Festival has undoubtedly provided unusual
opportunities to new generations of actors and directors, as well as tech-
nicians (prop, lighting, and sound) and costume designers to produce
and direct a unique training ground for the future. The extent to which
it has influenced the local theater can be assessed only after it has been
on the landscape for a more substantial length of time.

2 Burnt-Cork Nationalism:
Race and Identity in the Theater of 'Ali al-Kassar
Eve M. Troutt Powell

With its stark and dramatic play on contrasts of skin color, blackface performance amused generations of audiences across the globe for years. But although the makeup was the same wherever blackfaced entertainers performed, audiences were clearly not laughing at the same spectacle. How, then, does blackface performance translate? This essay explores the comedy of the Egyptian vaudeville actor 'Ali al-Kassar (see **figure** 3) and the political significance of the character for which he became famous, Osman 'Abd al-Basit, *Barbari Misr al-Wahid* ("the one and only Nubian of Egypt"). In 1916 'Ali al-Kassar began to perform in blackface makeup as Osman and the character became a popular mainstay of Egyptian theater for decades (see **figure** 4). But when 'Ali al-Kassar first began to perform in Cairo, before his Nubian character became something of an institution, the traditions of Egyptian theater had recently grown politicized and very diverse. The neighborhood of 'Azbakiya had long been the European quarter of the city, where European cultural tastes informed what was performed in the nearby opera and other theaters. But by 1916, Egyptian artists had insinuated themselves into many European-owned nightclubs and theaters and

were also beginning to create their own theaters. At a time of heightened nationalist feeling, there developed within the Egyptian popular press a discussion of realism within the debate over *what* should be performed within Egyptian theater.

Within such a context, then, the staging of any show in Cairo was political, no matter what stance was taken ('Awad, 1979, p. 8). Questions of national and cultural identity and social mobility were presented to Egyptian audiences every night in 'Azbakiya, their authenticity tested by the amount of applause or laughter they drew. Drawing on manuscripts of

Figure 3. 'Ali al-Kassar, *Effendi*, without stage makeup.

Figure 4.
'Ali al-
Kassar in
blackface
in *Abu
Nuwas.*

'Ali al-Kassar's earlier original comedies, this study examines the complicated way in which 'Ali al-Kassar and his writers fused the issues of racial and national identity. In many of the plays, both British and Egyptian officials question or tease Osman about his black skin and his racial origins. In his protests against British indignities, Osman's Nubian identity becomes a conduit through which Egyptians could express anger at British racism. But when confronting hostile Egyptian characters, Osman's pride in his racial heritage serves as a criticism of indigenous racial attitudes. His racial identity also performs an important political purpose, his humorous but fierce assertions of being half-Nubian, half-Sudanese, and all Egyptian reinforced the idea of the unity of the Nile Valley, a political concept very important to Egyptian nationalists in the early decades of the twentieth century.

Blackface on the Historical Stage

The Sudan had been a critical part of Egyptian nationalism since the movement's beginning in the late nineteenth century. Egyptian armies had conquered the Sudan in 1821 under the orders of the Ottoman viceroy and ruler of Egypt, Muhammad 'Ali Pasha. But though he governed Egypt in the name of the Ottoman Empire, Muhammad 'Ali intended to make Egypt a regional power in its own right, and the colonization of the Sudan was one means toward achieving this goal. He created a military administration there, which governed much of the Sudan for the next 60 years. In 1881, however, a powerful Islamic rebellion, the Mahdiya, rose up against the Egyptian administration; by 1884 the forces of the Mahdiya had laid siege to Khartoum and taken control of what had once been the Egyptian Sudan. Contemporaneous with these events in the south, the north was also experiencing resistance. In 1881, the first nationalist rebellion emerged in Cairo to protest increasing European control of Egyptian finances. Initially the rebellion was very successful, but by the fall of 1882, British forces suppressed it and occupied Egypt. In only a few short years, Egypt was transformed from

a colonizer into a colonized country. This embittered many nationalists and in the decades subsequent to the occupation, many published articles and letters in which they simultaneously called for Egyptian independence from Great Britain and the reconquest of the Sudan. This duality of perspective, this history of double colonialism makes 'Ali al-Kassar's choice of character that much more emblematic of Egyptian feelings about the Sudan. Burnt-cork makeup brought it that much closer to home.

There is also a wider context in which to consider blackface performances as well. Where blackface minstrelsy became most notably and controversially popular—the United States and Great Britain during the nineteenth century—it was entertainment in which "white men caricatured blacks for sport and profit." The blacks being caricatured were slaves in the American South, and the songs and dances that the minstrels performed obscured the realities of slaves' lives by "pretending that slavery was amusing, light, and natural" (Lott, 1993, p. 1). Even though many Americans found minstrel shows very entertaining, from its earliest days blackface minstrelsy provoked condemnation as a trivialization of slavery's wrongs. As Frederick Douglass, the famous orator, abolitionist, and exslave, described "black-faced imitators" in 1848, they were the "filthy scum of white society, who have stolen from us a complexion denied to them by nature in which to make money and pander to the corrupt taste of their fellow white citizens" (Lott, 1993, p. 1).

Douglass' words strongly influenced generations of historical examinations of blackface. But in a recent book, *Love and Theft: Black Minstrelsy and the American Working Class*, the historian Eric Lott has raised new questions about the racial politics of blackface performance, suggesting that the white audiences of early minstrelsy "were not universally derisive of African-Americans or their culture, and that there was a range of responses to the minstrel show which amounts to an instability or contradiction in the form itself" (Lott, 1993, p. 15). Lott has demonstrated that very commonly audiences believed that minstrelsy "represented authentic African-American culture" and in so doing, transformed blacks into a popular image of "American folk," an image, when stripped of the pain of slavery, that provided a sense of shared culture, a national culture. Blackface, as Lott constructs it, was thus a means of identification that many American whites made with black culture, a love that could seemingly be expressed only with artifice.

I am exploring whether this concept of blackface as both love and theft is applicable to blackface performance outside the United States and Great Britain. It is fascinating to learn that blackface performance

has been popular across the globe: in Cuba, Jamaica, Nigeria, Ghana, South Africa, India, China, Indonesia, and Australia. Outside the United States, the performance historically traveled along the routes of the British Empire in the late nineteenth century and flourished, as Catherine Cole put it, "perhaps finding fertile soil in the ideology of white supremacy that shaped relations between white and nonwhite populations" (Cole, 1996, p. 195). This was certainly the case in Africa's Gold Coast, now Ghana, but as the majority of the performers using burnt-cork makeup were themselves Africans, what did blackface signify for a colonial African audience? (Cole, 1996, p. 198). In Ghana, during the 1930s, audiences watched a dizzying panoply of identities when they went to a minstrel show. There would be "an African actor, performing in a former slave castle, [imitating] an American Jew [Al Jolson], imitating a white minstrel actor of the nineteenth century, who imitated American slaves, who came from Africa in the first place." Which was the copy and which the original? (Cole, 1996, p. 195). And finally, issues of race were explicitly discussed and debated in Ghanaian newspapers in the 1930s, as they were in Egyptian newspapers when 'Ali al-Kassar first performed as Osman. Still, according to Cole, journalists and readers found nothing offensive in minstrel makeup; rather, just like nineteenth-century U.S. audiences, "they seem to have believed that plantation songs, Sambo plays, and black-face characters in Jolson's movies actually were African Americans" (Cole, 1996, p. 213).

There are close parallels yet also sharp divisions between the performance of 'Ali al-Kassar and those of Ghana and the United States just described. Like the blackfaced actors in Ghana, 'Ali al-Kassar performed for a colonized audience. As in the Ghanian theater, he performed in an environment where the meanings attached to race were very different from those in America. But just as Lott described blackface as part of a nationalization of U.S. culture, 'Ali al-Kassar made his black character, Osman, a symbol of heartfelt Egyptian nationalism. In important ways, however, this homegrown quality of Osman's distinguishes this character from other traditions of minstrelsy. 'Ali al-Kassar's Osman character did not refer back to the plantation slaves of the American South but was from all parts of the Nile Valley. In fact, Osman possesses many of the characteristics of black figures created by earlier Egyptian writers, like the Nubian servants in Ya'qub Sanu'a's comedic sketches of the 1870s. 'Ali al-Kassar performed before a colonized audience, but the colonial experience for Egypt was very different from that experienced in Ghana. For most of the nineteenth century Egypt had dominated and governed its African neighbor the Sudan. After its loss, the Sudan remained an

important issue in Egyptian nationalism, even more so after 1898 and the British conquest of the Sudan. By World War I, when 'Ali al-Kassar first began to perform, control of the Sudan was a highly inflammatory issue between British officials and Egyptian nationalists and remained so for years. This was the particular context in which Osman 'Abd al-Basit was created. So what did his racial identity mean?

Making Cairenes Laugh

In the early twentieth century, there were various forms of comedic theater in Egypt. For decades there had been foreign musical and theater troupes who performed light comedies in Cairo and Alexandria. There was an even older tradition of the comedic skit, called *fasl mudhik*, brief sketches serving as intermissions during larger productions, in which entertainers imitated animals, told vulgar jokes, and impersonated caricatures of people like the provincial governor, the village chief, Coptic clerks, Ottoman officials, and Nubian or Sudanese servants. By World War I, the *fasl mudhik* was often incorporated into the theaters managed by Europeans, where many of the foreign troupes performed.

One of the first to bridge these two traditions successfully was Naguib al-Rihani, a comedic actor who became famous for his signature character, Kish Kish Bey, a wealthy Upper Egyptian *'umda* (village chieftain) who regularly made a fool of himself in Cairo (Abou-Saif, 1969, pp. 13–14). When al-Rihani's troupe became popular, the theaters of the 'Azbakiya neighborhood were the sites of careful scrutiny from different elements of Egyptian society. There was a quite a bit of public discussion in newspapers over the artistic standards of the theater and over what themes or plots were appropriate for Egyptian audiences. Some writers, notably the playwright Muhammad Taymur, insisted that it was the responsibility of entertainers to offer moral instruction though the realistic presentation of current events, and not to waste the time and minds of audiences with raucous music-hall reviews (Badawi, 1988, p. 102). Others believed there was nothing wrong with farcical comedy, provided that the humor and language in such shows could be more authentically "Egyptian," and less of an imitation of European theater (al-Rihani, 1959, p. 107; see also 'Awad, 1979, p. 240). Plainly, characters like Osman 'Abd al-Basit and Kish Kish Bey were created under considerable political pressure. One way that both al-Rihani and al-Kassar coped with this was to carve their trademark characters out of certain stereotypes and write them into contemporary situations. Naguib al-Rihani's first employment on stage came when the manager of a particular theater needed someone to play a Nubian servant (al-Rihani, 1959, p. 70). Actors

literally walked into expected characters, or rather, into time-worn personae they were expected to reanimate.

Osman came onto the stage in 1916 and soon rivaled Kish Kish Bey. By 1919, al-Kassar had a troupe of his own. Like al-Rihani, al-Kassar was a performer of reviews: raucous, often bawdy, and always musical variety shows in which colloquial Arabic was used. Troupes like that of al-Kassar and al-Rihani were hugely popular in an age when literacy was still the privilege of a minority. Their comedies were accessible to a much larger audience. And as these theaters grew more popular, there was a commodification of "types" around whom performers formed their own professional identity. These types experienced a variety of adventures in their comedies but rarely changed themselves—audiences got what they expected and paid for when they watched Osman abd al-Basit as *Barbari Misr al-Wahid* (Landau, 1958, pp. 90–91). Interestingly, once an actor was as successful as al-Rihani or al-Kassar, they became virtual prisoners of these characters, audiences refusing to see them in any other role.

But Osman's popularity was also a result of al-Kassar's deep connections to the nationalist movement, which was entering a new phase of protest at the end of World War I. Hoping to draw on the seemingly pronationalist statements of key international figures like Woodrow Wilson, a group of men known collectively as the *wafd* ("delegation") appealed to the British Consul General for permission to travel to Paris and address the League of Nations. Not only did the consul deny them this, but he ordered them exiled to Malta. These men, led by Sa'd Zaghlul, were very popular, and their exile incited large-scale demonstrations first in Cairo and Alexandria and more and more throughout the rest of Egypt. Even in moments of relaxation, in the theater for instance, Egyptians were angrily sensitive to British slights. The character Osman, however, made this funny, by making the British characters look so foolish, with their terrible accents in Arabic and their lack of understanding of Egyptian customs.

Osman was always having to defend his color to British officials portrayed in caricature. In *Qadiyah Nimra 14* ("Court Case Number 14") first performed on January 6, 1919, Osman takes on the British officials of the occupation by serving as a defender of three Nubian friends who had been arrested for brawling. In one scene, after just volunteering himself as a witness to his friends' fight, Osman musters his dignity and patriotism against the racial stereotyping of the English constable:

Constable: You saw something with your own eyes?
Osman: How could I not see, being right there with them?

Constable: At the time you were all arguing?

Osman: At that time like any other time.

Constable: What is that supposed to mean, you Nubian?

Osman: (still being ingratiating but defending himself as well)
 Oh my! Peace be upon you and on your words as well. Every
 one of you says "you Nubian." Do you mean a Nubian isn't
 one of God's creations just like you? (al-Kassar, 1991, pp.
 22–23)

The scene continues as the constable prepares to arrest Osman him-
self, but Osman's self-deprecating and dignified humor enables him to
wriggle out of the increasingly contentious situation. As al-Kassar's
son later wrote, this play offered audiences an example of patriotic
defiance against the British authorities and the tendency of those
authorities to label and insult the population over which they ruled (al-
Kassar, 1991, p. 25). In this sense, particularly within the context of the
rising nationalistic anger in Egypt, Osman's Nubian identity becomes a
conduit through which Egyptians could express indignation at British
discrimination.

Yet al-Kassar always came on-stage as Osman in blackface, a delib-
erately darker figure than the other Egyptian characters of the plays, who
in turn made many jokes and comments about his skin color and the
question of his actual nationality (see **figure 5**). For example, in the play
Al-Barbari fi al-Jaysh ("The Nubian in the Army") first performed at the
Majestic Theater on March 29, 1920, Osman's entire body and ethnic
identity is subjected to intense scrutiny for possible induction into the
army. The play opens in the council of the armed forces in Aswan (in

Figure 5. A true son of Egypt, Osman 'Abd al-Basit, *Barbari Misr al-Wahid* ("the one and only Nubian of Egypt") confronts two British colonists.

Upper Egypt) with the shaykhs and village headmen claiming that all the men eligible for conscription in their respective towns are dead or otherwise incapacitated for service in the army. But the 'umda from Aswan answers truthfully that he has two conscripts, one of whom is insane, the other a Nubian named Osman 'Abd al-Basit whom he thinks may be eligible for service. He is not certain, however, whether Osman's ethnicity will complicate this eligibility.

> Captain: Nubian? Nubian? How can you be the 'umda, son of
> the 'umda, and not know that Nubians are eligible for
> military service?
> 'Umda: No, well, this Osman, he is a mixed Nubian.
> Captain: Mixed, how?
> 'Umda: I'll explain to you how. That boy's mother is Nubian and
> his father is Sudanese. With us, that means he's mixed.
> (Sidqi, 1920, p. 4)

It is interesting to see how this question of parentage plays into who is considered eligible for conscription into the army. Had Osman's origins been completely Sudanese he might not have been inducted. The scene also expresses a surprising division between how Nubians and Sudanese actually fit into the national community on the whole. These points are raised again and again, after soldiers bring Osman to the council, which he mistakenly thinks is a police station, and force him to submit to a physical. The doctor looks at Osman and asks the 'umda once more if he is sure of the nationality of the man.

> 'Umda: What does nationality (jinsiya) mean?
> Doctor: It means that his mother is Nubian and his father is
> Sudanese, as I told you.
> 'Umda: That's right, effendi. His father is Sudanese, son of a
> Sudanese [next word illegible in the text].
> Doctor: Interesting. Well, then, we have the right to conscript
> him.
> Osman: And I have the right to exemption. (Sidqi, 1920, p. 6)

Osman's body is then weighed and inspected, much to his horror. Once clothed in uniform, however, his identity within the Egyptian army still appears strange to the other characters, as one officer named Foda says after watching Osman fumbling with equipment and military parlance.

Foda: You appear to be very new.
Osman: Very, I'm ultra new.
Foda: Strange that you're a Nubian.
Osman: Nubian only on my mother's side. Sudanese on my
 father's.
Foda: Ah! I'm also astonished because your language is
 completely Nubian. (Sidqi, 1920, p. 11)

Osman never seems to be able to just fit in as a soldier, as if every-
one looking at him cannot quite place him as an Egyptian who would
naturally have to serve in the military. All of this confusion occurs
while other village headmen could not come up with one live Egyptian
conscript. Yet Osman possesses entry into the secrets of these Egyptian
characters that even they do not share with each other, secrets gained
from his access to and intimacy with them in his functions as a servant.
For Osman, this means persisting in his hope that Egyptians will treat
him as a regular fellow, not just as a black-skinned Nubian. For certain
characters, like Foda, treating Osman as an equal is conceptually impos-
sible. This emerges as the plot thickens. Officer Foda is attracted to the
sister of the doctor who examined Osman. Long before, in the Sudan,
Osman saved this doctor's life. Moreover, Foda and Osman had met ear-
lier on the night of the fourteenth, in Foda's own house. Foda wonders
how he couldn't have realized at that time that Osman's face was black.
Osman answers "No, you didn't know I was Nubian. You know Osman
'Abd al-Basit, and that's that." Foda answers, "What a strange thing"
(Sidqi, 1920, p. 19).
 The doctor's sister has promised to kiss the man who saved her broth-
er's life and when Foda discovers this he arranges to swap identities with
Osman to steal that kiss. Many more reversals of identity follow. Finally,
all of these reversals sum up to the strangest of all, a black man being
the military superior of a white man. The very idea brings out the sar-
casm in Foda with whom Osman switched uniforms in the first place.

Foda: We all know that your face is the face of an officer. By
 God, that's the face of a first lieutenant.
Osman: Hey! Do you mean now I'm a first lieutenant?
Foda: That's right, O Sir, O Idiot, O Nubian Sir (ya-hadhrat
 al-ghabi, ya-hadhrat al-barbari).
Osman: Shut up, ugly!
Foda: What did you say?
Osman: You are here now in your capacity as the orderly of

Osman 'Abd al-Basit and you must serve your first lieutenant,
so beware (*zinhar*)!
Foda: O God, O God, have you gone completely nuts or what?
(Sidqi, 1920, p. 33)

As comic as it was supposed to be, *Al-Barbari fi al-Jaysh* uses its
central character, Osman, to defy abusive authority and the immorality
of foreign cultural practices. In many ways, the play articulates the
same points about Egyptian self-determination that were integral to the
demonstrations of 1959. The British, in fact, recognized the potential for
political agitation that the popular theaters of Cairo presented, and
shortly after demonstrations led by stage actors in 1919, the adminis-
tration closed all of the theaters until the uprising ended (al-Kassar,
1991, p. 27). Conceived in this environment of confrontation, *Al-
Barbari fi al-Jaysh*'s politicization was all the more dramatic in light of
the fact that in the audiences of the Majestic Theater were many for-
eigners including, it has been claimed, English officers and civil bureau-
crats ('Ali, Mahmud, 1992, p. 25).

Osman had to constantly stand up for his own dignity and against
the continual racial differentiations that other Egyptian characters often
lobbed at him, just as Sa'd Zaghlul did against the authority of the
British. But neither Osman nor the politicians of 1919 questioned the
actual social hierarchies that the British had used to their advantage to
solidify control. In fact, in none of the plays I found did Osman 'Abd al-
Basit ever question the higher social rank of Egyptians in comparison to
Nubians or Sudanese, or insist on his right to greater upward mobility
within that society. His simple pleas for respect are very significant, but
the actor's identity as an Egyptian in Nubian disguise presumes and
appropriates an understanding of Nubian and Sudanese sentiment. In his
very body, 'Ali al-Kassar personified nationalistic sentiments about the
unity of the Nile Valley.

This "Nubian" instrument serves not just as a servant to Egyptians,
but as a gauge of true nationalistic feeling among Egyptians, as in
another of Osman's plays, *Al-Hilal* ("The Crescent"), a spy story in which
the beautiful young woman, Oshaka, tries to infiltrate the military intel-
ligence of Egypt. Osman serves in this army as well, and has actually
won a medal for his bravery. He is late for the awards ceremony, and
when he finally shows up, he is drunk. The general awarding the medals
is as surprised by his color as by his stupor and remarks on how very
brown Osman is, to which Osman replies, "It's my right to be so brown"
(Kamil, 1923, p. 31). Every character calls him *ya-iswid al-wijh* ("you

black face"), forcing him to defend his right to be the color that he is.

Like other vehicles for 'Ali al-Kassar, *Al-Hilal* derives great humor from mistaken identities. Oshaka thinks she is a foreigner and so spies patriotically for her country. Ironically, she is actually the long-lost daughter of the female doctor who tends the soldiers of the other army, and who long before had tattooed her daughter's arm with her initials, her daughter's initials, and her husband's initials. The play thus revolves on the genetics of nationalism. Nationalism is a blood matter, as shown by Oshaka when she realizes that she is the daughter of parents from an enemy country. How can she atone for her misdeeds? she asks Osman, who is the first to figure out where she is really from:

Oshaka: I worked against my own nationality [*jinsiyati*, followed in the manuscript by *watani*, which is crossed out].
Osman: Don't think that that could be considered guilt.
Oshaka: Why not?
Osman: Because now you can serve your true nationality in the same way that you served your false one. (Kamil, 1923, p. 94)

He returns her to her real parents. Then, facing the judge at the tribunal, Oshaka demonstrates her new understanding of nationalism, insights learned from Osman:

Oshaka: Your honor, everything that I did, I did in total sincerity in defense of the nation that I thought was my nation. It was my duty to serve the nation. I thought I was a foreigner to this country. [lacuna in text]... But now, here are documents in which you'll find all the information that I took from you. I will also brief you on all of the secrets of the enemy that I possess. Here you are.
General: Your defense is your serving the country you thought was your own. And now you demonstrate the honorable love that runs through your veins. And here are your parents. Reunite with them, lost daughter. (Kamil, 1923, p. 109)

It is in the blood, this love of country, and although Osman the Nubian is always answering for his blackness, he is the one to prove to the other characters and to the audience the truth about nationalism. He is a stalwart Nubian defender of the Egyptian heartland, speaking and singing in a language that all Egyptians could understand, about the

meaning and duties and responsibilities of being an Egyptian.

In this sense, Osman 'Abd al-Basit was an interesting emblem of the Nile Valley's unity, an encouraging symbol that Nubians and Sudanese alike were staunch supporters of the same nationalistic feeling and cohesion for which Egyptians had demonstrated in 1919. From this, the argument could be drawn that Osman 'Abd al-Basit reminded his audiences of the geography of their homeland, where the Sudan and Nubia must always be considered part and parcel of the Egyptian nation (Mahmud 'Ali, 1992, p. 13).

But he leaves other questions unanswered: Does Osman's skin color reveal the actor's sensitivity to racial themes in Egyptian society? Did this character subtly educate audiences about the indignities experienced by Nubians and Sudanese in Egypt? Or is Osman just a painted Egyptian, who subsumes Sudanese and Nubian identity by making it Egyptian? On another level, the blackface makeup can be turned inside out. When confronting the British, Osman, this son of true Egypt, is made to look black by English racial discrimination. His dignity belies the insult. When confronting hostile and pretentious Egyptians, Osman's blackness gains dignity, lightens in a way the hypocritical and self-hating mannerisms of wealthier Egyptians (people, it is presumed, that the British would still distinguish as *black*). Perhaps what Osman really does is wipe away all racial difference, rendering it a distraction from true Egyptian national identity. Whether he succeeded in this depends, I think, on who his audience was, and what color they chose to be. I have come to consider the character of Osman the embodiment of a double colonialism, a perspective of both colonizer and the colonized. And in many ways, with his humor, 'Ali al-Kassar simply embraced these paradoxical identities and fused them, unquestioningly, together.

3 The Tears of a Clown:
Yusuf Idris and Postrevolutionary Egyptian Theater
Clarissa Burt

While best known today for his short stories and novels, Yusuf Idris also made very substantial contributions to Egyptian drama. Perhaps it is the ephemeral and timebound aspects of theater that have put Idris's dramatic works at a disadvantage in the eye of critics in comparison to his short stories. Due to the more obvious role of theater in public discourse, however, his theater pieces and productions certainly document aspects of Idris's interaction with and attitude toward the ruling political regime, as well as the ways in which Idris has been employed as a pawn by architects of power. His involvement in theater and drama, moreover, may afford a more definitive gauge of his ideological, psychological, and emotional development over time, and consequently may offer historical ground for the inevitable identification of Idris with cultural currents in public discourse, as well as his status as a major Egyptian cultural icon in the twentieth century. It is in this framework that we can trace and document a wave of fervor and enthusiasm around the revolutionary project to a waning, then mellowing, and finally disintegration of Idris's revolutionary hopes into absurdist discouragement, mitigated only by his resilient sense of humor.

Idris is considered favorably in the cadre of postrevolutionary playwrights, which includes Nu'man 'Ashur, Lutfi al-Khuli, Mikhail Ruman, Alfred Faraj, Rashad Rushdi, Mahmud Diyab, 'Ali Salim, and Salah 'Abd al-Subur, all of whom participated in the heyday of Egyptian theater in the 1950s and 1960s (Badawi, 1987, pp. 140–205). Nevertheless, short story writing was Idris's cardinal genre according to some, either because of his strengths in that genre or perceived shortcomings in the plot structures of some of his plays.

From his birth in 1927 in a village near Ismailiya to his medical education beginning in 1945 in Cairo, including diverse political activities during his time at the university, through his early medical career in some of the most impoverished and tradition-bound urban areas, Idris's life provided him rich experiences that he employed in his literary career in his development of characters and dramatic sense.

As a student Idris became involved with the nationalist movement against the British occupation, which led to his arrest and detention on political charges on more than one occasion (see Stagh, 1993, for more

details about Idris's experiences with governmental repression). His involvement convinced him of his calling to write and of the importance of writing in contributing to change. Political commentary and the critique of social ills continued to be themes in his writing throughout his career.

Although he had published individual short stories in the press, it was in 1954 that his first collection of short stories, *Arkhas Layali* ("The Cheapest Nights"), appeared to the acclaim of all. This collection drew the admiration of critics, encouraging Taha Hussein, best known as the "Dean of Arabic Letters," the most famous literary figure of the day, to write the introduction to Idris's second collection of short stories, *Jumhuriyat Farahat* ("Farahat's Republic"). This collection came out in 1956 and included a novella entitled *Qissat Hubb* ("Love Story"). Likewise, by the mid-1950s Idris had composed his first plays, the second of which, *Jumhuriyat Farahat*, he developed out of the short story of the same name. It was performed in 1956 to popular success and was published in 1957. By the end of the 1950s Idris had published five collections of short stories, two novels, and three plays. This tremendous initial burst of creativity was followed by a steady output that before his death in 1991 reached 13 collections of short stories, six novels, eight plays (Mahmud [ed.], 1995–98, p. 60),[14] four books of essays, and countless columns for Al-Ahram newspaper and other fora.

Idris's early work was and is tremendously popular and well received, due to his powerful literary abilities to create convincing characters, and fictional worlds to treat a huge range of personal, social, political, and economic issues in a sensitive and insightful manner. His plays from the late 1950s and 1960s are considered among his best, culminating with his best-known and most popular *Farafir* in 1966. *Al-Haram* ("The Taboo"), published in 1959, and *Al-'Ayb* ("The Sin"), published in 1962, may be his most famous novels, and both have been adapted for the screen. Perhaps buoyed by his successes, Idris decided to leave the practice of medicine in 1967 to devote himself exclusively to writing. It seems ironic that Idris's output of fiction and drama declined steadily after this point, although he continued to write and participate in cultural affairs throughout his life.

His reputation as a seminal littérateur in Arabic rests on both his early works, which critics have labeled a phase of literary realism, and on his later works, which are considered more symbolist and surrealist in nature. Despite his popular reception, Idris did face criticism in the lit-

14 This source mentions nine plays, but lists only the titles, performance dates, and publications of the eight plays that I have treated here. I cannot account for the discrepancy.

erary press. Critiques were leveled at his language, style, and treatment of issues, his literary experiments, and his morals. The sting of this criticism must have affected Idris; reports of his bitterness and disillusionment surfaced in the literary press from as early as the mid-1960s. Indeed, some attribute his change in style and tone to the crisis of the intellectual faced with the depressing contradiction between his ideals and the stubborn realities around him (Cohen-Mor, 1992, p. 44; Rejwan, 1979, pp. 143–161). The 1970s and 1980s witnessed a further decrease in his creative output, increasing problems with his health (including major heart surgery in 1976), and greater involvement in journalism. In the year preceding the awarding of the Nobel Prize for literature to Naguib Mahfouz, Idris was discussed in literary circles as a serious contender for it. There is no doubt about the disappointment that Idris felt when the prize winner was announced in 1988. Whether Mahfouz's or Idris's work is of greater literary value is a matter best left to critics, historians, and readers' personal tastes. However, the fact that Idris's work was seriously discussed in such a capacity merely confirms his now well-established status as a world-class littérateur of the twentieth century. The last phase of Idris's life was marked with increasing health issues, culminating in his death in London, in August of 1991.

His playwriting and use of theater as a vehicle for his artistic and political expression began in the mid-1950s with the composition, performance, and publication of his first scripts: *Malik al-Qutn* ("The Cotton King") and *Jumhuriyat Farahat* (Idris, 1957; both *Malik al-Qutn* and *Jumhuriyat Farahat* were performed in the 1956/57 theater season). Each of these early plays deals with themes that were of critical importance in public discourse of economic and social development of Egypt, and thus they played beautifully into the hands of the fledgling regime as a means of propaganda promoting the success and popularity of the 1952 revolution.

Malik al-Qutn

Idris examines the disenfranchised state of the Egyptian peasant farmer and his exploitation at the hands of landowners and middlemen in the capitalist marketing of agricultural products in *Malik al-Qutn*. This spoke to the growing dissatisfaction with agricultural policies under British occupation in the 1930s and 1940s, which witnessed a number of peasant rebellions and labor strikes protesting issues of fair wages and capitalist exploitation of the peasants (Beattie, 1994, pp. 66–120). Thus the play relates immediately to the political pressures for land reform that had been building for decades before the 1952 Revolution.

Set presumably in the 1940s, the events of the play revolve around the cotton harvest, ironically contrasting the lack of gain by those who sow the seed and the financial fortunes enjoyed by those playing on cotton futures in the international commodities market. Al-Qamhawi, the peasant farmer, who has worked the land, cared for the cotton, and delivered it into the hands of the landowner, has come for his share of the profits from the harvest. Al-Sinbati, the small landowner, is himself under great financial pressure, and has reckoned al-Qamhawi's share at a rate to minimize his expenditure, passing on his own costs to the peasant farmer. The living and school expenses of the more privileged al-Sinbati contrast with the hand-to-mouth situation of al-Qamhawi's illiterate and unschooled family. Dissatisfied with the wages offered him, al-Qamhawi asks for the mediation of al-Hajj, another small landowner in the village. While al-Hajj is forced to admit that al-Qamhawi's reckoning is more accurate, it is also revealed that he himself passes on higher costs to the peasant farmers who work his holdings.

The play comes to its climax with the appearance of the cotton merchant who collects the huge bales of cotton from the landowners to deliver them by train for export to international markets. Representing international interests, he pays the landowners for the crop according to the price set by the commodities market and broadcast on the radio. Al-Qamhawi sees that he is being paid for his share of the harvest at a lower rate, and angrily demands again and again that al-Sinbati pay him a fair amount. Al-Sinbati repeatedly refuses to raise his pay. Al-Qamhawi threatens to stop farming for al-Sinbati; the latter then threatens to have al-Qamhawi arrested and to bring in day laborers instead of members of al-Qahmawi's family. Al-Hajj retrieves the retreating al-Qamhawi, who has no alternative means of earning his living. The peasant farmer returns, grumbling about not letting anyone else touch his cotton. Suddenly, fire breaks out in the cotton storeroom, caused by the furtive cigarette smoking of al-Sinbati's oldest son. While the merchant and al-Sinbati raise the cry for help, it is al-Qamhawi and his family who jump to the task of putting out the fire in short order. Al-Hajj in a final aside chides al-Qamhawi for not letting the cotton burn (perhaps as revenge for the unfairness of his wages, but also as a way to put al-Hajj at an advantage over al-Sinbati). In the final lines of the play, al-Qamhawi expresses his integrity in the face of his unethical state of bondage:

How could I let it burn, people?! If you were the one who had sowed it you wouldn't say that—that's my sweat, my hardship; it's a piece of me—how could I let it burn?!

The injustices encoded in the play resonate clearly with the dissatis-factions of the day. There is no doubt that central to this play was a cri-tique of the impersonal and exploitive nature of the capitalist system as it relates to Egyptian agriculture. Indeed, anticapitalist sentiments and consternation at foreign interests that benefited from Egypt's wealth at the expense of the Egyptian masses were commonly expressed in peas-ant uprisings in the decades leading up to the Revolution of 1952 (Beattie, 1994, pp. 66–120).

These pressures were addressed in the postrevolutionary era through the promulgation of increasingly strict land-reform laws. These measures may have won the allegiance of the peasant farmer for Nasser's regime—their success in addressing both issues of justice and agricultural devel-opment, however, remains problematic to this day.

Jumhuriyat Farahat

On the other hand, Idris dealt more directly with nationalist aspirations on another front in *Jumhuriyat Farahat* (written in 1954, performed in 1956, and published in 1957 with *Malik al-Qutn*; Idris, 1957), presenting the dream of a prosperous Egypt, free of foreign interests and control, with particular focus on industry, development, and sovereignty over the Suez Canal. Based on a short story with the same name published in 1956,[15] the play offers an interesting contrast between Idris's short story writing and his adaptation for the dramatic needs of the theater.[16] The script necessar-ily develops minor aspects of the story for dramatic interest.

The events of the play occur at night in a Cairene police station at some prerevolutionary time. Muhammad, detained for political reasons for interrogation the next day, observes and interacts with the night-duty officer, Farhat (the Farahat of the play's title, shortened to accord with the colloquial pronunciation of the name). Amidst his brusque treatment of a series of complainants, arrested citizens, and fellow officers, Farhat falls into conversation with Muhammad, expressing his exasperation at the frustrations and insanities of his job. In contrast with

15 A short story set in an Egyptian metropolitan police station at night. While the city and date of the short story are not specified in the text, the internal evidence places the events in Cairo between the end of World War II and before 1952. "Farahat's Republic" was originally published in Arabic in 1956, and appeared in English trans-lation in 1967 in *Modern Arabic Short Stories*, translated by Denys Johnson-Davies (London: Oxford University Press, 1967). This was reissued by Heinemann/Three Continents Press in 1974. The short story was retranslated by Saad el-Gabalawy in his *Modern Egyptian Short Stories* (Fredericton, Canada: York Press, 1977), and in *Three Egyptian Short Stories: Farahat's Republic; the Wallet; and Abu Sayyid.* (Fredericton, Canada: York Press, 1991).
16 For an excellent treatment of the dramatic versus narrative versions of "Farahat's Republic," see Somekh, 1981.

the poverty and indignities enacted before him constantly in the station, Farhat relates the scenario for a film he has dreamed up.

In Farhat's story, a rich Indian visiting Egypt unknowingly dropped a priceless gem. An honest, unemployed Egyptian saw the gem fall, snatched it up, and returned it to the Indian, refusing any reward for his honorable deed. The wealthy Indian, frustrated in all attempts to reward the incorruptible Egyptian ultimately bought him a lottery ticket, which miraculously won. The Indian returned home, and with the lottery winnings he purchased and sent a boat full of goods all paid to the poor Egyptian, transforming him into a wealthy man himself. Using acumen and skill, the Egyptian then reinvested his earnings to ultimately buy up all the ships in the harbor, thereby freeing Egyptian waters of foreign vessels. The fortunate Egyptian proceeded to invest in one industrial field after another, purchasing factories, rebuilding the infrastructure, and providing a sunny existence for his fairly paid workers in planned industrial cities with all the amenities of life. He then transformed agriculture by reclaiming the desert and mechanizing agricultural work. In this utopian vision, all farmers and farm workers would enjoy good housing, electricity in their homes, short working hours, and literacy education to encourage effective citizenship. Having transformed and Egyptianized the entire economy and raised the standard of living for all, the philanthropic monopolist ultimately tired of his riches and his role as architect of the newly developed Egypt. When the philanthropist is announcing his relinquishment of all he owns on his new radio station, which could be heard throughout Egypt,[17] Farhat cuts off relating the tale of his filmscript. For just as he is about to reveal the content of the autocratic philanthropist's radio announcement, Farhat discovers quite by chance that Muhammad is a detainee. At this, he refuses to complete his story: "It's just talk. Either listen to it, or let it go—you believe it?!" Farhat dismissively turns to one of the beggars whose arrest he must process and gruffly bellows, "What's your name?"—the last line of the play (Idris, 1974, p. 52).

The utopian vision of Farhat's story relates directly to Egyptian aspirations that had been frustrated under the monarchy and had helped set the story for the 1952 Revolution. The desires for freedom from foreign control in all areas of the economy are realized in Farhat's scenario. We can easily read the honorable Egyptian who rises from poverty to transform and develop Egypt through his socially responsible capitalism as an attractive picture of Nasser with his early policy of guided capitalism,

17 "Voice of the Arabs" started broadcasting in 1953 shortly after the 1952 revolution.

almost predicting his subsequent nationalizations of industry and major economic interests. Furthermore, the open question at the end of the play is also germane to the question discussed at length in the early years of Nasser's presidency concerning the length of the transition period for centralized authoritarian rule. Farhat's autocratic monopolist seems to be on the verge of relinquishing control, just as Nasser's centralized authoritarian rule was expected to end with more democratic forms put in place. But Farhat cuts off his story, and we never know what happens— the relinquishing of control is indefinitely deferred, just as Nasser's presidency never ended its "transitional" status (Beattie, 1994, pp. 66–102).

Another possible reading of the rags-to-riches Egyptian is the shipowner and industrialist Muhammad Ahmad 'Abbud, who built a huge business empire in several economic sectors, starting in the 1920s. 'Abbud fits many aspects of the do-good Egyptian in the story, except for the fact that he was viewed in some quarters as a collaborator with the British and the monarchy. In an interesting connection with Idris's story, 'Abbud lent his fleet of merchant ships to Nasser's regime to complete the Czech arms deal of 1955 (Beattie, 1994, p. 144). After the arms were delivered, the ships were seized, and 'Abbud ultimately faced charges of collaboration. His holdings were confiscated and his family was forced to flee Egypt on the heels of the two waves of increasingly strict expropriations and nationalizations of 1955 and 1963 (Vitalis, 1995, p. 49ff.). Given this historical connection, should we understand *Jumhuriyat Farahat* as addressing a class of the Egyptian elite, who had gained huge fortunes in the 1930s and 1940s, and calling for the Egyptianization of their interests for the benefit of the whole people? Or alternatively, is Idris defending 'Abbud as a patriot? If there is merit to this reading, it nonetheless requires our acknowledging the easy superimposition of Nasser onto the role of the do-good Egyptian autocrat as well, as my first reading suggests.

The fact that Farhat's listener is a political prisoner may relate directly to Idris's personal experience in both prerevolutionary and postrevolutionary Egypt. Is Idris here indicating the hope that the revolution could eliminate the political repressions experienced under the monarchy? Or is this a veiled allusion to the fact that the arrest, detention, and torture of political prisoners actually worsened under Nasser?[18] Farhat's reaction to his discovery that his listener was a detainee is telling in this regard, for the fear of political repression led to fear of those so detained, through guilt by association. Although the Suez Canal is not specifically mentioned, Farhat's

18 For more on political repression of intellectuals and literary figures, see Stagh, 1993.

vision of Egyptian waters free of foreign ships resonated with the tensions and disputes with the British over control of the canal in the years leading up to the production and publication of this play. Furthermore, it is now remarkable in hindsight to note the ideas for economic development and the prediction of the industrial cities now ringing Cairo, which were established under Anwar al-Sadat two decades after the play was written.

The most remarkable thing about the play, however, is the ironic contrast between the utopian vision of Farhat's discourse and the poverty, social ills, and bureaucratic inadequacies and cruelties of the police as revealed in the course of Farhat's work at the station. The difference between the two levels of the story serves to show the tragic, comic, and cruel aspects of what separates Farhat's all-too-real day-to-day world from his utopian dream.

Al-Lahza al-Harija

If Idris's early plays played into the hands of the new regime, serving as helpful propaganda to popularize Nasser's new government, the aspirations that were expressed in those plays were tempered by the realities and responsibilities of postrevolutionary citizenship. On the heels of the Suez Canal crisis in 1957, Idris composed what is considered his first mature theatrical piece, *Al-Lahza al-Harija* ("The Critical Moment," Idris, 1958), in which he explores personal, psychological, political, and cultural conflicts in the Suez Canal crisis for individuals caught in the historical drama of the war, in the context of the larger transformation of modern Egypt, with its personal and national costs. The maturity of the piece is marked by its more complex character development and unabashed confrontation of tragic ambiguities and loss.

The events occur in the home of Nassar, a carpenter who has worked his way up in life at great cost in personal dignity from being a piece laborer to the owner of a mildly successful carpentry shop in Ismailiya. The household includes Nassar's wife, Haniya, their sons, Mus'id, Sa'd, and Muhammad, their daughters Kawthar and Sawsan, and Fardaws, Mus'id's young wife. First-born Mus'id has been his father's right-hand man since he was removed from school by his father, working in the shop that afforded the younger Sa'd the higher education to become an engineer, the pride of the family. Sa'd, however, disrupts the plans for his future by participating behind his father's back in military training mounted in response to the rising expectations of war after Nasser's nationalization of the Suez Canal in July, 1956. When Nassar discovers this, he rages at the betrayal of his household leadership, and considers Sa'd's actions more expression of

youthful rebellion than a serious threat.

The discussion over Sa'd's military training, however, reveals a complexity of attitudes that includes a critique of Egyptian society in the face of the challenges of foreign imperialism. Sa'd expresses a youthful nationalist pride: "We're the generation that defeated the English and we're [those] who will repel them again and defeat them if they think they're going to come back once more."[19] Nassar replies that Egyptians had to solve their own internal problems: "Your real enemy is inside you. So first train for war with the gangs here." Sa'd tries to rebut him by saying, "Our enemies who are inside us are imperialism too. They're the English. And if we overcome the enemies outside we'll overcome their shadow that is inside. There's no way to vanquish what's inside except by annihilating the enemy outside."

War breaks out nonetheless after the joint British and French ultimatum of October, 1956; and despite his father's prohibition, Sa'd plans to sneak away at night to join the combatants on the battlefield, after being called up. He is found out as he tries to slip out of the house.

Again the ensuing argument between father and son is the one of the most revealing sections of the play, showing powerful generational tensions between nationalist discourse and personal interests. Nassar relates the story of his struggle to make a living, the indignities he suffered in order to provide a better life for his children. Then he challenges Sa'd directly to carry on that responsibility:

Nassar: Answer me. Can you tell me, now I've struggled my
 whole life, what my fortune is today?
Sa'd: The workshop, of course.
Nassar: No! What's a workshop! My fortune is you all! You. You
 especially are my fortune. You're my struggle those 30 years.
 You're what I took your brother Mus'id out of school for, so I
 could put someone to work with me in the workshop, and
 educate one [of you]. So I could educate you. You're what
 has passed of my lifetime, and you're what's coming. You're
 my future. The future of your sisters, with whom I guarantee
 their future. And after I've done all that all these long years
 you come with your fare-thee-well today wanting to lose it
 all in a drink of water, in a moment, on some frivolous
 whim, a game?! You want me to let you go? You want me to
 cede to your wishes? Brother, not even in your dreams!

19 This and subsequent quotes from *Al-Lahza al-Harija* are translated by the author
 from Idris, 1974, pp. 113–136.

Sa'd cites a nationalist love of homeland and challenges his father's understanding of his dedication. "I'll respect what you say, Dad, but I see that as far as you're concerned, Egypt is just our family. As far as I'm concerned, our real family is Egypt, and this family of ours is in danger. So we have to defend it." Nassar remarks that no one has come to his rescue: "Why is it that in the hour of hunger one hungers alone, and in the hour of death someone wants me to die in his stead. Everyone fends for himself." Sa'd then declares himself not only son of his father, but a son of Egypt as well. He points out the web of interdependencies that bind the individual to the larger national community, and which contributed to his individual upbringing. With this logic, it his duty to defend Egypt just as he would defend his own family. Nassar, intellectually convinced, but emotionally opposed, expresses his distress:

> If it's from my point of view, you're my Egypt. Suppose, God forbid, you were to die! Then what would your Egypt be worth to me? What would the Suez Canal be worth to me? What would the people you speak of be worth?

Sa'd's final argument is a personal one: he considers it necessary proof of his manhood that he be prepared to risk death for Egypt. He asks his father to allow him to prove himself a grown man, declaring his independence and individuality. Nassar's last appeal is made to keep him alive:

> Nassar: Whoever stays in his home guarantees his own life. Stay here and fulfill your duty. If you want to defend, defend us and your home.
> Sa'd: You mean I should see danger coming and pretend I don't see it. Our country and our land are in danger, and I should sit at home?
> Nassar: Your country and your land are here (pointing to the floor of the living room).
> Sa'd: Every place in Egypt today is my land.

Mus'id, who has overheard the discussion between Sa'd and his father and has been deeply affected by Sa'd's nationalist discourse, exits the scene to fight the British, encouraging Sa'd to catch up with him at the rendezvous point. Nassar, however, tricks Sa'd, locking him in the bedroom to prevent risk of his death in the war.

The final act of the play occurs during the battle over the city.

Refusing to budge from his home, the fruit of his years of hard work, despite mass evacuation, Nassar stands guard over his imprisoned son. Sa'd bangs, argues, and cries at the door for release. Nassar secretly acknowledges his regret at imposing this cowardice on his son, made all the more problematic by the fact that the bolt locking Sa'd in is faulty. Mus'id returns from battle slightly wounded, but alive, and falls asleep from exhaustion. Nassar then triumphantly locks him in his room as well, congratulating himself on preserving his family in this fashion.

A group of British reconnaissance soldiers enters the building under orders to shoot to kill any Egyptian defenders. Nassar, trusting in the inviolability of his civilian home and in God, performs his prayers as a British soldier enters their apartment. Unable to understand each other due to the difference in culture, one soldier misinterprets Nassar's movements in prayer and shoots him as he prostrates himself. Sa'd, sensing something wrong, cowers in his room, fearing for his life.

The youngest child, Sawsan, comes in on this scene, and cries over her expiring father. The British soldier loses his wits, confusing Sawsan with his own daughter whom he has left in England. Finally, the soldier's comrades and officer come in and, discovering his mental state, take him to the hospital for treatment for battle fatigue. Sawsan then opens the trick lock to release Sa'd from the room; he then blames himself for cowardice, for unnecessarily trembling impotently at the critical moment, for not defending his home and father, and for failing his own test of manhood. Sa'd in his grief argues bitterly with Mus'id over the question of who mourns their father more.

The British soldier returns looking for Sawsan, imagining that she is his own daughter. Haniya challenges her son to take revenge for his father's death. Strengthened by this challenge, which reestablishes an opportunity to prove his manhood, Sa'd kills the soldier, with the approval and respect of Mus'id. The play closes with weeping Haniya ululating in pride at his proven manhood, as he leaves to join the Egyptian defense forces.

While emotional ambiguities around nationalist discourse may be the most important aspect of the play, other aspects are nonetheless remarkable. Gender discourse stands out as well, not only emphasizing a particular understanding of and emphasis on the nature and responsibilities of mature masculinity, but also articulating femininity as a negative pole by which that masculinity is measured. Sa'd acknowledges his mother's dignity only when she challenges him to fulfill his role as avenger.

The characterization of the British soldier, with his misinterpretation of Nassar's movements in prayer and his growing madness, nonetheless

displays his humanity through his identification of Nassar's daughter with his own. The madness and inhumanity of war is encoded in him, however, as the embodiment of enmity, which Nassar recognizes as he dies. At this point in the play, the national and the personal are identified, and Sa'd's argument is proven correct.

In this play, Idris makes a direct strike at British imperialism in fulfillment of all his early activism. I would contend that this play also marks the height of Idris's enthusiasm for the revolution, even as it also notes the complexity of conflicting allegiances, whose balance shifts in Idris's theatrical writing thereafter. The linguistic relation between the name of the father, Nassar, and that of President Nasser, however, is disquieting, in view of the reservations on the blind, reckless, youth-exploiting Nasserist nationalism that the character seems to represent.

Al-Farafir

Idris's next dramatic piece, *Al-Farafir* ("The Flutterbugs," sometimes translated as "Little Mousey"),[20] arguably his best and most famous play, first appeared in 1964, after a significant hiatus from dramatic writing. This work, which has perhaps received more critical discussion than any other single piece of Egyptian theater, was an attempt to transform theater from what Idris considered imitation of European dramatic forms to more authentically Egyptian drama, dipping back into performance and stylistic traditions from native performance genres, such as shadow plays, puppet theater, *maqamat*, and *samir* entertainment traditions (Zeidan, 1997, pp. 173–192). With these genres' potential for slapstick and the comedic, Idris mounts a remarkable critique of authoritarian political power, oppressive social structures, and individual complacency. Unlike his earlier pieces, which celebrate the (perhaps unrealistic)

20 The play was performed in 1964. It was published in 1966 jointly with his next play in Idris, *Al-Farafir wa-al-mahzala al-'ardiya.* (Cairo: al-Ahram, 1966). The term *farfur/farafir* poses a translation problem. Farouk Abdel Wahab left it untranslated in his *Modern Egyptian Drama,* (1974), simply using "Farfoor." By contrast, Trevor LeGassick used "Flipflap(s)," which is less than clear in English than the Arabic original, in his translation, "Flipflap and his Master," published in Manzalaou, 1977. Arabic-English dictionaries refer to small fluttery birds, butterflies or moths, or woolly lambs. The contextual meaning, however, is much closer to *drudge, slave,* or *toady.* The English slang term *flit* has the fluttery connotation of the Arabic with an added effeminate gender coloration, which is interesting in view of Idris's directions concerning the characters of Farfur's wife and child, but it lacks the necessary subserviency that the term implies in the play. Abdel Wahab (1974, p. 37) suggests that Idris made up the term or adapted it from his village dialect. Idris himself in the introduction to the play describes the qualities of Farfur's character at length, including those of a jester, clown, puppet, buffoon, innocent, and wise. Idris, 1974, pp. 176–179.

hope for revolutionary transformation of Egypt, *Al-Farafir* is a satire caught between the fatalistic and the absurd that employs innovative (in the Egyptian context) techniques for the use of theater space, planted actors in the audience, and metadramatic discourse on the role of author, character, and actor in the theater.

The first act is set in indefinite time and space, introduced by the character of an existential author of the play who then summons the main characters, Farfur, and his master. Farfur appears dressed as a buffoon, and comically and antagonistically tries to help the author find the master, whom they discover sleeping in the audience. Farfur sends the author off, asking him to send a mistress to match the master, and promising to practice a scene with the master in his absence. He then rouses the master with a beating. After the master wakes in protest, his mind is a complete blank, so he must be reminded of every aspect of his role. Farfur therefore tries to instruct the master of their respective roles as master and Farfur. A very comic interchange ensues while they negotiate the roles they should assume, possible names, and potential employment for the master.

The discussion of employment entails biting social commentary on all walks of life, with unflattering but hilarious images of lawyer, businessman, importer, intellectual, artist, doctor, accountant, soccer player, policeman, beggar, thief, detective, engineer, cabbie, and unemployed person. The master finally settles on the job of gravedigger, since "the best job is the most disgusting."[21]

Having established his means of living, the master hands the shovel to Farfur, and tells him to dig, citing the master-Farfur relationship. Farfur complains but cannot escape the unfair realities of the relation of master to his slave, subjector to subjected, if he wishes to be in the play. At this juncture, the master decides to marry and orders Farfur to arrange it. Farfur reminds him that he has asked the author for a mistress, but the master has no wish to wait further. They then select an attractive woman planted in the audience as an excellent candidate for a wife. A knock on the door announces the arrival of a belly dancer who has been hired by the author for the role of the mistress. The two women fight, until the master declares he will marry the better of the two, to be determined by contest.

Another knock comes, and an actor in black dress and scarf comes in, sent by the author for the role of the wife of Farfur. When Farfur catches a glimpse of the ambiguous gender of this character, he runs

21 This and all subsequent quotes from *Al-Farafir* are taken from Farouk Abdel Wahab, 1974, pp. 376–458 with slight modifications of the translation by the author.

away frightened. This masculine personage declares love at first sight and grabs him. These genderbending lines follow:

> Farfur: Police! Rescue squad! Ambulance! Health people! DDT!
> (he tries to escape)
> (Wo)man: Do you think you can run away? Not in this world!
> Farfur: I'd rather leave it than see you What a day! What a
> day! God have mercy on us. What are you?
> (Wo)man: I am a woman, Farfur, and a coquette too!
> Farfur: No, no. I am the woman. I renounce all manhood if
> women are like you. Please, I am a woman.

The two candidates for the master's wife vie, with Farfur's fiancé(e) adding comic counterpoint, until the indecisive master decides to marry them both. Neither of the women wishes to cede to the other. So they exit, each on one of the master's arm, while Farfur is carried off by his fiancé(e).

Marriage affects the two men differently. The master is happy and satisfied; Farfur is nursing his broken crown. They also become fathers instantaneously, despite Farfur's doubt that his wife is capable of motherhood. Indeed, she produces a full-grown man as her offspring. The presence of children creates pressure for master and Farfur to earn a living. The master is confident they will soon be digging graves, for death "never takes a holiday." Despite this, he quickly orders Farfur to kill someone to fill the need, or be killed himself.

A member of the audience again interrupts, saying that he is looking to be killed. He offers himself to die for hire. Farfur balks, refusing to kill the volunteer. The master steps in to do the job, but Farfur calls loudly for help. A struggle ensues, and the volunteer dies. Farfur, in fear for his own life, buries the corpse at the behest of the master, who then asks for another man to kill. In total rebellion now, Farfur refuses the order, questions the legitimacy of the master-Farfur relation and departs.

In the second act, the master and Farfur meet again. In the meantime, Farfur and his progeny have had many masters each worse than the preceding; the master has bred a race of gravediggers, each more capable than the preceding of burying thousands at one fell swoop. The master mentions a series of historical personalities who have contributed to the deaths of thousands of other human beings: Thutmosis, Napoleon, Mussolini, Hitler.

Now, however, the master and Farfur wish to start anew, except that Farfur objects to resuming the same old roles for the same play. Farfur

rejects the play and the author together, and scandalously proposes to be an author himself. Despite the objections of the master, who reminds Farfur how he used to bow to the author, Farfur questions the authority of the author:

> I'd like to understand. I've nothing against plays or against authors for that matter. I want a play that I can understand and an author who convinces me of everything. And the first thing is you, your excellency, your highness, your lordship, you, you. Why are you a master? And I, who am I? Why am I a Farfur?

Farfur goes on strike, trying to get the terms of the play changed, and work grinds to a halt. Soon, however, both Farfur and the master are under pressure from their wives to provide a living for their families. The women get involved in the dispute, each supporting the position of the husband of the other. The master's high-class wife says:

> What's that nonsense about a master and a Farfur? The world has changed and evolved: it's not a universal law or anything. That's just talk they invented a long time ago. But we're children of today! Nobody's superior to me or inferior. I am like you and you're like me. You're a human being and he's a human being! The concept of master and Farfur exists only in some people's heads. People who think of themselves as better than others or smarter than others even if you're smarter— who said that this gives you the right to control?

Under pressure to reconcile and get things moving, the master finally gives up his masterhood, and the two protagonists set out to work together, each as free agents in gravedigging. Unable to agree on how to divide and manage the labor, they try a series of experiments in different power relations, with increasing suggestions from actors planted in the audience.

With the reappearance of the die-for-hire audience member of the first act, this time as a corpse seeking burial, Farfur and master's lack of coordination and ability to delegate causes him and his family to go elsewhere for undertaking services. Die-for-Hire reminds them, however, that in free agency, the customer is the boss. Their poor management causes them to lose their business.

Next they switch roles, so that Farfur is master, and the master is Farfur. They must adjust to the culture of their respective new roles. By

the time the adjustment, which includes a hilarious bit on the language of subservience,[22] is complete, the master is as eager to change the power relations as Farfur is eager to maintain his privilege. Having merely inverted the original problem, another solution must be found.

Next they decide both to be masters. With no Farfurs as labor, however, nothing gets accomplished. Following a suggestion from the audience, they establish a state in which each citizen is his own master and the state does the work. This quickly escalates to an empire, with the two as emperors with state-controlled media at their disposal. Again, the lack of a labor force prevents production, so they decide to take turns putting themselves at the disposal of the empire. Farfur is first, and the master asks him to dig, then dig more quickly, to reduce production, increase production, to dig with one hand. Finally, the master tells Farfur that the empire needs corpses, so he should kill someone to supply the empire. Balking anew, Farfur realizes that the original relationship has now been reproduced with different labels.

Next, a woman planted in the audience suggests they try the Empire of Liberty, as she comes up on stage and assumes the posture of the Statue of Liberty. According to the discussion that ensues, this is an empire where everyone is free, where no one's dignity is impinged upon, and yet where the will of the majority can nonetheless oppress the individual. Discouraged and disillusioned, Farfur rejects Liberty as well, and matters devolve into a discussion of increasingly absurd "solutions."

The wives reappear, pressuring the men to get work to provide for their families. The master and Farfur even attempt to resort to the author, who they discover has disintegrated to the atomic level. Their own disgust and increasing pressure from wives and planted audience members alike make them receptive to a solution offered by the curtain operator, who wishes to finish the play and go home to his pregnant wife. He suggests suicide as an excellent resolution to the play, citing Romeo and Juliet as precedent. The two agree and, with the encouragement and assistance of the curtain operator, jointly commit suicide, hoping for eternal relief from oppression. To Farfur's chagrin, however, they find they have disintegrated to atomic particles that necessarily spin around each other according to the laws of physics. They discover that they are inseparably bound to each other and cannot be free of their interde-

22 Ibid., pp. 457–458. Farfur says, "Don't you know that Farfurs like you, and myself—formerly, of course—have their own language that they use for insulting their masters. When they want to tell the master that he is stupid, they tell him, 'What intelligence!' And if he tells you 'pardon,' it means 'I spit on you,' 'at your service' means 'over your dead body,' 'surely' means 'never,' and 'I'm your servant' means 'I come before you,' etc., etc."

pendency even on this plane of existence.

Idris's linguistic play on opposites, punning, hilarious repartée, and constant double entendres make this play entertaining throughout. The slapstick comedy of the play, which overwhelmingly characterizes Egyptian theater to this day, is skillfully combined with social and political critique. It is my contention that *Al-Farafir* marks Idris's complete disillusionment with the revolution and Nasser's regime. It may have been the lack of specificity, however, that made it possible for the play to be performed without interference from the state. For the play is equally critical of totalitarian, socialist, and democratic systems, even if the spoof on democracy is quite cursory and stereotyped. Despite the strong critique of authoritarianism and the minor power plays of stultifying bureaucracy, there is no one element that can be associated specifically with Nasser's regime.

The gender aspects of the play invite a more thorough analysis of gender in Idris's work. In addition to the genderbending mentioned above, the presentation of female characters is remarkably unsympathetic in contrast to the presentation of the two main characters. This negative presentation includes snide joking about multiple abortions, the vicious competition of the candidate wives over the master, and the imperious henpecking that serves as a symbol of the pressures for survival.

Another remarkable aspect of *Al-Farafir* is the veiled critique of religious sentiment that can to be found by reading the author as God, the unquestionable author of all things, including the power relations inscribed into everyone's roles. With the author's absence, inaccessibility and ultimate disintegration to the atomic level, Idris seems to declare "God is dead." The second act's attempts to restructure the relations of Farfur and the master outside the author's play, however, nonetheless arrives at an existential inescapability of irredeemably oppressive dualistic power relations of master to slave, and oppressor to oppressed, both in Farfur and the master's lifetime and after their deaths, in stark contrast with the consolations of religious sensibilities.

It is, I believe, the wrestling with major philosophical questions in combination with the sociopolitical critique delivered through the vehicle of comedy that has made *Al-Farafir* one of if not the single most acclaimed of modern Egyptian plays. Idris's artistry was all the more popular for the (artificial?) insemination of critically touted culturally specific forms into theater-in-the-round techniques, which were then innovative on the Egyptian stage. *Al-Farafir* certainly propelled Idris's reputation as a dramatist to its height, even if his theatrical production thereafter never reached the same level of artistry. The disillusionment

and absurdist despair that the play expresses reappears in his subsequent theater pieces.

Idris's turn toward the absurd and the pessimistic continued in his four other plays: *Al-Mahzala al-'Ardiya* ("The Earthly Comedy," 1966), *Al-Mukhattatin* ("The Striped Ones" or "The Cons," 1969), *Al-Jins al-Thalith* ("The Third Kind," 1971), and *Al-Bahlawan* ("The Clown," 1988), several of which clearly follow *Al-Farafir* in conception, plot, or message.

Al-Mahzala al-'Ardiya

In *Al-Mahzala al-'Ardiya* ("The Earthly Comedy," Idris, 1966), the events occur exclusively in the registration lobby of the mental ward of a hospital. The pivotal personality of the play, like Farhat in *Jumhuriyat Farahat*, is the intake doctor who, helped by his attendant, Zero (*sifr* in Arabic), must evaluate those brought in for hospitalization. The play begins with a police officer submitting a straightjacketed arrestee for evaluation. The patient, Muhammad the Third, is accompanied by his brother, Muhammad the First, who supplies the information. Following the leading questions of the doctor, Muhammad the First relates how the Third, a professor in the agricultural college, had finally lost his wits by striking his family members and attempting to murder his wife with a knife, which necessitated calling in the police. The doctor resists the bribe of a watch that Muhammad the First offers him, and proposes to send them back to the police station for routine signatures that would consign the Third to the hospital.

In order to complete his evaluation, however, the doctor directs his questions next to Muhammad the Third, after asking Zero to loosen his restraints. The Third sighs that he found the straightjacket a relief, and proceeds to answer the doctor's questions calmly, attempting to paint a picture of his own madness. He succeeds, however, only in proving his all-too-understandable disgust at the world and deep depression. When asked about the attempt on his wife's life, he denies being married. Confused, the doctor asks the First to explain the contradiction, at which the First leadingly reminds the Third of his wife. The Third quickly agrees. The First then produces a woman named Nunu as the Third's wife, who also quickly asserts that everything that the First had said was true. Disquieted, the doctor then asks the Third what day it is, in view of the fact that yesterday was Saturday. Remarking that he is not so ill as to be dislocated in time, Muhammad the Third, replies:

M. the Third: Today is Saturday too, then.
Doctor: So when does Sunday come?

M. the Third: When we feel that today is different from yester-
day . . . when we sense that life has taken a step with us . . .
when we see that today's oppression is less than yesterday's
oppression, and today's justice is greater than yesterday's jus-
tice . . . when we feel that we've gone up a level or become a
whisper more reasonable or we've progressed a tad, Sunday
would come. (Idris, 1974, p. 285)

Impressed by the Third's coherent philosophical attitude, and prefer-
ring caution, the doctor dispatches the two Muhammads back to the
police station for the requisite routine signatures.

Just as they are departing, a man rushes in and begs the doctor to
prevent a crime. Presenting himself as their brother, Muhammad the
Second, the intruder accuses Muhammad the First of attempting to com-
mit the Third to the insane asylum in order to take his land. When the
doctor suggests that they proceed on their way while Muhammad the
Second explains, the latter becomes agitated and pulls out a gun. Under
this threat, the First admits that the Third is not mad. The doctor con-
fusedly reminds them of the wife's testimony. When the woman First
presented as Nunu again appears, the Second scoffs that this is the wife
of the First, who instructed her to help in the plot. All the more confused,
the doctor wonders why Muhammad the Third would willingly accede to
the plottings of the First. At this point, Muhammad the First grabs the
gun, and denies what he had said under the Second's threat of violence.
Muhammad the Second reminds the increasingly perplexed doctor that
Nunu had acknowledged that she was the First's wife, as proof of his
contention. The three brothers then relate their different versions the his-
tory of their family relationships, the inheritance of their land from their
father and its division among them, and the Third's mental or emotion-
al distress. The tale that Muhammad the First relates about his brother
runs as follows:

He left the sciences and began to read philosophy, even the yel-
lowed books that had belonged to his uncle the writer. He read
them book by book, and despite this philosophy, he who had
never smoked a cigarette began to smoke hashish and take drugs
and speed pills and to go to cabarets, and once he had a relation-
ship with a female student in the college from among his stu-
dents; so the dean took notice. He said to him, "I'm free [to do as
I please]" and turned obstinate and married her. He took an apart-
ment for her, and in less than a month discovered that she was

still carrying on a relationship with one of her student colleagues. So he divorced her and went out from that moment on, going downhill until one day he came to me of his own accord and said to me, "That's it, I want to go into the sanatorium." I said "Why?" He said, "Gotta." I told him, your salary won't allow it. He said, "I'll go into the government hospital." I tried to break his oars [i.e., prevent him], but I couldn't, until finally—what could I do, I brought him in.[23]

After listening to the different versions, Muhammad the Third asks the doctor for his decision on hospitalization. The doctor, profoundly confused himself, sees that only the truth from Nunu will solve the conflicting riddles of the three brothers Muhammad. He asks Zero to produce Ms. Nunu, at which Zero denies that there was any such person. Beside himself at this point, the doctor asks the Third whether the woman whom he had wished to kill had been present or not. The Third replies that she had not. Now sincerely doubting his own sanity, the doctor ends the first act in great distress by calling for Ms. Nunu.

The second act resumes with the doctor calling out vainly for Nunu, and then crumbling on his desk. Zero then steps up quietly and suggest he takes things simply. Fearing for his own sanity, the doctor shortly thereafter espies a lady in the lobby who Zero says has been present all morning. Believing that she is Nunu, the doctor speaks to her. The lady, played by the same actress as Nunu, but appearing twenty years older, is acclaimed as the three Muhammads' mother, Nina.

The mother, who had married again after the death of the father of the three Muhammads, has come only to express her concern for the Third's fate. She relates another more detailed version of the division of inheritance after the father's death. The sons insist that she had stashed a huge amount of money that their father had gained from the illegal sale of the questions to the national exams. She counters that the money had been spent before his death, with the exception of the 300 pounds they had received on his death. Their constant accusations had driven her away from them. The new husband himself had thought she had stashed the money, and when it did not appear, he divorced her. Alone

23 Ibid., p. 295. It is my suspicion that dramatic characters, like elements of dreams, may represent different aspects of the mind that produced them. Muhammad the Third, like Idris, is highly educated and, as is my contention in this paper, exhibits profound disillusionment on personal, political, and philosophical levels. This posited relationship between character and author's personality is all the more troubling in view of the rumors concerning Idris, which include drunkenness, drug use, heroin addiction, and constant flirtation. The question is one for a biographer of Idris, first and foremost, and not an issue of literary analysis.

and exposed she married again, with similar results. All because she had pressured their father to care for their future. They all end up in tears.

Muhammad the Third then asks who is responsible for his sense of loss, his despair, and depression, his lack of sense of connection to anyone. Why, he asks, is everyone out to get something from everyone else at the expense of human feeling, brotherhood, and positive emotions?

Zero suddenly cries out that Muhammad the First's wife is outside. The same actress enters, looking many years younger. Muhammad the First introduces her as his wife Nawal. The doctor is on the verge of breakdown as he recognizes both Nunu and the mother Nina in her. The woman exchanges obvious looks of recognition with Muhammad the Third. She denies being married to the First, but to someone else named Muhammad. She declares she is an outpatient who was given a shot by another doctor. The doctor breaks down completely. Muhammad the Third and the woman then clarify that she is in fact Zahra, his exwife, who married her student colleague, named Muhammad the First. She has come to the hospital for vaccinations before her trip to Ghana for the Asian-African Conference, the one line that links the play to extratheatrical events during Nasser's presidency.[24] After some measure of resolution over their past involvement and a suggestion of reconciliation, aborted quickly by the Third, Zahra departs in anger.

The doctor tries to call the police over the suspected crime of the mother. The three brothers then say she has been dead for three years, sending the doctor to call to check on her death certificate. He discovers, to his chagrin, that indeed their mother had died three years ago. As the doctor cries out for help in view of his certain madness, Zero escorts in Hanifa, the doctor's wife, who is the same actress who has played all the other roles. She expresses her concern for his obviously agitated state, as he asks her questions pertinent to Nunu, Nina, Nawal, and Zahra. Breaking down, he calls for the police as the curtain falls.

The third act includes the posthumous visits from the father and grandfather of the three brothers, whose disposal of their land has contributed to the messy conflict over inheritance. The doctor, gathering the shreds of his mind, insists that only the presence and testimony of Nunu can help him resolve who is telling the truth, and who, including himself, is mad or not. A mock trial is proposed to investigate the truth, and Zero is placed as investigator, judge, and jury. Indeed, Zero conducts an

24 Ibid., p. 312. The first Asian-African Conference was held in Bandung, Indonesia, in April, 1955. This conference was considered a great success for Nasser. Member states tried to organize other Asian-African conferences in 1961 and 1964–65, but they were ultimately cancelled. This may be an important clue as to exactly when the play was composed.

interrogation that brings out the "family romance," as Camille Paglia would have it (1990, p. 4), of the three brothers. The significant differences of the individual versions begin to disappear with the increase in detail. Muhammad the Third acknowledges, quite sanely, his own measure of responsibility in constructing the current knotty crisis. Zero succeeds in dissolving the knots and arriving at a fuller picture of the dramatic reality. As Zero questions each of the brothers in turn, the experience of each becomes comprehensible, and their level of responsibility is also clear.

One of the strongest messages in this section is the theme of the desire to leave some provision for the future of one's children, along with the horrible possibility that that desire will cause deep divisions and heartaches for the very people you are trying to protect. This is the "earthly comedy" of the title. As Muhammad the Third says: "The earthly comedy. I wanted to be the lone spectator of the earthly comedy, but I got caught up in it. I am my [own] tragedy."[25] Finally Zero asks the telling question about Muhammad the Third: Is he sane or not? The Third interjects: "Well, I guess you can call me sane to the point that people think I'm mad. Or someone so mad they think he's sane." Zero ends the court session by suggesting that Muhammad the First be allowed to put Muhammad the Third in hospital, as both had agreed, even if Muhammad the Second disagreed.

The last short scene is the upshot of the third act's moot court. After finding them all simultaneously victimized and responsible, Zero pronounces his judgment: "Very possibly all of them are victims, very possibly they're all perpetrators. And possibly neither this [is true] nor that. It's possible the oppressed is the perpetrator, and the oppressor is the victim. Anything's possible. Very possibly even I will turn out to be responsible too."

The doctor reiterates his appeal that only the appearance of Nunu will determine whether he is mad or not. Nunu suddenly appears as at first, and acknowledges that she had been waiting outside all this time for her husband. The doctor asks her to solve the mystery, to set things straight and say who she is. She replies, "I am the picture on which each person can put the frame he wants." She elaborates that she is the positive aspect of everything, the hope that must be present in order to live. She is Hanifa, the doctor's wife. She proves it by reminding him of their discussion before work that morning. She enunciates the very phrases and pressures that had initiated the family tragedy displayed in Zero's mock

25 This and all subsequent quotations from *Al-Mahzala al-'Ardiya* are translated by the author from Idris, 1974, pp. 341–350.

court, then declares her husband free to do whatever he deems appropriate. The doctor, surrendering to the pressures building throughout the play, dons the straightjacket himself, raving delusionally that this will safeguard his wife and children from so maddening a family conflict as he had just witnessed.

This fast-paced and confusingly complex comedy again represents a continuation of the absurdist existential ponderings that occur in *Al-Farafir*, instead of engendering suicide, as in the former play, the multiple, mutually conflicting versions of the truth are maddening here. While it is no direct critique of Nasser's regime in the play, the issue surrounding the inheritance and sale of land may include a veiled criticism of the Nasserist land-reform laws. Overwhelmingly, however, like *Al-Farafir*, this play is an existential tragicomedy, dealing primarily with the psychological and emotional results of the pressures, peculiarities, and disappointments of life. The very tightly drawn comic plot, however, seems to answer the existential angst that is encoded in the character of Muhammad the Third. The doctor chooses, like the Third, to go mad sanely, and we are left to laugh and ponder whether we can possibly positively affect our own or our children's future with any certainty. The laughter evoked in *Al-Mahzala al-'Ardiya* is the only answer proffered to Muhammad the Third's tragedy, the existential tragedy of human existence.

Certainty is deeply challenged in the play, just as multiple versions of the truth, which are seemingly contradictory, are forefronted. The multiple faces of events presented by the brothers and their family is similarly encoded into the face-shifting single female actress, who plays Nunu, Nina, Nawal/Zahra, and Hanifa. Again, the gender aspects of the play are quite interesting, for the face of woman in the play changes according to the needs of those who perceive her. Nunu/Hanifa explains her multiple role in the comedy in some detail:

> [I'm] an image of things very easy to imagine, but very hard to encounter and touch. An image of concepts you've been talking about all your life as if they were present, like Justice, as if it were possible, like Happiness as if it were real. Like Truth, as if it were obvious. An image of the tomorrow you're waiting for as if it were completely other than today, and when tomorrow comes just like today, you say, 'Tomorrow!' An image of many dreams you make into a reality on which to build you life, even though that reality isn't there even in dreams. The image of Mother as a mother. The Lover as a lover, not a woman sick with love. Faithfulness as real-

ly faithfulness. The image of a smile coming forth one hundred percent from a heart that is all smiles. The image of truthfulness with which we can reply to liars. The image of the victory of good over evil. Has anyone ever seen for himself a victory of a real good over evil? An image of hope that all the evidence is against, and that everything around us denies. Something mysterious like me; something that has no guarantee.

This image of woman as hope contrasts with the other apparently fickle, treacherous, and lying images in the alter egos represented in Nunu, Nina, and Zahra. A deep ambivalence in relation to the feminine is evident.

It is the Farfurlike attendant, Zero, who ultimately makes some sense out of the web of madness spun before the audience and around the doctor. Only he, the wise jokester of lower-class status, really has understood the tragedy and has survived intact. Zero is also the only figure whose response to the need to survive and provide is to be cautious, helpful, and wise. For he is *sahib kam 'ayal* (i.e., has many children)[26] and he is his children's only guarantee of any future. He has no grudges, but rather a sympathetic ear, a readiness to challenge, and a readiness to forgive.

I would fault the play for being too intricately complicated. Only very deliberate staging would allow the detailed subtleties to emerge. The characters' despair, however, is beyond suicide. It is the existential joke, profoundly pessimistic. Tragedy is inevitable, even if you are personally able to avoid it. But don't count on being able to protect yourself or your kin from tragedy. Even the best you can do may not be enough, so despair and cruelty are all too possible. Only laughter in response to the earthly comedy softens the absurd blows of human fate.

Al-Mukhattatin

Idris continued his use of comedy when he returned to political critique in *Al-Mukhattatin* ("The Striped Ones" or "The Cons"),[27] on the heels of the disastrous 1967 defeat. Players gather at a vaguely defined place. Perhaps street people, each is named with a comic idiomatic word or phrase,[28] and disguised in very peculiar costumes, contributing to the

26 Zero repeats this phrase numerous times throughout the play as a justification for his cautious behavior.

27 Idris, *Al-Mukhattatin* in *Al-Masrah* (May, 1968) pp. 81–96. In view of the content and the fact that the play was censored, there is reason to also read *mukhattitin* "the planners, the stripers." The use of black-and-white stripes also reminds one of prison uniforms, adding to the sense that this is an illegal movement.

sense of dislocation in time and space. Once the awaited leader, named Brother,[29] arrives, the meeting begins. Some of the attendees exhibit dreadfully sychophantic behavior toward Brother. Denying the accusation of hypocrisy, Farkat Ka'b says: "Hypocrisy comes from people who fear you, who are scared to tell you the truth, who see, no offense, God forbid, something bad in your brotherliness, and say it is good."[30] He himself is incapable of taking any position lest he displease Brother.

This secret organization has obviously been discussing radical change, an overthrow planned in secret. The multiple meanings of the title of the play are emphasized by the repeated use of the title's triradical root *kh-t-t* in the Brother's discussion of what must come about:

Ahuw Kalam ("It's [Just] Talk," one of the collaborators):
The world must be defined and delineated (*yitkhattat*). Man must define everything, even himself. Everything becomes clear and understandable and whole. White is white and black is black. That next to this, not black melting all over white, nor white drowning the black. The lines (*khutut*) are straight, with a known course from beginning to end.
Brother: And how is that going to happen, Farkat Ka'b?
Farkat Ka'b: I'll only relax when I achieve what's in my head, and all the world is striped (*yikhattat/yukhattat*) black and white

The linguistic repetition of the root *kh-t-t* is played on purposefully throughout the play, forefronting the planning involved (*takhtit*), the association with prisoners, and the intention to demarcate everyone and everything according to a single measure of black and white.

This is the critical moment for which the group has been working, the approach of zero hour, in which their secret agenda will become public, and the members intend to change the world. The lamented lack of a bomb as a supportive weapon is resolved by the appearance of another conspirator, a bombshell movie star named Diamond, who appears completely striped from head to toe. Brother then offers a new striped suit to Farkat Ka'b, instead of his old grimy clothes. Each coconspirator in turn

28 The collaborators are Ahuw Kalam ("It's [Just] Talk"), Farkat Ka'b ("Scrape of a Heel"), 56 Gharbiya ("56 Western"—referring to a bus route), Doctor 'Ariq ("Doctor on an Empty Stomach"), Ta'miya ("Felafel"), Almaz ("Diamond") and their leader, al-Akh ("Brother").
29 There seems little doubt that Idris is pointing to George Orwell's *1984* through several details in this play. A more thorough comparative analysis is called for in this area.
30 This and all subsequent quotes from *Al-Mukhattatin* are translated by the author from Idris, *Al-Mukhattatin*. n.d., pp. 19–83.

signals the intention to also express his/her solidarity through stripes, along with the intention to reorganize the world and change history.

The second act opens with Brother standing, and the coconspirators, now all dressed in stripes, sitting in a row on a margin of the stage, as if in a seminar, observing the events occurring on center stage. There, the president of the board of administration of the Organization of Greater Happiness sits in his office, preparing to meet those requesting audience with him that day. He has his secretary escort in the head of public relations, who attempts to ingratiate himself with the president before presenting new slogans for the organization's advertisements, encouraging opportunism, murder, and stealing. Impatient, the president waves in the next guest, who turns out to be the poet, Abu al-'Ala al-Ma'arri.[31] Incorruptible in his lifetime, al-Ma'arri has come to offer his panegyric services to the organization, in view of the fact that "news of [the organization] started giving me insomnia in my grave, spoiling for me the pleasure of the twofold rest [i.e., of body and soul] What keeps me awake in my grave is the rivers of money pouring from your venerable budget." The president rejects his offer and sends him away.

The organization's Expert on Marital Happiness comes in next, at the request of the president who is upset at the rise in divorce rates. After a discussion concerning means to encourage (inter-) personal happiness, the expert refers the president to the Taboo Division, as her area was in lawful marriage only. With a signal from Brother, Diamond enters the scene, announcing that she wishes to register a critique of the Organization of Greater Happiness. The president, obviously smitten with her attractiveness, appoints her the Director of Special Relations, as a way to deflect her criticism and entice her into having a relationship with him.

Each of the striped ones is brought in turn into the scene being enacted as new members of the Organization of Greater Happiness. Diamond as the Director of Special Relations (encouraging the president's flirtation to make him more vulnerable) informs the president of her suspicion of plots among the executives, pointing out his consequent need for protection. Doctor 'Ariq is brought in as the president's bodyguard and head of security. When a fight breaks out among executives over who shall replace the suddenly deceased director of employees, Doctor 'Ariq convinces the president to follow legal hiring procedures and recites a

31 Ibid., pp. 40–42. The contrast between al-Ma'arri's *fusha* (classical and formal Arabic language) and the *'ammiya*, (colloquial, dialectal Arabic) of the rest of the play is remarkable, in view of the critiques that Idris faced for the language he used in his plays and other writings.

job announcement. In an obviously fixed process, 56 Gharbiya steps up for the job. Ta'miya is brought into the organization as fortune teller and prognosticator. Ahuw Kalam similarly seeks his opportunity, and Farkat Ka'b becomes the organization's Expert on Opiates. Then, Diamond enters the president's office, thwarting his continued attempts to have a "private relation" with her at work, and announces:

Diamond: How can we work? We can't work!
President: Why not? Here I am, here you are!
Diamond: No, it's no use this way. We can't do everything today
 and find no work tomorrow. We want a plan (*khitta*), my dear.
President: We'll make a plan.
Diamond: No, we're not the ones to do it. The Director of the
 Tomorrow Division that we made, he'll be the one to do it.

At this, Diamond ushers in Brother, who quickly deposes the president. The now-deposed president of the administrative board asks to stay on in the lowest capacity for something to do rather than to go home with no remaining purpose in life. His well-oiled flattery does the trick, and Brother allows him to stay, despite Doctor 'Ariq's objections. Brother then changes the name of the organization to the Organization of True Happiness,[32] and sends his grumbling minions to the far reaches of the earth to spread the new striped order of happiness to the whole world.

In the third act, a year has passed since the striped revolution, and celebrations are prepared to commemorate the revolution and glorify Brother. The whole world is now covered in black-and-white stripes. Diamond congratulates Brother over the success of the revolution, commenting that he must be the happiest person on earth. Obviously unhappy, Brother admits his doubts. He had really wished to make the world happy and had believed in the striped revolution. Now, however, he sees that stripes are not everything, and that they must effect another revolution in order to encourage true happiness. Scandalized at his admission of doubt and disillusionment, and unable to convince him otherwise, Diamond begs Brother not to reveal his ideas at the meeting of the Striped Council whose members have assembled for the anniversary celebration.

At the meeting of the administrative board composed of the former

32 Brother talks of the change of name by pointing out the change of acronym from *m-s-k* (from Mu'assassat al-Sa'ada al-Kubra) meaning "grasp, seize, take hold of to *m-s-h* (Mu'assassat al-Sa'ada al-Haqiqiya) meaning "wiping, wiping off, wiping out." Ibid., p. 70.

coconspirators (who greet each other with the most sycophantic and self-congratulatory salutations) and its former president, Brother calls for a return to revolutionary values. He accuses his coconspirators of forgetting the happiness of the people while personally benefiting from the division of goods, services, and influence. He proposes that the lords must be wiped out, and a revolution be mounted against black-and-white stripes. Dismayed and unbelieving, the board rejects his ideas, recognizing that Brother's ideas necessitate the abolition of their privilege and the destruction of what they had achieved, regardless of any validity those ideas may hold. Brother is abandoned by one after another of his former supporters, and ultimately is deposed by the former president, just as he had originally deposed him. Brother departs to take his message to the people.

In the final scene, Brother has been arrested on that same day, after having gone out to a café dressed in a red suit to share his revolutionary ideas against black and white with the public. He has been beaten up badly and is brought back disheveled to the Administrative Council. The citizens who had heard and been influenced by his talk had been dispatched without trial to the South Pole. The former president offers Brother two choices: either to die to preserve the cult of his personality for the benefit of the striped world, or to resume his place as president of the board and act the part completely, despite his lack of conviction. He collapses, defeated, into the president's chair, and starts the self-congratulatory meeting, accepting the sycophantic expression of delegates, and the completely insincere panegyrics of his colleagues.

In contrast to *Al-Farafir*'s political critique, which is limited due to its vagueness, *Al-Mukhattatin* is difficult to read in any other way but as a rather direct review of Nasser's revolution and a critique of the new regime. The points of the isomorphism with the play include the secret formation of the Free Officers, their infiltration into several levels of government, the overthrow of King Faruq, the establishment of the Revolutionary Command Council, and the promulgation of a new revolutionary ideology that characterized the early years of the postrevolutionary government.

All the more interesting is the self-doubt that Idris encodes in the figure of Brother, the obvious symbol of Nasser himself.[33] After the disastrous defeat of 1967, Nasser stepped down as president, only to be acclaimed by such an outpouring of public insistence that within twenty-four hours he reassumed the presidency. As much as the play criticizes, it

33 Brother says "I'm sick ... sick of the nights I've spent asking myself and wringing

also pities Brother, who is now captive of the very order he established, allowing that his good intentions have been covered over by those whose interests the new order now serves. The play points out the cyclical corruptions of power and the insincerities of sycophantic personality cults, and finally it accuses Brother's entourage (those around Nasser) of benefiting most from the revolution for themselves, at the cost of the real interests of the people.

Idris dares to accuse the regime of massive corruption and of deluding the masses, using the vehicle of the theatrical metaphor. Another fascinating aspect of this play is the metatheatrical discourse and interpenetration of one theatrical frame into another, and the actors' stated awareness of the audience.[34] Diamond herself points out the confusion: "Are you acting out a tale or what?" This also occurs when Brother charges the recently deposed president to spread the new striped order by taking control of a nearby comedy theater in Cairo. The resultant fluidity between reality and theatrical suspension of reality makes it all the more inviting to metaphorically project the implications of the play onto real time when Nasser and his regime had to recoup the defeat of 1967, in order to salvage the tarnished image of the revolution.

Al-Jins al-Thalith

Three years later, Idris published *Al-Jins al-Thalith* ("The Third Kind"),[35] which employs science-fiction fantasy in a radical departure from his other dramatic metaphorical works. Some have regarded this play as a philosophical investigation of Nietzsche's idea of the *Übermensch* (Badawi, 1987, p. 164), but I think it more likely a consideration of bipolar complementarity between the sexes. Many of the gender issues and stereotypes that have appeared in other of Idris's plays are drawn out more explicitly in this work.

With the help of his pretty assistant Nara ("fire"), Adam, a medical scientist, is working on an experiment in which life will conquer death. As he performs the first trial, a supernatural event occurs that locks the measurements into sevens. Concurrently, the sound of a strange feminine voice announces that Adam has an appointment in 'Ataba Square.

myself out and saying, 'Did you want to make the world happy in all earnestness, or did you want to stripe it so you could rule it and be leader?' It's been a year living by myself, a frightening nightmare, a strange horror. Sometimes I pull one over on myself and say 'What's the importance of truth as long as striping has succeeded and the people are pleased and you're the leader, you've entered history and you'll never get out of it?'" Ibid., p. 83.

34 See metatheatrical comments and interpenetration of levels, Idris, *Mukhattatin*, n.d., pp. 26, 27, 44.
35 Idris, 1971. Performed in the 1970–71 season; and see Mahmud, 1995–98, vol.1, p. 62.

Adam is taken off stage as if sleepwalking. In the next scene, Adam finds himself in 'Ataba, restricted mysteriously to a smaller and smaller circuit around a bench in the square. He has also become invisible to others. Shortly, another gentleman arrives, similarly summoned, only to escort Adam as his driver in a vehicle to another, elevated plane of existence.

Now left alone in a desert, Adam encounters conscious and moving trees, who instruct him that he has been summoned by "She" to the glowing city toward which they escort him. One of the trees, the Tamarhenna ("tamarind"), falls in love with Adam and, disregarding the order of things, wishes to waylay Adam from his appointment with She by entangling him in her branches in an expression of inappropriate cross-species love. As punishment for her sin (the first sin among trees), the Tamarhenna tree becomes fixed in her place and loses her ability to speak, while the rest go on toward the city. Adam is not held responsible for the sin.

Once the trees have brought Adam to the outskirts of the city, they withdraw. He then meets peculiar creatures that are mixtures of species and materials—a dog-sheep mix and a surreal creature of light—that escort Adam to the palace of the Scientist Savant. The newly created light creature criticizes earthly humankind for their murderous tendencies, as it flies Adam towards the palace. True humans, it informs him, are more refined, more capable of love and sympathy. For earthly humans to evolve beyond their animal nature, a new kind must be created. Adam has been summoned for this task related to the fate of all humankind (Idris, 1974, pp. 431–432).[36]

In the next scene, the Scientist Savant explains that the race of earthly humans is derived from the descendants of murderous Cain. The city Adam now visits is that of another, more spiritual kind of human, derived from the offspring of Abel, who had fled from the prehistoric slaughter between races on earth. Characterized by spirituality, love, and art, they had a low birth rate, but continually sent missionaries to earth (messengers, poets, reformers) in an attempt to save earthly humans from their animal nature. Consequently, the spiritual humans had all but gone extinct. Adam had been selected as the appropriate mate for She, the princess and mistress of that world, and the single surviving member of her kind. Their offspring would save both races, comprising some sort of spiritual and genetic survival for the Abelians and improvement for the

36 The remarkable religious aspects of this text should be noted, in contrast to rigid sectarian articulations. While formulaic lip service is given to religious belief in the sphere of Adam's "real" life in Cairo, the light creature shows Adam a temple from above, in which the creature citizens worship each other. Although it denies that they have gods, the hymn welcoming Adam refers to him as savior knight.

Cainians. Adam must seek out She and find her in his life, for She would take on the guise of an earthly human to be his greatest desire and greatest love—one whom he must recognize.

Adam is returned to his own existence and, transformed by his supernatural experience, can think of nothing but the mission he must accomplish to save a whole aspect of humanity by engendering the Third Kind. He has come to long for the unknown She with all his passion, heretofore directed into his scientific work. Nara notices his ennui, and tries to arouse him from his slump with the news that a female Swedish scientist is waiting to meet him. Though he tries to wave her away, Nara insists he meet the gorgeous woman, who represents a particular stereotype of the feminine. Not only is she buxom and blondly beautiful, but thrilled when he acknowledges her beauty.

Hilda, who has come to Egypt out of admiration for Adam's published work, innocently misleads Adam into believing that she is the prophesied She when she mentions an impending appointment in the middle of 'Ataba Square. He declares she is the awaited dream of hope. Hilda responds in kind, with an exaggerated self-effacing feminine passivity:

> My name is hard on your tongue—change it. Name me the name you please. If you don't like my clothes, I'll come to you nude, and you can clothe me as you wish. If you don't like what I say, tell me, and to the last day of my life I will abstain from speaking, I won't utter a thing! Just tell me, ask, give indication! Think it, even. I am your possession from the day I was born; till I die I'll be yours. Subject to any idea that comes into your head, any whim, any dalliance, even if you've gone mad!

Unfortunately, Adam discovers that he does not return her fierce passion. His hesitancy drives Hilda away in disappointment. Horrified that his lack of love for her will condemn the human race, Adam wishes to establish a relationship with Hilda out of a sense of duty. He dispatches Nara to convince Hilda to meet again, only to have Hilda again withdraw, unable to settle for the humiliation of one-sided love.

The last scene is back in the laboratory, where Adam and Nara are performing the seventy-seventh experiment with Adam's seventy-seventh version of the synthetic enzyme that should encourage the will to live and conquer the death enzymes in the body. Adam has placed his life's hope in the success of this last experiment, as he has failed in the greater task with She. Meanwhile Nara wishes for success because she can no longer bear watching the deaths of scores of animals. Adam then

requests rabbit number 95, which happens to be Nara's lab pet, and the control animal of the earlier experiments. Nara objects to the use of this rabbit. Adam insists, and injects the rabbit with the death enzyme, which hastens the rabbit's demise. Although he does inject the will-to-live enzyme, which should save the animal, the rabbit dies anyway. Nara, deeply sorrowful and guilty, curses the doctor's self-centeredness, for not dreaming big enough, for not loving enough and powerfully enough to save anything, for always wanting to control everything.

In a fit, and declaring she wishes to live only as a real full-fledged human being, not like a lab rat, she injects herself with the death potion. Discovering through the threat of losing her that he loves Nara, in horror Adam hastens to redesign his vaccine to try to save her. He discovers as she weakens before him that Nara herself is She, the feminine corresponding most completely to him and whom he most desires, had he only known. Referring to the supernatural events in the first session of the experiment that opened the play, in which sevens kept coming up, Adam changes his approach, dilutes his formula by seven parts, and injects it into the expiring Nara. She responds, with a smile chiding him for struggling to save her only because he had discovered that she was She, which Adam denies.

> Nara: So what about She? She was all of your hopes and
> dreams. Your love and your mission and faith. She was
> everything to you. Even in terms of form, you never
> imagined that you would love someone like Nara. All your
> life you've searched for someone like Hilda—another type
> altogether!
> Adam: You wicked girl! You know very well the type I love, and
> that's why you entered my life as Nara/fire. We don't love in
> our dreams. We only dream in our deprivation. But when we
> love, we love in our reality.

The play ends with their crediting each other with the greater power that allowed Adam to successfully discover the will-to-life potion, and bring Nara back from the edge of death. She beckons to him out of her longing, for now they may engender the Third Kind, their children of the future.

Idris has played with philosophical discourses in this play, with its discussion of freedom and constraint, the nature of humankind, and spirituality, higher spheres of existence, and supernaturally determined missions to save humankind from spiritual extinction. In this, Idris and Doris Lessing may share the Islamic philosophical and Sufi discourses

that inspired the second volume of Lessing's "space fiction" series (Lessing, 1980).[37] It seems less likely that Nietzsche is the source of these considerations in the play—with the possible exception of the idea of the will-to-live and will-to-die enzymes. There certainly is a greater power that manipulates from behind the scenes on all levels of the play, though it is disavowed as a divinity per se, even as it is asserted in formulaic language. Idris does seem to hold a less than rational faith in biochemical science's ability to conquer death, all the more intriguing in view of recent advances in contemporary genetics and the science of aging.

Ultimately, however, Idris explores in this play ideas concerning positive and negative interactions between aspects of the feminine and the masculine. The contrast in images of women set up between the Barbielike foreign scientist, Hilda, who surrenders her personality to be molded and affirmed by the man she loves, and the natural, unadorned, sincere, and subordinate lab assistant, Nara, whose personality is nonetheless unconquerable, has a nationalist overtone, favoring the Egyptian model over the European. Much of the ambivalence with the feminine that we have noted in Idris's earlier plays reappears here, with the elevation of the issue to cosmic proportions. All complaints concerning the nastiness of human nature can be redeemed only by the proper relationship with the feminine. The male protagonist redeems himself from ennui and deep disillusionment through union with the higher moral feminine, and for the sake of all humans. It is only those cosmic proportions that have called Adam into responsibility toward humankind and future generations.

Al-Bahlawan

After a significant hiatus from writing for the theater, Idris culminated his theatrical writing career with *Al-Bahlawan* ('The Clown"), which was performed in 1988.[38] Idris comments here on his long involvement in journalism, while also returning to the theme of sychophantic hypocrisy, evident in *Al-Mukhattatin*.

By day the main character, Hassan al-Mehaylami, is editor-in-chief of a major Cairo newspaper, called *Al-Zaman*,[39] and a clown with the name of Za'rab at night in the Egyptian circus. Hasan thus maintains "balance" in his life. His day job, where he carries on an affair with his secretary,

37 The idea of concentric spiritual spheres of existence ascending unto the divine is very common in both Arabic and Persian philosophy and Sufi thought, including the work of such major thinkers as Ibn Sina, Suhrawardi, Ibn 'Arabi, and Rumi.
38 Idris, *Al-Bahlawan*, n.d. Performed in 1987/88. Also see, Mahmud, 1995–98, vol. 1, p.62.
39 Idris worked for *Al-Ahram* newspaper starting in 1973 as a writer and cultural consultant (Mahmud, 1995–98, vol. 1, p. 60).

Eva, requires a considerable degree of flexibility to alter news coverage and editorials to suit the changing political climate as dictated by the government-appointed head of the newspaper. Hassan's wife, Sherifa, is suspicious of his daily absences until 1 a.m. The play is comprised of numerous short scenes divided among Hassan's office at the paper, the circus, and his home.

News arrives that the government has appointed an enemy of Hasan as head of the paper and replacement for Hassan's ally, al-Mahallawi. The new head, named al-Gharabawi,[40] has every reason to dislike Hassan, who had written extensively against him, with the support and encouragement of al-Mahallawi. The first thing al-Gharabawi does is to place al-Mehaylami on administrative leave, and make 'Ala', the executive editor, acting editor-in-chief. 'Ala', who hates al-Gharabawi, had planned to tender his resignation upon the news of the deposal of al-Mahallawi. Hassan, however, convinces him to accept the arrangement temporarily, while he himself tries to manipulate matters from behind the scenes in order to retain his own job.

Hassan asks his wife Sherifa to speak to al-Gharabawi's wife through another mutual friend to gain him an audience with al-Gharabawi. Sherifa is increasingly dissatisfied, however, with Hassan's excuses of being at work late at night, especially now that he is on administrative leave. To make things worse, Eva, the secretary, calls to mourn the loss of the hanky-panky, which has been interrupted by the leave. Although Hassan takes pains at the circus to hide his face constantly with that of a clown, fearing recognition, Mervet, a trapeze artist, nonetheless begins to fall in love with him for his philosophical utterances and his encouragement of her as she supports her siblings through her circus job.

Having won the hoped-for audience with al-Gharabawi, Hassan curries favor with him, blaming al-Mahallawi, his friend and former boss, for the negative comments he had written against al-Gharabawi. Hassan despicably agrees to write articles against al-Mahallawi, inventing evidence against him, in order to keep his own job.

The next morning Sherifa discovers the clown makeup in her husband's suit pocket and confronts him with the lipstick and powder. She has suspected an affair with another woman, but now fears transvestism or worse. To Sherifa's incredulity, he admits that he is working as a

40 The use of these two contrasting names is a linguistic ploy that influences the audience response to these two figures. Al-Mahallawi means essentially "local boy" while al-Gharabawi could be understood as "related to the alien, strange, or western." I believe this would stimulate sympathies for al-Mahallawi, who never appears in the play, as opposed to al-Gharabawi, who proves his double-crossing vengeful spirit in the action of the play.

clown at night in the circus. She finds the possibility deeply humiliating from the point of view of her social status and is unconvinced. Hassan tells her to go to the circus that night, and she would see him playing the clown, proving his innocence of all she suspects.

Back at the office, Hassan informs 'Ala' that he has returned to his duties and offers him a promotion and an opportunity to work directly with him as his right-hand man. 'Ala' demures, saying that he cannot work at the cost of his principles. He has read the lies that Hassan has written against his former friend and boss, and has finally lost all respect for his superiors in the newspaper. While Hassan attempts to convince 'Ala' otherwise, al-Gharabawi enters with a surprise turnaround.

Having forced Hassan to metaphorically stab al-Mahallawi in the back by publishing slanderous lies about him, al-Gharabawi now maliciously fires Hassan, citing as cause the nasty things Hassan had previously written about him. Hassan retreats, defeated, caught in the web of his own hypocrisy. Al-Gharabawi offers the job of editor-in-chief to 'Ala', who declines, unable to put aside his principles for the sake of convenience. In fact, he leaves his job—the only "straight" person in the play, the only one who lives by his own ideals. Idris shows the cost of keeping and living by one's principles.

Back at the circus, Za'rab/Hassan the clown performs his part. He clownishly fails a clown test, which now strikes too close to home, in view of his lost day job. The emcee then says he must pass the practical part of the test with the Indian faqir's box trick, in which swords are run through the box, and the clown must emerge magically unscathed. Za'rab turns the tables and has the circus emcee try the more dangerous game of the Egyptian faqir's box, in which he makes the audience laugh at the horrible, difficult current conditions in Egypt. After the performance, Mervet finds Za'rab crying.

Mervet: You're really crying!
Za'rab: I'm a failure in everything; I'm a failure.
Mervet: What's this insipid joking? That's part of your act.
 What? You want to show me that you're absorbed in your
 part? But however much you got taken up in the role, you
 never cried for real. What are these tears?
Za'rab: These are the tears of a clown, Mervet, the tears of a
 clown. Haven't you heard of them?
Mervet: No, I haven't heard of them.
Za'rab: They are the most valuable tears in the world—the tears
 of a clown, who makes the people laugh as he cries.

Mervet: And why does he cry?

Za'rab: Because the world is very hard, Mervet. Life is very insufferable. Making a living is very tiresome—very tiresome. Do I know why people are living it? By God, death is more merciful! A million times more merciful. Pain for an hour and that's it. One lives for tomorrow because he dreams that tomorrow will be better than today. Tomorrow comes more ridiculous and despicable than today. And day after tomorrow is cut more severely than tomorrow. One starts sitting torturing oneself more and more—for what? Sitting there taking the pain and suffering for something more pleasant. The more pleasant turns into disgust. We're disgusted. Do I know why we're holding on to life so in this fashion?

Mervet: Because we're taking it too seriously. Even though you're the one who shouldn't take it seriously. You're the clown who's against seriousness, whose job is to turn seriousness into silly tomfoolery and a laughingstock.

Za'rab: That's just the calamity! Alas for the time that comes on people that makes the clown turn joking into seriousness, it's a sign of the end.[41]

Mervet tries to rouse Za'rab, and hugs him from the back to lighten his gloom. At that moment Sherifa enters to witness the innocent hug. Convinced that she now has proof of the relationship she had feared, she rages that she will make a scandal and scoffs at the clown's "balancing" act.

The next day Za'rab the clown is called in to the office of the head of the circus, to find that al-Gharabawi has also replaced the head of the Egyptian circus. He prepares to fire Hassan from his clown job as well. Hassan again tries to mollify him by explaining the true vocation of a clown as court jester, saying what could not be said by any other person in court:

The art of clowns is a very grand art, greater than acting a thou-sand times over, because it's the art of acting inside the lion's mouth So I have to speak the truth and be insolent; and instead of cutting off my head, you laugh—these are the rules of the game. Do you want to play or not?!

Al-Gharabawi consents to let Hassan keep his clown job if he will hand Mervet over to him as his mistress. Hassan refuses. Al-Gharabawi

41 This and all subsequent quotes from *Al-Bahlawan* are translated by the author from Idris, *Al-Bahlawan*, n.d., pp. 14–119.

ups the ante, offering him his newspaper job back, his life restored, and a five-year contract. Hassan stipulates that al-Gharabawi must publicize the contract in the paper, declaring the zincograph ready to run. Al-Gharabawi agrees; Hassan agrees. Mervet emerges from her hiding place, to spit on Hassan. Al-Gharabawi completes the job by firing him from the circus too.

As he collects his things, having gambled and lost two jobs and his wife, Mervet tries to tease him out of his depression, declaring that she loved the truthful and risk-taking clown and had displayed her anger only to rid them of al-Gharabawi forever. The play ends with the two circus performers declaring that all the world is a stage—or rather circus! The clown lost all but gained true love.

While this play returns to contemporary social and political critique, it also retains the theme of the feminine as savior. While one could certainly argue that this play contains specific commentary on the world of state-controlled journalism, it can also be construed as a commentary on high-powered cultural and professional life with its temptations and dangers. The balancing act of Hassan reveals the tension between the ideological and the real, the experience of failure and humiliation, and the cost of survival—all issues in other Idris's plays, starting with *Al-Farafir*. The character of Za'rab the clown relates directly to Farfur and to the doctor and Zero of *Al-Mahzala al-'Ardiya*. It is these characters that most directly reflect the persona of Idris himself, the literary clown, who speaks truth to make us laugh, cry, and shiver in empathy. Idris also characteristically deals with the issue of personal, political, professional, and moral disillusionment, which we have seen in the characters Farfur, Muhammad the Third, Brother, Doctor Adam, 'Ala', and Za'rab.

I will be the first to say that I believe that *Al-Farafir* is Idris's best and singlemost important play, but several of his plays carry important philosophical and existential arguments. The gender messages again and again, however, present the image of great ambivalence toward the feminine, with the correctly matched feminine role serving as a redeeming factor in the life of the male protagonists who are also arguably the playwright's dramatic persona. The larger corpus of his plays traces a rise of ideological and national fervor to a peak in *Al-Lahza al-Harija* to follow thereafter a path of disillusionment, disappointment, and despair tempered only by humor. Idris's clown, then, does indeed represent the culmination of his dramatic career, in which, with the wryness of a survivor, he reviews the balancing act of any major player in the sociopolitical sphere of culture and reaffirms the importance of honest, balanced relations with the feminine to ground that player and provide the means

and support for cheerfully surviving the terrible risks faced in Egyptian political and literary culture. Direct political and social critique is nonetheless written into the clown's circus act.

Idris succeeded in his dramatic career in commenting on major issues of both universal and Egyptian scope. His plays exhibit a shift in perceptions and ideological emotional tone. His success can indeed be measured by how well he was able to speak his truth and entertain the masses at the same time. The comedic vehicle nonetheless allowed Idris to explore a variety of issues that may have sobering implications. The fatalist disillusionment that is encoded into the corpus is resolved and bearable only in the context of the comedy that lightens the burden for us all.

Louis Awad contrasts Idris along with Mahmud Diyab, Rashad Rushdi, and Shawqi Abd al-Hakim from followers of Nagib al-Rihani (colloquial comic) and Tawfiq al-Hakim (classicizing high drama). Of these four, Yusuf Idris is the most vital force and, if it were not that his power of dramatic construction fails him halfway through his plays, he might have become the greatest Egyptian dramatist of the Nasser era (Awad, 1975, p. 185).

Awad discusses the relationship of the theater to the critique of Nasser's regime, noting that dramatists "came to the conclusion that there was something rotten in the State of Egypt, and that it was nothing less than the Nasser regime itself which relied on the counterrevolutionary to effect the revolution, on the Kulaks to effect agrarian reform, on the capitalists to effect socialism; it relied on the reign of terror to extinguish free thought, to quell the sacred ire of the masses and to shield public thieves and treasonable characters" (Awad, 1975, p. 192). He also remarks that in 1970 at least five plays were banned before they were performed, including Idris's *Al-Mukhattatin* for the perceived critique of the regime.

Other cultural and literary critics have pointed to Idris's plays as important articulations of contemporary crises on many levels of public discourse (Fathi, 1991).[42] Idris himself knew well the personal and public costs of being a cultural player, and articulated these crises through the rich and intricate structures of his characters and plays. Much like Farfur and Za'rab, Idris's stature in dramatic discourse derives from his weeping the profound and hilarious tears of a clown.

42 For an excellent exploration of postrevolutionary theater and cultural critique, see Farag, 1976, and *Yusuf Idris bi-qalam kibar al-'udaba'*, 1986.

4 El-Warsha:
Theatrical Experimentation and Cultural Preservation[43]
Tori Haring-Smith

Before I came to Egypt, I associated this country with icons of preservation, the pyramids, the Sphinx, the Rosetta Stone. Having lived in Egypt from 1996 to 1999, I now have a very different sense of Egypt's relationship to its past. Simply put, Egypt's culture is in danger of disappearing, thickly covered over as it is by layer upon layer of colonizing influences. The physical monuments remain (at least some of them), but the culture is disappearing. The Bedouin are being settled, the Nile bridged and dammed, and the ancient songs and stories are being forgotten. McDonalds, Kentucky Fried Chicken, Xerox, Panasonic, Kodak, Demi Moore—these are quickly becoming the culture of contemporary Cairo. Along with this cultural loss has come a loss of identity, a sense of self.

Nowhere is this more apparent than in the Egyptian theater. The first recorded performance of a European play took place here 150 years ago, and since then, the theater has developed as an essentially Western form. The commercial theaters are dominated by domestic farces while the impoverished private companies superficially ape European experimentalism, both scrupulously censored for any shred of explicit sexuality or political critique. Only in the past few years has there been any evident interest in building a theater rooted in Egypt's indigenous arts.

The man who has spearheaded this movement and remains its most prominent and successful leader is Hassan El-Geretly. El-Geretly's theater company, El-Warsha ("The Workshop") was founded in 1987. Since then, the membership of the group has changed, of course. People have come and gone, but consistently some members have been amateurs (previously bakers, secretaries, students) and other theater professionals. Because El-Geretly often holds open rehearsals, there is certainly the sense that the boundaries of the group are permeable. However, El-Geretly does not accept casual comers. He likes to build long-term relationships based on a mutual understanding of mission. His is not a weekender's theater, but it does draw from all segments of society. Currently, for example, several members of his troupe have come from a choir school for Muslim and

43 Acknowledgements are made to the University of Michigan Press for permission to reprint this material, which appears with minor variations as "Preserving a Culture Through Community-Based Performances in Cairo," in Susan Haedicke and Tobin Nellhaus (eds.), *Performing Democracy: International Perspectives on Community-Based Performance* (Ann Arbor: University of Michigan Press, 2001).

Christian children that he has supported in rural Minya.

El-Warsha's first projects were to translate, adapt, and perform con-temporary European works (Pinter's *Lover* and *Dumb Waiter*, Kafka's *Penal Colony*, Handke's *Ward Wishes to Become a Guardian* and Fo's *Waking Up*) on the Egyptian stage. Hassan El-Geretly has been charac-terized in this period as "casting around for a compass to help him find his own cultural bearings after his long expatriate years" (Sleiha, 1993, p. 10). By 1989, when El-Warsha "Egyptianized" Alfred Jarry's *Ubu* plays, creating a close connection with the audience by adding material from popular culture, they felt like "people building their own temple in other's holy land" (El-Warsha, 1997), a phrase that captures both the desire for dialogue and the discomfort with it that characterized these early years. Their adaptation of the *Ubu* canon (called *Dayeren Dayer*) was set in Mamluk Egypt, a time of continuous, horrific bloodshed as one ruler after another fought his way to power. The narrator of the piece, Ibrahim, was a traditional shadow puppeteer who recounted the stories of violence as a contrast to his own faithful pursuit of the arts. This was the first time that El-Warsha used traditional shadow play. Performed in the courtyard of a sixteenth-century house, the story liter-ally pulled its audience back in time. They sat, like the spice merchants who used to frequent the house, and listened to a tale both lyrical and political. El-Geretly's early attempts to create typical middle-class pseu-do-European theater had been unsatisfactory, but with *Dayeren Dayer*, he found his voice. He told playwright and director Laura Farabough, "I recognized in this very old art form, a liveliness, and humor, and spirit that is deeply Egyptian. It's not so much that I wanted to make a shad-ow play as that I wanted to capture this imagination and put it into the theater" (cited in Farabough, 1992, p. 6).

The *Ubu* project marked the beginning of El-Warsha's long and fruit-ful research in Egyptian folk art. As part of their adaptation of *Ubu*, the group became associated with the few surviving masters of the tradi-tional shadow puppet play (see figure 6). Before they joined El-Warsha, one of these three artists was still working occasionally at *mawalid* (saint's birthday festivals; see ch. 13), another performed for handouts on the street, and the other one as a plumber making money. The craft was clearly dying until El-Warsha found a way to integrate it into its con-temporary performances. Now they not only incorporate shadow plays into cabaret evenings like *Layali al-Warsha* ("Nights of El-Warsha"), but they also use the nonlinear structure and the rhythms of the shadow plays to shape their own works.

This is the most important feature of El-Warsha's developing theatri-

cal form. They do not perform the traditional street arts as ossified museum entertainment for tourists. As El-Geretly puts it, "It is not enough that this [Egyptian] culture provide the subjects of the stories, it has to become the object of our work. This turns out to be almost impossible to achieve if we are using European techniques which have been developed for

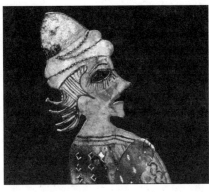

Figure 6. *Khayal al-zill* ("shadow play") character from an El Warsha production. Photo by John Feeney, courtesy of *Aramco World,* with thanks to Richard Doughty.

centuries to express an outlook so different from our own" (Farabough, 1992, p. 11). Although some critics of this early work faulted El-Warsha for stealing business from the shrinking market in folk art, the shadow puppet master Hassan el-Farran wrote, "I must admit, working with El-Warsha has developed our work: shadow play has come back, and I find the means to innovate. Without them, I think we would have given up this line of work" (El-Warsha, 1995, p. 28; for a discussion of criticism of El-Warsha, see Wright, 1993, p. 10). The combination of folk art and contemporary theater in El-Warsha is simultaneously preserving the traditional arts and enlivening the contemporary theater.

In 1993, El-Warsha produced its first fully Egyptian play, *Ghasir al-Layl* ("Tides of Night"). For this piece, they began with the traditional story/ballad (*mawwal*) of Hassan and Na'ima, a real-life Egyptian Romeo and Juliet whose love story took place in 1949. They interviewed people who had known the couple and produced a show told from many perspectives and through different forms of art, including shadow puppetry and dervish dances. The result was "truly Egyptian in spirit, but in no way 'touristy.'" (Enany, 1993, p. 47).

El-Warsha's successful association with the shadow puppet masters led them to seek out masters of other dying folk arts like public storytelling and stick dancing (a civilized form of dueling in which men carry a stick in one hand, usually balanced vertically, and then swing it at their opponent/partner in fierce, sweeping arcs). El-Geretly brought masters of these and other arts to Cairo to rehearse with the troupe and soon they were training young actors in their craft. The troupe quickly embraced folk art as a powerful means of defining a culture, as

a repository for human feeling and experience, from which to draw strength in unsettled times, and build upon when the instability is

over. Folk art is the coin whereby collective emotions are exchanged: all types of folk art have a common root in people's experience. The energy in folk art is massive: it is akin to the lava within a slumbering volcano, which erupts periodically to reshape the world. (El-Warsha, 1995, pp. 9–10)

One of the folk art masters who came to work with El-Warsha was Sayed El-Daoui, an epic singer and probably the only man who knows in its entirety *Al-Sira al-Hilaliya* ("The Hilaliya Epic"), a million-line epic, once the core of oral culture in Egypt. A newspaper reporter profiling El-Daoui described him saying:

Sayed El-Daoui has probably told more stories than any other man on the planet. The verses in his head outnumber all those written by Walt Whitman, Ahmad Shawqi, and a dozen other poets from a dozen other nations combined. If Sayed El-Daoui were to tell every story he knows, one after the other, without stopping, it might take six months or more. (Atla, 1996, p. 9)

This *Sira* is Egypt's *Iliad* and Sayed El-Daoui is like one of the Homerids who memorized the entire work. Yet when he was first asked to perform with El-Warsha, El-Daoui had not sung some of the epic's large sections (e.g., "The Book of the Orphans") for 25 years. Since 1993, El-Warsha has been intensively experimenting to find a theatrical form that will allow them to perform this epic in a way that is true to the rhythms and structures of Egypt's traditional street arts and that will connect contemporary audiences to the epic, not distance them from it.

Like the *Iliad* and the *Odyssey*, *Al-Sira al-Hilaliya* is the foundation book of a people: quoting Bridget Connelly's book *Arab Folk Epic and Identity*, El-Geretly calls it "the autobiography of the Egyptian South."[44] The story, a complex hero's quest tale, recounts the history of the Egyptian people's migration from Arabia to Egypt and their battle at Tunis. At the center of the story are the escapades of Abu Zayd al-Hilali, a warrior who is "a model of manliness and dignity and a Don Juan to boot" (Atla, 1996, p. 9). The events are not entirely historical, but like Homer's tale, weave together history with ethics and mythology into a complex fabric of romantic passion, spectacular battles, tribal politics, loyalty, revenge, and reconciliation. The story is set in the eleventh century, but the epic itself dates from the fourteenth century. It consists of four major books, each of which in turn consists of many subbooks and, within each of these, substories. The recording of Sayed El-Daoui telling

"The Orphan's Tale" (Book 4) has already consumed 35 tapes and it is still far from over. El-Warsha has been working on one substory, "The Sons of Rageh," which recounts how two young boys defied the formidable general of Tunis during the besieging of that city. This story alone took five cassettes to record.

Al-Warsha is, of course, interested in preserving this epic poem, but even more important for them is to reanimate Egyptian culture and theater. They know that merely recording the epic could freeze this dynamic art—killing the live genre in the act of preserving the product. For this reason, the way that they work on the enactment of the story receives as much or more of their attention as the story itself. Their goal is not to be archivists, but to redefine theater by producing theatrical pieces based on the epic. To accomplish this, however, has required the development of a new kind of theatrical performance. El-Geretly explains, "We would like to talk *with* rather than *at* the audience, in a dialogue based on emotions, where all parties have a common background to fall back upon. If folk art and theater do not interact through living artistic experience, both run the risk of degenerating into empty rituals presided over by high priests who profit by them, while concealing their demise from the public at large" (El-Warsha, 1995, p. 10). What they have discovered is that revitalizing the *enactment* of the folk art—specifically the way it relates to the audience—is more fundamental to sustaining a culture than merely preserving the precise *content* of its cultural artifacts.

From the beginning, the group rejected the performance practices of contemporary Egyptian theater, seeing it as distanced from real life on the streets. El-Geretly echoes writers like Joseph Chaikin and Peter Brook when he describes contemporary performance as "self-generating."[45] Too often, he says, commercial actors pattern their performances not on real life but on the performances of other actors. In his opinion these actors have lost contact with reality and so their art has lost contact with real people. Instead, El-Warsha began to study performance through storytelling. But soon they also rejected conventional storytelling as too often directed *at* the audience rather than *to* them. They observed storytellers whose eyes never made contact with those of the audience, who literally and figuratively never made contact with those they were addressing. Another storyteller was visibly upset when some latecomers entered her performance space. She could not adapt to her hearers. Al-Warsha knew

44 Personal interview with Hassan El-Geretly, July 6, 1997, during which he cited Connelly, 1986, p. 123.
45 Personal interview with Hasan El-Geretly; Chaikin, 1972, pp. 6–8; Brook, 1980, pp. 9–41 (ch. 1).

that the stories they were working on were "suffused with the spirit of the people and imbued with the souls of the great story tellers of the past," yet they were muffled when they were cut off from dialogue with the audience (El-Warsha, 1995, p. 6).

At present, the group is mixing elements of storytelling and dramatic performance to form a new kind of enactment, most closely resembling story theater. Al-Warsha's performances typically take place in tents and the courtyards of 400-year-old homes, not in formal theater buildings. The audience sits on two sides, facing each other, the performers moving between them. Since thrust and arena staging are hardly known in Egypt, the experience of seeing performers against the backdrop of other audience members is shocking. The state-run "experimental" theater building in Cairo also has railroad-style seating, but the stage is so wide that neither side of the audience can see the other. The El-Warsha arrangement actually recalls the seating for Egyptian funerals (also held in tents on street corners) in which rows of men sit facing each other. Those watching the play come from all segments of Cairo society: theater aficionados, diplomats, businessmen, artists, taxi drivers, fruit vendors, policemen.

The master storyteller still presides over the action, but others in the group take on characters, echo ideas chorally, and support the words with action. The master storyteller, musicians, and other singer-narrators, who enact the story, sit in two lines in front of each side of the audience, almost blending into them. The master storyteller is simply in the middle of one of these two lines, sitting next to the *rababa* player who accompanies him. When the performers are seated, they are spectators and musicians. When an actor/singer "enters," he or she simply stands and draws attention before moving to the center of the acting area. Sometimes, actors sing solos as their entrance pieces, beginning in the position of a musician and only gradually separating themselves from the crowd to become a featured player—at least for a while. When an actor's segment of the story is completed, he or she returns to the group of musicians. If the piece is performed in a courtyard, the architecture of the building is often woven into it so that characters may establish a doorway as a house entrance, and so on. Even upper stories overlooking the courtyard are used for chases and distant scenes. In these cases, actors may enter without going directly from the seated company to the acting area, but one still feels that, if the spirit moved a member of the audience, he or she might just stand up and join the fun. Indeed, the audience often does join in the singing of popular songs and repeated choral sections that punctuate the piece. The players and the audience are integrated into the same space. And there are none of the

ubiquitous gray wooden blocks that Egyptian theater designers love to use on their stages. If El-Warsha needs a chair, its designers find something on the streets (crates, carpets, saddles, discarded chairs held together by bits of string) and bring it into the space. Al-Warsha's set designer, Tarek Abou El-Fotouh, explains, "Ordinary chairs have within them a sort of history, a link with the people and the place and as such are far richer than the poor, stunted fossilized clichés trapped within theatrical walls" (El-Warsha, 1995, p. 15).

Like the epic stories they perform, this theater seems to come quite literally from people. The boundary between the players and spectators is blurred and permeable. The performance exists within the community as well as before its eyes. This impression is always heightened by the visible presence at the side of the acting area of Hassan El-Geretly, standing proudly, watching his actors, and clapping along to the music. He is clearly neither performer nor spectator, but both simultaneously. Not only the physical boundaries of the performance, but also its temporal margins—the beginning and end—defy the usual theatrical conventions that separate the tale from the audience. After the crowd has gathered, El-Geretly walks to the side of the playing area and casually welcomes the audience in English and Arabic, explaining the story in English for those who do not understand Arabic. Even as the play proceeds, spectators wander in from the street, crowding at the entrance to see what is happening. At the end, the performers take a bow, but the musicians often stand around casually and play familiar pieces to amuse the audience, some people remaining and singing while others may leave the space. Like a wedding or a funeral, performance bleeds into real life. The communal aspects of El-Geretly's theater are essential to his project. Whereas traditional tourist performances of indigenous arts typically "other" the performers, exoticizing them and separating them from the spectators, El-Warsha players seem indistinguishable from the crowd of onlookers except for their temporary roles as perfomers. It is clear that the audience recognizes what they are seeing as their own art, the art of the street fairs and feasts.

This commitment to communal enactment has radically altered the relationship of the players to one another and to the epic. Traditionally, the epic was always told by a solo, male voice—the voice of authority. Now all company members—male and female—are learning the piece. The story moves from person to person within the troupe, each adding his or her own energy to it. And so its meaning once again circulates among all those involved; the story is alive and dynamic, not static. In a recent performance of "The Sons of Rageh," for example, two sixteen-

year-old boys from the children's choir in Minya enacted the roles of the defiant soldiers who insult the venerable general of Tunis, played by the master storyteller. The old man reacted almost viscerally to their challenge. The moment shimmered; it was impossible to separate the master storyteller challenged by his pupils from the aged general insulted by his underlings. The story came to life, born again in the midst of the audience. The ancient words became a contemporary scene through the process of enactment—a perfect example of Richard Schechner's maxim: "Theater and ordinary life are a Moebius strip, each turning into the other" (Schechner, 1985, p. 14).

Although this kind of performance is new in Egyptian theater, this combination of storytelling and enacted improvisation in fact reflects the essence of the Egyptian epic. The richness of the poem relies upon improvisation. *Al-Sira al-Hilaliya* exists not only as lines to be memorized, but as a basic story line along with thousands of different narrative formulas that can be used to generate the narrative itself. These formulas encode the ethics and the philosophy of the piece. They can, therefore, change in context—depending on where they are used in the story or who the audience is. Each time the master tells the story, it may be slightly different, influenced by his mood and his audience. Each segment of the epic, then, has infinite possibilities in the telling. Like life, it is not fixed. El-Geretly explains that the story contains "everything possible" not just "only what we know already" (personal interview). When El-Warsha actors first encountered this kind of performance, they found it very difficult; they were accustomed to a more controlled theater with, for example, exact cues for their entrances and exits. However, the master always told the story a little differently anyway. Gradually, El-Warsha actors have learned to work in this improvisatory mode, and they now say they can sense "when the idea is completed," and so know when to speak. They do not need exact cues any more. Now the group's practice is to work through individual stories, bringing characters alive through improvisation, adding characters occasionally, and developing the music of the piece. In this way, the lively spirit of the epic is being preserved as well as its narrative content. And audiences have come to expect this kind of variation. They will come to several nights of "the same" El-Warsha production, wondering what play the actors will construct that particular night.

Because this process involves using the ancient narrative as a basis for telling contemporary stories—stories of the actor himself or herself—it involves new training for the actors. And the presence of the actor within the story—his or her active participation in its development—allows energy to pass directly between the actors and the audience. The

story becomes a means of communicating with the spectator. Eye contact become "I-contact." The actors strive to appear "naked" before the audience, not hiding behind characters and plot, but interacting directly with the audience, using the tools of storytelling and theater to speak directly to them. Khaled Goweily, a writer for the troupe explains:

> Our relationship with storytelling, for example, reflects the love of intimate interaction between story teller and audience, between enchanter and enchanted. The audience, enchanted with their own imaginations, become children once again, full of wonder as the words reach them, clothed in images, sounds, colors and feelings flowing through them with astonishing fluidity, taking them faraway and returning them but not unchanged: they return filled with wisdom, rich in imagination and images, and yet more importantly, haunted by a mysterious yearning that will be a part of them forever. (El-Warsha, 1995, p. 13)

This work recalls the way in which groups like the Open Theater and the Living Theater strove for direct contact with the audience.

This process of improvisation within a formulaic structure may in fact be the only way of preserving the epic that is the story of the Egyptian people. Although El-Daoui remembers the overall story and has mastered its structuring devices, he has to improvise in order to fill in the lacunae. He cannot teach all of what he remembers to his new apprentices. In the words of El-Geretly, the story is "unraveling." However, "there is enough pattern still visible that you can guess about what's not there" (personal interview with El-Geretly). This is what El-Warsha has observed with the art of stick dancing as well. As the new practitioners of this art practice what they know of it, "the bits that have vanished re-emerge" (personal interview with El-Geretly). Recreating the piece by coming to understand its essence, its basic structure, and the means by which it is self-generating will allow the epic to become once again a living part of the culture. El-Geretly defines their intentions saying, "We are citizens and want culture to develop. The intervention, the making, the oeuvre, is to do with theater. It is a joy to have the epic preserved, but it is not our function. It is a by-product of what we do" (personal interview with El-Geretly). In other words, this theatrical group is preserving an epic that encodes history and morals not as data but as living art. In so doing, they are not removing a text from the community that created it, but they are teaching the community how to keep the text alive, evolving, and growing.

There have, of course, been problems with this approach, and not everyone agrees with it. Some critics believe that in altering the performance of the epic, El-Warsha has violated it. The group has been repeatedly criticized by some quarters for playing around with this kind of traditional material. Some of the original group members also left when the group moved from conventional theater work to this new performance style—they said it wasn't "theater." Others criticize the group's reliance on foreign funding sources and their active participation in international festivals.

But such criticism is diminishing as the group's work spreads and brings more attention to Egyptian culture. El-Geretly is interested in disseminating his work through founding a school for actor training. And El-Warsha has begun to collaborate with several groups within Egypt and internationally in order to find ways of preserving traditional arts through revitalizing contemporary performance. In Upper Egypt, they have collaborated with two projects: a theater for children and a choir school where Christian and Muslim children work together. They also support a group of musicians in Port Said who are reconstructing the culture of that city, which was so heavily damaged by Israeli shelling. Through an Arab theater festival, the group has collaborated with a Jordanian company, Al Fawanees ("The Lanterns"), which is also exploring modes of performance. El Warsha wants to encourage such groups to remain autonomous—to remain free.

Most community-based theater addresses issues of immediate social or political concern (rights of the poor, abortion, the environment). El-Warsha's act of cultural preservation may seem much more remote from the immediate needs of the community. But, in fact, it addresses one of the most important problems facing the country—loss of self. It is not surprising that one of the formative narratives in this culture is *A Thousand and One Arabian Nights*. Just as Sheherazade told tales to survive, so this culture must learn to create and recreate itself through its own foundational stories. The work of El-Warsha has helped save the epic from extinction, but it has done so much more. The old masters are once again passing on their arts and so have become ten times more alive. The company has found a way to bring the ancient stories into the present—to hand them over to the audience where they can live and become part of the community again. And the very notion of theater has been redefined in a way that makes it central to cultural preservation, not ancillary to it. This is a country where surviving is an art and, as El-Warsha has demonstrated, art is part of that survival.

5 Persian Plays and the Iranian Theater
M. R. Ghanoonparvar

As in other parts of the world, the forces of modernity brought about changes in all aspects of Iranian life, including the arts and literature. These changes that began in the early part of the nineteenth century gained momentum in the latter part of that century and particularly the early decades of the twentieth century. At the same time, the traditionalist forces not only resisted any changes, but also usually opposed and tried to impede their progress.

In regard to new literary forms, such as poetry, novels, and short stories, for example, given the rich tradition of Persian poetry over many centuries and also the existence of narrative stories in various forms throughout the history of Persian literature, progress was more rapid, but the development of modern drama and the Persian theater, which in some respects were novel, occurred at a slower pace. Indeed, it was only in the late nineteenth century that formal secular drama in the Western sense appeared in Iran.[46]

Dramatic performances of different kinds, including religious passion plays and humorous and satirical performances, have, of course, been a part of traditional Iranian ritual and entertainment. However, the fact remains that they rarely found their way in written form into the arena of formal literature. *Ta'ziye*, for instance, is a centuries-old form of religious drama in Iran generally commemorating the martyrdom of Imam Hoseyn, the third Twelver Shi'ite imam, and other events related to it.[47] The language of *ta'ziye* is usually in verse form, and it is performed by amateur players on special occasions, particularly on the days commemorating the martyrdom of Imam Hoseyn, during the Islamic lunar month of Muharram. With the exception of costumes which are used for

46 Some critics believe that the relative absence of drama in the past in Iran is due to several historical and social factors, including the two official monotheistic religions, Zoroastrianism and Islam, that do not look favorably on this art form; the autocratic system of government that prevented the court and courtiers from supporting drama, for they could not tolerate criticism; the rural and tribal civilization of Iran; the dependence of the literati on the nobility and the court, which could not patronize drama; the inaccessibility of serious drama to the masses and the absence of subjects that reflect their concerns; the existence of general poverty and the lack of financial support for performers; and the lack of political stability, which is necessary for the development of public arts. See, for instance, Beyza'i (1965), pp. 12–15.

47 Since the Islamic Revolution, there has been an increasing number of studies of this religious art form. For an English study of *ta'ziye*, see Chelkowski (1979). For an overview of traditional performances see Gaffary (1984), pp. 361–389.

ta'ziye performances, little attempt at realism is made. Given the religious nature of such plays and the fact that they are part of Shi'ite mourning rituals, the purpose of *ta'ziye* is not entertainment. Since *ta'ziye* is regarded a religious activity, the audience readily suspends its disbelief. Symbolic gestures seem sufficient for the mourners to be reminded of such gruesome scenes as the decapitation of the martyrs or to accept the role of a female character being performed by a male actor. Similarly, the stagecraft and scenery are simple or nonexistent, since the plays are traditionally performed in religious centers that also serve as places for other religious gatherings. In fact, in some rural regions, such as Khomeyni Shahr (formerly Sedeh and Homayunshahr) and Qomsheh (also known as Shahreza), several religious centers with different audiences are set up for the performance of *ta'ziye*. Specific scenes of the drama are performed in the first religious center by the first group of players, who then travel, sometimes several miles, to play the same scenes in the second religious center, and so on. What is interesting in this instance is that usually several actors play the role of one character before the same audience. For instance, one actor will play the role of Imam Hoseyn in the first scene and then travel with the other actors in that scene to the second religious center to play the same scene again. At the same time, a second group of actors will arrive at the first religious center and a new actor will play that same character in a different scene, only to then continue on to the second religious center for another performance of the same scene. Such conventions are readily accepted by the audience without confusion.

The roots of *ta'ziye* may go back many centuries, even to pre-Islamic Iran, but in its Islamic form, it began to flourish during the Safavid period, in the sixteenth century and later, particularly in the nineteenth century, when it was patronized by Qajar kings. Other dramatic forms of performance also began to thrive in the nineteenth century. *Ruhowze* or *takhthowze* and *siyahbaze* are comic plays usually performed for special celebrations, such as weddings (regarding other traditional forms, see Malekpur, 1985, vol. 1, pp. 265–301). These forms, however, are primarily for entertainment and are not presented in verse. *Ruhowze*, for instance, is performed on a makeshift stage of a courtyard pool, which is covered with boards. Although entertainment is the primary purpose of *siyahbaze*, in which the central character appears in blackface and plays the role of a clown; it is also generally a form of social satire. Such plays use a number of stock characters, and their standard plots involve domestic quarrels, lovers' conflicts, and relations between rich and poor. Like *ta'ziye*, in these performances, stage and scenery are unimportant,

but unlike *ta'ziye*, actors are professional entertainers who appeal to the audience with their talents for slapstick and improvisation.

The old traditions of religious and secular performances have continued in Iran to the present day and have even been utilized in varying degrees by modern Iranian dramatists. But the roots of modern Iranian drama in terms of both form and content must be sought in the nineteenth century, when the Western theater began to have an influence on Iranian dramatic arts. As a part of the Qajar government's efforts to modernize the country and promote literacy and progress, Abbas Mirza (d. 1833), the crown prince, sent a number of students to Europe. Upon their return, these Western-educated Iranians began to introduce various aspects of Western culture, including Western theater, to their compatriots. Thus, the nineteenth century marks the earliest stages of Persian drama in the Western sense.

The first theater in Iran was built, during the reign of Naseroddin Shah, on the location that later became a part of *Darolfonun*, the first Western-style school in Iran. Modeled, built, and decorated in the style of European theaters, this theater seated about 300 people and was founded by Mozayenoddoleh Naqashbashi, one of those students who had returned from Europe. Naqashbashi had also prepared a play in Persian based on Molière's *Misanthrope*, which was actually the first play performed in that theater. As Edward Browne observes in his *Literary History of Persia*, in this rendering of *Misanthrope*, the translator took much liberty with the play, changing the names and even the personalities of the characters. He even employed Persian proverbs and expressions, making the play more Persian than French.[48]

Because of opposition from the traditional sectors of the society, these plays were usually performed privately for the royal family and their close associates, and therefore, their impact on the general public was initially minimal. Hence, it can be argued that the greater impact on the development of this art in Iran was made by the first Iranian plays in the mid-nineteenth century written by the Iranian reformist and writer Mirza Fath'ali Akhundzadeh (1812–78), in a volume of plays known as *Tamsilat* ("The Comedies"), which he wrote in Azari Turkish. Akhundzadeh, who spent most of his life in Russia, working many years as an official interpreter of Eastern languages, was familiar with the Russian theater and Western literature in general, and his attempts as a playwright were for the most part successful in terms of both dramatic storytelling and dialogue, in addition to dramatic techniques.

48 Edward G. Browne, *A Literary History of Persia* (London: Unwin, 1902–06), quoted in Jannati-'Ata'i (1977), p. 60.

Akhundzadeh's expressed purpose was to employ this literary genre essentially for moral edification. In his writings, he refers to the "noble art of drama" or the "noble art of the theater," openly stating this purpose. To him, the playwright is a teacher of morality. Akhundzadeh also wanted to introduce this art to his countrymen as a patriotic effort. On this point, he writes:[49]

> Europeans have written plays about the conditions and the behavior of the people and believe that it results in moral edification. There are obviously deceitful, evil, and foolish people among those of every country. Europeans write about and ridicule such individuals through drama as a lesson to others. (Fath'ali Akhundzadeh, 1963, pp. 108–109)

In an attempt to spread his ideas in Iran, through correspondence, Akhundzadeh sought the help of friends and acquaintances to find someone to translate his plays into Persian. He wanted his plays to serve as an example to the "educated and talented young people to test their talents in this noble art." Mirza Aqa Tabrizi, the person who made the first attempt to translate the comedies of Akhundzadeh, soon gave up this task, because, he stated, he did not want to misrepresent the eloquence of the original author due to great losses in translation. Subsequently, a person by the name of Mirza Ja'far Qarachehdaghi translated them.

However, even before the translations of Akhundzadeh's plays were made available in Persian, inspired by Akhundzadeh's work, Tabrizi wrote four plays and sent copies of them to Akhundzadeh for comments. Compared to Akhundzadeh, who had read Western playwrights and was familiar with the conventions of Western theater, Tabrizi was merely imitating what he had seen in written form; therefore, his plays suffer from many technical shortcomings (these plays were published with an introduction by M. B. Mo'meni in Tabrizi, 1976). Despite these problems, however, the thematic concerns of his plays were more in keeping with those in the work of other reformists and intellectuals in Iran at the time. Tabrizi's first play, for example, has a rather long, descriptive title, which is, in fact, a synopsis of its story: *The Story of Ashraf Khan, the Ruler of Khuzestan, during his Stay in Tehran, when in 1232 He Is Summoned to the Capital to Pay the Three-Year Taxes of the Province, and after Much Hardship He Is Granted the Robes of Governorship to Return to the*

49 In addition to Persian sources, these plays are also discussed briefly in English by Javadi, 1988, pp. 257–259.

Province and Continue His Rule; and This Story Is Completed in Four Acts, by the Grace of Almighty God (Tabrizi, 1976, pp. 9–49). In his play (usually referred to in Persian in short form, *Sargozasht-e Ashraf Khan*), Tabrizi deals with what seemed to him to be one of the most common corrupt practices during the nineteenth century. The main character, Ashraf Khan, learns very soon that in order to continue in his post as the ruler of Khuzestan, he must bribe not only His Royal Majesty and the Grand Vizier, but everyone else, including all the petty officials and secretaries, even the doormen, grooms and street sweepers. When he protests, he is told that he should be grateful for such an honor as the governorship of a province, because the bribes he would have to pay in the capital are only a small fraction of what he will be able to accumulate as a governor by plundering the people of the province. Parenthetically, after making suggestions in regard to the technical aspect of this play, Akhundzadeh warns his compatriots of the dangers of openly criticizing the king and proposes that no references be made to the monarch when the issue of government corruption is addressed.

Another play by Tabrizi is *Hekayat-e Asheqshondan-e Aqa Hashem Khalkhali* ("The Courtship of Aqa Hashem Khalkhali") that is different in content from his other plays, which generally deal with political corruption (Tabrizi, 1976, pp. 139–189). In this play, Tabrizi focuses on social and familial relations and precepts governing the society. Aqa Hashem, a young man of meager means, is in love with Sara, the daughter of a rich old man who objects to their union. Tabrizi essentially criticizes certain social mores, including the importance placed on money in marriages, superstitious beliefs, and resorting to charlatans such as fortunetellers to solve one's problems. Although the subject of this play appears to be a departure from Tabrizi's criticism of the ruling class, it illustrates his world view–that of an Iranian intellectual living under the Qajars–which is quite different from that of his compatriot, Akhundzadeh, living in a different society. And it is perhaps mainly because of this difference in their worldviews that in his commentaries on Tabrizi's work, Akhundzadeh consistently criticizes Tabrizi's plays for not having addressed moral issues, as he saw them.

But the importance of Tabrizi's contribution to Persian drama cannot be disregarded. Despite Tabrizi's rather naïve understanding of the theater and play writing, his experiments in the nineteenth century prepared the grounds for the development of this art in the present century. More importantly, Tabrizi seems to have established a precedent, which was followed in Persian drama in the following century, that is, a utilitarian purpose for art with emphasis on its message. In other words,

drama for Tabrizi is merely a vehicle, an instrument, which is of little use to him purely as art, except when it is utilized to convey social and political messages. As mentioned above, this is as true of Tabrizi's work as it has been of the work of many of his successors among the Iranian dramatists and other literary artists to date.

Some years later, during the Constitutional Revolution in Iran (1905–11), a number of new playwrights began to experiment with musical comedies and drama in verse form. Morteza Qoli Khan Fekri, Ahmad Mahmudi, Abdolrahim Khalkhali, Afrasiyab Azad, Ali Mohammad Khan Oveysi, Taqi Rafat, and Abolhasan Foroughi are among the playwrights of this period. After the revolution, various efforts that contributed to the development of modern Iranian drama include both translations of Western plays and the writing of Western-style Iranian plays, which in some instances were performed in public parks (Guran, 1981, pp. 100–103). In terms of subject matter, playwrights followed the course of Tabrizi in social criticism, exposing, for instance, the private life and ideas of Mohammad Ali Shah Qajar, who had escaped after his defeat in the constitutional movement.

Gradually, theaters began to appear in Tehran through the efforts of individuals familiar with the Western theater. During the Reza Shah Pahlavi period, although attempts continued by a number of writers, including Abolhasan Foroughi, Abdolhoseyn Nushin, Zabih Behruz, Ali Nasr, Sa'id Nafisi, Gerigor Yaqikiyan, and Sadeq Hedayat, strict government censorship curtailed for the most part plays with direct political implications (for a list of plays and playwrights during this period, see Jannati-'Ata'i, 1977, pp. 69–74). For different reasons, *ta'ziye* performances were also banned during this period.[50] Nevertheless, plays with historical themes, often glorifying pre-Islamic Iran, were written. Such themes, which are also found in many novels, were in fact often promoted by the government, with its strong nationalistic inclinations.

A significant play from this period is Hasan Moqaddam's (b. 1898) *Ja'far Khan az Farang Amadeh* ("Ja'far Khan Has Returned from Europe"), first performed in Tehran in 1922. Unlike Tabrizi's plays, which were not staged at the time and therefore remained unknown to the public for many decades, Moqaddam's *Ja'far Khan* gained almost immediate popularity and has undoubtedly been one of the most influential plays in the history of the theater in Iran (Moqaddam, 1922). As its name sug-

50 The banning of *ta'ziye* performances was a part of the Reza Shah government's modernization efforts. According to Beyza'i, during the Reza Shah period, "the violence that was widespread among mourning procession groups was deemed to be interpreted as savagery by foreigners. Therefore, in 1921, all religious demonstrations, including *ta'ziye* performances, were banned." See Beyza'i, 1965, p. 159.

gests, this play deals with the theme of cultural confusion resulting from the direct contact between the East and the West. On the surface, such confusion is the result of *Ja'far Khan*'s Frenchified Persian and the use of French words that are incomprehensible to his family in every sentence he utters. On a deeper level, however, in this play Moqaddam humorously criticizes the superficial imitation of Western ways as well as the decadent and superstitious beliefs of traditional Iranians.

Another play from the same period is Sa'id Nafisi's *Akherin Yadegar-e Nader Shah* ("The Last Memento of Nader Shah"), which is a satire of the new regime, with its preoccupation with the past glories of Iran and its new military. The protagonist is an old soldier, a survivor from Nader Shah's army, now living during the Irano-Russian wars. But, unaware of the passage of time and the changes that have taken place, he is still intoxicated with the glorious conquests of the past (Nafisi, 1926/7).

A very important development in Iran during the Reza Shah period was the advent of women on the stage. Because of religious restrictions, the entry of women to the theater was slow. The way, however, was paved by non-Muslim women, who were not as bound by such social limitations.

After the abdication of Reza Shah (1941) and the relative freedom of expression that ensued for about a decade, attempts were again made to revive the Iranian theater with plays, the content of which was reminiscent of that of the period of the Constitutional Revolution. Political parties found the theater an effective propaganda tool. Favorite themes of this period were nationalistic in nature, which in some ways fed on the ongoing debates and events that ultimately resulted in the nationalization of Iranian oil in the early 1950s. Worthy of note during this period is the attention to and adaptation of Western-style production techniques and stagecraft, which continued through the 1950s and contributed greatly to the development of the Iranian theater. These efforts led the way to the new experimentation in terms of both play writing and dramatic performance of the 1960s and 1970s, when Iranian plays and theater came of age and flourished, with the works of such writers as Gholamhoseyn Sa'edi, Bahram Beyza'i, Ali Nasiriyan, Bahman Forsi, Akbar Radi, Bizhan Mofid, Esma'il Khalaj, Parviz Sayyad, Sa'id Soltanpur, Mahmud Dowlatabadi, Mohsen Yalfani, Ebrahim Makki, Mostafa Rahimi, Naser Shahinpar, Arsalan Puriya, Naser Irani, Nader Ebrahimi, and Abbas Na'lbandiyan. A wide variety of government-sponsored activities, including the establishment of schools of drama and the sponsorship of art festivals, among other factors, helped Iranian dramatic arts to achieve some degree of international recognition, with

a number of Iranian plays even winning prizes.[51]

However, the government's attitude toward some of the best-known playwrights was ambivalent. Despite its wishes to support this art, at least for propaganda purposes, it could not tolerate the works of such writers as Gholamhoseyn Sa'edi, who were always implicitly and sometimes explicitly critical of the regime. Strict censorship and harassment of writers by government security agents usually resulted in the banning of publications and the halting of the production of sociopolitically engaging plays. As a result, partly for this reason, Persian drama as well as other arts and forms of artistic expression generally adapted enigmatic forms, perhaps in hopes of avoiding the wrath of government censors and police. Moreover, some playwrights, while avoiding risky subject matters, resorted to creating highly esoteric experimental works that were intellectually inaccessible even to the educated patrons of the Iranian theater. An example is Abbas Na'lbandiyan's highly acclaimed *Pezhuheshi Zharf va Setorg va Now dar Sangvarehha-ye Dowreh-ye Bistopanjom-e Zaminshenasi* ("A Modern, Profound, and Important Research on the Fossils of the Twenty-fifth Geological Era"), which was performed at the 1968 Art Festival of Shiraz.

One critic summarizes the play as follows:

A number of ghostlike characters appear at intervals on the stage—a vast, empty setting divorced from the world of the living. Each character enters calling out '*Zamenhoff*' and searching for something or somebody. Their encounters and their ensuing conversation constitute the body of the play.

The dialogue has an absurd logic, combining bookish recitation with coarse slang and poetic diction. As the search and dialogue continue and strange encounters keep occurring, a variety of revealing background material is brought to light. Different characters with varying pasts and divergent problems and pursuits are delineated. An interesting character is a poet of peace in a long robe who is full of praise for his father. He attracts the attention of the others who, in their desperate search, pin their

51 These activities included the establishment of the acting school by the Ministry of Culture and Arts; the addition of a Division of Dramatic Arts at the Faculty of Fine Arts of the University of Tehran, as well as the Iranian National Television's Kargah-e Namayesh, a theater workshop that produced television and stage plays. The Shiraz Art Festival began in 1967 and attracted the attention of experimental dramatists in both modern and traditional theater. For example, this festival organized an international symposium on *ta'ziye* in the summer of 1976 with the intention that it would attract worldwide attention to this dramatic genre. The proceedings of this symposium were published in Chelkowski (1979).

hopes on him. He tells them about his father's greatness. They implore him to give them The Answer. He is perplexed. He confesses he does not have the answer and that he is himself searching like the others, but they refuse to believe him; he must have The Answer. They undress him. He wears a crown of thorns it seems. He is molested. Eventually, he joins the rest of the characters, who follow each other in a circle, and the exhausting, cruel, unending search continues.[52]

Not all Persian plays during the period in question fall into the category of the theater of the absurd, as most of Na'lbandiyan's work has been described by some critics. A glance through the work of Iranian playwrights during the 1960s and 1970s shows that there were also many plays that do not require esoteric decoding to be appreciated by general audiences. Nevertheless, it is safe to say that Iranian drama, as a whole, relies extensively on symbolism, as do other Persian literary forms, in both classical and modern literature. A further link between modern drama and modern poetry and fiction in Iran may be partly explained by the fact that many playwrights have also published poetry, novels, and short stories.

Among the prominent Iranian dramatists of the two decades prior to the Islamic Revolution, Gholamhoseyn Sa'edi (1935–85) should be given a special place. Although he was a psychiatrist by profession, Sa'edi's literary output distinguishes him as one of the most prolific fiction writers of Iran and perhaps the best known Iranian playwright. He also wrote a number of prize-winning film scripts and ethnographic studies.[53] In his plays, Sa'edi intertwines his experiences and knowledge as a psychiatrist with sociopolitical themes. A typical play of Sa'edi's early period is *Karbafakha dar Sangar* ("Workaholics in the Trenches," 1960), in which he focuses on the conflicts that ensue as a result of rapid industrialization (Sa'edi, 1976). A mining company about to begin operations disrupts the lives of the people in a rural area in southern Iran. Not only do the furnaces destroy the date palms, a traditional source of livelihood, but also the company lures workers away from the established pearl-diving

52 Ehsan Yarshater, "The Modern Literary Idiom," in Ricks (1984), pp. 60–61.
53 Sa'edi's works include some fifty plays, pantomimes and film scripts, dozens of short stories, and several novels and ethnographic studies. Several of his stories have been made into films based on his own movie scripts, *Aramesh dar Hozur-e Digaran* ("Calm in the Presence of Others"), *Dayereh-ye Mina* (known in English as "The Cycle"), and *Gav* ("The Cow") are among the highly acclaimed Iranian films. *Gav* received a 1971 Venice film Festival award and *Dayereh-ye Mina* won a 1977 Paris film Festival prize. Some of Sa'idi's plays available in English translation are found in Kapusinski, 1987; and Ghanoonparvar and Green, 1989.

and fishing business. In the subplot of the play, Sa'edi explores the psychological aspects of modern Iranian marriage. It involves the marital life of the engineer who has established the mining company and his wife. The husband represents the new Iranian industrialist-capitalist businessman, who is so deeply devoted to and involved in his work that he becomes essentially oblivious to his wife. At the end of the play, when he tells his wife, who is on the verge of a nervous breakdown, that he is prepared to take her away to the capital to be with her family, we can still not be certain of the sincerity of his expressed decision. On both levels of the plot and the subplot of this play, Sa'edi provides an analysis of the dilemmas confronted by the society, in other words, the dilemma of industrial progress versus the traditional economic structure and subsequently the dilemma of the breakdown of family and individual relationships as a result of changes in the value system and the importance placed on progress at any cost.

In a typical political play of the later period, *Mah-e Asal* ("Honeymoon," 1978), Sa'edi presents a society being totally brainwashed and controlled by its governing apparatus (Sa'edi, 1976/7). *Mah-e Asal* is an allegory of Iran in the 1970s, when the Shah, with his secret police, appeared to many people to have created a police state, with spies seeming to infiltrate both the public and private aspects of people's lives. In contrast to *Karbafakha dar Sangar*, this play begins in an atmosphere of intimacy, showing an affectionate relationship between a newlywed couple. But, also in contrast to the first play, in which the husband's obsession with his work is the cause of the breakdown of his marriage, in the latter play, the couple has no control over the events that result in the symbolic physical and psychological metamorphosis of their relationship. The goal of Big Brother is intellectual uniformity and social conformity, which is achieved in the end at the cost of the complete annihilation of individual freedom and thought.

Another prominent playwright who began his artistic career in the early 1960s and still continues prolifically both in the theater and cinema and who has perhaps had lasting impact and influence on both media is Bahram Beyza'i (b. 1938). His work in general is rooted in Iranian tradition and folklore, and his outlook, as one critic observes, is philosophical, "wrapped in a cloak of complex similes to the extent that many of the characters in his work wander between mythology and historical and social symbols" (Sepanlu, 1983, p. 226).

An example of an early play by Beyza'i is *Arusakha* ("Marionettes," 1962), in which the protagonist, a champion who has fought many demons, has no interest in fighting another demon, which is a threat to

the city. Eventually, however, his love for a girl sends him into battle against the demon. The battle, in fact, becomes his last, since even though he succeeds in killing the demon, he also meets his own death (Beyza'i, 1976). Although the characters in this play are modeled after stock characters in traditional Iranian puppet shows, Beyza'i's treatment is highly symbolic and complex. The seeming simplicity of characterization is a part of the dramatist's strategy, which, especially given the poetic language of the play, soon directs our attention to deeper levels of meaning.

Another play by Beyza'i is *Chahar Sanduq* ("Four Boxes," 1967), in which the characters are presented symbolically as four colors and a scarecrow. Yellow, Green, Red and Black represent various factions in the society, the intellectual, the clergy, the merchant, and the laborer, respectively. The plot is simple: To prevent attack by some vague enemy, the characters decide to make a scarecrow, a figurehead, to safeguard their interests. But the figurehead comes to life and becomes an autocratic despot who rules by the motto, "divide and conquer." He forces the four to build four boxes, in which each is confined. But, as the play unfolds, we begin to see that their confinement is self-imposed, within the walls of their own interests.

Chahar Sanduq is one of Beyza'i's more directly allegorical works about Iranian society and political realities during the Pahlavi period, and for this reason, various attempts at its production in Iran were prevented by the government (Beyza'i, 1975/6). With the onset of the Islamic Revolution in Iran, new faces began to appear on the scene. In the confusion of the revolutionary climate, a number of short, topical plays were published in various literary journals that openly dealt with current events. *Qanun* ("Law"), by Mahmud Rahbar, and *Padegan dar Shamgah* ("Barracks in the Evening"), by Faramarz Talebi, are typical examples of such short plays. In *Qanun*, a prominent senator suddenly finds himself jailed by the regime that he has been serving all his life and, ironically, for expedient political reasons, is treated in the fashion that average Iranian political activists were treated by the regime's secret police. *Padegan* also has a topical subject matter, dealing with how the Shah's military could manipulate simple villagers into bloodthirsty killing machines who prove their loyalty by the number of demonstrators they kill for the mere reward of a few days leave and a bonus. The sort of brainwashing that has taken place in *Padegan* when the play opens is, in fact, reminiscent of the end of Sa'edi's *Mah-e Asal*.

Some political observers and historians believe that the Islamic Revolution in Iran began with the burning of a movie theater in Abadan in 1977, in which some 400 Iranians lost their lives. This incident has

generally been blamed on religious extremists in Iran reacting to Mohammad Reza Shah Pahlavi's policies of turning away from traditional Islamic values and forcing Western culture on the country. Indeed, the cinema was regarded as a symbol of those Western cultural influences that were believed to be contrary to religious values. The cinema, therefore, was a natural target of the antiestablishment religious movement. Western-style drama and theater, along with nightclubs, cabarets and taverns, and similar establishments, were also considered sources of sin; therefore, few older devout Iranian Moslems would ever visit a theater.

Given the avant-garde form and subject matter of Iranian plays during the last two decades of the Pahlavi rule, which seemed quite outlandish to most Iranians, Persian theater had alienated the majority of the public, and most observers of the Iranian theater presumed that with the establishment of a theocratic government whose mottoes emphasized religion and tradition, progress in dramatic arts had come to a halt. A number of events in the months following the revolution, for instance, the departure of a number of prominent figures in the Persian theater for Europe and America and the execution of Sa'id Soltanpur in 1981, whose well-known play, *Abbas Aqa, Kargar-e Iran Nasiyunal* ("Abbas Aqa, the National Factory Worker of Iran"), was reportedly performed on the streets in the early 1980s, reinforced this presumption.

The state of confusion that follows any revolution before a new system is put in place also occurred after the Islamic Revolution in Iran. For nearly a year before the new government was able to consolidate its control over various aspects of Iranian society, there was a climate in which freedom of expression appeared to be tolerated. During this period, not only were many previously banned books put on sale, but dozens of newspapers, literary journals, and other works saturated the Iranian market. In the absence of the overt censorship that had existed for many decades, these publications included stories, poems, and plays that openly addressed political and social issues. This period, however, was short-lived. The Iran-Iraq war, the Iranian hostage crisis, and the internal conflicts over the control of the government, among other factors, all contributed to the gradual imposition of strict controls over all aspects of Iranian life, particularly the print media, including materials written and produced for the theater. But contrary to the predictions of the observers of the Iranian cultural scene, the new government quickly became aware of the power of the performing arts in reshaping public opinion and instigating its value system in the country. Television, cinema, and theater were given particular

attention by the government.[54] Numerous movies and plays were pro-
duced in support of the government efforts in the war, its policies
against the West, and its attempts to Islamize the country. But interest-
ingly, with these measures, the government succeeded, for the most
part, in eliminating the taboo that had existed in the minds of many
Iranians with regard to the theater. The medium was no longer consid-
ered an evil instrument.

As a transitional period in the history of Iranian theater, the postrev-
olutionary decade has affected some changes in the form and content of
Persian drama. The change in the political system and with it more fun-
damentally the transformation that took place in the general value sys-
tem and social institutions in Iran influenced the content of Persian
drama, particularly because the prerevolutionary dramatists in Iran had
employed sociopolitical themes, directly or indirectly, in their work. In
other words, whether imposed or willingly accepted, the content of
Persian plays was more susceptible to undergoing a transformation with-
in a new political, social, and cultural milieu. This factor obviously left
its mark on other literary writings such as prose fiction and poetry.
Another factor concerns the staging and performance of plays. Given
that, unlike other literary genres, drama is primarily written to be per-
formed on stage, more practical matters, including women's veiling in
conformity with the Islamic government's rules and the imposition of
strict codes of dress for both men and women, and restricted contact and
interaction between the two sexes, require actors, producers, and direc-
tors to rethink and revise their production of plays in order to conform
to the standards and regulations established by the Islamic government.
To these must also be added questions pertaining to public performance
by female actors when males are in the audience. Similarly, the language
and form of presentations inevitably underwent changes. While many
plays in the decades prior to the revolution were characterized by high-
ly symbolic language and experimental forms of presentation with
which general audiences did not feel comfortable, plays that follow tra-
ditional and conventional narrative forms appeal to the same audiences.
The avant-garde theater of the earlier decades was usually identified
with and blamed on the Westernized Iranian intellectuals. In the anti-
intellectual climate that was created during the revolution, there was an
initial effort to cleanse the Iranian theater not only of its Western con-
tent, but also its alien form. Although this effort continued for some
time, in practice it did not succeed. In other words, experimentation has

54 See Hamid Naficy, "Iranian Cinema under the Islamic Republic," in Zuhur (1998), pp.
 229–246.

continued to be a distinguishing feature of the Iranian theater, as can be seen in the following overview of Persian plays since the revolution.

The postrevolution plays may be categorized into two groups. The first group consists of works by playwrights who left Iran and have continued their work mostly in Europe and the United States, while the second group includes works that have appeared in Iran and under the Islamic rule. It is interesting that the revolution and the new political and cultural climate in Iran have affected the works of both groups. In addition to the fact that dramatists in Iran, who are obliged to conform to the censorship regulations by the government as well as the social climate, have written plays that may be described as propagandistic to varying degrees, in some respects plays that have been written and produced outside Iran also tend to promote ideological views, albeit of those who oppose the Islamic regime.

Among the most prominent dramatists who left Iran soon after the revolution, Gholamhoseyn Sa'edi continued his work prolifically in exile until 1985 when he died in Paris. Two of his best known plays, written and published in Paris, are *Otello dar Sarzamin-e Ajayeb* ("Othello in Wonderland") and *Pardehdaran-e A'inehafruz* ("Mirror-Polishing Storytellers"; both of these plays were published posthumously; see Sa'edi, 1986).

Otello is a satirical treatment of the efforts of the Islamic regime to promote the arts, including the theater. In the play, a professional theatrical troupe has been rehearsing Shakespeare's *Othello* and finally obtains a permit from the Ministry of Islamic Guidance to stage the play, provided that all the women are veiled, that the play conforms to the objectives of the revolution, and that no religious rule is violated. Initially, the director of the play is able to convince the actors that they can somehow circumvent these restrictions, but soon the Minister of Islamic Guidance, along with two experts on Islamic arts, a security officer, and a revolutionary guard armed with a machine gun, descend upon the scene to oversee the production. The rehearsal continues, but is interrupted regularly by the comments, criticisms, and "suggestions" of the government officials in their effort to make the play an "Islamic" work. In this process, Shakespeare's play is metamorphosed into a farce. Othello becomes an Islamic revolutionary combating the infidels, Iago is transformed into a counterrevolutionary who must be punished for his sins, and even Shakespeare himself becomes an Arab Muslim brother, whose name had been Shaykh Zubayr but was appropriated and corrupted by Western infidels into Shakespeare. *Otello* was staged in Europe quite successfully, with videotapes of the play having been distributed in Europe and the United States.

The second play, *Pardehdaran-e A'inehafruz* is an antiwar work in two acts in which the playwright uses traditional *naqqals* ("storytellers") as characters to tell the story of the Iran-Iraq war. The story, however, deals with the effects of the war on the lives of individuals and families. In the first act, the storytellers, to present scenes of modern warfare, bloodshed, and destruction, use large canvases with pictures of war scenes. The second act depicts the effects of the war on the lives of families who have lost their loved ones as "martyrs" in the war against the "infidel" army of Saddam Hussein. In this act, while the bodies of the martyrs are brought back to their families, the audience is presented with gruesome scenes of families fighting over the remains that are brought back to them. Ghastly scenes follow with several families fighting over the remains that have been brought in one coffin, each claiming the dismembered parts of their sons' corpses. Although, like *Otello*, the general tone of this play is also satirical, it can be described as a black comedy with a strong antiwar message that resonates throughout the play.

Another playwright, who also lives in Paris, is Mohsen Yalfani, whose plays focus mostly on individual revolutionaries who belong to various political groups opposing the regime in power. Yalfani's work is characterized by his psychological probing of the minds of his characters and the inevitable tension that is created among members of political groups who live a marginal underground life for long periods of time in safe houses. It is in such settings that both the typical revolutionary protagonists of Yalfani's plays and his audience are confronted with situations in which they engage in some sort of self-analysis, not only as members of a combative revolutionary group, but also as individual human beings. Recent plays by Yalfani include *Qavitar as Shab* ("Stronger Than Night"), *Bonbast* ("Dead End"), and *Molagat* ("Visit").[55] The first play, *Qavitar az Shab*, takes place after the revolution in Iran. We see a group of revolutionaries in a "safe house" who begin to realize that being a revolutionary has become a way of life for them, while they have gradually lost or at least discovered that they are incapable of achieving their revolutionary objectives.

A similar theme is followed in *Bonbast*, in which we see a former revolutionary who has abandoned his comrades, and to some extent his ideology, realizing the futility of their fight. But a strong sense of guilt, which has resulted in nightmares and hallucinations, reveals that, as a former revolutionary, he can never be free of the strong effects the group has had on his life. In *Molagat*, the protagonists are a married couple

55 These plays were published as *Qavitar az Shab: Panj Namayeshnameh*; see Yalfani (1990).

who learns that contrary to what they had believed, their commitment to their revolutionary cause is stronger than their commitment to each other. A third well-known figure of the Iranian theater is Parviz Sayyad, who was one of the most popular actors in Iran prior to the revolution. Sayyad, who lives in the United States, has regularly written, directed, produced, and acted in plays as well as movies in recent years. Although his prerevolutionary fame in Iran was mostly connected with his comedic character of Samad, a popular "country bumpkin" persona he created for television serials and movies, in his recent work, Sayyad has engaged in a more serious treatment of his subject matter. In a play called *Khar* ("Jackass"), Sayyad presents a metaphor of a dictatorial police state in which individuals are gradually brainwashed to conform to the norms established by the regime in power without even realizing the metamorphosis that has taken place in them. The jackass of the title, which is presented in the play in the form of masks worn by the actors, connotes gullibility and stupidity in Persian and is used as a metaphor for an entire nation, which is in one way or another duped by the religious rulers in Iran (see **figure 7**).

Another play by Sayyad is *Mohakemeh-ye Sinema Reks* ("The Rex Cinema Trial"), which depicts the tragic death of some 400 people in the Rex theater fire in Iran in 1977. In this play, the Islamic regime has put several of the officials of the previous regime on trial, accusing them of

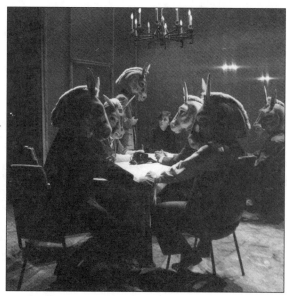

Figure 7. A scene from *Khar* ("Jackass"), by Iranian playwright Parviz Sayyad, performed in Los Angeles in 1983 shows characters who have metamorphosed into the jackasses of the title as they have become brainwashed by the norms of their society.

having had a hand in the arson. Although the Islamic court finds these officials guilty, the audience clearly concludes that the real perpetrators of the tragedy are, in fact, the trial court officials. The judge and the prosecutor blame others for the crime that they themselves had committed, justifying their action by stating that it was expedient and necessary for the revolution.[56]

Although many of the plays by exiled Iranian playwrights are openly critical of the Islamic regime and serve as propaganda tools against the government of the Islamic Republic, not all fall into this category. Coming to terms with the notion that they are in exile to stay, some Iranian writers have in recent years shifted some of their focus to their own dilemmas and are now trying to cope with the alien cultures in which they live. Nevertheless, antiregime plays have been received enthusiastically by Iranian audiences abroad. *Sinema Reks*, for instance, was performed in numerous cities throughout the United States (see **figure 8**).

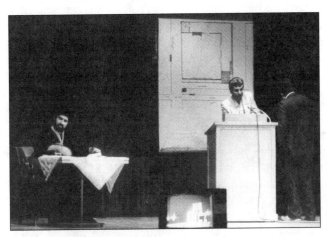

Figure 8. A scene from *Mohakemeh-ye Sinema Reks* ("The Rex Cinema Trial"), by Sayyad.

Perhaps more important than the works of Iranian playwrights in exile in terms of their eventual influence on the future of Persian drama are the plays written by Iranian writers in Iran. Among these writers are such well-known dramatists as Bahram Beyza'i and Akbar Radi, who have continued their work in the post-revolutionary period, either conforming inevitably to the new restrictions in regards to the production and language of their plays or evading censorship by choosing "safe" subject matters. The second group consists of mostly younger dramatists who wholeheartedly support the regime and would willingly lend

56 *Khar* ("Jackass") and *Mohakemeh-ye Sinema Reks* ("The Rex Cinema Trial") have been translated by Dabashi and Ghanoonparvar, 1993.

their pen to propagate its ideology.

Of the first group, Beyza'i has continued his prolific career without a halt since the Islamic revolution. His movies in recent years include *Shayad Vaqti Digar* ("Perhaps Another Time"); *Bashu, Gharibeh-ye Kuchak* ("Bashu, the Little Stranger"), and *Mosaferan* ("Travelers"), which have gained him additional fame both in Iran and abroad. His postrevolution play, *Marg-e Yazdgerd* ("The Death of Yazdgerd"), is described by some critics as one of the best plays in Persian. Thematically paralleling the fall of the last Pahlavi shah in 1979, the story is of the escape of the last Sasanian king, Yazdgerd III, in 651 to a foreign land when the Islamic Arab army invaded Iran. In this play, Beyza'i offers us a reinterpretation of the demise of the Sassanian dynasty and the story of Yazdgerd's murder by a miller (Beyza'i, 1980).

Another prominent playwright living in Iran is Akbar Radi, who wrote and staged *Ahesteh ba Gol-e Sorkh* ("Gently with the Rose"), which focuses on the conflicts that have developed among the members of many Iranian families as a result of the revolution and the differing value systems (Radi, 1989).[57] Even though the subject matter of these plays may be regarded as "safe," they conform, perhaps indirectly, to the tradition of sociopolitical commentary and criticism that characterized Persian drama from its inception in the late nineteenth century. A different kind of popular topic is represented in a play by Pari Saberi, *Man be Bagh-e Erfan* ("I to the Garden of Mysticism"), which in Iran reportedly enjoyed great success with the audiences, although it did not please the critics. The play, described by one critic as the playwright's effort to highlight the mystical dimensions of the work of the famous modernist poet and painter Sohrab Sepehri, was presented with dance and music in an abstract form. Among the prominent Iranian poets prior to the revolution, Sepehri, whose popularity has increased, wrote very personal poetry. He was perhaps the least political of the literary writers at the time and would, therefore, qualify as a "safe" subject for a play.[58]

The second category of Iranian dramatists is comprised of younger writers who generally support the Islamic revolution and the regime and who unabashedly use their work to advance the ideas and ideals of the revolution. These writers have developed their talents under the auspices of the government and its various agencies, such as the Ministry of

57 Radi's other postrevolutionary plays include *Monji dar sobh-e Namnak* and *Pellekan*. The latter play was considered by well-known Iranian critic Muhammad 'Ali Sipanlu as the best play written that year. See *Kelk*, 9 (1990):118.
58 *Man beh Bagh-e Erfan*, according to Qotboddin Sadeqi in *Teatr dar Sali keh Gozasht* ("Theater in the Year that Passed"), widely received negative reviews. See *Ketab-e Sobh*, Summer and Fall, 1989:3, pp. 139–157.

Islamic Culture and Guidance. By organizing theater festivals and providing financial support for small and large theater groups in large cities and even in small towns, the regime has in effect recruited thousands of young people in hundreds of theatrical groups as faithful supporters and propagators of its ideology. Prizes given in competitions at theater festivals as well as interviews in journals that are published by government and government-subsidized organizations also provide incentives for new writers, directors, and actors.[59] Although the subject matter of this group of plays concentrates on revolutionary and Islamic issues, it is immediately apparent that in terms of form and technique that these dramatists have learned from their prerevolutionary predecessors and continue with experimentation and innovation.

An example of this group of plays is Hamid Reza A'zam's *Shegerd-e Akhar* ("The Last Technique"), which was written in 1986. In this play, the playwright's main purpose is to rally support for the government in the Iran-Iraq war. The protagonist of the play is an old *naqqal*. All his life, he has told stories from Ferdowsi's famous epic, the *Shahnameh* ("Book of Kings"), in teahouses. His reputation as a master storyteller has brought him young apprentices who want to learn his storytelling techniques. The plot of the play unfolds as the old *naqqal* and one of his apprentices recount stories about the old *naqqal*'s life and career, especially his masterful technique of telling the story of the combat between two ancient champions, Rostam and his son Sohrab. Even though everyone is waiting impatiently for the *naqqal*'s performance, he refuses to perform. Instead, inspired by the heroism of the young men who are fighting in the war, he too decides to join them on the front, an act that is in fact the technique he teaches to his apprentices, and the audience (A'zam, 1989).

In the same vein, another play with a revolutionary message is *Ab, Bad, Khak,* ("Water, Wind, Land"), by Salman Farsi Salehzehi (Salehzehi, 1989). Written in 1987, the play has as its theme the struggle of peasants against landlords. In the beginning of the play, the peasants succeed in driving out the landlords. But soon they realize that their victory is not final. The landlords return and, by setting fire to the farmers' crops, try to take back the land and reestablish the old order. The message of the play becomes clear for the audience: To preserve your victory, you must not hesitate to engage in any action and self-sacrifice. Salehzehi conveys his message in the form of symbolic actions in much of *Ab, Bad, Khak,* reminiscent of the works of older playwrights, such as Sa'edi and Beyza'i.

59 An example is the Fajr Theater Festival, which is held annually in Tehran, sponsored by the Ministry of Islamic Culture and Guidance. For a recent overview and list of these plays, see Oskoui, 1992.

The change in the political regime of Iran, the fall of the monarchy, and the establishment of the Islamic Republic, have brought about a fundamental transformation in the entirety of the Iranian society, a process that still continues, perhaps more rapidly than during most other periods in that country's history. The passage of more than two decades has not as yet brought social stability, and the country is still in transition. The climate of this transitional period is manifested in all aspects of Iranian life and culture, including the arts. Persian drama, too, is still in a state of transition. In terms of artistic merit, many of the plays written during this period may not withstand the test of time, although they will remain important as a whole as reflections of the Iranian society of this transitional period. This is true not only of the plays written in Iran that must be approved by the regime's censors, and hence directly or indirectly advance its ideology, but also of those written by writers in exile whose work has been influenced at least subconsciously by the regime in Iran in terms of language, ideology, value system, and in general the Weltanschauung of Iranians of the present generation. Questions pertaining to the role of censorship and self-censorship cannot be answered with certainty; and conjectures about whether or not the Islamic regime will eventually decide to tolerate views expressed by playwrights and other artists that do not conform to its own, may be an exercise in futility at this point. What is certain, however, is that in many respects the transitional period has brought new experiences to Iranian dramatists whose work will influence the future of the theater in Iran. However, incidents such as the Iranian Parliament's attempt to impeach the minister of Islamic Culture and Guidance, Ata'ollah Mohajerani, who has openly advocated tolerance and freedom of expression, in the course of which conservative members of the parliament singled out playwrights such as Bahram Beyza'i as propagators of "corrupt" Western culture and therefore as evidence in the impeachment of the minister, as well as the setting on fire of the Tehran City Theater during the Persian New Year holidays in 1999, indicate that the future of this art, like other aspects of Iranian life, is still at best uncertain.[60]

60 The Tehran City Theater fire (reported in *Neshat*, April 6, 1999, p. 2) in 1999, two decades after the revolution, is reminiscent of the Rex Cinema fire in Abadan and similar incidents during the revolution. To these must be added the mysterious murders of several writers in 1998.

6 The Palestinian Hakawati Theater: A Brief History
Reuven Snir[61]

A Theater of National Identity

Following the war of 1948 and the proclamation of the state of Israel, the greater part of the Palestinian urban intelligentsia, the traditional and social leadership, and most of the property owners were either forced to flee or abandon the area within the Green Line. Those who remained were generally from the poorer or uneducated village populations; most cultural activities, including the newly developing theater, were uprooted (see Snir, 1990, pp. 247-248). A unified Palestinian culture was split and for almost 20 years there were almost no direct connections between Palestinian authors in Israel and those in the West Bank, Gaza Strip, or in exile. The war of 1967, while traumatic, brought about the idea of a Palestinian national identity; the consequent political and cultural reconciliation of the Palestinians inside Israel and those in the West Bank and Gaza Strip resulted in a revival of Palestinian culture. Palestinian theater developed extensively during this period and a Palestinian dramatic form was born, inspired by experiences inside the homeland as well as in exile. This was the context for the 1977 emergence of al-Hakawati Theater which later became a synonym for national Palestinian theater. Contributing to the formation of political and cultural national consciousness, and to the process of Palestinian nation-building, al-Hakawati also furthered the professionalization of Palestinian theater.[62]

Al-Hakawati, a joint project of Palestinian dramatists, directors, and actors, especially from Israel and East Jerusalem, was founded and developed by the Bethlehem-born Palestinian director François Abu Salim (b. 1952) and a group of theater people, prominent among whom were Adnan Tarabsha, Ibrahim Khalayila, Da'ud Kuttab, Muhammad Mahamid, Radi Shihada, Idwar al-Mu'allim, Iman 'Awn, 'Ammar Khalil,

61 This article has been slightly changed and adapted from "The Palestinian Hakawati Theater: A Brief History," *Arab Studies Quarterly*, 6:2/7:1 (1998–99), pp. 57–71, and thanks are also due Dr. Snir for allowing its adapted reproduction.

62 Unless otherwise noted, the analyses of the plays presented in the chapter are based on viewing them, whether in live presentations or on videocassettes. I also used extensively the excellent material (based upon interviews and information brochures) from Shinar, (1987), pp. 132–140. On Palestinian theater in general, see also Slyomovics (1991) and Snir (1993a, 1995b, and 1996). For pictures from Palestinian theatrical performances, see Snir (1995b), pp. 123–134; Shinar (1987), p. 133; and Slyomovics (1991), pp. 18–38.

and the actress and costume designer Jackie Lubeck, Abu Salim's Brooklyn-born Jewish first wife.[63] Additional actors as well as set designers, lighting professionals, and musicians were recruited according to need. The singer Mustafa al-Kurd, permitted by the military authorities to return to Jerusalem in 1982, also joined the troupe.

The theatrical work of Abu Salim, the product of a cross-cultural marriage between a French woman and a Palestinian man, has reflected not only the theme of homeland vs. exile that has characterized Palestinian theatrical activities since the late 1970s, but also the conceptual, cultural, and sociopolitical polarities of tradition vs. modernity, east vs. west, and south vs. north. Inspired by Bertolt Brecht, Jean Genet, and Franz Kafka, Abu Salim invokes the centrality of exile to the Palestinian cultural experience and attempts to reconcile the various polarities that he considers necessarily connected parts of the same whole. Abu Salim portrays modern civilization as destroying culture with its insidious insistence on conformity; it homogenizes needs, dreams, and desires, so that everything is round, soft, without angles, without dirt—surgical, like modern war. According to Abu Salim, it is no longer only homosexuals, prostitutes, artists, and the poor who are outsiders. Those who do not fit into an increasingly narrow definition of normal or who are too individualistic are simply rejected: "The modern individual is free, but marginalized to the point where he is reduced to a non-thinking consumerist automaton" (Ditmars, 1994, p. 35). It is precisely this refusal to comply with the "norm" that characterized the nature of the troupe under Abu Salim's leadership. The characters in the troupe's plays fight to maintain their identity and to save themselves from the oblivion of sameness through a constant struggle for authenticity—a resonating theme of domestic and exilic Palestinian experience.

Al-Hakawati's founders sought to establish a national theatrical framework that would contribute to the strengthening of Palestinian culture, as to well as provide an artistic venue to intensify the national awareness of the Palestinians. As Palestinian poet Mahmud Darwish (b. 1941) states: *Inna man yaktubu hikayatahu yarithu ard al-hikaya* ("Whoever tells his story will inherit the earth of the story").[64] However, al-Hakawati's aim was not only resistance against the occupation but also protest against negative phenomena in Palestinian

63 It was through his marriage to Lubeck that Abu Salim was able to stay in Jerusalem. Lubeck was his theatrical creative partner for 15 years until their separation in the early 1990s.
64 Interview with Abbas Baydun in *Masharif* (Jerusalem), October 3, 1995, p. 86.

society itself—both exilic and domestic. To express in dramatic terms the national aspirations of a society under occupation and in exile, the theater could rely, as had most of the former Palestinian troupes, on merely translated or wholly adapted repertoire. In shaping its own stories and style, the troupe drew inspiration from folkloric, traditional, and foreign sources. The troupe developed a unique theatrical language that enabled it to target intellectuals and professional critics, as well as workers, merchants, and villagers within the limitations of government regulation (however, it seems that the troupe did not reach wider audiences from the lower classes). This new discourse served as an artistic code between the theater and its audiences, using plot rhetoric, creative-interactive processes, and institutional structures as channels for its nation-building messages.[65] One of the main factors affecting the troupe's work was Israeli censorship which fought the process of Palestinian nation-building and which understood Palestinian culture, and especially the theater, as a state vehicle for that process.

Censorship and Theatrical Responses

In the 1970s and the 1980s, the Israeli authorities' treatment of Israeli Palestinians differed markedly from that of the Palestinians living in the Occupied Territories. While most of the restrictions on Israeli Palestinians had been lifted, the Palestinians in the Territories faced the same censorship as that under the British Mandate Defense Emergency Regulations of 1945 (Sulayman, 1988, pp. 212–218). The Palestinian press and educational and cultural institutions were the primary targets of these regulations. Gaby Baramki, the acting president of Birzeit University in 1987, describes the atmosphere in which Palestinian educational and cultural institutions existed:

> There is no need to describe at length the degree to which the universities suffer under occupation from censorship of books and periodicals, discriminatory taxes and customs, army raids on campuses, and violations of the rights of individual faculty and students. But from the experiences of the past twnety years a very important dynamic may be discerned, military harassment of the universities has increased with each year of occupation. This dynamic, which seems to be imbedded in the nature and structure of military occupation, outweighs other factors

65 Ibid., p. 134.

such as whether the prevailing government is Labor or Likud. (Baramki, 1987, p. 18)[66]

The Defense Emergency Regulations of the 1970s were enforced on Palestinian cultural activities, as well as newspapers and magazines in East Jerusalem, and made frequent use of the argument that they served as a threat to "the security of the state." Military order no. 50 (1967), which controls the licensing and distribution of newspapers, enabled Israeli authorities to prohibit publications from entering the occupied territories if they might "incite disorder or hostile activity" (Friedman, 1983, p. 98. Also see Metzger, Orth, and Sterzing, 1983, p. 4). The case of *Al-Fajr*, the most nationalist of Arabic dailies at the time, clearly illustrates the Israeli authorities' restrictions of the Palestinian press. According to Bishara Bahbah who served as editor of *Al-Fajr* from 1983 to 1984, the Israeli censor "is the actual editor-in-chief not only of *Al-Fajr* but of the entire Palestinian press in the occupied territories" (Bowen and Early [eds.], 1993, p. 171).[67] The word *Filastin* ("Palestine") was thought threatening enough to be censored, even in West Bank children's textbooks (see Ashrawi, 1976, p. 5),[68] and the Palestinian flag was banned. The words *'awda* ("return"), which signifies the return of the Palestinian refugees from exile, and *sumud* ("steadfastness") were also consistently censored. In 1982, the Israeli authorities issued a list of 1,002 banned books, putting the total number of banned books at 1,100. By 1987, the number of banned books, including school textbooks, reached 1,570. Moreover, several Palestinian writers have stood trial for having or publishing books of poetry or essays critical of the Occupation. Similar measures have been taken against Palestinian folkloric heritage, including the prevention or delay of folkloric festivals (Abdallah, 1990, pp. 47–50).

Indeed, *Al-Hakawati*'s troupe faced many problems with the Israeli censors who insisted, for example, that the troupe submit the complete texts of their plays although generally there were no such texts. As for Palestinian theatrical activities, while the Israeli military censored plays published or staged in the territories, the Council for the Criticism of Films

66 On the conditions of Palestinian universities under occupation see the series of articles by Penny Johnson in *Journal of Palestine Studies* 15:4 (1986), pp. 127–133; 16:4 (1987), pp. 115–121; 17:3 (1988), pp. 101–105; 17:4 (1988), pp. 116–122; and 18:2 (1989), 92–100.
67 In some cases, according to Palestinian reports, the Israeli censor cuts out 94.6% of the material submitted to him. See Abdallah, 1990, p. 13. Palestinian journalists used to provide Israeli Hebrew and Arabic newspapers with news in order to be able to publish them again in their own newspapers.
68 In banning books, the Israeli authorities made use of Item 88-81 of the British Emergency regulations of 1945. They also imposed Military Order 101 issued in 1967 and modified by Military Order 718 (Abdallah, 1990, p. 32).

and Plays served as the interdictor for plays published and staged in East Jerusalem. The Palestinians have argued that the disposition of this committee toward the production of Palestinian performing arts was essentially no different from that of the military censor. Out of twenty-seven dramatic works examined by the committee from 1977 to 1984, only seventeen texts were approved, and even those texts were partially censored (according to Balsam, April 1992, p. 86; see also *Encylopaedia Palestina*, 1990, vol. 4, p. 218). This control over Palestinian dramatic expression was prompted by the Israeli establishment's awareness of the potential role of the theater as an important platform for the process of nation-building. In a 1990 report, Ghassan Abdallah sheds light on the impact of the lack of freedom of expression in the occupied Palestinian territories:

> We should not also forget that Israeli military orders have resulted in a general cultural crisis. Such a crisis cannot be overcome by the holding of seminars or the founding of libraries that would deepen the theatrical culture of members of the local groups. *Balaleen*, a theatrical group, is an example of how theatrical groups fail to establish their own programs. In addition to this, it should be mentioned here that the general economic atmosphere, which is moving from bad to worse, explains the weak support the theatrical movement receives from the public. The sociopsychological instability in the area has negatively affected the development of the theatrical movement and led to the failure of theatrical groups, like *Dababees*, to carry out their message. Two members of this group, Mahmoud Jbeil and Sam Rafidi, were arrested. Despite all their restrictions, the Palestinian theater has continued to deliver its message due to the everlasting hopes of its members. (Abdallah, 1990, pp. 39–41)

Israeli assault on Palestinian culture in the territories encouraged Palestinian artists to resort to various means of resistance. One tactic was the use of symbolism, with its capacity for multiple interpretations, which playwrights hoped would lure censors away from a clear understanding of the play. Moreover, as used by al-Hakawati this distinct language served as an artistic code between the theater and its audience, using numerous resourceful techniques to convey nation-building messages (Abdallah, 1990, p. 134). The dramatists also employed a "mythical time to direct criticism at the present" (see also Jayyusi and Allen [eds.], 1995, p. ix). Tactics such as these enriched Palestinian theater and strengthened its ties to its Western, as well as to its Muslim and Arab,

heritage. Needless to say, the great success of al-Hakawati was both despite and because of the constant attempts to disrupt its activities by the Israeli authorities, the Jerusalem municipality, and the Council for the Criticism of Films and Plays. Several of al-Hakawati's plays were staged before Jewish Israeli audiences, inciting a great deal of professional and political interest. Some of these Jewish Israeli theater supporters protested the infringement of freedom of speech thereby disrupting the censors' attempts to quiet the theater.[69]

Cultural Motifs: Lahham and Hakawati

One way al-Hakawati has contributed to the conscience and process of nation-building is through the use of Arabic and Palestinian folkloric motifs. The folkloric inspiration is clearly illustrated by the theater's name, which alludes to the ancient *hakawati* ("storyteller"),[70] an itinerant storyteller who appeared in places such as cafés and public squares and told his stories that were based mainly on ancient folk tales and legends such as the noncanonical *Alf Layla wa-Layla* ("A Thousand and One Nights").[71] It should be noted that *Alf Layla wa-Layla* was, until the nineteenth century, associated in the Arab world with public performances for the illiterate working classes; only following its translation into European languages and becoming part of world literature did it acquire a canonical status in Arabic literature.[72] The storyteller was also known as *sha'ir al-rababa* ("the singer of the *rebab*," i. e., a stringed instrument with one to three strings) and under the influence of Sufism in some non-Arab Muslim societies, he has been known as *'ashiq*

69 For example, *Ha'aretz*, September 11, 1988 p. B6; *Ha'aretz* (Supplement), September 15, 1989, pp. 9–11; *Ha'aretz*, September 21, 1989, p. 10; and *Ha'aretz*, February 24, 1992, p. B3.

70 The East Jerusalem al-Hakawati is not the only Arab theater troupe using the name al-Hakawati. A famous Lebanese theater troupe bears the same name and its work alludes to the role of the traditional *hakawati*. On the Lebanese Masrah al-Hakawati, see Khalida Sa'id (1984); al-Khatib (1994), pp. 729–735; Basha (1995), pp. 137–150.

71 *Alf Layla wa-Layla*, composed in a mixture of *fusha* and *'ammiya*, was, until the nineteenth century, considered low-brow literature, hardly admissable into respectable households. These stories were part of a folklore kept alive by storytellers, and were considered to have no literary value. Ibn al-Nadim (d. 987) who included it in his comprehensive catalogue of books entitled *Al-Fihrist* ("The Index") describes it as *kitab ghathth barid al-hadith* ("a coarse book without warmth in the telling"). See Ibn al-Nadim, *The Fihrist* [English translation] (1970), vol. 2, p. 715; and *Al-Fihrist* [Arabic] (1985), p. 605. See also Franz Rosenthal, "Literature," in Joseph Schacht and C. B. Bosworth, eds. *The Legacy of Islam* (Oxford: Oxford University Press, 1979), p. 322; Rana Kabbani, *Europe's Myths of Orient* (London: Macmillan, 1986), p. 23. For a general account of *Alf Layla wa-Layla*, see E. Littmann, "Alf Layla wa-Layla," *The Encyclopedia of Islam*, vol. 1, 1960, pp. 358–364.

72 On the translations of that popular work, see Huart (1966), pp. 402–403. On Antoine Galland (1646–1775), who first introduced this work to European readers at the beginning of the 18th century, see Kabbani, pp. 23–29; Knipp (1974); and Macdonald (1932), p. 398.

("lover").[73] The storyteller accompanied his tales with gestures and different voices, encouraging his listeners to react and participate. As one of the long flourishing traditions of vernacular performing arts, the *hakawati* seemed to encourage the cultural development of a new modern Arab theater, although Arab audiences, as Abu Salim indicates, "do not always understand the need for a full company, when one storyteller can enact the entire plot" (Shinar, 1987, p. 134). The cultural institution of the storyteller almost disappeared in the middle of the twentieth century following the emergence of modern dramatic theater, the increasing influence of electronic mass media, and the development of the cinema. An excellent illustration of the decline of this cultural institution and its replacement by the electronic media of modern times[74] is found at the beginning of Naguib Mahfouz's novel *Zuquq al-Midaqq* (*Midaq Alley*, 1947) when the storyteller in Kirsha's café is replaced by the radio.[75] Nevertheless, some modern substitutes for the traditional storyteller are rather appealing due to their direct allusion to the folkloric tradition, striking a chord of traditional heritage in the hearts of Arab audiences.

One example is the Syrian comedian Durayd Lahham (b. 1934), who

73 On storytellers in the Islamic world, see 'Arsan (1983), pp. 353–359; Khurshid (1991), pp. 166–167; And (1963–64), pp. 28–31; Lane (1954) [1908], pp. 397–431. Sometimes the storyteller is "named" after the narratives he relates: Abu Zaydiya, for example, means that he is a specialist in relating the adventures of Abu Zayd al-Hilali. See Shiloah (1995), p. 127. Somehwat similar to the institution of the storyteller is the *sha'ir al-rababa*, perhaps its ancient cultural generator is the *rawi* (reciter), who goes back to the pre-Islamic era when every designated poet had a *rawi* who memorized his poems and transmitted them to others. After the advent of Islam, the *rawis* formed an independent class, also composing and reciting poems of their own (Shiloah, 1995, pp. 21–22). It should be noted that women were also famous as story-tellers and Charles Pellat stated that "the tales of the supernatural, the ancient *asmar* which correspond to the German *Hausmärchen*, are told by women, especially old women, while the heroic tales and historical legends are the province of men" (Pellat, "Hikaya," *Encyclopedia of Islam*, vol. 3, 1960, p. 371).
74 On that cultural aspect of Arab life, see the first section of the eighth chapter of Ibn al-Nadim's fihrist entitled *Fi akhbar al-musamirin wa-l-mukharrifin wa-asma' al-kutub fi al-asmar wa-l-khurafat* ("On Accounts of Those Who Converse in the Evening and Tellers of Fables with the Names of the Books which they Composed about Evening Stories and Fables"). See Ibn al-Nadim, *The Fihrist* [English] (1970), vol. 2, pp. 712–724, and *Al-Fihrist* [Arabic] (1985), pp. 605–613.
75 Naguib Mahfuz, *Zuqaq al-Midaqq* ([1947]), pp. 7–12; in English, *Midaq Alley* (1975), pp. 3–8. Mahfouz presumably wrote this episode following articles and reports such as Ahmad Hasan al-Zayyat's article "Al-Radiu wa-l-Sha'ir," in *al-Risala*, December 3, 1934, pp. 2121–2122. See also Mahmud Ghunayim's poem "al-Radiyu" in *al-Risala*, January 7, 1935, p. 7. Mahfouz has always been aware of the role and impact of the mass media on the literary and cultural life. In his article about the role of the intellectual in combatting the challenges of terrorism he indicates that "the more culture makes itself felt in the mass media, the greater is the impact of its messge and aims" (*Al-Ahram Weekly*, April 8–14, 1993, p. 6). An interesting intertextual allusion to Mahfuz's episode in *Zuqaq al-Midaqq* can be found in "Mughamarat Ra's al-Mamluk Kabur" by Sa'dallah Wannus (1989, pp. 50, 121) in which the radio is switched off as soon as the *hakawati* enters the cafe or starts speaking. On the decline of the status of the storyteller see also Schami, 1996, pp. 183–184.

held a favored position similar to that of the traditional *hakawati*. His video cassettes, especially those in which he plays the role of Ghawwar, a comic figure in the comedies of Lahham, generally representing the implied author, are very popular and are sold and rented throughout the Arab world.[76] Asked about the connections with the heritage of the past, Lahham responds with a very instructive answer that may clarify the origins and emergence of al-Hakawati Theater:

> The *hakawati* had become much less prevalent. The original reason for the *hakawati* was the widespread illiteracy of the people. [The storyteller] would sit on an elevated chair and read stories of Antar, Abla, Abu Zayd al-Hilali, and other heroic knights. People love stories of heroes, particularly ones as dramatic as Antar. The *hakawati* would read the story of Antar, and as they do in television today, he would stop reading the story at a suspense-filled point Sometimes the coffeehouse crowd would divide into proponents and opponents of Antar; sometimes the two groups would fight and splinter chairs on each other's heads I heard a story once, I don't know if its true, but it is certainly conceivable. A *hakawati* reached a stopping place in the story and said: "Come tomorrow for the next installment." At that point in the story, Antar was imprisoned and one of his supporters was so upset that he could not sleep. He had become a part of the story. He dressed, went to the *hakawati*'s house, knocked on his door, gave him money and said: "Take this money and read another page or so until Antar is freed from prison." Surely this story or its equivalent happened. (Bowen and Early [eds.], 1993, p. 268)[77]

Whether or not Lahham himself senses that the character of Ghawwar represents continuity with past cultural forms, it is clear that the popularity of this figure as well as his wide reception by all strata of Arab society is in great measure due to his identification with the traditional *hakawati* (see also Hamdan, 1996). Likewise, the Palestinian Hakawati Theater appeals to its Arab audiences because it strikes a chord of traditional and national (Arab or Palestinian) heritage in the hearts of Palestinian audiences.[78] Even the specific seating arrangement in the the-

76 On Lahham and his partnership with Muhammad al-Maghut (b. 1934), see Bowen and Early, eds. (1993), pp. 264–270; Kishtainy (1985), pp. 159–164.
77 The telling of the story of Antar lasted sometimes a year (see Pellat, "Hikaya," *Encyclopedia of Islam*, vol. 3, 1960, p. 371). On the adventures of Antar and a selected bibliography, see Norris, 1980.
78 Another recent example is the presentation *Abu Nimr's Tales* staged in Hebrew by the

ater reifies the traditional *hakawati*'s environment in that it resembles the atmosphere of a public café. The adoption of the storyteller and his techniques was undertaken by the troupe to suggest the ancient roots of al-Hakawati's methods of presentation, as well as those of Arab theater in general, in contrast to what might have been perceived as a new genre, something essentially foreign or borrowed.[79] These techniques motivated some of the original experiments and improvisations by the troupe in its first years to reach accordance with the censor's demands.

Contemporary Modes of Theater

Due to a lack of resources and out of an experimental incentive, the act of play writing, and devising plots, characters, and dialogues became a collective undertaking by the actors themselves in rehearsals and workshops, and was based largely upon improvisation and interaction within the troupe. In addition to the influence of the traditional semi-theatrical Arab tradition, Western theatrical strategies were merged with the Arab *hakawati*, Ariane Mnouchkine (b. 1939) and her famous Théâtre de Soleil, Jérôme Savary's Grand Magic Circus Théâtre, commedia dell'arte, as well as American slapstick, all inspired Palestinian dramatists. Critics have compared this amalgam to Gabriel Garcia Márquez's brand of "magic realism," and sometimes to Brechtian expressionism. Some Palestinians, however have criticized the troupe's leader Abu Salim for being too "Westernized" in his approach and less "nationalist," an accusation he swiftly rebuts by referring to both Palestine's history as a nexus between East and West, and dialectic interference of exile and homeland. The troupe, which emerged from the ashes of the Palestinian Balalin troupe's experimental theater company, has always walked the line between the traditional and the contemporary.[80] Al-Hakawati was unique in that it was the first real "crossover" Palestinian cultural export well-received by Israeli theater critics, camp-dwelling refugees, and European audiences alike. That wide reception was due in large part to the

Palestinian actor Bassam Zu'mut in the 17th Festival for Alternative Theater in Acre (September 28–October 1, 1996). It is interesting to note that this presentation is based on a Hebrew book by Dan ben Amots (1923–89) titled *Sipurei Abu Nimr* (1982). The subtitle of the book is a distorted Hebrew sentence that tries to imitate an Arab speaking Hebrew, *le-anashim shelo mefinim 'arvit ve-lo makrim tof al-aravim* (lit., "for those who do not understand Arabic and do not know the Arabs well").

79 On the relationship of Palestinian theater to the ancient storyteller, see Shihada (1989), pp. 173–174. On the roots of modern Arabic theater, see Moreh (1992); Moreh and Sadgrove (1996); and Snir (1993b), pp. 149–170.

80 Balalin was established in 1971 by François Abu Salim. The most famous play produced by the troupe was the avant garde experimental *Al-'Atma* ("The Darkness"), which the troupe wrote, prepared, directed, and performed collectively. For the text of the play see Anis, 1979, pp. 24–73. For a complete translation of the play, see Jayyusi and Allen, eds. (1995), pp. 189–211.

troupe's rhetoric and their various modes of delivery including Chaplinesque, Brechtian, alienated, and "poster theater" styles in a blend of traditional and modern symbols. This rhetoric was deliberately adopted in order to reach a wide range of language and behavior bordering on the vulgar. Moreover, in all the productions of al-Hakawati, as in Arab professional theater in general, only 'ammiya (colloquial language) has been spoken to the complete exclusion of *fusha* (classical Arabic). Brash humor has served to depict Palestinian and Israeli characters alike; consequently, Jewish Israeli civilians, army personnel, the military government, and Palestinian characters were often presented as equally grotesque.

Al-Hakawati's Plays

The first play produced by al-Hakawati was *Bismi al-Ab wa al-Umm wa al-Ibn* ("In the Name of the Father, the Mother, and the Son"), which was staged during the 1978–79 season. The play depicts the violent invasion of modernization and occupation into Palestinian life, illustrating the effects of stress on traditional family life. The play presents a predominant feature of post-1967 Palestinian literature in general: the criticism of Palestinian society and leadership. The characters, making their first appearance on the stage inside cages, are the husband Atrash (in Arabic, "a deaf male"), his wife Kharsa ("a mute female"), and their son Muti' ("an obedient male"), along with the tamer—their apparent master—who is outside the cages. While the training of Kharsa by Atrash is announced as a "special trick," a clever, intelligent, and modern, unknown character who may symbolize Israel or modernization (see Shinar, 1987, p. 135), sneaks his way in and imposes himself on the tamer's pets. The stranger stays on while the tamer tries unsuccessfully to get rid of him:

> OK stranger, time's up! Get lost. Excuse me folks, but this is definitely not part of the set. That stranger is taking over! Hey, wait a minute! Where is Atrash? Muti', get back in your cage! Kharsa, cook dinner! . . . The female is on the loose! The offspring is on the loose! I'm losing control!!!! My act! My creatures! My work! My act! (Al-Hakawati information brochure, 1985; Shinar, 1987, p. 135)

A Palestinian critic stated that, in this play, there is no difference between

> the social backwardness [of the Palestinians] and the military occupation . . . this society is falling between the hammer of the occupation and the anvil of poverty, economic, social, and intellectual backwardness. ('Abd Allah, 1979, p. 16)

Another drama, *Mahjub, Mahjub*, was written collectively by al-Hakawati members and directed by Abu Salim (Shinar, 1987, pp. 135–136). The play, staged during the 1980–81 season and performed more than 120 times, tells the story of Mahjub (played by Adnan Tarabsha), a guileless collaborator, holy fool, and perpetual victim. It portrays Palestinians as a community robbed of its vitality:

A new age for the living dead . . . a foggy, murky world where one comes and goes, speaks and writes, buys and sells, plants and ploughs, works and meets, faithfully, but uselessly beating the air and striking the wind.[81]

This is the dehumanized world into which the antihero and scapegoat Mahjub steps, soon to understand that such a bare existence holds no more joy than a peaceful death. He gives up and chooses to die but quickly awakens when his companions unfold his life before him. The core of the play comprises the three long nights of his wake during which his life is narrated, interpreted, and performed. The sequence of mishaps typical of Mahjub's life begins when, in the excitement of his birth, his father drops him on his head. Later, he leaves school after being reprimanded for asking too many questions. In a series of tragicomic episodes, Mahjub becomes aware that he does not know who he really is. Before 1967, as a Palestinian, he refuses to stand up for the Jordanian national anthem. He shouts for joy at the radio news bulletin that boasts Arab victory in the 1967 War, and droops in despair when he learns the bitter truth. Mahjub outwits an Israeli soldier who stops him at a check-point and is subject to interrogation after the colors of the Palestinian flag are recognized among other colors of his clothing.

Reflecting all aspects of Palestinian life, Mahjub directs caustic and bitter criticism at the sterile confusion of his brethren's existence and wonders at the contradictions in the occupiers' lives. On the one hand they display military power, social organization, and technological skill, but on the other hand they are obsessed with a ridiculous security ritual. The play utilizes various techniques and allusions akin to Woody Allen's movies as well as those in the 1974 novel by Emile Habibi (1921–96) entitled *Al-Waqa'i al-Ghariba fi Ikhtifa' Sa'id Abi al-Nahs al-Mutasha'il* (available in English as *The Secret Life of Saeed the Pessoptimist.* London, Zed Books, 1985). In Habibi's novel, the Palestinian tragedy is portrayed by a figure somewhat similar to

81 Quotations from the English translation distributed to the audience and in Shinar, 1987, p. 135.

Mahjub's, whose image ironically represents the absurdity of the life of the Palestinian people from the perspective of those who remained after 1948.

Another successful play staged by the troupe was *Jalili, ya 'Ali* ("'Ali the Galilean"), which deals with the identity crisis and adventures of Ali, a bilingual Israeli Palestinian villager working in Tel Aviv.[82] Leaving his home village, 'Ali (played by Edward Mu'allim) seeks his fortune in Tel Aviv, the very heart of the occupiers' country. However, his own country seems generally to be just another exile: "Tragic son, naive little boy, the thief in the night, the hot-shot cowboy, the imaginary lover, the silent worker, the steadfast militant, the black and the white . . . as he moves from the village of his ancestors to the city of his colonizers" (Shinar, 1987, p. 136). An Israeli friend he meets advises him to take an Israeli name, Eli (which is similar in its pronunciation to his Arabic name), to court a beautiful Israeli woman, to work, fight, and play "safely." At the end, a couple of Hebrew-speaking thugs enter the stage, shouting that their act will be presented instead, the act called "'Ali, the Terrorist" (Shinar, 1987, p. 137).

In November 1983, the al-Hakawati troupe leased al-Nuzha cinema in East Jerusalem and converted it into the first Palestinian national theater. Supported by a $100,000 Ford Foundation grant and donations from Palestinian individuals and organizations in the West Bank and abroad, the troupe managed to renovate the building and set it up as its base. The theater was formally opened on May 9, 1984. The main 400-seat hall, a small 150-seat hall, and additional facilities have enabled the troupe to pursue its objectives and have served as a facility for other professional and amateur drama, music, and dance groups, as well as art and photography exhibits.[83] Plays are also performed in the new theater by other Palestinian troupes such as al-Jawwal troupe, Bayt 'Anan's 'A'idun Theater, al-Sanabil troupe, and some troupes performing children's theater. Haifa's Municipal Theater staged Samuel Beckett's *Waiting for Godot* in Arabic and Hebrew. Films have also been screened, including the Israeli film *Beyond the Walls* (*Me-Akorei ha-Soragim*, literally translated as "Behind the Bars," 1984; on this film, see Shohat, 1989, pp. 252–253 and 268–271). Musical programs have been presented, featuring performances of folk songs, contemporary poems, sing-alongs of popular songs, and nationalist concerts, such as that performed by Mustafa al-Kurd (*Al-Qindil*, October, 1988, pp. 36–37). Other activi-

82 On the problem of Israeli-Palestinian bilingualism, see Snir, 1995a, pp. 163–183. On *Jalili, ya 'Ali*, see Slyomovics (1991), p. 31.

83 For example, during the Intifada, the lobby of the building was exploited to display photgraphs, chants, and pamphlets detailing the number and the extent of the injuries sustained by victims of Israeli bullets and tear gas.

ties there have included art exhibitions as well as cultural and political debates (Shinar, 1987, pp. 132–139). In 1989, the name of the theater building was changed to al-Markaz al-Thaqafi al-'Arabi ("The Arab Cultural Center"); and though its own original productions have decreased, al-Hakawati has become under its new name—al-Masrah al-Watani al-Filastini ("The Palestinian National Theater")—the central framework of the Palestinian theatrical movement. It has also increasingly served as a framework for various productions of Palestinian theatrical activities and festivals, including puppet shows and children's theater.

The first play to be staged in al-Hakawati's own theater in May, 1985, was *Hikayat al-'Ayn wa al-Sinn* ("Story of the Eye and the Tooth"), directed by François Abu Salim, which was another landmark in the development of Palestinian theater as "a nation-building communications medium" (Shinar, 1987, pp. 132). However, unlike earlier plays that relied mainly on the spoken word, this was more sophisticated. Employing nonverbal techniques including music, movement, costumes, puppets, lighting, and sets, the play concentrates on issues of tradition, modernity, identity, war, and peace through a composite process rather than through the specific adventures of individual characters. In the first scene, the musical score is composed of Palestinian country tunes featuring motifs popular in the West Bank villages. The second scene is accompanied by contemporary international rock music, while the musical finale features a majestic choir performance of the "Kyrie Eleison" section of Mozart's *Requiem* "as a symbol of total destruction and hopelessness" (Shinar, 1987, pp. 138).

Combinations of visual elements are used abundantly to convey the play's pessimistic message. Tradition is blatantly challenged when two sets of twins refuse to comply with the commitment assumed by their parents when they signed a traditional wedding contract on the babies' birth. The revolt triggers a long and bloody feud between the families, which is the central axis of the plot. A *sulha* ("reconciliation") ceremony between the feuding sides is imposed on the families by neighbors in a later scene during which the traditional *dabka* dance is performed by the elders who did not succeed in forcing their offspring to behave according to tradition. The past in which the elders determined the younger generation's ways has thus died, but it physically obstructs progress, forcing all the action on stage to move around dead bodies. The atmosphere of appeasement is disturbed again in the second part of the play when a new character, symbolizing Zionism and Israel, makes his entrance. The two sides in the conflict are no longer fathers and sons, but Palestinians and Israelis. The longer their endless war lasts, the

greater the losses suffered by both sides, and the weaker they become. Walking in blood up to their ankles, the protagonists cannot bring a message of hope for the present or the future.

One of the plays staged by the troupe and regarded later as a self-fulfilling prophecy was *Alf Layla wa-Layla fi Layali Rami al-Hijara* ("A Thousand and One Nights of the Nights of a Stone Thrower"). First presented before the outbreak of the Intifada, it portrays a confrontation between a Palestinian youth and the Israeli military governor as described by the narrator.[84] A series of confrontations depicts the Palestinians enduring and triumphing over 1,001 nights of oppression and humiliation. The military governor loses awkwardly, in the words of the narrator:

> Already a man by the age of ten, the child's game with the stones became a gesture of a free man. He saw that nothing remained but the stones themselves to defend his home from the gluttony of the governor, who was gobbling away at the trees, the stars, and the sun. (Shinar, 1987, p. 136)

The struggle is presented as a fight between the Palestinian David and the Israeli Goliath: the Palestinian boy armed with stones is confronting the military governor's well-equipped warriors. This sort of struggle, frequently reflected in Palestinian literature since 1987, develops into a Middle Eastern *Star Wars* with flying carpets, fighting rockets, and laser beams. This satirical confrontation between the occupier and the occupied is associated with the struggle between the traditional and the modern. Staged before mixed Palestinian-Israeli audiences prior to the Intifada's outbreak, the play was interpreted by some Jewish Israeli critics as expressing Palestinian readiness to talk about the fate of Israeli-Palestinian relations, and of signaling a hope for a future of mutually productive discussions. Regarding the troupe's performances before Israeli-Jewish audiences, the Jewish Israeli leftist critic Amos Kenan (b. 1927) said:

> If they show us a play called *1001 Nights of the Stone Thrower*, this means that instead of throwing stones at us, they want to talk to us. And if they want to talk, it's a sign that they want us to hear, and if they want us to hear it's a sign that they want us to talk; and if they want us to talk, it's a sign that they want to listen. (Urian, 1996, p. 343)

84 Quotations from the English translation distributed to the audience, based on Shinar, 1987, p. 136.

The staging of the play brought about the arrest of the leader of the troupe, Abu Salim (*Balsam*, April, 1992, p. 85).

The Intifada and al-Hakawati

The outbreak of the Intifada in December 1987, considered to be the most comprehensive revolt by Palestinian masses since 1936, created a new reality for al-Hakawati Theater as well as for the entire Palestinian community. "The Palestine Declaration of Independence, endorsed by the Palestinian National Council less than a year after the outbreak of the Intifada, confirms the new juncture at which Palestinian culture had arrived with this uprising" (Palestinian Declaration of Independence, November 15, 1988). And indeed, the political uprising, which began with the death of four Palestinians in a car driven by an Israeli driver, was accompanied by a cultural uprising within Israeli Palestinian society as well as in the Occupied Territories.[85] Nevertheless, the Hakawati troupe went into shock since their potential impact diminished in the face of mass demonstrations, stone throwers, scores of Palestinians killed and wounded, and thousands in prison. Though no restrictions were placed on the troupe itself, al-Hakawati was not permitted to present its work on the main stage of the Intifada–the West Bank and the Gaza Strip. The Hakawati troupe found themselves performing in a vacuum, unable to reach their community, although various productions were staged[86] and attempts made to adjust to new circumstances.[87] Several of al-Hakawati's founders and earliest members began to search for other new theatrical frameworks, and the original group crumbled. Since the late 1980s, the main al-Hakawati troupe led by Abu-Salim, the group's founder and the leader, stopped its activities. Abu-Salim himself preferred voluntary exile and left for Paris. "I felt powerless and impotent," he says about the hard days of the Intifada trying to explain his preference for exile, "The children controlled the street."[88] The name *al-Hakawati* has been used since then by different separate groups performing independently in the area of Jerusalem.

A successful production by an al-Hakawati group headed by Ibrahim Khalayila was *Al-'Asafir*, ("The Birds"), a political allegory presenting the

85 See also the statement of Palestinian poet Samih al-Qasim (b. 1939) that "the Intifada is not only a political movement but a cultural, spiritual and religious one" (Ann-Marie Brumm, "Three Interviews," in *Edebiyat*, 6, 1995, p. 84).
86 According to statistics published by the Association of Palestinian Writers, 52 theatrical productions were staged by Palestinians from the territories during the first three years of the Intifada (*Filastin al-Thawra*, January 20, 1991, p. 30).
87 For example, the staging of plays during the day in order to bypass frequent curfews imposed by authorities, according to *Balsam*, April 1992, p. 87.
88 *Yediot ahronot* (Supplement 7 Days), August 26, 1994, p. 37.

rebellion of the younger generation and the attitude of their fathers to occupation.[89] The play, directed by Palestinian Israeli director Fu'ad Awad from Nazareth, was inspired by a joke/riddle about a man seeking refuge in a tree to escape Israeli soldiers: "Now we are driven into the trees," he said, "and when they say, 'We shot in the air and killed some students,' they won't be lying. We shall no longer have to talk about 'flying Palestinians' to explain how shots in the air manage to hit flesh and blood" (Shehadeh, 1982, pp. 122–123). There are parallels between Al-'Asafir and the well-known short story "Al-Numur fi al-Yawm al-'Ashir" ("The Tigers on the Tenth Day") by the Syrian writer Zakariyya Tamir (b. 1931) from the collection of the same title (Tamir, 1979, pp. 54–58; for an English translation of the story, see Tamer, 1985, pp. 13–17). Both the play and the story examine the process of a wild animal's transformation into a domestic pet. Tamir's story tells of taming a tiger over 10 days and ends with the transformation of the trained tiger: "On the tenth day the trainer, his pupils, the tiger, and the cage disappeared; the tiger became a citizen and the cage, a city." In this story, as in most of the stories in Tamir's collection, man is both corrupt and guilty, having lost his innocence since childhood, thus necessitating the rewriting of history and purging from it any trace of humanity or glory. Since the contemporary Arab man does not deserve his own history, he returns to his animal self, loses his innocence, abandons reason, and becomes involved in a crescendo of violence (Badawi [ed.], 1992, pp. 323–324).

The success of al-Hakawati has not been confined to the Palestinian arena and the troupe has also won great international success. Since the early 1980s it has conducted annual tours in Israel and abroad, including participation in various festivals in England, France, West Germany, Italy, Switzerland, Belgium, Holland, Poland, Scandinavia, Spain, and Tunisia. One of the most successful productions staged abroad was Hikayat al-'Ayn wa al-Sinn, in early 1986 in London. In the late 1980s, al-Hakawati toured Japan, Europe, and the United States, and the performances were warmly received.[90] Nevertheless, throughout al-Hakawati's twenty-year history, the question of who and what the first internationally recognized Palestinian theater was speaking for was often raised: is it for Palestinian experience inside the homeland, or outside it in exile, or both? Is it for the "pure" cultural Palestinian experi-

89 On the play, see Al-Yawm al-Sabi', June 12, 1989, p. 41; Ha'aretz, September 11, 1988, p. B6. The passage on Al-'Asafir is partly based on Slyomovics (1991), pp. 20–22.
90 For a report about performances in Japan, see Al-Yawm al-Sabi', April 10, 1989, p. 32; Europe, Al-Yawm al-Sabi', May 15, 1989, p. 32; and the United States, Al-Yawm al-Sabi', August 7, 1989, p. 32.

ence or that which is cross-cultural? "At times," says Abu Salim, the leader of the original troupe, "we felt oppressed by the weight of our own Palestinianness" (Ditmars, 1994, p. 34). However, the troupe has generally succeeded in maintaining its artistic identity through a constant struggle for authenticity without ignoring either the Palestinian experience in the homeland or in exile. This dimension of al-Hakawati, especially under the leadership of Abu Salim, was highlighted following the emergence of the Israeli-Palestinian peace process.

Post-Oslo

In September 1993, Abu Salim returned from Paris to supervise a dramatic workshop. The new Israeli-Palestinian peace contacts inspired him to revive the activities of the main troupe of al-Hakawati with the presentation of a new play entitled *Ariha, 'Amm Sifr* ("Jericho, Year Zero").

This play, which Abu Salim wrote with his mother following the new political developments,[91] is a romance between a tourist and a refugee, both of whom are physically and spiritually displaced—the refugee by Israeli military occupation, the tourist by the alienation of modern Western society. Their coming together offers a glimpse of what might be a happy marriage of two cultures and presents a sobering portrait of the tragic misunderstanding that plagues the relationship between the Arab and European worlds. Like Sartrian characters, both the tourist and the refugee attempt to break out of their stereotyped prisons of narrowly defined selfhood. Betty (played by Abu Salim's second wife, Swiss actress Sylvia Wattes), the French woman on vacation, rejects her role as the "white tourist." Islam (played by Akram Tallawi), the young Palestinian, refuses to play the role of the obedient, caged animal, acquiescing to the demands of authority. But the reality that surrounds them both is stronger than their desire for escape, and the play ends like an absurd Greek tragedy. Although peace seems to be close, Islam rejects his grandfather's advice to heed the signs of Israeli-Palestinian reconciliation. He does not want to escape the struggle alive, choosing to die a pacifistic, mystical death that, as depicted by an enthusiastic Sufi dance, connects him with God.[92]

Despite the tragic ending, it is perhaps the meeting itself, the actual

91 *Yediot Ahronot* (Supplement 7 days), August 26, 1994, p. 37.
92 Although dancing and whirling belong to the oldest religious sects, this mystical dance of the Sufis was a major cause of differences among various Sufi orders and "there were complicated problems as to whether listening to music and dancing movement are genuine utterances of mystical states or illegitimate attempts to gain by own's own effort a state that can only be granted by God" (Schimmel, 1983, p. 179). On dance among the Sufis, see also Shiloah (1995), pp. 140–143.

coming together of the tourist and the refugee, that is the pivotal point of the play. This meeting launches a voyage of cultural discovery. Betty discovers the closeness and love in Palestinian family life, comes to realize the Israeli military occupation, and finds an inner strength of which she was previously unaware. For his part, Islam discovers that Betty is much more richly textured than his initial narrow concept of her as a one-dimensional "Western woman." But the most revealing part of their cultural exchange is the fantasies that they project onto each other. Betty becomes Islam's Sheherazade—the princess from "One Thousand and One Nights"—while Islam becomes Betty's childhood knight in shining armor. Ultimately, their fantasies fail to meet their expectations and in the end both characters feel cheated. "But the important thing," says Abu Salim, "is that for some brief moments a love story unfolds" (Ditmars, 1994, p. 35). The actor Tallawi, who also acts in the Hebrew theater and cinema, believes the final scene of the play bears an optimistic message: the new reality created by the Israeli-Palestinian peace process prevented Islam from undertaking a suicide attack on an Israeli target and he chose instead a pacifistic mystical death, which "compels people to stand and think. The new reality is like an imaginary present . . . This is the zero hour that the play is directing to, that enables people to look at the entire picture, creating a new situation in which they can freely choose."[93]

93 *Yediot Ahronot* (Supplement 7 days), August 26, 1994, p. 40.

7 Performing Depth:
Translating Moroccan Culture in Modern Verse
Deborah Kapchan

Our business is to count the stars, one by one
to chew the wind's haughty arrogance
and watch the clouds for when they'll throw us a handful

and if the earth goes far away from us
we'll say everyone is possessed
everyone has lost their mind
and time, never will its letters fall between our hands
until we write what we are.
 —Driss Mesnaoui, *l-wauw*, 1995, p. 73

All true feeling is in reality untranslatable. To express it is to betray
it. But to translate it is to dissimulate it.
 —Artaud, *The Theater and Its Double*, 1958/1970

In the fall of 1994 I went to Rabat for twelve months under the auspices
of the Fulbright-Hays program in order to study Moroccan postcolonial
theater. That year, however, the national theater in Rabat was closed for
repairs and there was little in the way of theatrical performance in the
capital for me to observe. Determined to study contemporary perform-
ance art and practices (and not just theater history in archives),[94] I began
to attend a series of cultural events organized by the Ministry of Culture
in Rabat. The first performance I attended was of a poet reading the
genre of *zajal*—oral poetry in Moroccan dialect—to the accompaniment
of two musicians. The poems were quite beautiful, full of metaphor and
allusion, and elicited gasps of appreciation from the audience. After the
performance I spoke to the artist, explaining my interest in oral per-
formance and my desire to become more fully acquainted with his oeu-
vre. He was flattered, but cautious, and immediately told me that he
wanted his entire manuscript translated and published; he made me
know that some of his poems had been "stolen," and subsequently pub-
lished in a major newspaper under another name. He agreed to meet with
me and talk "business" at more length.

94 See work on postcolonial theater by Berrechid (1977, p. 156; and 1993).

I will spare you the details of how he convinced me of his Sufi origins, his visions, his poetic craft. He sold himself to me as a fascinating character, a mystic poet (which, indeed, he is), and then began to negotiate. When I finally managed to convince him of my inability to publish his texts as a book in the United States, he insisted that we at least draw up a contract, stipulating that I would never publish his poems without his consent, that his name would always accompany them, that I would share any profits made from their publication, and that I would pay him 250 dirhams (about $28 at the time) for weekly recorded sessions of oral recitation and exegesis of two poems. By his accounts, I would have forty-eight poems by year's end and he would have 12,000 dirhams (about $1,200). Fortunately for my budget, I agreed only to a monthly contract, renewable upon expiration.

I begin with this anecdote because it illustrates in no uncertain terms the symbolic capital of poetry in the marketplace of national and transnational ideas and values. The poet perceived his worth in this market and wanted to exploit the situation for all it was worth. In the remainder of this paper, I tease out various "worths" of this and other sociopoetic performances of *zajal*, analyzing the *zajal* renaissance in Morocco and the performative task of poetic and cultural translation.

Zajal: Performing the Oral in Written Form

The word *zajal* has been used to define any form of oral poetry spoken or sung in the Moroccan Arabic dialect. Historically recited in open air performances in the marketplace, *zajal* has been used in lyrics of popular music, printed as political commentary in newspapers, and most recently, published as a literary genre in its own right. It represents the only genre of literature *written* in Moroccan dialect.

The inscription of this heretofore exclusively oral genre has engaged me in a difficult and passionate task—the actual translation of Moroccan *zajal* poetry from Moroccan dialectal Arabic to English. This project has come to epitomize for me the process of cultural translation that, as a folklorist and ethnographer, has defined my work since my first in-depth encounter with Moroccan culture in 1982. Through the years I have become aware that the performative forms of culture are the first portals of cultural entry. Going through the performance door is one thing, however, translating the experience is another. What better way to translate Moroccan performative modes of being and knowing, I asked myself, than to examine a genre of verbal art that has been charged with this task for hundreds of years?

I began to attend *zajal* readings and festivals. The readings are publicized in the newspapers and take place in school auditoriums and pub-

lic venues like the one mentioned above. Poetry festivals also occur yearly, and the festivalization of poetry in the annual month-long summer city festivals, particularly in Rabat and Casablanca, draw large crowds of appreciative listeners. As is usual in Moroccan performance events, especially those in the open air, there is always talking, noise, and the distraction of hawkers around the performance space. However, the poets make themselves heard. They speak into a microphone and there are usually about 100 avid listeners in close proximity to the stage—university students and professors, high school teachers, self-proclaimed poets and practitioners of traditional arts, actors, theater critics, film buffs, and journalists, in short, the growing cultural elite who are sculpting Moroccan public culture from the bottom up. The audience responds to particularly beautiful or politically astute lines with expressions of "Allah!" not unlike the gasps of ecstasy heard in heightened moments of Sufi rituals. After the performances, poets and audience members linger in the dusk, debating the role of the dialect in creating a Moroccan artistic voice or discussing the import of a particular performance of verse.

Poetry has an important position in the history of Morocco. The extant performance tradition of poetry—its living orality—also makes it a more popular and accessible form than it has been in the history of the West, where poetry is often addressed to a literary elite. In this sense, there is a higher "literacy rate" in oral poetry in the Middle East and North Africa than in Europe or America; it is a more popular and thus more politically effective form. Written literature—whether poetry (*qasa'id*) or novels (*riwaya*)—most always employs the literary language of classical Arabic. *Zajal* is an exception to this rule. Published in Moroccan Arabic dialect (though using Arabic transcript), *zajal* challenges the literary canon, with its focus on "high" forms and pan-Arabism.

The transformation of *zajal* poetry from an oral to a written form in Morocco has been taking place for several decades now, particularly in newspapers like *Ittihad Ishtiraki*, the socialist paper, and the voice of the Independence Party, *Al-'Alam*, dailies that are actively engaged in constructing a political vision and constituency, a community via print (Anderson, 1983). In these contexts, *zajal* functions as a forum for political critique, usually representing positions oppositional to those of the monarchy. Take, for example, these verses written by Hamid Bouhamid from *Ittihad Ishtiraki*, August 3, 1995:

The secret of authority is wisdom/and wisdom is expensive and rare
he who has it/doesn't need other qualities
 Ask those with reason

One among the people/poor thing, in spite of his education only reaped regrets
and another/[though] drenched in carelessness, took authority
 What more can be said?

Go around the marketplace/look, search, you have no scarf binding your head
Go here and there/you'll find [only] fighting and quarrels
 Count the mountains and the plains

Look at the people/they have mixed together, the tall and the short
You can't distinguish/the yeasted bread from that which hasn't fully risen
 Even if they could pass through sieves

How many a [true] master/became a little slave, with scarified cheeks
and he who had/[some] power, the son of this or that one
 He's the one who now has arrived

If you speak with reason/they will recognize you, with a look that could kill
But if you keep quiet/they'll scream and point at you as being ignorant
 And they'll eliminate you with a hammer and sickle

Someone like you must not raise his head/just look, be quiet or say yes
and if you do/just swallow it and take it
 Or you'll find yourself in trouble

Listen, those like you/know who to talk to
"Us, our business is to be masters"/When are you going to learn?
 They'll confuse you with details

They have the right/and more so, in this house of negligence
They'll beat you with rust/even if you combat it with opium
 Patience is not easy.

This poem plays with conventional *zajal* form—couplets composed of
four hemistiches and two caesuras—by adding a line between each verse.
Although the Moroccan dialect contains more internal rhyme than the
translation renders, there is no mistaking its message. It comments on
the injustice of a system wherein the sons of the privileged, though
incompetent, attain positions of power, while those who struggle for
education and ideas are kept in their place. This is an activist *zajal*, ral-
lying the sentiments of the disempowered behind a party that challenges
the status quo.

Zajal is also emerging as a "new" literary genre, however, with a specialized audience of poets and readers whose aesthetic ideals are in the process of reformulation. This artistic phenomenon is a result of the rapid rise of literacy rates in the past decades (Eickelman, 1992, pp. 643–655), the growth of an educated middle class of consumers who have nostalgia for folkloric forms of culture deemed "traditional," and the proliferation of independent Moroccan publishing houses that create and respond to new demands in the cultural marketplace. In the past decade, inexpensive books of *zajal* have appeared in bookstores and in kiosks. Because they are written in Moroccan colloquial Arabic (a heretofore unwritten language), these poetic texts represent a particularly Moroccan literary identity, one with deep roots in oral tradition yet whose branches are rapidly changing form. Indeed, few modern *zajali* poets write in rhymed quatrains anymore. Most prefer free verse, writing on themes as diverse as love, politics, and Sufism. This does not negate the link with history, however. Because of the rich use of pun, allusion, and formulas taken from oral tradition, contemporary *zajal* speaks most fully to those familiar with Moroccan popular culture, past and present.

Although old, the genre of *zajal* has been transforming rapidly over the past few decades. Revived as a postcolonial genre of Moroccan oral literature—a literature of protest—it became a carrier of national and political identity. This was due largely to the fact that *zajal* is a poetry performed in Moroccan dialect. Because of this, *zajal* is a touchstone of "Moroccanness" for many Moroccans, a repository of cultural metaphor and meaning. No longer improvised, these poems are first written and only then performed in public readings and festivals throughout the country, thus reentering the oral repertoire. Their birth as written literature, it should be said, does not guarantee accessibility to a larger audience in the Arabic-speaking world. Because it is written in dialect, *zajal* is essentially a Moroccan literary genre for Moroccan consumption. Judging from the responses of the largely young (20–40 years old), educated, and often unemployed audiences that attend *zajal* readings, the poets represent the voices of this population, thematizing human rights and civil liberties, while at the same time circumscribing new bounds around notions of individuality and freedom. The genre of *zajal* has become a medium of struggle, creating lively debates among intellectuals about the appropriate use of the mother tongue (*darija*, or Moroccan dialect) and the official language (modern standard Arabic), stoking long-standing controversies between pan-Arabism and particularism, and skewing the boundaries between the identity of the popular classes and the literary world of the elite.

Poetry as Performed Practice

In 1977 Pierre Bourdieu brought attention to the weight of practice in the reproduction of culture. What people do everyday, how they dress, work, play, cook their food, educate their children all contribute to the sedimentation of culture in experience, determining what a subject is and how subjectivity is experienced (Bourdieu, 1990). Genre is also a cultural practice (Hanks, 1987, pp. 668–692); embedded *in history*, it also actively embeds history *in the individual and social body.* Indeed, all cultural expression is woven through genres–conversational, autobiographical, performance, poetic (Bakhtin, 1981). *Zajal* has always been an oral genre performed in Moroccan dialect, an oral language. Its transformation into written text should be accompanied by an elevation of its form to the higher register of classical Arabic–the literary language. Instead, written *zajal* uses Arabic script to transcribe the oral dialect, creating, in a sense, a new form of written Arabic–one that falls outside the purview of the literary canon. Such decisions are not arbitrary. The mother tongue of Moroccan Arabic is a language associated with a cultural repertoire of affect, expressing not only a particular relation to popular history, but a way of being in the world that is unique to itself. What is expressed in written *zajal* cannot be expressed in classical Arabic poetic forms.

Speaking of the bilingual subject, Moroccan author Abdelkebir Khatibi notes that "every language is bilingual, oscillating between the spoken portion and another, which both affirms and destroys itself in the incommunicable" (Khatibi, 1990, p. 20). This paper documents some initial forays into the dense woods of intercultural poetic translation, elucidating the formal aesthetics of the genre of Moroccan *zajal* poetry through analysis of the process by which emotions that have heretofore been expressed orally are now rendered in written translation by Moroccan poets themselves. To this end, I examine the poetry of two *zajali* poets, paying particular attention to the "depth" of emotional valence present in each.

Were affective states reproduced as easily as cuisine, translating performed emotion would be as easy as purchasing the right herbs and ingredients (preferably on site), apprenticing oneself to, in this case, a Moroccan chef, and learning the secrets of measure and gustatory balance. Words, though also a matter of measure and balance, are less easily managed if only because they are referential; a literal rendering of a word–*lemon*, to stay with the gustatory metaphor–resonates differently in English than it does in Moroccan Arabic, where lemons are not only sour, but pickled and salty. The connotations of speech, words and sentences (to say nothing of metaphors, root and other varieties), cannot be

translated literally. This is well known. Each word, phrase, or sentence not only has a referential meaning, but resonates with historical associations both personal and social, the prior contexts of its use (Bakhtin, 1981). Without having lived these histories (or at least inherited them through association), how can a cultural translator unpack or even invoke the sentiment that imbues them?

One answer is to explore the realm of iconicity—how formal resemblance produces sympathetic response. Acknowledging that form and meaning are inseparable means also that affect is embedded in rhythm and sound, and demands that the anthropologist attend to these nuances of style if she is to translate not just the words, but the sentiment or emotional value of a cultural oeuvre. Insofar as emotion is translated through measurable vibration, it is incumbent on the translator to find the chords that produce similar resonance in the two languages. But I also call attention to the partiality of this position. It is a default position (a position at the fault line, slipping; a position of fault/guilt resulting from the lie of translation). For as is well known, affect also resides in the memories that imbue words. And memories reside in the body and in the flesh of words and images.

The Depth of Affect
The two poets examined here have a large following in Morocco. Each is capable of evoking tremendous affective response in their performed readings and in their written work. The adjective applied to them, often with gasps of appreciation, is 'amiq—deep. The poets have the capability of reaching into the cultural soul, so to speak, of their audiences.

Philosopher Sue L. Cataldi notes that the "deeper" the experience of emotion, the more we are felt to be "in" it; "emotional and perceptual depths are intertwined," she says (Cataldi, 1993, p. 2). Emotion has a bodily valence that is expressed metaphorically. This is as true in Moroccan Arabic as in English: tla' li-ya dam, in Moroccan Arabic, "my blood rose up," might be expressed as "I saw red" in English, sa'b l-kabda, "[having a] liver is hard," connotes that the liver, the organ of compassion, causes pain, the equivalent of "heartache" in English.

Emotions always have an object; they are deeply embedded in the social—one is "in love with," "angry at," "delighted by" (Cataldi, 1993, p. 2). "The asymmetry of body and language, of speech and writing—at the threshold of the untranslatable," declares Moroccan author Khatibi (1990, p. 5). A translator of emotion must divine this asymmetry and attempt to reproduce the measure. This is quite different from representing the outer form or sound symbolism of the work—the parallelism, the

rhyme, the meter. It is an internal measure that is here evoked—a depth-meter, gauging the percipient's experience of affect in the body.

In the remainder of this paper I translate time and spatial depth in a genre of oral poetry composed in Moroccan Arabic that is now written as a literary genre and framed in cultural discourse as an icon of difference.

Translating Time Depth

As evidenced in the renaissance of the poetic genre, *al-shafawi* ("the oral")—so easily associated with "time immemorial"—is being inscribed into a particularized history; *al-maktub* ("the written")—in the Arabo-Islamic world, a sacrosanct domain of transcendent authority—is being infused with the irreverence and relativization of popular humor and critique. Among the most vocal proponents of the movement for the canonization of *zajal* in the Moroccan literary realm is Ahmed Lemsyeh, a well-published poet (in classical and in Moroccan Arabic), a long-time socialist, and a member of the Moroccan writers guild (*L'Union marocain des écrivains*). Lemsyeh posits an oedipal relation between classical Arabic and spoken dialect; he compares the dialect to a young bride who is ensorcelled and killed by her jealous cowives, only to turn into a dove that flies above them, making music high above their heads (Lemsyeh, 1992, pp. 7–12). She is life, regenerating, transforming, allusive. For Lemsyeh, the mother tongue is a voice that translates "the [acultural] being." He asserts that he speaks neither in the name of the "people," nor the party, nor the nation, but rather for the rights of the individual.[95] Despite this, the poetry of Lemsyeh overflows with allusion to popular culture; he uses proverbs, song lyrics, and history. His prose is densely weighted in the particular:

I went down in my soul to look for the remains
I found happiness defending spring

I said, a head without a strategy [a trap]
merits decapitation

And I intoned,

Two pigeons singing, they sleep on the palm tops
He who doesn't love beauty, his life is mournful

95 As Lemsyeh asserts, "first of all I am an individual, but the voice that translates my being is *darija*...my voice is Moroccan" (Personal communication to the author, 1995).

He who has a fawn should keep his hand upon it
One hawks his life, another is the pawnbroker.

Lemsyeh begins by going down in his soul (*ruh*), looking for "the remains." What he finds are verses that exist in the oral tradition. The first of the couplets is based on a proverb: *ras bla nashwa qatiya halal*, literally, "a head without fragrance—or passion—its decapitation is permitted," but Lemsyeh changes the words slightly *ras bla nashba y-tsehel l-qatiya*: "a head without a strategy, or a trap [presumably for one's enemies] deserves to be cut off." Here he comments on the necessity to be savvy and alert to the silent battle of those in power ("silence has become their weapon," he says in another line). The second two couplets recall lines from the popular song genre of *l-'alwa*, a genre performed by women that is often associated with the lower classes: *juj hamamat y-ghaniyu, fawq an-nakhla y-batu/ lli ma y'ashq az-zin, y-t'aza fi hiyat-u* and *lli 'and-u shi ghaziyl, y-hat idit-u 'l-ih / wahed y-erhan 'amr-u u l-akhur y-uta lu fi-h*. Using these verses, Lemsyeh cites the "remains" of popular culture, repeating and recycling the oral repertoire into the written work. He thereby infuses the written word—associated with high culture—with the images and metaphors of oral folk performance.

The verses below, for example, play with parallel structures well known in the oral repertoire of marketplace discourse, however, they change the content of the metaphors to reflect a discourse on writing itself:

Words are not the bed and cover
Words are a path and people are letters
words are not true or false
words are a spring whose water encompasses it
paper is a shroud sewn with white
writing enables the eye to see
the robe becomes dotted with life,
its clothes and light, its meaning, are wool.
When you spin it, you find your love around it.
Exchange is rapture, joy, and fear
wear goodness and it means elegance
feather the wind, leave the sky plucked
The paper's blood is mixed with ink
its life doesn't want to stop.
(Lemsyeh, 1994, p. 94)

Compare these verses with the following well-known formulas recorded in the Moroccan marketplace:

l-mra ash ka-t-tsamma?
bir, u r-rajal ka-y-tsamma dlu.
l-mra ka-t-tsamma dwaya, u r-rajal ka-y-tsamma qalim.
l-mra ka-t-tsamma hawd u r-rajal ka-y-tsamma sagiya.
l-mra ka-t-tsamma-a frash u r-rajal aghta.

The woman, what is she called?
A well, and the man is a bucket.
The woman is an ink well and the man a pen.
The woman is called a field and the man, the irrigation.
The woman is called a mattress and the man, a cover.

The density and parody present in Lemsyeh's recycled verses present profound resistance to translation. These verses are woven into time and history, "restricted," in Bernstein's sense of the word (1975),[96] to a particular audience, and enigmatic to another. They are also dense with puns, which, as Bourdieu notes, depend on a shared habitus, a shared past, a notion of collective memory and language.[97] Not only is the language in dialect, however, but it uses regionalisms. Employing dialectal variation in poetry brings the Moroccan reader solidly into difference. Lemsyeh is lobbying for the validation of this difference. He notes (1992, pp. 7–12) that the word for dialect in Moroccan Arabic—*darija*—comes from the triliteral root which means to roll across the surface of something, to circulate like gossip, but also to pass away, to be extinct. The etymology of *zajal*, on the other hand, is related to play and musical entertainment. According to Lemsyeh, Moroccan poetry in dialect expresses a relationship between that which exists and that which is forgotten, because it is ephemeral. Lemsyeh is memorializing an oral/aural

96 Bernstein, 1975. Or rather, a deliberate facing of diversity, inhabiting a devalued form. Like Bernstein's restrictive code, *zajal* "relies greatly on situational context and implicit, local understandings among speakers. It is elliptical, formulaic, and relatively simple in syntactic structure..." Gal, 1989, p. 350.

97 Bourdieu, 1990, p. 57, notes that "If witticisms strike as much by their unpredictability as by their retrospective necessity, the reason is that the *trouvaille* that brings to light long buried resources presupposes a *habitus* that so perfectly possesses the objectively available means of expression that it is possessed by them, so much so that it asserts its freedom from them by realizing the rarest of possibilities that they necessarily imply. The dialectic of meaning of the language and the 'sayings of the tribe' is a particular and particularly significant case of the dialectic between *habitus* and institutions, that is, between two modes of objectification of past history, in which there is constantly created a history that inevitably appears, like witticisms, as both original and inevitable."

world of popular culture that is "passing away" from collective memory by playing with it and inscribing it as written text that nonetheless vies, because of its artistry, with the high and the official. At the same time, he uses these oral formulas to make searing political critiques. *Zajal*, he says, is a "thunderous music," opposed to the aristocratic and serious poetry of classical Arabic, containing the subversive laughter of the lower classes as well as metaphors of the lower bodily strata. Not surprisingly, the translation of this oral genre into written literature has been received as a transgression and, in Lemsyeh's words, has "encountered a ideological stoning and whipping from fervent opponents." At the same time, he says "it has [also] suffered from a different stoning, the stoning of its body (*dhat*) as it struggles with the tribulation of composition and the chaos of vowelization in the [written] language" (*mahna l-'iyagha wa fitna tashk-il b-l-lugha*; Lemsyeh, 1992, p. 8). Here Lemsyeh refers to one of the biggest obstacles in the translation of Moroccan Arabic into written (Arabic) script; namely, the absence of any rules for the vocalization of vocabulary in dialect. Because *zajal* is written without vowels (Arabic being a triliteral-root language whose consonants are marked for vocalization and syntax through the use of diacritics), the interpretative activity of reading becomes forefronted as a matter of course. The reader must struggle with the written utterance and its context; it is a work of engagement with sound and meaning, an active poiesis. Critics of *zajal* say that it must be pronounced, that *zajal* that is not verbally performed is not *zajal* at all. On the other hand, *zajal*'s dependence on its pronunciation (*ntaq*) transforms the act of reading itself, making it synaesthetically deep, a moving experience. Thus, not only does the poetry of Lemsyeh make memories come alive through his use of oral formulas, he requires the active engagement of the reader to *sound it out* from the page to its new life in cultural and written memory.

Translating Spatial Depth

Unlike Lemsyeh, whose poem achieved time depth through the revivifying of old oral forms, long-time *zajali* poet Driss Mesnaoui (an acknowledged influence on Lemsyeh) uses a freer form of poetry, one could say a modernist aesthetic, to evoke emotion in the body of the reader. What is striking about much of his poetry is its compactness, that is, its density and depth (two qualities that Casey, 1987, asserts are characteristic of body memory). The poem below makes reference to a historical figure—Abdelkrim Khatabi, who led the only successful, albeit temporary, resistance against the French in the north of Morocco. Written not long after independence, the poem stands as a banner of postcolonial

poetry. Although its subject is historical, however, bringing the reader back to a recollectable moment in Moroccan history, its images ground the reader in the body, allowing "the past to enter actively into the very present in which our remembering is taking place" (Casey, 1987, p. 168).[98] It is a poem about resistance and, by extension, about the genre of *zajal*.

Muqat'a min sinfoniya riffiya

shrubna az-zham qbal ma-n-dakhlu l-madina
l-ham labasna
u hna labasna jarah sif laghbina
lli kanu fi haya l' l-markab sebhu sfina
lli waldu-na
kla-hum aj-ju'a qbal ma ya-klu-h
lli kabru-na
bal'a-hum l-qbar qbel ma y-hafru-h
lqina as-sum dwa aj-ju'a
u latash shrabu dmu'a
u dmu'a nabtu-l-hum janhin
taru bi-ya
jalu bi-ya
ba'd man-i
qrib man l-bhar
nizlu bi-ya
shrabt hafna man mujat l-fitna
gharqt ana u l-muja f-bhar l-harub
bhal shams qbal l-ghrub
qmut-ni khayt an-nisyan
armat-ni gdam ar-rih farha tmadagh-ni liyam
ana insan?
f-sadr-i jamra ya-kul fi-ha ar-rmad
'la kataf-i shijra y-la'b 'li-ha aj-jrad
ana insan?
ana nasi . . . ana l-gharaq
ana sahi . . . ana l-faiyq

98 Casey also states, "Poets in particular were credited with the ability to intuit the past directly and without any mediation other than their own inspired words. These words not merely depict the past but transport us into it they make us contemporaries of the events described, and their order is the order of these events. As Socrates says to Ion, the rhapsode: When you chant these [verses of Homer], are you in your senses? Or are you carried out of yourself, and does not your soul in ecstacy conceive herself to be engaged in the actions you relate, whether they are in Ithaca, or Troy, or wherever the story puts them?" (Plato, *Ion*, 535 b-c).

mdit 'an-nq-i n-sa'd l-ghareq
l-'amal 'ayn-i u dra'-i
mdit iyd-i n-khayat ar-rqa't an-najma
tal'a man qa'a al-lil
l-ma'fun
n-khayat jald-i l-'adam an-nhar l-maslukh
berriq n-ghsal wajah l-had l-maghbun
al-'amal ayn-i u dra'-i
gult la'la u 'asa tanbat l-l-tayn dra'in u lsun
hfart f-mukh-i ... f-'aruq-i
qalabt f-bhar-i ... f-ham-i ... f-dam-i 'ali-ya
'la shwiya man-i
lqit Abdelkrim Khatabi tal'a ka l-marad man dayra
l-hem
shaq at-trab shaq l-habba
u nzal 'la ad-dafatr
hal iyd-ih u gal "ha l-qabla"
skun-i la'tesh jadid
a'tesh zahra lli l-qatra
a'tash-i ana ma t-sqi-h ghir dik najma l-hamra
jrit ura qatirat an-nda ... ura an-najma
lqit Abdelkrim f-'ayun l-ma f-'aruq ash-shijra
lqit-u mahsud ... mazru'a
lqit-u f-l-bukhar ... f-as-shab ... f-l-muwaj
lqit-u madad ... warqa ... risha ... janhayn ... ta'ir.

"Section of a Country Symphony"

The crowd drank us before we entered the city
Worry, we wore it.
And we wore the wounds of the sword of deceit.
Those who needed a boat became, themselves, a ship.
Those who gave birth to us,
Hunger ate them before they could eat it.
Those who raised us,
The grave swallowed them before they could dig it.
We found fasting the medicine for hunger,
our thirst, quenched with tears.
Wings sprouted from tears
They flew away with me
They wandered with me

far away from myself
and close to the sea
They brought me down.
I drank a handful from a wave of chaos.
I drowned with the wave in a sea of wars
like the sun before it sets.
The bands of forgetfulness swaddled me.
The heels of the wind threw me in the mill
the days chewed me up.
Am I a person?
In my chest is an ember eaten by ashes.
On my shoulders is a tree where crickets play.
Am I a person?
I'm the forgetful one . . . I am the drowned
I'm the inattentive one . . . I am the awakened
I put out my neck to help the drowning,
Hope, my eyes and arms.
I extended my hand to sew the patch of the star
rising from the bottom of the
dirty night.
I sew my skin to the bones of the flayed day
With saliva I'll wash the face of cheated luck.
Hope, my eyes and arms.
I said, it just might be that the buried root will live again
I said, it just might be that arms and tongues will sprout from the clay.
I dug in my brain in my veins
I looked in my sea, in my worries in my blood for myself
for just a bit of myself.
I found Abdelkrim Khatabi rising up like a giant from a vicious circle of care.
He split the ground . . . he split the seed
and he came down on the notebooks.
He opened his hands and said, "Here's the prayer niche"
A new thirst inhabited me
like the flower's thirst for a drop of water.
My thirst can be quenched only by that red star.
I ran behind the dewdrops of night . . . behind the star.
I found Abdelkrim in the spring of water . . . in the roots of the tree
I found him harvested . . . yet planted
I found him in the vapors . . . in the clouds . . . in the waves . . .
I found him . . . ink . . . paper . . . feather . . . wings . . . bird.

The images of embodied affect in this poem are striking. Mesnaoui is talking about his ancestors, their need and suffering during colonial occupation, and about a figure that represented a kind of national savior. The poem is full of metaphoric depth: in wounds; in the image of the body as a ship—concave and containing; in the image of being eaten by a personified hunger and swallowed by a grave, chewed up by the days. Logic is inverted: fasting becomes the "medicine for hunger" and tears quench thirst. Chaos is ingested, drunk from the sea in which the subject drowns. Is he, indeed, a subject? After the body has endured such trials, is one still a person? The protagonist is flayed and sewn to the bones of the day, becoming one flesh with the world. It is in this state of painful communion that he finds hope, in the image of Abdelkrim Khatabi, a giant, splitting the ground, splitting seeds, substituting writing for religion, a "red star" for tears. Like the bodies of the needy, his body also transmutes (he was eventually killed by the French); he becomes part of the landscape, growing up from the earth, in the waters of springs, in clouds, ultimately becoming the ink, the indelible marker of history, that itself transforms to a bird.

Conclusion

The event of a translation, the performance of all translations, is not that they succeed. A translation never succeeds in the pure and absolute sense of the term. Rather, a translation succeeds in promising success, in promising reconciliation. There are translations that don't even manage to promise, but a good translation is one that enacts the performative called a promise with the result that through the translation one sees the coming shape of a possible reconciliation among languages. (Derrida in McDonald, [ed.] 1985, p. 123)

The poets discussed in this paper are all engaged in a translation of emotion—from one language to another, from one modality (written-oral) to another (oral-written). For them, the promise of translation as defined by Jacques Derrida above is an important one; indeed, it is a performative act: the poets perform the promise. They do not celebrate its failures; on the contrary, even the most articulately self-reflexive among them imagines its possibility, just as the mother tongue, refusing to die, soars above its enemies in the form of a dove. The Moroccan essayist and novelist Khatibi, whose oeuvre theorizes and poeticizes the predicament of the bilingual, is inhabited by the desire to translate the limits of the untranslatable, to delineate them and make them recognizable. It is to

that end that I have introduced the notion of depth in the translation of performed emotion. Attending to emotional depth helps measure the limits of the translatable; it affords the translator a location from which to gauge the "thickness" of thick description, the intensity of feeling, and the immanence of the past in the felt body of cultural expression. However metaphoric, the concept of depth reminds the anthropologist to stay close to the perceiving and percipient body, to the flesh of the world, as well as our place in it, when translating cultural expression.

In regarding (or sensing) depth, we take into account the depth not just of metaphor, but depth in time. Thus, in Lemsyeh's poem, memories of the past are revivified by using old popular forms in new contexts. Mesnaoui, on the other hand, discusses the historical past referentially using new metaphors that express depth in the body. The former (time depth) is more resistant to translation, as it relies on a shared emotional-historic schema, a habitus, to which the anthropologist can only be an eternal apprentice. Such resistance, however, points to a juncture of unraveling, a location of encapsulement—in short, a place to dig.

The poets examined here have chosen to write in dialect, but are capable of writing in classical Arabic (indeed, Lemsyeh has established himself as a writer of classical *qasa'id*); they are college educated and urban. Yet they accord the mother tongue a privileged status because it expresses a repertoire of emotions not found in "the language," classical Arabic. Although the "deeper" the emotion, the less accessible it is to translation outside of a restricted audience, identifying *where* the depths lie in cultural expression—whether they are the time depths of history or the spatial depths of bodily memory—brings the anthropologist to the lips, if not the limits, of where cultural texts curl back upon themselves to encapsulate difference. It is because of this depth of bodily memory— the words that inhabit the body and the cultural bodies that create the words—that *zajal* continues to be performed, despite its increasing publication. The depth of the meaning resides, in large part, in the utterance of the words, in their oral performance.

The Political Economy of *Zajal* Performance

Susan Gal (1989, p. 349) has noted that "resistance to dominant representations occurs in two ways: when devalued linguistic strategies and genres are practiced despite denigration, and when these devalued practices propose or embody alternate models of the social world." The case of *zajal* illustrates both of these strategies: it asserts the poetic agility of the mother tongue in a strategic essentialism that elevates the dialect to a code of prestige through its inscription and publication as literature,

and it permits a critique of modernization, urbanization, and hegemony as it is taken up in *performance contexts* by disenchanted youth, spokesmen of political parties, and artists weaving with their natal language. "I want to weave words into images that imagine themselves," says Lemsyeh, "and the loom is the poem." Not surprisingly, few women have set up on this loom of *zajal*: as a poetry in dialect, that is, in a nonprestige language, women (whose artistic status is already insecure) have more to gain from a display of poetic competence in the higher code of classical Arabic than they do in dialect.

My entrée into the world of *zajal* was with an artist struggling to attain social capital in a literary economy that had written him out of the mainstream. It is notable that this *zajali* poet is not college educated as many of the contemporary published poets are, but is largely an autodidact who makes his living as an artisan. Ironically enough, much of his poetry is more esoteric and romantic than political, despite the fact that he and those of his class are the subjects of much politically inspired prose. The last time I saw him was on a city bus. He excitedly pulled a crumpled paper from the pocket of his jeans, reciting his latest poem to me with much aplomb. Although I have yet to translate his poems, I have come to appreciate them as examples of a voice that refuses to be silenced. The creation of the category of artist (as opposed to craftsman), the subsequent marginality of artists, as well as the institutionalization of amateurism, may be seen as a remnant of the excesses of capitalism and specialization. In this, the poet who introduced me to *zajal* is struggling for his own political freedom. He has a message to transmit, and he is savvy about the marketplace of performance.

My own writing about *zajal* is part of that marketplace. All the poets that I have worked with and translated expect me to bring their words to another audience. This added proliferation, or elaboration, of the *zajal* discourse has nothing of the liberatory in it, however. It is just one example, among others, of the multiplication of discourses wherein power and pleasure are not easily severed. It is noteworthy, however, that the move within a culture to particularize a genre through its enunciation and publication in dialect is here inverted into a move to internationalize the same genre, rendering its specificities in exegetical prose instead of poetry and recontextualizing its message for another audience.

8 Gender Challenges to Patriarchy:
 Wannus' *Tuqus al-Isharat wa-l-Tahawalat*
 Sami A. Ofeish

In one of Sa'dallah Wannus' greatest plays *Haflat Samar min Ajil Khamsa Haziran*, ("An Evening of Entertainment for the Fifth of June"), one of the actors shouts intermittently from the theater hall, *Wa haqu allahi inna al-atti li-adha wa 'azam!* ("By God, that which is awaiting us will be quite grave"). The Syrian director 'Ala al-Din Kawkash tells us that it took him many years after 1968, when the play was first performed, to realize the accuracy of these prophetic words; he considered Wannus's prophecy superfluous when he first directed *Haflat Samar* in 1970 and was about to tone it down.[99] In Kawkash's mind at that time, and to those of his generation, the question was baffling—what could be worse than the defeat of June 5, 1967? For that failure of Arab states to defend their territories led to Israeli occupation of new Arab lands in a matter of days, an outcome that was considered of utmost degradation in the Arab world. As a result, major changes in political assumptions, values, and dynamics ensued in the region following the defeat.

Sa'dallah Wannus was a pioneer of contemporary Arab theater. From the late 1960s, his writings significantly contributed to the evolution of political theater. Wannus was born in the village of Hasin al-Bahr, northwestern Syria, in 1941. He studied journalism in Cairo, graduating in 1963, and served later as an editor for arts and culture at the Syrian newspaper *Al-Ba'th* and the Lebanese newspaper, *Al-Safir*, as well as the editor-in-chief of the Syrian children's magazine *Usama*. His interest in theater evolved in the early 1960s, culminating in the publication of his first collection of short plays in 1965. Wannus traveled to France in 1966 where he became acquainted with the various trends and schools of European theater at a crucial stage of its development.

The June 1967 defeat had a great impact not only on Arab politics, but also on the rise and expansion of Arab political theater. Theater's ascendance drew energy from the Arab intellectuals and artists' resentment of their regimes' attempts to shape popular culture, curtail freedom of speech, and disallow critical assessments of society, culture, and authorities. This theater drew on the production of Western pioneers in documentary theater such as Weiss and political dramatists such as Brecht.

99 'Ala al-Din Kawkash. "Jaras al-inzar, fikrah." *Al-Tariq*, 55:1, January–February, 1996, p. 197.

In congruence with the Brechtian tradition, Wannus contributed his first political play *Haflat Samar* to the new theater. This production, with its critical review of the Arab defeat and its causes, had an astounding success in Damascus and Beirut during 1968. As a young man shaken by the 1967 defeat, my first exposure to political theater was through attending *Haflat Samar*. I still remember vividly the great impact of its performance upon a captivated audience in Starco Theater, Beirut, toward the end of 1968. Beirut was then the capital of the new Arab political theater, a role disrupted by the outbreak of the Lebanese Civil War in 1975.

Wannus was interested from his early years of playwriting in promoting cultural productions that address people's needs and aspirations. In this respect, and along with other playwrights, he called for the establishment of an Arab Festival for Theater Arts in Damascus during 1969. Within that festival, he spoke of the need for a "theater of politicization"— a theater that provokes people to think critically and seek change. Along with his calls for transformative political change, Wannus was able to modify his own arguments at different stages of his creative journey.

The underlying goal of politicization was clear in his cultural production since then, including founding *Theatrical Life*, a specialized journal published in Damascus, where Wannus served as its editor for years. He also helped to establish the High Institute for Theater Arts in the late 1970s in Damascus, where he taught. In addition, he was indulgently involved with the "experimental theater" that allows for more effective means in communicating messages relevant to common Arab issues. By using live music, songs, storytelling, and direct conversation with his audience and allowing his actors to improvise on stage, Wannus forcefully engaged his audience and provoked them while in the theater hall to take a stand on the social, moral, and political issues presented in his plays. Among the most powerful plays he wrote in the late 1960s and 1970s in that style we find *Al-Fil ya Malik al-Zaman* ("The Elephant, the King of All Times," 1969), *Mughamarat Rais al-Mamluk Jabir* ("The Adventure of Jaber's Head," 1970), and *Al-Malik Huwa al-Malik* ("The King Is the King," 1977).

In the aftermath of the Israeli invasion of Lebanon, which began in June (again!) of 1982, Wannus ceased writing plays for almost a decade. Alarmed by the dominant state of confusion and despair as well as the general sense of defeat in the Arab world, he went through a process of reexamining his assumptions and methods for achieving change, including the politicizing role of theater. Wannus did not retreat from political themes, but his vision, methods, and emphasis shifted to a certain extent.

In two interviews published in 1996 and 1997, he suggests that theater is weakened by a number of factors, including primarily the universal advent of audiovisual entertainment and commercial art as well as restrictions placed on an active civil society in the Arab world. Although he is interested to see theater rebound from these constraints, drama should avoid preaching packaged ideas and shiny slogans. In a self-critique, he admits that initiating change in society is a very complex phenomenon that requires much more than mere attempts to overpower the state. For example, many coups d'etat in the Arab world ran short of initiating change. He also points out that his past emphasis on understanding history and its progress had led him to unintentionally overlook personal suffering and the issues of the individual in his writings.[100] This shift in emphasis was clear in the plays he wrote after 1982, which were no less political than their predecessors. These plays include *Al-Ightisab*, ("The Rape," 1990), *Munamnamat Tarikhiya*, ("Fragments from History," 1994), *Yawm min Zamanina*, ("A Day of Our Time," 1995), *Malhamat al-Sarab* ("The Epic of Mirage," 1996), and *Al-Ayam al-Makhmura* ("The Drunken Days," 1997). Wannus, diagnosed with cancer in 1992, died on May 15, 1997.

Tuqus al-Isharat wa-l-Tahawalat ("Rituals of Signs and Transformations"), published in 1994 and first performed in late 1996 in Beirut, is an elaborate example of his theatrical focus in the second stage of his career. The issues of gender and patriarchy and, to a lesser extent, masculinity and sexual orientations are forthrightly addressed. Many of the characters make choices based on their interests as individuals.

We nonetheless find two typically Wannusian themes present, even dominant, throughout this play: the first theme is associated with a powerful critique of authority, showing both its complexity and affects, and the second theme entails a steady exploration of the process of change along with many of its intricacies and signals (or *al-isharat*, "signs").

In the introduction to the play, Wannus attracts the reader's attention to three major points that should be taken into consideration for a better understanding of *Tuqus*. He insists first that the play's characters should be appreciated as individuals with social and psychological constructions who are tormented by the choices they encounter, rather than machinelike functionaries who are limited by the interests of their institutions. I believe he is warning us here against stereotyping the roles of major characters as, for example, representatives of religious vs. civic vs.

100 "Hiwar Wannus 'an Kitabatihi al-Jadida," interview by Marie Elias, in *Al-Tariq*, 55:1, January–February, 1996, pp. 96–104; "*Madha ya'ni al-masrah al-'an*," interview with Wannus by Marie Elias in *Al-Tariq*, 56:3, May–June, 1997, pp. 5–24.

state institutions. He would like us to emphasize instead the inner dynamics of individuals and their choices.

Secondly, he suggests that although the play's events are set in Damascus during the second half of the nineteenth century, space and time here are symbolic and unconfined. Thirdly, he states that his aim in writing *Tuqus* is to raise contemporary questions and address issues that he believes are timely and regenerated. Among the issues that Wannus presents is a sweeping critique of gender relations and patriarchy during a period of change.

Tuqus is divided into two parts. The first part, entitled *Al-Makayid* ("Schemes"), includes eight scenes, and the second part *Al-Masayir* ("Destinies") includes 17 scenes. The play starts with two initial subplots. The first is caused by a growing dispute among the elite of the city, between 'Abd Allah, *naqib al-ashraf*, and the Mufti.[101] As a result, the chief of police, tipped off by the Mufti's men, invades 'Abd Allah's privacy while he is drinking, singing, and dancing with his mistress, Warda. The chief arrests them and parades them, 'Abd Allah still partly undressed, on the back of a mule through the city.

The humiliation of 'Abd Allah creates a wider rift between the *ashraf* (elite class) and the Mufti. The Mufti tries to diffuse the city's growing tensions by facilitating 'Abd Allah's release. So the Mufti hatches the second scheme: Mu'mina, 'Abd Allah's wife, replaces his mistress in jail, a move that invalidates the police chief's case against 'Abd Allah. When the Mufti calls upon Mu'mina to join in the scheme, she agrees to participate in return for the Mufti's support in helping her obtain a divorce. During this period in Syria, divorce for women was quite uncommon, and it was granted on very limited grounds under Hanafi law. In addition, society strongly discouraged divorce, and divorced women were socially marginalized or discredited in many cases.

Mu'mina took advantage of the Mufti's need for her assistance to gain his help in breaking away from a failing marriage. Mu'mina's plan is the turning point in the play, leading to a spiral of events that are in fact *adha wa 'azam* ("quite grave," as the actor had shouted in *Haflat Samar*) in terms of their significance and impact. The initial event, the arrest and humiliation of 'Abd Allah and Warda, soon recedes into the background.

In the second scene of *Al-Masayir*'s segment of the play, Mu'mina pays Warda a visit in her brothel, asking for her guidance and help, as

101 *Naqib al-ashraf* is the marshal (*naqib*) of those who claim descent from the Prophet, the *ashraf* being a privileged group commonly present in many cities during the Ottoman Period. *Mufti* is the title of the leading Sunni religious authority in the city.

she wishes to become a prostitute. Warda, stunned and perplexed by the request, rejects Mu'mina's arrogance in taking such a course of action so lightly. After all, Warda believes that oppressive circumstances rather than choice are the predetermining factors for prostitution.

Upon Mu'mina's insistence, Warda finally obliges her and leads her in a joyful rite of passage that also includes the selection of a new name Almaza. Thus, Mu'mina, denoting a "believer," changes to Almaza, signifying "diamond," a shiny precious stone that can attract many viewers.

Mu'mina/Almaza's decision to terminate her marriage and move to the brothel was a major leap in her quest for freedom. Her relationship to 'Abd Allah was "no more than a marriage," as she tells him when they met in prison. It was a life full of uncertainty and confusion, and she agonized between two choices: whether to stay bound to her marriage or to slip into "temptation" and go over the edge. Thus, when the Mufti calls on her to replace Warda in prison, she resists, thinking of the consequences of such action. She knew that the opportunity to bargain for the Mufti's support to gain her divorce was then at hand—she warns the startled Mufti that he is pushing her into a "dangerous slope." And when 'Abd Allah apologizes to her for his affair with Warda, she responds that she is jealous of prostitutes who can dance without constraints and set their bodies free. Mu'mina/Almaza was already searching for control over her own body and her sexuality.

Mu'mina utilized a moment of contested power among the elite, a weak link in a dominant patriarchal system, to terminate her marriage. Almaza's choice of freedom via sexual freedom was a major step towards shaking the foundations of that system. Simply put, Almaza upsets the rules of the patriarchal system as she slips out of its control. These rules suggest that women should not achieve independence, freedom of choice on crucial matters like divorce, and control over their sexuality. Preservation of these rules is men's domain, and any challenge to the systemic principles should be dealt with strictly. In addition, her unexpected challenge to patriarchal control was highly visible due to her upper-class lineage, high-status marriage, and learned background.

Several of the elite are interested in Almaza, including the Wali ("governor") and the Mufti, along with some merchants. She becomes a celebrity. New fragrances, jewelry, silk products, even the highest quality tea are now named after her. To avoid a breakdown of patriarchal control, other members of the elite rush to rein her in. Their efforts are careful, gradual, and systematic.

The first step aims at applying pressure on the decision makers to deal with Almaza. Two merchants, who acted throughout the play as

defenders of the status quo and ideologues of a dominant male perspective, visit the Mufti calling for more decisiveness in Almaza's case.

The Mufti is torn between two choices. On one hand, there are his strong feelings of attraction toward Almaza, and on the other hand, his credibility as the most dominant community leader and its "moral guardian" is placed in check. The Mufti then proposes marriage to Almaza with the claim that he is "rescuing her from the pit that she is falling into," but she declines his offer.

The desperate Mufti then moves to introduce new regulations that ban both female and male prostitution, the production of any items named after Almaza, nonreligious books, alcohol, singing, and dancing. The Wali, who also has an amorous interest in Almaza, rushes to protect her and diffuse the resulting tensions by declaring his support for these sanctions, but delaying their implementation.

When Almaza's father, the "pious elder," also intervenes to control her in the name of family honor, she fires back by crediting him for her early sexual awareness, triggered by his invasive scrutiny that followed her from room to room in their home. Almaza reminds him also that her heightened sexual desire is a product of the lascivious environment that he together with his older son had created in their home. She then confronts him with a charge of raping the young girls who had served in his household, including Warda who was then driven into prostitution.

In association with Almaza's continuous defiance, and the growing challenge to the patriarchal system, Wannus addresses three related issues: homosexuality, the construction of shame, and masculinity.

The weakening of patriarchy had allowed for more open acknowledgment of homosexuality in discussions among the Mufti's goons, Abbas and Afsah. But Abbas soon ends his relationship with his lover Afsah, because Afsah tried to "shame him" by "coming out." However, Abbas is simultaneously working for Almaza as her manager and protector or, let us say, her pimp. When Abbas is asked about his "shameful role" as a pimp, he wonders why should that be shameful if the respected and "moral" leaders of the community (like the Wali or the Mufti) are all interested in Almaza? This also suggests a very complex and selective social construction of shame that is aimed primarily at female rather than male behavior.

It is interesting to note the variant social constructions of masculinity in this play. In both the cases of Abbas and Almaza's brother, Safwan, the construction of masculinity is exclusively associated with a display of the ability to control women, and in both cases it reinforces the patriarchal system. For Abbas, it is acceptable to be privately engaged in a

homosexual relationship, since his masculinity is validated not only in being a goon, but also by pimping for Almaza. For Safwan, who is ridiculed by his father, who calls him a spoiled kid, shouting for his sister's death validates his masculinity.

Some of those who made individual choices paid dearly for its price. The Mufti, haunted by his love for Almaza, sleeps with her, and then retracts all his sanctions. But his retraction does not prevent Safwan from proving his manhood by killing his sister. And Afsah, saddened by Abbas' mistreatment of him, by his social position after "coming out," and his abhorrence of the dominant hypocritical social values, commits suicide.

In one of the play's final scenes, immediately after the Mufti retracts his sanctions and his leadership weakens, one of his goons calls on Abbas for a joint authoritarian takeover to stop the "deterioration" of society. This call is reminiscent of many military coups d'etat in the Arab world and elsewhere. The takeover is necessary for defenders of the status quo, for the deaths of Almaza and Afsah alone do not guarantee the recovery of the patriarchal system. Once again, masculine and patriarchal control must be reproduced and maintained by force.

Tuqus concerns the transformations triggered by a woman's rebellion. Almaza's choice of liberation, her challenges of various authorities had shocked and threatened masculine and patriarchal dominance. Major characters make individual choices in the subsequent unfolding events, some aiming at protecting the status quo from collapse, but others divert significantly from their expected roles. As such, the play shows the complexity of individual personalities. Their wills, determination, and judgments contrast in many cases with traditional stereotypes of human behavior. Complexity moves us back to Wannus' proposition in the play's introduction to dislodge any illusions that its characters are machinelike functionaries bound by their institutional roles. After all, as director Nidal al-Ashkar suggested while preparing for the play's first performance, this play "constitutes a dancing game of masks falling one after the other."[102]

Wannus shows how Almaza's moves constituted the ultimate challenge to masculine authority on individual, communal, and state levels. She defied her father and brothers, "shamed" the *ashraf* and merchant classes, created jealousy and tensions among leaders, secular and religious alike, and shook the public perceptions of traditional gender stereotypes. Her moves not only created a strong impetus for women's liberation, but also opened up a Pandora's box of social transformations. A woman's actions

102 Marie Elias, "*Ba'da al-qira'a wa-qabla al-tadribat: madinat Sa'dallah Wannus 'ala Masrah al-Madina.*" *Al-Tariq*, 55:1, January–February, 1996, p. 163.

became the focal point in the city's life. Warda and Almaza bonded with each other regardless of their different class backgrounds and they shared repressed memories of male violations that affected their lives deeply. Homosexuals also challenged patriarchal control by openly revealing themselves. And a breakdown in elite cohesion ensued.

One of the most intriguing effects of *Tuqus* has to do with the fundamental questions it provokes regarding the nature and outcome of attempts for change. The text also allows for different readings of events and their consequences.

For example, a set of questions could be raised regarding whether individual choices were beneficial to the characters in the context of change.[103] Can individuals' choices actually facilitate their goals and under what conditions? Or would collective efforts be more effective in achieving their aims? We have already stated that Almaza's choices, for example, undermined a patriarchal society. She was successful in separating herself from her husband and in self-delineating her sexuality. Yet she was physically eliminated at the height of her rebellion. Both her "success" and "failure" could be interpreted as directly associated with her individualistic efforts and upper-class status. Her upper-class background had facilitated her willingness to bargain for divorce and sexual liberation at first, but her class-based visibility also led to the concerted patriarchal effort to overpower her.

Another set of questions could be raised in association with the intended versus actual outcomes of individual choices. For example, did Mu'mina-turned-Almaza achieve her freedom as a result of her decisions? Her initial move to control her sexuality through divorce had undoubtedly liberated her, but did she continue to preserve her freedom after joining the brothel? (Is a prostitute sexually free if she depends on sex for income?) On the one hand, it could be argued that Almaza had in fact achieved her individual freedom, regardless of the consequences. This accomplishment could be exemplified by her control over her body and sexuality and her success in moving toward the public domain. On the other hand, it could be argued that her move to the brothel had in fact supported a male-oriented service institution and reinforced the patriarchal system as a result.

The play was very well received in Beirut, when it was first performed in 1996, and subsequently in other Arab countries. It was also video-taped and shown on television in Lebanon. According to critic Zahi

103 In similar fashion, Mahmud Nassim eloquently addresses the progress or defeat of individualism in *Tuqus*, in "*Al-Tuqus wa al-Isharat: su'al al-fardiya am indiharuha? wa madha ba'd al-haffa.*" in *Al-Tariq*, 55:1, January–February, 1996, pp. 166–177.

Wehbe, Wannus, who was well known for being liberal in allowing those who direct his plays their own input and approaches, was satisfied with al-Ashkar's approach and style of directing *Tuqus*.[104] The play's first performance in Beirut was seen as an indication of the capital's postwar return to its leading regional cultural role. In Beirut and other Arab cities, *Tuqus*, which is both entertaining and serious, was perceived to be daring in addressing issues of gender, patriarchy, and homosexuality and in defending the relevance of personal choices.

Elias Khoury notes that, unlike any other modern Arabic text, Wannus had reached a shocking climax in *Tuqus*, after delving deep into explorations of the human psyche along with its complex makeup.[105] By allowing Mu'mina to turn into Almaza in search of her self and her sexual freedom, Wannus was not only successful in upsetting societal values and structures, but also forcefully moved issues of gender and patriarchy from the private to the public domain. This move is ultimately irreversible as Almaza tells her brother as he comes to kill her: "Safwan, I am a story. And the story cannot be assassinated. I am an aberration, lust, and temptation. Daggers cannot kill aberrations, lust, or temptations."

There is no doubt, as Wannus brilliantly shows us, that Almaza's decision to liberate herself was a breakthrough and should be understood as part of a more comprehensive attempt for change that weakens patriarchal dominance. Thus, Wannus' comprehensive critique of patriarchal dominance in *Tuqus* also suggests that if we do not comprehend the signs and accommodate social transformations, then what is *adha wa 'azam* will indeed arrive.

104 Zahi Wehbe, "Al-Tahawalat fi al-Nass li-Tusib Ma'zaq al-Awda' wa-Hina Yasdur al-Ghina' innama Taddad al-Ma'ani," *Al-Nahar*, November 20, 1999, p. 21.
105 Elias Khoury, "Sa'dallah Wannus: Haffat al-Hawiya," *Al-Nahar: Al Mulhaq al-Thaqafi*, January 14, 1995, p. 19.

9 From Cultural Authenticity to Social Relevance: The Plays of Amin al-Rihani, Kahlil Gibran, and Karim Alrawi
Rashad Rida

At a reception to honor playwright Karim Alrawi whose play *A Gift of Glory*, subtitled *Edsel Ford and the Diego Rivera Murals at the Detroit Institute of Arts*, at Meadow Brook Theatre in Michigan, Salvador Monroy, the Mexican Consul General in Detroit, spoke admiringly of Alrawi's ability to transcend cultural differences and to present a portrayal of the Mexican painter Diego Rivera that was every bit as real to a Hispanic audience as his portrayal of Edsel Ford was real to an American one.[106] It is this ability to effectively situate and reconstruct the individual in a social and cultural context that has remained an enduring quality of the work of Alrawi (Carlson, 1993a). It also heralds the maturity of Arab-American playwriting and its release from the limiting perspective of the need to maintain cultural authenticity that often besets writers in the Arab world and in the Arab diaspora. Alrawi's plays transcend that perspective by a process of rethinking what it means to develop socially relevant theater.

This rethinking is not an abandonment of cultural origins, as some have claimed,[107] but an inclusiveness that is an exploration of what different communities have in common. It is an opening out of the diaspora viewpoint to include all who have reason to feel excluded from the mainstream of American society. It is a far cry in both subject matter and sentiment from the plays of the founding literary figures of the Arab-American community, Amin al-Rihani and Kahlil Gibran. As such, it is a rethinking that bears analysis and interrogation. Debate in the Arab world on Alrawi's plays has often taken the form of questioning his authenticity as an Arab writer and his choice of perspective on the subjects he has written about (Eysselinck, 1994). Significantly, the meaning of authenticity is never delved into, nor is the validity of using such a term for literary criticism purposes ever questioned.

A positive appraisal of Alrawi's plays using this ill-defined notion of authenticity is found in an early study prepared by Sabri

106 Speech given at a reception held at Meadow Brook Art Gallery on Saturday, March 27, 1999.
107 See Amir al-Amry, in *Al-Quds al 'Arabi*, May 17, 1991; and in *Adab wa Naqd*, August,1991; Ibrahim Essa in *Ruz al-Yusuf*, September 30, 1991, as well as Nasri Hajjaj in *Adab wa Naqd*, October, 1991.

Hafez.[108] The same critic was also responsible for an extremely negative appraisal of Alrawi's work some years later proceeding from the same starting point of authenticity,[109] thus proving the elasticity of the concept and its weakness as a critical tool. Such concepts represent a limiting approach to the work of such a prolific, accomplished, and complex playwright as Alrawi.

Studies that start from preconceived notions of cultural authenticity seem to ignore the obvious, which is that writers express themselves as they must and in response to current realities. Such expression is every writer's creative license and it is not open to question. Approaching a literary work with preconceived notions, inappropriately imported from the realms of political discourse, leads inevitably to censorship. Censorship is not the function of criticism; achieving some understanding of the complexity and depth of the creative product is. A literary work has to be approached, in the first place, on its own terms. It must also be granted that a writer's subject matter and means of expression can sometimes be read as more than personal choice. For there are times when such literary output can be seen to mark the stages of passage of a community's self-expression from reticence to self-assurance and from cultural narcissism to universal relevance. These are the qualities that deserve analysis rather than uncritical notions of cultural authenticity that are ill defined and largely bogus. Even so, issues of authenticity are important to Alrawi in the sense in which he reinterprets the word. It is his sense of what is genuine authenticity that marks him out as a singularly important writer.

So as not to use the term uncritically, we should reflect for a moment on what authenticity entails, in the sense that a literary critic may legitimately use the term. Within those parameters, authenticity is an articulation of a sense of belonging to a group and a place, maybe even an expression of being. It is a conservative term implying allegiance to what is already there. It means basing oneself on tradition and custom. It implies adapting oneself to a preexisting mold. It is a dependence on the past to give meaning to the present. As such, there is much in Alrawi's recently produced American plays that is relevant to a discussion of authenticity in the theater. Before we uncover his interrogation of the concept, we will review the theater of his Arab-American predecessors including that of Amin al-Rihani.

108 See Sabri Hafez, "Karim Alrawi: Katib Masri fi al-Masrah al-Inglizi," *Asfar*, 536 (1985), pp. 165–175.
109 Sabri Hafez in *Al-Arab*, May 14, 1991, and May 21, 1991.

Amin al-Rihani: The Philosopher of Freike

Born in Freike, Lebanon, on November 24, 1876, Amin al-Rihani was one of six children and the oldest son of a raw silk manufacturer, then a flourishing local industry. His father had commercial ambitions that led him to the United States.

Young Amin, then 12 years old, was placed in a school in the State of New York, just outside the city of New York. Later, he was taken out of school to become the chief clerk, interpreter, and bookkeeper of his father's business.

During this period, Amin developed a love for reading. In 1895, he joined a theatrical touring company. During the summer of that year, the troupe became stranded in Kansas City, and the prodigal son returned home to his father, chastened but far from repentant. Amin set aside his theatrical ambitions to study law. He passed the regent's exam, and in 1897 entered the New York Law School. A lung infection interrupted his studies and he had to return to Lebanon, where he taught English for a couple of years in a clerical school.

Al-Rihani returned to New York in 1899 where he joined the Poetry Society of America and the Pleiades Club and became a regular contributor to the Arabic-language press. His literary career is usually dated from his *fin de siècle* return to the New World. After a distinguished, productive and high-profile career, mainly as a political commentator and advisor, al-Rihani died on September 13, 1940, at the age of sixty-four in his hometown of Freike.

The Philosopher of Freike, as he was dubbed by the Arab press, was a prolific writer in both English and Arabic, whose range of publications covered fiction, poetry, and stage plays, as well as political and social essays. He was also an accomplished public speaker. His importance as a seminal figure in the Arab-American literary scene was officially recognized by the granting of awards during his lifetime and posthumously by the renaming of streets and schools in his honor in Lebanon and Syria.

In the following discussion of his work I will confine myself to his published plays (al-Rihani, 1989), which are all in Arabic, and their significance for a contemporary theater.

From Allegory to Political Commentary: al-Rihani's Protoplays

By far the longest and most substantial of al-Rihani's dialogue-based works is his *Al-Muhalafa al-Thulathiya fi al-Mamlaka al-Hayawaniya.* This title can be translated as "The Triple Alliance in the Kingdom of the Animals." This allegorical play was written by al-Rihani when he was twenty-seven years old and published in 1903 by al-Huda, an Arab pub-

lishing house in New York. As with most of al-Rihani's work, this play should be read as an address by an Arab-American writer to his compatriots of the diaspora about issues relevant to life back in the towns and villages of Lebanon and Syria.

The play opens with a long prose introduction that is neither stage direction nor a monologue for an actor addressing an audience. Instead, it is a prose narrative for a reader who does not appear on stage. The language is classical and stilted without any attempt to ease its expression and make it stageworthy. Unlike his near contemporary Tawfiq al-Hakim, al-Rihani's stage dialogue makes no concession to the needs of the actor to articulate a language that is clear and easy to speak while also being accessible to the general theater-going public. Al-Hakim's concern with developing a "third language," as he called his experiments towards a stage language, was never a consideration for al-Rihani.

Another factor that betrays al-Rihani's intention to write a prose story with dialogue, rather than a real stage play, is the large and undefined number of cast members in the form of animal servants and hangers-on. Another impediment to performance are the many long speeches spoken by the various animal characters that continue for several closely printed pages. Especially laborious is the character of the horse, who is prone to stream of consciousness speeches that are as tedious as they are long-winded. That such verbosity was intentional on the part of al-Rihani, as a reflection of the animal's boorish character, is not in doubt. Its effect on an audience, though, cannot be in doubt either—these are not stageworthy speeches—this dialogue can only be read, not performed.

Given al-Rihani's experience as an actor for a touring company, we can safely assume that he never intended that this play be produced, nor could he ever have considered it to be a play in anything but name. Al-Rihani was well aware of what it takes to turn the written word into acceptable stage dialogue. He must have known the formal relationships between the various parts of a play script, and the correct relationship between stage directions and character dialogue. If one were to read this play not as a stage play but more along the lines of Tawfiq al-Hakim's advice for reading some of his own scripts—as plays for the mind and not for the stage—then we can better appreciate al-Rihani's intentions with this piece.

The correct response, therefore, is to dispense with the formal issues of whether this is really a play with a dramatic conception and plot and how would one stage it if it were. Instead, the story needs to be approached as a parable that is written partly in dialogue form. Only then can we get a sense of what al-Rihani was attempting.

The use of animal characters allows al-Rihani to select and emphasize traits for the various professions represented in this story. For example, the priests are stubborn mules, while the students are quick-witted foxes. The traits of stubbornness or smartness are then fixed from the start and remain unchanged through the course of the story. Character development is clearly not a factor in the unfolding of this story.

The climax of the story is the trial of the fox on a charge of blasphemy. The question that he is forced to answer to is, "Are you of the creed of the Lion?" This was a charge to be echoed many years later by the U.S. Senate's Committee for Un-American Activities, "Are you or have you ever been a Communist?" The flavor of all inquisitions remains the same regardless of the time and place.

The fox's defense is to cite Darwin's theory of the evolution of species. As a result, he is tortured and returned to the animal courtroom to face further questioning. At times his answers to the judges echoes those of Christ in the New Testament. The trial concludes with the fox's condemnation to death and execution. Despite the Christian overtones to the dialogue and some of the arguments, the play is more a Nietzchian parable than a Christian one. The allegory is an attack on ignorance and stupidity as personified by the Eastern churches. Their dogma is ridiculed and their methods mocked as bestial responses to rational argument. The fox is clearly a martyr for reason in a world of oppressive irrationality. That this play gave offense cannot be doubted. It was meant to. It shows a young writer of bold imagination with a strong social conscience whose literary skills are still at a rudimentary stage of development.

Al-Rihani continued to divide some of his prose work into what he called scenes and to intersperse the narrative with long stretches of dialogue. This is particularly evident in his *Kharij al-Harim*, which may be translated as "Beyond the Harim." This "beyond" is a dream of female emancipation and freedom. The novel is divided into 16 scenes and recounts the adventures of a young woman by the name of Jehan from her dreams of freedom to her execution for the murder of a European army general. The story is a plea for liberation of the Arabs from foreign domination as well as for female emancipation. Once again, despite the terminology and the reliance on dialogue, this is not a stage play in any meaningful sense of the word. At best, this and the previous work, *Al-Muhalafa*, can be referred to as protoplays. This term is equally applicable to two other works by al-Rihani, which reflect his growing mastery of stagecraft.

The first of these two works is *Abd al-Hamid fi Sijn al-Istanbul*, ("Abdul Hamid in the Istanbul Prison"). The Abd al-Hamid referred to here is the Sultan Abd al-Hamid II of Turkey who was deposed by the

movement of the Young Turks in favor of a constitutional government. This short play is in three scenes. The first is set in a prison where the prisoners, mainly common criminals, discuss the fact that Sultan Abd al-Hamid has been deposed. They question whether he should be held under house arrest, as he actually was, or whether he should be in prison with them. At the end of the scene, Haydar Pasha throws off his prison garb to reveal his true identity and the prison walls fall away. But the persona of Haydar Pasha is never explained to the reader—somehow we are supposed to know who he is.

The next scene places us with Abd al-Hamid under palatial house arrest. He is visited by the ghost of Haydar Pasha, who incites the ghosts of the other prisoners to attack the deposed Sultan Abd al-Hamid. The final scene is set in the same location as the previous one and shows Abd al-Hamid racked with guilt and remorse for his past evil behavior and in fear of being the subject of revenge by those he has wronged. One can only assume that the second scene was meant to be a nightmare and possibly the first one was too.

Though the date of authorship is uncertain the play reads as a commentary on recent political events. We can therefore favor a date sometime before the outbreak of the World War I. Because it is so intrinisically based on a recent historical event, the play suffers from being too closely tied to its topic. It is difficult to escape the conclusion that the audience would have had to have been steeped in the news coming out of Turkey to have been sufficiently aware of who all the named characters are and what the significance is of most of the references. This criticism does not invalidate the script. It does, however, explain its limitations and its inaccessibility to a contemporary audience.

From a technical standpoint, we can say there is little in the way of psychological depth to the characterizations and almost nothing in the way of plot. The summary given above encapsulates the whole story, and Abd al-Hamid's remorseful speech takes up the whole of the third scene. The political sentiments of the author are the single dominant thought in the play and they dominate to the detriment of any characterization. So clearly are al-Rihani's feelings set out that the script is totally lacking in any conflict or drama. At no point does the script allow for Abd al-Hamid to have been anything but a bad man who, now that he is about to face death, realizes the evil of his ways.

In 1934 al-Rihani returned to writing a stage play. This time he was writing for the Firdawsi Festival in Iran. The play *Wafa' al-Zaman* ("The Fidelity of Time") was published with extensive notes on who al-Firdawsi was and his significance as a poet. In two acts and 12 scenes

we are given an account of how and why al-Firdawsi composed the *Shahnameh*, the poetic epic of Iran's kings.

The play opens with al-Firdawsi with the Persian sultan in his palace. There he strikes a bargain to write in verse the *Shahnameh* in return for a considerable amount of gold. But once al-Firdawsi departs to collect the stories and compose the poetry, the sultan is persuaded to retract his promise. When al-Firdawsi contacts the sultan for his payment, he is cheated and paid in silver. This angers the poet who returns the money and lives the rest of his life in poverty. He dies just as the sultan feels remorse for his actions. In the last scene Father Time delivers the final sermon. He informs us that whereas the Sultan did not keep his promise, he—Time—has, because in the 1,000 years since al-Firdawsi's death, his fame has grown.

Once again the characters show no growth during the course of the play. None of them seem to have learned anything by their encounters with each other. The plot is simple and there is no subplot to speak of.

A common theme in both these plays is the remorse felt by the rich and powerful when it is already too late. There is no dramatic conflict in either script, only positions taken by the characters that do not interact and cause change. If we are to sum up al-Rihani's worldview from his plays, we would have to say that it is one of naïve romanticism where sentiment rules over reason and where conflicting positions never actually clash and result in change. It is a static worldview where contradictory positions coexist and rub shoulders side by side. These plays reflect the world of authenticity, where being and belonging are preset molds into which all the characters fit. These molds are obvious and easily identifiable and remain unchanging and unchangeable throughout the course of the play.

Kahlil Gibran: The Spiritual Rebel
Gibran Kahlil Gibran's life shows a similar pattern during his early years of immigration and return to his homeland to that of al-Rihani, his near contemporary. In 1895, at the age of 12, he moved with his family to Boston only to be sent back to Lebanon three years later where he attended Madrasat al-Hikma until 1901. After a two-year stay in Paris he returned to the United States. Shortly after, he published *Spirits Rebellious*, which, much like al-Rihani's *Muhalafa*, resulted in widespread denunciation by the Maronite Church with threats of excommunication. Gibran's response was to claim that he abhorred manmade laws and stale tradition in favor of God's laws and the Spirit of Truth.

Gibran continued to write, his command of the English language

growing to the point that he developed a distinctive and highly poetic style. His prose writings do not fit easily into any particular genre. A work like *The Prophet* is neither a novel nor an instructional essay. It shares a style with Nietzsche's *Thus Spoke Zarathustra*, but is not an iconoclastic work in the same manner. Rather than endorsing Nietzsche's position that God is dead, it appears to say, on the contrary, that he is alive and well and speaks to us all if only we are willing to listen.

In 1929, when he was 46 years old, Gibran wrote *Lazarus and His Beloved*. This was his first and only stage play. It was also one of the last things he wrote. On April 10, 1931, he died of cirrhosis of the liver with complications caused by incipient tuberculosis.

Lazarus and His Beloved

The *beloved* in the title is Jesus who, as set out in the Gospel of John (9:40-44), raised Lazarus from the dead. The capitalization of the "H" in the title is therefore significant, in that it stresses that Jesus is also the beloved of God.

The play depicts Lazarus after his raising from the dead consumed him with feelings of estrangement from his own family and longing for union with God. His death had been a moment in which he had been lost in the vast infinity of the Absolute. The love that is God had consumed his very being. The raising from the dead had been anything but welcome. He is now lost in a world where men and women are distinct from the Absolute. He yearns for a chance to return to death. His mother and his two sisters cannot understand this longing. A madman sits alone watching the family and acts like a chorus commenting on their thoughts and words. Finally, with the appearance of Philip, a disciple of Jesus, who tells him that Jesus has risen, Lazarus is free to flee to the darkness of the hills where he knows death is awaiting him.

Gibran's language in this short play is rich with symbolism and meaning. His plot is well constructed and the conflicts between the characters well structured. Nevertheless, he shares with al-Rihani a romantic point of view where sentiment rules over reason and character is fixed and unchanging. Conflict in the play is purely verbal, felt rather than demonstrated in actions. Yet there can be no denying the beauty and passion of Gibran's writing. The spiritual message is clear and moving. If any play can be said to mark the beginning of an Arab-American theater it is this play.

Lazarus and His Beloved raises the issue of what is meant by the designation "Arab-American" in this context. It must be admitted that the term is vague at best. For it to be meaningful, it must signify more than

plays written by someone whose ethnicity is Arab and who lives in America. It must involve a perspective that is in some meaningful way affected by Arab culture. Without a doubt *Lazarus and His Beloved* is like a beam of light refracted through a prism comprising a value system of *hikma*, or spiritual understanding, and the heritage of the Arabic language, with its richness of style and its tradition of poetic prose. Gibran's great art is his mastery of both the style of Arabic prose and the idioms of the English language, while creating a tension between the two that runs through all of his best works.

Al-Rihani's plays, for all of their advocacy of liberal points of view, are very much within the bounds of traditional conservative Arab writing. Characters are statically defined by stereotype and are cast into literary molds that are outdated and too rigid for their content. With Gibran the spirit has been set free from the outmoded forms, but the preoccupations are still much those of a rebel against the rigidity of the Eastern churches. That his work struck chords with American readers results from their reading into his poetic prose their own longing for a spirituality lacking in their world. In some ways, it is to Gibran's good fortune that his religious rebelliousness coincided with America's return to religion. What this has done is give a conservative reading to his work that is far from his initial literary intentions.

Alrawi: Authenticity and the Search for Social Relevance

Karim Alrawi was born in Egypt and received his higher education in England. He has been working in the United States since 1991 when he was International Guest Artist at the University of Iowa (see Carlson, 1993b). Since then he has taught at several North American universities and has worked at a number of theater companies. He is currently Playwright-in-Residence at Meadow Brook Theatre, Michigan's largest not-for-profit theater company, where several of his plays have been successfully produced. He is currently the editor-in-chief of *Arabica* magazine.

Before moving to the United States from the United Kingdom, Alrawi had established himself as one of the leading voices of his generation of playwrights.[110] His play, *Migrations*, was thus described by Malcolm Hay in *Time Out* magazine: "Like *Look Back in Anger*, this is a seminal work because it articulates the fears and frustrations of one segment of the younger generation which, against all the odds, still cares enough about our society to attack it" (Malcolm Hay quoted in Eysselinck, 1994). This is high praise indeed from the leading British entertainment magazine.

110 Sabri Hafez, n. 108 supra.

In 1994 Alrawi moved to Canada before returning, once again in 1996, to the United States. While in Canada he wrote three plays. Two have received workshop productions in the United States and the third was produced in San Francisco. We will now consider these Canadian plays as we explore Alrawi's critic of the concept of authenticity as he searches for a theater of social and personal relevance.

Across the Morne

Alrawi wrote *Across the Morne* shortly after he settled in Canada. It is based on an unpublished account of mail delivery in the 1920s in Newfoundland, on the far eastern Atlantic coastline of Canada. This is an inhospitable and bleak part of the country. Traditionally, most people lived by fishing or by cutting lumber. With the waters overfished and the trees now felled, Newfoundland suffers from a stagnant economy. The people are generally good-natured and tough, as well they need to be to survive the long, harsh winters.

It is in this beautiful, but bleak landscape that Alrawi situates his first Canadian play. The structure he chooses is deceptively simple. It is composed of two monologues that dovetail by the end of the play into a dialogue between two characters. The first is by a man called Jack who delivers the mail cross country by dog sledge from the main town of Deer Lake to the coastal villages. The first act is an account of his outward journey from Bonne Bay to Deer Lake to collect the mail that arrives by train and his relationship with the dogs in an environment that is cold and heavy with snow. Like almost all monodramas the action is in the words and Alrawi paints a picture of resilience and strength that is exhilarating and full of humor.

Jack's descriptions of his journey are evocative and give a strong sense of place and time:

> I load the mail sacks at Woody Point, a small settlement between the Morne and the ocean's edge. I can see the sky's not going to help. The winds have been blowing clouds all morning. It's only a matter of hours before the storm breaks, blocking the paths and slowing the dogs. Whenever I see the clouds like this, I have one hope. It's that I don't lose too many dogs to the ice. There's always some death mixed in with a storm.

The play is detailed in its descriptions of villages and sites:

> As we near Shay Cliff, before Norris Point, we come to a small bay of water known as the Tickle. This seldom freezes up. In a snowstorm

you must hold your course, otherwise you may fall into the bay. There is such a tide there at all times, and the water is so deep. It takes a bitter frost to freeze it over. Even so, it'll never stay frozen more than a day or two at a time. As a kid I once saw a man try and cross it on a horse. The ice cracked open. He sunk through and drowned.

This winter there's a whale made his home in the Tickle. It had gotten there when the drift ice was floating in. He can't get out now until the spring thaw. A whale's got to come up to breathe, and the ice is thick-packed in the inlet of the bay and out into the ocean. He feeds on the fish in the Tickle, coming up now and then for a blow.

Part way through the act, the promised storm breaks, catching Jack with the sledge and the dogs crossing an ice lake he calls the Pond.

My hands are numb as I clasp the sticks. There's no feeling in my legs and feet. I beat my arms against my body to keep the blood circulating. It's too cold to even shout at the dogs. I don't think they could hear me over the wind if I did. They're pulling best they can. They're just as anxious to reach the forest. Among the trees the storm seemed to be easing, but out on the ice it seems to be getting more fierce as the wind rushes down off the mountains carrying drifts of snow with it.

The team slows down, then comes to a halt. Though my limbs are numb from the cold, I investigate immediately. To stop like this in a blizzard is sure death for man and dogs. There among the team lies Jeff, a black and white Labrador. I pull him free of the harnesses. He's dead. His lungs are frozen. The other dogs had dragged him for fifty yards or more before stopping. I leave him on the side of the trail. I tie the empty harness to the mail sacks and we are away in under three minutes. I am down to thirteen dogs and fearful of losing more. Even a three minute stop can cost me another dog.

No sooner do we start than Carlo collapses with frozen lungs. I shake him free of his harness and tie it back. I'm down to twelve dogs. To lighten the load on the pack and to warm myself up I run by the side of the sledge, using it like a shield to break the cold wind from my body. Then Rob drops, his lungs frozen from the blizzard. Three good dogs lost to the wind and the Pond.

The relationship between the man and the dogs is vividly described. Special attention is given to Jack's relationship with the leader of the dog pack, called Pharaoh:

> When alone with me Pharaoh's as gentle as a lamb. But when in harness she is wild and will attack a stranger or fight to the death every dog in the pack. It is that which makes her a leader and worth her weight in gold. Men have been known to form such close ties to their pack leader that her death can break their hearts. It's a strange thing to say, I know. In worse storms than today's, I have lain down on the mail bags and left it to Pharaoh to find her way through a blizzard to the nearest safe camp. She's never failed. If ever the pack turns on me she is all I can trust to save me.

Jack underscores this relationship with the tale of uncle Enos:

> Many times I've heard my father tell the story of Uncle Enos. It was a fine March day and he was carrying the mail across the frozen bay with a team of dogs. He stopped the sledge to straighten a harness, slipped, and fell on the ice. Every dog, but the leader, pounced on him. He tried to beat them off, but they'd smelt blood. The leader sat on the ice and howled for help. The men in the nearby village grabbed pitchforks and axes and rushed to the rescue. They killed every dog in the team. In their excitement they even killed the leader. Uncle Enos was rushed to Grandmother where she worked to heal him. His clothes were all torn. They counted fifty-six bites on his back, not counting other parts and limbs. I heard he grieved more for the death of his leader than he did for the state of his own body.

The second act starts with a monologue by Judith, a young nurse from the northern territories:

> My father was of the inspirational church. He believed in the promise to the children of Zion: 'It shall come to pass that I will pour out my spirit upon all flesh; and your sons and daughters shall prophesy.' He believed himself to be a prophet of the Hebrews in the Northern Territories, an Elijah among the Inuit. But he never found the tribes of Israel he came looking for. Every morning before breakfast he'd wait for the Spirit to speak to him in tongues. But it never did. His daily prayer was 'Lord see how my life is bereft of peace and comfort and reward me for my sacrifice.'

Judith describes how she has moved to Newfoundland where she has formed a relationship with a foreman at a lumbercamp who kills himself one night. Gradually the pieces fall into place as we realize that the people she is talking about are the same that Jack told us about earlier in passing, and that she is the strange woman he has already mentioned in an earlier speech. We then return to Jack who has collected the mail and is now heading back to the villages with his sledge loaded.

The climax of the play is a chilling scene where the dogs in the sledge team turn on each other and on Jack. These creatures, part-wolf and part-dog, tear at each other to settle old scores. The play ends with Jack and the nurse arriving at an accommodation to share each other's fractured lives. The language in these last speeches is hesitant and uneasy, and yet very touching. There is an intensity to the words that makes the play emotionally gripping.

The quality of storytelling is vivid and mesmeric. The two worlds of the mailman and the nurse are presented with fidelity and subtlety of emotion. It is a haunting play that speaks of the search to belong in a world that is cold and unforgiving. Yet even so, it is a fundamentally optimistic play in which people impart meaning to the world and, by doing so, change it. However harsh and lonely the environment we live in, it is still subservient to the human spirit.

The impact of place on people is strikingly given artistic form in the careful descriptions of the real locations and the marking of the weather. There are few plays in which the weather plays such a vital part. Its presence is felt throughout the play. Yet though it shapes the characters of Jack and the nurse, it does not dominate their spirits. Their humanity stands aside from the brute forces of Nature as self-defining. They are both all, and more than what made them. In contradistinction to the argument for authenticity, the play appears to be saying that people are more than where they are from. *Across the Morne* can therefore be seen as a rebuttal to those who insist on type casting people with labels of authenticity.

As an aside we can say that *Across the Morne* reads like a new beginning. It is an attempt by Alrawi to strip his writing back to its basic elements, which are character-driven plots and the art of storytelling. As such, it is a fitting place to start when considering the American phase of his writing.

Natural Alien

Alrawi's next play, *Natural Alien*, takes the argument against authenticity and the power of place a stage further. He pits the horrors of the siege of Sarajevo against the free-running imagination of Helena, a primary school teacher. Though she is subject to the full effects of a devastating

war, her mind can wander across centuries and countries to search out answers to her questions. Our contemporary reality is only one arm of a dialectic of existence that needs the power of imagination to clothe it and interpret it. Place is real, but it lacks the power of imagination.

Helena's roommate, Lana, is concerned with the preservation of the past. But even she has to settle for a substitute (see **figure 9**).

> Lana: I took a walk this afternoon. The forests had been quiet all morning. I walked out towards Kosevo and the Olympic Stadium. People had opened the gates to their courtyards and gardens. There were lilacs and cherry trees in bloom. It seemed so unlikely that such beauty could still be hiding in this city. In the shade of an almond tree two old ladies were sipping coffee in *finjans*. 'How amazing!' I thought. 'They still have coffee.' They saw the surprise on my face and invited me in to their garden. They served me a *finjan* and candies. They asked me what I was doing alone. 'I collect old photographs,' I said. I go to bombed-out apartments and search through them for pictures of people and places. It doesn't matter that I don't know who they are. What matters is keeping the memories alive. When it was time for me to leave they gave me these four books filled with photographs. Many of them sepia. 'If you ever come back again,' they said, 'we can give you box loads of pictures from before this Stone Age.'

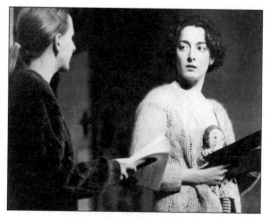

Figure 9. Sarah Wolf (left) as Lena and Nicole Kadovitch as Helena in Meadow Brook's 2001 production of *Natural Alien* by Karim Alrawi.

The photographs represent an "authentic" past that Lana misses. It is almost as though authenticity, as it is represented by the past, is an option only when the present is no longer a comfortable reality.

Toward the end of the first act, Helena meets Don Giovanni during one of her dream sequences and is impregnated by him. During the second act she carries the child to term and delivers a baby girl. We are given no explanation for the mysterious pregnancy. Lana, at first incredulous and opposed to the pregnancy, agrees to share in the responsibility for bring up the child in a country at war. Finally, the two women stand in the rain as the guns fall silent:

Helena: Rain. How wonderful?
Lana: The guns have stopped.
Helena: The air feels so clean. I'm soaked to the skin. It feels
 great.
Lana: In the rain everything's as it used to be. Everybody's in
 the street talking and laughing. It's wonderful.
Helena: Just like at Christmas, Hanukah, and Bairam. There'd be
 lights hanging all over the city. We used to celebrate each
 other's holidays: Christian, Jews, and Muslims.
Lana: I can feel the water running down my back. It feels so
 good against my skin. It's washing out the dust and dirt.
Helena: It's like being born again, but somewhere else.
 Somewhere far away from this time and place.
Lana: No, Helena.
Helena: It could be on the open plains of China or the Black
 Hills of the Dakotas. Or somewhere yet to come and
 unimagined.
Lana: No more time-traveling.
Helena: I could close my eyes and fly away with the clouds.

By this time, the two women have come to accept one another and the new child, born of the imagination into the real world of strife.

It is a striking story, full of humor that raises several serious issues about people's resilience in the face of disquieting odds. Once again, the characters rise above the limitations of their situations and give meaning to their worlds. They are more than the products of their situations. The play also implies that it is the exaggerated attachment to concepts of authenticity that made the civil war in Bosnia more likely. During the following exchange Lana and Helena are making candles from old wax and planting carrots for the winter:

Lana: You're spoiling my concentration. I'm planting carrots.
Helena: I never used to care who was a Serb or a Croat or a

Muslim. That sort of thing never seemed to feature very
much in my life.
Lana: Carrots are an intelligent life form. Which is more than
you can say for most people in this part of the world.
Helena: Now it's important to know who's a Serb with a big "S"
and who's a Croat with a capitol "C" or a Muslim with a
large "M." They should abolish upper-case letters from the
alphabet. Then maybe the war will end.
Lana: Make sure you save the melted wax. We can make another
candle out of it.

The point most poignantly made is in a scene at a demolished mosque
where Lana and Helena go to collect tile fragments. They encounter the
ghost of the Prophet Muhammad's martyred grandson, Hussein.

Lana: These were from the dome of the mosque. They were
glazed with silver-leaf stars.
Helena: They're beautiful. They're cracked and scorched by fire.
Lana: They've burnt everything we've ever loved. Even our
hearts are scorched by their shells.
Hussein: It's the grief done to a child's heart that keeps the wars
going.
Helena: It's seeing the world uncaring that makes them dream of
vengeance.
Hussein: For a thousand years people have fought to avenge me.
For another thousand they'll still keep killing. That's
humanity's most enduring trait. Everything else, science and
poetry, is to justify the slaughter.
Lana: I visited my niece Melica. She's ten years old. She lives
alone with her mother. Her father, Abvo, was killed as he
rode home on a bus. A sniper shot him in the throat. He bled
to death. Melica said to me "Last night I dreamt of my father.
I dreamt of him on purpose."
Hussein: Some day the world must watch out for the children of
Sarajevo who dream of their fathers on purpose.

Deep Cut

If *Across the Morne* is a taking stock of circumstances, then *Deep Cut* is
a revisiting and reevaluation by Alrawi of the sources of his basic mate-
rial. This complex, powerful, and funny, yet deeply disturbing play takes
Alrawi's probing of authenticity a stage further. The play is, in many

ways, about the tyranny of memory and the search to belong that accompanies the experience of displacement. The structure of revelation is exceptionally well realized.

In Alrawi's play the personal revelation also has profound cultural and social implications. Farrah is a young Arab-American woman whose mother, now dead, was Egyptian and whose father is Andrew, an American. She returns to her parents' home on one of the islands off the coast of Washington state. Her widowed father is planning to announce his engagement to Jennifer, a woman he has known for some years. Also in attendance are a neighbor, Bertrand, and Chan, a Chinese patient at her father's clinic.

The general tone of the opening scenes is humorous. Information is imparted about the characters and their backgrounds in a way that is extremely witty and amusing. Bertrand in particular carries much of the humor with an adroitness that is as telling as it is revealing of his own and the other characters' pretensions.

> Bertrand: I did Shiatsu once at a hotel in Munich. It was at the Heideggerian Circle's annual Valhalla, where we dazzle ourselves with the impenetrability of our prose and the incomprehensibility of our ideas. Then, as hormone levels skyrocket, we try to fornicate with as many of our colleagues as possible. As there are usually only six women to every hundred men it's a major miracle if you can bed one at all. Of course, if you do it's proof of the persuasiveness of your argument and you're guaranteed university tenure.
>
> Jennifer: You're scandalous.
>
> Bertrand: Last year's circle meeting was in Bangkok. Such an evocative name, Bang-cock. The Iowa delegates were so worried about catching syphilis from the Thai food they'd brought their own cans of pork and beans.
>
> Jennifer: You're from Ohio. That's not much better.
>
> Bertrand: At least Ohio's a state. Iowa is a condition for which there is no known cure.
>
> Jennifer: Bert, what's Chan going to think?
>
> Bertrand: He'll think I'm a free-ranging bigot, which is just about right. You see, Chan, I'm white, middle-aged, and mediocre. My wife's left me for my best friend and I'm a bore to most people who know me. I'm the white backlash that's sweeping America. You should take a good look at me. We're the ones who fill the White House and Congress and then wonder why the country's in such shit.

The play is structured around the events leading up to dinner and the immediate aftermath of the meal. During this time a range of topics are discussed from torture in Chinese jails to whether whales have a culture and a language of sorts. Issues concerning the significance of cultural relativism and authenticity are lightly touched on. Andrew comments:

> The essential factor about cultures is that they're myopic, exclusive, and introverted. I am an American. I drink Bud and watch baseball. I don't, as a rule, drink British bitter, nor do I watch cricket. That's not an acceptable drink or sport.

Gradually the cordiality of the evening breaks down as Farrah starts to probe her father about her past. Arguments of cultural appropriateness are raised and discussed then discarded.

> Chan: China is an authoritarian society. In authoritarian societies physical punishment is a culturally accepted deterrent. So is it all right to torture people in China?
> Andrew: That depends upon your cultural values. Physical torture is not culturally acceptable in America.
> Chan: So you help me because I am now in America. But if I was in China being tortured you would leave me to be tortured, because I am in China.
> Andrew: It's totally hypothetical. I've never been to China and I didn't meet you there.

The discussion escalates further as Farrah intervenes.

> Farrah: It's not difficult at all, Chan. He's being very clear. If you were in China he wouldn't help you.
> Chan: Because you would be afraid of what would happen to you?
> Andrew: Because if I did I would be interfering in the internal workings of another culture.
> Chan: What about what you think is right and wrong?
> Andrew: That doesn't come into it.
> Chan: Why not?
> Andrew: My belief system doesn't come into it. It would be arrogant of me to impose my values on others.

Andrew's defense is that of cultural relativism and authenticity, which he holds to tenaciously. He has some strong arguments to marshal

in his defense. But gradually his position becomes increasingly untenable as Farrah finally reveals that, in conformity with African cultural practice, she had been circumcised by her mother.

There are few plays that deal with the social and psychological role of cultural authenticity and conformity with such intelligence and understanding. The play was produced at La MaMa Experimental Theater Company in New York and later won the Pacific Playwrights Award for best new play. It has received readings at a number of major theater venues in North America and was most recently produced by Golden Threads Productions in San Francisco.

Deep Cut demolishes the pretensions of the arguments often raised in favor of cultural authenticity. The play appears to be saying that cultural authenticity is an uncritical acceptance of customs and traditions that may be personally damaging and may even be criminal. It goes further by implying that only by moving beyond such considerations can there be socially useful intervention. The argument for cultural authenticity is most often a means to justify all that is repressive and destructive in a culture. It is a turning of one's eyes away from the iniquities of the present to a false and fabricated image of the past. Theater that is socially responsible must reject the argument for cultural authenticity as bankrupt and as a product of coercion.

Whether one agrees with these conclusions, there is no denying the passion and emotional power of the play. It is the culmination, so far, of Alrawi's criticism of the notion of authenticity. It also represents a reversal of some of the arguments seemingly endorsed by Alrawi in his 1987 play, *A Child in the Heart*, produced in England by Joint Stock Theatre.[111]

Patagonia

Alrawi's next play to be produced in North America, *Patagonia*, is a structurally complex piece of theater. Several fractured story lines are interwoven and time frames shifted to create a play that moves forward and backward in time, as we shift from scene to scene finally culminating in an ending that is also the play's beginning. By the play's end, what we took for reality is revealed to have been a fantasy. This is probably Alrawi's most structurally complex play to date.

It is difficult to adequately summarize the story line of this play because of the shifts in reality that take place. The main story is that of Isabel, a young Chilean woman, who becomes involved with a left-wing group during the Allende years. After the military coup she was arrested, tortured, and made into an informer. When confronted by Marcia, a long-

time friend, she decides to escape from Chile and ends up in Canada, where she tries to remake her life, only to find that the past will not go away. Added poignancy is gained by having a small cast of actors play characters from both Chile and Canada. This casting across story lines allows for rapid scene changes and underlines the similarities of experience in north and south. Though set in South America the story could be as easily set in many other parts of the world, including the Middle East.

Thematically, it appears to combine both the passion of *Deep Cut* as well as the appeal to the redeeming power of the imagination of *Natural Alien*. As such it is an underscoring of what both these lines of reasoning lead to. That is a belief in the individual's power to overcome both political and cultural limitations and to assert their humanity in the face of overwhelming pressures, even in the face of death. Speaking of her friend, Isabel, Marcia laments:

> I have often wondered what she must have dreamt as she lay dying. I have imagined her dreaming of the life she would have led. Dreaming of being married, of being a prisoner, of being free. I took from the stories of my friends and gave them to her. I know I can not think of what her future might have been without corrupting it. Just as I know that none of us can live with our memories without distorting them. I am forced to invent stories for Isabel because I come from a continent that suffers amnesia, from a world that has forgotten. There are few records and no archives on the hundreds of thousands who have disappeared. We are forced to talk of them, because only the telling of stories can fill the void left by their interrupted lives. It is only the stories that can remind us of the waste, and the terrible complicity of silence of the times we now live in.

> Like thousands of others I come back every year to Santiago cemetery to look at the field of black crosses. The unnamed, but unforgotten victims of those years of slaughter. They lie here, but their shadows are with us everywhere. By the field of crosses stands a black wall with the names of the disappeared. Etched on the stone is a verse of poetry:

> > All my love is here
> > And it has remained
> > Entwined with the rocks
> > Nourishing the mountains
> > Replenishing the ocean.

It is in that short dream before death, a final exercise of the imagination, that Isabel completes her life cycle. It is not life that circumscribes imagination, but rather it is the imagination that brackets Isabel's life. This play takes a beyond the issue of authenticity by suggesting that imagination is the means by which the individual and society can find their redemption. This is a concept developed more thoroughly by Alrawi in his next play, *A Gift of Glory*.

A Gift of Glory

Probably Alrawi's most commercially successful theater venture in the United States so far is his play *A Gift of Glory* (see **figure** 10). This play opened at Meadow Brook Theatre, Michigan's largest professional theater. The production proved to be an event of some local significance. The play received much coverage in the press and won the Detroit Free Press Award for Theater Excellence for 1999. Alrawi had already won the Canadian Theater National Playwriting Award that year and the USA Plays Today Playwriting Award the year before (see **figure** 11). The praise for *A Gift of Glory* was unstinting and the audience reaction unprecedented.[112]

Figure 10. Dan Kremer as Edsel Ford and Kirsten Giroux as Eleanor Clay Ford in *Gift of Glory*, performed at the Meadow Brook Theatre in 1999.

Often, after each of the 16 scenes in the play, the audience would applaud. This is an extremely unusual reaction from an audience at a major U.S. regional theater.

Expressing popular sentiment, Frank Provenzano wrote in *The Observer & Eccentric*:

> Few plays accomplish something before the curtain rises. But Karim Alrawi's *A Gift of Glory: Edsel Ford and the Diego Rivera Murals at the Detroit Institute of Arts* is that rare original work whereby the promise of regional theater pays off. Before the play opened at Meadow Brook on Saturday, Alrawi's story about the struggle behind the famous murals had already raised the quality

112 See, for example, George Bullard, "Play Shows Detroit as an Art Sanctuary," *Detroit News*, March 6, 1999.

of discussion about the integral role for regional theater as a place where local stories are dramatized. That's hardly a small feat *Gift of Glory* is one of the most compelling pieces of regional theater in recent years.[113]

The story line, based on real events, is deceptively simple. Edsel Ford, the son of Henry Ford the founder of the Ford Motor Company, is appalled by the needless killing of hunger marchers outside the gates of the Ford plant in Dearborn during the Great Depression. He therefore commissions a known communist painter by the name of Diego Rivera to paint a mural on the walls of the Detroit Institute of Art (DIA) to celebrate the working man. Rivera's paintings incense local right-wing groups who then plan to destroy the murals. Local people organize a defense force to protect the murals. Thus, the murals are saved. These are also the historical facts. What Alrawi does with them is weave a detailed account of Ford's relationship with his wife, Eleanor, his father, Henry Ford, his father's henchman, Harry Bennett, and Rivera. It is a remarkable piece of social history come alive on stage.

Figure 11. Karim Alrawi receives the Canadian Theatre National Playwriting Award for 1999, presented to him by John Tennant, Canadian Consul General in the United States.

Into this relatively straightforward historical account, Alrawi packs a world of social and individual activity. The major conflicts of the 1930s are played out through the interactions of a handful of characters. The play covers so much ground with such ease and lightness of touch that to summarize the full range of topics would be difficult. Nevertheless, a key element in the play is the social role of art. Rivera

113 F. Provenzano, "Meadow Brook Finds Its Role with *Glory*," *The Observer & Eccentric*, March 18, 1999.

discusses the relationship between art and life with William Valentiner, the director of the DIA, as they both witness an eclipse of the sun:

> Rivera: What is a word, Dr. Valentiner? It is a sound that has a meaning. Without meaning the sound has no value. Art gives meaning to life. A life without art is meaningless. Art without freedom is impossible. If I can have more freedom to paint in America than I can in Mexico I will stay. If not, I will go back.
> Valentiner: I've said everything I can to convince you. It's totally your decision, Mr. Rivera.
> Rivera: What happens once the sun is blotted out?
> Valentiner: You'll see a ring of flame around a black orb. The temperature drops by ten or fifteen degrees . . . (a beat) . . . It's like a Biblical miracle. Darkness covers the earth and, for a moment, all life comes to an end.
> Rivera: The real miracle is not that there is darkness, Dr. Valentiner, but that the light returns and life starts again.[114]

Later still, preparing the walls for the murals at the unheated DIA in the dead of winter, Rivera complains of the working conditions.

> Rivera: There is no heat in this building. My assistants are always falling sick. One of them was in bed for a week. He had nothing to eat for four days. I didn't know. These are terrible conditions to be working under.
> Valentiner: I'm sorry. But the city's cut ninety percent of our funding. Mr. Edsel is himself paying our wages. We cannot afford any heating. There is nothing I can do.
> Rivera: Dr. Valentiner. I am not complaining for myself. There are my assistants. They have to mix the plaster in the basement. It is damp and freezing there. That is intolerable. But even more important you have paintings here, like the Breughel. Freezing will damage the paint. That is criminal.
> Valentiner: I've stopped drawing my salary. What more can I do? The banks have crashed. Mr. Edsel has lost almost twenty million dollars. We cannot ask him to pay more.
> Rivera: Do you know what art is Dr. Valentiner? It is more than paint on canvas. Art is the soul of a people. If you want to

114 All extracts are from the published script by Karim Alrawi, *A Gift of Glory*, (Rochester, Michigan: MBPAC Press, 1998).

destroy a nation you destroy their art. That, Dr. Valentiner, is
what the conquistadors did in Mexico to the Aztecs. That is
what your people did here to the Indians (a beat)
When your art dies in the frame from the cold and the frost
you will become a people without a soul. That is a terrible
price to pay.

It is art then, a product of the imagination, that gives meaning to life.
It is the soul of a people. It is this concept of a living heritage that must
be continually renewed that Alrawi juxtaposes to the idea of authentici-
ty. It is not belonging to a place and sharing traditions hallowed in col-
lective memory, but rather the individual imagination of the artist, set in
a social context, that matters. It is not custom and the collective habits of
the mind that define a people, but their relationship to a living, changing
culture as represented in the artifacts of their artists. Compared to this
dynamic concept of a living culture the notion of authenticity can be seen
to be stagnant, soulless, and dead. It is this dialectic between the artist
and society mediated by the artifacts created by the artist's imagination
that allows for a theater of social relevance. Without this dialectic, there
is only stereotypical portrayals of character or esoteric adventures.

In the series of plays above, whose surface we have barely touched,
Alrawi has undertaken an analysis, and a refutation, of a concept of
dynamic culture and cultural interaction that is central to the thinking of
many cultural critics in the Arab world and elsewhere. That he has done
so in a series of provocative and well-written stage plays is both extreme-
ly unusual and a considerable intellectual and artistic achievement.

Dance and Spectacle

10 Dance: A Visual Marker of *Qabili* Identity in Highland Yemen[115]
Najwa Adra

Introductory Images

I have a key chain with eight laminated photographs showing Yemen's President 'Ali 'Abdallah Salih in various costumes (see **figure 12**). He appears in a military uniform, a light-gray businessman's suit and tie, and in a leisure suit with sunglasses. This collection of photographs is sandwiched between a picture of the Yemeni eagle and flag, insignia of the modern Republic of Yemen (established in 1962 and united with the southern former People's Democratic Republic of Yemen in 1990) and a photograph of a group of men in tribal dress[116] at a *bara'* dance event. In the latter, several drummers are accompanying two dancers: President Salih and Palestinian leader Yassir Arafat.

Figure 12. Key chains showing Yemeni President Salih in military uniform, leisure suit, suit and tie, and performing *bara'* with Yassir Arafat. Also shown is the emblem of the republic.

115 For stimulating discussion during various stages of research and/or for their invaluable comments on earlier drafts of this paper, I am indebted to Steven Caton, Selma Jeanne Cohen, Andre Gingrich, Paul Hockings, Mary Strong, Daniel Varisco, Delores Walters, Shelagh Weir, and Sherifa Zuhur. This article is adapted from "Dance and Glance: Visualizing Tribal Identity in Highland Yemen," *Visual Anthropology*, 11, 1998, 55–102. Copyright Overseas Publishers Association and included here with permission from Gordon and Breach publishers.
116 "Tribe" and "tribal," as used in this chapter, are a direct translation of the Arabic

A jovial President Salih also appears in posters, wearing a tribal headdress, and a tribal *jambiyya* ("dagger"), white shirt, and dark suit coat. One of these is stereotypically tribal: the shirt is rumpled, with the top button left open. In another, he appears with shirt completely buttoned, and a shawl draped elegantly across his chest (see **figure 13**). Still other photographs, notably in Yemen's English-language newspaper, *Yemen Times*, consistently depict a very serious President dressed in dark suit and tie. These images could be dismissed as stereotyped, which they are. However, as Richard Dyer has poignantly demonstrated, stereotypes are representations that replicate perceived realities while simultaneously constructing such realities (Dyer, 1993). This chapter will explore traditional and contemporary Yemen and the role of representations in the construction of Yemeni identities.

Figure 13. President Salih in tribal clothes.

Introduction to the Yemeni Context

Throughout Yemen's history, aesthetically charged visual, aural, and tactile phenomena have distinguished recognized social groups from each other and highlighted perceived similarities within groups. Before the 1962 revolution, three major recognized status groups existed in northern Yemen along with an important rural/urban distinction. The tribal population (*qaba'il*) was predominately rural and comprised over 90 percent of the population. Tribal Yemenis were distinguished from Yemenis not defined as tribal by clothing, dancing, poetry, music, and cuisine. These markers also replicated tribal values and furthered the construction of tribal identities. In the past twenty years, identification with a Yemeni nation and with a cosmopolitan global environment has transformed

qabila and *qabili*. Readers who are not familiar with the ethnography of the Middle East may balk at the use of the word *tribe*. Unlike its misuse elsewhere, the term in the Arab context denotes a regionally recognized social group with clearly defined parameters that will be described in this article. As used here, the term does not in any way connote "primitive" as may be the case in its use to describe social contexts outside the Middle East and East Africa.

traditional distinctions. Dress and performance have also changed. I will argue here that these markers, like the stereotyped images of President Salih described above, continue to represent and construct traditional and changing concepts of what it means to be Yemeni. The ways in which Yemenis are incorporating new images and identities into a tribal perspective point to a particularly Yemeni style of postmodernity.

President Salih, for example, can direct the gaze of others to Yemen as a modern, developing nation-state or to a tribal nation that honors its traditions. In his role as leader, he may, through his dress, identify with the military, urban youth, rustic tribesmen, mature traditional tribal leaders, or Westernized leaders seen on television. That he chooses all of these images, sometimes in juxtaposition, is significant. President Salih's government has strenuously sought to foster and develop a new Yemeni nationalism since his ascension following a military coup. This nationalism presents Yemen's tribal tradition with considerable ambivalence, often denouncing tribalism as divisive and retrograde. Yet the president himself is from a central highland tribe. Tribal leaders continue to play important roles in government. Thus, the importance given in the media to tribal, as well as cosmopolitan, images is significant. It encompasses the complexity with which the government perceives the young nation and its relationship to its traditions and development and to other nations.

Much of this chapter is based on ethnographic fieldwork conducted in the valley of al-Ahjur in Yemen's northern highlands in 1978–79 and again in 1983.[117] Supplemental data were gathered in brief periods of research conducted elsewhere in north Yemen, 1983–86 and 2001. On my initial trip and several times in the 1980s, I was accompanied by my husband, Daniel Varisco, also an anthropologist. I also draw on earlier literature and recent ethnographic studies on highland Yemen (Bédoucha, 1987, pp. 139–50; Caton, 1990; Dresch, 1989; Gingrich, 1989a, pp. 129–149; Gingrich, 1989b, pp. 127–139; Miller, 1996a; Miller, 1996b; Mundy, in Serjeant and Lewcock [eds.], 1983; Swagman, 1988, pp. 251–261; Friedrich, 1988, pp. 103–112). In this chapter, I include as wide a variety of "voices" as were accessible to me: the perspectives of members of different social strata, of urban vs. rural individuals, returned migrants, and perspectives from different time frames.

Aesthetic markers in the northern highlands are considered here in the context of others that mark the nontribal population. I argue that the

117 My research in 1978–79 was funded by a National Science Foundation Grant for Improving Doctoral Dissertation Research and a Temple University Graduate Fellowship. My fieldwork in 1983 was funded by Middle East Awards in Population and Development, Population Council. Portions of this chapter are taken from my dissertation, Adra, 1982.

markers in question did not serve simply to identify members of various status groups, but that identification was lived and constructed through an acceptance and utilization of these markers.

Culture is not static; markers and loci of identity have changed with the rapid political and economic changes of Yemeni society. Changes in markers and contexts of use are described. Many traditional markers continue to represent and construct tribal identity. Some have gone into disuse, while others have been revived in new contexts. As the significance of the tribe in modern Yemen is being contested, its markers are being manipulated by all sides.

First Impressions

March, 1978, was a time of rapid change in Yemen. Agricultural fields lined the road from the airport to Sanaa, and the city itself was a small, dusty sprawl of low buildings bordering on a walled old city with majestic stone skyscrapers. The small river that flowed through the city and watered its gardens before the revolution had dried up as a result of the city's rapidly increasing population. The shops in Sanaa were crammed with the usual cigarettes, Pampers, baby formula, canned Kraft cheese, popcorn, and beautifully colored synthetic fabrics. One could also buy German rye bread, Scotch marmalade, Sharp televisions, Panasonic tape recorders, Seiko watches, Lark luggage, Guerlain makeup, and the latest Paris perfumes. Armed as I was with the usual stereotypes on veiling on the Peninsula, I was surprised to see veiled women walking hand in hand with men (husbands or brothers) and riding on the backs of small motorcycles.

My first impressions on our exploratory trips to rural Yemen in search of a field site were of the spectacular terraces, green and brown mosaics that covered entire mountains well into the remotest spots. The fresh air of villages and the hospitality of rural Yemenis were warming. We were first taken to al-Ahjur by the late Muhammad Muhammad al-Shami who invited us to spend a few days with his family in al-Ahjur. The beauty of this lush valley, watered by a legendary 360 springs, was striking. Its villages, like others in the rural highlands, were situated on mountain tops or rock outcroppings, with the houses on the perimeter sharing an outside wall, looking very much like medieval fortresses. Land was cultivated with sorghum or maize, or with cash crops of coffee, *qat* (a mild stimulant), or tomatoes.

The first car roads into the valley were built just four years before our arrival, making Toyota trucks the favored means of transportation. Flour mills were available in a number of villages, and electric generators were just being installed. Frozen chickens, imported mainly from France, were

sold wherever generators were available to power freezers. Clearly, life was changing rapidly in this beautiful country.

Paradoxes

Early in the fieldwork experience, I was confronted by a number of apparent paradoxes. I originally engaged in field research to investigate the extent to which cultural information can be gleaned from an analysis of a group's dancing and dance events. I planned to conduct an ethnographic study while I observed and studied the dances performed. When I told Yemenis—scholars and others—that I was interested in studying Yemeni dancing, they all referred me to *bara'* as the most important dance to study. While *bara'* varied by region, it was a line dance performed by men to the beat of drums in the highlands around Sanaa. Elsewhere, it could be performed by two men at a time. In some places, it was accompanied by sung or chanted poetry. I was surprised to discover that *bara'* was not technically described by the term generally translated as dancing (*raqs*). A *bara'* performer was not called a *raqqas* ("dancer") but referred to as a *mubtari'*. The Arabic verb, *ibtara'a*, rather than *raqasa* is employed to describe *bara'* performance.

The second paradox I faced concerned the degree of stratification as experienced "on the ground." In Yemen's northern highlands there were historically three largely endogamous social status groups. They included a religious elite composed of two subgroups: descendants of the Prophet Muhammad (*sada*, sing. *sayyid*) and scholars of tribal origin (*fuqaha'*); tribesmen or *qaba'il*, (sing. *qabili*); and *Bani Khums*,[118] a client group responsible for providing ritual and menial services to the tribes. The *Bani Khums* are internally stratified and are composed of a number of subgroups, each specializing in a particular occupation. A large number of *Bani Khums* lived in towns. Others, spread out through the countryside, maintained relationships of clientage with particular tribes or villages. *Bani Khums* residing in al-Ahjur include the *muzayyin* (pl. *mazayina*), who was both the barber and musician, the herald (*dawshan*), the butcher (*jazzar*) and the vegetable seller (*qushsham*). In the absence of a *muzayyin*, members of other low status groups could be hired as musicians. *Mazayina* were, however, and continue to be, ritual experts. They direct proceedings during weddings and circumcisions. Traditionally, the various status groups were marked by descent, occu-

118 This group was sometimes called *ahl al-thulth or khadama*. When the term *akhdam* is used in Yemen, however, it designates members of a pariah group not often seen in the rural northern highlands. This is a group whose low status is clearly marked in the behavior of others to them. See Walters (1987 and 1998).

pation, and dress. The Republic of Yemen has officially condemned traditional status distinctions, but they continue to influence patterns of identification, endogamy, and occupation.

Having read about this system of stratification in travelers' accounts and ethnographic works,[119] I expected to find appropriate deference behaviors reinforcing these distinctions. For example, I expected seating arrangements to reflect a hierarchic scheme, and that lower status groups would defer to higher status groups in conversation and in greeting behavior. I was surprised to find members of all groups eating and socializing together as equals. In al-Ahjur members of all social classes eat together from the same plate and sit together. Where there is marked deference behavior, it is towards older age or occasionally by someone who wants a favor. Anyone who wished to performed at dance events. It was virtually impossible to distinguish members of the lower service groups except when they were performing their ritual roles. With the exception of one *muzayyin* who reinforced his low status by playing the clown, nothing in the daily dress or behavior of *Bani Khums* sets them apart from others. In fact, individuals in this status group exercised considerable social control through their roles as ritual experts. They could criticize or praise *qaba'il*, as well as members of the religious elite, through their choice of song lyrics. Respected *mazayina* were sometimes asked to help mediate family quarrels of *qaba'il*.

Neither did *qaba'il* routinely defer to *sada*. *Qaba'il*, when referring to individual members of the *sada*, occasionally used the traditional honorific, *sayyid* or *sayyida* (lit., "master" and "mistress" respectively), but rarely did they do so in the second person. When asked about this, they would respond, "*sidak Allah*" ("God is your master"). By this they meant that the honorific properly referred to God alone and not to ordinary mortals. I found this to be the case even in Sanaa. The understating of recognized status differences reflected an ambivalence that I did not expect to find.

Behavior contradicting the indigenous model of social structure spilled over into the expressive forms. *Bara'* was defined as a tribal dance, and in theory, *qaba'il* performed *bara'*, while members of the religious elite performed *lu'b*, another genre of dancing that is defined as *raqs*. In practice, I saw members of all social strata performing *bara'* and *lu'b*. Likewise, members of all social strata dressed alike in al-Ahjur, with

119 Early references in European languages that discuss social structure in Yemen
 include: Bujra (1971); Chelhod (1970), pp. 61–86; (1973a), pp. 3–34; (1973b), pp.
 47–90; and (1975), pp. 67–86; Dostal (1974), pp. 1–15; Gerholm (1977); Glaser
 (1884), vol. 30, pp. 170–183, 204–213; and Serjeant (1967), pp. 284–297.

perhaps one or two exceptions. Although the ability to compose poetry is regarded as a characteristic of *qaba'il*, in practice all members of the society are expected to compose poetry on various occasions. It took some time before I could appreciate the apparent paradox of a hierarchical society that denied hierarchy and valued equality in behavior. The resolution of these paradoxes is relevant to the significance of *bara'* and tribalism in the northern highlands.

Theoretical Frames

Aesthetic parameters, such as dance style, underlie, replicate, and construct conceptions of the tribe in Yemen's northern highlands. By conceptions of the tribe, I mean tribal self-definitions as well as perceptions of the tribal population by other Yemenis. I define aesthetic processes as those in which form (stylistic information) is primary and in which people indulge mainly for pleasure. For example, dance events may have social and psychological functions beyond the aesthetic, but people in Yemen ultimately dance for fun. The dances discussed here are not mimetic—there is no story line to communicate particular values. Nonetheless, many dances performed in Yemen are considered tribal or regional markers along with other visual, aural, and tactile forms.

Further, I argue that stylistic elements of aesthetic forms such as dancing contain cultural information and that they themselves are culturally embedded. That is, the principles of organization that grant a culture coherence and distinguish it from others are replicated in the principles that motivate and define its art and performance styles. Culture is thus defined in terms of particular ways of ordering the elements of social life rather than consisting of collections of traits or symbols.

A number of anthropologists have discussed art style as an instrument in the production of culture. Gregory Bateson explores this function as it pertains to Balinese painting where the relationship between the various components of a particular painting are icons of Balinese cultural concerns (Bateson, 1972, pp. 128–152). James Fernandez's entire monograph deals with these concerns (Fernandez, 1966, pp. 53–64; Fernandez, 1977). My research on dancing in al-Ahjur suggested that tribal dancing is a metaphor or icon of what it means to be tribal in Yemen. Steven Caton's work has shown that Yemeni tribalism is also replicated in tribal poetry (Adra, 1982; Caton, 1990). Other anthropologists and ethnomusicologists have described similar metaphoric relationships between aesthetic pattern and cultural principles (Adams, 1973, pp. 265-279; Gell, 1975; Ness, 1992; Schieffelin, 1976; Sugarman, 1989, pp. 191-215; Turino, 1989, pp. 1–30; Urban, 1997, pp. 1, 7; Wade, 1976, pp. 15–26).

Metaphor and iconicity are important concepts here (metaphors being one example of iconicity). As Charles Sanders Peirce has argued, an icon condenses information, so that, "by the direct observation of it other truths concerning its subject can be discovered than those which suffice to determine its construction" (Peirce, 1940, pp. 98–119).[120] Metaphors frequently involve relationships that have natural referents. For example, the American eagle as a sign of the United States means different things to different people at different times, and these meanings are tied closely to American social history. To this extent, the sign is arbitrary. What is not arbitrary is that the choice of an eagle points fundamentally to strength, cunning, or power. A wolf or lion could conceivably replace the eagle in representing the United States without significantly altering the intended meaning, but a kitten or puppy dog as symbol would create an entirely different image.[121] In the same vein, ideas of what constitutes a "natural" balance vary with culture. In some cultures, it means a resolution of opposing forces; in others, symmetry in opposites; in still others, coordination of equal parts. These concepts are arbitrary on a cultural level, but their representations in art forms are frequently iconic. European and American novels, symphonies, and dances of a certain time period strive towards resolution, while Balinese paintings and dances juxtapose opposites in ways that that may be discomfiting to those unfamiliar with the culture (Adra, 1973). Cultural concepts of hierarchy and egalitarianism may also be iconically represented in the arts.

When artistic process replicates relations considered important to a culture, its products are appreciated for expressing truth as well as beauty. As a corollary to this, one finds that in situations of culture change, a portion of the population appreciates and holds on to traditional forms, while others participate in and are attracted to newer configurations. This has been the case with Yemeni tribal dancing and tribal poetry (Adra, 1993, pp. 161–168; Caton, 1990; Miller, 1996b; for an example from Indonesia, see Peacock, 1968).

120 Peirce's triadic model of the sign (index, icon, symbol) is useful for understanding the ways in which aesthetic forms signify cultural values. Like any sign, a dance, poem, or costume is simultaneously an index, icon, and symbol, although the relative weighting of these three qualities will vary in each case. A sign is a symbol to the extent that its significance is conventional. It is arbitrary in the Saussurian sense when it is symbolic. A sign is iconic to the extent that it replicates significant relations in the object represented. Diagrams and metaphors are icons. A sign may also be indexical to the extent that it focuses attention to an object, event, or concept. Neither icons nor indices are necessarily arbitrary, although an index is more likely to contain conventional, hence arbitrary, elements.

121 Those who have read Bateson (1972), will note the congruence between this example and his of the lions at Trafalgar Square. Bateson's example, however, focuses on iconicity in the material out of which the lions are made.

The close fit between cultural change and artistic change is significant and implies a connection between artistic process and the formation of identity. I also contend that artistic process (e.g., dancing) recreates fundamental cultural relations and also helps to form cultural identities. In this, I follow Caton's lead. He contends that tribal poetry not only reinforces values held dear, but that traditional and changing tribal identities are constructed in its performance. The poems studied by Caton are living historical agents. That is, tribal poetry is constitutive as well as representative.

This position echoes the conclusions derived from ethnographic research elsewhere. Adrienne Kaeppler has written of Tongan laments and eulogies, "Rather than 'reflecting' or 'mirroring' social activities, the oratorial voice *constructs* fundamental cultural values" (Kaeppler, 1993, p. 478). Janet Wolff sums up this position as follows:

Cultural forms, like dance, do not just directly represent the social in some unmediated way. Rather, they *re*-present it in the codes and processes of signification—the language of dance. Moreover, far from reflecting the already given social world, dance, and other cultural forms participate in the production of that world. (Wolff, in Grossberg, Nelson and Treicher [eds.], 1992, p. 707)

My aim in this chapter is to show that tribal dancing and other tribal markers are similarly representative and constitutive. They not only recreate tribal ideals, but tribal identities are created, at least partly, through performance. Aesthetic phenomena, far from being marginal to issues of identity and meaning, foreground underlying social currents.

I do not wish to imply that expressive forms are not to be appreciated in themselves. Yemeni dances and poems (or Martha Graham performances) are bounded entities that can be admired or dismissed in their own right; but they are also products and producers of culture. The issue is not simply the imbeddedness of art in culture; it is the extent to which art constructs culture as it reflects it. It may be that we learn, perpetuate, and change our culture through manipulation of artistic metaphors. Perhaps the overriding issue is the relationship of aesthetics to culture. I would like to suggest that what we intuit as cultural pattern is an issue of style, that cultural similarities and differences are, at base, aesthetic rather than technological or psychological.

Traditional aesthetic markers in Yemen (like clothing, dancing, poetry, and food) identified social groups and distinguished them from each other. These markers, like Dyer's stereotypes, and all metaphors, were "simple, striking, easily grasped, but none the less capable of condensing a great deal

of complex information and a host of connotations" (Dyer, 1993, p. 12).

The role played by tribal dancing in representing tribalism and constructing an ever changing tribal identity is my focus. However; dancing is situated among other important aesthetic markers. These include poetry, dress, and cuisine, all of which provide important images of tribal identity.

Historical Background

The geographically challenging highlands of North Yemen have never been colonized by a Western power. Although various parts of Yemen were occupied by Ottoman Turks in the sixteenth and nineteenth centuries, making it a nominal part of the Ottoman Empire, the Sublime Porte did not control the country as a whole. By the turn of the twentieth century, Yemen was ruled by an absolute religious monarch, Imam Yahya, who succeeded in the difficult task of unifying the area that came to be known as North Yemen, and in expelling the last remnants of Turkish troops in the area. Fearing European colonization, Imam Yahya and his son Ahmad, who ruled from 1948 to 1962, severely restricted the travel of foreigners into the country and of Yemenis abroad, although they could not control emigration through the port of Aden in the south. In 1962 a revolution toppled the imamate and established a Republican Yemeni government (YAR) in the north.

Thus, for at least half of the twentieth century, North Yemen was relatively isolated from global hegemonic influences. The two world wars, the Arab-Israeli conflict, and oil economics were quite removed from the praxis of Yemeni life. Although Yemenis of the northern highlands lacked the conveniences associated with industrial society, they maintained a pride in their own heritage and civilization that contrasted radically with attitudes of colonized peoples. Not well informed about modern industrial and technological capabilities, rural Yemenis had very little reason to question the validity of their own civilization that once controlled the coffee trade, commerce in silk and spices from Asia, and the fabled incense route.

The revolution was followed by a seven-year civil war in which Egyptian forces, using Soviet tanks and weapons, propped up a nascent republic against the old guard, supported by Saudi Arabia and Anglo-American policy. When the civil war ended in 1969, and Zaydi rule was replaced by a republican government, goods and ideas from industrial nations began to flood the country. The number of imports increased dramatically. By 1978–79, almost any manufactured product could be obtained in the capital, Sanaa.

Large numbers of Yemeni men emigrated to work in the nearby oil-rich

countries. Entrepreneurs used remittance wealth to set up flour mills, electric generators, and schools to serve their own and neighboring villages. With cash available through remittances, Yemenis—rural and urban—were now able to purchase the plethora of available imports. It became cheaper to buy imported foods than to grow these locally. Subsistence agriculture began to give way to cash cropping.

Farmers began to migrate to Yemen's towns and cities, rapidly increasing the urban population. The small, picturesque city of Sanaa, once known for its grape arbors and rose gardens, grew into a dusty metropolis complete with traffic congestion. Roads were built to connect the various parts of Yemen, facilitating travel and the exchange of information. Toyota trucks quickly replaced camels as the preferred means of rural transport. Within the next decade, television transmission reached most of Yemen's rural population, which quickly became acutely aware of the rest of the world (Adra, in Crawford and Hafsteinsson [eds.], 1996). Although the revolution had officially banned social status distinctions, members of the traditional elite continued to hold positions of power by virtue of their education and wealth.

South Yemen, in contrast, was under British control from 1839 until its 1969 revolution which established the socialist People's Democratic Republic of Yemen (PDRY). Although many Yemenis traveled regularly between North and South Yemen, there was some degree of ideological discord, with Yemenis from the northern highlands tending to be critical of socialism, while those of the southern highlands of North Yemen tending to have more sympathy with PDRY. In 1990, the former YAR united with the former PDRY to form the Republic of Yemen. Throughout the 1990s, the new government has faced major political and economic challenges to unity (Carapico, 1998).

Yemenis are currently struggling with the implications of change on their own value systems and lifestyles, specifically how to construct cultural axioms in a rapidly changing world. Gone is the chronic poverty and frequent hunger that characterized the lives of the rural population during the imamate. On the other hand, the same people often deplore their perceived lack of energy, strength, and endurance as compared to the past. The term they use is *ta'ayabna*, which literally means, "we have become flawed," and implies that honor has been compromised. There is also a marked decline in dancing and other local expressive forms that many decry. My concern as an anthropologist, of how to accurately describe relations of a society in flux, parallels the concerns of many Yemenis of how to make meaningful and palatable adaptations to changes in their own society.

Aesthetic Markers

Tribal markers include dancing, poetry, music, and clothing, among others. Each is valued highly by *qaba'il*, both as a tribal symbol and for its own aesthetic qualities. Tribal representations signal to the Yemeni population not only what is "ours" but also that which is "best" and most "beautiful." This section describes some of the visual, and aural markers[122] that traditionally identified members of the three social strata and distinguished between urban and rural folk.

Traditional Clothing and Arms

Modesty is the rule for both men and women, and all wear several layers of clothing and headdress. Today, as in the past, costume varies with status, region, and fashion.[123] In the late 1970s in al-Ahjur, most tribal and *Bani Khums* men wore a gathered skirt (*futa*) over white shorts, a collared, Western-style shirt, and imported Western suitcoat. An embroidered headdress, imported from Pakistan, was wrapped around a cotton cap. The manner of wrapping the headdress distinguishes tribes or tribal groups from each other. Long shoulder cloths were worn for warmth or used to carry items. A few traditional men wore black handwoven woolen vests (*'abahs*) with white geometric designs instead of suit coats and locally made black headdresses with long fringes.

Some returned migrants from Saudi Arabia wore an ankle-length robe (*thawb*) in subdued colors instead of *futa*, shirt, and suitcoat. Those who wanted to appear particularly urbane wore a white *thawb* following the fashion in Saudi Arabia and the Gulf countries.

Urban men were more likely to wear a *thawb* regardless of their social status. A very few older members of the religious elite continued to wear their signature large robes with wide sleeves. Many wore Western-style suits, jeans, or leisure suits which were fashionable at the time. Professionals of all status groups wore Western clothing to work but would change into more comfortable *thawb* or *futa* at home.

While clothes were traditional social markers, the dagger (*jambiyya* or *janbiyya*) and the rifle were, and continue to be, the ultimate material signifiers of tribal affiliation. The tribal dagger (*'asib*) has a handle made of wood or horn, sometimes studded with silver coins and is carried in a

122 Of the markers mentioned, music will only be discussed in its relation to poetry, dancing, and social change. For discussion of the rich music traditions in urban and rural Yemen see Lambert (1993), pp. 171–186, and (1997). See also Schuyler (1990), pp. 1–18, and (1993), pp. 45–51.

123 For details of dress in Sanaa, see Mundy, 1983. Yemenis have been interested in fashion since antiquity; Niebuhr, an eighteenth-century traveler to Yemen noted an interest in fashion in urban centers (cited in Mundy, p. 533).

J-shaped sheath mounted upright on a leather belt. Traditionally, only *qaba'il* wore the *jambiyya* of this shape and particular styles of sheath could distinguish tribal affiliation. Another item associated exclusively with *qaba'il* is the rifle, and more recently, the Kalashnikov. Arms carried by tribesmen reinforce the continued tribal association with warfare, even in times of peace.[124]

In contrast to the tribes, the dagger worn by the men of the religious elite had an ornate silver handle. Its sheath, made of embossed silver, was curved gracefully and mounted sideways towards the right. In the 1970s it was often worn over the *thawb*. Nowadays, men of all social strata in large urban centers can be seen wearing a white Saudi *thawb* with tribal *jambiyya*. This costume, which combines urban and rural elements, has increasingly come to represent the new cosmopolitan Yemeni.

It would appear that traditional status markers are disappearing quickly. Subtle markers remain, however. Whereas a certain nonchalance or carelessness is considered typical of tribal men's attitudes to clothes, members of the traditional elite and urbane tribal leaders are visibly more meticulous (see Mundy, 1983, p. 538). President Salih's rumpled shirt in the photograph described above is a parody of tribal attitudes and signals a good-natured and humorous identification with Yemen's tribal population.

Women's dress is less status specific than men's and varies more with region and economic standing. Wealthier women of all social status groups wear clothes made from more costly fabrics and more expensive jewelry than poorer women. Fashion changes tend to originate in the capital and progress into the surrounding villages. Women wear a dress, underdress, and leggings that vary according to fashion. With time, dresses have grown shorter, from ankle to knee length and loose shifts have given way to dresses gathered at the waist. Head coverings include several layers of scarves and bonnets, and these differ by region.

In Yemen, the veil is an important marker distinguishing urban from rural. A community is defined as urban if its women veil outside their homes and rural if they do not. The Turkish black *sharshaf* was adopted by some elite women of Sanaa during the reign of Imam Ahmad; it became an urban "uniform" after 1962 and is composed of a pleated wrap skirt and a triangular hood that covers the body down to the waist (Mundy, 1983, p. 539). The face is covered with a black gauze veil that

124 Warfare is no longer an issue in al-Ahjur. Although al-Ahjur's fertile fields were frequently raided in the past by its less fortunate neighbors, this has not occurred in recent years and al-Ahjur's last tribal war occurred a hundred years ago, according to folk reckoning.

can be lifted. The *sharshaf* worn before the revolution reached just below the knees. It has been getting progressively longer as attitudes towards women have become more conservative, and fashions have changed accordingly. In the 1990s new styles of *sharshaf* and *hijab* have proliferated in Sanaa as they have elsewhere in the Arab world.

As in other rural areas, women of al-Ahjur traditionally draped large woolen handwoven shawls loosely over their heads and shoulders when traveling between villages but did not cover their faces. This shawl, called *maswan*, was often layered and folded on top of the head in attractive ways. Considered to be beautiful and seductive, it was also worn indoors on dress occasions such as weddings. While in 1978–79 only the women of two urban based families wore the city *sharshaf* instead of the *maswan* in al-Ahjur, an increasing number of young rural women were wearing the *sharshaf* by the mid-1980s.

Wearing the *sharshaf* is regarded with some ambivalence in this society where the seclusion of women is a cultural ideal. On the one hand, it threatens rural women's cherished freedom of movement, as its length and bulk make walking on the rocky mountainous terrain difficult. On the other hand, the *sharshaf* is considered a sign of urban sophistication; a woman accentuates her status by veiling, implying that she is not necessarily available for all to see. Thus, the greater demand for the *sharshaf* reflects a greater identification with urbanism. It should be noted that whereas urban men of all social strata have taken on tribal symbols in their clothing, women have increasingly used clothing to identify with urbanism.

Cuisine
Cuisine also distinguished urban from rural Yemen. Bread baked at home and porridges made from the flour of locally grown grains and lentils (*'asit* and *matit*) are strongly associated with tribes and contrasted with foods classified as urban, notably whipped fenugreek (*hulba*), vegetable stews, rice dishes, and commercially baked loaf bread. Although tribal people eat urban foods, they consider local porridges to be more nourishing. Robust porridges are associated with the strength of *qaba'il* while more delicate foods are defined as urban.[125] A reliance on the more delicate urban foods is thought to weaken the body. *Qaba'il* may deride townspeople as weaklings by saying, *Ahl al-madina ghayr haqq al-hulba* ("Town people are nothing but *hulba* eaters"). Urban Yemenis, on the other hand, consider *hulba* to be a healthy aid to digestion.

With the decline in subsistence agriculture and the easy availability

125 While town dwellers may also eat *'asit*, they consider it simple food, not fancy enough to offer to guests.

of food imports in the 1980s, it became cheaper to buy imported foods than to grow or raise food locally. While most imported foods are as available to the rural population as they are in towns and cities, traditionally grown local foods have gained in economic value and fetch grossly inflated prices. Ironically, the consumption of *'asit* has declined markedly in rural areas since the 1970s, but its consumption in towns has increased because the dish has now acquired nostalgic value.[126] Again, urban Yemenis are acquiring rural habits while rural Yemenis are indulging in urban ones, thus blurring traditional distinctions.

Poetry

Nearly everyone composed poetry in traditional Yemen. Scholars composed long poems to express their feelings about social issues. Tribesmen composed poems to present their cases in dispute mediation. Women composed poems that they sang while grinding grain in order to influence decisions that concerned them, including marriage arrangements. And although it is said that *Bani Khums* do not compose poetry, the *muzayina* (female professional musician) of the community I lived in frequently sang her own compositions. I was also told that in communities close to Sanaa, women dancers (*qaba'il* and elite) would engage in poetic repartée with professional musicians. As is the case with dancing, poetic style is metaphoric of social life, and the various genres represent different aspects of the social fabric.

All Yemeni poetry is sung or chanted, and particular genres of poetry are associated with particular styles of singing. Some poetry is accompanied by drum, some by other musical instruments, and some is sung without instrumental accompaniment. Caton analyzes three genres of poetry performed in Khawlan al-Tiyal, southeast of Sanaa: *bala, zamil,* and *qasida*.[127] *Bala* is a poetic competition performed at men's wedding parties. As part of their responsibility toward their host, guests compose two-line poems. Poets perform singly, and each tries to outshine the one before him. Humor and teasing are significant components of this exchange. Insults may be traded. Yet, if an exchange becomes heated and threatens to degenerate into physical violence, someone always steps in with a concluding poem that ends the sequence.

Bala is a performance of verse and movement and involves three parties: the poet, chorus, and audience. The chorus, which decides the tune

126 Many Yemeni immigrants in New York City eat *'asit* daily as a sign of their Yemeni ethnicity.

127 The following description of tribal poetry is taken from Caton (1990). The discussion of *bala* is taken largely from pp. 79–126.

and the refrain, consists of two ranks of men who form a circle. One rank chants the refrain, and the other chants a part of the verse. As they do so, they move sideways to a slow beat. Meanwhile, the other guests are silently composing poems. When a poet has a verse, he enters the circle and chants the first hemistich while walking half the circle's circumference. The chorus may then chant part of his verse before he completes his, as he walks the remainder of the circle. When he is done, the poet exits the circle, leaving the chorus to chant the refrain. Then, he either re-enters the circle with another verse, or someone else enters the circle and tries to top his composition. The audience listens carefully to judge verses for their quality, appropriateness, and adherence to established rules of poetic composition. This game of challenge and response lasts for the duration of the party. Participation is required of all *qaba'il* present, and a good performance enhances the poet's honor. The focus of the event is on the performance itself: the act of composition, the poets' adherence to rules of rhyme and meter, and the suspense invoked during the competition. The actual verses are soon forgotten.

The poetic text is given greater emphasis in *zamil*, another genre of tribal poetry (Caton, 1990, pp. 127–179). A *zamil* is a two-line poem, composed by a single poet and chanted by two ranks of men marching towards an audience. It is performed when members of two or more families or villages meet, as is the custom during weddings, religious festivals, and the mediation process in tribal disputes. Styles in *zamil* performance vary with tribe. Thus, performance of *zamil*, like clothing, marks a group as tribal and identifies the particular tribe or region involved. The performance of *zamil* may be accompanied by drumming or *bara'* dancing.

Zamil poems are more politically oriented than those of *bala*. The text always addresses a specific issue, often a grievance. Parties and mediators in a tribal dispute will frame their points of view through *zamil* poems. *Zamil* is greatly admired as art, and the texts of good examples are recited repeatedly and preserved for generations.

Whereas *bala* is always performed indoors at night, *zamil* is performed outdoors. Melody is important in both *bala* and *zamil*, but the verb used to describe the recitation of both poetic genres is *sayyaha* ("to chant") rather than *ghanna* ("to sing"). While musical instruments are absent in *bala* performance, *zamil* may be accompanied by drumming. The drums used in this context are the *tasa* and the *marfa'* (two kinds of kettledrum). These drums also play important ritual roles in rural Yemeni society. During weddings, the *tasa* accompanies the groom to the mosque and back. Drumming on the *tasa* greets important guests from outside

the village and accompanies them to the host's house. It heralds announcements and *bara'* dancing, and its beat supports men engaged in cooperative work projects. The two drums are beaten to announce the beginning and ending of the fasting month of Ramadan. The beat of the *marfa'* alone, on the other hand, signals extraordinary events, such as a flood or a murder (Lambert, 1990). It becomes apparent that *zamil* events are intricately linked with tribal issues.

The *qasida*, the third genre of poetry discussed by Caton, is a long poem, composed by a master poet and delivered by messenger to another poet (Caton, 1990, pp. 180–248). The messenger may be a professional musician who will then set the poem to music and sing it. This type of singing, which may be accompanied by musical instruments and/or dancing, is called *ghina'* (from the same root as *ghanna*.) It is considered frivolous play and not as honorable as chanting.

Like *zamil*, a *qasida* is issue oriented, but it is defined as a personal response to historical situations which touch the poet's emotions. Of the three genres discussed here, it is the only one that may also be a love poem. Like the other two genres, a *qasida* requires a response, but the response may be separated in time and space. The poet who composes a *qasida* "sends" it, in writing or orally with a messenger, to another poet, who is expected to compose a response. In contrast to the other two genres of poetry discussed, the focus of the *qasida* is on the individual composer, and the topics covered need not be specifically related to tribal issues.

Qasida poetry is now distributed throughout Yemen via cassette recordings, and political questions are debated through this medium. W. Flagg Miller, who studied contemporary cassette poetry in Yemen, writes that traditional tribal metaphors as well as traditional food metaphors are used to discuss current events (Miller, 1996a). Currently, as in the past, tribal and national leaders try to influence public opinion through poetry. They try to keep poets on hand to compose for them, when they are not accomplished poets themselves. It is clear that poetry is a powerful political tool in this society, where power is exercised through persuasion, rather than coercion, and where political life is not divorced from social life.

While *bala* is not performed in al-Ahjur, tribal poetry is very much part of ceremonial and daily communication. I heard *zamil* most frequently in wedding processions. Many families hired a famous poet from the nearby town of Kawkaban to lead these processions and compose the verses that all in the procession would then recite. (Ironically, this poet was a member of the religious elite and would not be composing *zamil* if the community adhered strictly to the folk model of social structure

described above.) *Zamil* was also performed during the celebration of religious holidays by dancers as they walked from one dance site to another. Almost everyone in al-Ahjur listens attentively to *qasida* poetry sung on cassette tapes or on the radio, and they quote verses from poems to punctuate conversation. Professional musicians regularly compose songs of praise for guests at large parties; the person honored is expected to tip them. Women regularly recited verses of their own composition to express admiration or annoyance. Because women no longer grind grain by hand, however, they no longer compose poems at the mortar, and many younger women do not compose poetry at all.

Dancing

Two genres of dancing are performed in al-Ahjur.[128] The first of these, *bara'*, is recognized as one of the most important tribal markers in Yemen. *Bara'* is performed by men only to the accompaniment of drumming. By definition, all *qaba'il* perform *bara'*, just as they all compose poetry. Each tribe has its characteristic form of *bara'*, which differs from others in beat, steps used, and the ways in which performers wield their daggers. Thus, like *zamil* poetry, clothing, and arms, *bara'* performance identifies performers' tribal affiliation as well as marking tribalism in general.

The dance is performed out of doors, during weddings, religious holidays, cooperative work activity, whenever tribesmen travel together, and at home to honor distinguished guests. In other parts of the highlands, it is performed during the mediation of disputes, in conjunction with *zamil*. *Bara'* is also performed by leaders of the republic at important functions.

In al-Ahjur and the surrounding region it is performed in an arc formed by three to over twenty men, each holding a dagger in his right hand and a *shal* in his left. The men stand close enough to one another so that each can place a hand on his neighbor's shoulder or his waist, with elbow slightly bent (see **figure 14**). To the fast-paced accompaniment of one or two drums (no other musical instrument or chant is used to accompany *bara'* in this area) the men perform hops, skips, small jumps, slides, turns, and knee bends while brandishing their daggers above shoulder level. The line of dancers may reverse its direction of movement, or lunge forward towards the middle of the arc and step back. The coordination of steps to drumming is so close that it is not initially clear to the observer whether changes in rhythm are initiated by dancers or drummers. In practice, all eyes are directed toward a leader

128 Unless otherwise noted, the material presented here on Yemeni dancing and on tribalism is based on my own fieldwork. See Adra (1982), pp. 238–287, for in-depth discussion of dancing in al-Ahjur in 1978–79, and pp. 29–211, on the tribal concept.

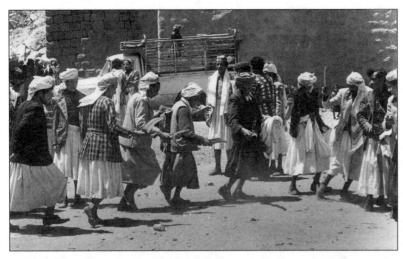

Figure 14. Tribesmen from al-Ahjur wearing tribal clothes and *jambiyya*. (Photo by Daniel M. Varisco)

who performs near the middle of the line of dancers; it is he who decides which steps to perform and initiates changes in rhythm. This leader is flanked by the older and more skillful dancers, while novices perform at the two ends of the arc. During a performance, others may join in, but always at the edges. As in most Yemeni dances, the performance is divided into three sections, each with a progressively faster rhythm. When all three segments have been performed and the line breaks up, two of the more adept dancers may perform a duet of complicated turns and grapevines, while others watch (see figure 15). Alternately, dancers leave the dance as they tire, until only two are left to perform this duet.

In the past, the "whole of al-Ahjur," the adult male population of some 24 villages, would perform together in what is reputed to have been a wonderful spectacle. They would begin near the bottom of the valley and dance their way toward the higher elevations in the course of an afternoon. Religious holidays were celebrated with dancing for a week or two. Yet in 1978–79, *bara'* was performed only by members of a single village together. They performed for a mere two days during each religious holiday. Members of the tribal as well as the nontribal population often commented on the decline of *bara'* performance, saying that it used to be performed more frequently, for longer periods, and by more people. By 1983, only one *muzayyin* connected to a four-village cluster knew the local traditional beat for the *bara'*.

In one village that prided itself on its modernity, young men taught each other new *bara'* steps from other parts of the country that they had seen on television or in Sanaa. This would have been inconceivable in the

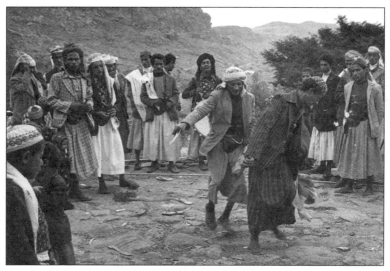

Figure 15. Duet performed at the close of a *bara'* on a threshing floor in al-Husn, al-Ahjur, 1979. Drummer, Salih Muhammad, is standing center rear. (Photo by Najwa Adra)

past, since *bara'* is believed to have survived unchanged since pre-Islamic times, like the tribal names with which various forms of *bara'* are linked.

As *bara'* performance in some of al-Ahjur's villages became half-hearted, this dance was revitalized in new urban contexts. By the l980s, *qaba'il* were going into Sanaa to celebrate religious holidays and performing *bara'* in the public squares of Sanaa instead of al-Ahjur.[129] This situation was common to other rural communities as well. *Bara'* could be seen on Fridays in the nearby town of Shibam, whose market had expanded fourfold in the span of a few years. Traditionally, *bara'* had always been performed during the day. Now, one could see it at night during weddings in Sanaa. Most surprising of all was that *bara'* was now regularly incorporated into the weddings of al-Ahjur's resident *sada*. This signature dance of rural *qaba'il* now seems to be favored by urbanites and *sada*.

The national government has appropriated *bara'* to represent Yemeni nationalism. Government officials perform *bara'* at formal functions, and national day celebrations include performances of *bara'* from all over Yemen. Yemen's professional dance troupe performs a choreographed version of *bara'* daily on television. The choreographed *bara'*, however, lacks the improvisation and spontaneity of the dance as it is usually performed. Since many Yemenis criticized the dance as "not *bara'*," Sanaa television has responded by bringing in expert tribal dancers to perform.

129 Until this time, those who lived in towns would go back to their home villages to celebrate holidays. Although the cities still tend to empty out during the holidays, they do not do so to the same extent that they did in the past.

Yemenis agree that *bara'* is dancing behavior, but they do not classify it as *raqs*. *Raqs*, the generic Arabic term usually translated into English as dancing, connotes frivolity. It is associated with light hearted play, music, and flirtation, and it is contrasted to the dignified public presence required of leaders and scholars. While the latter may perform *raqs*, they will do so only in the most intimate contexts. In fact, the appropriate contexts of performance of all genres of *raqs* are clearly delimited. To perform *raqs* outside these contexts is highly censured (see Adra, in Cohen [ed.], 1998, vol. 4, pp. 402–413). But *bara'* performance is not defined as frivolous; it is considered a demonstration of skill and valor, and thus legitimately performed by adult men in public.[130]

There is a second genre of dancing that is performed in al-Ahjur. It is called *lu'b* (lit., "play"), which is classified as *raqs* and is performed indoors, at night, to the accompaniment of love songs. Like *bara'*, it is highly appreciated by *qaba'il*, but unlike *bara'*, it is considered play, pure and simple. *Lu'b* is not said to symbolize tribe, and the performance of *lu'b* cannot normally serve as a tribal marker. *Bara'* and *lu'b* differ, not only in their contexts of performance and verbal associations, but in their musical accompaniment, identity of performers and audience, steps, and dynamics.

Lu'b is a couple dance performed by two women at gatherings of women, two men at gatherings of men, or in very intimate contexts, a man and woman together. In contrast to the immutability of *bara'*, *lu'b* is expected to change constantly as new steps and tempi are added and others deleted. As with fashion changes in clothing, changes in *lu'b* performance are usually initiated in Sanaa and take some time to filter to al-Ahjur. *Lu'b* may vary with region or village, and local dancing may be influenced by steps learned from other villages through travel or from visitors.

Lu'b is performed in the evenings and throughout the night during wedding celebrations. It is also performed at parties held to celebrate the end of a woman's postpartum seclusion, the circumcision of a boy, or at any other festive time. In the past, when a whole village would harvest crops together, *lu'b* would be performed in the evening after harvest.

These dancing events are held in the largest room in the village. Invariably, the room is packed with people sitting very close together on mattresses on the floor. The bride, groom, or new mother in whose honor the celebration is held sit in the farthest corner away from the door, as

130 Some scholars have argued that such performances not be classified as dancing, e.g., Shay (1995), pp. 61–78. The English term *dance*, however, can denote any rhythmic movement. It is the Arabic *raqs* that has more limited meaning, referring only to some forms of what is called dancing in English and not to others.

do any special guests of honor. Others fill in the space as they come in. The host or hostess does not sit with the guests, but rather caters to their needs and those of the musicians by serving them drinks and making sure that they are comfortable.

Musicians sit near the center of the room, and face a small space (about four feet square) that is left vacant for dancing. When two guests wish to dance, they get up and move into the dance space, vacating it after they finish dancing. The spectators watch the dancing while they converse with each other. Women may ululate or confer blessings on the dancers. If a dancer makes a mistake, it is recognized good naturedly with comments like "She/he lost the beat" or "She/he's going too fast." Verbal compliments are not usually given, but when a dance is performed particularly well, conversation stops.

The traditional *lu'b* performed in al-Ahjur in the 1970s only by older men and women was called the *la'ibiyya*. It is a slow dance consisting almost entirely of the two dancers, side by side and holding hands, slowly shifting their weight from one foot to the other while bending and straightening their knees. This creates a sense of flow, gently rising and falling. Until the 1940s, this dance was performed on top of a kerchief (*mandil*), and dancers had to restrict their movements to its boundaries.[131] The dance is performed in three parts, each with a different rhythm. When women perform this dance, the last part is extended into what is known as *nuwwash*. Each dancer will begin to rhythmically throw her head and upper torso forward and to the sides with increasingly larger movements until the movements themselves appear to separate the partners. Then the music quickens and the performers enter the crowd of spectators each from a different side of the room while they continue to fling their upper bodies. They travel in this manner through the crowd, and their paths cross at some point near the far end of the room, ideally before the bride or guest of honor. The spectators ululate and bless each dancer as she approaches them, and they may extend a steadying hand to her. The dancer may stop to perform for short periods before a friend or an honored guest, but both dancers will eventually make their way back to the musicians whom they will kiss to signal the ending of the dance. *Nuwwash* is characterized by considerably greater abandon than is found in any other parts of the dance. Traveling among the spectators in *nuwwash* is called *khidma* (lit., "service") and is done as a gesture of respect to spectators (*ihtiraman lahum*). It is recognized as the expression of deep heartfelt emotion, and often performed by women whose person-

131 Personal communication from al-Sayyid 'Abd al-Karim Muhammad Sharaf ad-Din, Kawkaban, March 10, 1979.

al lives are unhappy. Men in al-Ahjur do not perform *nuwwash*.

The traditional dances are not appreciated by the younger members of the community. Conversation level among spectators is notably higher during performance of the traditional dances than it is when contemporary dances are performed, indicating a lack of interest. Nevertheless, these are the dances that are performed during an important protective wedding ritual (*mashajib*) at both women's and men's wedding festivities.

Younger women perform variations of another dance. The *dasa'*, named after the beat of the first part, involves more complicated footwork. In the first part, each dancer outlines a square on the floor through a series of weight shifts forward and back. This is punctuated by small, quick circles drawn by the left foot as it is held slightly above floor level. Dancers may turn and perform with their backs to the audience for some of the time, while remaining side by side. The second part has a faster beat and more complicated footwork. A square is also outlined on the floor, but it is done with considerably more flourish, with faster turns, and the focus of the body remains forward. A good dancer barely touches the floor during this segment. The last part is also fast, but the step is a simple sideways weight shift like that of the older *la'ibiya*. In the 1980s, the more accomplished dancers followed contemporary Sanaa fashions and skipped the first part of the dance, beginning with the second part, embellished with more complicated steps.

Men's dancing differs in the use of space. Men face each other and move around each other instead of dancing side by side. They hold daggers in their right hands, and hold each other's left hand. Some men also shimmy their upper bodies during dancing (see **figure 16**). In both women's and men's dancing, close friends or relatives usually dance

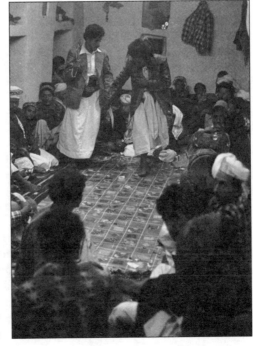

Figure 16. Men performing *lu'b* at a wedding in al-Ahjur. The two professional musicians are seated on the right. The man is playing *mizmar*, while his sister, who is veiled and seated next to him, plays drum. (Photo by Daniel M. Varisco)

together. Changes in beat and length of duration of the dance are decided by the lead dancer, as they are in *bara'*.

Whereas *bara'* is performed to drum alone, *lu'b* is accompanied by song and a variety of musical instruments: *'ud* (lute) in urban or urbane settings; *mizmar* (a double reed flute), *sahn* (a form of cymbal in which a copper tray is struck by a ring) and kettle drum in the countryside and by rural folk in towns. Professional musicians are hired to accompany *lu'b* at large parties. *Mizmar* is played by men, while the *sahn* is played by women.

Song lyrics are important to the appreciation of the dance. In urban settings, they may be *qasida*s set to *'ud* music. Songs that accompany *mizmar* are usually love songs or involve praises to the Prophet Muhammad. Lyrics which are chosen by the musicians also may provide social commentary and praise and criticism of the dancers. Yet song lyrics considered appropriate for *nuwwash* are always religious and meant to support and protect the dancers.

Classified as *raqs*, *lu'b* performance is not considered dignified behavior, and its legality in terms of Islamic law is open to debate. The *mizmar*, in particular, has sexual connotations. It is jokingly referred to as the cock of heaven (*dik al-janna*). The act of playing the *mizmar* is said to look indecently phallic because the player's blown up cheeks resemble testicles (Lambert, 1990, pp. 315–316). The last two imams of Yemen banned *lu'b* performances in Sanaa, officially for religious and moral reasons, but apparently because sung poems were often critical of the imamate. Even during the ban, however, residents of Sanaa continued to perform this dance. They stuffed their windows with cushions to muffle the sounds of music or transformed the first floor windowless storage area into a sitting room (*diwan*) so that they could dance undetected.[132]

Both *bara'* and *lu'b* have undergone change. The changes in *lu'b* performance are expected, since change is a defining element of this genre of dancing. Changes in *bara'* and the decline in its performance were more disturbing to residents of al-Ahjur. In general, they blamed declining energy levels. They would argue repeatedly that due to prosperity and the availability of modern technology, people no longer had the stamina to perform *bara'*. They blamed auto transportation as well as the availability and consequent dependence on new, "weak" city foods, such as rice, sugar, wheat flour, and soft drinks. Some said that, due to migration, there were not enough *mazayina* around who knew the appropriate *bara'* rhythms. Innovations in *bara'* performance introduced by young

132 Ironically, in spite of the ban, Imam Ahmad was reputed to be fond of *lu'b* and an accomplished performer.

men were severely criticized, and older men, the traditional leaders of *bara'*, refused to participate in the new dances.

The Tribe and Its Markers
An appreciation of the extent to which the images described in the previous sections replicate and construct tribal identity depends upon an understanding of what tribalism means in Yemen.

The Tribe in Context: The Traditional Model of Social Status
The tribal population forms the large middle grouping in the traditional three-tiered model of social structure described earlier. Yet the model alone does not indicate the extent to which all social status groups depended on the tribes economically and militarily. The religious elite was ascribed the highest social status, mediated intertribal disputes and served as healers and Quranic teachers. In return for their services, they were paid in agricultural produce, land, or sometimes currency. During the Zaydi imamate, members of the elite were in a good position to accumulate wealth, since tax collectors were recruited from this group. The religious elite was associated with towns and identified with urban civilization. Those who lived in rural areas actively maintained ties with relatives living in towns and contrasted themselves with less sophisticated country folk.

Bani Khums, who were also defined as nontribal, held the lowest status positions in this society. Yet they shared some characteristics of the elite in their dealings with *qaba'il*. Both groups were protected by tribal customary law. It was considered a major felony for a tribesman to hurt a member of a protected group. Both groups were associated with towns and markets and both were paid in cash or agricultural produce for their services. In contrast to the elite, however, *Bani Khums* were not permitted to own land before the revolution. It is interesting to note that tribal valuation of economic independence compromised the respect due to members of the elite as well as *Bani Khums* who depended on wages for their subsistence.

Between the religious elite and *Bani Khums*, in a system of mutual dependence, were the tribes. The Yemeni tribe is a territorial unit as well as a political and military unit. Lip service is given to a genealogical segmentary ideology. That is, *qaba'il* are likely to explain the unity of a tribe or tribal segment in terms of "sharing an ancestor" (*jad wahid*). In practice, however, mobility between territories and shifting allegiances lead to fluidity in tribal membership. Essentially, Yemeni villages and tribes are cooperative territorially based units whose members owe each other specified sets of responsibilities (Adra, 1982, especially pp. 115–132; Bédoucha, 1987, pp. 139–150; Dresch, 1989; Gingrich, 1989b, pp. 127–139).

The Tribal Honor Code

Qaba'il are considered to be descendants of Qahtan, the eponymous ancestor of southern Arabs, and they maintain genealogies to a depth of five to seven generations. This contrasts with *sada*, who are descended from 'Adnan, ancestor of northern Arabs, and who trace their genealogies to the Prophet Muhammad. *Bani Khums* lack a genealogical status that is recognized by *qaba'il* and *sada*. Occupation also serves to define the tribes. *Qaba'il* of the northern highlands are primarily small farmers who own some land which they supplement with a variety of sharecropping and rental arrangements.

Qaba'il are also defined as those who adhere to customary law. This is a flexible set of principles and precedence that is based on consensus and persuasion rather than coercion (Adra, 1982; Caton, 1990; Dresch, 1989) and on the inviolability of one's word. That is, if someone agrees to an arrangement, he or she is honor-bound to abide by it. Disputes are mediated by those who are cognizant of the principles of customary law and who are not directly involved in the conflict. Ideally, these are members of the nontribal elite, or they may be tribal leaders from other regions. The resolution of disputes is sealed with the sacrifice of animals of varying value, according to the seriousness of the breach involved, and all parties are expected to partake of the meat together. Also implicit in customary law is an egalitarianism that belies the societal status distinctions described above in that its dictates do not vary according to the wealth or power of disputants.

Customary law helps define and regulate a tribal honor code that, more than anything else, serves to define *qaba'il* to themselves, and by others. In accordance with this honor code, a *qabili* is defined as someone who is courageous and generous, recognizes his obligations toward protégés, is faithful to his word, values his autonomy, and is industrious. This picture also forms an important element in urban stereotypes of the *qaba'il*, and numerous verses of poetry have historically lauded these virtues (al-Mas'udi, 1865, p. 236; al-Hamdani, 1884, p. 194). Piety is also an important component of tribal self-definition (Caton, 1990), although one that is not recognized by the elite. These ideals provide the standards of honor with which *qaba'il* are judged. They are not intended to define personalities. No one thinks, for example, that individual *qaba'il* cannot also be weak, dishonest, or stingy.

Among Yemenis, conversations about the tribe and what it stands for are usually couched in terms of males and their responsibilities. This is not to say that women are not recognized as tribal. Women actively work towards the construction of family honor as men do, and their informal

input is important in the resolution of disputes. Some tribal women, especially of the eastern desert, are known for their marksmanship as well as their tribal poetry. But tribal women are not displayed as tribal symbols, and they do not participate in public rituals.

The complex of law, values, and ideals of expected behavior is known in Yemen as *qabyala* (Adra, 1982, pp. 139–160).[133] In al-Ahjur the term refers to honor and valor and signifies beauty as well. A primary component of *qabyala* is, of course, tribal political organization, with its emphasis on autonomy, resistance to authority, and an ethic of the equality of leaders to constituents. Tribal customary law perpetuates and protects *qabyala*. Moreover, *qabyala* refers to proper and honorable behavior according to accepted standards and to a tribal aesthetic. Also described as *qabyala* is a beautifully and appropriately dressed man or woman. For the tribal population of the northern highlands *qabyala* represents the good, the true, and the beautiful.

The tribal honor code was respected by all members of Yemeni society. Although many of the elite associated tribalism with warfare and arrogance, they recognized that *qabyala* connotes values that they also cherished—integrity, responsibility, hospitality, and courage. In important ways, all members of the population aspired to be seen as espousing these tribal ideals through their behavior.

While *qabyala* is the motivating ideology for appropriate behavior in public contexts, it masks the importance of strong agonistic pulls that are also integral to this culture. The intense cooperation idealized in *qabyala* is not a communalism. It is a cooperation of distinct individuals with recognized divergent interests. A positive valuation of political and economic autonomy is basic to customary law, but there are contexts in which autonomy is assumed that are potentially disruptive to the cohesion demanded of *qabyala*. These include, for example, the pulls of romantic love, friendship, economic interests, and personal whim, which may come into conflict with the demands of kin and tribal affiliation. The way in which these potentially disruptive components are dealt with in Yemen (and elsewhere in the region) is to keep them out of the public gaze. Nevertheless, they are not repressed; their expression is permitted and encouraged, but only in prescribed, carefully bounded contexts that are defined as intimate. Caton comments that there is no single word for autonomy as there are for other recognized components of honor, e.g., piety, generosity, courage (Caton,

133 The term *qabyala*, which is derived from the same root as *qabila* and *qaba'il*, is purely Yemeni and not found in other dialects of Arabic, although it appears to be synonymous with the Arabic *muruwwa*.

1990, p. 31). This may well be due to the ambivalence surrounding the concept of autonomy in this culture.

Historically, the roles of *qaba'il* as Yemen's warriors were utilized rather than diffused by the imamate which relied on tribal support for a fighting force and a tax base. More recently, the civil war that followed north Yemen's 1962 revolution was fought largely by tribesmen. While the elite admired the courage of *qaba'il* as warriors, they also feared them as destructive and too easily roused to anger. In South Yemen, *qabyala* is defined as "tribal arrogance" by those who disapprove of tribalism. As Dyer has observed, "cultural forms do not have single determinate mean-ings—people make sense of them in different ways" (Dyer, 1993, p. 2).

The Crude and the Rude

An urban/rural distinction that cross-cuts the social stratification model described above perpetuates this ambivalence even further. The tribes are defined as rural, while members of the elite and *Bani Khums* are associ-ated with market towns. Yet even this opposition of urbane town dwellers to rural rubes is marked by ambivalence. On the one hand, the perceived leisure and wealth of townspeople are envied by rural *qaba'il*, and the "sophistication" of urban life is sometimes contrasted positively with the "simplicity" of tribal life. Not infrequently, *qaba'il* will apolo-gize for their simple cuisine and their ignorance of the outside world by saying ruefully, *Nahnu ghayr qaba'il* ("We are only tribespeople"). *Qaba'il* will disparage city folk for their "weak legs" and contrast this weakness to their own physical endurance.

Urban life is considered by all to be easier than farming and rural chores. Although *qaba'il* may envy urban leisure, they set great value by hard work. Their perception of themselves as industrious is an important component of their own tribal identification. So when a plump town dweller is described as *muftin* ("comfortable"), the term also has sarcas-tic connotations of idleness. A humorous verse illustrates this attitude:

Qad qultillak la tishfaq al-ghalida
Yawmayn thalath taqul 'Ana marida.'

"I told you not to fall in love with a heavy woman.
In two or three days, she'll say, 'I'm sick.'"

In other words, if one falls in love with and marries a heavy (i.e., comfortable) woman, she will feign illness to avoid her chores. Town dwellers, on the other hand, compare their life of relative leisure favor-

ably to rural hard work, and urban women value body fat over slim figures. Nevertheless, they often express their admiration for the strength and endurance of *qaba'il*.

Another area of ambivalence concerns different sources of knowledge. While the religious elite may disparage tribesmen for their ignorance of religious law, *qaba'il* disdain the urban population for their ignorance of customary law. Compare this with Caton's description of the urban educated attitude towards colloquial (largely rural) poetry, "denigrating it for its supposed ungrammaticality while at the same time admiring it for its spontaneity and wit" (Caton, 1990, p. 23). Members of the *Bani Khums* use these ambivalent attitudes to their advantage. While those who live in rural areas participate actively in tribal life, they self-consciously adhere to urban rather than rural fashions in dress, thus turning the hierarchical model on its head. They may ally themselves with the urban elite in informal conversation, implying their perceived superiority to the farmer whom they refer to as *sahib al-baqara* (rube, literally, "cowman"). Thus, relations between Yemen's social strata is characterized by mutual dependence and a simultaneous mutual disdain and admiration.

Tribal Dominance

Although the tribal population technically fell into the middle position of traditional northern Yemen's three-tiered social stratification system, tribal dominance was the established fact, historically, during the time of fieldwork in 1978–79 and well into the mid-1980s. Several factors restrained the expression of the stratification implied in the folk model of the social structure. The religious elite and the client groupings depended on the tribes economically and militarily; tribal customary law did not grant anyone coercive power; and both customary law and Zaydi Islamic law were egalitarian in principle. Furthermore, the tribes protected and fed the country in their roles as warriors and farmers. In return they received needed services. *Qaba'il* could not remain tribal in the absence of the elite and *Bani Khums*; neither would these groups have a *raison d'être* in the absence of the tribes and tribal institutions. Finally, the tribes were associated with an honor code that was admired and emulated by all members of the society.

Changes: Images of a Nation

Beginning with the revolution and the establishment of a republican central government, the relationship between tribes and government began to change. This shift was aided greatly by televised images attest-

ing to the power and benevolence of the government.[134] The president was shown daily receiving ambassadors, conferring with other heads of state, ministering to the needs of the country, and leading the army. The array of military hardware shown on television engendered the respect of a people who associated warfare with honor. Many *qaba'il* joined the army, thus forming new allegiances to a national, rather than regional, body.

As government services, such as roads, hospitals, clinics, and schools, expanded to al-Ahjur and other tribal regions, *qaba'il* began to recognize benefits to a strong central government. Participation in the world market economy and the subsequent decline of subsistence agriculture, made a myth of tribal economic autonomy. Migrants returning from Saudi Arabia brought with them new attitudes and the desire for more urbanized lifestyles. Tribal self-definitions have altered. Their lives are no longer so rugged as before. Those who remain farmers can now buy, rather than collect, fuel wood. They travel by truck and light their homes with electricity.

Schools and television affected the ways in which other Yemenis were perceived as well. During the 1980s students in school learned the new national anthem and participated in discussions of the national charter. Through television they became aware that countless other Yemenis were also participating in such discussions. Television programs featuring rural life showed *qaba'il* farming, reciting tribal poetry, and performing *bara'* and other dances. While such programs brought to awareness the diversity found in Yemen, they also stressed the commonality of all Yemenis. It could be seen that all Yemenis shared in valuing *qabyala*. A new sense of nation as an "imagined community" developed (Anderson, 1991).

A new, largely urban understanding of Islam was imported, along with nationalism, and taught in schools. This is a conservative interpretation of religion that encourages the veiling and seclusion of women, discourages *raqs* dancing and music, all night wedding celebrations, and recourse to customary law. This point of view, which presents itself and Islam as nationalist, is self-consciously antitribal.

By the mid-1980s, people who used to refer to themselves as qaba'il were now likely to use the term *fallahin* (farmers, peasants). This term, which is most often used on television for Yemen's rural population, does not imply a tribal honor code. An increasing number of families began to refer their disputes to the government court, instead of relying on tribal mediation techniques. Simultaneously, a number of tribal markers, such as *bara'* (and *bala*) declined in importance.

134 Television transmission reached al-Ahjur in the spring of 1979. See Adra (1996) for a discussion of the impact of television on Ahjuri perceptions of themselves and others.

Signs of Tribe and Tribalness

Given the tribal system described above and the changes brought about by modernization, how do old and new tribal markers signify Yemeni tribalism? Or, in Bateson's terminology, what information do the markers and the tribal system contain about each other? Tribal clothing styles were indexical of social status groups. To the few older men who continued to wear the highly elaborate, flowing garments and cumbersome sleeves of the traditional urban elite, this has become "a symbol of the old order" (Mundy, 1983, p. 538).

The arms carried by *qaba'il* index their roles as warriors and protectors of the weak. The upright and utilitarian tribal *jambiyya* is iconic of tribal definitions of self. That urban men of all strata are now wearing this style of *jambiyya* indicates an identification with tribal values. That young tribal women are now wearing the urban *sharshaf* as an item of dress clothing signals a shift in identification and an increase in the values ascribed to urban life.

In terms of poetry, *qaba'il* play at being tribal in the *bala* event. *Bala* performance not only establishes the honor of individual poets, it also signifies *qabyala*: the ideal tribesman, autonomy and its relationship to tribal cohesion and the egalitarian ethic. Through poetic content and the structure of the event, younger *qaba'il* learn the attitudes and behaviors expected of them. To compose a poem is a guest's responsibility to his host; the mutual responsibilities entailed in the guest/host relationship is itself a metaphor of tribal relationships (Adra, 1982, pp. 180–184; Gingrich, 1989a). The structure of the *bala* is an icon of the principles of tribalism. The chorus both supports the poet and establishes the tune that he has to follow. When the poet recites his composition, he stands alone and is allowed space in which to express himself. Anyone at the party may compose a poem, just as all are equal under customary law. The three groups—poet, chorus, and audience—replicate the three parties necessary for dispute mediation. The element of competition—of challenge and retort—represents the opposition that exists in this system between tribal units.

Caton argues further that this poetic genre is symbolic violence. He writes that, *bala's* challenge and counterchallenge is "like a gun . . . a weapon by which a man wins and defends his honor" (Caton, 1990, p. 28). Moreover, as symbolic violence, poetry restrains the uncontrolled passion that may lead to actual violence (p. 30). All of the poetic genres discussed—*bala*, *zamil*, and *qasida*—are iconic of the value placed on self-control:

When we see . . . how massively the poet is restricted by conventions of meter, rhyme, alliteration, and line structure, we can

appreciate the control, the self-possession that this art form requires. Yet the poet is not suppressing or muffling his emotions. In the poems he speaks of the great passions that events have stirred in his breast and that have moved him to compose verse. Thus, the good poet may vent his passions but always in perfectly controlled technique. (Caton, 1990, p. 31)

This is a perfect metaphor of the relationship between *qabyala* and the agonistic side of tribalism. Within specified constraints, a tribesman is encouraged to express his emotions.

The *zamil* also replaces coercive force with persuasion, and is thus a tool that preserves the autonomy and honor of *qaba'il*. (Caton, 1990, p. 13). In an egalitarian system that does not incorporate any accepted means of coercion, peace can only be maintained through successful efforts at persuasion. This explains the power of poetry in dispute settlements.

The *qasida* similarly holds considerable persuasive power. This genre, with its focus on the individual composer and its musical and dance accompaniment, replicates and constructs the more agonistic, emotive side of tribalism. (To some extent, the bawdy humor and focus on individuals in competition of *bala* performance also does this.) The three genres of poetry together, with their contrasting styles and contexts of performance replicate the two sides of tribalism—*qabyala* and that which it masks.

Changes in the poetry, such as shortening the formulaic greeting and greater emphasis on the message, bring this poetry in line with newer, urban attitudes and behaviors. With this new model, the *qasida* is redefined. Yet even more recent poetry is actively incorporating traditional tribal and food metaphors. This is another case in which tribal images have been revitalized by young urban Yemenis. It is, as Miller observes, "a kind of self-reflexive metacommentary on traditional ways of life and expression that many find highly engaging" (Miller, 1996a, p. 7).

Dancing, like poetry, is thought to be inherently Yemeni. At a party in Sanaa, I once heard an older woman chiding a young woman who told me that she did not know how to dance. "Are you Yemeni?" the older woman asked. In reply to my friend's affirmative, she said emphatically, "If you are Yemeni, you can dance!"

As the various genres of poetry replicated all aspects of tribalism, the same iconicity is readily apparent in the opposition of *bara'* to *lu'b* in the dancing of al-Ahjur. *Bara'* presents the ultimate *qabyala* behavior, structurally analogous to the *bala* discussed above. *Qaba'il*, by per-

forming bara' outdoors in plain daylight are showing off and con-
structing their *qabyala* to themselves, each other, and to any strangers
present. That the leader performs in the midst of the dancers and is not
distinguished by any particular markers other than his skill in dancing,
is iconic of the egalitarianism in tribal society. The duet at the conclu-
sion of a *bara'* highlights individual virtuosity. Yet the fact that it is
optional and not an intrinsic part of the performance reinforces a non-
hierarchical message. Performers flourish the tribal dagger, and some
carry rifles while performing, both signals of tribal affiliation. Someone
who does not own a dagger, or does not have his with him, will borrow
one in order to perform. These also reinforce the association of the trib-
al population with warfare.

Performing *bara'* requires endurance as well as skill, a reflection on
the value placed on hard work. The skill required in performing *bara'* is
the ability to coordinate one's movements with others and with music in
a small space, where lack of such skill and coordination would certain-
ly result in upsetting the performance but might also result in physical
injury. These are exactly the skills required of *qabyala*—to be very much
aware of what others are doing and to adapt and coordinate with them.
In *bara'*, skilled performers gently help guide those who are less skilled
with a touch of the hand. Similarly in real life, tribesmen are expected
to help those in need. Performing *bara'* is considered a performance of
skill and a demonstration of honor—of *qabyala* and all that it means to
be tribal (Adra, 1982, pp. 274–287).

Lu'b, on the other hand, expresses and constructs the agonistic sides
of tribal life. That *lu'b* is performed indoors, at night, away from public
gaze, defines the appropriate contexts for intimate behavior.[135] Further,
there is more room for personal expression in the performance of *lu'b*
than there is in *bara'*. Whereas all tribal men in a particular community
are expected to participate in *bara'*, performance of *lu'b* is determined
purely by individual whim. Improvisation in *lu'b* is more idiosyncratic
and focuses attention on the individual performer. The small space avail-
able for *lu'b* performance is metaphoric of the clearly bounded contexts
in which such free expression is permitted. The message is clear:
"Express yourself, but do so within accepted contexts." The available
space for *bara'* performance, in contrast, is potentially unlimited. One
can perform anywhere outdoors. This then explains why *lu'b* perform-

135 Whereas large celebrations are not at all "private," neither are they contexts that
are openly displayed to people defined as "other." A person's skill in dancing *lu'b* is
admired, but it does not form part of general conversation and may not be general
knowledge in the way that honorable behavior can be.

ance is not accorded the dignity of *bara'*. A society that values *qabyala* as the ultimate in dignified presentation behavior will not flaunt its agonistic, deeply personal side.

The following words, given to me by a Yemeni poet, support the notion that poetry, dancing, and agriculture are all metaphors of *qabyala*:

'allim ibnak li-l-shara'a wa-l-bara'a
wa-l-'amal bayn al-zira'a
wa dakhlat al-suq kulli sa'a.

"Teach your son poetic composition and bara' performance,
and work in agriculture,
and regular attendance at the market [lit., enter the market
 every hour]."[136]

Shara'a refers to poetry, but it can also denote adjudication, as in tribal customary law or even Islamic law (*shari'a*). *Bara'a*'s most concrete denotation is the performance of *bara'*. Also intended is a pun referring to generosity. Farming is clearly a reference to the signature occupation of *qaba'il*. "The market" refers to weekly rural and permanent urban markets that were traditionally the social center of tribal life. The person who frequents the market participates fully in tribal life. A tribesman, then, must be knowledgeable in tribal law and lore, generous, a bara' performer and a poet, as well as a farmer.

In sum, poetry and dancing, like the *jambiyya*, tribal clothes, and rural foods, are signs of the tribe. Particular genres of poetry and dancing are iconic of various components of tribalism, and some are indexical as well. With the changing relationship of the Yemeni tribe to the central government and to other countries came a devaluation of many tribal symbols. Many of the old images were no longer satisfying; what they expressed was no longer relevant. Paradoxically, some tribal markers have been revived with considerable enthusiasm in urban contexts. They have come to symbolize a new Yemeni who is somehow both tribal and urban. This is readily apparent in the new poetry, which uses tribal imagery to discuss issues of nationhood, in *bara'*, which has come to represent identification with the Yemeni nation rather than a particular tribe, and iconically, in the new urban costume, which superimposes the indigenous *jambiyya* on the imported *thawb*.

136 Personal communication from al-Sayyid 'Abd al-Karim Muhammad Sharaf ad-Din, Kawkaban, March 10, 1979.

Conclusion

Aesthetic markers are not marginal to changing concepts of tribalism. The relationship between artistic process and its culture is one of mutual feedback carried on through performers and audience. As the traditional model of the self-subsistent tribe began to lose its relevance in Yemen, so did the appreciation of its aesthetic representations. Enthusiasm and support for the performance of tribal symbols waned. Young *qaba'il* began to experiment with new forms that better signified their changing allegiances and identities. Yet the new forms did not entirely reject traditional values.

Political changes in Yemen are not dissimilar to those in other Arab countries where nationalism is attempting to supplant an indigenous tribalism.[137] What happens when nationalism, with its causal chronological view of history and backed by military prowess, comes to define modernism in a society based on tribal values?

> In Yemen, tribalism and nationalism are being explored in discourses, of nationalism, tribalism and regionalism . . . set not so much *against* one another—as advocates of the modernization paradigm have argued—as *in correspondence* with one another through persuasive and popular visions. (Miller, 1996a, p. 4)

President Salih has repeatedly denied that Yemen was moving away from tribalism. In a newspaper interview in 1986, he declared, "The state is part of the tribes, and our Yemeni people is a collection of tribes" (Dresch, 1989, p. 7). Important tribal leaders have all established a presence in Sanaa to safeguard tribal interests.

Tribal images—*bara'*, poetry, and costume—are appropriated on television, at government functions, and by the President himself. These are combined, however, with new instrumental music ensembles and imported choreographed dances. An operetta, *Maghnatu Sadd Wadi Saba'* ("The Song of the Sheba River Valley Dam") was commissioned to celebrate the opening of the reconstructed Marib dam. Itself an imported genre, it included a mixture of traditional and imported musical and dance forms (Schuyler, 1993; see ch. 18). All of these are framed within new urban, cosmopolitan contexts that render issues such as tribal political and economic autonomy meaningless.

137 Layne (1989) describes an analogous situation in Jordan, where tribal symbols have been appropriated by the state to foster nationalism. There are significant differences between the two countries, however. Not least of these is that the Yemeni president and most government officials are themselves tribal, whereas the Jordanian royal family is not defined as tribal. See also, Shryock (1997).

A modern sixth grade textbook criticizes "tribal clannishness" as divisive, while it gives credit to the tribes for cooperation, courage, generosity, for protecting the country from foreign invasion, and for ridding it of "tyrants" (Dresch, 1989, p. 390). While tribal egalitarianism, courage, and cohesion are praised, identification with particular tribes is discouraged. Regional particularism in words of songs or steps in *bara'* are modified towards greater uniformity.

In the name of religion, modernism, and respectability, the agonistic components of tribalism—all-night dancing, bawdy humor, mobile women—are discouraged. This does not differ from the elite condemnation of these behaviors in the past. The difference is in the number of *qaba'il* who have come to accept and identify with this reconstructive point of view.

Urban youth are, on the one hand, rejecting some of the trappings of tribalism, while at the same time, they are reveling in others: wearing the *jambiyya*, eating tribal food and using tribal metaphors in poetry. The ambivalence and flexibility that has been characteristic of traditional Yemen still operates.

It has been difficult, in this discussion, to separate descriptions of culture change from images that represent culture change. The reason is that the sign and that which it signifies are always closely intertwined. Like Bateson's Balinese painting, tribal markers depict, replicate, and construct a changing tribal identity. Wearing tribal clothing, performing tribal dances, and composing tribal poetry constructed images of ideal *qaba'il* while they simultaneously fostered an appreciation of tribal values. As these values have been reinterpreted, so have the markers changed. The aesthetic forms of a society appear to work together to construct notions of personhood and society. In this case, tribal notions of honor, equality, and cooperation are integrated with an urban, cosmopolitan nationalism.

On the key chain described at the beginning of this chapter, the dancing scene only mimicked a traditional *bara'* performance. The *qaba'il* in the photograph are not wearing the *futa* and vest or jacket. Their costume combines the newly fashionable *thawb* with a modern imitation of the traditional vest that has come to represent tribalism in televised dances. In the end, the message is that tribalism is good, but not exactly as it was.

11 Race, Sexuality, and Arabs in American Entertainment, 1850–1900
Lori Anne Salem

In the latter half of the nineteenth century, American popular entertainment was peppered with Arabs. In addition to the high-profile and popular staged versions of Cleopatra, "Ali Baba and the Forty Thieves," and other stories from the *Arabian Nights*, there were a host of low-budget, low-prestige Arab acts, including acrobatic troupes, Arabian giants, *danse du ventre* artists, dervishes, and more. Most of the performers were Americans, not Arabs, though it hardly matters: the performances were so thoroughly encased in a theatrical idea of "Arabness" that no performance could have been real or authentic in any meaningful way.

In the discussion that follows, I describe a number of these acts in detail. This detail is warranted because, with a few exceptions, these performances are largely missing from histories of the American theater. Thus, part of the purpose of this article is simply to uncover a previously shaded corner of American entertainment and to connect it to the art and literature that preceded and responded to it. I read these performances, as I believe American audiences did, against then current notions of body, sexuality, and race. It is true that these acts, like all theatrical acts, also speak of gender and class: race, gender, and class are always inscribed on the performing body, often in overlapping and contradictory ways. However, my purpose here is to tease out the part of these acts that is about race, not because the other analyses are less important, but because Arab acts in American entertainment have something to say about race that other theatrical forms do not.

Previous studies of Orientalism have focused largely on texts and, to a lesser extent, on art and advertising images. These studies have been valuable in defining the terrain of Orientalism, and part of my aim in this article is to add to this literature. I argue that Arab acts in American theater had a particular importance in the development of Orientalist thought because they were enacted by a body-in-person: the performance by an actor or dancer on stage had an in-the-flesh persuasiveness to it that textual Orientalism did not.

One might wonder about the value of studying Arab acts in American theater at all; after all, there was no compelling social or political connection between Arabs and Americans in the nineteenth century. There was no significant Arab immigration to the United States until well into

the twentieth century, nor was the United States a political force in the Arab world. But this lack of direct contact is itself significant. In his study of blacks in Germany, Sander Gilman develops the point that imagined racial interactions assume an enlarged, fantastic quality that is missing in arenas of direct contact (Gilman, 1982, pp. xi-xiv). When they are divorced from real interaction, racial images assume a malleable and freewheeling imagination. Moreover, as I will argue, "fantasy" races offer a convenient ground for exploring the complexities of "real" racial conflicts. Therefore, I argue here that the Arabs acts in the American theater contributed not only to the development of Orientalism, but also to both defining the American self and negotiating the black-white racial conflict that characterized the American social arena in the late nineteenth century.

Freaks by Definition, Part I

In the 1850s, P. T. Barnum's American Museum featured a performer named "Colonel Goshan" who was an Arabian giant. Goshan appeared in full military regalia and his act consisted of telling stories about his life and his abnormal physical size. The museum published and sold copies of a pamphlet, *The History of Palestine and the Present Condition of Old Jerusalem and the Life of Col. Routh Goshan* (New York: Popular Publishing Co., 1880), that reproduced the stories as well as engraved drawings of the giant (see **figure 17**).

How audiences read Goshan's act was undoubtedly influenced primarily by the setting in which he appeared. The American Museum was a prestigious and established version of what was then known as a dime museum or a curiosity show. Typically housed in a storefront or tent, the curiosity show was essentially a series of booths occupied by human and animal oddities. The shows presented themselves as educational forums for studying the hierarchical ordering of plants, animals, and especially the human races that was the cornerstone of Victorian race theory. Many museums hired scientists to give lectures explicating and authenticating the uniqueness and scientific value of each curiosity. The scientific and the entertainment agendas of the curiosity shows produced a logical contradiction: each oddity was advertised as unique, but in the case of the "exotic," non-Western oddities, it was also presented as a specimen representative of a broader racial "type." Thus, the abnormality of an American "monkey-woman" was truly a unique curiosity that attached to no one but herself, whereas the abnormality of an Arab "monkey-woman" was representative of the curiousness of the Arab race.

Historian Robert Bogden, who traced the development of the dime

museum into the twentieth-century freak show, demonstrates that the "freakishness" or oddity of these human exhibits was largely not a function of their physical attributes, e.g., extreme height in Colonel Goshan's case (Bogden, 1988, pp. 104–106). Rather, it was a set of visual and discursive frames through which the audience viewed the freak. Thus, on the street, Goshan might simply have been a very tall man, but in Barnum's museum he became a "giant" by virtue of the way he was introduced, the costume he wore, the

Figure 17. Engraving showing Colonel Goshan, one of the major Arab acts of Barnum's circus in the 1850s.

set that he occupied, the "educational" discourse that surrounded him, and most fundamentally by the museum itself and audience's understanding of its function.

If Goshan's act was entirely a fabrication—or even if it wasn't—one might well ask why he played an *Arab* giant in particular. Given that giants were fairly common on dime museum stages, the Arab element might simply have been added for the sake of novelty. At a deeper level, however, the Orientalism (and race theory in general) that infused American culture in the nineteenth century lent a certain rightness to a physical curiosity who was an Arab. As Linda Nochlin (1983, pp. 119–191) has demonstrated, the stock in trade of Orientalist art and literature was the picturesque and exotic oddity of the Arab world. This is true from the earliest picture postcards of the Arab world that carefully framed images to exclude familiar things to travel literature that omitted mention of the many Western amenities that travelers found abroad. It was, after all, the very core belief of Orientalism that the

"East" is something different from the "West."

Colonel Goshan is a rarity among nineteenth-century curiosity-show Arabs in that he was an individual performer with a name: the majority of the nineteenth-century Arab entertainments were more or less anonymous group acts. For the most part, these were acrobatic tumbling acts, usually performed by companies of three or more men, which appeared in dime museums, circuses, and variety shows. Ali Ben Abdallah's Troupe of Bedouin Arabs, the Arabs of the Desert, the Beni Zoug Zoug Arabs (who were also known as Thirty Children of the Desert), the Great Arab Troupe, Ten Mahdi Arabs, and the Arabian Brothers are among the many troupes that are listed in advertisements for curiosity shows, variety theaters and circuses. Although most of the acrobatic troupes were men, occasional performances by women did occur, and these seem to have drawn reviewers' attention more than the men's acts.[138]

Common as these performances were—and they were remarkably so—few descriptions of the acts can be found. Clearly these were low-prestige performances: they were rarely headlined, and if reviewers mentioned them at all, they typically simply noted that they occurred. Still, the nature of the acts can be discerned from the occasional explicit review and from illustrated advertisements. One such poster advertises a "Bedouin Arab" act. The illustration shows three men balanced one on the others' head, their Arab identity signaled by tunics and billowing trousers. A description of the "Arab Girls" act boasts that they performed "the most extraordinary and wonderful feats ever attempted," forming human pyramids on a revolving Grecian column.[139]

The very lack of description of these acts, combined with their frequent presentation, is itself significant. The stage names of curiosity show performers typically incorporated descriptive tags that advertised their oddity and explained why they were interesting: "Rosa, a lady of hirsute adornment," "Millie Christine: the two-headed girl," "the infinitesimal Lucia Zarate," for example. However, the Arab troupes received no such tag. This might suggest that there was a typical Arab tumbling act that was common enough and popular enough that audiences would have known what to expect even without a descriptor. But given the layout of posters and handbills, which typically offered a rhythmic list of name-plus–descriptive tag, the reader would certainly have noticed, if only subconsciously, the absence of the descriptive tag.

138 See, for example, columns by George C. D. Odell in *Annals of the New York Stage*: vol. 5 (1843–50), pp. 400, 401, 496; vol. 6 (1850–57), p. 79; vol. 8 (1865–70), pp. 221, 264, 438, 505; vol. 13 (1885–88), p. 136; vol. 14 (1888–91), pp. 668, 672, 662.

139 Odell, ibid., vol. 8 (1865–70), p. 264; Durant and Durant (1957), p. 31.

Without it, the advertisements imply that the Arabs were freakish by definition—no explanation needed.

What sense did American audiences make of these acts? Acrobatic acts offer an ambivalent physicality. On the one hand, the skill and daring of the acrobatics lend them a sort of heroic quality. They could be read against the Victorians' grand civilizing march to control the natural world, in this case by besting the very law of gravity. The advertisement for the "Arab Girls" certainly evokes this sense of progressive achievement. On the other hand, the acrobatic acts were, in the parlance of turn-of-the-century theater, a "dumb" or nonspeaking act. In short, their performance was reduced to the physical, and Victorian America's view of the body was nothing if not conflicted.

In their study of Victorian notions of the body, Peter Stallybrass and Allon White argue that Victorians viewed the body according to a complex accounting of high and low strata. The high strata of the body (head, face, and arms) corresponded to the high strata of society occupied by the bourgeoisie and "high" moral and social goals. The low strata of the body (feet, legs, genitals) corresponded to the lower strata of society occupied by the working class and nonwhites and debased moral and social goals. The high strata belonged to the privileged self, whereas the low belong to the other; thus the high self was an "identity-in-difference" created by the act of rejecting the low other (Stallybrass and White, 1986, p. 21). Rolling and tumbling on the floor, squatting and flexing his body, the Arab acrobat was hardly the rational uplifted body of civilized man. Moreover, the fact that the acrobat was not seen as an individual but as part of a group, and indeed part of a group merged into mass forms like human pyramids, means that audiences might have read the acrobat's body as what Mikhail Bakhtin has described as a "grotesque" body. In Bakhtin's formulation, the privileged "classical" body is the one that is entirely individuated and separated from its environment and from other bodies, whereas the "grotesque" body has permeable boundaries. The grotesque body has open, gaping orifices, its inside comes out and the outside goes in; just like the visual distortions of acrobatics (Bakhtin, 1984, pp. 303–367).

Arab acts, then, presented a visual metaphor of racial difference. Their very bodies were constructed differently and functioned differently, which confirmed what seemed to be a clear and immutable boundary between the Western self and the Arab other. Of course, the difference represented here was not the neutral difference of equals, but a difference that defined status and rank. The freakishness of the Arabs who appeared on American stages amounted to a pictorial nar-

rative justifying Arabs' inferior position in Victorian racial hierarchies, and by extension it justified European colonial control over the Arab world.

Freaks by Definition, Part II

In 1880, an array of Arab curiosity acts banded together to form a traveling show, under the sponsorship of theatrical promoter O. W. Pond. The troupe of eight "Arabs" included seven men and one woman, and they performed a series of scenes depicting the "queer social and religious customs of Palestine," including Arabs' ways of greeting, bargaining, eating, marrying, praying, and dancing. One member of the company, calling himself Professor Rosedale, introduced himself as a scientist and took the role of interlocutor. His bizarre and hilarious commentary offered "expert" explanations of what was happening during the show. During the marriage ceremony, for example, the village chief served coffee first "to show that it wasn't poisoned." The bride held a sword in front of her face "to keep the groom from kissing her." During the "Arab Feast" scene, the performers conspicuously picked up any crumb of food that dropped on the floor because their religion (presumably Islam, even though all but one of the performers were said to be Christian converts) didn't allow them to leave bread where it might be stepped on. When the "Arabs" acted out their way of eating, it entailed rolling dough into huge wads and stuffing it forcefully into each other's mouths. The highlights of the evening, however, were the "howling" and "twirling" dervish performances presented by one member of the cast.[140]

American theater audiences were familiar with dervishes through accounts of their performances in travel literature. Indeed, "howling" and "twirling" (or "whirling") dervish performances were, according to one contemporary observer, "the most popular of all sights" in Cairo (Reynolds-Ball, 1987, p. 193). Quite apart from the inherent interest of the dervish services, it is not at all surprising that a sight might become popular among tourists. Travel writers read each other's works, used the same Baedekker's guidebook to help them navigate their surroundings, stayed at the same hotels, and employed the same guides.

Eustace Reynolds-Ball, an American traveler, explained that the major tourist hotels adjusted their Friday meal times to accommodate the schedule of the dervish services (Reynolds-Ball, 1987, p. 193). In his account of the dervishes, F. C. Penfield parodied the subservient hotel dragoman who reassured the Western women in their charge that the

140 "Odd Sights in Brooklyn: A Howling Dervish in Mr. Beecher's Pulpit," *New York Times*, December 11, 1880, p. 7.

performance would be respectable: "very nice—very nice, yes. Mrs. Vanderbilt of Chicago she came last week, yes" (Penfield, 1899, p. 29). Why this particular performance was so popular was at least partly explained by its rather remarkable physicality. As with the Arab acrobatic acts, there was a certain heroic dimension to the dervishes' physical performance. Travelers who enjoyed the performances typically spoke of the difficulty of the gymnastic feat that the dervishes accomplished. One American tourist rationalized his attraction to the dervish exhibits by adopting the language of machinery to describe their performance:

> For twenty-four minutes, without pause, rest or change of speed, he continued to whirl around like a top. The velocity was exactly fifty-five revolutions to the minute. I timed it frequently and was astonished at the regularity. (from "Passages of Eastern Travel," *Harper's New Monthly Magazine*, 12:69, [February 1856], p. 379)

But most American and European travelers were disturbed not only by the seemingly self-injurious nature of the dervishes' movement, but also by the Bakhtinian grotesqueness of the sweating, foaming, and filthy bodies. The fact that this served a religious function confirmed for many the primitive backwardness of Arabs and Islam. C. F. Gordon Cumming's description of the performance he saw captures this awed and disgusted tone:

> The dervishes rapidly sway from side to side, rolling themselves and their unlucky heads in wondrous style; every feature writhes, the eyes roll wildly, while with deep sepulchral groan they grunt out "Al-lah! Al-lah!" Then with violent, spasmodic jerks, dashing themselves backwards and forwards, they touch the ground with their hands, and their wildly disheveled hair tosses right back in our faces, when we shrink back in some alarm, and all the time the shout of "Al-lah! Al-lah!" Followed by a deep groan, goes on unceasingly in measured chorus.
> The exhaustion is terrific—every muscle strained, the eyes bloodshot, the mouth foaming, the whole frame quivering with frightful excitement. ("Egyptian Dervishes," *Littell's Living Age*, December 16, 1882, p. 669)

On the other hand, many travelers also overlaid their descriptions of the dervish events with suspicion about the dervishes' religious motivation and about their seeming insensibility. Travelers worried that even

while the dervishes acted as if they were deep in a trance, they were in fact planning cunning robberies of the travelers, that they were simply "performing" rather than praying, and that the whole idea of a dancing dervish was a hoax. Penfield fumed that the best thing about the performances, which he deemed "a fraud," was getting away from them, and he insisted that the dervishes howled only during tourist season (Penfield, 1899, pp. 28–30).

The dervishes' performance and Penfield's rejection of it speaks to the underlying problematic of the Orientalist entertainment. As with the curiosity shows and with the O. W. Pond company, the dervish performances depended on a certain notion of separation and authenticity. The performances combined educational and entertainment promises—"come and you will learn," "come and you will be amused"—both of which were predicated on the notion that there was a stable and authentic difference between the races. If the acts were not authentic, that is, if it were revealed that American audiences were being shown exactly what they wanted to see, and that they themselves had a role in creating these odd and picturesque scenes, then the educational pretense would evaporate and the promise of entertainment would become very disturbing.

In this regard, perhaps the most telling moment in the O. W. Pond company performance was not any of the scenes, but a comment by the interlocutor. At the end of the "Robbing the Traveler" scene, Professor Rosedale reported that the performers who played the robbers were "disgusted" to learn that they had to give back what they had plundered from their fellow actors.[141] The suggestion here, of course, is that the company wasn't acting the part of Arabs, they were simply being Arabs. The fact that their real/performed intent was to rob a traveler, which was exactly American and European travelers feared was true, made the suggestion that much more real. The point, however, is that what American audiences wanted was not to see a staged representation of Arab culture, but to be in the presence of "real" Arabs.

This becomes particularly interesting when it is read against travel writers' penchant for describing how they "passed" as Arabs in the Arab world. Indeed, perhaps the most valued discourse in travel literature was a narrative about how the traveler blended smoothly and invisibly into Arab affairs, especially when these affairs were private and intimate. Underneath this pretension was a strong but unspoken goal of becoming an Arab—of transforming oneself into an Arab and then back again into an American or a European, just as an actor temporarily assumes a role.

141 "Odd Sights in Brooklyn," p. 7.

The writing employed numerous rhetorical strategies to produce this effect: dialogue with Arabs, chronological narratives, and a constant stream of comments testifying to the effectiveness of their Arab play-acting. Thus, the travelers subtly assumed what Edward Said calls a "double presence": they apparently became Arabs, but a submerged part of themselves—the authorial part—maintained Western privilege and perspective. The readers of travel literature became the audience for this indirect performance; as Said observed, travelers were "both exhibit and exhibitor" in their writings (Said, 1979, pp. 161, 160).

Here, then, was the peculiar quality of Arab performances: the Arab performer was not performing, but the audience was. Why this is so is partly explained in Stallybrass and White's formulation of identity-in-difference. They explain: "what starts as a simple repulsion or rejection of symbolic matter foreign to the self inaugurates a process of introjection and negation that is always complex in its effects" (Stallybrass and White, 1986, p. 193). In other words, the rejection of "Arab" characteristics (lowness, grotesqueness) as part of the construction of American identity, created an unstable and dangerous boundary between the American self and this Arab other. Because Arabs represented the forbidden and rejected, they were always, to some degree, fascinating. Thus, there was a will to transgress the boundary, to be near the Arab other, and even to be the Arab other. As long as the Arabs on stage were being themselves, American audiences could feel that they were transgressing the white-Arab boundary and contacting exotic and forbidden others, just as did the costumed traveler "passing" as an Arab among Arabs.

Are We Not in Egypt Indeed?

In response to American audiences' desire to be near the "other," theatrical producers began developing performances that systematically blurred the distinction between the on-stage and off-stage identities of the performers. These reality-performances reach their acme in the so-called living villages that were presented at the Chicago World's Fair of 1893. The prominence of the fair, as well as the shrewdness of the theatrical form made the Egyptian, Algerian, Turkish, and Persian living villages the most important and influential representations of Arabs ever to appear in American entertainment. The living villages were designed to give fair-goers a window on life in other countries by setting up replicas of homes, shops, mosques, streets, and so forth, all filled with "natives" going about their "native" business. The villagers sold crafts and food, and acrobats, dervishes, sword swallowers, glass-eaters, snake charmers, singers, and dancers performed. Since the central concept of

the villages was that the inhabitants were actually living their lives in the villages, rather than performing for the fair-goers, marriages and other life events were enacted.[142]

According to official accounts of the fair, the Egyptian exhibit, dubbed Streets of Cairo, was peopled by nearly 200 men, women, and children. There was a café where "mysterious Cairoene dishes are served up to the infidel visitors" and a mosque with praying Muslims.[143] A replica of the tomb of Luxor was replete with statues, dust, and an American Egyptologist as guide. Fair-goers found in the exhibit everything that they had read about in travel accounts of Cairo, except the city was remade into a romantic, Orientalist version of itself, without the distracting contradictions present in the real Cairo. For those who had only read about Egypt, the living village had an in-the-flesh persuasiveness to it that convinced many of the truthfulness of the representation. One visitor declared the exhibit "more like Cairo than Cairo itself," and continued:

> Are we not in Egypt indeed? What signifies the ground beneath our feet? Here are the architecture, the merchandise, the manners and the populace of Egypt; its atmosphere is in our nostrils, its language in our ears. What is it that constitutes a country? (Julian Hawthorne, "Foreign Folk at the Fair," in *The Cosmopolitan* 15:5 [September 1893], p. 576)

However, the most remarkable feature of the Egyptian village, as well as the other Middle Eastern exhibits was their presentation of the so-called *danse du ventre*, or belly dance. The performances proved enormously popular, garnering attention in newspapers and periodicals, and occupying considerable space in souvenir guidebooks. Some fairgoers thought the dance was indecent, and they attempted, unsuccessfully, to shut it down; others supported the performances, citing either their educational value or the "heroic" physical skill they required (see Salem, 1995, pp. 138–141). But whether they supported or rejected it, writers nearly always described the dance, as the writer below, in terms that emphasize both its grotesque body qualities and its sexual appeal:

> The Arabs with drum and flageolot fill the air with discords, and a little Arab girl comes forward with a smile on her face that one

142 For a fuller discussion of the Middle Eastern living villages at the Chicago World's Fair, see Salem (1995), pp. 116–199.

143 Major Ben C. Truman, *History of the World's Fair* (Philadelphia: Standard, 1896), p. 551; *The Columbian Gallery: A Portfolio of Photographs from the World's Fair*, (Chicago: The Werner Co., 1894), p. 3.

sees on the features of a morphomaniac just after a dose of her favorite drug. She wears a rakish-looking cap of red and silver, heavy brass ornaments at her neck, a plum-colored jacket, a broad silver girdle with dependant tassels, baggy trousers of gold and lavender, brass anklets, and rose-colored slippers. She shuffles and stamps and undulates to the cry of her companions, and the crowning glory of her dance is in protruding and revolving her stomach until it appears to roll up on itself, her arms outstretched, the hands hanging limply downwards holding handkerchiefs that wave as she sways to and fro.[144]

Although the term *danse du ventre* was new to American audiences at the World's Fair, the dance itself drew on an extensive history of representation of Arab women's dance in Orientalist art and travel literature. In the latter venue, the dance was typically identified as *ghawazee* dancing, after the troupe of dancers who lived and performed in Luxor. Like the dervish ceremonies, these performances were a regular stop for travelers, and the dancers, their costumes, music, and so forth are described in great detail in many travel accounts. European Orientalist artists, on the other hand, typically identified the performances as *almeh* dances, after the term for women singers.

One of the most well-known examples of this Orientalist genre was Jean-Leon Gerome's painting "The Dance of the Almeh," which, according to contemporary accounts, drew crowds when it was exhibited at the Parisian Salon of 1864.[145] The painting, sold to an American collector shortly after the salon, was frequently reproduced in magazines and newspapers to illustrate pieces about the Arab world. Set in a dim café, the composition shows a young woman dancing before a rapt audience of nine "Bashi-Bazouk" soldiers. One man claps as he watches and another leans expectantly forward, while behind the dancer, three robed and turbaned musicians sit on the floor playing *rebab*, *darbukka*, and *nay*. Waterpipes, guns, baskets, and a vase adorn the room; a brown striped carpet, thrown over an earthen floor, serves as a stage for the barefooted performer, who wears baggy white trousers slung low on her hips. A loose-sleeved gauze undershirt and a small yellow vest barely conceal her breasts. The dancer's abdomen is exposed, and her round, white belly forms the focal point of the composition. Facing the (Western) viewer, and

144 Ibid. (*The Columbian Gallery*), p. 3.
145 Jean-Leon Gerome, "Dance of the Almeh," oil on panel, 1863, Ohio: The Dayton Art Institute, as reproduced in Donald A. Rosenthal, *Orientalism: The Near East in French Painting 1800–1880*, 1982, plate 76.

not her Bashi-Bazouk audience, the dancer's stomach is pushed forward, and one hip twists softly upward, while her head lolls impossibly toward one shoulder. She appears to be standing, but collapsed; the angles off her body droop softly as if she is sleepily reclining on the air.

How would contemporary audiences have read this image? Bram Djikstra's study of images of women in Victorian painting suggests that audiences would have read this image in medical and moral terms. Djikstra found that images of "collapsed" and exhausted women were a common theme in Victorian art, and that they were related to the then current belief that the body had a finite store of energy requiring judicious conservation (Djikstra, 1986, p. 65). Physical pleasure and sensual stimulation were thought to dissipate this energy, causing illness and moral decline. Thus there was an implied connection between abstinent living and professional success since an abstinent person would have more energy to spend on productive labor. By the same token, exhaustion implied indulgence. In Orientalist art, Arab women were nearly always depicted in this collapsed, somnolent state. Indeed, the defining image of women in Orientalist art is the "odalisque," a woman reclining or sleeping, usually nude and usually surrounded by a richly sensuous environment. Gerome's "Almeh," then, was a complicated somatic argument about Arab women's lascivious sexuality and the dissipated lives of Arab men around them, and more broadly about the nature of the Islamic world.

Consider art critic Earl Shinn's commentary on the painting:

> Here ... the rank and file of the khedive's soldiery sit and stare with eyes that make emphatic the degradation of Eastern society, the abasement of the family system, the brutal contempt of women, the horrors of a carnal religion. Here, with vigor never before applied, we are transported bodily among women who really have no souls, and worshippers who are allowed to study almeh dances as an accurate picture of paradise.[146]

In this brief passage, Shinn connects the Almeh's dance to Islam several times, in particular implying that the dance is a form of worship and an image of paradise. These comments reveal something of the West's view of Islam's relationship to the body and sexuality. Shinn's remark about the "debasement of the family system," of course, refers to Islam's

146 Edward Strahan [Earl Shinn], *The Art Treasures of America, being the choicest works of art in the public and private collections of North America*, (Philadelphia: George Barrie, 1879), p. 80.

acceptance of polygyny; more broadly, however, it references the powerful Orientalist trope of the harem as an institution of wanton sexual and sensual pleasure. Since abstinence and monogamy were foundational tenets of Christianity and since Christianity was the moral foundation of the West, harems and polygyny constructed the Islamic world as a society without morality.

But evidently this society had a certain appeal to Western audiences. Like the dervishes, the debased "Almeh" dancer was not simply repulsive, but also attractive. And in this case, the attraction was decidedly sexual. Those who objected to the *danse du ventre* performances at the Chicago World's Fair inadvertently revealed this when they framed their objections as an attempt to prevent the corruption of American men: one writer called the dances "vile and licentious," while another asked that they be shut down "for the good of public decency and morality."[147] Clearly, then, American audiences recognized how appealing the dance was to their fellows, and some worried about it. Exactly what they were worried about becomes clearer when one considers the responses of American audiences chronicled in travel literature.

Travel writers who saw performances of *almeh* or *ghawazee* dancing spent as much time describing their own physicality as they do the dancers. They describe how they had to duck into low doorways, how they reclined on divans or squatted on the floor while watching the performance, how they sipped *arak* and smoked waterpipes, and how they were lulled by the repetitive strains of the music. Some travelers took this a step further: the dance performances often served as gateways into a sex trade patronized by European and American men. Flaubert's well-known diaries of his travels in Egypt document his sexual encounters with numerous male and female dancers. The best known of these was Kutchuk Hanem, a dancer Flaubert met in Luxor; his descriptions of his sexual encounter with her detail everything from her snores and smells to the texture of her genitalia and the bedbugs in her room (Steegmuller, 1972, p. 117). On one of Gerome's travels to Egypt, he had a similar encounter with a dancer named Hasne, and this encounter is also chronicled in detail in an article in *Harper's* magazine.[148]

The implication here is that the dances gave travelers an opportunity to "become" Arabs temporarily, to play the role of the dissipated Arab, whether by collapsing on the floor and becoming entranced by the sen-

147 *The Columbian Gallery*, p. 6; "Trouble on the Midway," *New York Times*, July 22, 1893, p. 1.
148 J. Ross Browne, "In a Caravan with Gerome the Painter: Concluding Paper," *Harper's New Monthly Magazine*, 6:32 (May, 1874), p. 534.

suous experience or by merging with the dancer in sexual intercourse. In Stallybrass and White's formulation, the travelers became "grotesque hybrids," a disturbing in-between identity that incorporated characteristics of both self and other. As with other Arab acts, this revealed that the creation of these performances was not a function of Arab culture, as the discourse claimed, but of submerged Western desire.

White Slaves/Black Slaves

In the 1860s, a performer named Zalumma Agra appeared in P. T. Barnum's American Museum. Billed as a "Circassian Slave," Agra's act consisted of telling a rapt American audience about her life as a concubine in a Turkish harem, and how she was eventually rescued from sexual servitude by an American man who was an associate of Barnum. Agra's act was remarkably popular, and it spawned a series of imitators: Zoe Maleki, Zobeide Luti, Zuleika, and Aida were other "Circassian Slave" performers who appeared in the 1880s. Each created an exotic biography for herself, similar in outline to Agra's: they told of being captured and sold into slavery, gave elaborate and titillating details about a concubine's life in the harem, and finally accounted for their presence in America and their fluent English, by describing their rescue and subsequent education.[149]

Part of the context for these performances was the news coverage of the Crimean war, and subsequent conflicts in the region. American newspapers printed dramatic tales of atrocities committed in the Ottoman empire, including accounts of Circassian women being captured and displayed in Constantinople's slave markets, where they were purchased for the harems of wealthy Arab and Turkish men. According to race theory, these Circassians were descendants of a pure white "Caucasian" race. Some journalists accused Circassian parents of profiting from the sale of their daughters "to stock the harems of wealthy Mussulmans," but most stories attributed the horror of white slavery to Oriental depravity. Newspaper stories described the "effeminate, pleasure-sodden monarch" of the Ottoman empire as "sick" and "extravagant," particularly with regard to his seemingly insatiable need for women. One article reported the Sultan's demand for a dozen teenaged girls, to be delivered "at the earliest possible date," while another announced that the Sultan's harem numbered an incredible 1,200 women.[150]

149 *P. T. Barnum*, 1873, pp. 579–581; Saxon, 1989, p. 102; "Zobeide Luti, the Beautiful Circassian 'Lady of Beauty' at Barnum's Museum," ([no publisher credited], 1868).
150 "Slavery in Turkey," *New York Times*, July 17, 1876, p. 3; "A Sick Man's Amusements," *New York Times*, May 21, 1876, p. 6; "Thousands for the Harem—Nothing for the Army," *New York Times*, October 7, 1878, p. 8; "The Sultan's Extravagence," *New York Times*, December 27, 1875, p. 3.

As with Arab women's dancing, the Circassian slave performances demonstrate the simultaneously fascinating and repulsive nature of the Arab exhibits. American audiences were "horrified" by the notion of sexual slavery in the harem, but they were also attracted by it. This is evidenced not only by the popularity of the stage performances, but also by the fact that images of Circassians were used to sell tobacco. "White Slave" brand tobacco packages, for example, pictured seminude white women in a harem setting. Dolores Mitchell argues that images of "exotic" women were used in these advertisements because they presented a metaphor about the availability of pleasure: the pack of cigarettes or cigars was like, in one writer's words, "a harem of dusky beauties," waiting to be enjoyed by their owner (Mitchell, 1992, pp. 338–340).

The Circassian curiosity show performances quickly metamorphosed into a more interactive entertainment that allowed American men to enjoy the white slave at closer range. This happened in American concert saloons, which were bars that offered staged entertainment. The "Circassians" began appearing as "waiter girls" in concert saloons like the Sultan's Divan in New York and the Egyptian Hall in Boston.[151] The waiter girls served drinks and flirted with the customers, and according to writers, they were as closely watched as the performers on stage. Like the White Slave cigarettes, Circassian waiter girls gave American customers the opportunity to experience some of the pleasure that Arab sultans and pashas were purported to have. In the Sultan's Divan, an American man played the part of the "pleasure sodden" Turk. The waiter girls pleased their "master" by bringing him drinks, and their availability to the patron's gaze was symbolic of the harem concubine's sexual availability.[152]

Thus, like the dance performances, the Circassian performances encouraged American patrons to become grotesque hybrids, that is, to temporarily assume an Arab identity in order to experience being the other. But for American audiences, there was more to the Circassian exhibits than playing the Arab sultan: when one considers the larger context of slavery in America, another meaning emerges. A popular American play titled *The White Slave* told of a white woman who was mistaken for nonwhite and sold into slavery in the American south. Whereas the white slave in the Arab world was always purchased for the purpose of providing sensual pleasure to her owner, the white slave in the play endured only hard work, which she bore without compromising her virtue—or perhaps more importantly without compromising the morality of her master (Mitchell, 1992, pp. 338–340). Thus, part of what

151 Odell, op. cit., vol. 10, p. 482.
152 Campbell, 1882; synopses in Odell, op. cit., vol. 11, p. 471.

the Circassian slave acts did was to point out an alleged difference between Arab slave owners, whose sexual appetite was uncontrollable, and American slave owners.

However, in spite of what Americans admitted publicly about American slavery, it has been well documented that there were extensive and mostly coercive sexual interactions between whites and blacks under slavery. But, especially in entertainment imagery, this fact was obscured beneath representations of black women as homely mammy figures, more comic than desirable. Cigarette advertisements make a neat parallel here: whereas the Circassian/Arab scenes in tobacco advertising showed beautiful women in alluring poses, the black/American scenes showed black women haranguing their husbands, picking cotton, stirring porridge, and other decidedly nonsexual and nonalluring activities. Thus, the racial/sexual transgression that was actual, but denied, in Victorian America was essentially transferred and inverted into a white-Arab transgression, with the Arab playing the dominant, "master" role. The Arab man took on the role of the sexual predator, while both white and Arab women under his sphere of influence collapsed into limitless sexual availability.

Perhaps the most exquisite example of this transfer is Gerome's "Almeh." *Harper's* chronicle of Gerome's tour of Egypt mentions only one dancer with whom he interacted, namely Hasne. The article includes a sketch of her, and she is a dark-skinned woman (Browne, 1874, p. 534). Yet all of the many dancers depicted in Gerome's paintings have light skin and European features. At the very least, this demonstrates the power of the Orientalist construction: Gerome chose to depict his *almehs* as white women, in spite of having been personally in contact with living evidence to the contrary. Whatever this may have meant to Gerome and his European audiences, for Americans this image represented a complex mixture of desires expressed and repressed, actions taken openly and actions taken in secrecy.

Conclusion

Arab acts in American entertainment were part of the project of defining the American self as an identity-in-difference. The Arabs stood as the grotesque and low other against which the privileged American self defined itself. At the same time, these acts gave Americans a chance to approach and sometimes merge with the forbidden other. These acts also served as indirect representations of sexuality in black-white relations, which was perhaps the most difficult political and moral issues facing Americans in the latter half of the nineteenth century.

What, then, can we see here about what the confluence of race and sexuality meant to Victorian Americans? In his analysis of Victorian sexuality, Foucault argues that sexuality exists at the pivot of two axes, one relating to the pleasures of the body, the other relating to the regulation of populations, or put in another way, of sexual potency. When Victorian America embraced sexual self-control and distanced itself from the sexual urges of the body, it assigned these qualities to the racial others. And in doing so, it metaphorically ceded to them enormous power: the power to reproduce, to create populations, and ultimately to overwhelm the American self. Clearly Americans did not worry about being overrun by Arabs, but they certainly worried about being outnumbered and overpowered by blacks.

Thus, paradoxically, these images of Arabs provided a way for white Americans to express difficult and politically loaded fears about their own impotence. It was far easier to do this by transferring the fears onto an Arab fantasy race than to look straight in the face of American race relations. However, it would be wrong to conclude from this that images of Arabs in American entertainment functioned only as a symbolic struggle for American identity, when in fact they affected quite directly the lives of Arabs in the Arab world. Arab sources and the writings of American and European travelers both suggest that the Americans' expectations of sexual conquest and beliefs about Arab sexuality and body were a significant force in the colonial experience.

Western travelers created or expanded a market for sex workers, dancers and other entertainers, and this did not pass without objections from Arabs. The writings of Abdallah Nadim, a journalist and Egyptian nationalist, attest to the oppressiveness of this Western presence and to its effects on Arab lives. The West, according to Nadim, was "a hunter pursuing its prey by spreading places of entertainment" (Osman, 1979, p. 77). Moreover, many of the travel writers reveal, wittingly or not, the clumsiness, eagerness, and insults of their attempts to procure sexual entertainment. This is not to suggest that intercultural sexual contact is always exploitative or that sexualized performance could not have existed independently of Western presence in the Arab world, but simply that American beliefs about the Arab's body and sexuality were imposed on Arabs. Indeed, performances like those described in this chapter were one arena in which Americans, who were not directly engaged in the colonial enterprise, maintained a controlling presence.

12 Farewell to Tahia[153]
Edward W. Said

The first and only time I saw her dance on the stage was in 1950 at the summertime Badia's Casino, in Giza just below where the Sheraton stands today. A few days later I saw her at a vegetable stand in Zamalek, as provocative and beautiful as she had been a few nights earlier, except this time she was dressed in a smart lavender-colored suit with high heels. She looked at me straight in the eye but my 14-year-old flustered stare wilted under what seemed to me her brazen scrutiny, and I turned shyly away. I told my older cousin's wife, Aida, with shamefaced disappointment about my lacklustre performance with the great woman. "You should have winked at her," Aida said dismissively, as if such a possibility had been imaginable for someone as timid as I was.

Tahia Carioca (see **figure 18**) was the most stunning and long-lived of the Arab world's Eastern dancers (belly dancers, as they are called today). Her career lasted for 60 years, from the first phase of her dancing life at Badia's Opera Square Casino in the early 1930s, through the reign of King Farouk, which ended in 1952, then into the revolutionary period of Gamal Abdel Nasser, followed by the eras of Anwar al-Sadat and Hosni Mubarak. All of them except Mubarak imprisoned her one or more times for various, mostly political offenses. In addition to her dancing, she acted in hundreds of films and dozens of plays, had walked in street demonstrations, was a voluble, not to say aggressive member of the Actors' Syndicate, and in her last years had become a pious though routinely outspoken Muslim known to all her friends and admirers as al-Hagga. Aged 79, she died of a heart attack in a Cairo hospital on September 20, 1999.

Figure 18. Tahia Carioca, the most stunning and long-lived of the Arab world's Eastern dancers (her career spanned 60 years), performs in an Eastern setting in one of her films.

153 Copyright by Edward W. Said. The Editor thanks Dr. Said for allowing her to reprint this material here with his permission.

About ten years ago I made a special pilgrimage to Cairo to meet and interview her, having in the meantime seen dozens of her films and one of her plays, the appallingly bad *Yahya al-Wafd* ("Long Live the Wafd"), written by her then husband and much younger costar, Fayez Halawa. He was an opportunist, she later told me, who robbed her of all her money, pictures, films, and memorabilia. Though she was robed in the black gown and head scarf of a devout Muslim woman, she radiated the verve and wit that had always informed her presence as a dancer, actress, and public personality. I published an appreciative essay on her in *The London Review of Books* that tried to render justice to her extraordinary career as a dancer and cultural symbol not just in Egypt, which was where she did all her work really, but throughout the Arab world. Through the cinema and later television, Tahia was known to every Arab partly because of her stunning virtuosity as a great dancer—no one ever approached her unrivalled mastery of the genre—and her colorful, thoroughly Egyptian playfulness, i.e., the wordplay, gestures, ironic flirtatiousness synonymous with the country's sparkling and engaging reputation as the Arab world's capital when it comes to such matters as pleasure, the arts of desire, and an unparalleled capacity for banter and sociability.

Most Eastern Arabs, I believe, would concede impressionistically that the dour Syrians and Jordanians, the quick-witted Lebanese, the rough-hewn Gulf Arabs, the ever-so-serious Iraqis never have stood a chance next to the entertainers, clowns, singers, and dancers that Egypt and its people have provided on so vast a scale for the past several centuries. Even the most damaging political accusations against Egypt's governments by Palestinians or Iraqis are levelled grudgingly, always with a trace of how likeable and charming Egypt—especially its clipped, lilting dialect—as a whole is. And in that glittering panoply of stars and elemental joie de vivre Tahia stood quite alone because, if not despite, her flaws and often puzzling waywardness. A left-wing radical in some things, she was also a time-server and opportunist in others; even her late return to Islam coexisted incongruously with her admitted fourteen husbands (there may have been a few more) and her carefully cultivated and implied reputation for debauchery.

So much has already been written on her that I'd like to mention only three things about her that seem to be fittingly recalled now that she has passed from the scene. The first is her essential untranslatability, the fact that despite her enormous fame to and for Arabs, she remained largely unknown outside the Arab world. The only other entertainer on her level was Umm Kulthum, the great Qur'anic reciter and romantic singer whose records and videos (she died in 1975) continue to have a worldwide audi-

ence today, possibly even greater than she had when she was alive, and her Thursday evening broadcasts from a Cairo theater were transmitted everywhere between the Atlantic and the Indian oceans. Everyone who enjoys Indian, Caribbean, and "world" music knows and reverently appreciates Umm Kulthum. Having been fed a diet of her music at far too young an age, I found her forty-plus minute songs insufferable and never developed the taste for her that my children, who know her only through recordings, have for her. But for those who like and believe in such cultural typing she also stood for something quintessentially Arab and Muslim—the long, languorous, repetitive line, the slow tempi, the strangely dragging rhythms, the ponderous monophony, the eerily lachrymose or devotional lyrics, etc.—which I could sometimes find pleasure in but never quite came to terms with. Her secret power has eluded me, but among Arabs I seem to be quite alone in this feeling.

By comparison with her Tahia is scarcely known and, even when an old film is seen, it somehow doesn't catch the Western audience's attention (I except from this other belly dancers, all of whom today seem to be non-Arab—lots of Russians, Americans, Ukrainians, Armenians, and French—who appear to regard her as their major inspiration). Belly dancing in many ways is the opposite of ballet, its Western equivalent as an art form. Ballet is all about elevation, lightness, the defiance of the body's weight. Eastern dancing as Tahia practiced it shows the dancer planting herself more and more solidly in the earth, digging into it almost, scarcely moving, certainly never expressing anything like the nimble semblance of weightlessness that a great ballet dancer, male or female, tries to convey. Tahia's dancing vertically suggested a sequence of horizontal pleasures, but also paradoxically conveyed the kind of elusiveness and grace that cannot be pinned down on a flat surface. What she did was obviously performed inside an Arab and Islamic setting, but was also quite at odds, even in a constant sort of tension with it.

She belonged to the tradition of the 'alima, the learned woman spoken about by great observers of modern Egypt like Flaubert and Edward Lane, that is, a courtesan who was extremely literate as well as lithe and profligate with her bodily charms. One never felt her to be part of an ensemble, say as in kathak dancing (a North Indian form of dance and music), but rather as a solitary, somewhat perilous figure moving to attract and at the same time repel—by virtue of the sheer promiscuity she could communicate—men as well as women. You could not take Tahia out of a Cairo nightclub, stage, or wedding feast (or zaffa, as it is called). She is entirely local, untranslatable, commercially unviable except in those places, for the short time (twenty to twenty-five minutes at most)

her performance would normally last. Every culture has its closed-off areas, and in spite of her overpowering and well-distributed image, Tahia Carioca inhabited, indeed was, one of them.

The second thing about her that strikes me now that she has died is how untidy and shiftless her life seems to have been. I suppose this is true of performers in general, who really exist before us for the brief time they are on stage and then disappear. Audio recordings and film have given a kind of permanence to great displays of virtuosity, for instance, but somehow one feels that mechanical reproduction cannot ever have the edge and excitement of what is intended to happen once and then end. Glenn Gould spent the last sixteen years of his life trying to disprove this, even to the extent of pretending that a listener or viewer equipped with superrefined VCR or amplifier could "creatively" participate in the recorded artist's performance. Thus the idea of playback was supposed to mitigate the rarity and perishability of live artistic energy.

In Tahia's case, all of her films, as a case in point, are probably available in video form, some of them available on street corners throughout the Arab world. But what about her thousands of other performances, the ones that were not recorded—plays, nightclubs, ceremonies, and the like—plus, of course, her uncountable appearances at soirées, dinners, all-night sessions with fellow actors and actresses. At times she seemed to be a revolutionary and even a Marxist; at other times, she went the other way, kowtowing to the establishment, as she did in one of her plays in which she made uproarious fun of the Soviet experts in Egypt because of Nasser's policy of taking Egypt into that camp.

Perhaps it is too much to say of her that she was a subversive figure, intransigent by virtue of her imperious way with herself and her surroundings, but I think that her meandering, careless way with her many male relationships, her art, her prolifigacy as an actress who nonetheless seemed to have nothing left of her scripts, her contracts (if she had any to begin with), her stills, costumes, and all the rest, suggests how far she always was from anything that resembled domesticity or ordinary commercial or bourgeois life or even the comfort of the kind so many of her peers seem to have cared about. I recall the impression that she made on me a decade ago when I spent the afternoon at her nondescript apartment, that she was a great Nanaesque figure who had had and then dismissed her appetites, and could sit back, enjoy a coffee and smoke with a perfect stranger, reminiscing, making up stories, reciting set pieces ("when I danced, I felt I was entering the temple of art," she said to me tendentiously and with a great deal of mock seriousness), relaxing, and being evasive at the same time. What a woman!

Lastly, Tahia's life and death symbolise the enormous amount of our life in that part of the world that simply goes unrecorded and unpreserved, despite the videos that will undoubtedly proliferate now, the retrospectives of her films, the memorial occasions when she will be eulogized as her great rival, Samia Gamal, whose public funeral procession was banned, could not be. There exists no complete record of Tahia's films, no bibliography, no proper biography—and there probably never will be. All the Arab countries that I know do not have proper state archives, public record offices, or official libraries any more than they have decent control over their monuments, antiquities, the history of their cities, individual works of architectural art like mosques, palaces, schools. This realization does not give rise to anything like the moralistic feeling provoked by Shelley's witness to Ozymandias's ruin, but a sense of a sprawling, teeming history off the page, out of sight and hearing, beyond reach, largely irrecoverable. Tahia seems to me to embody that beyond-the-boundary life for Arabs today. Our history is written mostly by foreigners, visiting scholars, and intelligence agents, while we do the living, relying on personal and disorganized collective memory, gossip almost, plus the embrace of a family or knowable community to carry us forward in time. The great thing about Tahia was that her sensuality or rather the flicker of it that one recalls was so unneurotic, so attuned to an audience whose gaze in all its raw or, in the case of dance connoisseurs, refined lust was as transient and as unthreatening as she was. Enjoyment for now, and then, nothing. I wonder what kind of legacy, what kind of posthumous life, she will have.

Music and *Maqam*

13 *Tarab* ("Enchantment") in the Mystic Sufi Chant of Egypt
Michael Frishkopf[154]

Introduction to Music, Emotion, and Sufism

The aesthetic concept of *tarab* finds no ready translation from the Arabic. Narrowly defined, it refers to musical emotion and the traditional musical-poetic resources for producing it, especially expressive solo singing of evocative poetry, in an improvisatory style, employing the traditional system of *maqam* ("melodic mode"). Traditionally, the singer is accompanied by the *takht*, a small, flexible, heterogeneous instrumental ensemble. Affective texts, precise intonation and enunciation, proper elaboration of the *maqam*, idiomatic improvisation, tasteful modulation, and correct execution of the *qafla* ("melodic cadence") are all factors critical to the development of *tarab* in performance.[155]

Tarab also depends on consonant performer-listener interactions, in which experienced listeners (*sammi'a*) react to the music by expressing emotion through vocal exclamations and gestures, especially during the pause that follows the *qafla*; the singer in turn is moved and directed by such "feedback" (Racy, 1991, pp. 7–28). Through this dynamic relationship, emotion is shared, exchanged, and amplified among participants. The harmonious relation between the singer and the words he or she sings is also critical to *tarab*, since the singer must sing with *sidq* ("sincerity"), expressing true feeling in order to communicate emotion to listeners.

More abstractly, Egyptians describe *tarab* as a relation of harmony

154 This chapter is based on dissertation research performed in Egypt from 1992 to 1998. It could not have been written without the generous assistance and cooperation of Shaykh 'Abd al-'Alim al-Nakhayli, Shaykh Yasin al-Tuhami, Taha Gad Salim, and Shaykh 'Izz al-Hawari; Dr. Muhammad Umran, Dr. Ibrahim 'Abd al-Hafiz, Dr. 'Abd al-Hamid Hawwas of the High Institute for Folk Art; and Dr. Qadri Sourour of the Institute for Music Education. I also thank my teachers at UCLA, especially my supervisor Dr. Jihad Racy, Dr. Timothy Rice, Dr. Hossein Ziai, and Dr. Jacques Maquet. Dr. Valerie Hoffman (University of Illinois), Dr. Muhammad 'Alwan, Dr. Virginia Danielson (Harvard University), Dr. Dwight Reynolds (University of California, Santa Barbara), Dr. Earle Waugh (University of Alberta), and Dr. Regula Qureshi (University of Alberta) provided most valuable feedback. Support was provided by the Fulbright Commission in Egypt, the American Research Center in Egypt, UCLA, the Social Science Research Council, and the Woodrow Wilson National Fellowship Foundation.
155 For background on *tarab* and musical aesthetics see Racy (1981a), pp. 14–26; (1982) pp. 391–406; and (1983b), pp. 396–403.

(*insijam*) or equilibrium (*mu'adala*) between performer and listener, the exchange of feeling (*tabaddul al-shu'ur*) between them, to the point of *wahdat al-shu'ur* ("unity of feeling"), or the affective melting (*dhawb*) of the two into one; or the harmonious coexistence (*mu'aysha*) of performer and listener, or poem and performer; or the connection (*irtibat*) between a person and anything of beauty, for all beauty has an emotional aspect.

Technically, only the singer of *tarab* ought to be called a *mutrib*, but the latter term has come to mean *mughanni* ("singer"). *Mutribin* are plentiful in Cairo, but most Egyptians say that after the passing of the great secular *tarab* singers, such as Umm Kulthum, *tarab* has become rare in secular music. However, many describe Sufi *inshad*, the mystical music that is the subject of this chapter, as being rich with *tarab*. Indeed, in its musical features and performative dynamics, it is reminiscent of the older pre-1930 *tarab* tradition, and in its emotional impact it is far more powerful than other forms of contemporary Egyptian music.

Why should this Sufi music be so laden with *tarab*, while contemporary secular music is bereft? In part the answer is historical: religious music, inherently conservative, has preserved features of the *tarab* tradition, which generally prevailed in Arab music before the 1930s, but which have gradually disappeared from secular music as a result of aesthetic transformations wrought by rapid political, social, and economic change. But historical factors cannot explain why Sufi music has also changed dramatically in recent years, but not in such a way as to displace *tarab*. The explanation is better sought in the Sufi system of belief, practice, affect, and aesthetics, which *facilitates* the relationships of *insijam* and *tabadul al-shu'ur* among poet, singer, and listeners upon which tarab depends.

Moreover, the performance contexts of Sufi *inshad* outside the purview of the Sufi orders *demand* a high level of emotional communication, for this music has a key role to play in constructing solidarity within the fluid and ephemeral social groups of so-called popular (what I will call "informal") Sufism. Thus, *tarab* is not only expedited by Sufism, it is required. These factors are absent in secular Arab music, which has consequently undergone a variety of transformations resulting from political change, commercial interests, Western influences, demographic shifts, the impact of technology, changes in lifestyle, and so forth.

Here I focus upon the role of the Sufi poet, the affective power of his[156] poetry, and his relation to the *munshid* ("Sufi singer") and listener in creating *tarab* in performance. I argue that it is the shared domain of Sufi thought, feeling, and practice that enables a Sufi poet to communi-

156 In this paper, I use the male pronouns to refer to any person. Women in Sufism

cate intensive mystical emotion, through the medium of language, to a *munshid*, who perceives the poet's words so strongly as to experience the affective state that engendered them. This emotional conformity is precisely *insijam* and *wahdat al-shu'ur*, and so the *munshid yatrab min al-sha'ir* ("gets *tarab* from the poet"). It is again this shared Sufi domain that allows for the development of emotional conformity between singer and listener, so that the listener *yatrab min al-munshid* ("gets *tarab* from the singer"), and hence transitively from the poet as well. In secular music, emotional level is lower and emotional connections weaker, because the common ground furnished by Sufism is absent.

In what follows, I first present ethnographic sketches of Sufism and Sufi *inshad* in contemporary Egypt. Next, I offer a detailed discussion of the Sufi poet, his status in Sufism, and the nature of his creative process, and the source of his poetry's power. I then discuss the professional *munshid*, his expressive art, and his spiritual relations to poetry, poets, and listeners. Finally, I outline the dynamic communicative processes by which *tarab* is constructed in performance.

In examining these issues, I weave my observations of Sufi discourse and practice into speculative theories. Behind these problems in musical emotion thus stands an epistemological one: What is the relation here between "outsider theory" (my ideas about music, mysticism, and emotion) and "insider discourse" (an informally articulated quasiconsistent body of knowledge drawn from many participants in Sufi *inshad* performance, what might be loosely called a "theory," combining mystical and aesthetic ideas). I have my theories, and my Egyptian Sufi colleagues have theirs.

This situation is not an instance of the well-known "etic/emic" dichotomy, which stresses the incommensurability of outsider and insider frames. Nor are my theories generalizations empirically supported by field data, as physicists' theories relate to experiment. Rather, I regard theory and discourse as a continuum. Theory summarizes (and conditions) an interactive dialog between speculations of a weakly acculturated outsider (with various abstract paradigms in tow) and insider discourse, generated in part by that dialogue. This metaphor of "dialogue" represents my own reflective thinking, as much as the social processes of fieldwork. After years of living with Sufis, their concepts permeate mine;

include major saints (mostly within the Ahl al-Bayt), poets (such as Rabi'a al-'Adawiya, and the contemporary Egyptian 'Aliya al-Ja'ar), *munshidin* (such as Shaykha Sabah, who sings in *mawlids* around Cairo), leaders of Sufi orders (such as Hagga Zakiya, buried next to the shrine of Sidi Abu al-Hasan al-Shadhili), members of *turuq*, and subscribers to the informal system of Sufi belief and practice ("informal Sufism"). However, women comprise a small minority in all categories except the last. See Hoffman, 1995.

I think *with* them. My own reasoning, in dialogue with their discourse, thus becomes a part of it.

Thus, I envision this chapter as a natural theoretical extension of Egyptian Sufi thought. Sometimes my role is merely to sift and codify what I have observed and experienced, filling gaps, sorting ideas, smoothing inconsistencies, and drawing logically proximate implications. Elsewhere, my reasoning leaps forward into the realm of speculation, but without implying a contradictory universe of critical reality (as "etic" theory tends to do). Here there is no critical metalanguage. At no point do my theories call local discourse into question, or posit some true reality beyond the ken of Egyptians, but miraculously available to the researcher. Insider discourse does not contradict my theories, but only leaves gaps because of what remains unpondered, unanalyzed, or unspoken. My theories are perhaps best described as a kind of philosophical elaboration of Sufi experience, which might also have been written, albeit rather differently, by Egyptian Sufis with the inclination for such a project.

Contemporary Egyptian Sufism[157]

At first glance, the processes of expressive emotion in Sufi *inshad* may appear similar to those of *sha'bi* ("popular") singing. Indeed, Sufi and secular music in Egypt, rural and urban, do share many elements. But Sufi *inshad* is distinguished in that its music, poetry, performers, context, and listeners are informed by the rich and diverse world of Sufi practice, language, thought, and theory, a common ground providing avenues for expressive emotion that are not available elsewhere.

Orthodox Islam rests upon *shari'a*, sacred law based upon Qur'an (revelation) and *sunna* (prophetic custom), which describes the order of the cosmos, decrees the articles of faith, and regulates behavior. But a purely legalistic formulation of Islam would leave an emotional vacuum. That vacuum is filled by Sufism, which aims at suprarational religious experience, stressing divine love (*al-hubb al-ilahi*) and the potency of the world of spirits (*'alim al-arwah*), especially the saints who are objects of love and devotion, as well as a source of blessing (*baraka*) and intercession. Many Sufis maintain that while *shari'a* is necessary to regulate society, it is *al-tasawwuf* ("Sufism") that is the *jawhar* ("essence") of Islam. *Shari'a* appeals to the intellect (*'aql*), that is insufficient to comprehend spiritual truth (*haqiqa*). Rather, spiritual perception (*basira* or *shafafiya*) is situated in the *qalb* ("heart"). The *'aql*, is clever but veiled (*mahjub*), being lim-

157 The most comprehensive overviews of contemporary Egyptian Sufism are to be found in Hoffman (1995); Johansen (1996); and Waugh (1989). Slightly outdated but still extremely valuable is Gilsenan (1973).

ited to the visible and logical; the *qalb* transcends these limits to perceive higher truths constituted of feeling (*ihsas*). Sufism privileges the *qalb* over the *'aql*, and likewise affective insight over discursive intellection. As in the West, the *qalb* is also the locus of *hubb* ("love").

In Egypt today, Sufism is commonly described as *kitab* (Qur'an), *sunna*, and *hubb*. In one way or another love, the capacity of one spirit (*ruh*) to join selflessly with another, forms the basis for nearly all Sufi discourse and practice. What stands in the way of this love are sensual and egotistical cravings (*shahawat*), rooted in the self (*nafs*; the luminous *ruh* and the earthly *nafs* are the two antagonistic elements of Sufi psychology). In the Sufi view, pure love is for God only, not for any selfish end. The Sufi strives towards *tazkiyat al-nafs* ('purification of the self,' seat of desire), in order to obtain *tarqiyat al-ruh* ('ascension of the spirit" towards pure love and towards God).

Sufi love is of many kinds and degrees, including the platonic love of one's fellow Sufis and shaykh (spiritual guide); the spiritual love of the *awliya'* ("saints") and the *anbiya'* ("prophets"), especially the beloved Prophet Muhammad, and the Ahl al-Bayt (literally "people of the house"; the Prophet's immediate descendants through his daughter Fatima and son-in-law 'Ali); and *al-hubb al-ilahi*, divine love. The joy of love, described as *widad* ("affection"), *mahabba*, *hubb*, *sababa* ("love"), intensified as *hiyam*, *'ishq*, *walah*, *wajd* (ecstatic love, passion), is often commingled with the pain of longing, due to the absence or remoteness of the *mahbub* ("beloved"): the words *shawq* ("passionate longing"), *law'a* ("lovesickness"), *huzn*, *kadar*, *shajan*, *shajw*, and *asan* (anguish, grief) are employed; the lover's body may become weak, emaciated ("*saqim*"), and ill (symbolic of the destruction of the *nafs*, and the effect of unfulfilled passion). The source of all of these conditions is love and the desire for unification with the beloved, even to the point of self-sacrifice. In the most extreme degrees of love (*'ishq* or *wajd*), the lover loses his or her individual attributes and becomes assimilated within the beloved, a condition technically known as *fana'* ("annihilation"). A Sufi may seek *fana'* in his shaykh or in the Prophet, but the highest form of *fana'* is in Allah. On a lower plane, Sufi love is manifested as selfless generosity, tolerance, compassion, and empathy for others, regardless of their religious affiliations. Nearly all Sufi poetry speaks about love, longing, or praise for the beloved, and the Sufi is often called a *muhibb* (pl. *muhibbin*) or *'ashiq* (pl. *'ashiqin*); both words mean "lover." As one Sufi poet told me:

There is a *hadith* [Prophetic saying] which says: your faith is incomplete until you love God and the Prophet more than you love

yourself. This love is a major theme for the Sufis as well. You must remember those whom you love. God gave to us through love; we return the love to Him, rapt in it The Sufi loves until he forgets himself.

Underlying the theory and practice of Sufi love is the notion of spiritual proximity. The Sufi cosmology is centered on the *'alim al-arwah*, which—unfettered by the limitations of the physical world—allows one to establish emotional relationships with others irrespective of their physical-world existence in time and space.[158] The world of spirit existed in preeternity (*al-'alim al-azali*), before Creation. During this time, some spirits established close relationships with others; the spiritual rapport two people on earth may feel indicates their spiritual relation before time began. Sufis say that after the death of the body most spirits go to the *barzakh* ("isthmus"), where they await Judgment Day. But the spirits of the *salihin* ("virtuous people"), including the *awliya'*, are free to come and go as they please. In this way, they can meet with the living, often in dreams, and are present at their shrines, particularly on the occasion of saint's festivals (*mawalid*; singular *mawlid*).

For the Sufi, God is not infinitely far, but rather infinitely near; one draws near to Him through spiritual closeness with one's shaykh and with the *awliya'*. Indeed, the word for saint (*wali*) literally means "near" or "friend." The Prophet, Ahl al-Bayt, and other saints are beloved by God, near (*wali*) to Him. Through great spiritual gifts or efforts, the *wali* receives mystical illumination and *baraka* from God. The *awliya'* are thus objects of great spiritual love, respect, and devotion in Egyptian Sufism, especially the Prophet Muhammad, and the Ahl al-Bayt (on the subject of love and devotion to the Prophet, see Hoffman-Ladd, 1992, pp. 615–637).

Although there is no official procedure for canonization in Islam, *karamat* ("miracles") are indications of the *wali*'s exalted mystical station, gifts God bestows upon the sincere seeker. Sufis constantly recount miracle stories, reinforcing the reputation of the saint who performed them, the majesty of God who granted them, and the limitations of the *'aql* that

158 The concept of *'alim al-arwah* illustrates the Sufi notion that everything has an inner (*batini*) aspect, visible only to those with spiritual discernment (*shafafiya*). Eye-sight (*basar*), connected to mind (*'aql*) and perceiving material reality, is thus distinguished from insight (*basira*), proceeding via the eye of the heart (*'ayn al-qalb*), and perceiving the more essential and permanent spiritual reality. Inasmuch as aesthetic experience and emotion depend upon perception, this mystical extension of perception from mind's eye to heart's eye implies a corresponding extension of aesthetic sensibility, communication, and affect. A concise answer to the opening question ("Why should Sufi music be so laden with *tarab* . . . ?") is then possible: Sufi music generates emotion by harnessing mystical perception, while secular music relies upon ordinary perception only.

cannot comprehend them; *karamat* are felt by the heart, not understood through reason. To love someone is also to praise them and ask for their blessings from God, and so Sufism is replete with praise poetry, called *madih* or *madh*, most of which honors the Prophet Muhammad.

Since spiritual proximity to God is possible, and not all are equally close, one seeks *shafa'a* ("intercession") or *madad* ("assistance") from another who is closer to God, particularly the *awliya'* who have His *baraka*. Thus relations to saints, while rooted in love, are also characterized by *tawassul* ("petition"), especially at the *maqam* (shrine) of the *wali*.[159] Shrines for important saints are always busy, but the pace of visitation intensifies on special festival days, especially during the yearly *mawlid*. Visitors recite the *fatiha* (opening chapter of the Qur'an) in front of the *maqsura* ("grill") surrounding the shrine, and make vows (*nudhur*), often to obtain intercession and *baraka* from the saint (de Jong, 1976–77, pp. 26–43). This system of saint veneration is linked to the respect shown to the living shaykh of a Sufi order, since when a great shaykh dies, his tomb becomes a *maqam*, and a locus for devotional and supplicatory acts. After a number of years, he may begin to be regarded as a saint and an annual *mawlid* may be held in his honor.

Progress towards the goals of taming the *nafs* and elevating the *ruh* is formally accomplished within the *tariqa* ("order"; literally "path"; pl. *turuq*), which is a social, practical, and doctrinal unit of Sufism, led by a shaykh. A Muslim wishing to join takes an *'ahd* ("oath") from the shaykh or his deputy, upon which he becomes a *murid* ("disciple"; pl. *muridin*). The members of the *tariqa* are collectively called *ahbab* or *muhibbin* ("lovers"), and the theme of brotherly love among *tariqa* members is emphasized in practice. Some *turuq* employ special greetings, such as the simultaneous kissing of hands, to signify the affection and respect between members. The greatest degree of love and veneration is shown to the shaykh, because of his knowledge, piety, refinement, and elevated spiritual station. The shaykh is considered to be not only a spiritual teacher and guide, but also a source of *baraka* inherited from *his* shaykh.

The shaykhs of Sufism comprise a single spiritual genealogy; every shaykh has a shaykh, and every shaykh's chain (*silsila*) of spiritual ascendants leads to the Prophet Muhammad through the caliph 'Ali. All of the great Sufis and saints, indeed all Sufis everywhere, are thus linked in one spiritual family. However, the early Sufi teachers did not establish *turuq* as formal social organizations. It was only around the twelfth century that major *tariqa* lines came into being.

159 The *wali* may or may not be buried at the location of the *maqam*; Sufis say that every *wali* has forty *maqams*.

In Egypt, Sufis trace the principal *turuq* to the *arba'a aqtab*:[160] Sidi 'Abd al-Qadir al-Jilani (founder of the Qadiriya), Sidi Ahmad al-Badawi (founder of the Ahmadiya), Sidi Ibrahim al-Dissuqi (founder of the Burhamiya), and Sidi Ahmad al-Rifa'i (founder of the Rifa'iya). To these names, Sidi Abu al-Hasan al-Shadhili's (founder of the Shadhiliya) is often added. These founders are considered *awliya'* of the highest order, and thus a copious source of *baraka*, flowing to them from God through the Prophet Muhammad and the Ahl al-Bayt. This *baraka* flows through the *silsilas* to present-day shaykhs.

Most Sufis say that the different *turuq* are merely different paths to the same goal, just as the spokes of a wheel all lead to the hub. All *turuq* emphasize the purification of the *nafs* and the elevation of the *ruh*, in order to draw closer to God, the Beloved. All *turuq* stress fulfillment of *furud* (basic religious duties, such as daily prayer) as prescribed in the *shari'a*, and emphasize refinement in word and deed. To be *mu'addab* ("well mannered"), *akhlaqi* ("moral"), *sadiq* ("truthful"), *khalis* ("sincere"), *muhtarim* ("respectful") are basic requirements for the *murid*, without which there can be no spiritual progress. Doctrinal differences between *turuq* are relatively minor.

The *turuq* are most distinctive in their social structures and in their rituals. Each *tariqa* has its body of special prayers and poetry to be used in individual and corporate practices. Books of *qasa'id* ("poems," sing. *qasida*) often feature poems written or selected by the founder of the *tariqa* or by one of his spiritual descendants. Many poems praise the Prophet or another holy spiritual figure, declaring love or asking for spiritual intercession. Other poems express the shaykh's mystical feelings and teachings. Such poetry is rooted in the emotional experience of Sufism itself.

Under the tutelage of his shaykh, the *murid* performs supererogatory ritual acts, and thereby progresses along the *tariqa* from one spiritual station (*maqam*) to another. Along the path, God may grant the seeker *ahwal* (sing. *hal*): transient states of mystical insight or emotional rapture. The *murid* attends to his character and behavior, performs daily devotions, and participates in group activities of the *tariqa*. He may be called upon to serve the shaykh in any number of mundane capacities, serving tea, cleaning the mosque, or running errands; the shaykh in turn monitors his spiritual progress and assigns new spiritual exercises as he sees fit. Most *turuq* also conduct one or two *hadras* ("group meetings") each week, either in a mosque or another meeting place. The *hadra* may

160 The *awliya'* form a spiritual hierarchy, in which the highest rank is the *qutb* (pl., *aqtab*), the pole or axis of the world. See Schimmel (1975) and (1982); and Hoffman (1995).

include Qur'anic recitation, *durus* (teaching sessions), *inshad*, and *dhikr*.

Dhikr ("mention" or "remembrance" of God) is a term covering a number of practices, both solitary and corporate, in which participants concentrate on God. The central corporate Sufi ritual is *dhikr al-asma' al-husna* ("remembrance of the divine names"). In this ceremony, *muridin* draw closer to God through collective rhythmic chanting of His names, often while performing *tafqir* (rhythmic body movements). Alongside this chanting and movement, Sufi *munshidin* ("singers") may perform *inshad*, sometimes with *musiqa* ("instrumental accompaniment"). In each segment of *dhikr*, there is a gradual buildup of chant, movement, music, and emotional level. In Egypt today, *dhikr* is performed both inside and outside the *turuq*.

Within the *tariqa hadra*, *dhikr* may include *inshad*, but melodic instruments are used only rarely, and never within a mosque. Intensive displays of emotion are curtailed and trance behavior is generally forbidden. However, when *dhikr* is performed outside the *turuq*, for social occasions such as weddings and in *mawalid*, the strictures of the *tariqa* and its shaykh are absent. In such contexts, the use of melodic instruments is nearly universal, there is more spontaneity and less formal structure in performance, and participants display a much wider range of emotional behavior.

Sufism is often identified with the orders themselves. This is a mistake, because in Egypt, participation in the orders is relatively limited, whereas the underpinnings of Sufi belief and practice permeate a very broad segment of Egyptian Muslim society. What I term "informal Sufism" is the larger system of thought, feeling, and action, which includes the *turuq* as particular crystallized social structures, but which extends amorphously beyond them, though without central authority, hierarchy, explicit doctrine, or fixed ritual forms. Others may call this system "popular religion," but in fact it is essentially the same Sufi worldview as that found in the orders. The main difference between formal and informal types is the absence of the social structures in the latter and formal spiritual disciplines characteristic of the *turuq*. In fact, many "informal Sufis" are officially members of orders, but for various reasons may not attend a regular *hadra*. In colloquial parlance, they are often called *muhibbin* or *'ashiqin* (literally, "lovers," though the meaning comes closer to "devotees").

Informal Sufism centers upon the veneration, love, blessings, and intercession of the Prophet, Ahl al-Bayt, and *awliya'* in informal and individual practice. While the regular, structured *hadra* is the focus of corporate practices within the *turuq*, the most important social occasions

for informal Sufism are the hundreds of yearly *mawalid*, which punctu-
ate the calendar irregularly, each lasting from one night to two weeks
(McPherson, 1941). Spiritually and spatially each *mawlid* centers upon
the *maqam* of a particular *wali*.[161]

The *mawlid* gathers members of many Sufi orders, along with other
muhibbin, who come to greet the saint, bask in the radiance of his or her
baraka, and meet friends. Wealthier Sufis may set up a *khidma* (tempo-
rary dining/kitchen area where food and drink are served without charge),
a focal point for informal and convivial gatherings of *muhibbin*, or may
sponsor a *munshid* to sing for large informal performances of *dhikr*,
"public hadras," which anyone may join. Sufi mendicants and *majazib*
(Sufis who by birth or through excessive mystical practice have lost their
intellective faculties), often dressed in extraordinarily odd garb, are gen-
erously provided for. The *mawlid* also draws throngs of non-Sufi onlook-
ers, who come to enjoy the festive atmosphere of food, games, rides; there
are no restrictions on who may attend. The *mawlid* is open, creative,
improvisational, and sometimes chaotic, as opposed to the closed ritual
order of the *tariqa hadra*. It is an occasion glowing with good feeling and
altruism, a practical demonstration par excellence of Sufi love. On a
smaller scale, *layali diniya* (lit. "religious nights") lasting only one
evening and celebrating a variety of social occasions with a public *hadra*
(including *inshad* and *dhikr*), exhibit much the same atmosphere.

Throughout Sufism (formal or informal), participants are bound
together by shared feelings of love, for each other and spiritual entities,
based on a common worldview and experience. In the *tariqa*, emotional
unity is the result of initiation, shared allegiance to the shaykh, long
familiarity with one another, common beliefs and teachings particular to
the *tariqa*, and regular devotional practices, including performance of
the corporate *dhikr*. Here, *hadra* is only one factor out of many, mani-
festing unity at least as much as constructing it.

Informal Sufis attending a *mawlid* or *layla* are likewise bound by
love. However, the lack of fixed ritual formats and attendees, regular
meetings, or definite ritual boundaries means that the emotional power
and unity of these events is more transient, and constructed largely
through *hadra* performance alone. The emotional force of these rituals is
sufficient to forge a kind of collective affective order, at least for the
duration of the *mawlid*. That order is never manifested as social struc-
ture or rigid ritual form; rather, it is the order of shared mystical-emo-
tional experience. Within the public *hadra* of *mawlid* or *layla*, Sufi music

161 The sole exception is the *mawlid* of the Prophet himself, which is celebrated every-
where in the Islamic world on the twelfth of Rabi' al-Awwal.

is more critical to the construction of this emotional unity than in the *tariqa hadra*. For this reason, *tarab* is more urgently required in the public *hadra* performances of informal Sufism. At the same time, it is the inherent flexibility of the public *hadra*, combined with the emotional potentialities of Sufism, which enables *tarab* to flourish there.

Inshad Sufi[162]

Though frowned upon by conservative Islam, musical sound is widely accepted, both in theory and in practice, within Sufism. Emotions stirred by organized sound, together with movement, breath, and chant, have long been used as tools for the generation of mystical feeling in the Sufi *hadra*.

In Egypt, Sufi music is generally called *inshad*, or *al-inshad al-Sufi*. Here I use the word music to cover "sound designed for perceptual concentration." But I must clarify that the English word "music" has a different semantic scope than its Arabic cognate *musiqa*. The latter implies the use of musical instruments, which have negative connotations derived from association with the *haram* ("forbidden") aspects of secular entertainment (e.g., dance, alcohol), while most Sufi "music" consists of singing (*ghina'*) only, with emphasis on mystical or devotional poetry; such music is not *musiqa*. But even the word *ghina'* is too laden with secular connotations, and so Sufi music, together with other genres of Islamic singing (*ibtihalat, tawashih,* and *qisas diniya*), is referred to as *inshad* ("hymnody"); the singer of religious song is called a *munshid*.[163] While most Egyptian *inshad* consists of solo or choral singing, instruments, such as the *daff* (frame drum), *riqq* (tambourine), *tabla* (goblet-shaped drum), *kawala* (reed flute), *kamanja* (violin), *'ud* (Arab lute), and even *org* (synthesizer), are commonly found outside the mosque, especially in the *mawalid*.

In Sufi exercises, focusing on spiritual closeness to God, His Prophet, and other holy figures, and the negation of sensual desires, the aesthetic ought not be an end in itself, but rather a means of developing mystical feeling. The danger that the sensual means may be mistaken for the spiritual goal accounts for the controversy that has constantly swirled about the issue of music in Sufi ritual. Most contemporary Egyptian Sufis carefully distinguish spiritual uses of music from the production of *tarab* as a sensual end in itself. The avoidance of the Arabic word *musiqa* and substitution of *inshad* for *ghina* is one example. Another is the

162 On the Sufi *inshad* of Egypt, see also Waugh, 1989. His approach differs from mine in significant ways, but most of our conclusions are congruent.
163 For an overview of Egyptian *inshad*, see Frishkopf, "Al-Inshad al-Dini (Islamic Religious Singing) in Egypt," *Garland Encyclopedia of World Music*, vol. 6 (New York: Garland Publishing, forthcoming).

emphasis placed on the didactic function of Sufi poetry, music some-
times held to be nothing more than a means of attracting people to the
spiritual benefits of its texts, even though much mystical poetry is intel-
lectually incomprehensible to most listeners.

Sufi *inshad* employs a variety of poetic forms in both classical and
colloquial Arabic, including the *qasida, murabba', mukhammas,* and
muwashshah (in classical Arabic); and *mawwal, sharh,* and *zajal* (in the
colloquial). The preeminent themes are *al-hubb al-ilahi, tawhid* ("praise
and glorification of God"); *ibtihalat* ("supplication of God"); *tawassul*
(requests for intercession); *madih* ("praise"); and *ghazal* (descriptions of
the beloved) for the Prophet Muhammad, the Ahl al-Bayt; and *awliya'*;
mawa'iz ("exhortations"); expressions of mystical experience (often
employing the metaphors of love, longing, and intoxication); and gnos-
tic affirmations (*ma'rifa*).[164]

Sufi *inshad* is frequently used within the *turuq,* as an accompaniment
to corporate *dhikr* or at other occasions within the *hadra.* In *dhikr,* the
extent of musical accompaniment varies with the *tariqa,* but normally
does not include more than percussion (drums and handclaps). Songs
also function as pedagogical devices for the *muridin,* who imbibe the
poem's content through group singing, for poetry used within the *turuq*
is often composed (or at least selected) by the founding shaykh, to
express and promote his mystical philosophy or teachings. The presiding
shaykh or his deputy strictly controls the performance of *munshidin,*
who are amateurs drawn from the ranks of the *tariqa.*[165] Many songs are
responsorial: leaders sing a verse, while others respond with a refrain,
unless they are engaged in *dhikr;* there is no "audience."[166] The structure
of this participatory music is necessarily relatively simple. Choral songs
are metric and strophic, employing brief precomposed melodies of nar-
row ambitus. Short solo passages may be improvised and wider ranging,
but without deploying the full resources of Arab music which could pro-
duce powerful *tarab,* due to lack of freedom, skill, or necessity. The *tariqa
munshid* is controlled by his shaykh, and must time performance to fit
tariqa ritual within short allotted segments; being an amateur, he is only
rarely a virtuoso. *Tarab* is not required, and may not even be desired,
particularly in *turuq* that view the power of music with suspicion.

164 For portions of this classification I am indebted to Dr. Ibrahim 'Abd al-Hafiz of the
High Institute for Folk Arts.
165 For a discussion of the role of the *munshid* and *inshad* within the *tariqa* and the
relation between shaykh and *munshid,* see Waugh (1989), p. 68.
166 In this chapter, the word "audience" is sometimes used to denote all participants
other than singers and instrumentalists when the distinction between musical per-
formers and others seems clear cut. This is often the case outside the Sufi orders, but
only rarely within them.

Outside the *turuq*, in the realm of "informal Sufism," the roles of music and *tarab* are vastly expanded. Here, inshad occurs within the "public *hadra*," featuring a skilled professional *munshid* accompanied by a *takht* (similar to the format of secular *tarab* music before 1930), whose musical performance regulates and energizes the *dhikr*. *Mawalid* provide sacred spatiotemporal settings for public *hadras*, near the *maqam* of the saint. More often, the *munshid* is hired to sing for a variety of socioreligious occasions, such as the return from the *hajj*, *farah* ("wedding"), *subu'* (the celebration held seven days after a child's birth), *dhikra* ("memorial"), or in fulfillment of a *nadhr* (vow made to a saint in exchange for intercession and baraka). All of these performances (called *layali*) are public and open.

Because these occasions transcend the bounds of any one *tariqa*, they are not usually directed by a Sufi shaykh. Instead, the *munshid* himself takes control of all dimensions of performance, choosing poetry and constructing melody in an improvisatory style according to his taste and mood. Unlike the *inshad* of the *turuq*, the *takht* is heavily amplified, creating a concert atmosphere, in which musical performers are sharply distinguished from other participants (and here the term "audience" is more appropriate, if not ideal) by their access to a microphone and exalted status atop a platform of some kind. The audience does not sing, although they may perform *dhikr*, clap, or express feeling through exclamations. They too are largely free from any central controlling authority (although there is always at least one *mustaftih* to coordinate *dhikr* movements with the music), and so emotional expression usually reaches a much higher level than within the *turuq*.

Due to the freedom and skill of performers, the musical structure of *inshad* in the public *hadra* is much more elaborate than in the *tariqa hadra*, drawing on the full resources of Arab music, and borrowing musical styles, techniques, and melodies from secular music, both urban and rural. Such *inshad* is heavily influenced by the *tarab* aesthetic. Most of the performance is designed to facilitate *dhikr* and thus employs a metric line (sounded at least by the percussion section), although completely nonmetric segments are also used.

In the Delta area, professional Sufi *inshad* draws heavily on the *mawwal* (colloquial poetry featuring varied rhyme schemes with clever paronomasias, sung in an unmeasured style), the *sharh* (a monorhyme *mawwal*), and the *taqtuqa* (colloquial strophic metric song), all performed over the regular beat of *dhikr*. These poems are usually handed down anonymously and learned orally, although modern poets sometimes write for the *munshidin*, and poems may be published and learned

from books as well. Musical accompaniment is close to secular folk music, adapted to accommodate *dhikr*, and often evokes a dancelike ethos.

By contrast, in the Sa'id (Upper Egypt), and especially in the province of Assiut, many professional *munshidin* perform classical Arabic *qasidas*, including difficult Sufi poetry by masters such as 'Umar Ibn al-Farid, Rabi'a al-'Adawiya, al-Hallaj, Ibn 'Arabi, 'Abd al-Karim al-Jili, 'Abd al-Rahim al-Bur'ai, Sharaf al-Din al-Busiri, and many others. The vocal style is free, but does not employ melodic patterns typical of the secular *mawwal* or invoke dance music, as in the case of Delta singing. The Sa'idi style is generally considered more serious and difficult than Delta *inshad*. This Sa'idi tradition of Sufi *inshad* for public *hadra* is the principal subject for the analysis that follows, although most remarks would apply equally to the Delta tradition as well.

Shaykh Yasin al-Tuhami, from the village of Hawatka near Assiut, is the premier performer of the Sa'idi tradition today, a tradition that he has been instrumental in defining over the past twenty-five years. Besides having spawned a wide circle of imitators in the Sa'id, he has become so famous that he has widely influenced the style of Sufi *inshad*, even in the Delta. Thus, in studying Shaykh Yasin one is indirectly examining a widespread musical, social, and religious trend extending across Egypt, of which he is the leader and primary exponent.

Shaykh Yasin al-Tuhami[167]

Shaykh Yasin al-Tuhami, widely acclaimed as the greatest professional Sufi *munshid* in Egypt today, leads a largely nocturnal existence. Arising at seven or eight in the evening, he dresses in a fine *jallabiya* ("robe"), colored *shal* ("shawl"), and brilliant white *'imma* ("turban"), entertains visitors, and conducts business (he is always booked many months in advance). About nine or ten in the evening, with his *sibha* (string of prayer beads) in one hand, he descends from his apartments, boards his vehicle, and together with his musical group (*firqa*) travels to the site of the *layla* (see figure 19).

There he is met by the *layla*'s sponsors and hundreds of *muhibbin* who have flocked to see him, some of them having traveled hundreds of kilometers. He pushes through the thick crowd that immediately gathers about his car, shaking hands and exchanging greetings with his many admirers. Slowly he makes his way to the sponsor's home, where he and his group, together with other special guests, are provided a supper, often consisting of soup, rice, salad, bread, and roasted meats, followed by highly sweetened tea.

167 Shaykh Yasin is discussed extensively in Waugh (1989), pp. 63, 116, 150, and elsewhere.

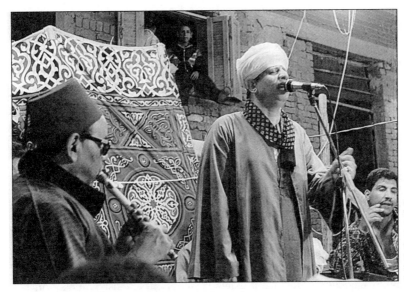

Figure 19. Shaykh Yasin al-Tuhami performing a typical high-amplification *layla*.

The performance area (*saha*) is clearly marked by its colors and light. A tent (*suwan*), constructed out of heavy cloth imprinted with brightly colored Islamic designs in red, black, blue, green, and white stretched over a lashed wooden frame, usually encloses the *saha* on all sides except one, which is left open to accommodate the crowds and *dhikr*, which spill over into adjoining areas. Against the back wall of the *suwan* is a carpeted wooden stage (*masrah*), upon which the musicians sit or stand in a semicircle around the *munshid*, and which also supports a sound system, including microphones for Shaykh Yasin and melodic instrumentalists. Just in front of the *masrah* is a wide carpeted strip, upon which *dhikr* will be conducted. On the fringes of this carpet are rows of chairs, though many more will stand than sit. Large speakers are placed on stands around the periphery of the performance space, directed inward. Strung upon the wooden frame of the *suwan* and adjacent buildings are strings of thousands of tiny colored lights, and powerful floodlights illuminate the area with such power that the cool night approaches the heat and light of noontime.

Generally, the sponsor must pay Shaykh Yasin and rent equipment for the *layla*; however, the performance is open to all without charge. At several of the largest and most important of the *mawalid*, including those of Sayidna al-Husayn, Sittina Sayida Zaynab (grandson and granddaughter of the Prophet, respectively, and patron saints of Cairo), and Sayid Ahmad al-Badawi (the famous saint of Tanta, whose *mawlid*

allegedly draws more than two million participants), Shaykh Yasin per-
forms gratis. Many fans bring tape recorders, bravely holding them aloft
in clusters just in front of a speaker for the entire performance in order
to make the best possible recording; later, these tapes will be widely
copied, traded, and distributed throughout Egypt.

The crowd gathers all evening in anticipation. Shaykh Yasin's audi-
ence comprises mainly villagers and recent urban immigrants, who are
not necessarily poor or uneducated.[168] He also draws a small but
significant number of upper-class *nouveaux riches* and intellectuals;
many of these subscribe to the Sufi world view, if they are not actually
members of *turuq*. Most of his audience is drawn from the locale in
which he performs, but a large number of fans travel about with him,
and can be seen at his performances throughout Egypt.

Around 11 p.m. Yasin emerges from the home of the sponsor and,
together with his *firqa*, makes his way to the *suwan*, where he ascends
the *masrah*, tests the microphone, adjusts gain and reverb levels on the
amplifier, and supervises precise placement of the speakers, so as to
avoid feedback problems. Musicians unpack their instruments and take
their seats. One of Yasin's innovations was his popularization (some say
introduction) of *alat al-tarab* (instruments of secular *tarab* music), such
as *kamanja* and *'ud*, which (unlike the reed flutes *nay* and *kawala*) are
not traditional in Sufi music. Including also a small percussion section
(*riqq*, *daff*, and *tabla*), his group resembles the *takht* of *tarab* tradition.
Shaykh Yasin, dressed like the *imam* ("prayer leader") of a mosque in his
white *'imma*, is considered *imam* of the *hadra* when he performs. He
maintains ultimate control over the event, combining the functions of
both *munshid* and shaykh in the *turuq*; the *mustaftih* follows his lead.

Shaykh Yasin usually divides his *hadra* into three *waslas* ("parts").[169]
(The Sufi use of the term *wasla* to describe a unified segment of music
and *dhikr*, featuring an escalating emotional level, is reminiscent of its
use in older secular *tarab* music of Egypt, and thus illustrates another
connection between Sufi *inshad* and the *tarab* tradition.[170]) The first *wasla*
incorporates a percussive metric base and lasts about ninety minutes.

168 In Egyptian society it is important to differentiate between economic and cultural
class structures. Thus, a man may migrate from his village to Cairo and open a shop,
gradually becoming wealthy enough to afford an upper-middle-class lifestyle, and
yet cleave to a relatively traditional lifestyle in a "popular" (*sha'bi*) neighborhood
full of less fortunate immigrants.

169 When performing at *mawalid* Yasin sings one *wasla* only. This *wasla* resembles the
first *wasla* as described below, but longer (lasting from one and a half, to two and a
half hours).

170 For a thorough discussion of the *wasla* in older Egyptian music, see Racy (1983b),
pp. 396–403.

Following a break of twenty minutes or so comes the second *wasla*, which contains neither percussion nor meter, lasting about half an hour. The second *wasla* may be followed by a second break, or may plunge straight away into the third *wasla*, which is similar to the first, but a good deal shorter. The whole performance lasts from two and a half to four hours.

Yasin may precede the *inshad* performance proper with solo recitation from the Qur'an, beginning with the *fatiha*, in the clear and simple *tartil* style, followed by recitation of the *hizb* ("extended prayer") particular to the Sufi order represented by the *layla*'s sponsors. The recitation of Qur'an and *hizb* serves as a kind of benediction for the *layla*, a prayer for its success, and the inspiration of the performer. Yasin finishes after about twenty minutes.

After a break, melodic instrumentalists connect to the sound system and tune up; percussion is not usually amplified. Tuning moves imperceptibly into a nonmetric prelude, in which the first *maqam* ("musical mode") is established with a short *taqasim* ("improvisation"), as in the secular *tarab* tradition. During this time, the coordinator of the *dhikr* (the *mustaftih*) begins to arrange those men who wish to perform *dhikr* into facing lines, perpendicular to the front edge of the platform.[171] Shaykh Yasin begins the *dhikr* by rhythmically intoning "Allah . . . Allah"; the *mustaftih* picks up the beat and sets a pattern for the others to follow, swaying his body and clapping his hands.

At a cue from Shaykh Yasin, the percussion section enters, and the first *wasla* is underway. He then launches into a standard opening piece, "Ya a'zam al-mursilin" ("O Greatest of Messengers"), a *madih* for the Prophet Muhammad. Next, he sings an initial *madad* section, in which the word *madad* ("help") is repeated over and over, followed by various names. Each instance of the word *madad* is a plea for assistance from the following named entity (e.g. *madad ya Sayida Zaynab*), to the extent of his or her capabilities. Normally requests for *madad* are directed towards God, the Prophet, the saints, the Ahl al-Bayt, and the great Sufi poets (who are also regarded as saints), although in theory anyone could be named. Who is mentioned depends upon performance locale; *hadra* participants often hand Yasin slips of paper on which are written the names of local saints they want him to call. The mention of saints whose shrines are physically proximate—particularly the saint in whose honor a *mawlid* is being held—always creates a great emotional stir. In Yasin's performance, *madad* also functions as a release from the

171 Women, if they participate in the *dhikr* at all, stand at the edges of the crowd, rarely in the main *dhikr* lines. However, many women do attend these events, often watching from balconies and rooftops.

difficulties of the poetry and is performed at the fastest tempos.

Following the initial *madad* comes a sequence of "buildups," each comprising segments of poetry interspersed with musical interludes. The interludes, which function to give the singer a rest and to solidify changes in *maqam*, consist of *taqasim* or musical *lazimat* ("melodies," often taken from songs of Umm Kulthum and other famous Arab singers). Shaykh Yasin draws his poetry from many sources, but there are normally one or two principal *qasidas* in a *layla*, with other short poetic excerpts inserted here and there. This poetry is often extremely difficult, densely symbolic mystical language in classical Arabic, and while everyone understands fragments, few are able to grasp it completely. Still, they appear to feel it, and respond with gesture, movement, and vocal cries, particularly at the close of each musical-poetic phrase (*qafla*). Shaykh Yasin is free to choose poetry to match his own mood and the mood of his listeners as expressed in their feedback, and he is skillful in manipulating musical and poetic resources to raise the emotion of performance to a high pitch. The tempo increases, and the meter moves from low, to mid, to high "gear" during each buildup, until its culmination in *madad* (see also Waugh, 1989, p. 123).

The *dhakkira* (those who perform *dhikr*) must follow tempo and meter changes, guided by the *mustaftih*. Their emotional responses, expressed in movements, facial expressions, cries, and shouts, are much more pronounced than in the *turuq*, since there is no authority to impose restraint. One frequently witnesses varieties of "trance" behavior not tolerated in most *turuq*. *Dhakkira* may jump wildly up and down, flail their limbs, or fall unconscious, sometimes interrupting the *dhikr* in the process. During this metric section, emotional behavior generally correlates with the tempo of the music and the transparency of the text; being occupied with the *dhikr*, it is difficult for *dhakkira* to concentrate on poetic meaning. When Shaykh Yasin reaches the climax and begins to sing *madad*, great emotion is unleashed by the mention of saint's names (understood easily enough), as well as the rapid tempo. One entranced is variously described as *fi hal* ("enraptured"), *mitdarwish* ("in a mystic's state"), *nashwan* ("ecstatic"), *fi halat wajd* ("in a state of ecstasy"), *hayman* ("madly in love"), *tayih* ("lost"), or *sakran* ("intoxicated"), among other terms. The same adjectives can be applied to the *munshid* or poet, as we shall see later.

After several of these buildups, the first *wasla* concludes, and there is a break, during which *muhibbin* wishing to greet Shaykh Yasin mob the stage. Some consider him to have *baraka*, for he is an inspired *munshid* whose father was a *wali*. He is beloved and respected by his listeners, whose behavior toward him is similar to that of *muridin* toward their

shaykh. Indeed, the *muhibbin* who follow him from one performance to another may be considered as a virtual *tariqa*-in-flux constituted in and by performance, for which Yasin is the shaykh and teacher, as well as *hadra* leader.

In the second *wasla*, Shaykh Yasin sings ametrically, accompanied by melodic instruments only. There is no meter or *dhikr*; instead, everyone sits quietly, concentrating on the singing of poetry. Here, emotion is more closely tied to the poetry than the music. When Shaykh Yasin finishes a phrase, cries of appreciation (Allah!" "*Aywa, ya* Shaykh Yasin!") rise from his "audience." The longer the poetic phrase, the greater the emotional response, although the number of people who can actually explain its poetic meaning may be few. These interactions between Shaykh Yasin and his audience intensify the emotional tension of the moment. It is here that a central enigma of this music—how esoteric Sufi poetry may generate such a powerful emotional impact—presents itself most clearly.

Following this *wasla*, there may be another break, or Yasin may enter the third *wasla* directly. The third *wasla* is a shortened version of the first, consisting of two or three buildups only. The final buildup leads to one of several conventional closing pieces (such as "*Salat Allah 'alayhi wa sallam*" ["May God bless him [the Prophet] and give him peace"]). After the percussion has ceased, Shaykh Yasin calls for the *fatiha* to be read, and the *hadra* ends.

Sufi Poets, Poetry, Sufism, and Emotion

The poetry of Sufi *inshad* is one of the primary keys to its power. Poetry is a main criterion for the aesthetic evaluation of a *munshid* and the most salient feature of his performance. During the *hadra*, listeners appear deeply affected by specific phrases, and often memorize them, even though they cannot explicate their meanings. What is the source of this poetry's power? Why might the affective impact of Sufi poetry far exceed that of its secular counterpart? The answer is intricately bound up with the nature of the Sufi system out of whose meanings this poetry comes, in which it is embedded, and for whose sake it exists.

The Sufi Poet and the Sufi Tradition

Sufi poetry is qualitatively different from ordinary poetry, just as the Sufi poet is qualitatively different from the ordinary poet. The mystic is filled with powerful inner feelings, which demand expression through word or deed. When the expressive medium is poetry, he is called a Sufi poet. But he is first and foremost a Sufi; writing poetry is essentially the

expression of mystical experience, not an artistic effort. For the Sufi, being a poet is a spiritual necessity, a response to the inner pressure of feeling that demands release, not an external vocation. The Sufi poet thus stands at an interface, communicating the Sufi reality he experiences on the one side to the reader or listener on the other.[172]

The spiritual station of an individual poet is critical to the affective efficacy of his words, because his poetic creativity requires spiritual inspiration, and will be judged in the context of his spiritual reputation. To write true Sufi poetry requires *iman* ("faith"), *safa'* ("purity"), and *qurb min Allah* ("closeness to God"). One Sufi told me that the great Sufi poets were *tahir ma'a Allah* ("in a state of purity with God"), *qulubhum minawwara* ("their hearts were illuminated"). They were truly Sufi masters, a status critical to understanding their words. Shaykh Yasin himself refers to important Sufi poets as *asyadna al-kubar* ("our great masters").

Socially and mystically, the Sufi poet is well connected to the Sufi genealogy, participating as a conduit for its flows of *baraka*. He is first of all a *murid* and a *muhibb*. Generally he has taken the *'ahd* from a shaykh (at least after the advent of the *turuq*), and may have had other spiritual teachers as well. From these teachers he inherited the accumulated riches of Sufi spirituality, in which he immersed himself. It is the palpable presence of this legacy, sincerely expressed in his poetry, which authenticates him as a Sufi poet and his work as Sufi poetry.

Originality is not important in this poetry; authentic feeling is. The mysticism of his own shaykh often reverberates powerfully through his own writings, to the point where their voices merge. Indirectly, his poetry echoes meanings of the entire tradition. One Sufi stated that all Sufi poets are spiritually related to Imam 'Ali ibn Abi Talib, and through him to the Prophet. The Sufi poet may also have had disciples of his own, to whom he bequeathed his spiritual insights in poetic form, or he may have been the shaykh of a *tariqa*, for which he composed poetry, thereby expressing mystical feeling for the benefit of his *muridin*.[173] Because the Sufi poet is firmly placed in the great spiritual genealogies of Sufism, and because he conveys true mystical feeling in his poems, he is the lynchpin joining the *inshad* tradition to the vast spiritual universe of Sufism, a conduit through which meaning can flow from its wellspring in the absolute into performance.

172 The great Sufi poet Mawlana Jalal al-Din Rumi remarked: "By God, I care nothing for poetry, and there is nothing worse in my eyes than that. It has become incumbent upon me, as when a man plunges his hands into tripe and washes it out for the sake of a guest's appetite, because the guest's appetite is for tripe" (Schimmel, 1982, p. 12).

173 Such is the case for example with two modern and prolific shaykh-poets of Cairo: Shaykh Salih al-Ja'fari, and Shaykh Muhammad Madi Abu al-'Aza'im.

Saint and poet exist on a continuum in Sufism; any distinction is hazy. The great Sufi poet is regarded as a *wali*, even when he did not found a *tariqa*. In Cairo, 'Umar Ibn al-Farid has been venerated as a saint since shortly after his death, and is credited with *karamat*; his *mawlid* is celebrated today (Homerin, 1994). During *madad* sections, when he is calling out the names of the saints, Shaykh Yasin often names the great Sufi poets, such as Ibn al-Farid, Ibn 'Arabi, Rabi'a al-'Adawiya, and al-Hallaj. The saintly position of Sufi poets means that their work is regarded as qualitatively different from that of ordinary poets; it is imbued with *ma'rifa*, the gnosis of mystical illumination, and is authenticated by the *baraka*, accumulated meanings, and the authority of the author's spiritual *silsila*. For the ordinary secular poet there are no comparable sources of power.

Likewise, the *wali* is a poet. Poetry is attributed to the great saints of Egypt, such as Sayyid Ahmad al-Badawi, and Ibrahim al-Dissuqi, and to members of the Ahl al-Bayt as well. Sometimes these saints composed poetry themselves; other times they inspired a spiritual disciple to do so. Many poems are received by a Sufi from his shaykh in a dream; he then attributes the poem to his shaykh, *'ala lisanihi* ("on his tongue"), as an instance of shared feeling. This creative collaboration between shaykh and disciple glorifies the former, while bestowing authority on the latter.[174] In this way the attributed poetic output of a shaykh comprises far more than what he composed in his lifetime; rather, his spiritual force becomes an impetus for creation in his name among all of his spiritual descendants. Thus, Ahmad al-Rifa'i (founder of the *tariqa al-Rifa'iya*), who (apparently) never wrote any poetic works directly, inspired disciples (such as the nineteenth century Syrian religious scholar Abu al-Huda al-Sayyadi) to write in his name. The stature of the attributed author endows his putative words with tremendous affective power.

Despite the essential interiority and ineffability of mystical experience, the meanings and forms of Sufi poetry are universal within Sufism. For Sufi feeling is shared, through common training, common experience, and the continuity of tradition via the shaykh-disciple relationship. Poetic phrases and images expressing that feeling are borrowed from a common Sufi literary heritage. The Sufi poet is wholly original neither in experience, nor in language; he is inspired by common streams of rich tradition, flowing from his spiritual ascendants. In the other direction, following the linkages of Sufi mentoring, his language and feeling is

174 Another means of creative collaboration occurs through the poetic techniques of *takhmis* and *tashtir*, involving the interpolation of new material into an existing *qasida* while maintaining rhyme and meter; such poems are common in Sufism. See Schimmel (1982), p. 46.

likewise not only his own, for it is shared and reaffirmed by those who follow, in a line leading ultimately to the living shaykh of a *tariqa* and its *muridin* or the *munshid* and listeners at a performance of Sufi *inshad*. Significantly, one often finds collections of Sufi poetry in which the attribution preceding a poem is anonymous, such as *li ahad al-afadil* ("attributed to one of the learned"), or even plural-anonymous, such as *li ba'd al-muhibbin* ("attributed to some of the *muhibbin*"). Authorship is thus explicitly distributed across the tradition, rather than located in any one person; meaning is thereby empowered by the tradition as a whole.[175]

The rich spiritual genealogy of the poet, shared authorship, inspired authorship, invocation of common Sufi tradition: together these factors provide Sufi poetry with a collective force unavailable to ordinary poetry—the force of shared and accumulated metaphysical experience. Because they express ultimate reality, meanings of Sufi poems are universal, perennial, and infinitely rich. Shaykh Yasin says that the poetry of the saints is unique because it is always *bikr* ("novel"), revealing new meanings at every reading. This property results in part from the weight of the shared tradition that it expresses in such condensed form "every word a world of meaning," said one Sufi poet), although its meanings are comprehensible only for those who have already experienced the like. In a sense the poet is a corporate spokesperson for the entire tradition, encoding in language what others only feel with their hearts. This is one of the secrets of his words' power for those subscribing to the Sufi world view.

The Sufi Poet and Mystical Experience

Nevertheless, the poet is not merely the scribe of common experience and tradition. The poet writes in order to express veritable personal mystical experience, casting molten inner feeling—grief, joy, love, pain, or desire—in linguistic forms. The greatest Sufi poetry, that which expresses the experience of the advanced mystic, is the spontaneous linguistic expression of *hal*, a transient, noncognitive state in which one is plunged into an awareness of divine realities, or is overcome with emotion resulting from such awareness. To be in *hal* implies the absence of the intel-

175 The critic may view this confusion over authorship as symptomatic of the ignorance that fuels emotion. Many fans of Shaykh Yasin, for example, wrongly believe that he sings primarily the work of 'Umar Ibn al-Farid, and they seem to derive emotional power from this belief. "And what if they were to be disabused of this belief?" the critic asks. "Would the poetry then lose its affective power?" But such a critique betrays a misunderstanding of the notion of creation within the Sufi tradition. It is true that many poems attributed to Sidi 'Umar cannot be located in his *diwan* (collection of poetic works), and are found instead in the *diwans* of other lesser poets. However, attributions of poetry in Sufism are intimately connected with belief in the interconnected network of Sufism as a whole, in which meanings and expressions are freely shared, and spiritual inspiration is transferable.

lect, often together with the presence of strong emotions of love or long-ing. Synonyms for the poet's *hal* include *hayman* ("madly in love"), *wal-han* ("mad with love"), *fi halat wajd* ("in a state of ecstasy"), *sakran* ("intoxicated"), *mushtaq* ("yearning"), *hazin* ("grieved").[176] The emotion-al force of the poet's *hal*, his creative condition, is mysteriously imbued in his words as a nonobjective quality, capable of tremendous affective power for the Sufi possessed of spiritual insight and sensitivity (*shafafiya*). For the non-Sufi, cryptic and emotional language expressing mystical experience, especially *shathiyat* (ecstatic expressions of divine union; Ernst, 1985) sounds at best unintelligible, at worst heretical.

Many Sufis say that Sufi poets are not *shu'ara'* ("poets") at all, because true Sufi poetry arises from *ilham* ("inspiration"), as a verbal translation of *hal*, not out of studied craft (*sina'a*), which requires intel-lect (see Waugh, 1989, p. 86 for a discussion of *ilham* and the applica-tion of this concept to *inshad*). The Sufi poet is not so called by profes-sion. The professional poet must rely upon craft in order to write—promptly, upon request—about subjects of little personal concern. But the Sufi poet is a mystic first; his poetry cannot exist apart from his feeling and inspiration. Indeed, *sina'a* is denigrated in Sufism; the great Sufi poets composed naturally, without artifice, even without ego or intellect. Craft is a construction of the *'aql*, which is viewed as a veil upon truth, while true expression emerges from the ruh, whose origin is Allah.

Thus, the Sufi poet exemplifies the principal Sufi value of *sidq* ("truthfulness") in his writing. Unlike the professional poet, he can write only what he feels in his heart. This quality lends power to his poetry, as Sufis often say: *Alladhi yakhruj min al-qalb yadkhul al-qalb wa alladhi yakhruj min al-lisan yadhhab ila al-udhn* ("What comes from the heart enters the heart; what comes from the tongue reaches [only] the ear").

Shaykh Yasin prefers to describe the great Sufi poets as *mukhatibin al-arwah bi al-arwah* ("addressers of spirits via spirits") to *shu'ara'*, because their words come from "the tongue of their *hal*" (*kalamhum min lisan hal-hum*), "the result of their feeling" (*natijat ihsashum*) translated into lan-guage. Such poetry is *khali min al-madda* ("free of the material"). Another Sufi explained that the great Sufi poets wrote from inspiration provided by mystical experiences: *tajalliyat* ("theophanies"), and *nuraniyat* ("divine light"). While writing, they were absent from themselves, as if *madhub* ("dissolved") in water[177] or *fana' ma'a Allah* ("annihilated in the divine").

176 In the Sufi treatises these words may have distinct technical definitions, but in prac-tice they are used more or less synonymously.

177 The metaphor of dissolution or melting (*dhawb*) for the assimilation of one spirit into another, or into God, is common in Sufi parlance; the same trope is sometimes used in describing the emotional exchange of *tarab*.

Most Sufi poetry is about and inspired by love, and thus incorporates themes and images of secular love poetry. But Sufi love is spiritual; its source is intense longing for God, the Prophet Muhammad, the Ahl al-Bayt, and *awliya'*. As one Sufi poet told me, when the beloved is present, poetry is unnecessary. Poetry is born of a painful yearning (*shawq*) for the beloved, expressing the lover's grief (*kadar*) of separation. Since the beloved exists only in the spiritual realm (*'alim al-arwah*), it is not possible to quench this *shawq* through physical unification. These emotions are expressed poetically as praise, love, or desire.

The most potent Sufi poetry arises from *hal*. For *hal* entails an excess of spiritual feeling (*wajd*), which may be painful to bear. The great Sufi poet is a mystic able to translate *hal* into poetry. The expressive act of composition, the communication of inner feeling to others, and the consequent socialization of that feeling, all help to relieve the pressure and pain of *hal*. Unexpressed or uncommunicated, *hal* can produce madness. Composition of Sufi poetry is thus spiritual expression and therapy more than art. One contemporary Sufi poet says that his inspiration is a superfluity of emotion, such as *ziyadat al-shawq* ("excess of longing"), or *ziyadat al-safa'* ("excess of joy"). Another told me that the expression of religious emotion for him is paramount; without release, one will surely burst. Shaykh Yasin told me that he writes poetry in order to awaken from *hal*, to free himself from it, only incidentally providing others with spiritual benefits. A contemporary Sufi shaykha said that when *wajd* ("the ecstasy of mystical love") increases to a certain point, one must translate it ("*yutarjimu*") into words. Thus, she explained, all the great Sufis have *diwans* (books of poetry); for "you cannot just sit with all of that *wajd* inside of you; by writing, the Sufi *yinaffis 'an halat al-wajd* ("vents his *wajd*")."[178]

The Sufi poet composes rapidly, from a sudden flood (*fayd*) of inspiration from God, obviating craft (*sina'a*). Subsequent revisions are usually minimal. Often he composes out of the vivid memory of a state of *hal*, or while in the state itself. In the latter case, he may utter the poem spontaneously, while disciples capture his inspiration on paper. Sufi poetry is capable of great rhapsody because the speed of its composition enables it to trace the ebbs and flows of the mystical-emotional experience, the matrix of its inception. Thus, 'Umar Ibn al-Farid is said to have entered into a state of trance, upon awaking from which he sponta-

178 The emotional state that requires expression is not found only in the poet. *Tarab*, *wajd*, *hal*—all of these conditions require release, whose form depends on the capabilities of their bearer. Thus, the poet writes, the *munshid* sings, some dance; others may fall unconscious or exhibit violent or bizarre behavior.

neously uttered poetry (Homerin, 1994, p. 39). Likewise, Shaykh 'Abd al-
'Alim al-Nakhayli, a contemporary Sufi poet, writes a mystical love *qasi-
da* in minutes, immediately following a deep spiritual experience.

Poetry written from *hal* may trigger *hal* in the spiritually sensitive lis-
tener, even though his intellect cannot comprehend it. The process of
composing poetry the Sufi way is a prismatic refraction of feeling into
word, resulting in affective, often enigmatic, language carrying with it
the emotional power of the state out of which it was born. Such poetry
can be difficult to interpret rationally, because its meaning is primarily
nonintellective; Shaykh Yasin says, "*Kalam asyadna al-kubar yuhass wa
la yufassar*" ("The words of our great [Sufi] masters are felt, but not
explained"). Yet spontaneous genesis in *hal* guarantees that this poetry
will be felt by the spiritually sensitive reader or listener, who will there-
by establish an intimate spiritual connection with the poet himself, since
"that which comes from the heart enters the heart."

Nor does the effect of such poetry diminish with familiarity or age.
This is another remarkable attribute distinguishing the "words of *hal*"
from ordinary poetry. Shaykh Yasin told me that because Sufi poetry is
written in *hal*, its meanings are inexhaustible, always *bikr* at every hear-
ing; the product of *hal* is infinitely rich, concentrated. Although many
of these poems are very old, the words come from *lisan halu* ("the tongue
of his [the poet's] *hal*"), and so "you feel as though they were spoken to
you directly." Such poetry thus has the power to address everyone indi-
vidually, across space and time, from heart to heart.

The Sufi values this poetry for its authentic, forceful, and spontaneous
expression of *hal*, not for technical polish. Perfection in *wazn* ("meter")
and *qafiya* ("rhyme") is not critical in Sufi poetry, although some Sufi
poets followed the rules of *'arud* ("prosody") impeccably. A Sufi shaykh
writing for his *tariqa* may compose technically imperfect poetry; so long
as it expresses his *hal*, it will be treasured.[179] Indeed, ignorance of the for-
mal rules of poetry is widely considered a touchstone of true *ilham* ("inspi-
ration"), since craftsmanship can easily produce cleverly arranged words
lacking in feeling.[180] As we shall see, the value placed on the expressive
force of spiritual language in Sufi poetry, possibly at the expense of craft,
precisely parallels the value placed on emotional expression in the *mun-
shid*'s performance, even at the expense of vocal refinement. In the case
of secular poetry, and secular singing, the situation is reversed.

179 Thus, Schimmel (1982, p. 18) comments upon one *qasida* of Rabi'a al-'Adawiya with
 the words "the author's feeling is stronger than her art."
180 Similarly, the illiteracy of the Prophet Muhammad is a touchstone for the authentici-
 ty of the Qur'anic revelation.

The *Munshid*, and His Relations to Poet and Listener

The Sufi poet's status as *wali* and privileged position within the spiritual genealogies bestows authority upon his words, while his mystical experience saturates them with meaning. But it is left to the *munshid*[181] to give the poet a voice, making this meaning palpable and public, in performance. The two mystical artists, poet and *munshid*, exhibit structural parallels. The Sufi poet, mystic and writer, mediates Sufi reality (*al-haqiqa*) and poetry, standing astride that colossal divide that separates mystical feeling from language. The *munshid*, mystic and singer, mediates language and listener via sonic expression, giving the poet's mystical experience an affectively compelling voice so as to create *tarab* in performance. Alone, the poet quietly encodes his feeling in words, sending it to a future audience, of unknown extent in space and time. The *munshid* interprets that code sonically, according to his own belief and feeling, instantaneously producing a communal spiritual ecstasy, bounded by the space-time of performance, through social interaction with listeners. In so doing, he creates *tarab*—a socialized version of the poet's inner feeling—even for those who do not understand the poet's words.

Tarab requires relations of *insijam* ("harmony") and *tabaddul al-shu'ur* ("exchange of feeling") among participants, or even the "melting" (*dhawb*) of individual identities into one. *Tarab* is an emotional resonance among participants, powerful enough to create *wahdat al-shu'ur* ("unity of feeling"). How is the *munshid* able to produce this profound transformation? And why is he better positioned to do so than the secular singer? The answer is to be found in the *munshid*'s Sufi experience, especially "living with the poetry" (*mu'aysha ma'a al-kalima*), his expressivity and musicality, and his status as shaykh. We now examine each of these in turn.

The *Munshid* as Sufi

The professional Sufi *munshid* grows up immersed in a world brimming with Sufi thought, feeling, and practice. In *mawalid*, and later as a member of a Sufi *tariqa*, he imbibes the Sufi world view together with its affective models; he learns to *feel* love for God, the Prophet, Ahl al-Bayt, *awliya'*, and shaykhs. He performs Sufi practices, and attains a mystical level in which he experiences the exultation of *wajd*, and the pain of

181 The discussion in this section concerns the professional Sufi *munshid*, performing outside the framework of the Sufi *turuq*. The *tariqa munshid* sings similar poetry, but operates under the authority of a shaykh within a more rigid ritual form which usually precludes a comparable buildup of *tarab*. On the other hand, the *tariqa* is an on-going social structure which does not depend exclusively upon *dhikr* performance for identity or emotional cohesiveness.

shawq. He comes to know the Sufi luminaries—saints, shaykhs, poets—and to appreciate the weight and authority of their writings. He learns the poetic repertoire of many *turuq*. This diversity gives him more flexibility in singing to heterogeneous audiences outside the *tariqa hadra*, in which many Sufi orders may be represented.[182]

There is no formal training to detach music from context; the *munshid* learns his art aurally and imitatively, by attending *mawalid* and *layali* in which the established *munshidin* perform. Thus, he absorbs *inshad* in rituals awash with Sufi feeling; the meaning of the text he learns is reinforced by the meanings of its context, a feature uncommon in secular music.[183] These experiences also help establish common emotional ground with other Sufis, including poets and listeners.

He "lives with the poetry," internalizing it until he can feel its meaning as expressing his own experience. Shaykh Yasin stresses the importance of *mu'aysha*, saying that until he has lived a *qasida* internally, he cannot learn it or sing it. After he has "lived with it," when it accords with his inner spiritual state, he memorizes it effortlessly and sings it easily. The *munshid* need not be capable of providing a lucid explanation of the *qasida*'s meanings. Rather, he understands it affectively, resonating with his experience; he senses its weight as a parasacred text, a crystallization of the numinous; he intuits the immense scope of meanings to which it alludes. His feelings are intensified by his appreciation and respect of the poet's status as advanced mystic, as saint, as shaykh, and as the affective voice of a vast tradition.

The great *munshid* possesses special talents, including *ihsas* ("spiritual feeling"), *basira*, and *shafafiya* ("spiritual insight"). Such gifts may result from his religious training, or may have guided him into Sufism in the first place. Because of these spiritual gifts, he is deeply affected by poetry and can sense the feelings of the poet from his words. He is also able to perceive the emotional state of his listeners and can choose poetry addressing their spiritual conditions. These talents greatly facilitate his role as mediator between poet and listener.

Muhibbin credit Shaykh Yasin's spiritual capabilities to his *tarbiya diniya* ("religious upbringing"). Shaykh Yasin's religious family inculcated in him proper Islamic values; he studied at the local al-Azhar secondary school for training in religious sciences and Arabic language, where he developed an appreciation for Sufi poetry. He attended count-

182 Waugh (1989. p. 74) rightly describes this diversity of repertoire as an "ecumenical" requirement placed upon the *munshid* who sings outside of the *turuq*.

183 Thus, secular singers rarely learn their love songs while in love or in a context in which love predominates; rather, love is an emotion feigned in performance.

less *mawalid* and *layali*, and joined a Sufi order. Shaykh Yasin's father was a *wali* to whom are attributed many *karamat*; his *mawlid* has become a great yearly festival in his home village. This religious and Sufi upbringing is thought to be responsible for his *ihsas*, and hence his success in *inshad*, beyond mere musical talent or vocal gifts.

The *Munshid* as Expressive Singer

But the professional *munshid* must also possess certain basic musical skills. Most importantly, he must have the ability to express feeling vocally by manipulating musical resources, such as timbre, dynamics, timing, rhythm, tempo, pitch, melody, and tonality. He is an experienced improviser, capable of adjusting musical and poetic dimensions of performance in real time in order to maximize emotional rapport with the audience. This is the art of *tarab*, once widespread in secular Egyptian music, but today virtually lost.

He differs from the secular singer in that he sings poetry representing what he feels in his heart; his expression is truer because his *ihsas*, welling out of a permanent source in his inmost being, is more true. Unlike the secular singer, the *munshid* can always sing with perfect *sidq* ("sincerity"). As for the poet, Sufis say that "what emerges from the heart [of the singer] enters the heart [of the listener]; what comes from the tongue goes to the ear [only]." If the *munshid* feels the words deeply in his heart, then he will be able to express this feeling in performance such that he reaches the hearts of others.

True *ihsas* is possible at every performance because the *munshid* is a Sufi believer; when he sings words that describe his beliefs, feeling always flows spontaneously. The *munshid*'s song is thus always an aesthetic expression of an authentic mystical condition. The secular singer is more like an actor; at best, feeling may be artificially and temporarily synthesized to support expression, but even this much cannot be guaranteed, since there is no special belief system available to assure the correlation of words with feeling. Further, the Sufi singer performs within a religious context that reinforces and conditions his expressiveness, and for a sensitive audience of Sufi listeners searching for true feeling, many of whom can detect emotional forgery through their *shafafiya*. His words not only describe his own state, but also the states of his listeners, creating emotional feedback that intensifies his performance. Finally, many Sufi poems overtly describe mystical practices such as music or *dhikr*, which are actually taking place during the *munshid*'s performance: such words are objectively true. This self-referential aspect of *inshad* constitutes another level of sincerity, supplying emotional power.

The aesthetics of expression in Sufi *inshad* of public *hadra* is quite different from that of secular Arab music. In the latter (as in Western art song), a premium is placed upon vocal beauty and precision. A singer who maintains perfect vocal timbre and intonation, though lacking in emotional warmth, may be criticized as overly calculating, but will not be dismissed entirely. Sufi *inshad* exhibits just the opposite situation. In the context of *dhikr*, emotional expression is paramount, vocal purity and control secondary, because *sidq* (not craft), *tabaddul al-shu'ur*, and emotional buildup are central to the ritual's purpose. Furthermore, since there is no presiding shaykh, the *munshid* is freed to take risks towards greater expressiveness, and he will not be criticized for an occasional slip in vocal timbre or intonation. It would be much worse for him to deliver a cool, calculated performance in perfect vocal form but lacking expression.[184] These priorities facilitate *tarab*.

The *Munshid* as Shaykh, and His Relation to the Listeners

The great Sufi poet is regarded as a *wali*, because of the depth of feeling and *ma'rifa* ("spiritual knowledge") he expresses in his poetry. Accordingly, he is addressed with the honorific "sidi" ("*sayyidi*," "my master"). Correspondingly, the professional Sufi *munshid* is regarded as a shaykh, and the title "shaykh" is prefixed to his name, in honor of his mystical experience, and the depth of true feeling he expresses in his voice.

In Islam, the title *shaykh* denotes the *'alim* ("religious scholar"), *muqri'* ("Qur'an reciter"), imam, *khatib* ("preacher"), and *tariqa* leader. The *munshid* is perceived to combine one or more of these statuses. Because of his extensive religious poetic repertoire, he may be regarded as an *'alim*, particularly if he has studied at al-Azhar. He has often learned *'ilm al-tajwid* ("the science of Qur'anic recitation"), and may recite Qur'an in public (Shaykh Yasin does so). Sufi experience and broad knowledge of *tariqa* prayers and poetry lends him the status of Sufi leader; although he does not usually give the *'ahd*, he does attract dedicated followers, *muhibbin* who flock to hear him at *mawalid* and *layali*.

In public *hadra*, outside the authority of any one *tariqa* shaykh, the *munshid* is regarded as the imam of the *hadra*, and dresses accordingly, with turban, flowing robes, and rosary. In his texts, which may contain *mawa'iz* ("exhortations"), and in his moving extemporaneous performance before a large and responsive audience, he resembles the *khatib*. Thus, the

184 This contrast between the *munshid* and the secular singer of *tarab* is the counterpart of the contrast between the ordinary poet (who is primarily concerned with literary composition) and the Sufi poet (who is primarily concerned with expressing an experience).

munshid is addressed as shaykh, and shown deference and respect.

This shaykh-status provides the *munshid* with self-confidence as an interpreter of Sufi poetry, and helps ensure expressive communication with his audience. Unlike the secular singer, the *munshid* is perceived as an expert in the subject about which he sings. Listeners respect him for his spiritual knowledge and for his spiritual feeling. Believing in him, they believe his words and emotional expression. Just as the *khatib* moves and convinces his congregation at a Friday prayer, or the Sufi shaykh at a *dars* ("teaching session"), so does the *munshid* as shaykh move his audience while singing for *hadra*.

The relation between *munshid* and listener is based on more than respect, however. The *munshid* is a trusted and beloved figure of author-ity. He maintains personal relations with many of his listeners, and knows many more by name, or at least by sight, as he sees them again and again at *mawalid* and *layali*. They in turn love him in his various statuses as *munshid*, shaykh, and *muhibb*. These relations are augment-ed on the metaphysical plane through connections established via *shafafiya*. Such relationships facilitate empathy between performer and listeners, and thus the free flow of emotion in public *hadra*, which con-tributes to the rise of *tarab*, and serves the feedback and control mecha-nisms of performance, as we shall shortly observe.

The Relation between Poet and *Munshid*

The *munshid* is ideally situated to establish a close relationship with the poet and his words, one which will facilitate the development of *tarab* in performance. He understands the poet's mystical feeling via his poetry, living the words (*mu'aysha ma'a al-kalam*) in order to align his emotional state with the poet's. A Sufi poet explained the relationship between poet and *munshid* as follows: "The *munshid* must be completely familiar with the *ahwal* of the poet, his power, and his methods in poetry. He must know that the poet is truthful, and that his feelings are truthful—that his feelings come from the heart, and not from poetic craft (*sina'a shi'riya*)." If he can do this, then his singing will be imbued by *tarab* from the poet.

Personal relationships between *munshid* and poet are also possible in the Sufi context. Many *munshidin* request living Sufi poets to compose *qasidas* for them, just as in secular music. However, in the context of Sufism, in which relations between the *muhibbin* are based on love and mutual spirituality, the *munshid* and poet often are emotionally much closer than a mere professional partnership would allow. The poet may teach the *munshid* his poetry, perhaps recording it for him. He may coach the *munshid* in singing it, and accompany him to *layali*, standing by him

and encouraging him with exclamations and praise. He may even be the *munshid*'s shaykh.

On a more ethereal plane, Sufism provides the possibility of intimate spiritual relationships across gulfs of time and space between *munshid* and poet since the spirits of Sufi saints are "free" after death to travel as they please. In Egypt, the precise meaning of poetry is commonly said to be in the *batin al-sha'ir* ("interior of the poet"), and thus generally inaccessible. Sufism has produced some of the most recondite poetry of the Arabic language, while at the same time enabling forms of spiritual insight (*basira*) that reveal its meanings. Thus, one may access the poet's hidden meanings via direct spiritual connections with him, or through an intermediary. Such connections sometimes take the form of dreams, visions, or even physical encounters. Thus one shaykh affirms his ability to contact 'Umar Ibn al-Farid directly, in order to obtain explications of his poems. The *munshid* may develop an intimate spiritual relation with the poet whose work he is singing, to the point that his listeners feel that they are hearing the voice of the poet himself.

Poet, *Munshid*, and *Tarab* in *Hadra*
In the ideal performance, the *munshid* becomes the channel through which the poet's voice is heard in *hadra*. In order for this to occur, there must be unity of feeling among poet, *munshid*, and listener, a *dhawb* of emotional boundaries, an emotional exchange that is the quintessence of *tarab*. We now examine how this unity is constructed in performance.

The Adaptive Quality of Sufi Performance
Part of the role of Sufi *inshad* in *hadra* is to intensify the emotional atmosphere. Through performative decisions regarding poetry, pacing, tempo, tonality, and many other variables, the *munshid* creates and molds emotion in *hadra*; he feels and expresses emotion, and his listeners empathetically feel with him. He must also adapt his performance to the prevailing mood according to feedback provided by listeners, in the form of gesture, movement, or audible responses. Such adaptation is possible because Sufi *inshad* is improvisatory (hence, inherently flexible), because listeners may express themselves freely, and because communicative channels from listeners to *munshid* exist. Furthermore, the emotional feedback from listeners to *munshid* not only provides the latter with a means of making performance decisions, but also is the *tabaddul al-shu'ur* ("exchange of feeling") required for the production of *tarab*.

Indeed, this cycle of feedback and adaptation is also part of the *tarab* dynamic in secular music. However, due to commercial factors, contem-

porary secular music is seldom performed live, and improvisation is downplayed in favor of predictable and repeatable melodies, which are quicker in rehearsal, and more efficient in the studio. Furthermore, musical aesthetics drawn from Western classical music has contributed to audience passivity, an emphasis on precomposed and notated music in fixed arrangements, and a general decline in the authority and control of the singer in favor of the composer, conductor, and arranger. All of these factors, inhibiting musical flexibility and performer-audience interactions, have contributed to the demise of *tarab* in secular music.

Tarab in Sufi music, by contrast, has remained relatively impervious to commercial and Western influences.[185] It is not enough to point to historical factors that tend to insulate religious traditions from rapid change, for there is always some change, and indeed Sufi music has changed considerably, even since the late 1960s (before which there is a dearth of recorded evidence). What is striking is that this music has not changed in such a way as to preclude *tarab* (as has the bulk of secular music). The reason must be located in the fact that this music has a particular religious purpose in the non-*tariqa dhikr*—the buildup of intensive *nashwa ruhiya*, ("spiritual emotion")—for which it requires attributes of live performance, flexibility, improvisation, feedback, and adaptation, and these are the enabling attributes of *tarab* in Arab music.

The *munshid* enjoys wide improvisational flexibility with regard to his text, which he effectively constructs in performance (albeit on a large scale, by choosing and arranging lines from various poems in his repertoire), in response to feedback from his listeners, enabling him to adapt to the circumstances of the moment (who is present, the purpose of the event, the general mood) in order to build and focus emotional intensity. One Sufi told me that the true *mutrib* always sings words that he or she feels; this is what distinguishes the **mutrib** from the mere *mughanni* ("singer"). However, the fixed texts of secular music render this process more difficult. It is easier for a singer to bring words and feeling together when he completely controls his text, as in Sufi music.

The Influence of Performance Context

The emotional level at a performance of Sufi *inshad* is much higher than the typical secular event, in part because of the context of performance. Public *hadra* performances display an especially festive atmosphere,

185 The active business in the recording and sales of Sufi *inshad* on cassette tapes has only tended to promote the primary role of this music in live performance, whereas the dominance of the cassette tape industry in popular music has led to the virtual disappearance of the live concert. For Sufi purposes, live musical performance is always required.

replete with milling crowds. At *mawalid*, the sacred atmosphere is more palpable, and performances usually take place next to the saint's *maqam*. The words of the Sufi poet are both energized and illustrated by the religious environment in which they are presented; one feels their meanings by reference to contextual experience, not merely in a literary-musical sense. Participants are sensitive to this spiritual atmosphere, and the informality of the event allows everyone to experience and express freely, thus adding to the overall level of energy.

Performance context makes the singer receptive to the poet's words, often putting him into a *hal* similar to that in which the words were engendered. Shaykh Yasin says that he obtains *ihsas* from specific individuals present, the crush of the crowds, the presence of shrines radiating *baraka*, the purpose of the event, all of which exerts a special *ta'thir* ("influence") upon him. A *mawlid* has greater *ta'thir*, he says, because of the sacredness of time and place, and because of the spiritual presence of the *wali*. This context helps him to prepare for the *layla* emotionally. The *munshid*'s mental state as he prepares to sing resembles the poet's as he prepares to write; he is awash in feeling. He is now ready to "compose" his text.

Munshid, Listener, Poetry, and Feeling in Performance

When he climbs onto the stage, the singer is in a particular emotional and spiritual state. As he performs, he observes audience feedback, mustering all of his powers of spiritual insight to glean their emotional-spiritual conditions. He brings to the performance a large memorized poetic reservoir: many poems of Sufi poets, old and new, on a wide variety of themes. Drawing on this repertoire, he spontaneously constructs a text that expresses his own state, while addressing the state he detects in his listeners, in order to make emotional contact, and create harmony in the *layla*.

But once he selects his text, sung poetry produces an emotional effect upon him, and upon his listeners. The *munshid* tries to feel the meaning of his poetry as deeply as possible, so that he can sing with greater *sidq*. Other participants, too, are moved by his words, which are imbued with the *hal* of the great poets who wrote them. The emotional-spiritual states of participants consequently shift, inducing changes in feedback from listener to singer. One can only broadly outline this complex dialectic between performed texts and emotional states of participants; both texts and states are continually in flux, and influencing each other. This feedback dynamic relies upon the flexibility and improvisatory nature of Sufi *inshad*. By carefully manipulating the improvisatory variables at his disposal—especially poetry—a *munshid* can maximize the degree of shared feeling among participants.

Shaykh Yasin claims that he never selects his poetry prior to performance; rather, all of his words emerge naturally from the *ihsas* of the moment, that they are imposed upon him (*yufrad 'alayh*) out of his feeling. Due to the improvisatory flexibility of Sufi *inshad*, he doesn't have to sing a text he doesn't feel. Even within a poem, he can repeat or skip lines of poetry as he desires.

Textual improvisation leads to the fragmentation of Sufi poems in performance, which further accentuates the priority of feeling over understanding within this music. While Sufism generally values the *qalb* over *'aql*, many dimensions of Sufism are nevertheless both theoretical and articulate; indeed, some Sufi poetry exhibits a narrative line. However, in public *hadra* the goal is emotional expression, communication, and unity. Towards that end the *munshid* crushes his repertoire into its constituent elements—lines, phrases, words, even phonemes—then brandishes these fragments as emotional stimuli, often singing only a line or two from one poem, before moving to another. At times he may repeat one phrase or a single word over and again.

He thus concentrates attention upon individual thoughts, images, concepts, and sounds, at the expense of narrative flow and logic. The comprehension of Sufi poetry, difficult enough for the intellect when presented whole, is here turned over wholly to *ihsas*, the affective interpretive faculties of the heart. As Shaykh Yasin has remarked, it doesn't matter if no one understands the words; the *jawhar* ("essence") of the *hadra* is in *ihsas*, *tabaddul al-shu'ur*, and *shafafiya*.

As a result of *inshad* and *dhikr*, participants may enter *hal*—including the *munshid*. According to one shaykh, *hal* provides Shaykh Yasin with inspiration (*ilham*) and creativity (*ibda'*). While in *hal*, there is no *fasl* ("disjunction") between tongue and heart; "He sings only according to what he feels," said another. Without *hal*, he sounds like any one of his lesser imitators. A Sufi poet stressed that the *munshid* must be absent from his self (*yaghib 'an nafsu*) while performing:

> *Hal* is an absorption ("*indimaj*") into the *dhikr* and into God; when one listens in the *dhikr*, becoming lost ("*tawhan*"), or withdrawing from the people ("*yaghib 'an al-nas*"), then one may enter *hal*. In *hal* one is always occupied with God ("*inshighal billah*"), who brings upon one states ("*ahwal*") according to His nature. God is the *Basit* ("The Expander"), and the *Qabid* ("The Contracter"), and so brings upon one occupied with Him the *hal* of *bast* ("joy") and *qabd* ("pain"). *Hal* occurs when you think of the beauty of creation ("*al-kawn*"), and of

the Beloved; then that beauty overwhelms you, and you with-
draw with God.[186]

Hal is a direct connection to God, ultimate source of all true mean-
ing and feeling. The words a *munshid* sings may be triply imbued with
hal: by the poet who wrote them from *hal*, by the *munshid* who sings
them in *hal*, and by the listener whose *hal* the *munshid* addresses. If the
munshid can unite these three *ahwal* in performance, then the level of
tarab will be exceptionally high. But this mystical source of *tarab* is
unavailable to the secular singer.

The Role of the Poet in *Hadra* Performance
The poet may play an active role in the performance of Sufi *inshad*, by
virtue of his relation to the *munshid*. This role is most evident in the case
of living poets, who may attend *hadra* and encourage the singer. Several
muhibbin reported that Shaykh Yasin always sang most powerfully when
one of his poets, Shaykh 'Abd al-'Alim, was standing beside him. The
poet could inspire Shaykh Yasin using physical channels of communica-
tion, in addition to their spiritual rapport.

Even a deceased poet may play an active role in performance,
because the *'alim al-arwah* is not bound by the physical laws of the vis-
ible universe. The chanting of *dhikr*, the great concentration of *muhib-
bin*, and mystical poetry, may attract spiritual presences, including the
poet-saint. Some say that the poet inspires the *munshid* with the inner
(*batini*) meaning of his words, so that he sings with greater impact.
Shaykh Yasin affirms that to sing a poet's words is implicitly to ask for
his presence. He performs at the annual *mawlid* of the great Sufi poet
'Umar Ibn al-Farid, invariably focusing upon the latter's poetry. One
murid told me that Shaykh Yasin always gives a powerful performance
at this *mawlid*, for Sidi Umar gives him material and inspiration. If Sidi
Umar weren't with him, he wouldn't be able to perform at all.

Conclusion
Out of both possibility and necessity, informal Sufism outside the
purview of the *turuq* has engendered a music of great emotional power.
Because its world view is so richly saturated with feeling; because it
idealizes relationships of love, empathy, and spiritual proximity
between persons; because it emphasizes metaphysical means of noncog-
nitive communication, Sufism as a commonly held spiritual system is

186 Shaykh 'Abd al-'Alim al-Nakhayli, personal communication, August 14, 1995.

ideally situated to provide the basis for emotional development and interaction in performance, and hence the affective exchange, resonance, and unity of feeling among performers and listeners upon which *tarab* depends. Secular Egyptian music, lacking access to a system of belief and practice of comparable scope and depth, is consequently unable to generate performances of equal affective power.

At the same time, because informal Sufism is a system of belief, feeling, and practice largely devoid of permanent social structures or explicit doctrines, there is necessarily an emphasis on shared affect and emotional harmony—*tarab*—as the principal means of constructing social unity in performance. Thus the Sufi context and purpose of this music renders *tarab* both more possible, and more necessary.

In this chapter, we have traced the role of poetry in the generation of *tarab* for *inshad* performances in informal Sufism. The Sufi poet, at once author and saint, is a luminary firmly positioned within the unbroken chains of Sufism, whose words, rich with shared sentiments, bear on the reader with the full weight of the tradition behind them. At the same time, the poet writes out of his own subjective mysticism, and his words, sincere even if not always technically perfect, communicate the affective impact of that experience forcefully to those who have tasted the like.

The *munshid*, at once singer and shaykh, shares the Sufi world of the poet, and so comes to taste his experience, live his words, and thereby establish a relationship of mutual feeling with him. His spiritual gift of *ihsas* facilitates intuitive understanding of poetry and poet, and the states and needs of listeners; his status as shaykh provides him with authority and power in performance; his musical gifts enable him to express the affective essence of Sufi poetry in musical sound. The *munshid* is thus ideally positioned as a mediator of feeling between poet and listener in performance. Moving himself and his listeners with the poetry he selects, and selecting poetry according to his *hal* and feedback from listeners, he carefully tunes the performance, seeking that elusive frequency of emotional resonance among poet, *munshid*, and listener, that melting point at which individual boundaries dissolve away, leaving the emotional unity which is *tarab*.

Sound Recordings for *Inshad*
A large number of commercial tapes are available only in Egypt; the visitor need only ask for "*inshad Sufi*" or "*madih nabawi*" at cassette kiosks around the country. Two CDs of professional Sufi *inshad* are widely available. However, the listener must bear in mind that these

performances have been specially formulated and recorded for the Western market:

al-Tuhami, Shaykh Yasin. *The Magic of the Sufi Inshad: Sheikh Yasin al-Tuhami.* 1998. [Two compact discs.] Long Distance 3039552 ARC 338. [Sufi *inshad*, representing Middle Egypt]

Barrayn, Shaykh Ahmad. *Sufi Songs.* Long Distance 592323. [Sufi *inshad*, representing Upper Egypt]

14 Musical Stardom and Male Romance: Farid al-Atrash
Sherifa Zuhur

Farid al-Atrash, a Syrian emigré to Egypt was one of the twentieth century's most important Arab male solo performers and composers. He acquired greater fame and longevity in the field of music than his sister, Asmahan, whose increasingly forgotten musical legacy and life story first attracted my interest.[187] Much of Farid's musical work lives on in the contemporary popular repertoire and his cinematic image is still familiar to many in the Arab world. Yet he did not possess the dazzling beauty of his sister, nor was he considered by music critics to match her vocal talents during the late 1930s and early 1940s. With maturity and through self-direction of his career, however, he came into his own, and deserves some explanation—as a performer, a composer, a producer, and a male icon.

Musically, his compositions and vocal and instrumental style formed a bridge between the Arab repertoire in the first third of the twentieth century and the last quarter-century of musical output since his death in late 1974. Farid, as the star of more than thirty movies has a secondary import as a figure who shaped the general image of Arab masculinity and the romantic hero (see **figure 20**). His male image, and the particular brand of romance he concocted affected other artists who followed him from 'Abd al-Halim Hafiz to the current pop idols.

The written sources, and cursory review of Farid in performance and on film lead one to see the artist as an existential man, an Arab "Jacques Brél," as Ibrahim and Pignol suggest (Ibrahim and Pignol, 1987, dossier 2). This image is substantiated by the writing and popular lore of artists as it emerged in the twentieth century when several male performers, including Farid, claimed to marry their art. Farid's selection of the stage name Wahid, ("the lonely one") in many of his films, and his seeming inability to remain happily in love enhanced this image. After further research and consideration, I found this particular facet of the artist—the lonely Wahid—to be superficial, or at least simplistic. The tragic, lovestruck hero was also a madcap comic, a gambler, an egocentric performer, and one devoted to certain family ties, while cut off from others.

While his sister's career was brief, abbreviated by her untimely death in 1944, Farid's spanned four and a half decades, thus traversing a series

187 Sherifa Zuhur, "Asmahan: Music and Musicianship beyond the Myth," in Zuhur (1998), pp. 81–107; Zuhur, 2000b.

of changes in musical styles and ideas. Some of his compositions carried across genres into the pop era, or electronic age, of Arabic music, and his instrumental technique remains an exemplary model for the *'ud*, the lute considered to be the most "Arab" of instruments. Improvisation, known as *taqasim* in Arabic, is an essential component of performance, generally sandwiched into composed pieces (and in ever briefer segments as time goes on). Master players were distinguished from amateurs by their mastery and inventiveness in *taqasim*, as is also true of improvisation in modern jazz. Farid's improvisations were renowned, captured on film, and emulated by all solo *'ud*ists to follow him, just as pianists often perform Chopin's Nocturnes or violinists Paganini's work to demonstrate their virtuosity. This is particularly true of a segment that borrows from flamenco, specifically, from a well-known Albeniz' fantasy on Andalucian themes, using the lower string as a rhythmic counterpoint against the melodic movement on the higher strings.

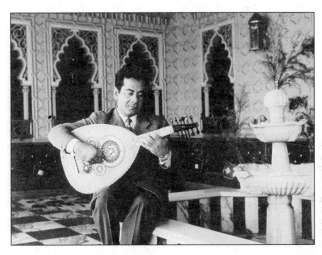

Figure 20. Farid al-Atrash, who shaped the image of Arab masculinity and starred in 31 movies, is shown in a typical pose, playing his *'ud*.

Farid al-Atrash is credited as the composer of at least 111 musical compositions (a few are "traditional" folk melodies set by the composer or introduced by al-Atrash as in the case of "Ya dairati malak 'alayna"). While many songs were introduced on stage or on the radio, the majority appeared first and achieved wide popularity through his films, many of which were produced by Farid himself, who had recognized the impact of the cinema on the Arab public.

His compositions reflect a blending of the popular and classical traditions of Arabic music, (a mixture of *lawn tarab*, *lawn baladi*, and *lawn gharbi*, to use the indigenous system of musical catego-

rization) and also a regional mix of Syro-Levantine and Egyptian components. Farid introduced a style of linear compositions, with varied and distinct sections (Racy, 1982, p. 393), more complex than contemporary popular Arabic music, and more sophisticated in the instrumental segments than the increasingly simple or folk-based melodies upon which the song-line rests. Farid's compositions continued certain preexisting traditions along with novel rhythms, new instrumentation, and an emphasis on the serious, the modern, the authentic, and the romantic.

The other feature of his compositions that sets them apart from those of the other important and best-known composers of the first half of the twentieth century, like Muhammad 'Abd al-Wahhab or Muhammad al-Qasabji, is that the melodic line in Farid's songs and dance pieces has a certain magic whether orchestrated for smaller or larger numbers of instruments. That is not true, for example, of the Ottoman-based repertoire written earlier in the century, nor of much of the work of the two composers listed above. However, this particular malleable quality of his work was crucial to its success. It allowed for delightful variations of instrumentation within pieces, and successful renditions of his work by other musicians.

His work is recorded on Sono Cairo (and Cairophone/Graphophone of Greece) and has been rerecorded throughout the region. The songs and instrumental compositions for which I have notation (and there are many more) include:

"Adini mi'ad"
"'A halfalak ma tasada[q]sh"
"Ayh fayida qalbi"
"'Aysh inta"
"'A[l] Allah tu'ud"
"'Alashan malush ghayrak"
"'Al kurnish"
"'Ala bali"
"Ana ahwa" (sung by Asmahan)
"Ana kuntu fakarak malak"
"Ana wa illi bahabbu"
"Ana wa inta law hadana"
"Ana wa inta wa bas"
"Ana wa inta wa-al-hubb"
"Arhamni wa tamani"
"Ashta[q]lak"

"Awwal hamsah"
"Ayami l-hilwa"
"Bahabbak"
"Bahabbak inta"
"Ba[q]i 'ayyiz tinsani"
"Banadi 'alayk"
"Bita'mir 'al-ra's wa-'al-'ayn"
"Busat al-rih"
"Dayman ma'ak"
"Al-Fallaha"
"Fawqa ghusnik ya lamunah"
"Gamil gamal"
"Ghali ya buyi" (buyi is Syro-Levantine colloquial, for abuya)
"Ghani ya qalbi"
"Habbina, habbina"
"Habib al-'umr"
"Halat layali"
"Hamawi ya mish mish"
"Al-Hayat halwah"
"Hilwa bi-shakl"
"Hizzi ya nawa'im"
"Huwwa, bas huwwa"
"Idhnitni bi-al-hajar"
"Idi fı idak"
"Inn habaytni ahabbak aktar"
"Inta wahishni"
"Isma' lama a[q]ulak"
"It[q]al, it[q]al"
"Jabr al-khawatir 'ala Allah"
"Kahraman" (instrumental)
"Kana li amal"
"Khuddi qalbi"
"Lahn al-khulud"
"Al-Laylat al-nur" (also an instrumental piece)
"Layali al-uns" (sung by Asmahan)
"Law tisma'ni li-akhir marra"
"Leh ana bahabbak?"
"Li-katab 'a[l] waraq al-shajar"
"Ma[q]adarsh 'ala kida"
"Ma lu al-hilu ma luh?"
"Ma nahar mish al-'umr minnik"

"Manhasamak ya qalbi"
"Mankhabish 'alayk"
"Marhab, marhab"
"Marra yahanini"
"Min al-Muski li-Suq al-Hamidiya"
"Min ya'raf?"
"Mish mumkin ahabbak"
"Al-Muhammal al-sharif" (also known as "Alayk Salat Allah")
"Nash'id al-ba'th"
"Nawait adari al-ummi"
"Nujum al-layl"
"Nura ya Nura"
"Qudam 'aynay"
"Qalbi wa muftahuh"
"Al-Qalb qalbi"
"Raqsat al-Gamal"
"Raqsat al-jawari"
"Raqsat Kahramana"
"Sa'alni al-layl"
"Salahani wa salam bi-yadak"
"Sana wa sanatayn"
"Shams ghabit anwarha"
"Suq al-'abid" (instrumental)
"Thawrat Mayu"
"Thalathin ya habibi"
"Ti[q]ul la'"
"Tutah"
"'Udta ya yawma mawladi"
"Ubaratta al-rabi'a"
"'Ushshak ya bulbul"
"Wa hayat 'aynayki,"
"Wa sadani 'a[l] 'aish"
"Wa shwaya shwaya"
"Wayak wayak"
"Ya 'awwiz filfalu"
"Ya bad'a al-ward"
"Ya baladi"
"Ya bu dhahak jinan"
"Ya dayrati malik 'alayna"
"Ya dakhalin ardhina"
"Ya dala' ya dala'"

"Ya farhati yawm ma tahini"
"Ya gamili, ya gamil"
"Ya habaybi ya ghayabin"
"Ya halwah"
"Ya khufi bu'duh la yatul"
"Ya layali al-bashár"
"Ya li-hawwak shaghil bali"
"Ya malikat al-qalb"
"Ya mudala' ya hilu"
"Ya qalbi kifayat duq"
"Ya qalbi ya majruh"
"Ya raytni tir"
"Ya salam 'ala hubbi"
"Ya waili min hubbuh"
"Ya zahrat fi khayali"
"Zahrah" (instrumental)
"Zaffat al-'arusa"
"Zayna"
"Zaman ya hubb"
"Zanuba"

The pieces most commonly performed by contemporary musicians fall into certain categories—several are popular as dance music, first viewed as compositions for solo performers of Oriental dance (belly dance), and later played for audience dance participation, or are compositions for voice and instrument that could be simplified. In some compositions, this simplicity was due to the use of folk melody or the patterns typical to folk melody in these songs. Since these were pleasant to hear, even with less complex orchestration, this meant that lesser musicians could play the simpler compositions, and that they were played widely and more often, in turn leading to their longevity.

Among these living parts of Farid's repertoire are: "Ya habaybi ya ghayibin," "Gamil gamal," "Nura, ya Nura" "Ya gamil[i], ya gamil," "Hizzi ya nawa'im", "'Ala bali" "Habbina," "It[q]al, it[q]al" "Raqsat al-Gamal," "Tutah," "Zayna," "Wayak" and "Zaffat al-'arusah" (also known as "Du[qq]uh al-mazahir"), which is often a processional for weddings all over the Arab world.

Less often performed today are Farid's longer "song poems," especially as popular memory (which will eventually fade) would call for nothing less than duplication of Farid's instrumental and vocal improvisations and ornamentations on the melodic line. A good example is "Sa'alni al-layl." The sum effect of this song is far more than its individual seg-

ments. The song is made up of three verses of five lines (10 hemistiches); each is followed by a separate section built around one or more lines, starting with: *Sa'alni al-layl bisahhar leh?* ("The night asks me "why do you stay up?"") Within sections, Farid elaborates on each repeated phrase, thereby demonstrating the ability of a master singer who can introduce musical variations and nuances on a relatively simple phrase. This ability is one of the performance standards expected of a master singer, the other, certainly in the Eastern Arab world being the *mawwal* or *layali*, vocal improvisations sung upon a short phrase or lines of poetry.

Farid's talent was recognized in his own lifetime; composers Baligh Hamdi and Ahmad Fu'ad Hassan, at the fore of the next generation of popular Arabic music, wrote of Farid's impact as musical personality, and as a friend.[188] In an enormously competitive field, this attribution is telling. He is also identified by composer Fu'ad Hassan as a career influence who deserved the status of *mutrib* (one who creates *tarab*, "enchantment," as opposed to a simple musician, an *'awadi*, or *'ud* player, or a *mughanni*, or "singer") not simply in the Arab world, but internationally.[189] Of course, this praise was printed posthumously and within the context of a particular tradition of mourning for public figures. Another publication showed photographs of the funeral automobile bearing Farid's body, the family's receiving line at the funeral and a crying mourner collapsed on the floor. Grief for the departed artists, Farid al-Atrash and, later Umm Kulthum far outweighed that displayed for certain politicians. Still, there is much evidence of the esteem in which he was held by musicians during his lifetime as well.

Farid did suffer from certain aspects of the competitive entertainment field. He began his life in Egypt in extreme poverty, and as a non-Egyptian, certain difficulties and jealousies affected his career,[190] particularly as he exploited the multiple musical traditions he had mastered. This seemed apparent toward the end of his career, when he had relocated to Beirut as a base, whether to escape inroads of the nationalization process in Egypt or to be close to his mother and the nightclub he established. In contrast, the rising star, 'Abd al-Halim al-Hafiz was acclaimed at the Officer's Club, presented as a truly Egyptian rags-to-riches story.

188 Baligh Hamdy, "*Habib al-'umr wa al-sanawat al-akhira min 'umrihi*," in 'Abd al-Wahhab, et al., 1975.
189 Ahmad Fu'ad Hassan in "*'Azizi Farid al-Atrash*," in 'Abd al-Wahhab et al., 1975, p. 115.
190 Personal interview with Fahd Ballan in Suwaida, Syria, August 16, 1993. Fahd Ballan was a fellow Syrian Druze singer who was treated as a younger brother and protégé by Farid al-Atrash.

Some of Farid's goals remained out of reach; he would like to have composed a song for Umm Kulthum, but their competition, or his sister's previous competition with her, or his non-Egyptian status precluded such an offer. On the level of public rumor, this rivalry was supposedly so extreme that Umm Kulthum had rejected his services as a composer, describing him and 'Abd al-Halim Hafiz as mere "crooners." He reportedly wrote an anthem for the Palestinian nation that has been lost or misplaced (Asmar, 1998, p. 34), and there are allegations that certain songs attributed to Farid were composed by other individuals.

Through his extensive repertoire, Farid al-Atrash helped to formulate the image of the male musical star, an emblematic romantic figure in the Arab world. He perpetuated a cinematic type, a romantic male lead who is also an entertainer. Some critics felt that the popularity of his film genre, *aflam ghana'iya* ("singing, or musical, films") was due mainly to the cinema audiences' lack of filmic sophistication or political unconsciousness (Hennebelle, 1976; Samak, 1979). I would contend that the charge of sacrifice of plot to music is a misconstructed critique developed during the era when the arts (cinema in particular) were expected to convey explicit ideological messages concerning social conflict and struggle. The engineers of this critique never understood the continuing popularity of lighter commercial music or film, viewing them as an alternate "opium of the people." It seems to me that attributing false consciousness to the public is always a bit arrogant; certainly escapism was present, but also, both box office and audience saw in the musical spectacles a cultural echo drawing on the strong tradition of a romantic lover-hero in Arabic poetry and history. This tradition resurrected a masculine model for screen and recording celebrities that was very different from the "bad bad wolves," the male stars of American cinema (Mellen, 1977).

When the Arab public, indeed, fused their knowledge of and interest in Farid's personal life with his career, the male image projected was one of a romantic, inevitably singing of love, but doomed to bachelorhood, and a gambler who made good. If there is a parallel to the American myth of social and career mobility—a Horatio Alger for the Arab world— then Farid al-Atrash appears as its epitome, gaining success, recognition, and wealth, with which he opened the Farid al-Atrash casino and nightclub before his death.

Some of my questions about Farid were answered through my research on his sister's life, but others remained. How did an outsider to the Egyptian entertainment industry, a child brought up by a single mother, lacking the protection of his family's lineage and status, become successful? Why did Farid never marry? What impact did his sister's

death have on him? What effect did his compositions have on the evolution of Arabic music? Did his cinematic image have any effect on popular culture? Do Arab men emulate his image as Wahid, "the lonely," and personify, yet resist, romance in the quest for fame and fortune?

We have been neglecting Middle Eastern men's studies, and although recently some scholars, like Mai Ghoussoub and Emma Webb, have been exploring some of the many possibilities for research on the male gender,[191] I had to consult mainstream psychological literature for clues, a field that is essentialist, and Western-dominated with just a few cross-cultural studies. In one of the latter, I discovered that Farid's character fits the psychological profile of Mediterranean men as aggressive, protective of dependents, intent on career success (for provisioning), and "autonomous wayfarers" (apparently based on a historical-cultural explanation) (Gilmore, 1990, pp. 48–51). Rather more helpful, and based upon an ethnography of northern Lebanon, an area not terribly different in many ways from Farid's place of origin is Michael Gilsenan's work on Lebanese men that shows that assertiveness and resolve, even if these lead to conflict, are fairly constant markers of maleness (Gilsenan, 1996). However, Cairo, where Farid was acculturated and lived most of his life, has different class and occupational constructions than those in Gilsenan's northern, rural Lebanese case.

Farid was a man who had, through his career, achieved what Karl Jung described as the archetype of Parsifal's quest. Jung writes about the male's need to recover his *anima*, his feminine artistic/creative side (or in Goethe's terms, to serve his inner woman, or muse).[192] The male artist or musician is unique in the resolution of the dilemma, between animus and anima (male and female aspects of the psyche). As compared to the warrior (or soldier) model, creativity is a necessary aspect of the poet/singer/artist's life-function. It is interesting to note that Arab society has not viewed creativity in the arts (or poetry) as a nonmasculine trait—it is only with the imposition of certain Western ideas and income categories introduced through market circumstances that traces of any such prejudices have crept into the contemporary scene. Even those who would disagree with this assertion will bend their rules when considering artists and musicians at the top of their field, for financial success is identified with the male gender, and therefore male characteristics, such as decisive-

191 Mai Ghoussoub and Emma Sinclair Webb, eds., *Imagined Masculinities: Male Identity and Culture in the Modern Middle East*. (London: Saqi Books, 2000).

192 Karl Jung, *Psychological Types* (New York: Harcourt, Brace and Co., 1926); see also Robert A. Johnson, *He: Understanding Male Psychology* (New York: Harper & Row, 1977), p. 44.

ness and clarity of discrimination, are attributed to the successful artist.

Historically, the male entertainer tended to be either a slave or a member of the elite in urban settings (Farmer, 1929), or possibly a member of an outgroup in rural settings, as with the *muzayyin* of the *Bani Khums* in Yemen (see ch. 10). In the twentieth century, the male entertainer was freed somewhat from the past dictates of slave or royal origin, although not entirely from the stigma of seeking patronage. Karin Van Nieuwkerk comments that although there is a stigma for male performers, it is weaker than that for female performers, because, according to her informants from the urban lower classes, male performers "do not move [their bodies] in performance." Her respondents meant that male performers' bodies are not perceived to be moving, visual sources of temptation as are women's bodies (Nieuwkerk, 1995, p. 130).

Male singers, musicians, and composers were not stigma-free. Composers Muhammad 'Abd al-Wahhab and Da'ud Husni both encountered parental disapproval of their pursuit of a musical career, and Husni had to run away from home. The critic, Muhammad al-Taba'i used a pseudonym, Hundis, for his reviews so as not to impugn his family name. Even contemporary musicians often tell stories of their family's disappointment with their decisions to pursue music rather than some more sober, or lucrative occupation.[193] However, Farid's encounters with conservative disapproval of entertainers was confined to branches of his own Syrian Druze community and mitigated by his distance from that community, and his success in the world of music.

There are some parallels between Arab men's work in the field of entertainment, and the leisure strata for African-American men described by Robin Kelley in which self-commoditization (through athletics or rap music, for example) fit into the myth of modernity and capitalist progress, but are still seen as "play," or nonwork (Kelley, 1998). However, as suggested earlier, these are mediated by success, with Michael Jordan and Smokey Robinson at the apex, and neighborhood players, rappers and part-time musicians at the other end of the range.

Farid represented the achievement of modern success through recording, cinema, and performance and simultaneously laid claim to Arab authenticity through music and poetry, a respected activity of the past (as Virginia Danielson describes for Umm Kulthum) (Danielson, 1997).

193 Simon Shaheen described the atmosphere in the "musical" village of Tarshiha, where there are an amazing number of amateur musicians, as their families insist on alternative education and professions. "Parents will not, however, encourage their children to pursue music as a career. They want them to study medicine or law, and keep music on the side." Simon Shaheen, "Beyond the Performance," an interview with Sherifa Zuhur, in Zuhur (1998), p. 163.

He was able in his films to reflect a new kind of success for ambitious and talented men, a success born of inherent talent and hard work, not that of a pasha's son or privileged insider. There are positive side-effects here for other Arab men, in that romantic, artistic, and emotional expressiveness are sometimes rewarded with popularity and success. The romantic model that Farid displayed (there were always women in his film plots) was one who floods his love objects with words, sounds, and emotions—not taciturn or violent (like certain American male icons).

"Safar habibi wa-hajar"[194]

Farid bin Fahd bin Farhan bin Ibrahim Pasha, bin Isma'il Ibn Muhammad al-Atrash was said to have been born in "a village" that may have been al-Qrayya (and was probably altered to *al-qariya* [a village] by a non-Syrian writer) in the Jabal Druze on Eid al-Adha of 1915.[195] Other dates given are 1914 (al-Jundi, 1954–58, p. 302) and 1910 (al-Taba'i; but this date is too early). It is more likely that he was born in Suwayda, the provincial capital of the Jabal, the origin of his father's branch of the Druze al-Atrash clan. That clan, known collectively as the Turshan, had dominated this region of southern Syria as a lordly clan over the Druze peasants (see **figure 21**).

Farid died on Thursday, the twenty-sixth of Kanun al-Awwal (December), 1974, in a Beirut hospital (*Farid al-Atrash*, n.d., p. 48). There was an outpouring of grief in the entertainment circles, and the traditional seventh-day-after-death ceremony took place in Suwayda, although like his sister, Asmahan, Farid had planned to be buried in Cairo. There were similarly obscured themes in the articles concerning his death, some (although untrue) claiming that the Druze refused to bury him "on their mountain," the implication being that it was dishonorable for him to have been an entertainer.

His father, Fahd, was educated in Istanbul, and had first married Tarfah al-Atrash in 1905, according to his family,[196] and married his

194 "My love traveled and emigrated," from "Li-Katab 'a[l] waraq al-shajar."
195 Darwish (1998, p. 26) gives Farid's birthdate as 1907 (far too early); Asmahan's birthdate was also in question, as Muhammad al-Taba'i, the entertainment critic, believed that the siblings had changed their birthdates to make themselves seem younger. However, their parents were married in 1910 and there was an elder sibling; too early a birthdate conflicts with this information, but too late a date conflicts with the contention that Farid's father had received an official posting under Sultan 'Abd al-Hamid II. See Sahhab (1987), p. 272, who gives Farid's birthdate as 1915 and his elder brother's as 1911, and see Zuhur (2000b), pp. 25, 46–47; *Farid al-Atrash* (n.d.), p. 57.
196 Ibid., p. 57; also personal interviews with the al-Atrash clan in Suwayda, al-Era, and al-Qrayya, 1993. Another source (Labib, 1975, p. 63) inaccurately names her as Bandar al-Atrash, who was actually one of Hasan al-Atrash's (Farid's brother-in-law and Asmahan's husband) wives.

Figure 21. Farid al-Atrash with a French official and Syrian relatives including governor and Minister of Defense, Hasan al-Atrash, third from the left.

mother 'Alia al-Mundhir of Hasbaya, Lebanon, in 1910. One source says that his father was the *qa'im maqam* in the Jabal, which is incorrect, other family members thought he was a *qa'im maqam* in Lebanon. Still other sources claim that Fahd was posted with his family to Anatolia, as an official (a "governor") for some years before his sister Amal was born. All that is certain is that Fahd worked for the Ottoman/Committee for Union and Progress government until the late teens, and eventually became a *qadi* in Suwayda, the provincial capital of the Jabal Druze. Some journalistic sources wrote that Fahd was artistically inclined, but family sources attributed musicality to Farid's mother's side.

There are two constant false themes in the biographical information for Farid. One emphasizes Farid's noble lineage in contrast to many entertainers who came from the lower classes, and the other deemphasizes his status as an immigrant child without family protectors. Various Egyptian sources (including Farid's elder brother, Fu'ad) claimed that Farid was an *amir*, a prince, and his mother and father likewise were royals, lending him an aura of nobility and imaginary wealth. While his clan was elite in the Druze social structure of the late nineteenth century, they were not wealthy, nor "princes" in anything but character and traditional Arab virtues. One source confuses the name of his famous revolutionary cousin, Sultan al-Atrash, with the title "sultan" (writing "they are all *salatin* there [in Druze Syria]"[197]), and this, along with other facts, such as his mother's use of the title, *amira* on an early Columbia

197 Ibid.

recording and Asmahan's marriage to a cousin (Hasan), who actually held the French-created title *amir* of the Turshan, confused the matter. Farid's brother, Fu'ad, who lived with him in Egypt and remained there all his life, insisted on the use of these titles into his old age, apparently to assert the noble status of the Turshan clan, but the living al-Atrash relatives in Syria explained that the title held little meaning after Hasan's time.[198] However, Farid's well-deserved epithet was *amir al-'ud* ("prince of the *'ud* for his mastery of the instrument").

Farid was one of five children born to 'Alia, two of whom died in early childhood, and she is said to have become very protective of him in consequence, locking him in the house on occasion when he was a youngster. He came to reside in Cairo with his mother, elder brother, and younger sister at approximately age nine, after his mother fled the Jabal Druze during hostilities with the French. Herein lies another discrepancy in the story: his father did not send the family to Egypt and did not approve of their flight there. This was his mother's independent decision based on fear of the French bombardment of the Jabal and a direct threat of French retribution against the clan, by which she explained her reluctance to leave Cairo to return to the Jabal. Or this was because 'Alia, who played the *'ud* and sang, hoped to capitalize on her music in Egypt and was unhappy living with Fahd. So she manipulated the emergency circumstances to suit her own ends (Zuhur, 2000b, pp. 38–41).

According to Robert Betts, even with migration, it is unusual for Druze to abandon their roots or ignore their identity (Betts, 1988, p. 64). The political emergency in the Jabal calmed after the suppression of the revolution, and Fahd was not exiled as was his cousin Sultan. 'Alia's suppression of her Druze identity in Egypt can only be understood as a desire to fit into the dominant culture in Egypt. She tried to assimilate into the Levantine immigrant community in Egypt and enrolled her sons in a Catholic French-language school. Farid's subsequent masking of his Druze identity, was at first due to necessity or his mother's actions, but it may be noted that as an adult, he did not hide his national or religious identity. In the entertainment world, his nationality was not considered relevant until after the Revolution of 1952, and his religion was seemingly unknown.

When Fahd divorced 'Alia for failing to return to the Jabal, he sent

198 I visited the current *amir* in al-Era living in the ancestral Turshan home, who has fallen upon hard times after land reform (personal interview with Salim al-Attrache, al-'Ara, Syria, August 18, 1993), although his title means that he may participate in the mediation of disputes, as I witnessed in a separate visit to Mansur al-Atrash in al-Qrayya (personal interview with Mansur ibn Sultan al-Attrache, al-Qrayya, Syria, August 18, 1993). Mansur inherited no title, but the great respect for his father, Sultan, and his own political career meant that he was the senior actor in this particular mediation.

no financial support; Farid's early years in Egypt were hungry. This was not honorable treatment of a divorced wife and not in concert with the Turshan clan's general mores. There are various anecdotes told about Farid's poverty which no doubt spurred him on to acquire material as well as artistic success. Farid and his brother hid their true name and used a ridiculous pseudonymn (kusa, "zucchini") in their Catholic school to obtain tuition assistance. The money troubles also fueled the family's decision to permit careers in entertainment. Farid is supposed to have lingered at a coffee shop to hear a favorite recording being played. An attendant dumped cold water on him to chase him away, and after sleeping in his wet clothes, he became ill with fever, wrapping himself with newspaper to ease the chills.

Other stories (not included in the earliest written sources) have it that Farid sang in his Catholic school choir, which exposed him to a repertoire of Western sacred music and probably improved his musical knowledge. But the director told him that he needed to sing more expressively and so he adopted the lamenting tone considered his trademark (Asmar, 1998a, p. 34, based on Al-Wasat). Lebanese contacts have informed me that they heard that he adopted his lamenting tone after his sister Asmahan's death. This particular tonal quality, which is even more pronounced in the singing of Wadi' al-Safi, for example, is one of the Syro-Lebanese aesthetics for male voices, which should be simultaneously slightly nasal, flexible, and powerful.

His mother made friends within the musical community in Cairo and Farid's talent was "discovered" when he was a teenager either by Farid Ghusn, the Lebanese musician who instructed him on the 'ud, or Riyad al-Sunbati, a composer, or by Madhat 'Assim, pianist and composer and later director of the Egyptian Radio.[199] 'Alia acquired the funds to entertain and hold a monthly musical evening, at least partly from a certain Baron Ikrane who wanted to help the now divorced relative-in-law of Sultan al-Atrash, the Syrian revolutionary.

Farid thus gained access to an excellent musical education from various sources, at home, at private musical gatherings, through the Nadi al-Musiqi al-Sharqi (the Oriental Music Club whose members later formed the Ma'ahad al-Musiqa) and through performance experience in the early 1930s. The elements of his story: a young talented poor boy, struggling for education and recognition and without a father in the home show similarities to other artistic biographies including that of 'Abd al-Halim Hafiz. (see ch. 15).

199 Al-Sharif (1992), quoting Madhat 'Assim, p. 279; personal interview by the author with al-Sharif, Damascus, August and September, 1993; and Sahhab (1987), p. 280.

His first significant engagement was as part of the band playing in Mary Mansur's salon (*sala*) to accompany his sister, Asmahan. He was later hired by Badi'a Masabni, an entrepreneur and promoter of new talent in Cairo to perform at her *sala* (Badran, 1995, p. 190), and as a member of the orchestra of Ibrahim Hamuda (al-Jabaqji, 1993, p. 10). 'Alia had made a recording on the Columbia label with the "folk" artist Taj (according to Jabaqji), but in this period, it was Farid and Asmahan who began to gain recognition from musicians around them, rather than their mother.

Asmahan received more attention than her brother in the musician's gatherings and parties at which they entertained, due to the mature quality and skill of her voice. When she received a film offer, her elder brother Fu'ad discouraged it, for reasons of honor. However, he allowed her to sing in nightclubs. Farid was accompanist and chaperone. He also witnessed Asmahan's discomfiture and confusion when their cousin Hasan visited them and extended a marriage proposal (Zuhur, 2000b, pp. 61–64).

When Asmahan left Egypt to marry Hasan, Farid had to obtain work independently as a musician in other ensembles. His weekly salary after he graduated from school was only four Egyptian pounds. This increased slowly until he was able to break into cinema where films commanded higher single payments, and he eventually became a wealthy man.

He recorded the song, "Nawayt adari al-ummi" on the Egyptian Radio in 1936, but that composition generated much more interest when his sister Asmahan sang it in 1938 upon her return to Cairo and her resumption of her singing career. Does this mean that her voice outshone his? Critics and musicologists may have been more interested in male performers and singers over the long run, and male entertainers make higher salaries than women (as in the West); however, from the late 1920s into the mid-1940s, the public was attracted to and more interested in female vocalists. Asmahan's voice was certainly a more facile and unusual instrument, with her beautiful middle range and able soprano, but Farid's achieved the period aesthetics described above, which also called for true pitch, emotion in the tone, and he went far beyond the norm in his breathing, interpretation, and dramatic control in vocal improvisations.

Farid's distributor, 'Aziz Sadiq, fulfilled the function of what we would call an artistic agent, and the decision to showcase Farid's compositions via Asmahan's better-known voice in the late 1930s can be attributed to him. Sadiq had produced 'Abd al-Wahhab's operetta (a form novel to Arabic music) *Majnun Layla*. The composer himself insisted on Asmahan's voice in the female lead although she did not appear onscreen. Asmahan, having returned to Egypt, had apparently decided that she need no longer concern herself with the outrage that a film

appearance would cause among the Syrian Druze.[200] But it was by no means a given that her brother would be cast as her costar in the film that Studio Misr and studio head, Gabriel Talhami, had planned.

"Al-Akh wa al-Zamil"

Al-Akh wa al-Zamil ("the brother and the boon companion") is Fiktur (Victor) Sahhab's opening description of Farid. These two roles, brother and dear friend, are a means of desexualizing his romantic appeal on screen and portraying him as a sort of wholesome backdrop for his sister's outstanding talent. Younger than Muhammad 'Abd al-Wahhab, who also described Farid in this way—as a sort of appendage to his sister[201] — Farid's cinematic and musical success was clearly in competition with 'Abd al-Wahhab, his senior, and a performer, who despite his ingenuity as a composer, had not realized success on the silver screen. Despite their competition, the two were photographed together (e.g., feeding each other—an indication of how close they were).

To the Arab public, the brother-sister team was quite unusual, although sibling or family performers are fairly often found within the broader world of entertainment. Shared interests and sibling rivalry were characteristics of the duo. This partnership was an important factor in their early careers and the transition from radio and recordings to cinema. Farid's presence as costar in Asmahan's first film, *Intisar al-Shabab* ("The Triumph of Youth," 1941) an appearance crucial to his own subsequent renown, demonstrated a necessary concern for her honor in the public mind. In musical circles as well as on screen, Farid and his older brother Fu'ad expected their sister to entertain with Farid at parties, and to socialize with them with patrons, but were angry with her when she escaped their surveillance to spend time with her own friends. Coperformer and chaperone as well as *akh* and *zamil* were functions that frequently conflicted, as appears to have been the case with other female talents. Danielson, for example, has demonstrated that Umm Kulthum contended with such family control and presence and bought out her male relatives early on in her career, thus freeing herself from her less talented coperformer/chaperones (Danielson, 1997, pp. 59, 60, 63).

Farid argued aggressively to convince the producer of *Intisar al-Shabab*, Gabriel Talhami, to hire the pair, and to allow Farid to compose all of the film's songs, which would under normal circumstances have

200 Others suggested that she was not cast because her looks were not typically "Arab" (al-Taba'i, 1961), or that she was nervous, or had stage fright. See also Mustafa Darwish (1998), p. 26, and Zuhur (2000b), p. 85.

201 However, 'Abd al-Wahhab's chief purpose is to describe Farid's life path on which he emerged from his sister's shadow to become a musical giant in his own right.

been allocated to other studio contacts. The film illustrates the struggle of entertainers, cleverly casting the brother and sister as a brother and a sister, Wahid and Nadia, both immigrant performers. Wahid's compositional talent and appeal as a performer is featured alongside his sister's artistry. The plot concerns their struggle for success, but also social acceptance as each falls in love with an Egyptian and encounters discrimination based on their lower status as entertainers and immigrants.

For *Intisar al-Shabab*, Farid composed "Yali hawak shaghil bali" (with lyrics by Ahmad Rami), "Ya layali al-bashar" (Yusuf Badrus), and "Kana li amal" (Ahmad Rami), "Ya bad'a al-ward" (Hilmy al-Hakim), "Idi fi idak (Ahmad Rami), and "Shams ghabit anwarha" (with lyrics by Ahmad Rami), as well as the operetta within the film *Ubarattat Intisar al-Shabab* (with lyrics by Ahmad Rami).

The story and the operetta were the obvious theme of Wahid/Farid's life and his quest for musical success. It demonstrated the struggle of two groups of lesser-status (immigrants and entertainers) to break the barrier of class crystalization by marrying respectable Egyptian partners. The plot witnesses the resolution of romantic conflicts for brother and sister, and is somewhat unrealistic in erasing the status differences between occupational groups. However, it complements the vision in Egypt of the 1940s that the upper strata included individuals of many different religions and national origins, as Samir Raafat notes in his study of Ma'adi in that time period (Raafat, 1995).

Two striking visual images presenting a modern yet traditional hero should be noted within this film. The first takes place when Farid, along with his comic sidekicks, Filbert, Almond, and Hazelnut stops to telephone the girl of his dreams. He drops the coin into the box, "Hallo, hallo!" he says, and then, naturally bursts into song, the telephone conveying his resolve. The second moment, partly captured in some of the stills taken for promotion of the film, occurs as Wahid is performing in the operetta he has composed. He—an archaic, but charming prince—sings to address his beloved (played by his sister) and she, bound by the rules of modesty, answers in song from her upper chamber, leaning out and opening wide the *mashrabiya* (wooden latticed shutters).

During the production of *Intisar al-Shabab*, Asmahan fell in love with the director of this film, Ahmad Badrkhan, and Farid's brother Fu'ad and their mother opposed the couple's marriage. Farid seems to have been sympathetic to his sister, but his family objected to the union either because Badrkhan was not a Druze,[202] or because they hoped to convince

202 Betts (1988., pp. 49–50) explains that marriage of a Druze to a non-Druze is strictly forbidden and not recognized when it does occur, and is thus easily dissolved.

or compel Asmahan to return to her husband Hasan, which was accomplished in 1941. This painful incident—according to some, Asmahan and Badrkhan were well suited to each other—may partly explain Farid's later reluctance to marry any of his sweethearts, as none were Druze.

Between 1941 and 1944, Farid continued his career in Egypt while Asmahan traveled to Syria in 1941, living for the next three years in the Levant. In his much-praised song, "Raja'at Laka" (but criticized by Sahhab, 1987, p. 281), written for Asmahan in 1941, the year in which she returned to Syria and remarried Hasan, the lyrics are supposed to concern her longing to be reunified with her former husband. Perhaps the song more clearly conveyed Farid's sadness about his sister. "Kana qalbi 'alil wa malush khalil," "My heart is sick, and it has no bosom friend."

He, unlike other family members, supported Asmahan's return to Egypt in 1944, and indeed may have played a role in the necessary arrangements, which involved resurrecting a contractual relationship with Studio Misr and engineering a marriage with an Egyptian so that she could obtain a visa. He wrote three songs for her 1944 film, *Gharam wa Intiqam* ("Romance and Revenge") costarring Yusuf Wahby: "Layali al-uns," (with lyrics by Ahmad Rami) with a very inventive waltz segment and guitar solo, "Ana ahwa," a staging of the Arab coffee-serving ritual (lyrics by Mamun al-Shanawi) and the *mawwal*, "Ya dayrati malik 'alaina lawm." This is actually a traditional improvisation to lyrics (that Sahhab inaccurately grants to Bairam Tunisi!) set by a cousin, Zayd al-Attrache (al-Atrash) (Sahhab, 1987, p. 281; Zuhur, 2000b, pp. 176–178; 180–182; 197–199; 202–203).

Then the brother-sister team were permanently parted by Asmahan's death in a car accident in 1944. Farid was devastated by her death, refusing on many occasions to speak about her.

Music in Film: Sound and Sight

"Leh lamma bashufak bi-'ainaya ruhi tghanni?"[203]

In these words above, captured in one of Farid's most poignant stories of love and miscommunicated intent, *Lahn al-Khulud*, is the secret of dual sensory appeal. Today, song-videos proliferate on television and the visual image of top performers is as important to their audiences as their sound. Before the advent of television, cinema was a powerful means of expanding audience contact with musical performers. Farid al-Atrash made the most of this medium.

203 "Why does my soul sing when I see you?" from "Gamil gamal" sung in *Lahn al-Khulud*.

Lahn al-Khulud was directed by Henri Barakat, one of the very best Egyptian directors, and despite its operatic plot, the timing and camera work make it a classic. Farid plays an composer/musician, Wahid, who overlooks the bluebird in his own garden, the young Fatin Hamama playing a young relative named Wafa'. The musician falls instead for a taller, showier beauty, Siham, and when Wafa' sends a little message of love, Wahid, believing that it is from Siham, asks for her hand in marriage. Wafa' collapses into an eventually fatal illness, and it takes nearly the entire film for Wahid to realize that it is she who is his real love.

The film begins with a clarinet rendering the song "Wayak, wayak" over the radio and the finale, Wahid's triumphal compositional presentation, features both modern instrumentation—with clarinet and saxophones leading the string section—and gorgeous venue. Sandwiched in between are "Duquh al-mazahir" for the wedding presentation and Wahid's "Gamil gamal" sung to cheer up Wafa'.

Some of Farid's most memorable compositions were paired with consistent filmic images, although his long life predicated various experiments within a basic formula. A constant emphasis is placed on his musical talent, displayed through the symbols of modernity in that era—we see the radio in salons and hear his music echoing over the airwaves. In addition to the example given above, Farid's costar in *Yawm bila Ghad* ("A Day with No Tommorrow"), Maryam Fakhr al-Din (Layla), falls in love with his voice over the radio, and is also wooed by telephone. But Layla tries to prevent their romance, for she is ill and cannot walk, and does not want her beloved to see her as she is. The film explores her psychosomatic illness, triggered by her guardian/father's smothering protection (a time-honored Arab tradition). This character has to admit his obsession with her before there can be a resolution to her illness and he clarifies his relationship to her. Farid's love is a true cure—teaching her that he loves her despite her illness and releasing her from the unhealthy paternal obsession of Arab fathers.

Along with the continuous image of Farid as musician/composer and lover/hero, another category of situational images range from the sentimental to the striking to the banal. Since Hollywood and previous Arab film had some success with madcap comedy, certain ridiculous visual images of the artist were included, creating a counterpoint between comedy and pathos when mediated by his musical talent. *'Ayiza Atagawwiz* ("I want to get married") was one of two films costarring Nur al-Hoda, a singer who billed herself as singing in the Eastern style, and was therefore cast opposite Farid, as she might remind viewers of Asmahan. In this film, directed by Badrkhan, Nur al-Hoda plays a

manic/comic young lady, Nur al-'Ain, whose determination to marry puts Farid in ever more awkward situations. She first meets Farid sitting on a park bench who is singing, first in *lawn gharbi* (a musical term meaning Western coloration or style), then in *lawn tarab* (with the coloration or style of classical Arabic music) and she comes over to sing with him. After three gigantic sighs "Ah!" "Ah!" "Ah!" she faints! Has his song killed her? No, she is revived, but clearly in trouble, and when she faints again, he carries her home. She proposes an artistic collaboration around the story of Samson (transmuted to Chemchem), and Dalila (Daldal). After she attempts to cut his hair and he fears for his eyes, they both collapse, having drunk too much. When her lover and his uncle arrive in the morning, he must hide in her wardrobe to protect her reputation. Farid, who resembles Desi Arnaz ensnared by Lucy's messes in this film, is thus comically captured on film playing music in his underwear hiding in Nur al-Hoda's wardrobe—and as her lover finds him and puts a pistol to his temple, he continues playing.

Strumming the Nile

In many of Farid's films, a romantic use of country scenery is employed to convey further nostalgia: we see Farid meandering on walks where he finds his costar amid the dunes, groves, or riverside, situating him as a character in love with the beauty of Egypt as well as his music. This bucolic expression of romance is also captured in the song "Al-Rabi'a" ("Spring").

Adi al-rabi'a 'ad min tani	*W-al-badr hallat 'anwarhu*
Wa fayn habibi illi ramani	*Min jana al-hubb li-narah?*
Ayyam ridhah ya zamani	*Hatha wa khad 'umri*
W-illi ra'iyatah ramani	*Fatani, wa shaghil fakri*
Kana al-nasima ghinwa	*Al-nil yaghanniha*
Ramyatah al-hilwah	*Tafdhil ta'id fiha*
Wa mawjuh al-hadi kana 'uduh	*Wa nur al-badr awtaruhu*[204]

"Spring returns again; / The light of the full moon has appeared
Where is my beloved who has cast me / Out of the Paradise of love into Hell?
Days of solace, o time, / Let them return and give me back my life.

204 Ibrahim and Pignol (1987), pp. 30–31. They provide the following translation into French: Voici le printemps revenu; la pleine lune est apparue/ Où es-tu, mon amour, toi qui mas jeté du paradis de l'amour dans l'enfer?/ Jours de féliticité, o temps, fais-les revenir et ôte-moi mon age/ L'objet dont je prenais soin m'a jeté, m'a laissé, pourtant il occupe ma pensée/ Le zéphyr était chanson; le Nil les chantait/ La douceur de ses eaux en répétait les paroles/ Le vague du Nil tranquille était un luth dont la lumiére de la pleine lune tissait les cordes. Lyrics by Ma'mun al-Shanawi.

The one I cared for has thrown me aside, / Left me, although still telling
my thoughts
The breeze was a song / The Nile sang
Its valley of its sweetness / Caused me to repeat its words
The calm ripples of the Nile formed an *'ud* / And the moonlight, its
strings."

In the film, *Inta Habibi* ("You are my love"), Farid's song "Zayna,
Zayna," flew from the screen onto records. The film is a farce involving
love and betrayal between Farid, playing himself and called Farid, and the
young and beautiful Shadia, playing Yasmine, who marries him at her
family's behest. Farid, however, already has a girlfriend, the dancer Nana,
played by Hind Rustam. Farid and Yasmine travel to Upper Egypt by train
on their honeymoon. When Farid's girlfriend appears on the train, he
recruits a male friend to act the part of her husband. His new bride sens-
es his perfidy and paradoxically this causes her to fall in love with him. A
musical highpoint of the film is the performance of the song "Zayna." The
travelers have reached the countryside, and there, frustrated wife and dis-
tracted two-timing husband, evoke the Bedouin past, in the desert, as Nana
dances seductively to the song. The disjuncture between filmic image and
musical score create an unintentionally high camp effect, as the perform-
ers are true urbanites playing out a fantasy of desert Arabness. The song
is an apt demonstration of the deceptive simplicity and beauty of Farid's
compositions featuring solo voice sections juxtaposed to a driving choral
refrain on the words "Zayna." It is interesting that both Farid and his com-
petitor 'Abd al-Wahhab composed songs with the title "Zayna," with sim-
ilar lyrics, the use of chorus and in *lawn baladi* ("folk color").

Wahid vs. Farid/Region vs. Nation
In reviewing Farid's films for this chapter, I realized that the sad, croon-
ing, lonely, struggling Wahid, the name of his character in several films
was a caricature of Farid. Many cartoons showed him with his instru-
ment, one actually melding the singer with his *'ud*, as tears stream out
of the *'ud*'s body. This image fused the romantic message with the
romantic messenger.

These images fit in with ideas propagated by critics of the era, and
were well established in popular belief: the notions that a great artist is
lonely, and more importantly, alienated, and that his songs of unrequit-
ed love in popular tropes should be mirrored in biographical details of
unrequited or stormy love. Here, indeed, was an existential man caught
up in his modernity and in his career—and Farid participated actively in

the creation and projection of this image.

However, this was not Farid's only persona, and his film roles, and message depicted through film and song were over time quite diverse. His life outside of film included the daredevil, the gambler, a man who lives in the fast lane, all Arab and Mediterranean characteristics of masculinity. He sponsored other artists, was patriotic (to the Arab nation and to Egypt and Syria), and financially generous, other desirable Arab male traits. He also experienced conflicts with his mother and other family members, some of which involved his special and on film, invisible, Druze identity.

Farid began his cinema career as a character who closely resembled the artist himself, Wahid, young, unknown, talented, and an immigrant, in the above-mentioned *Intisar al-Shabab*. He thus established his singer/hero pan-Arab persona in the memory of his audience.

In other films, Wahid is a more established artist, as in *Khuruj min al-Janna*, which shows how the development of his career collides with his efforts to realize love and romance. Similarly in *Mata[q]lush li-Hubb, Risalat al-Gharam, Yaum bila Ghad,* and *Lahn al-Khulud,* the hero's artistic self is essential. In several films, he appears as Farid—his own name—but with a simplified background, the references to his Syrian immigrant status are not repeated (and there is never a hint of his Druze antecedents). There is a very pronounced shift toward Egyptian identity in all aspects of text, language, and lyrics, except when Farid includes *mawawil*, vocal improvisations, in filmed performances and weaves in the Levantine vocal tradition that he had mastered along with the orchestration identified at that time as Egyptian and also more generally Arab. So the lonely one was an exile no longer.

Perhaps for this reason, when I mentioned my work on Farid and Asmahan in Damascus, a young Syrian radio producer challenged my characterization of siblings as Syrian singers, arguing instead that they had become quintessentially Egyptian. It was quite difficult for me to adequately convey the problems and irony of such an image, a purely Egyptian Farid in abbreviated form. Later, among colleagues more aware of the shifts in nationalist feeling in the arts, it was suggested that Farid had tried to play both sides of the fence—projecting both an Arab and an Egyptian image, a task that became more difficult from the mid-Nasser era onward.[205]

Farid spent much time, particularly in the 1960s and early 1970s in

205 Thanks are due to Ibrahim Karawan, Peter Sluglett, and other individuals who offered suggestions at the Center for Middle Eastern Studies, University of Utah, where I presented a paper contrasting the lives of the two singers, "Middle Eastern Entertainers, Gender and Honor: Asmahan and Farid al-Atrash," on March 23, 1999.

Beirut and on tours of the Arab states, but the heart and motor of the entertainment business remained in Cairo. He expressed his notion of "place" as being a part of a pan-Arab world; this is reflected in certain lyrics, as in these from "Min al-Muski," which evoke the dream of the United Arab Republic: "Min al-Muski li-Suq il-Hamidiya, ana 'arfah al-sikkat il-wahdiya, kulima afrah wa layali mlah, wa habiyib Misriyan Suriya," ("From the Muski [of Cairo] to the Suq al-Hamidiyya [of Damascus], I know the path is but one [united] . . .). Or in the song "Busat al-rih," wildly popular in the early 1970s, thanks to its verse-by-verse tour of the Arab capitals, Amman, Baghdad, Cairo, etc. Farid and singers who took up the song after him added impromptu verses celebrating Arab capital cities depending on the audience—but the point of the song was that the spirit (and the wind) of the Arab world was felt in each of its local capitals.

Artist as Lover
Farid starred alongside a number of actresses and actress/singers including his sister Asmahan, Samia Gamal, actress-dancer, the singer, Nur el-Hoda, Hind Rustam, the singer, Sabah, Samira Ahmad, Fatin Hamama, Maryam Fakhr al-Din, and Shadia. His films center around romances, thwarted, comedic, or achieved. As his career had been propelled by partnership with his sister, it was only logical to search for a costar whose singing abilities could match his. This led to the two films with Nor el-Hoda, the performer, who despite her reputation as a "classical-style" singer does not seem to have had the artistic strength or timing to match Farid's performance.

He then made (and produced) nine films with Samia Gamal, the dancer, and her dance sequences are highlights of the films. Another interesting costar was Maryam Fakhr al-Din, tall, blonde and substantial, and appearing far younger than the actor, featured in both *Yum bila Ghad* and *Risalat al-Gharam*.

Sometimes his persona as an entertainer constrains him from realizing true love even when parents do not stand in the way. He falls in love with the wrong woman, one who can manipulate him, but who loves him in *Al-Khuruj min al-Janna* (with Hind Rustam). She seems intent on smashing his every move toward her, as she destroys the jewelery he gives her. In *Risalat al-Gharam*, Farid is featured as a father and bereft lover—his sweetheart dies and he raises her daughter. Ever the entertainer, the plot is essentially a lengthy flashback occurring while Farid, here the father, hosts his daughter's marriage party. This image of Farid as tender, sentimental, and nurturing provides some relief from the other prevalent image, the performer and aging lover.

Farid is enmeshed in his destiny as an artist. He never considers an alternate career and no cinematic complications are so serious as to prevent him from sitting down and picking up the *'ud* to ease his misery. Herein lies an important contrast with his sister's life story—she apparently vacillated between a respectable life offstage and her artistic career. Was it his maleness that predicated no escape from his musical destiny?

Gender is central to Farid's appeal on screen. His is a romantic, rather than a sexual appeal, a distinction explained by Michael Malone, who writes that the view of Elizabeth Taylor superimposed over Montgomery Clift's form in his walk to the electric chair is romance as opposed to sex. Similarly the romance offered by Ginger Rogers and Fred Astaire, or by John Gilbert and Greta Garbo forms a striking contrast to movie sex offered in many contemporary American films, or in pornography. Malone makes the distinction that romance is both art and artificial, whereas sex is an act; further, to understand romance, one must remember that it is based on sexual suspension, suggestion, postponement, and sublimation (Malone, 1979, p. 21).

The Arab ideal of courtly love and the face of romance transposed from literature into Arab cinema is a little different. It allows the public to see Farid as a romantic symbol, whether he achieves his love aim on screen or not; one who may openly admire female physical beauty (as in Farid's typical head-on scrutiny of his coperforming belly dancers), but one for whom music itself is romance even when love is lost, or as in Farid's personal life, never legitimized through marriage.

Journalists always noted and explored Farid's bachelor status. I was struck by the fact that his Syrian relatives omitted all comment on this matter, but differentiated him from his sister by saying, "Farid was our ambassador, and we heard him with pride."[206] Asmahan, on the other hand, born in the wrong era, they had regarded with considerable shame and dismay (Zuhur, 2000b, p. 161; 2000a, p. 168; and forthcoming).

Farid gave the impression of being married to his art, and disengaging from any need for conjugal domesticity after a certain point in his life, despite the very strong social expectations of marriage for all men in his culture. Was it, as his brother Fu'ad suggested, because he could not contemplate marrying a Druze relative as Fu'ad himself had done? Or was his artistic career so consuming that there was simply not enough of the man left over for a private life? Or was it due to bad timing as an incident below suggests?

Farid considered marriage with dancer Samia Gamal, and risked much

206 Personal interview with 'Abd Allah al-Atrash in Suwayda, on August 16, 1993.

of his newly earned fortune to produce the first of his films with this star. Yet the pair never tied the knot, and their break was reportedly stormy. One line of rumor had it that he could not decide whether to marry her or not, another claimed that she did not want to marry him, as she feared that he would denigrate her in time (as a performer? as a non-Druze? as a person whose origins were lower in status? or as the undesirable familiar?).

Farid was also linked romantically with Shadia, many years younger than he, but he wavered over the question of marriage, resolving finally to take the plunge while he was in Paris. When he returned from Paris to Cairo to propose to her, he discovered that she had already married 'Imad Hamdi (al-Jabaqji, 1993, p. 11). Farid continued looking for love, and from women much younger than himself—a pattern set both in traditional Arab society and in the world of entertainment. At the end of his life, he was close to Salwa al-Qudsi (*Farid al-Atrash*, n.d., pp. 54–55), and true to form, they did not marry.

The Arab man is said to have difficulty freeing himself from ties to his mother. This is at the heart of the Freudian and neo-Freudian interpretations of male identity. Farid had fallen out with his mother, but he was also inextricably linked to her; she had, in essence, created his destiny as an outsider and his identity as an artist. The sources of his romantic difficulties might be due either to continued family expectations that he should marry a Druze (who would be unlikely to be an entertainer), or to the combined controlling personalities of his mother and his elder brother along with the problems of narcissism supposedly inherent in the artistic personality.

Early in 1929 or 1930, a fortune-teller predicted death by water for Asmahan, a long illness of the heart for Farid, and for Fu'ad, a loss of "his love." At that time Fu'ad was planning to travel to the Jabal with his fiancée, his first great love and a Jewish girl. He was very surprised after living in tolerant Cairo, when his Druze relative Hasan forbade his marriage to this girl, predicting ostracism by his Druze community. Fu'ad and the family subsequently put much emphasis on Asmahan's marriage to a fellow Druze, and regarded her other marriages as nonbinding, and contracted for reasons other than love. Farid's love choices could not have been acceptable according to this yardstick, but as a wealthy man who supported his elder brother and mother and who had escaped the control of his more conservative relatives, censure was unlikely, although marriage might have remained problematic.

The other relevant information concerns the pattern of gambling and overspending that Farid established once he became a success in films. Gambling can serve as an avenue for sublimation, but also is a means of

asserting masculinity. A film about immigrants under pressure, *One Last Chance* (Beaumont, 1990), who test their masculinity through risk and gambling could as easily pertain to Arabs as to its Greek subjects. In this film, male identity and gambling are juxtaposed to femaleness and the stability of marriage (Panayi, 1993). Perhaps, Farid's risking all he had gained, by throwing it on the table when he began his own productions, elicited a thrill that could never be equaled by or reconciled with domestic bliss.

Bachelorhood is an undesirable state in Arab society and the Mediterranean region, a social state that contradicts the norms of manliness; only homosexuality would be worse. And in research for this paper I came across some suggestions, based perhaps on wishful thinking that Farid might have been so inclined. However, Farid's professional success, and his assertion of other masculine virtues—gambling, carousing, and socializing in the world of men, his victory over poverty and the processes of immigration and the creation of his own professional niche—allowed him to be widely excused for his single status.

Besides, his films convey his role as a lover and a patron of lovers. When he broadcasts his new compositions, lovers listen together to the radio in clip after clip, sighing with the beautiful mood created by his songs. And throughout his large repertory of love songs is the idea that the expression of love is love itself, that naming the beloved is all that is really necessary to declare love:

"Banadi 'Alayk"

Banadi 'alayk ... banadi 'alayk asma' nadaya ma'aya qabla ma nadahlak
wa-ana ghannit bi-l-hammak lahn al-khulud
bi-hammit 'ainayh banadi 'alayk
bi-lamsat 'idayh banadi 'alayk
banadi 'alayk, banadi 'alayk

"I name you, I name you. My entreaty reaches you before I can express it . . .
I sing for the melody of eternity
For a blinking of the eye, I name you
For the brushing of the hands, I name you
I name you, I name you"[207]

Farid fulfilled another aspect of the ideal man in reportedly being generous with his money and in helping other artists. For example, he aided,

207 From the film *Lahn al-Khulud*, first line and most of the last verse of the song. Lyrics by Ma'mun al-Shanawi.

mentored, and gave a strong push to the regional career of fellow Syrian Druze singer, Fahd Ballan, recently deceased (August 1998), who sang several hit songs in the 1960s such as "Washrah laha" (recently remade a hit in Egypt) and al-Atrash's "Busat al-rih." Ballan, as a fellow immigrant, attested to the cutthroat climate of the entertainment industry, and Farid's status as a sort of permanent outsider—not an exile, or an expatriate, but definitely an emigré. In a very interesting part of our candlelit interview, which was attended by some Atrash family members in the Artist's Union of Suwayda, (the electricity being cut off for hours everyday), Ballan more accurately described the division of labor in the composition and arrangement processes. It was clear that Farid's status as composer was being contrasted to that of a mere performer. Ballan also gave credit to the climate of musicality and musical sensibility important to Farid's era and its contrast with the many overly simplistic hits in the current pop scene.[208]

Conclusion

The various facets of Farid al-Atrash simultaneously express the potential for artistic expression as a model for Arab men and a problematic success story that few could actually aspire to. Certainly his love for and understanding of the possibilities inherent in Arabic music dominated the other aspects of his life.

Colleagues challenged me to look further into Farid's image in order to understand Asmahan's, and I have reflected on this elsewhere (Zuhur, 2000a, pp. 178-179; 2000b, pp. 206-221 [ch. 7]). It seemed to me that the category of entertainer mediates the messages of gender to some degree. Farid's maleness was at first a detriment, rather than an asset, although he was free to avoid marriage, whereas she was not. Nevertheless, over the course of their lives the greatest contrast in the two figures lies in the manner that the Arab public (like her relatives) valued Farid's artistic contribution over and above the image of the man himself, while placing Asmahan's personal image over and above her nearly forgotten artistic output.

Farid's musical contribution to a century of Arabic song and compositions is quite important and worthy of further detailed analysis. To date this has not taken place, perhaps because of his musical location between genres or more accurately among several genres. What is important is to remember that in the struggle between *taqlid* ("imitation of past forms") and *tajdid* ("renewal")—as translated into the arts—Farid was an innovater, and at times, like 'Abd al-Wahhab, a brilliant borrower and adaptor who had no doubts about the value of music to society.

208 Personal interview with Fahd Ballan in Suwayda, August 17, 1993.

15 Modern Arab Music: Portraits of Enchantment from the Middle Generation*
Sami W. Asmar with Kathleen Hood[209]

The modern classical music of the Arab world was shaped by a genera-
tion whose work reached its apex in several waves from 1915–70. The
pioneers credited for constructing this era include, but are not limited to,
the Egyptian musicians Sayyid Darwish, Muhammad 'Abd al-Wahhab,
Zakariyya Ahmad, Muhammad al-Qasabji, Riyad al-Sunbati, and Umm
Kulthum as well as the Syrian musicians Farid al-Atrash (see ch. 14) and
his sister Asmahan, whose careers were established in Egypt. "Musicians"
is used here to refer to composers, vocalists, and instrumentalists. These
musicians, many of whom combined two or more of these musical skills,
made significant contributions to the development of various aspects of
Arab music such as the vocal forms (*qasida, dawr, muwashshah, maww-
al,* and *taqtuqa*) and instrumental forms (*dulab, sama'i, longa, bashraf,
taqasim,* and *tahmila*).

Overlapping with this generation, a second stratum of musicians
made their own momentous advances in the musical field in the second
half of the twentieth century. This "middle generation" included many
artists from whom we have selected 'Abd al-Halim Hafiz, Fairuz, Munir
Bashir, and Wadi' al-Safi.

The first generation of musical innovators in the twentieth century
inherited and built on Ottoman musical forms as well as the nineteenth-
century repertoire of the brilliant musicians 'Abduh al-Hamuli and
Muhammad 'Uthman (both students of Egyptian Shaykh Muhammad
'Abd al-Rahim al-Maslub). In addition to urban music, they also drew on
the folk heritage of Egypt and the Levant, as well as the invaluable train-
ing of religious chanting. Finally, they were exposed to Western classi-
cal music more than previous generations through European orchestras
that performed in Egypt and their own travels to Europe (Sednaoui, in
Zuhur, 1998, pp. 123–134; and ch. 17, this volume). In the process, many
composers of the period introduced Western orchestral instruments to the

* Three sections of this chapter are adapted from articles by Sami Asmar that were pub-
lished in *Al Jadid,* a U.S.-based review of Arab culture and arts, and are reprinted with
permission: "Over Two Decades After His Death, Musical Legacy of Abdul-Halim Hafez
Revisited," *Al Jadid,* 4:24, 1998c, pp. 20–21; "Fairouz: A Voice, a Star, a Mystery," *Al
Jadid,* 5:27, 1999, pp. 14–16; and "Three Musical Legacies Left by Sayyed Makkawi,
Munir Bashir, and Walid Akel," *Al Jadid,* 4:23, 1998b, pp. 20–21, 25.
209 Sections on 'Abd al-Halim Hafiz, Fairuz, and Munir Bashir written by Sami W.
Asmar and that on Wadi' al-Safi by Kathleen Hood and Sami W. Asmar.

traditional *takht*, which eventually grew into large ensembles.

The middle generation grew up listening to the voice of Umm Kulthum and the compositions of 'Abd al-Wahhab, among others. They had the advantage of drawing on a rich and highly developed urban music that had become the "new" classic genre, and their own work developed from it. The foundation for further innovation was already in place.

The artists selected for this study distinguished themselves from a host of their contemporaries in three main features. Firstly, the quality of their work has made them an integral part of a lasting Arab musical legacy, not a short-lived success story based on one or two successful albums or hit songs. Secondly, they have made unique and significant contributions to the field placing them in the classical-popular genre that illustrates the special qualities known as *tarab* ("enchantment"), and finally, they have become the teachers influencing the current generation.

The reader may be aware of the many artists who have not been mentioned here such as Layla Murad, Nur al-Hoda, 'Umar al-Batsh, Zaki Nasif, Filimun Wahbah, Sabri al-Mudallal, Nadhim al-Ghazali, Baligh Hamdi, Kamal al-Tawil, Muhammad al-Mugi, Nagat al-Saghira, Warda, Fayza Ahmad, Sabah, and Sabah Fakhri. They, along with other musicians from the middle generation are worthy of discussion. The page limitations imposed by practical considerations of publication led us instead to select but a few of these worthy artists for discussion in order to more fully examine their work. Hence, artists were selected who represent a certain degree of stylistic individuality, not necessarily reflecting the authors' personal tastes. We have also avoided any intentional selection based on the country of origin. It is worth noting, however, that the first generation comprised the core of a musical tradition in Egypt—reflecting the growth of the recording and cinema industries in that country—and that since that period, numerous artists from every part of the Arab world have played a role in the development of modern Arab music.

Finally, since we have coined the labels "first" and "middle" generations of classical Arab musicians of the twentieth centuries there must be a "third" or "current" generation. Identifying this generation is somewhat problematic. Again, with personal appreciation of their work aside, names worthy of exploring in future work would include Ziyad Rahbani, Marcel Khalife, Charbal Rouhana, Muhammad 'Abduh, Milhim Barakat, Kadhim al-Saher, Nidaa Abu Mrad, 'Ali al-Haggar, and others. Yet contemporary songs and compositions, with few exceptions,

do not compare to classic works in maintaining the ideas of *tarab* and exploring the *maqamat*, the building blocks of Arab music.

'Abd al-Halim Hafiz

'Abd al-Halim Hafiz (Hafidh) left a special legacy for popular romantic singing in Arab music (Asmar, 1998c, p. 20; see **figure** 22). Hafiz, whose appeal in Egypt has often been compared to that of Elvis Presley in America, was born 'Abd al-Halim 'Ali Isma'il Shabana on June 21, 1929, in the village of Hilwat, 80 km north of Cairo in the Nile delta. His mother, Zaynab, died the day he was born and his father passed away a few months later. He, his brother, and sister were left in the care of their older brother Isma'il.

Desperately poor, the four children moved to the city of Zaqaziq where an uncle resided. 'Abd al-Halim then attended various schools—a religious Quranic school, an elementary school where he joined a music ensemble, and then the Zaqaziq orphanage, where he received formal training on various instruments. He also learned to repair bicycles which brought in a small income. His eldest brother meanwhile moved to Cairo and attended the Fu'ad I Institute for Arab Music (Hasanayn, [n.d.], p. 14).

Figure 22. 'Abd al-Halim Hafiz (1929–77), a major popular singer (and heart-throb) of twentieth-century Egypt and the Middle East.

As a teenager, 'Abd al-Halim loved the popular singer and composer Muhammad 'Abd al-Wahhab whom he heard on the radio. On one occasion, he walked to the nearest big city to hear him perform. Too poor to buy a ticket, he climbed to the roof of an adjacent building to obtain a better view. His plan backfired because he fell and broke a leg (Shalaby, 1998, p. 45). At age 16, he joined his brother in Cairo, bringing with him just a clarinet and a few clothes from the orphanage. This coincided with the opening of a new music conservatory in the country, al-Ma'had al-'Ali li-l-Musiqa. Both brothers joined the conservatory, Isma'il in the vocal section and 'Abd al-Halim in the instrumental section where he learned to play the oboe.

In the conservatory, he formed strong friendships with fellow students Muhammad al-Mugi and Kamal al-Tawil (Shalaby, 1998, p. 45).

Al-Tawil is credited with discovering 'Abd al-Halim and building a bridge to his eventual success. After graduation, al-Tawil became a staff composer in the Egyptian radio station while 'Abd al-Halim was employed as an oboe player in a small ensemble and also taught at a girls' elementary school. This ensemble was engaged to record a song composed by al-Tawil for a celebrity singer. They rehearsed with al-Tawil in preparation for the recording, but the singer failed to appear; al-Tawil, in some desperation, asked his friend 'Abd al-Halim to sing. Surprised and hesitant, 'Abd al-Halim rendered the song in such a beautiful manner that he surprised himself and his friend. Kamal al-Tawil quickly persuaded the station manager to hire 'Abd al-Halim as a singer in the radio station (Shalaby, 1998, p. 47).

This critical event led to a meeting that al-Tawil arranged between 'Abd al-Halim and the manager of the Alexandria radio station, named Hafiz 'Abd al-Wahhab, who was greatly moved by the young singer. He insisted on arranging an appointment for the young man with the *ustaz* ("professor") of Arabic music, the composer Muhammad 'Abd al-Wahhab. Out of gratitude for this introduction, 'Abd al-Halim Shabana changed his name to 'Abd al-Halim Hafiz, in honor of the station manager. Muhammad 'Abd al-Wahhab was amused by the change of names and suggested that the new name was more musical in sound.

In their meeting, 'Abd al-Halim played the *'ud* and sang for 'Abd al-Wahhab. The latter was typically parsimonious with his compliments, although he reportedly was extremely impressed with the quality of the young man's voice. He made a few simple, polite remarks and decided to remain in touch with Hafiz. Hafiz and al-Tawil told their friend and fellow musician al-Mugi about the meeting with the *ustaz*. Al-Mugi was not impressed and surprised them by advising Hafiz not to pursue his artistic venture. He insisted that the real success and money were in the private sector, not in a government job at a fixed salary. Al-Mugi, however, volunteered to compose Hafiz' first song and arranged with a producer to have him perform at a beach club in Alexandria for a fairly good fee.

The three friends and a lyricist rehearsed and traveled to Alexandria for their first performance. 'Abd al-Halim sang the song "Safini marra" to an inattentive and restless audience. They yelled at the young man to stop performing the new composition and to sing instead some current hits. After a few nights of dwindling attendance, the nervous club owner intervened and begged Hafiz to sing better-known material. The singer refused and cancelled the contract, blaming himself for his failure. The distraught artist sought counsel from 'Abd al-Wahhab who noted that he him-

self had a similar experience at that same beach club early in his career. The senior performer explained that beach audiences are not real listeners, simply summer vacationers seeking late night entertainment. This episode illustrates the artist's dependence upon and requirement for true musical connoisseurs (*sammi'a*) (Racy, 1991). Audiences containing *sammi'a* who attended al-Wahhab's performances had a certain level of appreciation for the Arab musical forms (e.g., *ughniya*, *qasida*, *muwashshah*, etc.) as well as the technique of the performers and emotion present in their delivery. Many were familiar with the commonly used musical modes (*maqamat*). This familiarity could lead them into a state of *tarab*, or enchantment, as could be expected of a master performer like al-Wahhab.

Hafiz subsequently chose to perform for more refined audiences and gained the support of musicians and composers. He sang "Safini marra"(see **table 1** for translation of song titles) again immediately after the 1952 revolution that toppled the Egyptian monarchy, and received so many accolades that some considered that performance his birth as a singer. Shortly thereafter, al-Tawil's tune "'Ala add eshu" became a hit. Listeners started comparing Hafiz to Farid al-Atrash for the quality of the singing and his melancholy, romantic themes. Hafiz quickly broke through that "melancholy" image as he introduced cheerful patriotic songs and "Wa hayat [q]albi w-afrahu," which became a theme song during graduation seasons over Arab radio and television.

Most of his songs featured romantic lyrics but experimented with instrumentation and occasional harmonies. The electronic keyboard was more frequently used in compositions he sang, and his work introduced the saxophone to the Arab music public through the superb playing of Samir Surur. Over the span of his career, his work may be divided into three phases.[210] The first phase began with "Safini marra" and ended with the songs of the 1962 film *Al-Khataya* ("Sins") and is characterized by purity and sensitivity. The songs in this period were highly romantic in their vocabulary of the pain of love and deprivation.

A second stage begins with the songs "Gabbar" and "La takdhibi" and extends to "Gana al-hawa," where daring experimentation in the instrumental sequences was obvious. The songs in that phase varied greatly in their style and "color" without sacrificing quality. The third stage in Hafiz's repertoire consisted of long songs such as "Zayy il-hawa" and ending with "Qari'at al-finjan" that were characterized by a uniform

210 "Abdul Halim Hafiz, Seven Feet Under Ground and Still Singing," in *Al-Musiqa al-'Arabiyya*, issue number 15, Kifah Fakhuri, ed. (Amman: Noor al-Hussein Foundation, undated).

Title	Translation	Lyricist (if known)	Composer
• Gana al-hawa	Love Has Come to Us	Muhammad Hamza	Baligh Hamdi
• Maw'ud	Promised	Muhammad Hamza	Baligh Hamdi
• Ahwak	I Love You	Husayn Sayyid	Muhammad 'Abd al-Wahhab
• 'Ala hisb Widad	On Account of Widad	Salah Abu Salem	Baligh Hamdi
• Qari'at al-finjan	The Fortune Teller	Nizar Qabbani	Muhammad al-Mugi
• Al-Hawa hayawa	Love is My Mood	'Abd al-Rahman al-Abnudi	Baligh Hamdi
• Sawwah	Nomad	Muhammad Hamza	Baligh Hamdi
• Wa hayat [q]albi w-afrahu	My Heart's Happiness	Fathi Qura	Munir Murad
• [Q]ulli haga	Tell Me Anything	Husayn Sayyid	Muhammad 'Abd al-Wahhab
• Hiyya di hiyya	She Is the One	Mursi Aziz	Kamal al-Tawil
• Tuba	Never Again	Husayn Sayyid	Muhammad 'Abd al-Wahhab
• Awwal marra	The first Time	Ismail al-Habruk	Munir Murad
• Uqbalak	Happy Birthday	Husayn Sayyid	Muhammad 'Abd al-Wahhab
• Dayy al-qanadil	The Light	Rahbani Brothers (lyrics and arrangement)	Kamal al-Tawil
• Asmar ya asmarani	O Dark One		Kamal al-Tawil
• 'Ala add eshu	How Much I Miss You		Kamal al-Tawil
• Kamal al-awsaf	The Perfect One		Kamal al-Tawil
• Safini marra	Clear the Air		Muhammad al-Mugi
• Ayy dam'it huzn la	The Tear of Sadness		Baligh Hamdi
• Samra'	The Dark One		Kamal al-Tawil
• Nibtidi mnain al-hikaya	Where Do We Start the Story?		Muhammad 'Abd al-Wahhab
• Fatat jambina	She Passed by Us		Muhammad 'Abd al-Wahhab
• Hawwil tiftikirni	Try to Remember Me		Baligh Hamdi
• Risala min taht al-ma'	Message from Underwater		Muhammad al-Mugi
• Gabbar	Strong One		Muhammad al-Mugi
• La takdhibi	Do Not Lie		Muhammad 'Abd al-Wahhab

Table 1:
Selected
Songs in
'Abd al-
Halim
Hafiz's
Repertoire

theme, despite the complex, sectional construction within the songs.

Hafiz's growing success coincided with the growing power of the regime. He became the darling of the Officer's Club after he was introduced to the Free Officers, and received personal compliments and warm support from Nasser (Hasanayn, [n.d.], p. 94). Among the patriotic songs he performed was "Thawratuna al-wataniya" ("Our National Revolution") in which he praised the aims of the revolution to achieve "freedom and social equality." Hafiz sang about Christ in "Al-Masih," using lyrics that described Jerusalem and Christ's pain in an expressive and emotionally captivating fashion, the same style he used in his romantic and nationalistic songs. That expressive delivery of lyrics and in his performance is what distinguishes him from most contemporary singers.

Hafiz competed with other singers but did not exhibit jealousy in public. At one social event, for example, at the home of Theodore Khayyat, the list of attendees included Hafiz, 'Abd al-Wahhab, Fairuz, Filimun Wahbah, and Wadi' al-Safi; the latter performed for the gathering. Hafiz was asked to sing next but he demurred, complimenting al-Safi by saying "how can I sing after listening to this beautiful voice? I should quit music and go sell beans (ful)!"[211]

Hafiz starred in several successful films. His best known film, *Abi fawq al-shagara* ("My Father Is on Top of a Tree"), showed him at his finest visually and displayed his singing and unexpected sense of humor. The Hollywood-style "Du'u shamasi" song about seaside vacations was the equivalent of Gene Kelly's "Singing in the Rain"!

Producers initially hesitated to cast him, as he was frail in appearance. His sense of humor and charm, however, made him a successful costar opposite Shadiya and Fatin Hamama, the top female stars of the Egyptian cinema in that period, in the movies *Lahn al-Wafa'* and *Ayamna al-Hilwa* respectively. With his success, he was allowed to select his costars and he chose Najla' Fathi, Sabah, Maryam Fakhr al-Din, and others, in addition to repeat work with Shadiya and Hamama.

Hafiz's turn of fortune from early failure to stardom was not simply a matter of luck. He had realized that his success could not ride on his talent and hard work alone in a tough and competitive music market. He set out to court influential patrons in the arts and to win the press and critics to his side. He befriended members of the artistic elite and the government, including the president as well as other Arab leaders, notably Morocco's King Hasan II (Jabr, 1998, and Hasanayn, [n.d.], p. 186). He, like 'Abd al-Wahhab before him, pursued such connections as

211 Inaya Jabr, "Abd al-Halim Hafiz fi dhikra ghiyabih al wahid wa ishrin," *Al-Safir*, March 31,1998, *Thaqafa* page.

a form of compensation for his deprived upbringing.

He sent gifts to writers, invited critics to his concerts and parties, and set up a large army of vocal supporters, cheerleaders, and defenders. Through this public relations strategy he not only contained criticism, he also prevented the competition from rising to his level of popularity, to the disadvantage of singers like Muharram Fu'ad, Kamal Husni, and others. The media flooded him with praise, most of which was well deserved. He managed to monopolize the airwaves, and that may be why even today most Arabs know his most popular songs. Hafız's connections with his supporters went beyond the superficial. He was quite loyal to famous writers and novelists like Ihsan 'Abd al-Quddus, Hasanain Haykal, Kamal Shinnawi, and the brothers 'Ali and Mustafa Amin, even as the latter ran into political problems leading to imprisonment.

Hafız scrutinized every word and note of his songs, his stage outfits, and every line in his films, rejecting any that failed to reflect the proper image. His rehearsals took months and he often conducted the orchestra himself. It is reported that he tried for five months to locate the Syrian poet Nizar Qabbani and convince him to change one word in the lyrics to "Qari'at al-finjan" ("The Fortune Teller") that he was uncomfortable singing (Shalaby, 1998, p. 49, and Hasanayn, [n.d.], p. 88). The line "she lives in a palace guarded by dogs and soldiers" was modified to delete the reference to dogs.

Qabbani's beautiful poem portrays a fortune teller staring at the residues of his coffee cup and proclaiming "it is preordained for you to fall in love with a woman with no address." The composition and arrangement were as compelling as the lyrics, with music and synthesized sound effects portraying images of wizardry. A section of the song with a particularly complex and compelling rhythm juxtaposed with the orchestra's plaintive melodic line is especially striking. As with his other long songs, an attempt at *tatrib* (causing the audience reach a state of enchantment) during live performances was accomplished through numerous repetitions of sections of the song whilst assessing the listeners' reaction. This classic technique [Editor's note: also employed by the masters of Sufi *inshad*, see chapter 13] was utilized by the *tarab* singers he was emulating.

Hafız was not in good health, suffering from complications from bilharzia (a pest-borne disease that may remain dormant for some years, before it attacks the internal organs) for most of his life. He died in a London hospital on March 30, 1977, at the age of forty-seven. Unmarried, he left his wealth to his siblings and a close cousin.

Hafız is normally categorized as being part the era of modern Arab

classical music. But he is far from being in the same category as 'Abduh al-Hamuli, Sayyid Darwish, Muhammad 'Abd al-Wahhab, Zakariyya Ahmad, Muhamad al-Qasabji, and Umm Kulthum, whose work preceded his. Their fans considered Hafiz a modern iconoclast and cynically called his enthusiasts the "'Abd al-Halim generation." But generational conflict and stylistic differences often characterize great artists. Perhaps today, Hafiz is viewed in retrospect as a classic performer, in that contemporary songs do not compare to his work in their depth and complexity, nor do the vocalists equal his technical gifts. "Al-Andalib al-Asmar" ("the dark nightingale"), 'Abd al-Halim Hafiz's epithet, has become an integral part of the Arab music legacy.

Fairuz: Defining Contemporary Lebanese Music[212]

In the 1920s, a small group of Lebanese and French poets selected the Roman archaeological sites in Ba'albak as a meeting place to recite their poetry. They initiated a trend that made the ancient city (and later, other historical sites) the focus of arts festivals throughout the remainder of the century. Young Lebanese artists were invited to perform at the Ba'albak Festival in the 1950s and 1960s, and some of these performers achieved fame over the years. They included Fairuz, Sabah, Wadi' al-Safi, Nasri Shams al-Din, 'Assi and Mansur Rahbani, and the dance company of 'Abd al-Halim Caracalla. The nucleus of a generation of legendary artists was formed at this historical site, the meeting place of Arab, Hellenic, and Roman cultures. With this festival, a trend followed wherein other Arab countries held arts festivals and concerts specifically at historical sites such as Syrian city of Bosra, the Jordanian Roman ruins of Jerash and Petra, Babel in Iraq, Luxor and Giza in Egypt, and the Marib dam in Yemen (see ch. 18).

The singer Fairuz acquired her fame on the steps of the Temple of Jupiter in Ba'albak during feature presentations called "Lebanese Nights" (see figure 23). Every season, the composers and lyricists Rahbani Brothers, 'Assi and Mansur, created a musical play (*masrahiya*) that typically included a dozen songs that were performed, recorded, and then resonated for the rest of the year. The artistic products of this festival have become a special genre of modern folk and popular music.

Fairuz was born in Beirut in 1934. Her real name was Nuhad, and she was the eldest child of Wadi' Haddad and Liza Bustani. Her father was a print-shop technician who moved his family to Beirut from the village of Dbayeh al-Shuf to make a better living. His other children were Huda

212 For an earlier version of this segment see Asmar (1999), p. 14.

(who also became a singer in the Rahbani productions), Amal, and Joseph.[213] Nuhad exhibited her vocal talents as a child, often performing the songs of Layla Murad and Asmahan for her family and neighbors. At age fourteen, she was discovered in school by a musician named Muhammad Fulayfil who scouted for singers for a performance at the new national radio station (Boullata and Boulus [eds.], 1981, p. 21). Struck by the shy girl's talent, he quickly became her mentor, advising her in all details, from her diet to vocal techniques, and helped her to gain entrance to the National Conservatory where he taught.

During her studies, she was offered a job as a chorus singer at the radio station, thus posing the first dilemma of her career. According to her brother, their conservative father initially objected to the job offer, but the modest and religious girl (who later recorded an album of Christian liturgical music) convinced him that the salary from the choral position could help her achieve her real goal of becoming a teacher. Her father approved under the condition that her brother would escort her to work every day (Boullata and Boulus [eds.], 1981, p. 22). This aspect of Fairuz's background and character was often discussed by commenta-

213 References on Fairuz's birth year are inconsistent, with some reporting 1934 and others 1935. "Origins of a Legend" in Boullata and Boulus, eds. (1981), p. 19 states that she was born in Beirut after the family moved there in 1935 from the village. Similarly, "Fairuz: Ayqunat al-Ghina' al-'Arabi" in *Al-Musiqa al-'Arabiya*, edited by Kifah Fakhuri, a publication of the Arab Academy of Music, (Queen Noor Foundation, Jordan, Issue 16, n.d.) states her birth year as 1935. However, *Who's Who in Lebanon 1999-2000*, 15th ed., s.v. "Fayrouz" (Beirut: Publitec Publications, 1999), p. 105, Abu Khalil, "Fairuz," in *Historical Dictionary of Lebanon*, Asian Historical Dictionaries, No. 30 (Lanham, Md.: The Scarecrow Press, 1998), p. 70, gives the year as 1934, which we have accepted.

tors—the fact that she is a private and conservative woman. Despite her later success as a popular singer, Fairuz shied away from public events and maintained a serious demeanor, in part due to her upbringing and also as a deliberate choice to create a certain image for herself. She reacted to criticisms that she lacked expression on stage by saying that she preferred to concentrate more on singing than moving her body.[214]

In the late 1940s and early 1950s, Nuhad absorbed necessary skills for her musical career while working at the radio station, memorizing long poems and noting the nuances of every melody. It was fairly common in that period for singers to adopt stage names, especially those suggested by a mentor. Her enthusiastic radio station supervisor, Halim al-Rumi, suggested that Nuhad Haddad sing under the name Fairuz, meaning "turquoise," because her voice was like a precious stone. Al-Rumi also introduced her to a young, aspiring composer named 'Assi Rahbani, who, along with his brother Mansur, were policemen by profession but frequented the radio station hoping for a break in the business as writers and composers. The brothers had received an extensive education in Western music from French professors in Beirut and had also studied Arab music with their father, who taught them to play the *buzuq* (a long-necked, fretted lute).

For their first collaboration with the young singer, the Rahbani brothers wrote the song "'Itab," a romantic poem about blame and the agony of love. Surprisingly, this song launched Fairuz's career as a singing star in Lebanon practically overnight (Boullata and Boulus [eds.], 1981, p. 23). She traveled to Damascus with 'Assi and Mansur in 1952 to record the song at the Syrian radio station. This first record circulated throughout the Arab world.

In 1953, while on a break from a work session at the radio station, 'Assi proposed to Fairuz and in 1954 they were married and moved into a house in the Rahbani family's beautiful village of Antilias near Beirut and the Mediterranean. Their first lucky streak of success continued as the young couple was invited to travel to Egypt the following year. Cairo was the cultural center of the Arab world and every artist hoped to gain acceptance there. 'Assi and Fairuz, however, turned down offers of collaboration from the Egyptian art community at the time, as the pregnant Fairuz sought only introductions and new friendships that might lead to collaborations in the future. She gave birth to their son Ziyad in early 1956. Ziyad Rahbani would eventually become an innovative composer and a critical participant in shaping his mother's music in the later stages of her career.

214 Neil MacFarquhar, "This Pop Diva Wows 'Em In Arabic" *New York Times* (May 18, 1999), an interview coinciding with her 1999 concert in Las Vegas.

The next step in the progression of her career was to schedule live performances, not an easy feat for a fiercely reserved personality. Yet Fairuz amazed large audiences in her first performance at the Ba'albak Festival in 1957 and each summer thereafter; the festival was halted during the civil war in the mid-1970s. The Rahbanis chose a song about Lebanon's natural beauty for Fairuz's debut, a clever strategy that quickly earned her a medal from the president, the first honor of many, including a memorial stamp with her image.

Throughout her career, leaders of various Arab nations honored her, including the late King Hussein of Jordan, and the late King Hasan II of Morocco. She received a key to the city from the Arab mayor of Jerusalem when, in 1961, she accompanied her father there on pilgrimage. Years later, she sang a series of songs about Jerusalem (collected in the album *Al-Quds fi al-Bal*) including the song, "Zahrat al-mada'in" ("The Flower of Cities") that elicited much admiration from the Arab masses and won her the 1997 Jerusalem Award from the Palestinian Authority.

Arab intellectuals worried that popularity with local politicians would influence the Rahbani family to praise the powerful elites in song. Instead, 'Assi and Mansur wrote verses extolling the land rather than its leaders. They composed a series of songs for the major Arab capitals such as "Amman fi al-qalb," "Uhibbu Dimashq," "Al-Kuwait," "Qasidat al-Imarat," "Ghanaytu Makka," "Bahabbak ya Lubnan," and others that became so popular they were frequently played as second national anthems by those nations. Furthermore, during the long civil war in Lebanon, she did not seek shelter outside the country and refused to perform for the interests of factional warlords. This reflected on her ability to rise above local divisions and showed the power of art in uniting people in conflict.

With "Akhir ayyam al-sayfiya," "Nassim 'alayna al-hawa," "Shayif al-bahar shu kbir," "Habbaytak bissayf," "Shatti ya dinya," "Kan 'inna tahun," "Shadi," "Kan al-zaman w-kan," etc.), Fairuz' reputation grew; her plays and several films were disseminated throughout the Arab world (Racy, 1981b, p 37). She performed at venues such as Carnegie Hall in New York, the Masonic Auditorium in San Francisco in 1971, and the Olympia in Paris in 1979.

Over her lengthy career, Fairuz's repertoire spanned a wide spectrum of genres. She sang older *muwashshahat* and new simplified versions of that form composed by the Rahbani brothers such as "Balighu ya qamaru." She also sang adaptations of folk tunes and the popular songs of the Egyptian composer Sayyid Darwish (1892–1923), such as "Zuruni kulli sana" and "Til'et ya mahla." She sang in classical Arabic as well as in Lebanese dialect. The Rahbani Brothers composed *dabka* dance songs for Fairuz in

their plays and even combined lyrics titled "Ya ana" with a Mozart melody.

The special talent of the Rahbani brothers was introducing new textual and musical images. In the 1950s, audiences in Lebanon and elsewhere had been accustomed to Egyptian lyrics centered on the agony of love. Then, the Rahbani brothers' verses introduced the vision of a young girl carrying a water jug (*al-jarra*) or the *dabka* dancers celebrating in the mountain area (*al-jabal*). The simple local imagery was made appealing. The subject matter in their musical plays followed a formula that became their trademark: romance and human interest mixed with melodrama and humor, built on a structure of poetry and music. Lively dances and colorful costumes added visual energy.

In the play *Mays Irim*, for example, Fairuz played the role of a woman whose car broke down in an unfamiliar village (the fictitious town of the play's title) on her way to attend a wedding. The only local automobile mechanic in that village could not assist her because he was depressed over his inability to marry the woman he loved. The girl's father was a rival of the mechanic's father and the village was polarized into two camps led by the two families. The two fathers sparred in song and a traditional form of poetry (*zajal*) as groups of youngsters competed in line dances set to high-energy music. While attempting to mediate the dispute, Fairuz was blamed for starting a complicated, well-choreographed stick fight. The "Mayor of Mayors" was called in to adjudicate the case but she sang her way out of it. He was enchanted by her voice, solved the families' problems, and ordered Fairuz's car fixed—but only if she agreed to marry him!

This formula and style of new "folklore" became known as the "Rahbani School," imitated by many others. However, the Rahbanis' son, Ziyad, eventually rebelled against his family heritage despite his own musical talents, becoming active in left-of-center politics in Lebanon. Although Ziyad initially entered the family business and composed some excellent songs for his mother ("Sa'aluni in-nas", "Ana 'indi hanin," "al-Busta," "Wahdun," "Ba'atillak"), he then broke away and produced plays that satirized his father and uncle's musical formulas. In one parody, for example, a singer tells the story of his travels overseas to sing to the Lebanese immigrant community. The airline has lost his suitcase, and sadly, it was the bag that had contained all the lyrics for his vocal improvisations (*mawawil*) and folk songs.

In 1986, 'Assi Rahbani died shortly after a separation from Fairuz. In commemoration of his death, Fairuz and Ziyad re-issued an album (*Ila 'Assi*) of 'Assi's compositions, reorchestrated in Ziyad's contemporary instrumental approach. In fact, after his father's death, Ziyad played a

much larger role in his mother's work. Ziyad took on the responsibility of composing for his mother, often incorporating jazz themes in some songs and eastern themes (manipulating *maqamat* masterfully) in others. Fairuz appeared in another major concert in the summer of 2000 at the Beiteddin Festival in Lebanon with son Ziyad setting the program and conducting the orchestra. Additionally, in the album entitled *Wahdun*, he composed three jazz songs (including the hit "al-Busta") and three in Eastern style (including the hit "Habaytak") with a small ensemble, and vocals by Fairuz. His work may actually be seen as a commentary on the debate about the ability of Arabs to compose in Western style or on the need to even make the distinction between Western and Eastern styles, which have fused more tightly in recent years.

The Rahbani brothers had experimented with mixing Western and Eastern musical elements, as had Muhammad 'Abd al-Wahhab and Farid al-Atrash before them, while creating their own musical imprint. According to ethnomusicologist 'Ali Jihad Racy, the Rahbanis meshed a delicate orchestral blend in which certain Arab instruments figured prominently but which also subtly incorporated European instruments. He notes the use of various melodic modes (*maqamat*) of traditional Arab music and particularly in later years, the extensive employment of the Western major and minor tonalities (Racy, 1981b, p 37). The three melodic instruments essential to the Rahbani "sound" in Racy's analysis, were the accordion (modified to produce neutral intervals), the *buzuq*, associated with gypsy musicians of the region, a "fipple flute or recorder," reinforced with a small violin section, and the piano (Racy, 1981b, p 41). Although they shied from the extensive use of the *qanun*, *'ud*, or *nay*, the Rahbanis made prominent use of traditional percussion instruments, in particular the *tabla*, or *darabukka* (goblet drum), and the *riqq* (tambourine).

The most significant contribution of the Rahbanis and Fairuz was the inclusion and handling of folk music in novel arrangements. This was not a simple musical strategy as much as a demographic trend reflecting a cultural phenomenon of that time and place. After Lebanon's independence, the capital city absorbed scores of villagers seeking better economic opportunities. This segment of population eventually wielded social and political influence that enabled all traditional arts to rise in status. In order to avoid further stereotyping of a "primitive" society by the prestige-conscience elite, the movement to organize and reformulate the folk arts played perfectly into the hands of the Rahbanis. The government supported these efforts and sponsored the festivals as a tool to display Lebanon's cultural and artistic wealth with the unstated subtext suggesting that the country is independent,

peaceful, and stable. Having been themselves raised in a village and educated in the city, 'Assi and Mansur Rahbani were able to produce an innovative synthesis of folk and urban, Arab and European music.

The Rahbani's strategy for audience enchantment was completely different from the strategy of Egyptian performers. An Egyptian vocalist from the old school of *tarab*, including Umm Kulthum, used *maqam* (modal structure) modulations as well as *tatrib* (repetitions to bring the audience to a state of *tarab*) ad infinitum. This was only effective in long, live performances where the singer can receive feedback from the listeners. The Rahbanis, however, aimed for short songs that would be equally as successful in recordings as in live performances. Short songs rarely allowed for more than two *maqam* modulations, and the Rahbanis rarely included instrumental improvisations (*taqasim*). Instead, they relied on the high standard of their compositions and the quality of their lyrics, as well as the beauty of Fairuz's voice, to move the listeners. They often resorted to writing poetry in the classical language to increase the effect of *tarab*, fully knowing the love of the Arabs for their literature, especially for nationalist or religious allusions as in the example of "Ghanaytu Makkatin." When the lyrics lacked depth, the use of comic relief and *dabka* dance provided the punch as in "Hanna al-sakran" ("John, the Drunk").

The Rahbani Brothers and Fairuz did not work together exclusively. Some of Fairuz's most popular songs ("Jayibli salam," "'At-tahunah," "Ya mirsal al-marasil," "Ya dara duri fina," "Ya Karm al-'alali") were composed by Filimun Wahbah, a brilliant folk musician with no formal training, who sometimes played comedic roles in the *masrahiyat*. Fairuz also sang the compositions of Najib Hankash who composed the music for a popular poem by the Lebanese-American artist and philosopher Kahlil Gibran entitled "A'tini al-nay wa ghanni" ("Give me the Flute and Sing").

The Egyptian singer and composer 'Abd al-Wahhab also composed several songs for Fairuz, the most famous of which is "Sakana al-layl" ("The Night Became Calm"). She also recorded al-Wahhab's songs "Khayif a[q]ul illi fi [q]albi" ("I Fear Expressing Myself") and "Ya jarat al-wadi" ("The Valley's Neighbor"), a song composed for the city of Zahleh, in the Biqa' valley, as he admired its beauty. The Rahbanis composed for Sabah, Wadi' al-Safi, Nasri Shams al-Din, and many others. They also arranged the song "Dayy al-qanadil" for 'Abd al-Halim Hafiz.

In 1998, Fairuz appeared at the Ba'albak Festival, and in 1999 in Las Vegas, attracting over 13,000 people from all over the Western hemisphere. She had not performed in the Americas for about twelve years Repeated standing ovations compelled her to return to the stage to per-

form five encores. A performer not known for displaying emotion on stage, she finally smiled ear-to-ear as she waved goodbye.

A few months later, she released a new album of songs composed by her son Ziyad called *Mish Kayin Hayk Tkun*. Ziyad's brilliant work was, as expected, a mix of old and new. It contained humorous lyrics in one song about getting impatient and a movingly romantic classic poem by Qays al-Mulawa' called "Uhibbu min al-asma'," along with modern instrumental compositions.

Through her performances and the artistic brilliance and sociopolitical savvy of two Lebanese brothers and their collaborators, Fairuz has developed a genre of Lebanese and Arab music that made an impact on a generation of musical listeners (Ubaid, 1974; Aliksan [Alexian], 1987). Her large and versatile repertoire helped revive the public's interest in the indigenous music and also aroused the listeners' curiosity about Western music, thus profoundly influencing contemporary Arab culture.

Munir Bashir: Master of Improvisation

Munir Bashir (1930–97) was considered to be one of the leading 'ud players of the twentieth century, comparable to composers/'udists Muhammad al-Qasabji and Farid al-Atrash. Bashir was born in the Iraqi city of Mawsil to an Assyrian father and Kurdish mother. He was only five when his father began to instruct him and his older brother Jamil in the basics of the 'ud (Asmar, 1998b). His father, who was also a poet, believed that a pure tradition of Arab music had developed early on in Baghdad, once the capital of the Abbassid Empire. In the Abbassid period, the city of Mawsil produced Ibrahim and Ishaq al-Mawsili who, along with his former student Ziryab (who escaped Iraq and settled in Andalusia), are considered fathers of classical Arab music.

The Bashir children became apprentices of master 'ud instructor Sharif Muhi al-Din Haydar. Jamil Bashir excelled in his musical studies and later developed his own style on the 'ud and the violin. His work, for unclear reasons, never caught on and he died in the 1970s having achieved little recognition. It did not take long for Munir, however, to master the subtleties of playing the instrument and become a virtuoso performer and recording artist. Bashir elevated the 'ud to the important position it had obtained in ancient Baghdad. He used his instrument for its meditative benefits through enchantment as well as for composition, and fought the commercialization of the Arab musical forms that he loved (in ch. 22, artist Huda Lutfi discusses creating art as a form of meditation).

Bashir, like Haydar, became a professor at the Iraqi Academy of Art and also served as music director in the country's broadcasting company,

where he resented government officials' influences upon music and the arts. Seeking further musical progress, Munir traveled to pursue higher education in Budapest. He married a Hungarian woman and, in 1965, obtained a doctorate and an appointment at the Hungarian academy of science as a lecturer in folk art. Bashir was "discovered" for the world at large while in Beirut, by Swiss ethnomusicologist Simon Jargy who invited him to perform in Geneva, thus moving him to the international arena. At various times in his life, he had maintained residences in Iraq, Lebanon, and Jordan, but spent most of his later years at his home in Budapest where he died of a heart attack at age sixty-eight. Before his death, he recorded an 'ud duet with his son Omar released as "Bashir and Bashir."

Bashir's approach to performing was centered on an aesthetic appreciation of the 'ud's melodic and rhythmic capabilities. As a result he expanded the potential of the instrument and played it in ways that had not previously been fully explored. His idea concerning "respect for the 'ud" meant that he believed it should not be reduced to mere accompaniment for singers as was frequently the case. This idea of solo performance on the 'ud was later adopted by a generation of musicians such as Marcel Khalife, Simon Shaheen, and Charbal Rouhana, who experimented successfully in featuring the 'ud as a stand-alone, fully expressive instrument, as Bashir dreamed it should be. Khalife and Rouhana even wrote scores specifically for the 'ud, in Western fashion, inspired by Bashir's early efforts (Kassem, 1999, p. 19).

Bashir also discovered a connection between his music and Sufi spiritual traditions when he was invited to a Sufi conference in the United States. He accepted some of these spiritual concepts and reportedly believed in music's power to heal physical illnesses.

Despite recording numerous precomposed compositions, Bashir is best known for his improvisations. He was known as the "king of improvisation" (taqasim); and although the Arab world delights in bestowing such exaggerated titles, this one was justified. Despite his higher education, he learned the theory of Arab modal structures (maqamat) in an instinctual manner, through the traditional systems of musical knowledge acquired through apprenticeship. In this method the student trains using repeated exercises of short phrases and builds up longer compositions having learned the characteristics of the particular maqam.

The fantastic improvisational style of Bashir, which earned him awards from heads of states on every continent, was clearly art music, not popular music. In fact, he is not particularly well-known at a grassroots level, and some of the musically less sophisticated mistake his work for Turkish or other non-Arab music. Al-Wasat magazine included in an

article Bashir's idea that the Egyptian populace was not familiar with him because he did not sing while playing (in a subtle ridicule of Farid al-Atrash) and he did sit not behind a singer either (probably referring to Muhammad Qasabji, Umm Kulthum's *'ud*ist). In an interview with the Lebanese Broadcasting Corporation (see LBC archives, Hiwar al-Omr program) not long before his death, Bashir mentioned listeners in the Arab world who were uneducated and who enjoyed those who sang banal lyrics rather than instrumental expertise. He was bitter that the West seemed to appreciate his work more than the Arab world had, and wondered why Arabs could not embrace an "independent musician"! Ironically, the West had demonstrated great appreciation of his mastery of an "eastern" music while the Arab world seemed to favor musicians who adopted elements of fashionable Western music.

As he studied Western music, Bashir became convinced that the development of flamenco music was influenced by, if not derived from, Arab music and published a recording under the title *Flamenco Roots*. In the recording, he presents a half-hour long improvisation to illustrate his ideas concerning the connections of the two musical system.

Turko-Ottoman musical influences in Bashir's work came from his teacher Haydar. His CD *Promenade with the Oud* is subtitled "inspired by Indian raga." The Indian influence on Bashir was also reflected in his minimal *maqam* changes within a *taqasim* whereas other performers might introduce additional modulations (as the modal Arab structure permits).[215] He also borrowed the idea of a brief silence within a *taqasim* from Indian musical improvisation, although this innovation was unsuccessful with Arab audiences. These various influences in tandem with his technique and fingering gave Bashir a unique and recognizable sound.

Munir Bashir preached the "art of listening" and "listening to art" and stressed the purity of Arab music. Habib Touma best summarized Bashir's contribution to Arab music by noting that he had satisfactorily and convincingly solved the dilemma of the further development of traditional Arab music through innovation without destruction of traditional forms (Touma, 1996, p. 147). Bashir created a new attitude and feelings towards the instrument without destroying its rich history. He demonstrated the virtuosity of the instrumentalist and challenged the instrumentalist's demotion to the role of subsidiary to a famous singer. In the process, he gave tremendous weight to pure improvisations that featured the capabilities of the instrument he so cherished. (See **table 2**.)[216]

215 Personal communication with Asmar by Simon Shaheen (*'ud*ist and composer), Northampton, Massachusetts, August, 1999.
216 Bashir's name is transliterated as *Bachir* on certain labels.

Recording Title	Type	Label	Date of Release	Description
• Art of the 'Ud	Audio CD	Ocora	1998	eight cuts of solo improvisations in different modal structures
• Duo De 'Ud	Audio CD	Ethnic	1998	Munir Bashir and his son Omar Bashir, folk tunes and other compositions
• Flamenco Roots	Audio CD	Byblos	1998	
• In Concert Live From Paris	Audio CD	Inedit	1998	
• Meditations	Audio CD	Inedit	1996	solo improvisations
• Maqamat	Audio CD	Inedit	1994	five cuts of solo improvisations in different modal structures
• Babylon Mood	LP Audio CD	Voix de l'Orient	1974	Munir Bashir compositions with small ensemble

Table 2: Selected Recordings by Munir Bashir

Wadi' al-Safi: Fashioning "Folk Art"[217]

Of the many contributors to Lebanese folk music, Wadi' al-Safi occupies a special niche. With a career spanning forty years, he is a renowned artist in Lebanon and the Arab world—a pioneer in popularizing the Lebanese urban-folk genre. The story of his artistic development parallels those of his contemporaries Fairuz and Sabah as well as lesser-known artists such as Nasri Shams al-Din, Zaki Nasif, and Filimun Wahbah.

Wadi' al-Safi was born in 1921 in the Lebanese village of Niha al-Shuf as Wadi' Francis, son of Beshara Francis and Shafiqa Shadid al-'Ujil.[218] He was born into a musical Maronite family; his father sang and his maternal uncle was his first 'ud teacher. Al-Safi began to study religious chanting at age eleven (Sahhab, 1998, p. 43). His first musical instrument was the *rababa*, after which he learned the violin, and finally at the age of fourteen, the *'ud*. As a young man, he developed his singing style by hearing the stars of the Egyptian cinema, and was particularly influenced by Muhammad 'Abd al-Wahhab (Sahhab, 1998, p. 42). The folk art influence came mostly from his grandfather who taught him many poems and tunes from the village tradition, a tradition that later made its way to the capital city of Lebanon.

217 This section on Wadi' al-Safi was co-authored by Sami W. Asmar and Kathleen Hood.

218 Sahhab (1998), p. 19; "Safi, Wadi' Bechara," in *Who's Who in Lebanon 1999-2000*, 15th ed., (Beirut: Publitec Publications, 1999).

After World War II, Beirut became a cosmopolitan urban center that combined European as well as Middle Eastern elements. Many of Beirut's inhabitants had moved there from rural villages, and were thus still connected to the expressive culture of the village. The heterogeneous nature of the population, comprised of Lebanese Sunnis, Shi'ites, Druzes, Maronites, and Catholics as well as Europeans, Armenians, and Palestinians, eventually resulted in new musical forms based in part upon rural traditions and in combination with Western and modern urban styles (Racy, 1981, pp. 36–41; and 1986, pp. 413-427; also see ch. 17, this volume).

During World War II, when he was twenty-three, al-Safi traveled to Egypt with vocalist Nur al-Hoda, where he was exposed to a variety of urban genres. However, Halim al-Rumi, credited with discovering Fairuz, encouraged him to stick to Lebanese folk music arguing that it suited his voice (Sahhab, 1998, p. 113). Following that advice, he participated in a Radio Far East project to preserve folk music. It was not until the first Ba'albak International Festival took place in 1957 that the art community took notice of Lebanese folk music and an effort to preserve it was initiated.

During the decade prior to that festival, al-Safi relocated to Latin America and sang for the Lebanese communities in several countries. Al-Safi was following a pattern of migration that has been important to the development of Lebanon and the Lebanese people, and indeed, his father and grandfather before him had each traveled to Brazil as young men to earn some money and then returned to Lebanon to start their families.

His experience as a Lebanese expatriate living in Brazil for four years was perhaps a further catalyst for making folksongs an integral part of his repertoire. He built a network of fans homesick for their native land, for whom the folk song forms like *abu-zulluf, dal'una, mijana*, and *'ataba* were a nostalgic reminder of their homeland.

Al-Safi and Fairuz, performing the music of 'Assi and Mansur Rahbani were among the first proponents of the new Lebanese urbanized folk style, although they exemplify differing approaches. This new style met with criticism at times from snobbish critics, since other singers in Lebanon of that period were not performing the music of the villages (Sahhab, 1998, p. 113). The music of the Rahbani brothers, while folk derived, avoided some of this criticism by incorporating Western influences. They succeeded in achieving a blend of the sophisticated and folksy. Al-Safi did not rely on European influences but still managed to turn folk music into "art." With his success in Ba'albak, this urbanized folk style became acceptable and musicians became encouraged to explore their village heritage for inspiration. This was similar to Italian and German classical composers, for

example, who drew inspiration from folk music.

In al-Safi's repertoire of over 800 songs, covering religious, nationalistic, and romantic genres, he collaborated with a wide variety of lyricists but composed the vast majority of the melodies himself. Of the few songs composed by others, the Rahbani brothers appear most often (see extensive table in Sahhab, 1998, starting on p. 363). Muhammad 'Abd al-Wahhab composed al-Safi's hit song "'Indak bahariya ya rayyis," a song about a sea captain, and Farid al-Atrash composed another hit song " 'Alallah t'ud," a song about awaiting the return of a loved one from afar. Despite being a prolific and capable composer, al-Safi is most acclaimed for his singing, especially his vocal improvisations (*mawawil*).

His repertoire contains numerous examples of the *mijana* and *'ataba* genre that are truly a marriage of urban and rural elements. The *'ataba* is a nonmetric, strophic folksong form popular in Lebanon, Syria, Palestine, and Jordan. Originally a Bedouin genre that was improvised by a solo *sha'ir* ("poet-singer"), who accompanied himself on the *rababa*, it deals with themes of love (Shiloah, 1980, p. 529; Racy, 1996, pp. 411–412). The *mijana*, a metric choral refrain, is a purely urban addition. Although the *mijana* and *'ataba* were originally two distinct genres, al-Safi learned the technique of connecting them from his grandfather, who called it "breaking of the *mijana*" (Sahhab, 1998, p. 36). For example, in the work entitled "Mijana wa 'ataba,"[219] (lyrics by 'Abd al-Jalil Wahbi), al-Safi first sings the nonmetric *'ataba*, accompanied not by the *rababa*, as in the style of Bedouin music, but instead with a small *takht* comprised of *nay*, *qanun*, violin, cello, and *'ud*. This is followed by the *mijana* section, sung by a mixed chorus and accompanied by the *takht*, with the addition of a *riqq*. There are four stanzas of *'ataba*, alternating with three stanzas of refrain. The song begins and ends with the *'ataba*, the last one the longest and most impassioned.

The piece is in *maqam* Bayyati, which is also reminiscent of the modal structure used in Bedouin *'ataba*.[220] Another urban characteristic of this song is that al-Safi's baritone voice contrasts with the high, strident vocal style of the typical Bedouin poet-singer. At the same time, the melodic contour of the *'ataba* sections roughly follow the descending contour of the Bedouin models. Thus, the folk form and mode of the *'ataba* combines with the urban additions of the choral refrain and instrumentation (see

219 Wadi' al-Safi, "Mijana wa 'ataba," from *The Best of al-Safi*, vol. 2 audiocassette (Voice of the Orient, TC-GVDL237, 1976).

220 The Arab *maqam* system is associated with art music rather than folk music, since folk melodies often span a range of only four or five notes, and do not exhibit other characteristics of the *maqam* system. Their melodic cells, however, do have intervallic structures similar to the Arab *maqamat*.

Racy, 1996, pp. 417–418, for a discussion of the *'ataba-mijana* genre).

The complex interplay between nomadic Bedouin, sedentary rural, and urban Arab culture in the Levant has been noted by 'Ali Jihad Racy in his in-depth examination of the Bedouin ethos in Arab music (Racy, 1996, pp. 417–418). In general, ambivalent and conflicting feelings about things Bedouin exist in this region, ranging from stereotypes portraying unsophisticated Bedouins to idealizations of the Bedouin as the only "true" and "pure" Arab. This idealization has led to a genre of songs in the Bedouin style known as *lawn Badawi* (lit., "Bedouin color"). This genre does not include the *'ataba* and other actual Bedouin song forms, but alludes to Bedouin forms through the use of melodic and rhythmic references, in addition to lyrics expressing Bedouin themes such as love, chivalry, generosity, and bravery (ibid.).

The love song "Habibi wa nur 'aynay,"[221] with lyrics by 'Abd al-Jalil Wahbi and music by al-Safi, is one of al-Safi's many songs in the *lawn Badawi*. Its use of the *maqam* Bayyati, as in the previous example, is evocative of Bedouin ethos. The melodic structure of the first part covers only the range of a fifth, also a common feature of Bedouin music. It features urban violins, but they are used in a way that is reminiscent of the rural *rababa*. The rhythm used throughout is duple-meter *ayyub*, and the song is metric except for a *mawwal* section near the song's conclusion.

Al-Safi may well be primarily remembered for his innovations with the *'ataba* and *mijana* genre. Such performances came to symbolize the "old country" among Lebanese immigrants in the West, who listened to this genre on recordings and heard it live at their gatherings and festivities (Rasmussen, 1991, pp. 230–246). Other Arabs also appreciated his songs. Even Egyptians, not typically familiar with Lebanese folk music, received him warmly as he sang in the prestigious Cairo Opera House in 1993 and in 1995 he received Egyptian citizenship (Sahhab, 1998, p. 22), to add to his many honors and awards.

On March 11, 2000, al-Safi performed in Las Vegas with the Syrian singer Sabah Fakhri in a concert entitled the "Two Tenors of Arabic Music." Thousands of Lebanese-Americans and others came to reminisce with their folk idol. The frail, nearly eighty-year-old man performed enthusiastically, interacting with the audience with animated humor and characteristic fatherly warmth. One of us (Asmar) spoke with al-Safi (during a press conference, March 12, 2000) and asked about his technique to help his audience reach a state of *tarab*. Al-Safi insisted that he did not use a specific formula so much as express his love for his audience. The

221 Wadi' al-Safi, "Habibi wa nur aynay," from *Wadi' Al-Safi*, compact disc (Voice of the Orient, VLCD 527, 1976).

simplistic explanation reflected his sincerity and that his loyal listeners are enchanted simply because they love him and they know he loves them (see the conclusion below for a contrasting response from Sabah Fakhri to the same question). Indeed, the crowd was emotionally attached to his work, waving Lebanese flags during his patriotic songs, relating more to the symbols he represented than, for example, to the *maqamat* of the songs.

Al-Safi's musical contributions are significant to the development and popularization of the various musical genres, but his historical importance lies in his ability to represent the hopes, feelings, and aspirations of postindependence Lebanon and to unite a disparate, newly urban population. Like the people of Lebanon, his music was a unique combination of urban, rural, and Bedouin elements that expressed both the newness and continuity of their existence. (See **table 3**).

Title	Translation	Lyricist (if known)	Composer
• Allah yirda ʻalayk ya ibni	God Bless You, Son	Tawfiq Barakat	Wadiʻ al-Safi
• Jayyin ya arz al-jabal	We Are Coming to the Mountain Cedars	Asʻad Saba	Wadiʻ al-Safi
• Bi-saha tlaʼayna	We Met in the Town Square	ʻAbd al-Jalil Wahbi	ʻAfif Radwan
• Bitruh-lak mishwar	Your Errand Is Coming to You	ʻAbd al-Jalil Wahbi	Filimun Wahbah
• Jina al-dar ya ahl al-dar	We Have Come Home	Rahbani Brothers	Elias Rahbani
• Al-Hubb hal harfayn	Love Is but a Two-letter Word	Marun Karam	Wadiʻ al-Safi
• Tayr al-tayer min inna	Flying Bird	Marun Karam	Wadiʻ al-Safi
• Khadra ya bladi	My Green Country	Marun Karam	Wadiʻ al-Safi
• Zraʻna tlalek ya bladi	We Planted the Country's Hills	Marun Karam	George Tabet
• Sahrat hubb	Evening of Love	Rahbani Brothers	Rahbani Brothers
• Sayajna Lubnan	We Fenced Lebanon	Tawfiq Barakat	Wadiʻ al-Safi
• ʻAmmer ya mʻalem liʼmar	Build, Master Builder	Rahbani Brothers	Rahbani Brothers
• Tallu habbabna	Our Loved Ones Appeared	Mustafa Mahmud	Zaki Nasif
• ʻAl hada yaba	I Won't Let Anybody See You	Rahbani Brothers	Rahbani Brothers
• ʻAlallah tʼud	I Hope You Return	Michel Toʻmah	Farid al-Atrash
• ʻAndak bahriyyeh	Sea Captain	Michel Toʻmah	Muhammad ʻAbd al-Wahhab
• Ya Abu Mirʼi	Calling Abu Mirʼi	Elias Rahbani	Elias Rahbani

Table 3: Selected Songs of Wadiʻ al-Safi

The Quest for Enchantment

We have examined the works of four musicians from the middle genera-
tion and elements of their approach to enchantment (*tarab*), that quality
sought by traditional Arab audiences from their music. Analyses of these
musicians' work can help us understand the advances made in Arab
music of the twentieth century, and provide a link between the first and
third generations that may otherwise be overlooked. Although *tarab*
addresses an emotional state of being, there are specific concepts such as
saltana that are internal to the conceptualization in Arabic music and
explain its potential achievement. In an interview (March 12, 2000, in Las
Vegas) with Syrian master singer Sabah Fakhri, well known for his per-
formance of *muwashshahat* and *qudud*, explained (in an interview with
Sami Asmar, March 12, 2000, in Las Vegas) that he requires extremely
accurate intervalic ranges of the maqam, supported by at least one musi-
cal instrument that feeds him the reference notes. "I reach *saltana* ("mas-
tery") myself first, but that can be easily spoiled if any instrument in the
ensemble is sounding even slightly inaccurate intervals." Absolute pitch
is secondary to accurate intervals that Fakhri, as an example of typical
tarab-style performer, needs to internalize while performing.

This process thus begins with the achievement of a state of con-
sciousness called *saltana* wherein the performer masters (becomes the sul-
tan of) the *maqam*. Only one who has reached that *saltana* can commu-
nicate enchantment (*tarab*) to the audience. The process typically involves
instrumental introduction in the particular *maqam* with many repeated
refrains followed by instrumental improvisations (*taqasim*) as well as
vocal improvisations (*mawawil*) until the intervals of the *maqam* are
absorbed by the performer and the audience. Although of the performers
we have discussed, al-Safi and Bashir's method of inducing *tarab* may be
the closest to that described above, each of the four performers achieved
tarab in their work, and audiences responded accordingly.

16 The Classical Iraqi *Maqam* and Its Survival
Neil van der Linden

Defining Iraqi *Maqam*

The Arabic word *maqam* may be generally defined as "place" or "situation." In the context of music the word *maqam* refers to two different aspects of musical form. One definition is common everywhere in the Arab world, the other is specific to Iraq. Throughout the Arab world, the word *maqam* refers to the specific Oriental tone scales, of which there exists an enormous variety in Arabic music due to the vast range of different "microtones," intervals that differ from the " Western" so-called well-tempered intervals. In this respect the Iraqi maqam is the equivalent of the *mugam* of Turkey and Azerbaijan, the *dastgah* in Iran, and the *maqam* of Uzbekistan. Both in the general Arabic modal system and in the Iraqi maqam genre many Persian and Kurdish names occur.

Each *maqam* corresponds with a mood or an emotion. It is interesting that in the English language etymologically the words *mode* and *mood* are closely related as well, that in the German and Dutch languages respectively the words *Stimmung* and *Stemming* carry the meaning of both *mood* and *tuning*, and that the closely related English words *temper, tempered,* and *temperament* alternately refer to musicological phenomena and moods.

Experts have counted up to more than fifty different *maqam*s in Iraq and some consider the number to be more than seventy, especially if one considers some subdivisions as separate forms. All of them are derived from twenty main *maqam*s. No Iraqi *maqam* singer masters every *maqam*, and even the leading singers specialize in only a few.

In addition to the more general meaning of *maqam*, the classical *musique savante* of Iraq, the term *maqam* refers to a special kind of "suite" consisting of improvisations based on standard rules of performance and aesthetics. This "suite" has a basic structure involving several standard melodic and rhythmic patterns. A *maqam* opens with a long recitativelike section, in classical and popular dialect, called *she'erwas abudyyeh.* Then follows a distinct rhythmic section based on prescribed melodic structure and improvisations, like "theme and variations," or the "development" of the Western sonata model, and applying a standard range of *maqam*s in the sense of tonal scales, like key changes and modulations in the Western sonata.

The *maqam* is usually concluded by a light song, the *pesteh.* In the

pesteh, the instrumentalist members of the ensemble share in the singing role. This practice is partially intended to give the lead vocalist an opportunity to let his voice rest before the next part of the performance, but at the same time it is an invitation to the audience to join in with the singing. Many *pesteh*s have become popular as separate pieces. Some singers, like the renowned Nazim (Nadhim) al-Ghazali and Salima Murad (husband and wife), mainly sang *pesteh*s.

However, defining the technical structure of the *maqam* does not fully convey its essence, as there is a sort of "immaterial" quality to the Iraqi *maqam* as well, as any Iraqi musician is eager to emphasize. The different scales correspond with different moods, enabling, in principle, a much larger variety compared to the moods of the major and minor scale in combination with the different keys of the classical Western music (where a larger variety of shades in moods is partly conveyed by harmony). For example, the Iraqi *maqam* Saba is strongly characterized by certain microtones. The effect of this mode is a very sad mood. The Iraqi *maqam* explores this relation between scale and mood further through the choice of text. The *maqam* Saba, one of the most popular Iraqi *maqam*s, thus becomes a total work of art of melancholy.

The Rules of *Maqam*

In the performance of the *maqam* a great deal is attributed to improvisation, although as stated above the frameworks of improvisations are based on traditional rules. The performer is assessed by the way in which he or she emulates the melodic rules and how he or she applies the improvised melody lines to the meanings in the text.

The texts of a *maqam* may be derived from poetry in classical Arabic and be from either the ancient or modern period. The selection may vary, for instance, from the satire combined with sensuality explored by Abu Nuwas (eighth century), the melancholy and oppression of al-Mutannabi and al-Hallaj (both from approximately the tenth century), to the rebelliousness and black pessimism of the exiled Muhammad Mahdi al-Jawahiri (twentieth century). They might include translations of Persian poets like Omar Khayyam and Hafiz (eleventh and fourteenth centuries respectively). Several vernacular dialects in Iraq are practiced as well; for instance, on a recent recording by the young singer Farida Muhammad 'Ali, two *maqam*s contain texts that come from anonymous, traditional sources, starting in classical Arabic and are followed by the same text in a dialect from Baghdad.

Nor is the language strictly confined to Arabic. Aramaic, Hebrew, Turkmen, Persian, Armenian, and Turkish texts incidentally occur as well.

A famous *maqam* in Turkish is the *maqam* Tiflisi by the nineteenth century composer Shiltegh. This *maqam* is said to be dedicated to an Armenian boy the composer had fallen in love with and who was to move with his parents to Tbilisi, the old Tiflis, now in Georgia. Recordings in Turkish by the famous twentieth-century *maqam* performers Muhammad al-Qubanshi and Youssouf Omar exist. But in recent times Hamid al-Saadi performs this *maqam* with the text translated in Arabic.

About twenty main *maqam*s are distinguishable, and it is possible to count up to fifty to seventy varieties, depending on the extent to which one considers some subdivisions as separate *maqamat*. No Iraqi *maqam* singer masters every *maqam*. Singers specialize in a few *maqam*s.

Relation to Musical Forms Elsewhere

The Iraqi *maqam*, in the sense described here, is different from the classical forms in the rest of the Arab world and is in many respects closer to classical forms in Turkey and Iran. There is one other musical form in the Arab world that clearly shows a close resemblance with the *maqam*: the *nawba*, a formalized combination of the *maqam*, compositional structure, text and mood, which exists in Tunisia, Algeria and Morocco. This relationship is a remnant of the Abassid period, when Baghdad was the capital of the Arab empire, and when the cultural influence of Baghdad prevailed in the Arab world.

Elsewhere in the Arab world we find the *'ud* (lute) and the *qanun* (zither) as the leading instruments of classical music, together with the *darbukka* (vase drum), *daff* (large hand drum), *riqq* (tambourine) and possibly the *nay* (flute) and the *rababa* or *kamanja* (fiddle or violinlike instruments).

The Iraqi *maqam* ensemble, at least the line-up used in Baghdad, called *tchalgi Baghdadi*, lacks the *qanun* and may exclude the *'ud*. Instead the typical instruments are the *djoze* (a special regional Iranian form of the *rababa*, a spiked four-stringed fiddle, the resonance box consisting of a half coconut shell with a fish skin stretched over it) and the *santur* (a hammered zither, comparable to the *cimbalon* in gypsy and Hungarian music, which existed since antiquity in Arabia, Iran, and the Caucasus, and continues to be played in Iran). Another instrument, which does not occur in the classical music of the rest of the Arab world, is the *naqqara* (small vase drums with a sharp, high-pitched sound, frequently used in popular music in the Gulf region). The other instruments in the *tchalgi Baghdadi* include the *darbukka*, the *daff*, and the *riqq* (tambourine), while the *ney* may appear as well. Especially due to the piercing sound of the *santur*, the *djoze* and occasionally the *naqqara* playing

together, the *tchalgi Baghdadi* produces a sharp, almost metallic sound.

This sound as well as the predominantly slow tempo, the recurring absence of rhythm, and the frequent occurrence of delicate microintervals add to a wailing, sobbing quality. Later in the *maqam*, as soon as rhythm patterns and faster tempi are introduced, the music acquires a compelling pulse, with the *djoze* being played by plucking, with fast arpeggios on the *santur*, and with a culmination in striking rhythmical effects on the percussion instruments.

The use of the *djoze* and the *santur* in Iran is an example of the close ties between the culture of the Mesopotamian lowlands and the Iranian highlands. In fact, the great desert to the west of Mesopotamia was often a stronger barrier to cultural continuity than the Persian mountain ranges to the east. From the north came a great deal of Turkish and Kurdish influences on Iraqi *maqam* as well, including the use of Turkish poetry in the Iraqi *maqam* during the Ottoman period, like in Shiltegh's aforementioned *maqam* Tiflisi. And in the specific names of Iraqi *maqams* many Persian, Kurdish, and Turkish words occur.

The Historic Sources of the Iraqi *Maqam*

The underlying musical structures of the *maqams* can be traced back at least to the Abassid period, when a flourishing Arabic empire with Baghdad as its capital expanded to the east and west. A towering figure of the greater Abassid period was Ziryab (Abu al-Hassan 'Ali ibn Nafi, d. ca. 850 CE). He was the student of Ishak al-Mawsuli, one of the leading musicians at the court of Caliph Harun al-Rashid (786–809 CE). It is rumored that Ziryab came to Baghdad from the East, perhaps Persia or the Sind. Popular history has it that the caliph showed favoritism to Ziryab and his master became jealous and forced Ziryab out of Baghdad through intrigue. He traveled and finally settled in the court of Cordoba in Andalucia where he became extremely popular. The Iraqi *maqam* did not exist yet as such, but Ziryab helped to spread and develop the underlying principles of the *maqam* in the Arab world. It is said that, like his contemporary Al-Kindi, he had access to the musical theory of late antiquity, which he reconciled with the prevailing musical principles of Baghdad court music. Thus, it would be possible to trace the origins of the Iraqi *maqam* to antiquity. He was a master of the *'ud*, an extraordinary singer, and an influential teacher in singing. The seventeenth-century historian al-Maqqari cites descriptions of Ziryab's singing methods in his "History of Muslim Spain."

Musical principles were transmitted orally from teacher to student, while developing along the transmission. Thus, a chain of musicians

added to the evolution of the *maqam*s. As a result, it is difficult to trace each individual's contribution, and no musical notation system was practiced widely. The first *maqam* performer to rise out of a sort of anonymity after Ziryab was a musician of Turkmen origin, Rahmat Allah Shiltegh (1798–1872). Some of his compositions have been preserved through a written musical notation, and many of this compositions were practiced for a long time or are still being performed as, for instance, the aforementioned *maqam* Tiflisi.

As each good student was expected both to follow the tradition as well as develop his own individual style, there was a slow but steady evolution in the *maqam*. Of course, since the first electronic recordings, the musical evolution in modern times can now be clearly traced.

Major Performers of *Maqam* in Modern Times

The most influential *maqam* singer of the twentieth century was Muhammad al-Qubanshi (1900–89). His long life span covered the final decade of the Ottoman empire until a year prior to the time when a new generation of U.S. Tomahawks were tested over the skies of Iraq. In the work of the greatest innovator of the Iraqi *maqam* of the twentieth century, the melodic line aims to support the expression in the poetic text. The words are clearly understandable. Surprisingly, there are only two CDs of his work available. These consist of BBC recordings of his performances at the Cairo Music Congress in 1932, the first international event for Arabic music. According to some scholars, these CDs are not even true representations of his work, as there are some problems in the recordings that were made during the editing process. Nevertheless, they are the only indication of al-Qubanshi's artistic power available in the West; from cassettes available in Iraq and from archival materials, one can get a much more varied impression of al-Qubanshi's vast career.

Youssouf Omar (1918–87) was a student of al-Qubanshi. According to some, as a singer, in technicality and expressiveness, he surpassed his teacher, although for innovations in style he relied on the achievements of his teacher. The renowned Iraqi musicologist Scheherezad Qassim Hassan has made a collection of *maqam*s by Omar (available on CD), recorded in his later period (*Iraq Makamat–Scheherezade Qassim Hassan*. L'Ensemble al Tchalghi al Baghdadi et Yusuf Omar. Disques Ocora-ORTF).

Nazim al-Ghazali (1920–63), was also a student of al-Qubanshi, was renowned for his *pestehs*. Apart from these, there are recordings by him of full *maqam*s or at least large sections, sometimes with his wife Salima Murad (see below). According to many, his refined, mellow voice was the finest in the field. Maybe this, perhaps in combination with his very

handsome appearance, was the reason why he became the only Iraqi *maqam* singer of the past to become well known outside Iraq.

The other dominant *maqam* school of the twentieth century was led by Rashid al-Qundarshi (1887-1945). In Qundarshi's style, the melodic lines and the virtuosity in singing are similar in focus to bel canto, the traditional Italian style of vocal production. Vocal expression, if not sheer virtuosity, becomes a core element of style by itself, far from being just a mean for expression of text. Notwithstanding the sheer vocal beauty this leads to, al-Qundarshi was criticized for this sharply as well. However, Najim Al-Sheikhli (1893–1938), Salim Shibbeth (born 1908), and Hassan Chewke (1912–62) were other acclaimed followers of this school.

Other renowned *maqam* singers include Mullah Othman Mosuli (1854–1923),[222] Ahmad Zaydan (184?–191?), Antun Dayi (1861–1936), Mahmud al-Khayyat (1872–1926), Salman Moshe (1880–1955), Youssouf Huraish (1889–1975), Najim al-Sheikhli (1893–1938), Salim Shibbeth (born 1908), Hassan Chewke (1912–62), Filfel Ilyas Gurdji (d. 1983), Hassan Daud, Yakub al-Imari, Hizkel Qassab, 'Abdalrahman Ghudr, Hamza Sadawi, 'Abdalrahman al-Shaikly, Jamil and Badr al-Adhami, and three much younger singers, Hussein al-Adhami (born 1952, cousin of Jamil and Badir), Hamid as-Saadi, in his forties now, and Farida Muhammad 'Ali, in her thirties.

Female *Maqam* Performers

Since the 1920s, there have been quite a few women *maqam* singers. Sadiqa al-Mulaya, born Sadiqa Saleh Musa (1901–68), who entered her singing career as a *mulaya*, a religious singer. She specialized in a limited amount of *maqams*. It is said that she spent the last years of her life, impoverished, as a cigarette seller.

Maida Nazhat, born in 1937, performed a few *maqams* as well. Other Iraqi female singers performed *maqam* as a sidebar to a different repertoire. Among them was Salima Murad (1900–72), the wife of Nazim al-Ghazali, and in Iraq just as popular as he. She was of Jewish descent, honored during her lifetime with the title *pasha*, so her full name should read as Salima Murad Pasha. She concentrated on singing *pestehs* as separate pieces. Then there was Munira al-Hawazwaz (1895–1955), with her extremely emotional voice. Zakiya George (1900-61) came from Syria and was born a Muslim, but took a Christian artist's name to hide

222 The famous song "Zuruni kulli sanna marra," widely known as a song composed by Sayid Darwish of Egypt and famously performed by the Lebanese singer Fairuz, is said to owe its melody to Mullah Othman al-Mosuli, who composed it as "Zuru qabra nabi marra," a religious hymn that Darwish heard when meeting him in Aleppo.

her family name. She later became the fiancée of Saleh al-Kuwaity, one of the famous Kuwaity brothers, Saleh and Daud al-Kuwaity, of Jewish descent, renowned instrumentalists and composed many *pesteh*s for her. Another impressive female part-time *maqam* singer was Sultana Youssif (1903–81), who was born Jewish but converted to Islam and was called Hajja Sultana Youssif.

There have been other distinguished female vocalists in Iraq who included only fragments of *maqam* in their repertoire, but are worth mentioning. Zuhur Hussein, with her powerful voice, came from the south. She died tragically when her car crashed into a tree, while on her way to her husband, who was in jail. Lamiya Tawfiq was another singer with a tragic life, which may explain the tormented quality in her repertoire. Afifa Iskander (still alive as of this writing) was ravishingly beautiful, of Assyrian descent, with an extremely refined voice. She was a refugee from Turkey, arriving as a girl with her mother, who made a living in Iraq as a nightclub dancer. Afifa first followed in her footsteps (see **figure 24**). Seta Hakobian, still alive, is of Armenian descent and now lives in the United States. Ensaph Munir came from Syria; after arriving in Iraq, she lived in the garden house of Nazim al-Ghazali and Salima Murad, but later was expelled from Iraq on charges of espionage.

Narzjes Shawki was another artist from Syria seeking fortune in the richer and more liberal Iraq, distinguishing herself with her highly emotional voice. Wahida Khalil had a very sweet voice, which when combined with lightly played percussion instruments, made her the happiest sounding singer of Iraq. The younger Anwar 'Abdul Wahhab, still living, left Iraq after the political execution of her father. But the only true female *maqam* singer since Sadiqa al-Mulayya is Farida Muhammad 'Ali. She masters a wider range of *maqam*s and regularly extends her repertoire. She is now living in the Netherlands (see **figure 25**).

Figure 24. Afifa Iskander, of Assyrian descent, performed *maqam*s with an extremely refined voice.

As might already be clear to the reader from the explanation in the introduction to this section, the styles and development

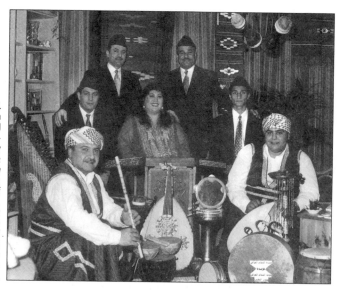

Figure 25. Farida Muhammad 'Ali, a contemporary female *maqam* singer, with members of her group. She is master of a wide range of *maqam*s and regularly expands her repertoire.

in *maqam* singing have been named for the major vocalists of this genre, although the instrumentalists are just as important to the *maqam* tradition.

Venues for *Maqam* Performance

As an indication of its descent from court music, the *maqam* was often performed in middle-class homes during special concerts and literary meetings. But there were also performances at religious feasts, *mawlids*, such as the feast celebrating the birth of the Prophet, and at more secular feasts, such as weddings and birthdays, and coffeehouses. Another venue for the *maqam* was the *zurkhane*, a Sufi-related sports school. At all these outlets, the genre could reach broader parts of the population.

Many *maqam* performers practiced a nonmusical profession as well. Mahmud al-Khayyat was the chief of the tailors' guild. Rashid al-Qundarshi started as a shoemaker—in fact, his surname means shoemaker. Hassan Daud was a butcher. In this respect the maqam tradition is comparable to the Meistersinger tradition in medieval Germany. Performances took place in their shops and workshops as well.

Later, the radio concert became a very popular vehicle for spreading the popularity of the *maqam* widely, followed by the gramophone record. The radio enabled the broadcasting of pieces of any length. The popularity of the *pesteh* and *pesteh* singers like Nazim al-Ghazali and Salima Murad were particularly enhanced by the rise of the 45 rpm record as a

popular medium; a full *maqam* was too long for the 45 rpm record, but it was suitable for the *pesteh*. Even the "classical" singers Muhammad al-Qubanshi and Youssouf Omar recorded *pestehs* in the 45 rpm format. With the arrival of the cassette recorder and tape player, popular distribution of longer musical structures became possible and in many Iraqi homes one may still find longer recordings of al-Qubanshi and Omar on cassette.

Contemporary Conditions in Iraq and Musical Practice

Since the days of the monarchy each consecutive government strongly supported music. Notably, Nuri Said (1888–1958), the prime minister for years under King Faisal I and King Ghazi, was a strong sponsor of music and he was closely befriended by all the leading musicians. In the homes of the senior music lovers in Iraq one can still see pictures of Said with large groups of musician gathered around Muhammad al-Qubanshi and of Huzkel Mu'allim and others together with Umm Kulthum during her visit to Iraq in the 1930s (see **figure 26**).

Since the republican revolution in 1958 until the 1990 Gulf War, consecutive regimes have more or less continued supporting the national musical culture, e.g., through state radio and national festivals. For instance, the now deceased phenomenal 'ud player and renowned teacher at Baghdad conservatory, Munir Bashir, was transformed into a musical icon. He was promoted heavily through the state radio and record companies, was sent abroad to international festivals, even becoming the head of the music department of the Ministry of Culture, and was enabled to set up the internationally renowned Babylon Festival, before he left the country in 1993.

The aftermath of the Gulf War in Iraq has led to unfavorable conditions for musical culture, or for any other aspect of life for that manner, with devastating effects on the basic needs of the largest part of the population. Due to the current situation, as well as the impact of competition with modern popular music forms from the Arabic world and from the West, the *maqam* is an endangered musi-

Figure 26. Three *maqam* performers (Huzkel Mu'allim, standing at right in the background, Yusuf Zarur, standing foreground, and Hughi Petaw, seated at table), with legendary Egyptian singer Umm Kulthum.

cal species. In this respect Hussein al-Adhami, Hamid as-Saadi, and Farida Muhammad 'Ali may indeed be the last survivors of the genre. Apart from this marginalization, the *maqam* is also in danger because, in its current status, there is little opportunity for the necessary evolution that kept the genre alive in the past. Paradoxically, partly due to the erstwhile strong governmental support of the surviving musical forms, the practice of *maqam* has come to be at risk of being kept alive artificially, an object of musical museology. In this respect, however, the Iraqi *maqam* is still in a healthier state than Egyptian "classical" music. Since the deaths of the last important voices associated with Egypt's past, like those of Umm Kulthum, Fathiyya Ahmad, Farid al-Atrash, and Muhammad 'Abd al-Wahhab, the "classical" music of Egypt is in danger of disappearing from popular music practice, notwithstanding the vast popularity of these artists on recorded media. It is like the preservation of a rare biological species that survives in a microhabitat, without much chance for successful genetic evolution, but which is being preserved through artificial intervention. In Iraq, the classical tradition is better integrated into musical life in general.

Farida Muhammad 'Ali, Hamid as-Saadi and Hussein al-Adhami are keeping the genre alive. A younger generation of musicians is interested in the classical styles too. Under better circumstances they might enable the *maqam* tradition to flourish again. For instance, a young singer, Jamal 'Abdalnasser, who has great potential, has been taken under the wing of venerated musician Salim Hussein, who has accompanied Nazim al-Ghazali, Salima Murad, Afifa Iskander, and Lamiya Tawfiq.

Apart from this, the popular Kadhem Saher, an Iraqi singer well-known throughout the Arab world, was a student of the Baghdad conservatory and regularly inserts elements of *maqam* and other traditional musical forms in his compositions, thus creating a potential hybrid style, and he seems to be keen on continuing incorporating this national musical heritage in his popular style.

Today in many homes, including those of the now relatively poor families of the lower-middle classes, if a cassette recorder is still present, people cherish recordings of the music of the past, just as singers of the past are kept alive in Egypt. Thus, even in relatively modest homes, one can find the recordings of Nazim al-Ghazali, Salima Murad, Zuhur Hussein, Youssouf Omar, and Muhammad al-Qubanshi. Meanwhile, Iraqi radio and television are active in broadcasting the nation's musical heritage. In this respect it may turn out that the *maqam* is not or not yet on the verge of extinction.

Jewish Iraqi Musicians and Emigration to Israel

Many cultures, creeds, and ethnicities were involved in Iraqi music. In the text above, the names of Assyrian, Armenian, Syrian, Shi'ite Muslim, Sunni Muslim, Christian, Arab, Kurdish, Turkish, Turkmen, Jewish, and Persian musicians and influences were mentioned. Many others can be added from the several hundred cultural, religious, and ethnic groups who have flocked to the banks of the Euphrates and Tigris and their outskirts and lived in a remarkable degree of peace and harmony together for ages.

The Jewish share in Iraqi musical life had been considerable. For instance, of the *tchalgi* group that accompanied Mohammed al-Qubanshi in 1932 to the Cairo Music Congress, only one individual was not Jewish. Although there have been Jewish *maqam* singers (see above) the Jewish participation was mostly as instrumentalists (see **figure 27**). Renowned instrumentalists of Jewish background were the aforementioned Kuwaiti brothers.

The creation of the state of Israel was one of the events that changed all this, as well as leading to the emigration of many of the Iraqi Jewish musicians. Among those who established themselves in Israel were Youssouf Huraish, Salim Shibbeth, Yakub al-Imari, Hizkel Qassab and

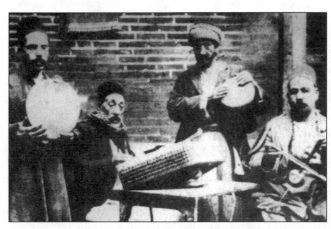

Figure 27. People of many cultures, creeds, and ethnicities have performed Iraqi *maqams*. A Jewish group, the Hughi Petaw *tchalgi Baghdadi* ensemble, is shown in a photo circa 1930: On the *daff* (standing, left) is Huzkel Ben Shutah; on the *darbuka* (standing, right), Harun Zongi; on the *santur* (seated at left), Hughi Petaw; and on the *djoze*, Nahum ben Jonah.

the Kuwaiti brothers. Thus, a part of the *maqam* tradition lived on for a while in Israel. The radio broadcast *maqam* concerts with Jewish Iraqi musicians who had emigrated to Israel. Recordings of these sessions became collector's items and even reached music lovers in Iraq as well. However, for the most part, the dominant Western-oriented Ashkenazi culture in Israel ignored the Oriental culture. This led to a loss of inter-

est in distinct Middle Eastern musical genres (see Simon Shaheen as interviewed in "Beyond the Performance," in Zuhur, 1998, p. 162).

Recently there was a renaissance of Oriental music, not only through the rise of popular Oriental music in Israel, but also through a heightened interest in traditional music, manifestations of the emancipation of the popular as well as the intellectual culture of Oriental Jews, who apparently wish to explore and honor their roots. The initial illusive prospects of the "peace process" after the Oslo agreements between Israel and Palestine added to this interest, through a few ethnically mixed musical enterprises. The Israeli *'ud* player of Iraqi descent, Yair Dallal, has performed and recorded some of the most interesting of such efforts together with Arab musicians. Some of Dallal's CD liner notes emphasize the role of Iraqi Jews in Iraq's musical tradition. Certainly the Iraqi government's official neglect of former Jewish participation in Arabic musical life is despicable. Still, I regard Dallal as a musician of Arab music, a tradition shared by various religions.

Meanwhile, the older Iraqi Jews in Israel recall with nostalgia the past in Mesopotamia. On an album called the "The Musical Heritage of the Iraqi Jews," issued by the Babylonian Jewry Heritage Center, one hears a recording of a song of grievance entitled "Hey hey Ben Gurion, what have you done to us?" a song that expresses the agony of the recent immigrants, who felt betrayed by the Israeli government. The Babylonian Jewry Heritage Center in Or Yehuda organizes *hafla*s, concerts, for instance, for the commemoration of the Kuwaiti brothers (who emigrated to Israel) or Salima Murad (who stayed in Iraq).

This Babylonian Jewry Heritage Center and its founder, Mordechai Ben-Porat, have naturally been involved in the dominant political discourse in Israel. Yet the Israeli musician of Iraqi descent Naim Razjwan expresses regrets: "We have been living in Iraq for two and a half thousand years in peace," he says. However, the value of the musical collections and the documentation of the Babylonian Jewry Heritage Center are unsurpassable.

Meanwhile, imagine the sight of this elderly Iraqi Jewish musician, Naim Razjwan, looking out of place in a high-tech supermarket in Tel Aviv, crying, although no bypasser understands why, as he listens to a Walkman playing a rare duet by Nazim al-Ghazali and Salima Murad on a cassette, which was just brought in from Iraq.

Another well-known person in Israeli-Jewish Iraqi musical life was Naim Twenna, the former general director of the Baghdad Electricity Company. He lived in Baghdad until 1975 and over the years he received the likes of Muhammad al-Qubanshi, Nadhim al-Ghazali, and Salima Murad in his home for concerts in his home.

Selected Discography

Farida Muhammad 'Ali:
Farida and the Iraqi Maqam Ensemble:
Classical music of Iraq, with liner notes by Neil van der Linden
Samarkand SAM CD 9001 (via ronalddv@yahoo.com)
Recent recording.

Hamid as-Saadi:
Hamid as-Saadi and al-Takht al-Sharqi
Al-Haneem EMEE EM CD001
Ash-Shawq EMEE EM CD002
Al-Mahabba EMEE EM CD003
Recent recordings.
Hamid as-Saadi has a website: www.iraq4u.com/hamid/. On
www.iraq4u.com/makamat.asp/ and
http://almashriq.hiof.no/base/music.html, the reader can find
valuable musical and biographical material on several other
Iraqi singers, including clips taken from television films.

Nazim (Nadhim) al-Ghazali:
Al-'Arousa
Al-'Arabia
Duniaphon LPCD 502
Nazim al-Ghazali vol. 1
Buzaidphone BUZCD 515
Nazim al-Ghazali vol. 2
Buzaidphone BUZCD 516
Note that Nazim (Nadhim) al-Ghazali is not solely a *maqam*
singer. On these CDs he performs many kinds of songs, includ-
ing some *pesteh*s, and only a few tracks could be considered
maqam in the proper sense. The sound quality of all the material
is quite bad. The author of this article has collected a few
recordings from Iraq of much better quality, which might be
released in the future. However, the beauty of al-Ghazali's voice
is clearly perceptible on these recordings.

Youssouf Omar:
Le maqam Irakien:
Hommage à Youssouf Omar
Inédit 260063

Maqams d'Irak
Harmonia Mundi Ocora C580066
Collections of full-length *maqam*s, done for radio, with very
informative sleeve notes by Scheherazad Qassim Hassan, who
seems to have encouraged Youssouf Omar's recording efforts, so
that at least some studio-quality disks of his work are available.

Muhammad al-Qubanshi:
Muhammad al-Qubanshi:
Congrès du Caire 1932
Club du disque Arabe AAA 083
Muhammad al-Qubanshi:
Congrès du Caire 1932
Club du disque Arabe AAA 087
These are amazingly good recordings considering the year.
Recorded by the BBC during the first world congress on Arabic
music in 1932 in Cairo. However, according to some connois-
seurs there are some artifacts in the editing.

Rashid al-Qundarshi:
Musique savante d'Irak
Rashid al-Qundarshi,
Le fausset de Bagdad
Al Sur Al-CD 183
The recordings sound "worn," apparently taken from copies of
78-RPM recordings or simple other recording devices. The book-
let text in French is excellent, however. The abridged English
translation contains many mistakes.

Hussein al-Adhami:
Hussein al-Athami et l'ensemble al-Kindi:
L'École de chant de Bagdad et la passion des Mille et Une Nuits
Al Sur Al-CD 157
This is a modern recording, but the sound quality is compara-
tively poor and the artist is reported as not being very satisfied
with the recording. It contains informative liner notes, some of
which appear on the al-Qundarshi's CD.

Chants de Bagdad
IMA CD 18
This CD was recorded at the Institute du Monde Arabe in Paris,

and although the acoustics of the concert hall in the Institute always lead to debatable sound quality in recordings, the quality still is better than in previous recordings and the singer sounds much more inspired. Excellent liner notes by Scheherazad Qassim Hassan are included.

Hussein al-Athami has a religious CD on Al Sur as well (*Chants d'extase*).

Al Sur has announced a CD called *Le Rossignol de la Mésopotamie: Najim al-Din al-Shaykhli*, which has not yet (at the time of compilation) appeared.

Munir Bashir:
Munir Bachir
Maqamat
Inédit W 260050l
The renowned late *'ud* player Munir Bashir has recorded a few improvisations based on maqams for *'ud* solo; a very example of this is his album *Maqamat*. Several albums of Munir Bashir are available. All the solo-albums are good examples of his adaptations of maqam fragments for solo *'ud*, in which he mixes melodic elements from the church rites of Northern Iraq, in his attempts of exploring musical structures of the Islamic and pre-Islamic period in Iraq.

I would like to thank Wafaa Salman and Muhammad Gomar for their help in writing this chapter.

17 Musical Attitudes and Spoken Language in Pre-Civil War Beirut
'Ali Jihad Racy

The intimate connection between language and other manifestations of culture has long been recognized.[223] Sociolinguists have spoken of an "integrated approach" to the study of "language in society" (Hymes, 1972, pp. 1–14) and explained that "language and society reveal various kinds and degrees of patterned co-variation," and offer insights into one another (Fishman, 1968, pp. 5, 6). In the area of ethnomusicology, Alan Lomax, with a team of researchers, devised a system of measurement, called "parlametrics" for establishing correspondences between styles of speaking and cultural profiles, defined in terms of techno-environmental structures, systems of governance, modes of emotional adaptation, sexual taboos, and so on (Lomax, et al., 1977, p. 18). Meanwhile, focusing on social attitudes in specific world settings, scholars from various disciplines addressed the connotative meanings and applications of folk proverbs, for example in India, Egypt, and Lebanon.[224] Comparably, it was shown that in Lebanon during the early 1960s, the imitation of regional accents was prescribed by social situations and the speakers' intentions, rather than mere interest in status enhancement (Nader, in Fishman, [ed.], 1968, p. 276).

At the same time, the link between speech and other facets of behavior has been problematized, and similarly, the complexity of the language-music relationship has been linked to a variety of theoretical premises. It is demonstrated for example that individual spoken idioms may exhibit considerable internal variation, may change significantly across time, and may differ stylistically depending upon the context of usage and the users' intent. In the same vein, it is noted that speech proper is practically inseparable from other modes of expression (body and facial gestures, or in the case of sung laments, cry breaks and falsetto effects) that play an essential role in the communicative process (Feld and Fox, 1994, p. 42). Furthermore, it is argued that speech, although it may pro-

223 Certain portions of this article appeared as "Words and Music in Beirut: A Study of Attitudes," in *Ethnomusicology*, 30:3 (Fall, 1986), pp. 413–427, and appear here with the permission of the University of Illinois Press.

224 Hari S. Upadhyaya, "Attitude of Indian Proverbs Toward High Caste Hindus." *Proverbium*, 3:1986, pp. 46–56; al-Sayyid Marsot, "Expression of Opinion Through Proverbs in Egypt," lecture at UCLA for the Egyptian-American Association, February 15, 1985; Racy, 1985, pp. 83–97.

vide ethnosemantic clues to individual cultures' cognitive-musical systems, is categorically different from music. The two are believed to represent distinct modes of cognition, thus verbal discourse does not adequately represent the musical experience (Blacking, 1982, pp. 21). For that matter, speech about music frequently assumes the form of "technical and metaphoric discourse" (Feld and Fox, 1994, p. 33). It is similarly posited that, although closely interlinked, speech and music are not mere reflections of one another. In other words, a community's musical system and its established style of verbalization tend to develop and operate in comparable rather than strictly congruous ways. Quite appropriate may be Clifford Geertz's analogy, namely that "culture moves rather like an octopus too—not all at once in a smoothly coordinated synergy of parts, a massive coaction of the whole, but by disjointed movements of this part, then that, and now the other which somehow cumulate to directional change" (Geertz, 1973, p. 408). In this light, experts have recognized the idiosyncrasies of both music and speech, in the case of the latter for example, illustrating the traits that characterize speaking as an art, or as "performance" that utilizes such tools as rhymes, stylized expressions, verbal formulas, and repetition with variation (Bauman, 1977).

This article demonstrates how one particular spoken idiom evokes the musical attitudes and outlooks of those who use it. More specifically, the aim is to reconstruct a speech-bound musical world view and to assess the relevance of that world view to the speakers' actual musical experiences, both past and contemporary. The research is based on the binary assumption that (a) ordinary speech tends to connote certain musical constructs and (b) what is connoted informs on, although may not totally coincide with, lived musical realities. With this in mind, I investigate a repertoire that embraces various music-related expressions, idioms, proverbs, jargon words, and the like that are all part of the colloquial Arabic spoken in Beirut, Lebanon. This verbal material, as well as the related musical setting, represents the city prior to the civil war (1975–90) especially during the 1960s, when Lebanon's culture seemed to retain prominent traditional traits, but also to undergo significant patterns of modernization and Europeanization. To a certain extent, however, the data and the findings apply to prior and more recent decades in the country's history, as well as to other neighboring Arab cities. The various expressions are examined in terms of their literal meanings, modes of application, contexts of usage, and ultimately the musical connotations they project. I write as an Arabic speaker and performer of Arab music, but also as someone who has directly experienced and participated in the culture and the musical milieu under investigation.

Musical Background

The music culture of pre-civil war Beirut constituted a complex conglomeration of Eastern and Western practices, repertoires, and aesthetic values. It presented a panorama of liturgies and styles that belonged to various religious sects and ethnic groups. The inhabitants, most of whom came from rural areas after World War II, consisted of Sunnis, Shi'ites, Druzes, Maronites, Catholics, Syriacs, and others. There were also Armenians, Palestinians, and citizens of Western countries. Beirut's traditional music also contained some elements from Arab nomadic culture, as well as from the Lebanese countryside, for example, *zajal*,[225] or sung folk poetry.

The city's Arab musical mainstream incorporated genres shared by, and in some cases derived from, neighboring urban centers such as Cairo, Aleppo, and Baghdad. The *mawwal Baghdadi* (see ch. 16), an improvisatory vocal genre extremely popular in early twentieth-century Beirut, was particularly prevalent in other cities of the Levant region (Pôche, 1969, p. 98). In Lebanon and Syria, itinerant Gypsy musicians have typically used the *buzuq*, a long-necked, fretted lute similar to the Anatolian saz. In the first half of the twentieth century, many Beiruti musicians also performed on the *buzuq*. In some cases, the instrument had developed urbanized features, including mechanical pegs and a sound box made from separate ribs rather than carved from a single piece of wood. Both professional and amateur musicians performed mainstream Arab genres, such as the improvisatory instrumental *taqasim* and the precomposed *ughniya*, literally "song." They also played Near Eastern instruments and included well-established artists such as Sa'id Salam ('ud player); 'Abbud 'Abd al-'Al (violinist); Bashir 'Abd al-'Al (*nay* player); 'Abd al-Karim Qazmuz (a *riqq*, or tambourine specialist); and Matar Muhammad (*buzuq* player).

Beirut's urban secular music was rooted in pre-twentieth-century practices. Beirut and neighboring Arab cities were all part of the Ottoman Empire, a sociopolitical entity that officially came to an end after World War I. In Ottoman-ruled cities, social life was typically dominated by a system of professional guilds that incorporated members of various crafts, including singers, instrumentalists, dancers, and other public entertainers (Chelebi, 1968; Racy, 1977, p. 64). The guild system, which gave guild members a measure of order and protection, treated music as an ordinary profession comparable to the various manual

225 The Arabic words appearing in this article are transliterated according to the system used by the AUC Press, but in the interest of representing general patterns of Lebanese colloquial pronunciation, some modifications appear, especially in the case of the vowels.

industries. The system also functioned within societies in which music-making as a profession, although indispensable, enjoyed a relatively low social status. A late nineteenth-century dictionary of crafts in Damascus listed a variety of music-related professions ranging from singing religious odes and playing the *qanun* (a type of zither) to presenting monkey or bear dance-shows and playing *tabl* (a large double-headed drum) and *zamr* (a double-reed instrument). Associated with Gypsy entertainers, playing *tabl* and *zamr* was referred to as a profession "altogether ignoble and undignified except by those who pursue it" (al-Qasimi, 1960, vol. 2, p. 288). Musical guilds probably did not predominate in Beirut itself, but their lore, concepts, and professional attitudes may have indirectly influenced all large cities in the area.

During the twentieth century, Beirut and neighboring Arab cities became part of a large pan-Arab musical public. The record industry, which began to thrive during the early years of the century, popularized Egyptian singers, Shaykh Salamah Hijazi (1877–1917), Shaykh Sayyid al-Safti (1875–1939), and others. It also gave wider recognition to artists from Beirut, such as the singer Farajallah Baida, and the singer and buzuq player Muhyi ad-Din Ba'yun (1868–1934). Many of Beirut's performers were recorded by Baidaphon Company, established by members of a Beiruti family around 1907 (Racy, 1976, p. 40).

After the country gained its independence from France in 1943, numerous Lebanese singers and composers became well-known throughout the Arab world. Many were well off socially and economically. Some were formally employed by the Lebanese Radio Station, which was founded under the French in 1937 and then taken over by the Lebanese government in 1946 (al-Jundi, 1954, p. 303). Others taught at the National Conservatory of Music, which was established in 1925 (Pôche, 1969, p. 87). A large group of musicians played in nightclubs, until many of these clubs were closed during the civil war. Furthermore, the existence of musical theaters such as *Masrah Faruq* (later called *Masrah Tahrir*) brought about further contact between Beiruti musicians and visiting ensembles from other cities, especially Cairo.

Lebanese artists also gained exposure and fame through the spectacular music and dance festivals, held in Ba'albak and other historical sites between the late 1950s and the mid-1970s, particularly during the peak months of tourism. These government-supported festivals usually presented musical plays featuring newly composed and orchestrated tunes, and newly choreographed dances. Festival music and dance, collectively known in Lebanon as *fulklur* ("folklore"), incorporated elements from Arab and European sources, as well as from the Lebanese folk repertoire.

The material was presented in modern, formally staged, and well-rehearsed formats. Festival music was associated with celebrities such as: the two Rahbani brothers, 'Assi (1923–86) and Mansur (b. 1925), both composers and lyricists; Fairuz (b. 1934), a female singer; Wadi' as-Safi, a male vocalist, and others (Racy, 1981, p. 36).

Beirut's exposure to the West had been long and extensive. In the late nineteenth century, Protestant Arabic hymnals based on Western tunes were printed and distributed by American missionaries in Beirut. One such hymnal, from 1873, taught Western music theory and notation (Lewis, 1873). After World War I, Beirut witnessed an increasing interest in Western instruments and Western-derived musical genres. This interest was illustrated by the nationalistic anthems composed by musicians such as Mitri al-Murr (b. 1880), whose career was associated with Byzantine liturgical music, and Wadi' Sabra (1876–1952), a French-trained artist who composed the Lebanese national anthem in 1925 (al-Jundi, 1954, p. 355). Many such compositions were performed by military brass bands, for example, the one directed by the two Fulayfil brothers, who were also composers (Poche, 1969, p. 96). During the 1960s and 1970s Western notation was already employed by both the Western and Near Eastern divisions of the government conservatory. The city also had dozens of Western-music teachers and composers of Arab, Armenian, and Western backgrounds. There were also local chamber ensembles and keyboard virtuosos, Diana Taqi al-Din, Walid Hurani, Salvador 'Arnitah, and others. Western music was taught and performed in private institutions such as Sami Salibi's Center of Fine Arts (established in 1954) and the American University of Beirut.

Interest in learning and hearing Western, particularly classical, music was most common among middle- and upper-income families, and among the city's educated elite. By the early 1970s, world-renowned figures, ranging from Herbert von Karajan and Mstislav Rostropovich to Joan Baez and Miles Davis had given performances at the Ba'albak International Festivals (Racy, 1981, p. 38). Consequently, many Beirutis were becoming familiar with Western popular music and major classical compositions, and "at home" with Western formal-concert mannerisms. They were also cognizant of traditional Western outlooks toward the fine arts, and the role of music in Western-based systems of education. An incident that I witnessed around 1964 in the cosmopolitan area of Ras Beirut, where many Westerners lived, may shed some light upon the musical culture of Beirut in the 1960s and early 1970s. On an Islamic holiday, two Gypsy musicians playing the *tabl* and *zamr*, with a female dancer, ventured into that quarter of the city, performing for donations.

The three were arrested by the city police and their instruments confiscated. One policeman admonished the group as follows: "What would the *ajanib* ("foreigners," specifically Westerners) say if they heard this?" This incident thus commented on: (a) differences among cultural milieus within the city; (b) local attitudes toward local street musicians, and (c) the officials' sensitivity about the country's image vis-à-vis the West.

After 1975, the city's music was adversely affected by the civil war. Many Lebanese, particularly the young, educated, and well-to-do, left for Europe, the United States, and other Arab countries. The collapse of tourism and the diminishing role of the central government contributed to the virtual downfall of the "folklore" movement. The war also had an adverse effect upon various musical institutions and musical life in general.

The Language of Music

Beirut's exposure to Western musical concepts, terminology, and aesthetic criteria made a noticeable impact upon the city's language culture. Thus, music-related expressions characteristic of the pre-civil war era combined old imagery, metaphors, and proverbs with European technical terms and Western-derived concepts and distinctions. The material studied in this article falls under two major categories. The first incorporates music-related words, idiomatic phrases, and proverbs that Beirutis and most other Lebanese applied to various musical and non-musical contexts. The second category is basically a jargon peculiar to the city's professional Arab-music performers and to a large extent encountered in neighboring Arab cities, such as Cairo. This jargon (apart from the formal theoretical terminology) was typically heard in radio station offices, in nightclub dressing rooms, and during musicians' informal gatherings in public cafés and private homes.

Public Expressions

Verbal forms used by the general public can be discussed under three general headings: complimentary, ambivalent, and pejorative. The differences among these often overlapping categories are not always clear cut, and in certain cases the dividing lines may be arbitrary.

Complimentary Usage

Favorable connotations apply to broad musical categories. The word *musiqa*, a medieval borrowing from Greek, may desirably depict musical artistry as well as denote urban secular music of the Arab world or refer to the purely instrumental genres. It may also encompass Western musical expressions, especially European art music. Similarly, *kunser*, from

the French word for "concert," applies to public performances of Western art music and, occasionally, Arab music. It implies formality, sophistication, and respect.

Complimentary connotations are associated with two types of musicians: accomplished performers of European art music and the more celebrated practitioners of Arab music. The title *musiqar*, roughly "musical master," applies to important names in European art music (Beethoven and Brahms, for instance) and similarly glorifies Arab composers such as 'Assi Rahbani of Lebanon and Muhammad 'Abd al-Wahhab of Egypt. The word *fannan* may be used as a synonym for "artist" in the modern Western sense and may define a pianist or a "star" singer such as Wadi' al-Safi or Umm Kulthum. In traditional Arabic usage, the word *funun* ("arts") means "crafts," "skills," or "industries," including music. But in the city's pedagogical parlance, music is also included under the auspicious title *funun jamila*, which means "fine arts" and appears to be a direct translation of the French *beaux arts*.

Complimentary concepts that depict the musician as an "artist" in the Western sense, and which have "romantic" overtones, are used to describe poets and performers of Western art music. The complimentary adjectives *'abqari* ("genius"), *mulham* ("inspired"), *hasses* ("sensitive"), and *murhaf* ("delicate") are typically applied to pianists, organists, opera singers, and the like. They are similarly used for notable performers and composers of Arab music, especially those clearly influenced by the West. Associating sensitivity and sophistication with such a group of artists is expressed in the popular adage: *Hmar wi-biydiqq byanu?* ("Could a jackass play the piano?")[226] Apart from its ludicrous imagery, this proverb reflects a general acceptance of the piano as an emblem of musical and cultural refinement.

In European languages, the concept of *performing* tends to embody notions that go beyond the mere mechanics of the activity—as in the English "to play," the French *jouer*, and the German *spielen*. The concept of "playing" implies leisure and personal motivation. By contrast, the words used to denote performing usually point to the specific physical action that takes place. Thus, *ydiqq*, which appears in the above proverb, means literally to "knock," or "beat." Because a word such as *daqqaq* ("beater") has derogatory overtones suggestive of the professional street musician, it may suit the image of the jackass but not that of an actual pianist, or, for that matter, a recognized *'ud* player. In making respectful

226 This is perhaps an updated version of an older dialogue-type of proverb, "They said to the camel 'play the reed.' He said, 'I have neither closed-in lips nor parted fingers'" (Freyha, 1974, p. 488).

reference to an artist, one might use a formal epithet such as *'azif byanu* or *'azif 'ud*—respectively "performer on the piano" and "performer on the *'ud.*"[227] Another term typically encountered among the Western-educated is *yil'ab*, which is a direct translation of "to play" and is used especially in reference to performing on Western instruments.

Ambivalence

Ambivalence may be found in expressions that refer categorically to the city's Arab secular music. Examples lie in the words: *fann* (art, or craft) and *tarab* (musical enchantment, or ecstasy). These terms may be neutral or complimentary, but since they implicitly suggest professionalism, they can downgrade music to a less dignified, wage-earning activity. A complimentary statement such as "he knows the rudiments of *art*," may be contrasted with the pessimistic and somewhat cynical saying popular among musicians and nonmusicians alike: *L-fann bita' mish khibz*, literally, "Art does not provide bread."

One also finds ambivalence in usages denoting common performance contexts. Arab music is typically presented not as a "concert" (*kunser*) but as a *hafli* ("party," or festive gathering), a *sahra* ("evening party"), or *jalsi* ("sitting," or small intimate gathering). Music thus occurs in a context of *kayf* or *bast*, both meaning "merriment." One is led to envision an active and perhaps noisy audience, audibly enjoying food and drink as well as the music. While the milieu suggests glamor and festivity, it might well connote rowdy indulgence and moral license as well. "I do not like to go to *parties*" may be said by a respectable elderly person or someone who is very religious.

Words of ambivalent meaning also apply to amateur musicians. An accomplished professional from a conservative, well-to-do family may emphatically state that he is an amateur. This ostensibly modest declaration absolves the performer from the disagreeable connotations of professionalism. However, a mildly negative nuance is inherent in almost all the words that mean "amateur." Such words portray the performer as rather delightfully eccentric and obsessive. Examples include *hawi* or *ghawi*, both literally meaning "being in love," *maghrum* ("infatuated"), *mitwalli'* ("obsessed"), and *ilu mazej fi* ("having a disposition for").

Another group of ambivalent terms is commonly used by the public and occasionally by the musicians when talking about renowned performers and composers of traditional Arab music. Although basically

227 This usage may seem curious. In pre-Islamic Arabia, *'azf* (or *'azif*) signifed the ominous whisting of the *jinn* or "demons." Musical instruments are referred to as *al-ma'azuf* or "tools of *'azf*" (Farmer, 1973).

complimentary, these descriptive labels would be tactfully avoided in the artist's presence. A dynamic virtuoso on an Arab instrument may be referred to by his peers or by musically-initiated audience members as a *wahsh* ("beast"). A Beiruti may say that a specific composer is a *banduq* ("bastard") or *mal'un* ("damned one," or "rascal"). Not to be taken literally, of course, these benign labels are used in nonmusical contexts as well. They imply that the person described is crafty and delightfully mischievous. Accordingly, a composer is a wizard who employs his mysterious *asrar il-mihni* ("secrets of the profession") to produce perplexingly outstanding musical compositions.

Another variety of ambivalence applies to professional Arab musicians in general. The Beiruti public may use the relatively neutral term *fannanin* ("artists") to refer to radio station musicians, nightclub entertainers, and others, but this collective term may also be used derogatorily to depict an occupational group of dubious reputation and humble social order. Of even baser implication is the commonly used French word *artiste* (typically in the feminine gender), a notorious euphemism for the lower echelons of entertainers, taking in cabaret dancers, bar girls, and prostitutes.

A similar ambivalence surrounds the word *mutrib*, which means "one who enchants," as it refers specifically to a professional singer. Depending on the context, the word may allude favorably to competence and recognition. Yet, by pointing so strongly toward professionalism, it can be less complimentary and even negative. A young aspiring singer may be ridiculed as "wanting to end up as a *mutrib*." Closer to derogatory would be the more direct *mghanni*, literally "singer," or "a man of the singing profession."

Ambivalence typifies musical concepts that are linked with professionalism and manual craftsmanship. In the Near East, the traditional terminology of music making overlaps considerably with that of manual professions. The same kinds of superlatives may be used to describe excellence throughout the whole spectrum of traditional professional life: *malik al-falefil* ("King of the Falafil Sandwich") *amir al-buzuq* ("Prince of the Buzuq"), *sultanat al-fann*, ("The Female Sultan of Art").[228] Words that refer to an instrumentalist usually consist of the name of the instrument plus a suffix that means "that of" or "the user of." By analogy to *hallaq* ("barber") and *naddef* ("cotton-beater"), an *'ud* player is an *'awwad*. Similarly the performer on the *qanun—qanunji—*is in league lin-

228 These specific titles did actually exist. They applied respectively to a sandwich shop in Ras Beirut, the famous Syrian *buzuq* player Muhammad 'Abd al-Karim, and the early 20th-century female singer from Egypt, Munira al-Mahdiya.

guistically with the cobbler (*kindarji*) and the jeweler (*jawharji*). These concepts and appellations can denote competence but may also depreciate. Many profession-related superlatives can be used for poking fun.

Denigration

Uncomplimentary words, idiomatic phrases, and traditional proverbs pertain to a variety of musical specialties and contexts. Many expressions make literal allusions to images and contexts familiar to the Lebanese either previously or at the time. Most often used figuratively, these verbal tools may criticize and ridicule as well as portray familiar patterns of human behavior (Racy, 1985).

Negative implications may appear in connection with singing in general. Relatively innocuous is a proverb portraying singing as a symbol of manipulation for one's own benefit. *Ib'ud 'an ish-sharr w-ghannilu* means "Steer away from trouble and sing to it." Another proverb uses singing to imply preoccupation with one's own ideas and "blowing one's own horn." *Kill man bighanni 'ala mawwaluh* means literally, "Each sings his own *mawwal*," an improvised vocal genre based upon a text of lyrical love poetry. In another version of the same proverb, *mawwalu* is replaced with *laylu*, referring to another traditional improvised vocal form.

The *mawwal* and the *layali* also symbolize preoccupation with unacceptable or ridiculous ideas. Indicative of such preoccupation is the phrase: *Tali' bi mawwal jdid*, "He is coming up with a new *mawwal*." The same implication is found in *tali' bi naghmi jdidi*, "He is coming up with a new tune." Either phrase could, for example, describe a politician flaunting a new slogan or a restless teenager who threatens to leave home to seek his fortune.

The idiom *'ala nafs il-istweni*—roughly, "playing the same record over and over"—could characterize the bothersome repetition of intentions or slogans, "like a broken record." This idiom appears to derive from the use of phonographs in cafés, a form of entertainment popular in the Near East during the first few decades of the twentieth century. It also brings to mind the sort of mobile disk jockey who carried a phonograph into various quarters and towns playing the same collection of records for a fee.

Other expressions pertain to the singer himself. An example is found in the famous adage: *'Imrak ma tqul lal-mghanni ghanni*, which literally means, "Never ask a singer to sing." Significantly, the phrase uses the potentially offensive label of *mghanni* in reference to the singer. The saying seems to imply that when asked to sing, the lowly entertainer

may be transformed into an unobliging prima donna.[229]

The last and probably largest group of pejorative idioms pertains to musical instruments. The most denigrated of all are those instruments traditionally played outdoors. These are associated with the professional street musician, symbolizing noisy exhibitionism and undignified behavior.

To refer to a group of musicians as *tabbalin* and *zammarin* (performers of the *tabl* and *zamr*, respectively) is an unequivocable insult. The saying implies degenerate and blatantly vulgar behavior. *Tabl* alone, by the same association, can mean a crude and stupid lout. The derivative verb *yitbul* means "to nag," or more specifically to badger someone with an incessant demand or complaint. Cross exhibitionism and loud or inappropriate music-making are described as *titbil w-tizmir*–literally, "playing the *tabl* and *zamr*." *Taqsh w-faqsh* can similarly apply to such disruption. This is an onomatopoeic pair that expresses finger-snapping or playing finger cymbals (*fiqqayshet*). In like usage is *tanni w-ranni*, which echoes the sounds of cymbals or strings.

Rivaling the *tabl* in proverbial usage is the only slightly less notorious *daff* (tambourine). In the public mind, the tambourine is reminiscent of such spectacles as dancing bears and monkeys (in previous years) and associated with the highly admired staged *zajal*, or folk poetry singing duels. Among the sayings in which the tambourine makes an appearance is the following, which describes the end of a brief and superficial relationship: *Nfakhat id-daff w-itfarraqu l-'ishshaq*, literally "The tambourine broke and the lovers dispersed."

The small kettledrum appears in a simile for the annoying recurrence of a sound or action: "Like the kettledrum of the *msahharati*," (*mitl tablat il-msahharati*). Representing an old traditional profession, the *msahharati* is the functionary who enlivens the predawn streets during Ramadan to awaken the faithful for their last meal before the daily fast (al-Qasimi, 1960, p. 384).

Finally, many derogatory phrases are connected with dancing and dancers. The expression: *min dun daff biyirqus* ("He would not need a tambourine to dance") is said of an impulsive and easily excitable person. Also popular is the expression that "while rising to dance, the bear killed seven or eight people," to mock a clumsy person, especially on the dance-floor. Connotations of dancing are embodied in such demeaning

229 In other versions, this proverb appears to acquire a different meaning, in one case advocating refraining from asking the singer to sing and the one who prays to pray. The implication is that people do things only at appropriate times and when they feel like doing them.

images as *tihrij* ("clowning") and *tirqis is-sa'dan* ("making the monkey dance"). Related similes include: *mitl in-nawar* ("like the Gypsies"; traditionally, many street dancers and musicians have been Gypsies) and *mitl il-karakuz* ("like a clown"), referring to the character of Karagoz in traditional Ottoman shadow puppetry (*karagoz*), a role akin to the venerable Punch of English tradition (al-Qasimi, 1960, p. 384).

Musicians' Expressions
Musical attitudes may be less explicit in the parlance of the musicians than in the various metaphoric usages of the general public. Nevertheless, musicians' jargon and characteristic verbal behavior provide clues to the performers' self-image and their outlook towards music-making.

Music as Craft
Idioms prevalent among musicians depict music basically as a manual vocation practiced by craftsmen. Musicians usually refer to their musical activity not as *musiqa*, but as *shighl* (*shughl*; "work"), *maslaha* ("livelihood," or "profession"), *fann*, or *san'a* ("vocation" or "industry"). The performers themselves are depicted in similarly down-to-earth terms: *'awwad* ("'ud player"), for instance, or *qanunji* ("*qanun* player"). Poetic or formal labels, such as *'azif 'ud* ("performer on the *'ud*") are less common. Musical instruments may be referred to categorically as *'iddi*, which means "tools" and applies to tools of various professions—plumbing, masonry, carpentry, and the like. In similar vein, during a vocal performance, the subtle heterophonic musical accompaniment is called *tiwriq*, meaning "to cover with a fine coating," as with plaster.

The act of playing an instrument is expressed in pragmatic terms. *Yimsuk eli* means literally "to carry a tool," but this is the expression favored for playing, especially in impromptu circumstances, when the player is an apprentice or when the instrument is other than the performer's usual one. A chorus member may "carry" a *daff* during a performance. Even more common is the word *shughl*—literally "work." *Yishtighil 'ala l-qanun* means to play the *qanun* (or literally, "to perform work on the *qanun*").

These connotative expressions are preferred to popular yet inauspicious designations which refer literally to the process of sound production. By the same token, the direct *mghanni*, or "professional male singer," is avoided in favor of *mutrib*, that conveys the same essential meaning by implying professional skill and specialization. Similarly, the verb *yghanni*, "to sing," is characteristically avoided in favor of *yqul*,

which actually means "to say" but also applies to both singing and play-ing an instrument. Prevalent in Near Eastern societies, this implicit cor-relation between music and speech seems to bring closer the notions of poet and singer and to portray the musician as a type of orator and con-veyor of a revered text.

Musicianship

Expressions that musicians use for describing musicianship are largely craft-oriented. A competent musician may be referred to as *ibn kar* ("son of the profession") or *'atiq bil-maslaha* ("oldtimer in the craft"). Both *ista* and *mu'allim*, each meaning "master craftsman," are honorifics that might be applied to musicians of high standing as they are to members of other traditional professions. In a 1985 Arab-music performance in Los Angeles, an established conservatory-trained violinist from Beirut requested that he be seated in the chair where the first violinist would sit. Although the concept of a "first violin" was obviously Western-derived and largely symbolic, this violinist's justification: *Ana 'atiq bish-shighl*, or "I am an old-timer in the work," was typical of a traditional Arab musician.

Admiration of a musical composition is typically expressed in famil-iar concepts and criteria of craftsmanship. An impressive musical piece may be described as *fiha shughl*, literally, "it has work." This term applies especially to well-wrought complexities in the music. Performing with-out mistakes is referred to as *shughl ndif*, literally, "clean work." Similarly, one Beiruti musician and nay maker used the expression "he cleaned him up," to describe how a well-known violinist and orchestra director had superbly trained the latter's younger brother, who is himself a *nay* player.

Music as Process

In describing ideal circumstances for music-making, musicians have used concepts which relate to the player's mental state. Some of these terms may suggest overtones of mysticism or a Sufi background. *Msaltin* describes a musician who develops a mental-musical state ideal for per-forming, particularly improvising, in a certain *maqam* ("melodic mode"). Such a state is evoked through listening or playing music in that *maqam*, particularly in a receptive ambience in which *sammi'a* ("responsive lis-teners") play an active role. The word *mitjalli* (cognate with *tajalli*, or "revelation") suggests being in a musically profound mood. Similarly employed is *mkayyif*, which connotes joy and intoxication in anticipa-tion of performing or being musically entertained.

Music and Verbal Behavior

Musicians' responses to musical performance tend to be subtle and restrained. Physical gestures and exclamations of approval are typically subdued. On occasion, reactions may be more demonstrative, as in voicing approval to please an amateur or encourage a budding artist. However, generally, musicians refrain from romantic labels like "genius," "beautiful," or "inspired." Indeed, exclamations such as "How lovely!" or "I could listen all night!" characterize the nonperformer or the performing amateur. Thus, jargon appears to identify the professional musicians as a community, and the nature of verbalizing often sets subtle boundaries between two mutually dependent yet distinct groups, musicians and listeners.

Musicians and the Public

Finally, musicians may use words, idiomatic phrases, and proverbs commonly employed among nonmusicians. Some music-related idioms may be applied to everyday circumstances. Commenting on members of the public who become disappointed with incompetent, less professional entertainers, a musician may cite the popular proverb 'Ati khibzak lal-khabbez w-law akal nissuh ("Let the baker bake your bread even if he eats half of it"). In other words, you're better off with the real professional, even if he's crooked.

A musician may also use common music-related expressions when defending himself against popular stereotyping or when attempting to dissociate himself from the more accessible or crowd-pleasing type of musical competitors. When feeling not duly appreciated, a radio musician or a conservatory teacher may remark, "We are no tabbalin and zammarin (tabl and zamr players)" or "Do they [the audience] think that we are mharrjin ("clowns")?" Similarly: "I am not a Gypsy!" (or beggar! or karakoz!). These and other expressions were voiced by some Lebanese musicians in 1975 during the Bicentennial Folk Festival tour in the United States. While in a Midwestern city, the musicians made these remarks upon learning that their local sponsor had (innocently) scheduled them to entertain outdoors during lunch hour in a busy shopping mall.

Conclusion

Music-related expressions used in pre–civil war Beirut, whether by professional musicians or by members of the general public, evoke both traditional and modern images and perceptions. Often reminiscent of pre–World War I professional guilds and earlier contexts of music making, the expressions represent the indigenous secular music as a com-

modity offered by a specialized group of practitioners whose social status is relatively low. The material studied also shows that the emphasis upon musical specialization and group cohesion functions as a two-edged sword. On the one hand, it appears to give musicians a sense of identity, power, and general recognition, but, on the other hand, it can become a context of public ridicule and denigration.

Furthermore, the spoken language implies a hierarchy of sorts. Roughly speaking, the highest prestige accrues to performers of Western art music and the celebrities of Arab music, especially those influenced by the West. Next come the established working musicians; for example, those employed by the government radio station and the local conservatory, together with accomplished amateurs. These are followed by various nightclub and freelance performers. The least prestigious of all are the city's itinerant entertainers, particularly those who play outdoors and use percussion instruments.

Three interacting concepts seem to underlie this hierarchy. One is that musicians tend to become less respected as they become more publicly seen and heard. This brings to mind one possible exception, namely those who attain various degrees of celebrity status through the mass media. Radio and television tend to grant professional musicians economic power, and possibly the type of protection offered earlier by musical guilds and individual patrons. In one sense, media channels make musicians more accessible, but in another, they grant them an auspicious barrier of exclusivity.

The second implied concept is that professionalism in the sense of economic dependence on music is essentially a social liability. The achievement of artistic recognition and economic power usually gives musicians a fair measure of immunity against this liability. Similarly, deemphasizing professionalism and projecting an amateur profile can improve the reputation of a musician especially for the less established.

The third concept is that a musician gains considerable status if his musical specialty falls in the domain of "fine arts" rather than traditional crafts. The importation of Western models and values brings with it a categorical distinction, namely that Western art music is "culture" and "art." As such, it cannot be subjected to the same criteria and stigmas applicable to traditional Arab music. Furthermore, there is evidence that the notion of music as art is already expanding into the indigenous music as well, particularly in urban venues where Westernization holds sway generally or where at least the contexts and mannerisms of performance are comparable to those of Western art music.

Based on the material examined, musical "artistry" is connected with: play, inspiration, and poeticism; focus on the "aesthetic" value of the musical work or product, expression of emotions, transcendence of utility, and thus, loftiness. In contrast, musical craftsmanship is associated with work, a contextually induced mental state, emphasis upon the performance process, enhancement of pleasure, or ecstasy, utility, and therefore, mundaneness. This vision brings to mind the distinctions made by Westerners particularly after the late eighteenth century, and articulated in various ways by philosophers and aestheticians such as R. G. Collingwood, whose ideas have been more recently revised and critiqued (Collingwood, 1958; Fethe, 1977, pp. 129–137; Osborne, 1977, pp. 138–148; Howard, 1982). It also complies in spirit with the opinions of numerous twentieth-century Arab modernists who have expressed categorical aversion to Near Eastern music and argued for the emulation of European musical models (Racy, 1977, p. 44).

In short, the expressions studied portray pre–civil war Beirut as a cosmopolitan and rapidly changing society. In this respect, they constitute an extension of the city's musical culture and overall attitudes toward music and musicians. At the same time, the verbal repertoire, through its highly stylized usages, idiomatic phrases, and proverbial constructs, displays significant features of historical continuity and fixation and thus provides us with a rare glimpse into the city's quaint musical past. As such, it both informs on the community's musical culture and points toward the distinctive nature of speech as a mode of communication.

18 The Sheba River Valley Dam: The Reconstruction of Architecture, History, and Music in a Yemeni Operetta
Philip D. Schuyler[230]

> That which we remember is, more often than not, that which we
> would like to have been; or that which we hope to be. Thus our
> memory and our identity are ever at odds; our history ever a tall
> tale told by inattentive idealists.

–Ralph Ellison (1964), quoted in Kammen, 1991, p. 2

On December 24, 1986, in Sanaa, capital of the Yemen Arab Republic (now the Republic of Yemen), the Yemeni Ministry of Information and Culture presented the premiere performance of an operetta, *Maghnatu Sadd Wadi Saba'* ("Song of the Sheba River Valley Dam"). The operetta depicts 2,500 years of Yemeni history in three acts, lasting one hour and twenty minutes altogether. This work is, so far, unique in Yemeni musical life. This paper offers at least a partial answer to the question: How do we relate music to seemingly unrelated processes, such as the building of water works on a monumental scale?

At the same time, it summarizes much of what is happening in the secular music of Yemen, and, I suspect, in much of the rest of the Arab world as well. Furthermore, the work as a whole raises a number of other social, cultural, political, and economic issues. This paper is meant to offer an initial overview of the operetta and its implications. Since the operetta deals explicitly with history, I shall begin with the historical background to the work. For a good overview of Yemeni history, see Stookey (1978) or Chelhod's compilation (1984–85), especially volume one. For a discussion of the Marib (Sheba Valley) dam and its irrigation system, see Schmidt (1987).

The Kingdom of Saba'—or Sheba, as it is known in the West—flourished as early as the twelfth century BCE. Sheba is, of course, mentioned in the Old Testament, and it may well have been traders from Marib, the capital of Saba', who provided the frankincense and myrrh offered to the

230 Acknowledgments are made to Begona Lola, the Director of the *Revista de Musicologia*, for permission to reprint this material, which originally appeared as "The Sheba River Dam: The Reconstruction of Architecture, History, and Music in a Yemeni Operetta," in *Revista de Musicologia* (Madrid), 16:3 (1993), pp. 1271–1277.

Christ Child by the Three Wise Men. Trade was, in fact, the source of Saba's legendary wealth, but merchants, administrators, and the ruling priestly class also had to eat. To that end, the Sabaeans built a series of dams, so that they could control the floods on the Wadi Dhana, and distribute water more efficiently to the surrounding fields, which were rich but dry. Over a period of 1,000 years, the system grew progressively more sophisticated until, in the sixth century BCE, the Sabaeans completed a great dam, more than 600 meters across, that could irrigate some 10,000 hectares.

According to the archeologist Wendell Phillips, the Marib dam was considered "one of the wonders of the ancient world"; when he visited the site in the early 1950s, Phillips noted that the ruins still presented a spectacle beyond belief (1955, p. 221). He was not exaggerating. The dam was supported by two massive piers, one on each side of the valley. They stood more than twenty meters high and were made of long blocks of basalt, finely hewn and fitted so precisely—with no mortar whatsoever—that they still stand solid after nearly twenty-five centuries. Mortar was used to repair the dam in the early centuries of the Common Era. This, too, remains solid. The center span of the dam, on the other hand, was pounded earth, and in 575 CE, around the time of the birth of the Prophet Muhammad, this section burst. Crops were destroyed, and the fields along with them. An estimated 30,000 inhabitants were dispersed—many of them crossing the desert to the shores of the Arabian Gulf. The greatest epoch of South Arabian civilization had come to an end. Let us jump forward now almost exactly 1,400 years. For much of the intervening period—from the late ninth century CE until 1962—Yemen was ruled by imams of the Zaidi school of Islam. During this period, Marib was a sleepy desert town. The temples and official buildings of the old Sabaean capital served primarily as a source of building material and the ruins of the dam itself as a metaphor for the wrath and the power of God.

In September of 1962, the last Zaidi imam was overthrown by a republican revolution. The new regime, in search of symbols to legitimize itself, eventually turned to the glory that was Saba'. Bilqis, the name of the Biblical Queen of Sheba, became a popular name for girls (and for businesses), while Himyar, the name of a successor state to Saba', was a somewhat less common choice for boys. The ashlar columns of a temple to the Sabaean moon god, Ilmuqah, appeared on Yemeni stamps, and a stylized version of the same columns stands opposite the reviewing stand where Republican troops parade on national holidays. On the fifth anniversary of his election to the presidency of the republic, Lt. Col. 'Ali 'Abdullah Salih chose to celebrate the occasion with a

ceremonial appearance, filmed for television, at the site of the old dam. In short, the Marib dam had become, in the words of the revolutionary poet Mutahhar al-Iriyani, "the symbol of civilization and immortality."

The dam was, indeed, dear to the heart of 'Ali 'Abdullah Salih. When he ascended to the helm of the revolution in 1978, he wanted it to be more than a symbol, and he was determined to rebuild the water works. But times had changed. Although Yemen had remained a nation of builders, it no longer had the wealth or the technical expertise to carry out a work of such magnitude. Happily, however, the President of the United Arab Emirates, Shaykh Zaid bin Sultan, was a descendant of the original Marib refugees, and he thought it an honor, as well as a good investment, to provide financial support for the new project. A French team was brought in to design and coordinate the project, and a Turkish construction company was contracted to do the work. Yemenis drove the trucks that delivered the building materials.

As construction of the dam neared completion in 1986, the President requested that the Ministry of Information and Culture produce an operetta to be performed at the time of the dedication. The performance was attended by Shaykh Zaid and his entourage, President Salih, his vice president and ministers, and various ambassadors and other dignitaries. The premiere was, in effect, a command performance for the Republican court, although it later also became a staple on national television.

The Libretto

The text, by Mutahhar al-Iriyani, is pure poetry. Iriyani is known for choosing vocabulary accessible to peasants and common people, but there is little in this libretto, aside from a variety of geographical and tribal names, that would not be understandable to any speaker of standard Arabic. Many of the poems are in *qasida* (classical ode) form. Other poems are in freer form with dialectical grammar and vocabulary. Some of these texts are declamatory, some narrative, but none of them is particularly dramatic. There is no dialogue as such.

The first act tells the story of the rise and prosperity of Saba', with happy workers cutting stones, building the dam, tilling the land, and harvesting crops. The emphasis is on the joy of collective labor. There is no suggestion that such an enormous and elaborate project would need firm guidance from above.

The second act presents a series of disasters. First, the country becomes a battleground for foreign invaders (Jews and Ethiopian Christians), who divide the people against each other. This division among the people foreshadows the cleavage of the dam. Soon, the

Persians annex the country, and then the dam breaks. The dawn of Islam is a brief, bright spot before the country again sinks back into darkness for 1,000 years under the rule of the evil imams. Relief comes only at the end of the second act, when the Republican flag is unfurled and we hear the voice of Radio Sana'a proclaim the Revolution of September 26, 1962.

The third act celebrates the revolution and the Republican victory in the subsequent civil war before finally bringing us to the present with the rebuilding of the Marib dam. The heroes wear the uniform of the Yemeni armed forces. The French engineers and the Turkish construction workers are not represented. This is, in short, history as the current government would like to see it.

The Score

A constant problem in musical theater is how to find performers who can act, sing, and dance. Versatile performers like Maria Callas and Fred Astaire are rare indeed, and even they were not equally talented in all domains. The Yemeni Ministry of Information and Culture solved this problem by keeping these elements strictly separate. Although the credits list five actors, there is only one real speaking role, al-Shaykh al-Jalil, (the "Grand Old Man"), who serves as the voice of history. Since he has no one to talk to, he mainly declaims. Action is represented by dancers, who mime various activities, from building to hoeing, to dueling, shooting, and dying, but who never speak a word. Singing is done by employees of the music division, who wear different costumes (contemporary) and who stand back from the action. Music is performed by musicians, who are invisible under the stage. In all, the production neatly reflects the bureaucratic divisions of the ministry itself.

Opera is by definition a collaborative art, but *The Sheba River Valley Dam* carries the principle to unusual lengths. The Ministry originally invited ten musicians to submit compositions for use in the operetta. In the end, the works of four were chosen: Ahmad Sunaidar (a popular singer of traditional music), Muhammad Qasim al-Akhfash, 'Ali al-Asadi (Director General of the Arts at the Ministry), and 'Abd al-Basit al-Harithi (leader of the national orchestra). Instrumental introductions and interludes were provided by Jabr 'Ali Ahmad, who also orchestrated the entire work.

Ahmad's work is not without interest. In some cases, for example, a *qasida* text (which is a unitary form) will be in part recited and in part sung, and the sung parts may include solo, choral, and call-and-response sections, each set to different melodies, and interspersed with instrumental interludes. There is also at least one instance of a protoleitmotiv. When the dam bursts and the dead are being carried away, an instru-

mental melody is introduced. Later, when the imam and his followers arrive to oppress the people, the same melody is repeated. This theme is in *maqam* Saba, a melodic type recognizably foreign to Yemen, but with definite associations of sadness.

The style of these examples would sound very familiar to listeners who know Egyptian or Lebanese music from the middle part of this century. Indeed, in both form and content, the music of the operetta seems to have little in common with the Yemeni tradition. The orchestra is composed of violins, cellos, basses, *'uds*, accordion, *qanun*, *nai*, bongos, and a trap drum set. Neither the individual instruments nor the size or configuration of the group is representative of Yemeni musical history. Such instruments as the old-style lute (*qanbus* or *turbi*), the lyre (*sim-simiya*), or local drums like the *tasa* or *marfa'* are completely absent. Other indigenous instruments, like the *mizmar* and the *qasba*, are represented on stage, but they are "played" only in mime by the dancers; they are not heard.

Any departure from old-style Yemeni music was strictly intentional. The 11/8 metric cycle known as *das'a*, said to be the most characteristic Yemeni meter, is not used specifically because of its associations with elite music from the time of the imams. The choice of melodic modes, meters, and orchestration used here is meant to point to the future, not the past. More than one writer pointed to similarities between the operetta and the dam itself. The original dam was the greatest accomplishment of the Sabaean civilization. The new dam is the greatest accomplishment of the revolution. The operetta is the greatest accomplishment of Yemeni musical modernism. Furthermore, the operetta, like the dam itself, is supposed to help Yemenis achieve economic and cultural independence. By providing local sources for programming, such works would free Yemeni television from the expense and the cultural invasion of foreign programming.

In that regard, it is curious that the operetta, again like the dam, benefitted greatly from foreign advisers. Jabr 'Ali Ahmad, the chief composer, is of course a Yemeni, but he was trained in Damascus and Cairo. 'Ali Salih al-Amri, the choreographer, studied dance in the former Soviet Union, and he was helped in this production by Hamza al-Azerbaijani, a former dancer in a Soviet folk troupe and an adviser to the Yemeni Ministry of Information and Culture. Emil Girgis, an Egyptian long in residence in Yemen, directed the work and did the set design.

I would like to conclude with three final ironies. First, within months after the completion of the new dam, the first drops of oil were pumped from fields less than forty kilometers from Marib. Thus, the

new irrigation system, like the old, will help support a society based on nonagricultural wealth.

Second, the new dam was supposed to represent a new national unity and, in fact, within four years, North Yemen and South Yemen ended decades of feuding and border wars and became one country, under the guidance of 'Ali 'Abdullah Salih.

Finally, as water pours into the land around Marib, fields that had been untouched for fourteen centuries are being ploughed and hoed. As the crops grow, the agricultural work is burying many of the archeological traces of ancient Sabaean civilization. The Sheba River Valley operetta may have a similar effect. That is, this work, and others like it, may help eradicate traces of older styles of Yemeni music, and yet Yemeni tradition, like the basic structures of the dam, will no doubt endure.

19 Middle East Peace Through Music: A Diwan in Weimar
Selim Sednaoui
Translated from the French by Sherifa Zuhur*

The little town of Weimar, with 63,000 residents in the former East Germany, greatly surpasses its geographic dimensions through its cultural effervescence. In this town none other than Goethe and Schiller lived and worked, as well as Johann Sebastian Bach, Franz Liszt, Richard Strauss, and the painter Lucas Cranach to cite only the best-known names. The artistic movement known as the Bauhaus, which revolutionized architecture and the applied arts of the twentieth century was likewise founded in Weimar. In 1999, on the occasion of the 250th anniversary of Goethe's birth, the town of Weimar was elected the "European cultural capital" by the European ministers of culture and it was entrusted with the mission to promote cultural understanding between Europe and the rest of the world.

Weimar, then, was the ideal spot for the musical workshop entitled "The Oriental/Occidental Diwan," as suggested by a late work of Goethe inspired by the Persian poet Hafız. *Diwan* is an Arabic word that means "poetic retreat" or a collection of poetry. Goethe was extremely interested at the end of his life in Arab and Islamic civilization and had encouraged Westerners to discover other cultures for themselves.

The idea of an experimental workshop was born from a discussion between Daniel Barenboim, celebrated Israeli pianist and conductor, and Edward Said, professor of comparative literature at Columbia University in New York, an eminent defender of the Palestinian cause in the United States, but also a distinguished musician (see **figure 28**). His views on the Arab-Israeli conflict have profoundly influenced Barenboim, who has openly declared his support for a Palestinian state. Through his musical career, Barenboim has made numerous additional gestures toward the Palestinians, for example, giving a concert in Ramallah in January of 1999, and, on another occasion, inviting the president of Bir Zeit University to a recital he gave in Jerusalem.

From that particular perspective, the Weimar workshop, held from August 1 though August 17, 1999, attempted to bring together young Arabs and Israelis with the aim of working with great masters and

* Adapted by Selim Sednaoui from an article that originally appeared in *Al-Ahram Hebdo*, in French, and translated here with permission.

forming a mixed cham-
ber ensemble and a
symphony orchestra.
This group would give
two public performances
at the end of the work-
shop. In addition to
Barenboim, who would
play the piano and
direct the orchestra,
there would be the
great American cellist

Figure 28.
The author
Selim Sed-
naoui (cen-
ter) with
Edward
Said (left)
and Daniel
Barenboim
in Weimar
in 1999.

of Chinese descent, Yo-Yo Ma, who is considered one of the greatest per-
formers of his generation. In addition to the instruction provided by these
master performers, the workshop permitted young musicians to establish
personal contacts with their colleagues from other Middle Eastern coun-
tries. I attended the 1999 Weimar workshop and had helped set up the
selection/audition process for the Egyptian participants.

Reversing Priorities
It must not be thought that Barenboim held any illusions concerning the
results of these encounters. In the first place, from a purely musical per-
spective, he said in the opening speech to the participants,

> It is terribly difficult to form an orchestra with a homogenous
> sound in just two weeks, with the different elements originating
> from all these different countries.

From the other side, he added,

> I know full well that music cannot resolve political conflicts. But up
> until now, our governments are constantly making the conditions
> for cultural exchange dependent on political relations. What if we
> ourselves try to reverse the priorities? Perhaps we could establish
> cultural relations like these, and we'd learn more or less how to
> become acquainted and establish channels of communication.

Not all of the participants necessarily agreed with this point of view.
Concerning the discussions that were led in the evening after the musi-
cal activities with Said and Barenboim, certain Arab musicians criticized
the political orientation of the workshop and indicated that they pre-

ferred to focus solely on the musical endeavor (see **figure 29**). On the other side, an Israeli cellist, who holds the rank of lieutenant in his army, said that he felt too much pressure to form a special friendship with Arabs, and he also preferred to concentrate on the music. To this Barenboim retorted, "If you don't feel comfortable, you aren't obliged to stay," pointing to the door. Suffice it to say that the young man did not budge and a week later he was playing ping-pong with a Palestinian and flirting with two pretty young Syrian violinists.

Figure 29. The focus is on the music. Young Arab and Israeli musicians perform in rehearsal under the baton of Daniel Barenboim.

Other Israelis made equally surprising statements, for instance: "This is the first time in my life that I've seen real live Lebanese and Syrians. To us they had only been these characters who threw bombs at us. We've discovered that they are normal people, just like ourselves. We were simply unaware, for instance that there was a conservatory in Damascus," and so on.

After discussions around the nature of identity, Lebanese violinist, Claude Chalhoub, who plays Arabic as well as Western classical music beautifully, complained, "You sound too Jewish," to an Israeli colleague who was trying to play *taqasim* (an improvisation) in an Arabic style. Well, does one have to be Arab to play Arabic music proficiently? Is it only African-Americans who can play jazz? Or white people who can play Mozart? Does one conserve the entirety of one's identity when opening it up to one of another culture? These are passionately interesting questions, and quite timely in light of the musical forms known as "fusion" and "world music."

In any case, Yo-Yo Ma is living proof that a non-European can excel in classical music. Moreover, he is appreciative of other musical traditions.

It was quite something to see him, with his modest air of a novice, listening to Chalhoub playing Arabic music, and then Chalhoub initiating Yo-Yo Ma into its secrets, the *maqamat*, and the quarter tones (see **figure 30**).

The selection of the participants in the Weimar workshop was made on the following basis: the conservatories of each specified country chose their most talented musical delegates and sent Barenboim audio or video recordings of the artists. Out of the 150 recordings sent, approximately seventy were considered to be at an appropriate technical and musical level. Given that the workshop was to be capped with a public symphony performance, certain instrumental positions were to be supplemented with Germans recruited locally. As soon as they arrived in Weimar, the workshop participants auditioned for an expert performer of their own instrument, for example, a cellist from the Chicago Symphony or a viola player of the Berlin Philharmonic. The best instrumentalists were assigned to the forward seats of the orchestral instrumental sections The concertmaster's seat was to be filled by a Lebanese alternating with an Israeli, the first cellist was an Egyptian, and so on. The expert performers selecting the musician participants who had expected a superior technical level on the part of the Israelis were impressed by the excellent quality of most of the Arab musicians.

A Palestinian Prodigy

Each instrumental section rehearsed separately. Once they were sufficiently prepared, the orchestra reunited to run through the planned program: the Overture to the *Marriage of Figaro* and the Concerto for Two Pianos by Mozart, Schumann's Concerto for Cello, and Beethoven's Seventh Symphony. One simply had to admire Barenboim's great ear, memory, and musicality, as he conducted impeccably without a score, tirelessly repeating the most minute details of these works until perfection was attained. He regaled us as well with impromptu recitals in the evenings, both solo and with Yo-Yo Ma.

Figure 30. Lebanese violinist Claude Chalhoub explains Arabic music to cellist Yo-Yo Ma (left).

The final public concert was a triumph, each piece received a standing ovation. This was also an occasion for the

Weimar audience to discover a young Palestinian pianist, named Karim Said (ten years old), who played Bach and Debussy with an astonishing maturity.

In addition to the official workshop, some privileged participants were also invited to attend two Wagner operas, "Tristan and Isolde" and "Der Meistersinger" at Bayreuth (that composer's favored city) conducted by Barenboim. (Tickets for the opera at Bayreuth are extremely expensive and reservations must sometimes be made five years in advance.)

A trip to the Buchenwald concentration camp was organized, some kilometers outside of Weimar. The young people had an opportunity to assess the two extraordinarily disparate sides to German history that coexisted in the same region: cultural refinement of the highest degree and barbarian treatment of the Jews and other minorities. Note in passing the bravery of the Germans, who seek not to obliterate one of the blackest pages of their history, but rather, on the contrary, to preserve this vivid reminder as a lesson for future generations.

It was naturally with much regret that everyone departed from the workshop. "It was a beautiful dream," commented a young Israeli as the moment came to leave. There was some talk of rescheduling the experience in the future, perhaps in Andalusia (southern Spain) where Muslims, Christians, and Jews once cohabited harmoniously. Since then, the second workshop was set for July of 2000, once again in Weimar, to nourish the interaction of young musicians and the seasoned masters.

Color Plates

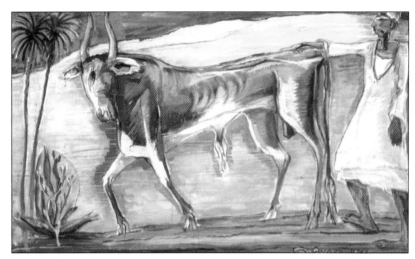

Plate 1. "In the Field," by Ragheb Ayyad, a pioneer in modern Egyptian art.

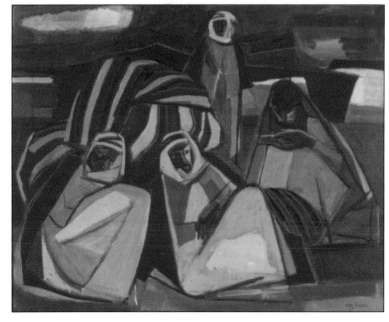

Plate 2. Iraq's Faik Hassan, "The Tent."

Plate 3. Syria's Elias Zayat, "Mahoula, Mazar."

Plate 4. Calligraphy has become a popular art form in Sudan, as shown in this work, "Letters from the Quran," by Ibrahim Awam.

Plate 5. Characteristic use of Sudanese scenery and characters is seen in this painting, "The Mourning Women," by Bastawi Baghdadi.

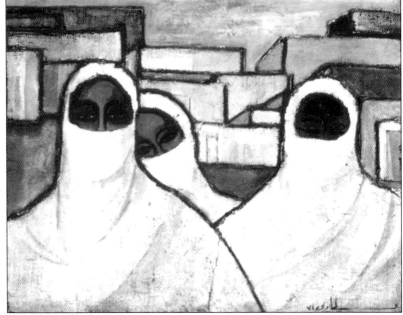

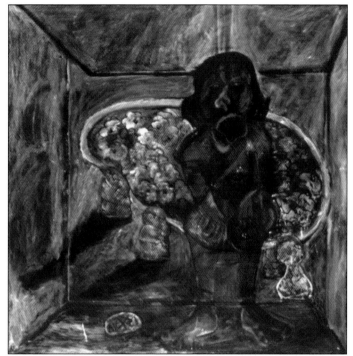

Plate 6. The distinctive Sudanese flavor is likewise seen in this painting that probes "Loneliness" by artist Kamala Ibrahim.

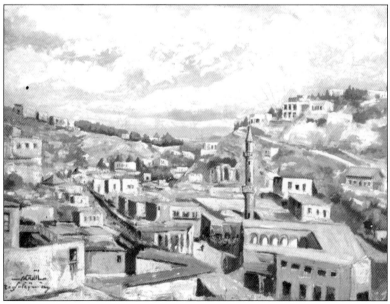

Plate 7. Turkish emigré Ziauddin Suleiman familiarized the Jordanian public with easel painting in the late 1930s. Seen here is his "City of Amman in 1932."

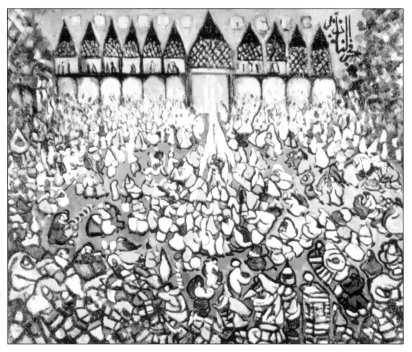

Plate 8. Fahrelnissa Zeid of Jordan, "The Bath," oil on canvas, 1950.

Plate 9. "A Child of Palestine," by Fateh Moudarres, of Syria.

Plate 10. Themes of the struggle for homeland often recur in works by Palestinian artists, wherever they live. This painting, dated 1994, by Palestinian artist Isma`il Shammout, is titled "Setting Pigeons."

Plate 11. Iraqi Rahen Dabdoub, "A Woman's Thoughts," oil on wood, 1975.

Plate 12. Kuwaiti artist Khazal Awad Qaffas's 1982 painting "Kuwaiti Sailor" is typical of contemporary Gulf works that depict scenes of everyday life.

Plate 13. Female Egypt in 'Abd al-Hadi al-Jazzar's surreal painting "Al Missakh" (1982).

Plate 14. Egypt as a woman, as portrayed in a newspaper insert prior to the 1999 elections.

Plate 15. "Women in Procession," by Huda Lutfi. Acrylic, handprinting, calligraphy on paper, six panels (38 cm X 18 cm each).

Plate 16. "The Search," by Huda Lutfi. Acrylic, wax oil, engraving, calligraphy. Detail of seven panels (28 cm X 25 cm each).

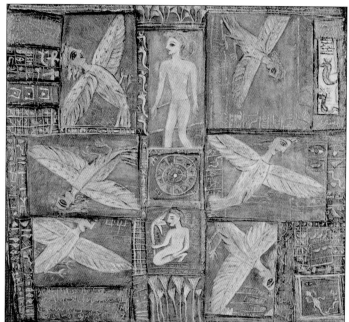

Plate 17. The Lotus and the Bird," by Huda Lutfi. Acrylic, oiled wax, engraving; text: Arabic and hieroglyphics (38 cm X 40 cm).

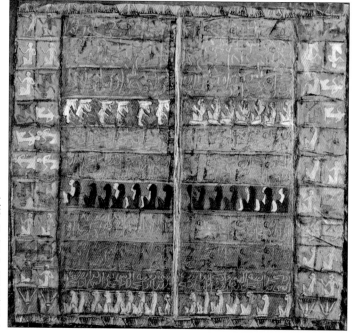

Plate 18. "The Magic of Prayer," by Huda Lutfi. Acrylic, oil wax, hand-painting, engraved calligraphy, on paper (37 cm X 35 cm).

Visual Images

20 Modern Painting in the Mashriq
Wijdan Ali

Introduction
Easel painting is a fairly recent phenomenon in Arab-Islamic art. As the aesthetic and creative fiber of traditional Islamic culture weakened in the nineteenth century, Arab culture yielded increasingly to Western art forms and styles that had already pervaded the Arab world due to the West's political, economic, scientific, and military superiority. Above all, increased means of communications between Europe and the Arab countries exposed the Arab world to the West at an ever-growing rate. This simultaneous weakness and exposure led to the expansion of Western art and culture in the Middle East. During the second half of the nineteenth century, Arabs in general were influenced by the newly-imported, progressive ideas coming from Europe. Western concepts, born with the French Revolution and brought into Egypt by Napoleon's expedition, coupled with the literary, philosophical, and artistic movements that had started in Europe in the nineteenth and early twentieth centuries, had the effect of liberating Arab artists, among other intellectuals, from Ottoman traditions that had constrained them. They offered a means by which people could attain their national aspirations based on the doctrines of liberty and equality.

Early Easel Painting in Lebanon and Egypt
The first Arab countries in the Middle East to adopt Western art were Lebanon and Egypt. In 1613, Amir Fakhr al-Din II, a local aristocrat who ruled the whole of Ottoman Lebanon, visited the Medici court in Florence and was impressed by its art and architecture. On his return, he built himself a Renaissance-style palace in Beirut, aided by the Italian architects and artisans he had brought back with him from Italy. Although there is no record of Italian paintings and murals in his palace, through Fakhr-al-Din, European architectural traditions in the form of foliate balconies and ornate arcades were introduced into Lebanon (Carswell, 1989). He also opened his country to the mainstream of Western civilization by ruling according to contemporary Western methods and launched an open-door policy toward Europe. This was followed by the introduction of Western-style painting. Amir Fakhr al-Din's rule

marked the beginning of a new epoch, particularly along the Lebanese coast. Thereafter, the early currents of Westernization permeated Lebanon at the hands of European missionaries who opened convents and missionary schools in the mountains and introduced the printing-press. The earliest allusion to painting in the Lebanese mountain region dates back to 1587, although the earliest Lebanese painters, whose works are known, date from the first half of the nineteenth century. They include Moussa Dib (Musa Dib; d. 1826), and his nephew and pupil Kenaan Dib (Kan'an Dib; d. 1873) who was influenced mostly by the Italian artist, Constantin Giusti, who came to Beirut with the Jesuits in 1831 and stayed on, and Youssef Estephan (Yusuf Istifan; fl. 1800). Apart from scant information, little is known about these Lebanese artists living in the early nineteenth century (Lahoud, 1974, p. 114).

The missionaries in Lebanon established the basis for a cultural, social, and political life centered on Christianity, which led to an intellectual and artistic awakening. Through the church, the Gothic style became popular in eighteenth-century Lebanon and eventually gave birth to a local Gothic school in religious painting. Works of art in this style filled the halls and corridors of numerous churches and convents in mountain towns and villages. It is obvious that the earliest Lebanese painters were Christian artists, whose aesthetic environment was limited to church circles where the depiction of religious themes and portraits of the clergy constituted their main repertoire.

The invasion by Napoleon's armies in 1798 abruptly subjected Egypt to European control making it the first Arab country to formally embrace Western art on a large scale in the nineteenth century. When Muhammad 'Ali became Egypt's effective ruler in 1805, after breaking away from Ottoman authority, he introduced European aesthetics to the urban Egyptian intellectual milieu. He displayed interest in the arts as well as sciences and military skills, and sent several study missions to Europe, which concentrated on learning the arts of engraving, painting, and sculpture, among other subjects. These individuals taught at technical craft schools once they returned. Meanwhile, the palaces and public parks built during Muhammad 'Ali's reign were designed and decorated by foreign architects and artists who filled them with statues and paintings (Iskander, Mallakh, and Sarouni, 1991, p. 11). In this manner, baroque[231] and rococo[232] styles entered nineteenth century Egypt. By the

231 Baroque is a European style in art and architecture that originated in Rome about 1600 and lasted to the early eighteenth century. It is associated with the Roman Catholic Church and is characterized by overt rhetorical and dynamic movement.

232 Rococo is a highly decorative style in art and architecture that emerged in France

mid-nineteenth century, Western Orientalism[233] had reached its peak in Europe. A number of foreign artists, among whom were David Roberts and Eugène Fromentin, visited the country and recorded its historical sites, native customs, and landscapes in a highly exaggerated and romanticized artistic fashion. Others, such as Jean-Léon Gérôme, settled in Cairo for months, sometimes years, and were the ones who introduced easel painting into Egypt (Julian, 1977, pp. 113–145). Muhammad 'Ali's successors continued his policy of modernizing Egypt according to Western norms. Khedive Isma'il (1863–79) used the opening of the Suez Canal in 1869 to further accelerate exposure to Western culture. He wanted to present his country as part of the "civilized" Europe, rather than "backward" Africa. Eventually, Western artistic influences came to pervade Egyptian upper-class society, without, however, touching on the aesthetic sensibilities of the masses.

Up to the beginning of the twentieth century, only European artists were commissioned by the rulers, princes, and elite as a manifestation of their urge to emulate the West. They decorated their palaces with paintings and architectural ornamentation and imported craftsmen from Greece, Armenia, and France to train local decorators in *trompe l'oeil*.[234] The Islamic tradition in Egyptian art thus gave way to the latest European styles, leading to Egypt's first exhibition held by the Orientalist resident painters, in 1891 at the Opera House under the khedive's patronage (Iskander, Mallakh, and Sharouni, 1991, pp. 11–12).

By the end of the nineteenth century, Lebanese culture underwent a major transition. Beirut was already an established bridge between East and West. It witnessed the birth of the theater, a public library, commercial printing, and local newspapers, including an art journal. Furthermore, the establishment of universities by American and French missionaries introduced more Western influences to the city's cultural and artistic life. The early pioneers of Lebanese modern art entered the scene during the second half of the nineteenth century. Most of them went to European cities like Brussels, Rome, London, and Paris to formally train at art schools and to gain first-hand knowledge of classical and contemporary Western trends by visiting museums and the studios of individual artists. In the 1870s

about 1700 and spread throughout Europe in the eighteenth century. It is characterized by lightness, grace, playfulness, and intimacy and was both a development of and a reaction against the heavier Baroque style.

233 Orientalism as a movement in art and literature began in the nineteenth century as a reaction to the drabness of the industrial revolution in Europe. Artists and writers turned to the Arab and Islamic East to depict what they believed to be its romantic mood, mystery, and passion, in a highly exaggerated, realistic style; they dubbed their style *Orientalism*.

234 *Trompe l'oeil* is a style of painting that deceives the spectator into thinking that the objects in it are real and not merely represented.

the first generation of Lebanese artists graduated from Paris and Rome. An example of this generation is Daoud Corm (Dawud Qurm) (1852–1930). Born in the mountains of Lebanon, in 1870 he went to Rome and joined the Institute of Fine Arts and studied the works of Renaissance artists whose styles he absorbed in his own paintings. Corm gained official recognition when he was commissioned to paint the portrait of Pope Pius IX, and later became one of the official painters attached to the court of the Belgian King Leopold II. On his return to Lebanon, he trained a number of promising young artists, including Habib Srour (Habib Surur; 1860–1938), and Khalil Saleeby (Khalil Salibi; 1870–1928) (Carswell, 1989, p. 101). Both painters continued their art studies in Europe and were among the pioneers of Lebanese modern art. Corm, who was known as a religious painter, freed Lebanese art of its previous narrow, anomalous tradition of a local neo-Gothic style, and led it to the wide horizon of Europe's great classical masters, making a significant step in the history of modern art in Lebanon. Besides Lebanon, Corm left a treasure of religious paintings in churches in Syria, Egypt, and Palestine (Lahoud, 1974, pp. 1–2).

In Beirut, a group of Lebanese youth who had studied in Turkey eventually created the Lebanese Marine School of painting which was distinguished by its scenes of the Lebanese coast with its beautiful setting, clear sky, ships, and historical events. Unfortunately, most works by Lebanese artists of the second half of the nineteenth century have been lost. Those left indicate that these early painters were lacking in originality.

Meanwhile, in other Arab countries such as Iraq and Syria, painting remained confined to Ottoman traditions. As subjects of the Ottoman Empire, a number of Lebanese, Iraqi, and Syrian youth went to Istanbul in the second half of the nineteenth century to continue their studies in Ottoman academies. Those who joined the military and naval schools adhered to contemporary trends prevalent among Turkish soldier-painters which in turn influenced painting in their countries. The topographical and formal artistic training of the soldier-painters, which was important for illustrating landscapes, buildings, roads, bridges, etc., in order to clarify or to report military actions, maintained an interest in nature, emphasized the outdoors, and assigned importance to perspective.

Egypt and Western Art Forms

In 1908, Prince Yusuf Kamal, a member of the Egyptian royal family and an enthusiastic patron of the arts, opened the School of Fine Arts in Cairo and employed foreign artists as teachers, thus creating the first institution in the Arab world to teach Western art. Its first students comprised

the nucleus of the pioneer generation of modern Egyptian artists. They included Mahmoud Mukhtar (1891–1934), Ragheb Ayad (Raghib 'Ayyad; 1892–1982), Ahmad Sabri (1889–1955), Youssef Kamel (Yusuf Kamil; 1891–1971), and Habib Gorgi (Habib Jurji; 1892–1965) (see color plate 1). Other pioneers were Muhammad Nagy (Muhammad Naji; 1888–1956), Mahmoud Said (Mahmud Sa'id; 1897–1964) and Hussein Bikar (Husain Bikar; b. 1913). This group of pioneering Egyptians, who were later known as the First Generation (Karnouk, 1988, pp. 4–5), established the basic concepts of their country's modern art movement, paving the way for a national Egyptian school of art. Both Mahmoud Mukhtar and Mahmoud Said succeeded in creating distinctive styles in sculpture and painting by drawing on their ancient traditions and linking them to Western art styles. Yet for most early modern artists, local subject matter was their sole expression of artistic identity, while in style they followed well-known European schools, of which the most common was impressionism.[235] Other contemporary artists followed in their footsteps.

The first student to be sent abroad was the sculptor Mahmoud Mukhtar in 1911 whose scholarship to the École des Beaux Arts in Paris was privately funded by Prince Yusuf Kamal (Karnouk, 1988, pp. 11–12). Since 1917, the Egyptian government has been regularly sending artists to train at Western academies. On their return, the graduates are absorbed as teachers into Egypt's various art colleges and institutes. Unlike other Arab countries, Egypt produced a number of early women artists who started painting even before the School of Fine Arts was established; foremost among them were the sculptor Princess Samiha Hussein (Samiha Husain), the daughter of Sultan Hussein Kamil (Husain Kamil; 1914–17)[236] and the women's rights activist Huda Sha'rawi (Iskander, Mallakh, and Sharouni, 1991, p. 29). The Higher Institute of Fine Arts for Female Teachers opened in 1939, under the directorship of the painter Zainab 'Abduh (b. 1906), and was the first art academy for girls in the region (Hussein, in Ali [ed.], 1989, pp. 34–35). Egypt has since bred a number of prominent women artists, including Marghuerite Nakhla (Margherite Nakhla; 1908–77), whose early expressionistic works betray influences of ancient Coptic art, and Tahiya Halim (Tahiyya Halim; b. 1920), whose stylized figures recall ancient Egyptian wall-paintings. Since the 1950s a new generation of Egyptian women artists

235 Impressionism is an art style originating in the 1860s in France and is regarded as the most momentous development in nineteenth century. Its practitioners attempt primarily to achieve a high degree of naturalism through the exact analysis of tone and color, and through the meticulous depiction of light on the surface of objects.
236 Sultan Hussein Kamil came to the throne of Egypt (1914–17) following Khedive Abbbas Hilmi, and before King Ahmad Fu'ad.

dominated the modern art scene. They include Nazli Madkour (b. 1949), Gazbia Sirri (b. 1925), Inji Iflatoun (see figure 31), I'tidal Hassan, Minhatallah Hilmi, and Rabab Nimr. Each one of them developed her work in an individual manner that left its imprint on the development of modern Egyptian art.

Since the 1920s, the state in Egypt has played a vital role in the development of the country's modern art movement. In 1925, the Ministry of Education began collecting works by local and foreign artists, including paintings by Manet, Monet, and Rodin. A legislative bill recommended special attention for the visual arts and, in 1927, Parliament passed a law to approve the founding of the Museum of Modern Art,

Figure 31. "Farmers' Roofs," by Inji Efflatoun, representative of a new generation of women artists in Egypt.

which opened in 1931 (Iskander, Mallakh, and Sharouni, 1991, pp. 167–173). The museum opened with a collection of Egyptian as well as Italian, Dutch, French, and English Impressionist and post-Impressionists. Meanwhile the Egyptian Parliament passed laws at that time to guarantee artists their freedom of expression and confer on the arts official protection.

Art societies also played a crucial role in the advancement of Egyptian modern art in its early decades. Egypt's first art association was the Society of Fine Arts, founded in 1918 and whose membership included native pioneers and a few resident foreign artists. In 1919, the society held the first successful exhibition, which showed works by native and foreign artists. One year later, its second and last exhibition took place, with five Egyptian women artists participating among its 55 exhibiting members (Iskander, Mallakh, and Sharouni, 1991, p. 108).

In the 1930s, several artistic groups were founded and later dissolved for lack of funds as Egyptian artists went through an unsettling period between 1935 and 1945. They were caught in the events of World War II and an internal political breakdown at home. The new avant garde groups rejected the current classical methods of teaching, labeling them as bar-

ren and academic (Iskander, Mallakh, and Sharouni, 1991, pp. 101). One such group was Art for Freedom, led by George Hunein (George Hunain). It was founded as a reaction to Fascist attitudes towards Western artists and the Nazi closure of Germany's Bauhaus School, thus making a statement for the freedom of artistic expression (Iskander, Mallakh, and Sharouni, 1991, pp. 120–124; Hussein, 1989, p. 34). Through the group's exhibitions, which lasted from 1939 until 1945, new artistic trends such as surrealism,[237] cubism,[238] and abstraction[239] were introduced into Egypt for the first time. Although the exhibitions provoked public derision, they enabled members to express their individuality through these unconventional artistic trends. The group dispersed by 1947 (Iskander, Mallakh, and Sharouni, 1991, pp. 120–124; Hussein, 1989, p. 34).

The Group of Contemporary Art, founded in 1944, by Hussein Youssef Amin (Husayn Yusuf Amin; b. 1906), constitutes one of the major early attempts to ground Egyptian art in its own culture. The members embarked on a search for Egyptian traditions and applied folk symbols mixed with popular philosophy in order to rid Egypt's art of romantic and unrealistic traces left by the earlier Western Orientalist painters. It continued as a rejectionist movement until the 1952 military revolution (Hussein, 1989, p. 37).

Twentieth Century Painting in Lebanon
With the end of World War I in 1918, Ottoman rule over the Arab world ended. In 1919, the French mandate was established over Lebanon and Syria, while Iraq, Jordan, and Palestine came under British mandate and Egypt became a British protectorate. In the 1920s and 1930s a most important generation of Lebanese artists appeared. Its leaders were Moustapha Farroukh (Mustafa Farrukh; 1901–1957), César Gemayel (Qaisar Jumayil; 1898–1958), Omar Onsi ('Umar Unsi; 1901–1969), Saliba Douaihy (Saliba Duwaihi; b.1915), and Rachid Wehbi (Rashid Wahbah; b.1917). They established the base for a modern art movement in Lebanon, and their impact continues to the present day. The work of these five pioneers manifested a spirit of freedom and originality, both in style and mode of expression, which had never materialized in the

237 Surrealism is an art style originated in France in the 1920s that consciously illustrates fantastic, imagined bizarre landscapes, and dream worlds in which natural laws are distorted.
238 Cubism is an art style developed in France by Picasso and Braque ca. 1907. It superimposes several simultaneous views of the same object by rejecting the principles of perspective.
239 Abstract art is a style that began around 1910. It either reduces natural appearances to radically simplified forms or constructs art objects from nonrepresentational forms. It is entirely independent of the natural world.

works of the previous generations. From the very outset, their founda-
tions were laid by their teachers Corm, Srour, and Saleeby, who helped
them ground their artistic roots within the intimate atmosphere of their
own national culture. Eventually, they all went to Rome and/or Paris. On
their return to Lebanon, they interpreted Lebanon's natural beauty from
every angle and, through their art, led the revival of national pride in
their own culture. A fortune of well-recorded authentication appeared in
their detailed depictions of the Lebanese coastline and mountain land-
scapes that included architecture, nature, and people in their national
costumes. The only one of the five artists to later develop his work into
abstraction was Douaihy.

This group of artists moved Lebanese modern art from church and
palace circles, enjoyed only by the clergy and the aristocracy, into the
contemporary mainstream. They made art training accessible to whoev-
er sought it. Through teaching in their studios and at secondary schools,
they were able to transmit to their students both the training they had
received at the hands of their predecessors, as well as new Western tech-
niques and skills they had learned at European academies.

In the 1930s, Beirut was fast becoming a cultural and artistic center
where artists from Lebanon, France, and other countries came to live and
work. Encouraged by the Mandate authorities, a number of exhibitions
were held to emphasize the cultural side of French policy (Carswell,
1989, p. 105). Regardless of the concealed motives, these exhibitions
enlivened artistic activities. Thus, Beirut's reputation as an Arab,
Francophile art center was confirmed. In 1937, Alexis Boutros founded
the Académie Libanaise des Beaux Arts in Beirut. He engaged French and
Italian as well as Lebanese teachers, one of whom was César Gemayel.
Through the Académie, the teaching of fine arts became accessible to
those who wanted to pursue it within Lebanon, although many still
chose to go to Europe for their training (Lahoud, 1974).

Painting in Iraq

In Iraq, soldier-painters trained in Istanbul were the first to introduce
Western easel painting to the country through their own works, private
lessons, and teaching at secondary schools. However, they lived in a
society where only a few members of the educated upper class favored
the visual arts. In the 1920s and early 1930s, a small group of painters
emerged who considered themselves more art teachers than artists.
During the 1930s, cultural progress accelerated as the state encouraged
art activities while Iraqis opened up to new Western ideas because of the
expanding contact with the West, especially England which had the

largest presence in the country. These ideas appeared progressive in comparison to the Ottoman thought under which they were raised. In 1931, the government, on the initiative of King Faisal I, began offering art scholarships for study abroad and Akram Shukri (Akram Shukri; fl. 1910) became the first Iraqi to receive such a scholarship to study in England.[240]

In 1936, the Ministry of Education founded the Music Institute in Baghdad. Its success induced the government to further open departments in drama, painting, and sculpture, making it by 1940/41, the Institute of Fine Arts. Unlike Egypt and Lebanon, only Iraqi artists taught at the Institute (Al-Sa'id, 1983, p. 111); they initially trained their pupils in drawing, painting, and sculpture, according to their own acquired knowledge of Western rules of art and aesthetics. By the 1940s, the fine arts had already become part of Iraq's intellectual life and in 1941 the Society of Friends of Art, the first of its kind, was formed by artists, architects, and art-lovers and held its first group show for professional and amateur artists (Mudaffar, in Ali [ed.], 1989, p. 159).

During World War II, a group of Polish officers came to Baghdad with the Allied troops. Among them were several painters, two of whom had studied painting with the French impressionist painter Pierre Bonnard. The Polish painters introduced Iraqi artists to the latest European artistic styles and to the concept of painting from a personal point of view rather than copying nature in its exalted ideal form (Mudaffar, in Ali [ed.], 1989, p. 159). These foreign, visiting artists played a crucial role in acquainting their local counterparts with modern European ideas such as impressionism, cubism, and expressionism,[241] and were responsible for cutting ties with the cold academic style popular among Iraqi artists at that time. The opening of the Institute of Fine Arts, which offered art scholarships for study abroad, in combination with the possibility of association with the Polish artists, and the activities of the local Society of Friends of Art, were conducive in stirring the Iraqi modern art movement towards a broader international forum.

The most important Iraqi artist was Jawad Salim (1919–1961), who guided his country's artistic movement towards internationalism. Salim received his training in painting and sculpture in Paris, Rome, and London, and later became head of the Department of Sculpture at Baghdad's Institute of Fine Arts. There he instructed his students to draw on their cultural heritage of Babylonian and Islamic traditions in order

240 Personal interview with Jabra I. Jabra, Amman, July 21, 1992.
241 Expressionism is an art style that began in Germany ca. 1905. In it the artist is concerned with communicating his subjective emotional observations reflecting the state of his mind or ideas rather than representing images that conform to reality.

to create a distinctive Iraqi artistic style (Jabra, 1983, pp. 12–20). He was probably the first Arab artist to embark on a quest for a national artistic identity within modern concepts. Unlike his predecessors in the Arab world, Salim rationalized folk motifs as symbols to express a national artistic identity. His style awakened a latent sense of nationalism in the public and inspired many Iraqi artists to emulate him. Other Iraqi pioneers were Faik Hassan (Fa'iq Hasan; 1914–92) (see **color plate 2**) who was the proponent of impressionism in Iraq, and Hafiz Drouby (Hafidh Drubi; 1914–91) who opened the first independent studio in Iraq and began his career under the influence of British postimpressionism and cubism.

An Art Movement in Syria

The beginnings of a Western-modeled art movement in Syria came much later than in Lebanon and took about four decades to mature. Two styles in art have affected the earliest known Syrian painters: the Ottoman rigid, classical style in representing nature, which was perpetuated by the soldier-painters, and the Orientalist style of the European painters who visited the Levant. At times the two fused into an early Syrian type of representation. The best-known artist after the Ottoman period was Tawfiq Tariq (1875–1945). He was a gifted architect and the first artist in Syria to introduce easel painting and oil colors and was popular among high government officials who paid him well for their portraits (Bahnassi, 1985, pp. 58–59).

The years of the French Mandate between 1920 and Syria's independence in 1946, witnessed the profound influence of French Orientalist painting and impressionism. The former recorded historical events with particular emphasis on detail and was introduced by visiting French artists, while the latter reached the country through indigenous Syrian painters who had gone to Europe on scholarships, as well as visiting foreign artists. Impressionism took the painters out of their studios and into natural settings. Sa'id Tahseen (Sa'id Tahsin; 1904–1986) was a self-taught artist and one of the first to rid Syrian painting of its sight-less imitation of nature. His narrative style, with bright impressionistic colors, had a naïve quality that could be attributed to his lack of formal training (Bahnassi, 1985, p. 60). Meanwhile, the most prominent early impressionist artist in Syria was Michel Kirsheh (Mishel Kirshah; 1900–73). Kirsheh went to Paris and was greatly influenced by French impressionism, which he adopted in depicting the outskirts and streets of Damascus. Impressionism also dominated the painting lessons he taught in secondary schools, leaving an enduring effect on a generation of students. Most Syrian artists practicing during the inter-war period had studied in Paris or Rome and had returned with a wholly academic con-

cept of depicting their subjects in an exact, realistic manner (Bahnassi, 1985, p. 56). Those who took up impressionism did so at a time when it was already declining in the West. Until the end of the 1930s, despite the art scholarships to Italy and Egypt, Syria produced a limited number of painters. This tardiness is related to the absence of an art institute or academy, such as in Egypt and Iraq, and the vigor of Islamic traditional arts for which Syria was famous and which the general public and the aristocracy appreciated and could identify with.

During World War II, Syria was under the mandate of the French Vichy government. The population suffered because of severe shortages and strict rationing of food and goods, including art materials, while internal resistance to the French escalated in violence. Meanwhile, the public was indifferent to modern art. Artists worked under strenuous conditions, without any support from the public; those who persevered did so out of personal dedication, and realism and figurative art remained the norm. Conditions however, began to change after the war, and a major exhibition of the Paris School was held at the Institut Laïque in Damascus in 1948. Works by Picasso, Modigliani, and Van Dongen were on show (Bahnassi, 1973, p. 17). Through this exhibition, Syrian artists were exposed first hand to modern Western art trends. Representative artists include Elias Zayat (see **color plate 3**).

Art in the Sudan

In the 1920s, poets dominated the Sudanese literary world. They were public orators and performers who delivered religious, historical, mystical, and romantic messages. In their poems, they portrayed a certain imagery that fused tradition with the force of drama. During the second half of the 1920s, untrained folk artists began to react to this mental imagery by painting images of local girls and watermelons, using house paints in primary colors, often the only colors available, in a naïve manner, and ignoring the laws of perspective and light and shade. They painted on wooden planks and a native cotton fabric which they stretched on wood frames. Their work, which was shown in popular coffee-houses and restaurants of Khartoum, was well received by the public.[242]

By the end of the 1930s, drawing lessons in pencil as well as classes in Arabic and English calligraphy were introduced into primary schools and at Gordon Memorial College, which had been founded by the British as a secondary school in 1902 (see **color plate 4**). In 1946, the School of Art was founded in Omdurman for talented graduates of Gordon

242 Personal interview with Muhammad Abdullah, London, May 26, 1992.

Memorial College and the government's Institute of Education (Bakht al-Rida). The next year, the School of Art was moved to Khartoum and became part of the College.[243]

Art education in the country in the 1930s was established by three educators: 'Abd al-Qadir Taloudi (a painter and sculptor), al-Khair Hashim (a painter), and 'Abd al-'Aziz al-'Atbani (a sculptor and designer). After graduating from Gordon Memorial College, all three continued their studies at the Colleges of Fine and Applied Arts in Cairo and on their return to Sudan, joined the faculty of Gordon College and gave lessons in drawing, sculpture, and design.[244]

In 1945, the Sudanese Department of Education (later the Ministry of Education) sent its first group of art teachers to Goldsmith College of Art in London on scholarships. It was followed in 1946 by a second group of scholarship art teachers who this time were sent to Egypt and England (Shammut, 1989, p. 31).

Due to the absence of an early Western art tradition and foreign cultural influences in Sudan, as well as the strong pervasive presence of indigenous handicrafts, local trends in art came naturally in paintings of the 1940s and 1950s. Unlike artists in other Arab countries, a distinctive Sudanese trend dominated the works of its early artists well before Western art styles became prevalent. Consequently, the artistic output of the first generation of modern artists was imbued with an indigenous character while international styles in art only appeared in the works of later generations.

Among the early pioneers are: Bastawi Baghdadi (b. 1927), a prominent artist of the first generation who approached the issue of national artistic identity in his paintings by depicting Sudanese scenery and characters, using burlap and other local materials as collages in his oil paintings (see color plate 5); Osman Waqialla ('Uthman Waqi'-Allah) (b.1925), who was the first among his peers to explore the visual and thematic qualities of Arabic calligraphy; Ibrahim al-Salahi (b. 1930), who is one of the early Arab calligraphic artists; and Ahmad Shibrain, who drew on his Arab-African background in his paintings and sculptures. Women artists likewise draw on their vibrant Sudanese character to express themselves in their works (see color plate 6).

Artists in Jordan
Before the 1930s, few traces of Western art existed in Jordan. In the 1920s and 1930s a few artists came to live in the country, sowing the

243 Personal interview Osman Waqiallah, London, May 26, 1992.
244 Ibid.

initial seeds of a modern art movement. They were the Lebanese pioneer Omar Onsi (1901–1969), the Turkish painter Ziauddin Suleiman (Dia'-al-din Sulaiman; 1880–1945) who held the country's first one-person exhibition in 1938 in Amman and familiarized the public with easel painting (see **color plate 7**), and the Russian émigré George Aleef (1887–1970) who came from Palestine in 1948 with the Palestinian refugees following the first Arab-Israeli war and was the only one among this group of early artists to give private painting lessons in his studio. The outstanding contribution of these artists to the Jordanian modern art movement was their ability to introduce Western painting to the public and generate art appreciation among their friends and acquaintances. Both. Suleiman and Onsi were personal friends of the ruler, Amir 'Abdullah, a man of letters who bestowed his patronage on the early artists, acquiring many of their works.

Local Jordanian artists of the 1950s were all self-taught amateurs who practiced painting as a hobby. The first art activities were initiated in the early 1950s through exhibitions held by literary clubs such the Arab Club. In 1952, the first artistic group, the Club of Jordanian Art (Nadwat al-Fann al-Urdunniya), was founded. Like related societies in other Arab countries, its main aim was to spread artistic recognition among the public and to encourage amateur artists to practice painting and sculpture. Representative artists from Jordan include Fahrelnissa Zeid (see **color plate 8**).

Art and Culture in Palestine

Unlike the French colonists, the British Mandate authorities were primarily interested in training qualified civil servants and hardly took measures to contribute to the cultural growth of the countries under their control. In Palestine, art education and patronage were low on their list of priorities. Furthermore, the internal clashes between Arabs and Jews, as well as uprisings and general strikes against the British, did little to encourage the authorities to send students on art scholarships or include art classes in government school curricula. Few foreign missionary schools included painting lessons in their curricula, but the German school sent Hanna Musmar to Germany to train in ceramics in 1920, while the Italian mission sent Faddoul Odeh (Fadhul 'Odah) to Florence in 1922 to study music and painting. Meanwhile, the few individuals who practiced painting in Palestine depicted religious subjects and simple landscapes, to sell to pilgrims and foreign tourists (Shammut, 1989, p. 31). As late as 1948, fine art in the Western sense of the word had not fully developed in Palestine. Traditional arts, folk arts, and crafts predominated the cultural scene.

Most early Palestinian artists were untrained amateurs. Those who were trained, such as Daoud Zalatimo (Dawud Zalatimo; b.1906) and Fatima Muhib (Fatima al-Muhibb; b.1920), blindly imitated the styles they were taught while executing figurative works in oils, watercolors, and pastels to depict landscapes, still lifes, and portraits of historical and contemporary personalities and Biblical themes. Not a single group or one-person exhibition was held among Arab Palestinians before 1948.

The union of the West Bank—the part of Palestine that was not occupied by Israel during the first Arab-Israeli War—and the Hashemite Kingdom of Jordan in 1949 joined the fate of the two peoples on the banks of the river Jordan. Among the refugees who crossed over were many Palestinian artists who were given Jordanian citizenship. Others were born to parents of Palestinian origin living in Jordan, making it difficult to draw a sharp line between the Jordanian and Palestinian art movements from the 1950s onwards. West Bank artists came to Amman to exhibit their work, and Palestinian artists were employed by the Jordanian Ministry of Education as art teachers at government schools and teachers' training colleges. Others such as Afaf Arafat ('Afaf 'Arafat; b.1926), Ahmad Nawash (Ahmad Na'wash; b. 1934; see **figure 32** and cover), and Kamal Boullata (Kamal Bulata; b. 1942) were sent on government scholarships to study art in Italy, England, and France. Even after the West Bank was occupied by Israel in 1967 and the declaration of an independent Palestinian body in 1988, many artists of Palestinian origin preferred to be recognized as Jordanian.

Syria After Independence

The end of France's mandate over Syria in 1946 marked the beginning of an active modern art movement that witnessed rapid developments. Due to their wider exposure to Western art, the public began to appreciate and look more favorably on painting and sculpture. Its preference for impressionistic local subjects was reflected in its popularity and Syrian impressionism began to take on local characteristics through the choice of a subject matter that depicted scenery from the countryside and the old quarters of Damascus and other Syrian cities. Other styles appeared such as surrealism, through which highly symbolic works were created. However, surrealism was never widely accepted and realism continued to dominate Syria's art scene.

A second generation of artists came onto the scene in the 1950s, providing Syrian art with new motivation and impetus. Most of them were trained in either Egypt or Italy and worked in the field of art education, where they gave their students the benefit of their experience, while search-

ing for individual styles through personal experiments. Through this group of artists who included Nasir Shoura (Nasir Shura; 1920-92), Fateh Moudaress (Fatih Mudarris; b.1922), and Adham Ismail (Adham Isma'il; 1922-63), Syrian art evolved from a realistic stage, with its simple

Figure 32. "Opposite Direction," oil on canvas (1985), by Ahmad Nawash, a Palestinian who lives in Jordan.

intellectual background, to an advanced stage that tried to build up its own cultural personality based on an original translation of imagery (see color plate 9).

Jordan: Contemporary Artists

The Jordanian government sent the first group of students on art scholarships to Italy in the mid-1950s. By the early 1960s, they all came back and began to lay the foundations for a Jordanian modern art movement. The leading painter in the 1960s was Muhanna Durra (Muhanna al-Durra; b.1938), who graduated from the Accademia di Belle Arte in Rome in 1958. A gifted and prolific artist, he established his own distinctive style at an early stage in his career. Durra opened a studio in Amman where he trained a number of young artists, the only local painter to cultivate his own students at the time. Even today touches of his style can be detected in other artists' works. Of Durra's generation there were Rafik Lahham (Rafiq al-Lahham; b. 1932), Ahmad Nawash (b. 1934), Tawfik Sayid (Tawfiq al-Sayyid; b. 1938), and Wijdan (b. 1939).

A second group of artists returned to Amman in the mid-1960s after completing their training at art colleges and academies in Baghdad, Cairo, and Damascus; among them were Aziz Amoura ('Aziz 'Ammura; b. 1944), Mahmoud Taha (Mahmud Taha; b. 1942), and Yasser Duwaik (Yasir Duwaik; b. 1940). After obtaining their first degrees, they went to either Europe or the United States for their postgraduate studies. On their return to Jordan, they taught at the Institute of Fine Arts (founded by the Ministry of Culture in 1972), government secondary schools, and the Department of Fine Art, which was established in 1981 at Yarmuk

University. Like their peers in the region, artists in Jordan have been concerned with discovering and establishing a Jordanian style and asserting their Arab cultural identity by depicting local subject matter, drawing on folk motifs, and Arabic calligraphy within an international framework.

Art in Gaza

In 1949, the Gaza Strip of Palestine came under Egyptian administration which began to provide the schools with art teachers and supplies, thus vitalizing art education and introducing art classes to talented youth. In Jordan, Lebanon, and Syria, Palestinian students followed the government's curricula and became part of the art movement in each country. Between 1953 and 1965 about 100 young Palestinian men and women, almost half of them from Gaza, pursued art in different institutions in Cairo, Alexandria, Baghdad, Damascus, London, Rome, Paris, Leipzig, Dresden, Tokyo, Washington, and Madrid (Shammut, 1989, pp. 60–61). Some were sent on scholarships by Arab governments while others went on their own.

Palestinian Artists

The earliest Palestinian pioneer was Ismail Shammout (Isma'il Shammut; b. 1930). Shammout was not only the first modern Palestinian artist to have a formal art training, but the first to establish a content-oriented movement that depicted only Palestinian themes and portrayed the affliction of his people, their loss of motherland, and dispersion throughout the diaspora, in a straightforward, figurative manner (see **color plate 10**). Furthermore, he was the first to utilize those subjects in the service of his people's cause. In 1964, the Palestine Liberation Organization was created and Shammout was appointed its Director of Arts in Beirut, thereby giving Palestinian artists the official acknowledgment they had lacked.

Little is known of individual Palestinian artists living in Israel between 1948 and 1955, probably because there was hardly any artistic activity of importance during that period. Arab schools were separated from Jewish schools and art education was never part of the high school curriculum. If there happened to be art classes in Arab elementary schools they were obstructed by the appointment of unqualified teachers. The early important pioneers among Palestinian artists living in Israel were Jamal Beyari (Jamal Bayyari) from Jaffa, Ibrahim Hanna Ibrahim (b. 1936) from Raini near Nazareth, Abed Younis, ('Abid Yunus) Daher Zidani, (Dhahir Zaidani) and Abed Abidi ('Abid 'Abidi; b. 1942) from Galilee. Abidi was the first Palestinian artist to exhibit his work in a one-person show in Tel Aviv, in 1962. The Israeli Communist Party provided the sole support given to Palestinians inside Israel and encour-

aged them to safeguard their political and cultural identities by organizing mixed cultural and intellectual activities with Israeli intellectuals. Following the 1967 war, the position of Palestinian artists in Israel was problematic and remains so. Israeli authorities consider them Israeli artists since they all carry Israeli passports and ID cards, and have citizenship, thus leading some to join the Israeli Artists Association. Consequently, certain differences exist between Palestinian artists in Israel and those in the West Bank and Gaza. The only means by which an Arab-Israeli artist can gain recognition in Israel is by assimilating within the criteria of Israeli mainstream art which connects directly to Western traditions (Makhoul, 1995, pp. 35–42). However, almost all Arab-Israeli artists confirm their Palestinian cultural identity by maintaining some native element in their work.

Since the 1970s there has been increased contact between Arab and Jewish-Israeli artists; the Zionist institution, Betsalel School of Art in Jerusalem, with an exclusively Jewish enrollment, began to accept more Palestinian students; joint exhibitions between the two groups as well as one person and group exhibitions by Palestinian artists were held in Israel and the occupied territories, and the works of a few Arab-Israeli artists were even acquired by Jewish Museums (Makhoul, 1995, pp. 35–42).

Since 1967, the work of Palestinian artists produced under Israeli occupation reveals anger and resentment. Working under difficult and sometimes very disruptive conditions, artists have attempted to express their defiance in their art work. Those living in the West Bank, like Suleiman Mansour (Sulaiman Mansur; b. 1947), Isam Badr ('Isam Badr; b. 1948), and Tayseer Barakat (Taisir Barakat; b. 1959), and in the Gaza Strip resorted to non-violent, artistic expressions of nationalism in order to be able to display their paintings without offending and incurring the wrath of the occupying authorities. As an example, Mansour used straw, chalk, lime, clay, animal fat, and natural dyes such as indigo, to construct his abstract and stylized works on wood, boycotting Israeli art materials.

Meanwhile, many of the Palestinian artists dispersed throughout the world have been successful in building art careers in the countries where they reside. Jabra Ibrahim Jabra (1920–94), from Bethlehem, a pioneer among Palestinian artists in expressionism and cubism, took up residence in Iraq in 1948 and became one of the best known Arab art critics and historians. Kamal Boullata from Jerusalem emigrated to the United States after the 1967 war, lived in Washington D.C. and is now in Paris. Laila Shawa (Laila Shawwa; b. 1940) is a Gazan who has settled in London since 1979 (see **figure 33**). Samir Salameh (Samir Salamah; b. 1944) from Safad lives in Paris. Vladimir Tamari (Vladimir Tamari; b.

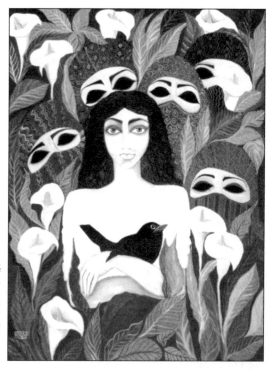

Figure 33.
A group of
women are
depicted in
"The
Prisoner,"
by
Palestinian
artist Laila
Shawa.

1942) from Jerusalem, moved to Tokyo in 1970. Samira Badran (b. 1954) lives in Barcelona.

Whether directly or otherwise, all Palestinian artists have experienced the stress and anxiety created by the political realities of their nation. Their subject matter is similar in that it is based on the political and social issues resulting from the loss of their homeland. Even those born outside Palestine and connected to the art movements of their host countries have shown strong national ties. This kind of obsession with one's homeland is certainly unique in the history of Arab art and has affected other Arab as well as moderate Jewish-Israeli artists; some of whom, like Kershon Kensbil, Zvi Goldstein, Moshe Gershuni, and David Reev, have actually exhibited with Arab-Israeli and Palestinian artists. Art for Palestinians has become an emotional and introverted mechanism by which they preserve their identity and publicize their cause throughout the world.

Postrevolutionary Egyptian Art

After the 1952 revolution that ended Egypt's monarchy, artists found themselves living in a new political atmosphere. They expressed their newly found freedom by adopting the slogans of the revolution, which supported the same ideals of freedom and equality that some had called for earlier. A new group of artists appeared who portrayed Egyptian nationalism through symbolic works. Egyptian peasantry, which had always been featured in modern Egyptian art, was sanctified, along with themes pertaining to the working classes. Popular ceremonies and folk customs were depicted in an effort to replace European aesthetics. These

works won official and public appreciation. However, despite the numerous attempts to develop indigenous artistic trends, ideas about reviving cultural heritage remained vague until 1956. When the nationalization of the Suez Canal and the Tripartite Aggression on Egypt took place, ideas of combining heritage with modernity evolved in the form of a quest for an Arab national artistic identity and was pursued by the majority of Egyptian artists (Hussein, 1989, p. 38).

Iraq: Politics vs. Art

In 1958, a bloody revolution by a group of military officers ended Iraq's constitutional monarchy. Thus came to an end a period in which the visual arts, literature, and music flourished alongside social, educational, and economic development. The unsettled internal political situation in Iraq during the early 1960s, with its numerous coups d'état, military dictatorships, state censorship, local uprisings, and mass executions, created an ambiance that hindered the progress of art. Cultural policies were dictated by political affiliations rather than academic or artistic qualifications. The untimely death of Jawad Salim in 1961, at the age of forty-one, further stunted art development in Iraq.

By the mid-1960s, young artists began to return to Iraq after completing their studies in Western Europe, the United States, the former Soviet Union, Poland, and China. Some of these newcomers managed to inject the stagnating artistic movement with new blood. Jawad Salim's spirit had imbued Iraqi modern art with a continued desire to break through domestic boundaries to the rest of the Arab world and towards internationalism. Modern communications simultaneously cut through local styles and paved the way towards more international artistic exchanges. Since 1968, the state has fully patronized Iraqi artists, morally, and materially. Consequently, artistic activities have grown considerably. Artists representative of major contemporary trends in Iraq include Rahen Dabdoub and Isma'il Fattah (see **color plate 11** and **figure 34**). However, the government utilizes art to serve its one-party regime and artists who do not comply with their government's dictates are pushed to the fringe of society.

The Beiruti Art Scene

In the 1960s, Beirut became the cultural center of the Arab world. Artists from other Arab countries gathered in the Lebanese capital, either to train, exhibit their works, or immerse themselves in the intellectual milieu of the city with its prosperous art galleries, informed critics, numerous cultural publications of high standard in English, French, and

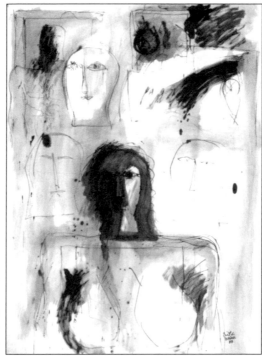

Figure 34.
Iraqi
Isma'il
Fattah,
"Ashtar,"
watercolor
on paper,
1988.

Arabic, and enthusiastic collectors. Such a cultural atmosphere permeated with freedom of expression that was lacking in most other Arab countries, created a euphoric climate for all types of creativity. Unfortunately, the Lebanese civil war, which broke out in 1975, dealt a severe blow to one of the most flourishing modern art movements in the Arab world. Art patronage by the state, the affluent middle class, and the intelligentsia ceased. Cultural and artistic activity suffered. Foreign cultural centers and commercial galleries closed down and universities held classes only occasionally, depending on the extent of the fighting and violence. A significant number of gifted artists left the country to live abroad, mostly in Europe and the United States. Those who remained behind had to make the difficult choice between safeguarding their artistic standards, or giving in to the predominant vulgar taste in order to sell their works and make a living. Only in 1991 did the Lebanese civil war come to an end. In the period of time since, cultural and artistic life has started to revive (see Introduction, pp. 14–16).

Modern Art on the Arabian Peninsula

At the start of the twentieth century, the Arabian Peninsula, which now includes the states of Saudi Arabia, Kuwait, Qatar, Bahrain, the United Arab Emirates, Oman, and Yemen, was geographically cut off from any outside cultural influences. Local crafts constituted the main form of visual artistic expression. However, once oil was discovered and modern technology prevailed, folk art declined.

Western aesthetics and modern art began to manifest themselves in

the Arabian Peninsula, in the 1960s. The first of three factors that was instrumental in introducing Western art into the Gulf countries was the introduction of a modern educational system through which Western art concepts first penetrated Arabia in the 1950s. Government scholarships constituted the second element that helped introduce Western art trends to the region, as educational authorities in Saudi Arabia and the Gulf states began sending students abroad to study art. The first art scholarship recipient from the Peninsula was the Kuwaiti Mojab Dossari (Mu'jab al-Dawsari; 1921–56) who was sent to the Institute of Decorative Arts in Cairo (1945). Since then, numerous art students have been sent abroad. The third factor was the formation of art societies which played a significant role in the development of modern art movements in Arabia (e.g., the Kuwaiti Society of Fine Arts and the House of Saudi Arts, founded in 1967; see Salman, 1984, p. 25). These societies combine the functions of an art fraternity, art institute, artists' union, and government cultural department, all put together. It should be noted that Kuwait was the first state in the Arabian Peninsula to manifest these three factors.

In addition, two new phenomena appeared in Kuwait in 1960 that had and continue to have a remarkable effect on modern art in the Arabian Peninsula. The first is the creation of the Free Atelier for Fine Arts that was later emulated by Qatar, Oman, and the United Arab Emirates. The Atelier provides art classes free of charge and furnishes the necessary studios and art materials. It was meant as a substitute for an art school. A second phenomenon is the state support of full-time artists in the form of monthly salaries given for two or more years, enabling them to dedicate themselves to their creative pursuits. Official patronage by the governments of the oil-producing countries has been instrumental in the development of modern art in the region.

The paintings made during the 1950s and 1960s throughout the Arabian Peninsula can be characterized by their primitive figurative style. Adhering to no consistent art school, they depicted their subjects realistically and in basic colors. The increase in the number of scholarships granted by the government and the ensuing exposure to Western art led to a departure from the old, rather rigid figuration, and a new era of experimentation with different Western styles and current modes gradually began to prevail. The most popular styles of painting have been impressionism, expressionism, cubism, and surrealism. In the 1960s, the Kuwaiti Abdallah Taqi ('Abd-Allah Taqi; b. 1940) was the first artist in the area to depart from academic restrictions and turn to abstraction.

Regardless of style and artistic level, paintings by Gulf artists, whether of cities or landscapes, still-life or portraits, realistic or surreal-

istic, abstract or calligraphic, have one common denominator—the choice of scenes of everyday life and indigenous culture as subject matter (see color plate 12 and figure 35). The first painter to insist on and propagate local subjects was the Kuwaiti Mojab Dossari to whom we have already referred. The most common subjects among painters are the sea, the desert, and life in their own communities. Arabian artists have made an attempt to visually conserve their original traditions, by recording for future generations those practices that have disappeared or may well do so with the encroachment of Western culture.

Politics and Artistic Trends

At this point it should be mentioned that two political events in the Arab world were responsible for introducing conceptual changes in modern Arab art, particularly painting. The first event was the Suez War of 1956 also known as the Tripartite Aggression by Britain, France, and Israel against Egypt, which induced many Arab artists to search for innovative styles and means by which they could confirm their national artistic independence from Western influence, as a reaction to the foreign invasion. The second event was the 1967 Arab-Israeli war with its military defeat and political setback which gave rise to a new trend in art and literature, that of a content-oriented work. Art displayed a pessimistic tendency that revealed the bitterness and disappointment of artists and intellectuals with their leadership. They also carried a nationalistic message opposing the Israeli occupation. Thus, the idea evolved in the form of a quest for an Arab national artistic identity, completely free of

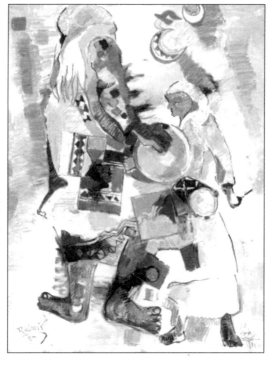

Figure 35. The rich indigenous cultural life of Saudi Arabia inspired Abdel Halim Radwi in his 1987 oil painting entitled "Folkloric Dance."

all kinds of imported artistic influences.

Consequently, Arab artists began to reject Western art styles and look into their Arab-Islamic heritage to express their political and social views. However, they also realized that modern art trends could be linked to their own cultural heritage and the Arab heritage revival movement picked up momentum. Coupled with the political events and general mood in the region, it carried artists to a new level in their development, which led to the emergence of individualistic styles in several new directions, such as the trend towards heritage and folk motifs and the modern calligraphic school of art. Most contemporary Arab artists who dig into the past for inspiration do so out of a desire to confirm their artistic and cultural identity. These works are characterized by three elements: solid technique, inspiration drawn from rich, indigenous cultural, classical, and Islamic sources, and bold, personal artistic experimentation.

Parallel to the heritage revival movements, two types of realism emerged: the first sensitively delineated the local surroundings and archaeological sites in a style that emphasized the beauty of the country, while the second treated nationalistic and humanitarian subjects such as war, aggression, poverty, and oppression, and endeavored to seek out the connection between image and reality in an exaggerated manner.

Simultaneously, the issue of internationalism and modernization was also being raised among artistic milieus within the eastern Arab world, leading to the emergence of a third trend that fosters international art and follows well-known Western styles ranging from impressionism to expressionism, abstraction, and pop art. The three trends continue to attract artists to the present day.

Although the political, economic, and social environment since the nineteenth century had caused the decline of traditional arts in the Arab world, it simultaneously paved the way for the development of a modern art movement in painting which encompassed Western aesthetics. From the mid-nineteenth century, an artistic renaissance developed in the Middle East which eventually led to a radical change in aesthetics and the unfolding of a new artistic evolution in the field of visual arts. By the mid-twentieth century, all Arab countries had modern art movements which reflected their cultural and artistic growth through their art institutions, artistic activities, the growing number of artists, and new art tendencies which are interacting with other art movements in Asia and the West.

21 Visualizing Identity:
Gender and Nation in Egyptian Cartoons
Tonia Rifaey and Sherifa Zuhur

Egypt was frequently portrayed as a female character struggling with her identity and political circumstances earlier in the twentieth century. Egypt appeared as a woman in various visual fora including cartoons, drawings, paintings, posters, prints, and sculpture. Within cartoons, the portrayals of Egypt were utilized to express messages concerning the international inequity of power, the innocence, vulnerability, and gullibility of the youthful nation, and also inserted visual comments concerning the role of various sorts of women in society. By the end of the twentieth century, it appeared that the image of Egypt as a woman was reduced and crystallized to a single "type" no longer essential to all references to Egypt as an actor.

Following the revolution of 1952, a strong cult of the leader developed along with exploitation of the media for ideological purposes, which meant that Egypt could more frequently be represented by an image of its leader (confined to some degree by censorship). The image of the early patriotic Egypt as *al-mar'a al-gadida* ("the new woman"), the title of Qasim Amin's controversial work, and later used to mean the new (Egyptian) woman of modernity, had disappeared except when illustrators or cartoonists were making specific references to past figures, the quest for liberty, or the birth of feminism. Instead, the one consistent image of Egypt displayed a woman of the people, as the mother of the nation. She bears a resemblance to the woman standing by the Sphinx in the pink granite statue by Muhammad Mukhtar, "Egyptian Awakening" (see **figure 36**).

Figure 36. "Nahdat Misr" ("Egyptian Awakening"), by Muhammad Mukhtar, now stands opposite the Giza Zoo in Cairo.

This symbol of hope and evocation of the themes of change and continuity has a dark side. It may be seen in the surreal and the green-faced, black-*milaya* swathed figure of the female Egypt in 'Abd al-Hadi al-Jazzar's surreal painting "Al

Missakh" (1982) whose crown bears Egypt's eagle and who holds a white book marked al-Mithaq in gold lettering (see **color plate 13**).

Somewhere in between these images we may note that in the 1999 Egyptian elections, a free page-sized poster insert was distributed in the newspapers displaying an incarnation of Egypt as a woman. Here, Egypt is dressed in a verdant and full green galabiya (the color symbolizes both fertility and Islam), its ruffled country-style neckline reflecting the foliage at the base of her gown (see **color plate 14**). The *fallaha*, peasant woman, has been recast. Earlier in the century, she was a symbol of traditional ways, stubborn, illiterate, and fierce. Here, she is a symbol of fecundity and patriotism, overshadowing the repetitive sketched images of city and countryside. With her gold necklace, earrings, and bracelets, her eyes closed in concentration, and she holds a red valentinelike heart containing President Mubarak's image over her own bosom. The caption reads *Salamat qablik ya Misr* ("Blessings be upon you, O Egypt").

Political poster art varies in certain ways from cartoons in newspapers, but in a January 1, 2000 review by Goma'a Farahat, a leading political cartoonist, of significant historical images from the twentieth century Egypt (Goma'a, 1999–2000, p. 19), we meet this Egypt again. Tall, robust, and labeled Egypt, she climbs toward the sun, holding Gamal 'Abd al-Nasser's hand. She is more than twice his size and the cartoon is labeled "The Twenty-Third of July 1952 Revolution." She appears again, "Egypt" clearly marked on her head scarf, with the date 1956 engraved upon her necklace. She beams with the widest possible smile, holding the first two fingers of her right hand in the V for victory sign.

How has this gendered and class-situated model of national pride emerged to elicit instant identification? Why has its genesis—Egypt as a young and modern woman in political cartoons—faded from everyday usage or melded with more controversial images of Egyptian women? Has this representation of Egypt as a woman decreased in iconic significance outside of exceptional situations, such as an election, or allusions to past (or presumably future) political or military victories?

While the scope of this volume prevents us from responding fully to these questions, we shall comment upon the elision of national iconography and symbolic usages of the female figure. One of us, Tonia Rifaey, has explored the development of political cartoons in Egypt in the period, 1918–1924 (Rifaey, 1997 and 1998). Within a large body of cartoons, we noticed the frequent portrayal of Egypt as a woman. The repetition of such images elided with Sherifa Zuhur's interest in the juncture of feminism and nationalism and the various cultural manifestations of national representations in the Middle East. We will discuss certain car-

toons created via nationalist discourse of the late teens and early 1920s, and make some suggestions concerning the gradual disappearance of Egypt as *al-mar'a al-gadida* ("the new woman") or "Lady Liberty" in the genre of cartoons and her simultaneous diffusion into other images of women and into gender issues and her metamorphosis into the symbolic figure discussed above.

The representation of the female in the cartoons collected from 1918–1924 varies. She is most frequently portrayed as an elite woman, sometimes a child or young girl, and less often as a peasant, or even a belly dancer—some article of her clothing (the peasant's outer wrap, or a baby girl's hair-bow) may be marked with a crescent and a star. While she usually represents Egypt, the cartoonist may indicate a more specific role, such as the constitution (then indicated by the words *al-dustur* on her or explained in the caption) or the declaration. The basic message in each portrayal, however, is constant; the female character represents the nation or some aspect of the nation that is resisting subordination by external forces.

Elite women in Egypt had not yet discarded the face veil in these years. Huda Sha'rawi and Saiza Nabarawi daringly exposed their faces in 1923. Emerging from the strict separation of the sexes imposed through the harem system, elite women had eased their transition into public space through their participation in the nationalist movement in Egypt. And earlier restrictions (which had applied to women elsewhere, outside of the Middle East) were lifting gradually. Writings by and for women began to proliferate. The ordinary reluctance to photograph women or visually depict women eased first in reference to elite women. Cartoons were less restrained, although they normally did not portray or lampoon specific women in this early period (with Huda Sha'rawi, Safiya Zaghlul, and Fatma al-Yusuf as initial exceptions, later joined by other women).

When Egypt appeared as an elite women, she most frequently retained her *yashmak*, the white gauzy face veil, her head covering, and her outer wrap, but her skirts rose to show ankles and high-heeled shoes. Gradually her more modest and fuller black garments would give way to a midi-length black skirt, a short blouse, jacket, and hat with a half-veil. This is Egypt-Hanim on her path to becoming, as in the title of Qasim Amin's book, the "new woman."

Although the gendering of Egypt remains consistent, her image shifts from the passive, naïve young girl to a more mature and aggressive woman demanding her rights. The use of the female image to encompass the nation is intended to conjure up affinal relations with women—

whether wife, daughter or mother—eliciting sympathy, anger, disgust, or concern from the audience of cartoons. It must be mentioned that virtually all cartoonists have been male, and that in the past they conceived of their audience as being predominantly male.

When, in some images, mistreatment or subjugation of the female is suggested, the references to sex and power are unmistakable. For example a cartoon in the newspaper *Al-Kashkul* displays Tharwat Pasha dressed as a chef, carrying a covered platter. Sa'ad Zaghlul the nationalist leader of the Wafd (who was disliked by the editors of *Al-Kashkul*), is force-feeding the Declaration of February 28, 1924, to an Egypt tied to a chair. Here, in contrast to the modest decorum and covering of many cartoons of the elite female figure, Egypt's low-cut, form-revealing gown is slipping off her shoulders and her face is fully exposed (*Al-Kashkul*, May 23, 1924, p. 158). In another image, Sa'ad Zaghlul Pasha has kidnapped a child (portrayed as a miniature man with a tarbush) who represents the parliament and is threatening to feed him with "Nestlé's milk" while his mother, Egypt, a *fallaha*, whose exposed breasts are swollen with milk, raises her hands in anger and exasperation (*Al-Kashkul*, March 28, 1924, p. 150). In an earlier explicit comparison between political corruption and sex, a Lady Liberty type of Egypt with a laurel crown, flanked by various flags, muses over her rounded stomach, "I fear that the result of all their conferences will fill my belly and make me pregnant" (*Al-Kashkul*, November 20, 1921, p. 17).

There are many reasons why cartoonists chose to depict Egypt as a woman. For instance, Beth Baron, who has discussed portraying the nation of Egypt as a female, points out that "by depicting the nation as a woman, nationalists hoped to stimulate love for the nation and draw male youth to the cause."[245] She also suggests that "the multiplicity [of images] indicated a measure of confusion about the content of Egyptian nationalism and its direction. It suggested that the notion of the 'nation' in Egypt was still fluid and that Egypt was not yet a coherent collective."[246]

Baron did not write exclusively about cartoons, but also explained the significance of sculptor Mukhtar's massive neo-Pharaonic work, "Nahdat Misr" (the awakening or renaissance of Egypt, constructed between 1919 and 1928), in which a female Egypt lifts her veil.[247] An

245 Beth Baron, "Nationalist Iconography: Egypt as a Woman," in Jankowski and Gershoni (1997), p. 121.
246 Ibid., p. 106.
247 Baron, ibid., and Liliane Karnouk both cite a writer from the period with the nom de plume of "May" who wrote: "In 'Egyptian Awakening,' Mukhtar gave the woman both national and social influence. Following her rising came the rise of a nation." May, "Nazra fi Fann Mukhtar," *Al-Siyasa al 'Usbu'iya*, November 12, 1926, p. 6; also cited in Karnouk (1988), p. 17.

interesting aside is that *Al-Kashkul*[248] mocked the slow progress of this sculptural project in a cartoon that showed the female statue holding a bag filled with 15,000 Egyptian pounds and a caption stating: "The sculptor changes the [statue's] hand for the third time. Now the Egyptian people know how much will be required to finish it" (see **figure 37**). With the exception of a few women from the press corps, women were prevented from seeing the statue when it was first unveiled in 1928.[249]

Another female version of nationhood was found in cartoons produced in Turkey and Iran in the same period. Such cartoons may have been modeled on the revolutionary figure of Marianne, created in France and similarly subject to various interpretations. Pamela Brummett describes the development of such a figure in cartoons of Ottoman Turkey. In this case, the "new woman" contrasted strongly with the figure of an "old nag," a traditionally dressed, lower-class woman whose position on the national question was ambivalent.[250] Brummett expands on the juxtaposition of these two images, applying them to the modernity vs. tradition dynamic that was prevalent in so many aspects of Middle Eastern intellectual life in Egypt as well as in Turkey.

In the Egyptian cartoons we refer to this figure as Lady Liberty. She continued to appear in cartoons after 1922, because Egypt did not receive full independence, but was constrained in particular ways by the British presence and interaction with the various political powers. Lady Liberty differs somewhat from Egyptian historical references to the gendering of Egypt. The well-known expression *Misr umm al-dunya* ("Egypt is the mother of the world") expresses Egypt's maternal role in the foundation of civilization, and the Egyptian's special niche in history. The phrase conjures up images of a fertile mother earth as well as a shelter for her people. The use of a young woman to represent Egypt may also be dated back to the pharaohs, who utilized the female to represent fertility. Linguistically, Egypt, or *Misr* in the Arabic language, is feminine, contributing to her visualization as a female.

Nonetheless, in this earlier period, Lady Liberty and Egypt-Hanim are more common and abstract representations of the nation than the fertile mother–Egypt-*fallah* that emerged after the 1952 revolution. That figure eventually evolves from the peasant woman, who in the late 1910s and

248 The newspaper also featured cartoons by Mahmud Mukhtar; see Karnouk (1988), p. 14.
249 Baron, op. cit., p. 121.
250 Pamela Brummett, "New Woman and Old Nag: Images of Women in the Ottoman Cartoon Space," in Goçek (ed.), 1997, pp. 37–43; see also female images in Firoozeh Kashani-Sabet, "Hallmarks of Humanism: Hygiene and Love of Homeland in Qajar Iran," *The American Historical Review* 105: 4 (October 2000) 1171–1203. Kashani-Sabet argues that "women were not just symbols of the nation, but custodians of civilization and practitioners of health." p. 1201.

1920s carried an ambivalence and signaling of tradition or backwardness that is comparable to the Turkish "old nag." Yet she is resuscitated and recast. Here we disagree slightly with Baron, who suggests that Egypt as a mother-figure was absent from *Al-Kashkul's* cartoons due to the living presence of Safiya Zaghlul and that "there was no abstract representation of a Mother Egypt."[251]

We would agree with her, however, in part, noting that Egypt-Hanim and Lady Liberty, although appealing, are often shown as being helpless, in need of guidance and somewhat lost. Thus, the modern gendering of power relations depicted the female as a lesser force, especially

Figure 37. Cartoon by Juan Santez, *Al-Kashkul,* June 18, 1922, entitled "Visible Changes in the Statue 'Nahdat Misr.'"

when she is being bullied or reprimanded by the burly John Bull, symbol of England. Perhaps cartoonists also suggested that Egypt had never paved its own course and had for decades relied on others to do so for her.

Al-Lata'if al-Musawwara ("Pictorial Anecdotes") and *Al-Kashkul,* two sources of cartoons, archived in detail the travails Egypt faced during the period from the end of World War I through the events known as the 1919 Revolution. The portrayal of Egypt in political cartoons was not only a visualization of the climate that had encompassed the nation but also a commentary on events and concerns for continuing trends in Egyptian politics. The first of these journals, *Al-Lata'if al-Musawwara* was published until 1920, but ceased publication soon after that, primarily due to censorship. The newspaper's leading cartoonists were Nihad Khulusi, a Turk, and Ihab (cartoonists, then as now, often employed a single name). While in circulation, the newspaper was subject to a certain degree of censorship.

Al-Kashkul, where Suleiman Fawzi became editor in 1921, is supposed to have reached a circulation of 10,000 between 1927 and 1928.[252] The newspaper opposed British imperialism, and the Egyptian leadership's weaknesses, satirizing Egyptian politicians as well as foreign officials during the peri-

251 Baron, op. cit., p. 124.
252 *Annual Report for 1927–1928,* Cairo, August 26, 1929, Ayalon Press, p. 149, and
 cited in Baron, op. cit., p. 116.

od between 1921–24. While Sa'd Zaghlul is described as a nationalist hero in many texts, he was mocked in *Al-Kashkul*, as were the British. However, no cartoon of King Fu'ad was ever published in those years.

Al-Kashkul employed an artist by the name of Juan Santez, of Spanish and Egyptian origin, to draw the cartoons. Santez had studied at the Institute of Fine Arts established by Prince Yusuf Kamal in 1906 (as did Mukhtar) (Sa'd Abu al-'Aynayn, 1990, p. 35). He was influenced by the French style of caricature, and his own style was indeed quite distinctive (Abu al-'Aynayn, 1990, p. 35). The caption writer for the cartoons drawn by Santez was probably Husain Shafıq al-Misri. He was a "writer with great sense of humor and wit, which he used repeatedly, often in poetic *zajal*, ridiculing the establishment and its application of the laws and regulations" (Kishtainy, 1985, p. 80).

Political cartoons themselves have been useful tools in gathering information on the sources of nationalism and political currents. The cartoons humanize the powerful by mocking their strength and poke fun at distressing conditions as comic relief for the people. To those who have suffered hardship or mistreatment by their government, cartoons offer a momentary means of escape. Just as Yusuf Idris points to the role of a clown in society, who may mock the powerful (see ch. 3) the cartoons fulfill a similar function. Creating a joke that vividly depicts and mocks injustice grants the viewer a sense of relief, as well as a sense of community; for he/she is not the only one persecuted (and not the only one to laugh).

For many decades political cartoons have been a rich but forgotten source of historical events. Goma'a (Farahat), a popular cartoonist previously mentioned, known solely by his first name, explained that cartoonists are today perceived as distinct from journalists, for they interpret the news, as well as reporting it.[253] They must do so in one image (cartoons in Egypt typically appear in single images rather than in strips). Creators of instant visual stereotypes and allusions, cartoonists are constant thorns in the sides of the politically powerful, for they can "convey instantly in an image as much as a columnist can in 1,000 words" (Lexington, "The Ink of Human Kindness," *The Economist*, June 18–24, 1994, p. 34).

The periodicals *Al-Kashkul* and *Al-Lata'if al-Musawwara* encompass a particular portion of Egyptian history. In addition to the unequal relations of power between the male England and the female Egypt, they also relayed the message that the masses were involved and participatory, awaiting, for example, the granting of the constitution. In Egypt,

253 Personal interview by Tonia Rifaey with Goma'a Farahat, February 4, 1997.

where illiteracy during the 1920s was close to ninety percent, political cartoons—a visual means of comment—symbolized the author's concerns with popular participation or political disgruntlement.

Political Cartoons Signal Change

It seems that cartoons may be traced back to the introduction of centralized power. Afaf Lutfi al-Sayyid Marsot (1971, p. 3) writes that the phenomena dates back to the ancient Egyptians, circa 2000 BC. These ancient political cartoons were drawn on papyrus and represented the truest form of political cartoons, those that do not require captions to explain their meaning (Abu al-'Aynayn, 1990, p. 26).

Marsot describes the introduction of the political cartoon into modern Egypt at the time of Khedive Isma'il's by Ya'qub Sannu'a (1839–1912) who was equally active in the creation of theater. The press, having developed in Egypt during Muhammad 'Ali Pasha's reign in 1828, began to flourish under Khedive Isma'il (al-Sayyid Marsot, 1971, p. 7). Sannu'a's satirical plays and newspaper created a new genre of comedy that was simultaneously praised and condemned. Sannu'a earned the Khedive's approval at first, for he bestowed upon him the title of "Egypt's Molière," for his play *The Two Wives*, in which he mocked polygamy. Unfortunately, Sannu'a angered the British who thought his work in *The Tourist and the Donkey* was seditious as he had mocked British imperialism.

This ended Sannu'a's theatrical debut, but with strong encouragement from Jamal al-Din al-Afghani, the well-known Islamic reformer, he established a satirical newspaper in 1877, entitled *Abu naddara zarga* ("The Man with the Blue Spectacles") (Kishtainy, 1985, pp. 70–71). Sannu'a here presented stories in the form of a dialogue between the characters of Abu Khalil and Abu Naddara. Khalid Kishtainy tells us, "With a typical tongue-in-the-cheek piece, he defended the corrupt and despotic Khedive Isma'il in what was known in Arabic literature as *al-tham min bab al-madh* ("dispraise in the way of praise")" (Kishtainy, 1985, pp. 70–71). Sannu'a lost favor with the khedive and was eventually exiled to France.

Sannu'a's efforts strongly influenced those who followed him. His style was traditional, based on the lampoon (in *saj'*, a type of rhymed prose, and *zajal*, a type of vernacular poetry). Al-Sayyid Marsot describes the use of *zajal* as folk art in competitions, cartoons, and songs, whereas Kishtainy describes *zajal* more pejoratively (al-Sayyid Marsot, 1971, pp. 5–6; Kishtainy, 1985, p. 73).

Another individual who influenced graphic humor and relied heavily on the use of *zajal* was 'Abd Allah al-Nadim, a former student of Jamal

al-Din al-Afghani, and a dedicated educational reformer who published *Al-Tankit wa al-Tabkit* ("Joking and Censure") in 1887 (al-Sayyid Marsot, 1971, p. 10). Al-Nadim (1845–1896) came from a working-class family, was educated in a *kuttab*, then at al-Azhar University. He took up arms against the British during the 'Urabi revolt, in which he became known as the "Orator of the Revolution" (Kishtainy, 1985, p. 76). Nadim then became very involved in the establishment of a prototype of an Egyptian Islamic school (the Islamic Benevolent Society School of Alexandria) in 1879 and in writing about the ideal forms of education in *Al-Ustaz* in 1892, using humorous dramatic sequences to illustrate his views.[254]

During the next several decades, political cartoons virtually disappeared from the Egyptian press. Marsot attributes this trend to that fact that journalism had become a "very grave profession to the Egyptian nationalists" (al-Sayyid Marsot, 1971, p. 12), while the rulers sought to more closely control representations of political events in the press, whether visual or in text. Silencing of political humor may not signify passivity on the political front; Itzhak Galnoor and Steven Lukes point out that the absence of political cartoons and jokes from social or political discourse can signify the beginning of a revolution (Lukes and Galnoor, 1985, p. x).

In 1914, Egypt was declared a protectorate by the British, and until the abolishment of the protectorate in 1922, British censorship was applied to everything published. *Al-Lata'if al-Musawwara*, whose leading cartoonists were Khulusi and Ihab, managed to continue in print until 1920, but disappeared soon after that (Kishtainy, 1985, p. 79). However, once the Great War ended, various periodicals were established in Egypt, including the founding of *Al-Kashkul* by Sulaiman Fawzi in 1921. The publication opposed the popular leader of the Wafd party, Sa'ad Zaghlul.

Al-Kashkul therefore critiqued the dominant political party, the Wafd. It satirized in visual parodies those who obtained high positions in the various governments during the period between 1920–24. Various members of the political parties were also objects of satire, as were the British. See, for example, cartoons lampooning Rushdie Pasha, (June 4, 1921), Adli Pasha, (June 9, 1923), Makabati Bey and Abu al-Nasr Bey (September 10, 1922), Tharwat Pasha, (August 20, 1922), Sa'id Pasha (July 30, 1923), Hishmat Pasha (September 21, 1923).

In a direct reference to the rise of Egyptian feminism, which had coincided with the nationalist activism against the British prior to 1919, one cartoon depicted the Women's Wafdist Committee (which was eventually transformed into the Egyptian Feminist Union) being taunted as Allenby

254 Linda Herrera, "The Soul of a Nation: Egypt's New Schooling and the Public School Pedagogy of Abdallah Nadim (1845–1896)," unpublished paper, 1999.

offers cigarettes to them. The women refuse to partake on the grounds as they are already smoking their own (national) brand and see a mirage of Zaghlul in the smoke (*Al-Kashkul*, August 6, 1922, p. 64). Nevertheless, women were more frequently portrayed as anonymous figures and even after 1922, they could not vote nor run for office.

The Effects of Political Cartoons and Jokes

Political cartoons, regardless of how exaggerated the depiction, are a form of journalism, or historical description of an event, leader, government actions, or condition. For example, a cartoonist explained, "You'll never understand inflation intellectually, so think of it as an overpowering monster that, by implication, the public must endure with fortitude until it goes on its own accord" (Morris, 1995, p. 6). Exaggerated depiction thus lends itself to the marking of particular areas of gendered identity. As a result, we see Egypt's weakness, or in some cartoons, actual sickness as when she is portrayed is lying in a hospital or in a sick bed, and her femaleness is a part of her condition. But we should ask, is the use of a gendered symbol a source of ridicule? Is the ability to cast weakness or powerlessness in a humorous light a sign of intellectual strength or is it merely an historic recourse of the weak or less powerful?

An Egyptian may be referred to as *Ibn Nukta* ("the son of a joke") due to the "national" expertise in the art of joke-telling and appreciation for clever humor. Indeed, Egyptians are known for this quality and as Edward Said, has noted, for their skills in entertainment and the arts of flirtation throughout the Arab Middle East (see ch. 12). Nadia Atif, who studied this aspect of Egyptian society in depth, held that the ability to satirize events denotes "the power to be a critical observer of society, a fearless judge of the issues and, more importantly, a spokesman for the folk" (Atif, 1974, conclusion).

In Egypt, verbal cartoons or jokes (the *nukta*) are deeply rooted in society. Al-Sayyid Marsot states that:

> The *nukta* is seldom a simple joke, it is more of a state of mind, a farce in the capsule form, or instant satire. It is endemic in Egypt, and arises at the least or the slightest provocation whether of a private or a public nature, and rises to dizzy heights of virtuosity in times of crisis. Where in other countries editorials are written and read as a measure of public reaction or where an irate reader might send off a letter to the *Times*, in Egypt *nuktas* circulate. The *nuktas* usually inspire many political cartoons that can be found today in circulation (al-Sayyid Marsot, 1971, p. 6).

The *nuktas*, like the political cartoon, are a way for the public at large to engage with their environment. Political cartoons criticize or ridicule the current policies and conditions in a demand for change. It is no coincidence that the President of Egypt, Husni Mubarak, has his staff collect political cartoons and *nuktas* following the passage of every new law in Egypt.[255]

Atif also observed that Egyptian humor had another function, for it attempts to be dynamic, by encouraging change primarily in people's attitudes, on the assumption that changes in thought and perspectives can bring on change in the realm of action. In that respect, Egyptian jokelore, similarly, constitutes a charter for action (Atif, 1974, conclusion).

The years 1919 to 1924 were a time of great agitation and constant demonstrations and confrontations between the British and Egyptians, as well as clashes among Egyptians themselves. However, any actions that were seen as contradictory to Egyptian national interests were immediately ridiculed in *Al-Kashkul* and to some extent in *Al-Lata'if al-Musawwara*.

For instance, in a cartoon captioned "Egypt and the Assassinations," Egypt (represented as a woman) is surrounded by skeletons and ghosts, and fearfully cries: "No, no! such vile assassinations frighten me and spoil the air. The smell of the innocent bodies suffocates me and is hindering my progress on the road to independence" (*Al-Kashkul*, January 7, 1923, p. 86). With this cartoon *Al-Kashkul* was depicting the negative turn of events in Egypt as a result of assassinations in that year that caused factionalism and impeded progress toward full sovereignty as the British had reason to interfere. This domestic in-fighting was, as the cartoonist indicated, distracting the various actors from the turbulent road to independence. The weakness of a woman frightened by death is another symbol of gendered uncertainty. The prescriptive nature of the cartoon is clear—this is a situation that should be avoided.

What is in the national interest is naturally, a matter of debate, even today. That is why we may observe that contemporary cartoons may protest change as frequently as they demand it.

The Visualization of the Female Egypt
The gendering of Egypt as a shy and innocent female figure begging for her independence is evident in the cartoons found in *Al-Kashkul* and *Al-Lata'if al-Musawwara*. She is more youthful, beautiful, and innocent than the foreign powers who clearly have the upper hand in the world.

A tension existed between the traditional female Egypt of the ancient past and the Egypt who demanded her independence. The gender of

255 Personal interview by Tonia Rifaey with Nashua al-Bindan, November 10, 1996.

ancient Egypt represents strength, whereas the young female Egypt of the modern period exhibits gender as but one of her debilities.

Although the Egyptian women's movement paralleled the independence movement, the cartoons did not often allude to the women's movement in Egyptian society spearheaded by nationalists such as Huda al-Sha'rawi, founder of the Women's Wafdist Committee, later the Egyptian Feminist Union. However, the idea of independence, of a powerless creature asserting her rights to life and liberty, pertained to both nationalism and feminism.

Although many of these cartoons chiefly depicted male figures, the use of female Egypt among her male counterparts, such as John Bull symbolizing Great Britain and Uncle Sam as the United States, is quite fascinating. Turkey experienced the same use of gender within its political cartoons to represent the state.

> These male personifications of the European states were the obvious counterpart to the female gendering of the Ottoman state. "She" was a mother, a wife, or a daughter, engendering sentiment through her need for protection and her guardianship of the national honor.[256]

In Turkey, the counterpart to the Westernized woman of Egyptian cartoons was the *ala Franga* woman (the Turkish Marianne) Although the respective Arabic and Turkish terms for nation (*watan/vatan*, "fatherland") are masculine, images of the nation had been feminized in both cases.[257]

In later cartoons printed in *Al-Kashkul* we note a contrast between the Eastern Egyptian traditions, represented by the young Egyptian woman, and the missives of the overbearing British, represented by John Bull (see **figure 38**). The Eastern traditions are seen as wholesome and pure, although challenged by British influence and thus changed over time. The young Egypt who is seen veiled and traditionally dressed, but not afraid to stand up for independence. Later, the cartoons depicted the young Egypt in many forms: unveiled, speaking to men, belly dancing, driving a car, and thus symbolizing the liberation that Egypt had attained or an Egypt that was rebelling its own boundaries. When Egypt-Hanim was depicted as a liberated woman driving an automobile, she was attired in fashionable Western clothing, which is more revealing than Eastern clothing. This may have symbolized the nation's longing for modernity, but it also represented a loss of identity. However, Egypt could be manipulated by her Eastern traditions, as is shown in another

256 Brummet, in Goçek, ed. (1998), p. 29.
257 Ibid.

Figure 38. Lady Egypt and John Bull.

cartoon where a leering John Bull says to Egypt-Hanim, "Why do you want to go to the Conference? [Lausanne] Even if all the countries accepted your independence, you, Lady, are Eastern and your traditions still forbid you from mixing with men"(*Al-Kashkul,* December 3, 1921, p. 81; see figure 38).

This theme continued as Egypt was portrayed several weeks later in the discussion of female "honor" with an Eastern man's twist this time: holding the arm of the portly Nissim Pasha, who says "I don't want you to go to Lausanne and not return to the *harim*. If you go, you will be disobedient and I will ask for your obedience." This is a reference to the practice of *bayt al-ta'a* by which a man could lock up his errant or disobedient (*nashaz*) wife (*Al-Kashkul,* December 24, 1921, p. 83).

Al-Lata'if al-Musawwara contrasted the British policies of insufficient liberties with the idealized independence that Egypt actually sought. Western efforts to appease the Egyptians through incomplete measures were always depicted as corrupt. In two cartoons discussed below, we note this juxtapositioning.

Figure 39 portrays the woman as the freedom and independence that the Egyptian gentleman is trying to attain. However, the shackles of his Western habits constrained him from realizing his dream. The irony in the cartoon is that although he is fighting to free himself from

Figure 39. Strong temptations prevent Egyptian youth from achieving independence, as seen in a 1920 political cartoon. Reading left to right: Woman: "Full independence." Owner of the pigeon-hunting club: "Never!" Liquor merchant: "Tomorrow." Cocaine merchant: "Tomorrow." Man in shackles wearing a fez, "Come to me, my beloved!" The shackles are labeled: "Foreign habits: Pigeon hunting, alcohol, cocaine."

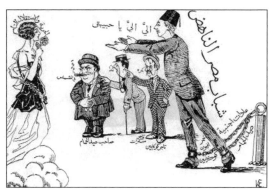

"Western customs," the "full independence" to which he was turning is identified with such customs. The woman, wearing a rather revealing gown, is rising from what appears to be a cloud of smoke. The men in Western attire stand watching and smiles knowingly, for even if the Egyptian man manages to gather the woman in his arms, he is still theirs, shackled by Western power. The cartoonist was trying to warn his readers that independence on British terms was a chimera and did not constitute Egypt's true aims.

In **figure 40** we see a contrasting image. This woman is seated in a restaurant, wearing the *yashmak*, and with her hair covered. As the young Egypt, she is demanding her complete independence on her terms, wearing the *yashmak* that her cultural conscience and nation still requires. The waiter, representing Britain, inquires as to young Egypt's order. The young Egypt is firm and resolved in her ordering "a warm entrée of full independence and a side order of freedom."

Figure 40. In a 1920 cartoon, Egypt asks for an order of full independence with a side of freedom.

Many other cartoons showed the British and Egyptian governments' unjust policies toward the *fallah*, the peasant. The *fallah* worked hard, gained little, and for the most part accepted his lot in life. The British argued that Egyptian administration would not uplift the condition of the *fallah*, and that British policies were intended to help this social class. In **figure 41**, we see a British soldier dumbfounded (as he is being hit with a jug) by the Egyptian peasant woman's hostility. Al-Sayyid Marsot observes:

> Many local and foreign authors writing about Egypt have made the mistake of assuming that because the *fallah* was ignorant he was also stupid. Jokes abound in all the chronicles, ancient and modern, about the credulity of the *fallah*, and how easily he was gulled by the towns-man when he came to sell his wares. The reality is quite different.
>
> There are obviously clever *fallahin* and stupid ones, as in any society, but the major characteristics of the Egyptian peasant is one shared by many other peasants, distrust of the stranger. The

fallah may be gulled by his shaikh, but rarely by anyone else except by a foreigner. In the past, however, his major handicap was his illiteracy, so that he often signed documents that he could not read and was cheated out of his land by the foreign money-lender. His mistrust of the outsider was born of oppression and exploitation and honed during the struggle for survival and his hunger for land (al-Sayyid Marsot, 1977, p. 31).

The *fallaha* was always considered a force to be reckoned with in Egyptian society. Her strength and power in the household was remarked on, as well as her ability to get her own way.

Egypt, when represented as a *fallaha*, unswervingly seeks her rights. The cartoon (**figure 41**) is titled appropriately titled "stupidity," boldly

stating what perhaps all of Egypt felt at the time—that since the British did not comprehend that they were unwanted in Egypt, then they (not the *fallahin*) must have been rather stupid. The officer arrogantly sucks on his pipe and shouts to the *fallaha*: "It is very strange that you don't love me anymore" after she has shattered a water jug on his head. The *fallaha*, wearing the traditional peasant garb emblazoned with a crescent moon, stands with her hand still in motion covering her face, symbolizing British censorship of Egyptian thought and also conveying her modesty.

Figure 41. A 1920 cartoon, entitled "Stupidity," by Juan Santez.

End of the Protectorate

The Egyptians demanded an end to the protectorate status imposed on the country by Great Britain. In January of 1922, the official status of independence was ceded to Egypt. However, this independence was limited, as the British had stipulated four conditions:

(1) security of communications of the British Empire
(2) British defense of Egypt against all foreign aggression or

interference, direct or indirect
(3) protection of foreign interests in Egypt and protection of
minorities (Marsot, 1977, p. 31)
(4) continued British presence and control in the Sudan.

Al-Kashkul reacted with great suspicion to the Declaration of
February 28. In April of 1922, the Council of Ministers approved a
memorandum that proposed the creation of a commission to oversee the
writing of the constitution. The Commission consisted of thirty mem-
bers (*Lajnat al-Dustur* or "Commission of Thirty") appointed by 'Abd al-
Khaliq Tharwat and presided over by Hussayn Rushdi Pasha. Despite
Zaghlul's rhetoric on the matter, the commission was made up of a well-
balanced group representing different interests. Rushdi intervened when
the commission threatened to dwell on certain issues and he broke the
commission into smaller subgroups. Al-Sayyid Marsot reflects that
Rushdi had a difficult job of "compromise between the ideal and the
possible" (al-Sayyid Marsot, 1977, p. 64).

Al-Kashkul indicated distaste for Zaghlul's policies in a number of
cartoons. **Figure 42** indicates the preeminent role that Rushdi played in
the creation of the constitution. Young Egypt is adorned in a magnificent
dress and cloak, the proper garments for an independent nation. Rushdi,
shorter than the statuesque Egypt, is seen as her tailor, finishing the last
stitches. The cloak is Egypt's constitution, which is rather lengthy and
weighing her down. Although this
Egypt is an obvious version of
Lady Liberty, one may also note
various ancient Egyptian symbols.
The bracelet on the leg and the
headpiece, which resembles the
figure of a snake, are traditional
ancient Egyptian symbols, as is her
coiffure. Here, as in the neo-
Pharaonic trend in visual art that
came after this period, there is an
effort to compose a true Egyptian
identity, drawn from the past as
well as the present. However, Egypt
is not smiling, but is surveying her
cloak that is overwhelming her and
may not necessarily fit her. Egypt
has arrived at the symbolic thresh-

Figure 42.
Rushdi
Pasha puts
final
touches on
the fitting
of Egypt's
cloak of
independ-
ence in
September,
1922, car-
toon from
Al-Kashkul.

old of idealized independence according to Western standards, but her discomfort is evident.

The creation of the constitution brought more government bickering to the Egyptian public's attention than ever before. Egyptians did not agree on the implications of the constitution. In another image, Egypt has retrieved her original identity, but is now blinded by the constitution that has been ratified. Egypt-Hanim wears her traditional headcover and gloves, but a blindfold hinders her movement forward. The Sphinx, a representation of Egypt's old glory, shines in the background (Al-Kashkul, March 25, 1923, p. 97).

The Next Act

"And after independence, what then?" (Smith, [ed.], 1976, p. 134).

Sa'd Zaghlul faced intense scrutiny after independence—expectations were perhaps too high. The cartoons in the anti-Wafdist Al-Kashkul focused on Zaghlul's autocratic personality and his broken promises, as in the force-feeding of the young Egypt alluded to above.

Another cartoon alludes to the Declaration of February 28, although in this instance John Bull reprimands the young Egypt as if she were a naughty school girl. Although she has molded herself in a Western image to gain her freedom, she is still not free.

Zaghlul's popularity with and incitement of the masses finally backfired when, on November 19, 1924, Sir Lee Stack, the sirdar, or commander-in-chief of the Egyptian army, was assassinated. When Zaghlul heard the news of the sirdar's death, he said: "We are lost" (al-Sayyid Marsot, 1977, p. 82). Britain, in a sense, had given Egypt just enough independence to demonstrate that it was not able to ensure the continued security of the British—somewhat like the contemporary Israeli claims against the Palestinian National Authority. Now, Zaghlul and his new government would be held responsible for the act of violence. Therefore, the cartoons in this period continue to represent John Bull holding the upper hand.

The political cartoon combines two forms of language, the visual and the textual, Alan Douglas and Fedwa Malti-Douglas point out that "This double coding leaves greater space for ambiguity and contradiction, making strips an ideal location for the examination of unconscious messages" (Douglas and Malti-Douglas, 1994, p. 6).[258] In the case of Al-Kashkul and Al-Lata'if al-Musawwara, independence and the need for Egyptians to stand up to their oppressors were the gist of messages that

258 Ibid.

gained more power or recognition through the use of various visual symbols—masculinity and femininity being but one aspect of these visual codes.

In the second chapter of *Imagined Communities*, Benedict Anderson (1983) emphasizes that mass communication had a profound effect on nationalist movements. Certainly political cartoons illustrate this trend.

In these Egyptian cartoons, the female figure stands simultaneously for a vulnerable site of identity, that constantly reacts to the British and Zaghlul and for independence. These cartoons were meant to incite the Egyptians, who had reached a crossroads politically, to stand up for their identity and selfhood. They did not simply address Egypt's vulnerability as the object of external powers' interests. After 1922, they also illustrated, commented, critiqued, or bemoaned the policies of Egyptian leaders, thereby providing important texts concerning the difficulties of building a nation. The ambiguous messages they carry concerning gender and power accompany their more clearly etched nationalist and populist content.

Cartoons Protesting Change: Gender in Cartoons vs. Woman as Nation
In hunting for allusions to Egypt-Hanim, who apparently disappeared or was absorbed by the emergence of the "New Woman," we found that the press may also protest change through the use of women's images. Cartoons on the passage of the new law of personal status in January of 2000, for example, wittily explored the dilemmas of gender roles or reversals. The new law included articles allowing women to obtain *khul'* (a female-initiated form of divorce) on any grounds so long as she gives up the unpaid portion of her *mahr* ("dowry") and any gifts from the groom. One article of the new law, cut as a concession to conservatives, would have allowed women to travel more easily without male consent. The press, and especially the opposition papers, lampooned women and men, showing women rushing off to obtain divorces, packing for the airport, or beating their husbands with brooms—a portrayal of role-reversal that dates at least back to the 1930s in a prototype by the cartoonist Saroukhan, originally published in 1935 in the magazine *Ruz al-Yusuf,* dusted off and reprinted with reportage of the new laws.[259] Others showed the men scrubbing the floor or dressing as women, as they will soon presumably lose their edge in a legal system that is gradually eroding male privilege

259 Saroukhan's cartoon appeared above an article by Mariz Tadros entitled,"The Word is Out" in *Al-Ahram Weekly*, February 20–26, 2000; see also the following issues of *Al-Ahram*: January 5, 2000, p. 15; January 6, 2000, p. 15; January 18, 2000, p. 15; January 25, 2000, p. 15; January 26, 2000, p. 15; January 29, 2000, p. 15; February 1, 2000, p. 15; February 10, 2000, p. 15; February 27, 2000, p. 15.

(Zuhur, 2001). One cartoon showed workers in a factory producing large-sized plastic freezer bags complaining of the slowdown in sales since the new divorce law passed. The reference is to pre-*khul'* macabre stories and cartoons of women who kill their husbands and bag their bodies in the freezer.

The few abstract images of women appearing at the same time were of the angel of peace bearing an olive branch and peeking through a keyhole in the numbers 2000 (the year) and then, the next day, the angel's dress is caught in the doorway of the year 2000. She is being pulled back, as the caption says *bidun kalam* ("without a word") (*Al-Ahram*, January 12, 2000, p. 15; *Al-Ahram*, January 13, 2000, p. 15). The reference is to the negative fate of the peace process. Yet the angel's gender is not particularly important.

It is significant that few recent images of women in cartoons represented Egypt; rather as in the series of cartoons on the divorce law, male cartoonists wield female images to portray women and men as contentious players in the games of society. It appears that Egypt as a woman has been reduced to a visual formula that may recur under certain circumstances today, but no longer with the sense of urgency contained in the political cartoons of the 1920s. Egyptian women in cartoons are another subject altogether, one no doubt deserving of further study, for in their images the multiple reflections of past visualizations—of Egypt-Hanim, Lady Liberty, stubborn or fertile Fallaha, the subsequent "New Woman" and today's women—merge in the complexities of the postcolonial environment.

22 Meditations on Painting and History: An Interview with Huda Lutfi
Samia Mehrez and James Stone*

James Stone: *I understand that you became a painter fairly recently. What originated your interest in painting? What effect does the origin of the work of art in personal experience continue to have on your output?*

Huda Lutfi: Fairly recently, yes, as a painter. But I was always interested in aesthetics; in the harmony between space and form. In my twenties, I developed a taste for old and beautiful objects. Then, at McGill University in Canada, where I was a doctoral student, I started to appreciate books on art. McGill had a fantastic library, where I could browse through the large collection of books on Arab and Islamic art and calligraphy. I was fascinated by these art forms, and I then began calligraphy as a form of relaxation. I observed that when I relaxed through calligraphy, my mind became empty; it was an act of cleansing thoughts, an act of meditation.

I returned to Egypt in 1983. Two years later, I bought land in a small village in Fayyum and I built a house there. It was then that I discovered mudbrick molds and mud plastering. The clay mud was inviting me to play with it, for it is so malleable. I did not want simply to make shapes with it; I felt I wanted to paint on these mud walls. So I started doing calligraphy on the walls, choosing my favorite verses of poetry, especially poetry with humor and irony.

Color also captivates my attention—color in clothes, in furniture, jewelry, in the arrangement of things; it is so much fun to play with colors. I began to mix different materials—color oxides with clay, collecting shells and pieces of stained glass, old pottery, anything. And then I arranged them together as a mural on the walls.

I traveled to the United States in 1991–92, and taught at Harvard University. I missed home, my family, and my house in Fayyum. I was alone and I had more time on my hands. So I went to museums, and collected art brochures, and cards of my favorite artists. After six months, I had to undergo a major operation. It isn't easy; losing a part of your body. After the operation, I was in pain and couldn't do much. A week

* This chapter was originally published in *Alif: Journal of Comparative Poetics*, vol. 19 (1999), pp. 223–236, © The American University in Cairo Press and the Department of English and Comparative Literature.

later, I sat at my desk, and got the cards and brochures and I started cutting and pasting. I began a collage, and when I was finished with it, it looked like a coherent piece. I remember that this first collage was about the mutilation of a woman's body; the figure of a woman's body cut in half. Perhaps I did that as a way to face my pain and fill my time. And I think that was the beginning.

I'm not formally trained as an artist or painter, and I didn't know how to draw. So I chose collage as a medium, selecting imagery from art books. Being a historian, to start with, this took me to ancient art forms. I have a great liking for ancient art because it holds a feeling of the archetypal. I enjoy representations of the goddesses and the gods, especially the goddesses of ancient Mesopotamia, Egypt, Crete, and India. Their murals are beautiful and spiritually peaceful. I photocopied these figures, painted over them, and arranged them as coherent pieces. Photocopying made it easy for me to repeat these images for meditative effect. In ancient murals, there were a lot of images of women, but there were also pieces in which man and woman are interacting. At that time, it was the human body that appealed most to me. That's how it started.

Without technical training, I just did what I liked. It was like playing, and I was making two pieces every week. It was something that was pouring out of me and my great liking for Arabic calligraphy, ancient art forms, Egyptian art. When I was looking at art books, there was always an image that struck me, that hits something inside of me, that expresses a similar emotion inside of me.

I returned to Egypt, it was still my sabbatical year, and I had some free time. So I built another house in Fayyum. One is much freer with mudbrick architecture; one is not afraid to make mistakes, because mudbrick is a malleable medium and therefore easier to experiment with in the creative use of form and space. I collected windows and doors from old houses pulled down in Cairo and Fayyum, so as to recycle them into the arrangement of new space. During this time, I was simultaneously painting and doing research on the *mawlid* of Sayyida 'A'isha.

I continued doing collages for a while, and then I discovered another technique. I was in Mallorca staying with a friend, and Xavier Puigmarti, a Spanish painter, was experimenting with a new technique; he carved motifs into styrofoam to use it to stamp onto paper or canvas. I thought this was a great idea, because I could then produce the effect of repetition without cutting and pasting (see **color plate 15**).

Technique is experimentation. You learn more as you do it, and you are free to use what you want and wait for surprises. This sense of freedom is quite fulfilling. I am not bound by any rules. Apart from the

peace of mind that art grants one, or observing the emotions on experiences while in the process of doing art, it is a wonderful form of experimental play. Also when negative emotions are experienced, these come out well in the paintings, the stabbing, the cutting of feet, evoking the image of helplessness, etc. At certain moments, I strongly feel the helplessness of the human being—we always think that we can control things and when we can't, we feel helpless. In art, you can temporarily escape this sense of helplessness, because you create a little space for playing, for feeling free.

Samia Mehrez: *Given that you have no formal training in painting, have you nonetheless identified artists who inspired you? What is the nature of the relationship between your work and theirs?*

Huda Lutfi: I'm fascinated by ancient art, perhaps because it is more connected with the spiritual, with evoking rhythmic imagery of movement or images of meditation.

My favorite modern Egyptian artists are 'Iffat Nagi, 'Abd al-Hadi al-Gazzar, Mahmud Sa'id, Kamal Khalifa, and Anna Boghiguian. 'Iffat Nagi, I enjoy because she plays with magical imagery. I use a lot of Coptic imagery, magical signs, scripts, the numerals, geometric symbols, and Coptic dolls (see **figure 43**). Lately I introduced images of animals: lizards, snakes, scorpions, and fish (see **color plate 16**). 'Iffat also uses snakes, and she does beautiful collages of Coptic dolls that no one can reproduce, because she used original pieces. When I look at her work, I say, yes, she knew how to play.

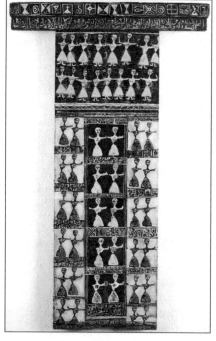

There is also the magical in al-Gazzar's work. I like his surrealist/brute art style. In some of my collages, I used images from Mahmud Sa'id's paintings. I like his women—not many artists portray women with such

Figure 43. "Black and White," by Huda Lutfi. Acrylic, handprinting, calligraphy on wood (27 cm X 60 cm).

intimacy. I also find his women fascinating because they are very masculine, with heavy features, and are quite sensuous.

Kamal Khalifa succeeded in doing something very difficult, the brilliant integration of the figurative and the abstract, he reached a point where he was able to paint women in the form of a flame or a candle. Even his still lifes and portraits are like flames reflecting a quiet but flowing energy. What intrigues me most about his work is its powerful spirituality which he enhances through colorful strokes that are flowing and free.

There are other international artists who fascinate me: Dubuffet, Basquiat, Allouise, a fantastic Swiss woman painter. I am always attracted to brute art—naïve art—because it is unpretentious, spontaneous, and playful. I like Picasso's work because it inspires confidence and humor. He paints the body in an extremely sensuous manner, he's so brilliant with his lines, he can paint figures in credible postures.

One of my favorite artists now in Cairo is Anna Boghiguian. In some of her recent art work, she did a series of black and white paintings on Cafavy, which evoke strong feelings in me. She also has that capacity to draw so well and quickly that she captures everyday life; cafés, people in the metro, walking in the street, people on the trains.

James Stone: *Your early collages draw upon easily recognized icons from both Western and Egyptian traditions and your art continues to draw from your experience as a witness to/of canonical art. How do you nonetheless achieve an unmistakably personal vision amidst the dense allusions in your painting?*

Huda Lutfi: The icons that I used are not merely Islamic or Egyptian; I also use some Mediterranean, Western, or Indian symbols. This is significant because I had always felt guilty about being someone who bridged two cultures. I asked myself, how is that I'm an Egyptian and an Arab and, at the same time, I teach in English and work at the American University? I write and read a great deal in English and I feel comfortable living in a Western culture. My ambivalence about my cultural identity appeared when I was in the United States; I discovered that although I missed Egypt, I was enjoying the taste of another culture and appreciated many aspects of it. I was gradually coming to terms with my anticolonial and nationalist feelings. I am now less conflicted about my cultural identity. Being culturally attached prevents one from appreciating or experiencing the beauty and richness of other cultures. It was through art that I came to understand this. The art museums and libraries in the United States are wonderful, and while there, I viewed many art

forms—Peruvian, Mexican, Chinese, Indian, American, French, you name it. I wanted to express this feeling of freedom from cultural boundaries in some of my collages and so juxtaposed Western and Eastern icons with no discomfort. Certainly, the West colonized the East, but it was a part of our experience, and as with any negative or positive experience, one must go on. Without cultural blocks, I feel I can freely enjoy the creativity of all human cultures.

In terms of creating a personal vision, I feel that I have created and am now more at ease with my own artistic vocabulary. When I feel a certain emotion, the appropriate image instantaneously captures my attention. For example I introduced a snake with legs, an ancient Egyptian symbol of wisdom, or positive instinctive energy, but it could also be evil or dangerous energy. I wanted to become friends with the snake, I wanted to befriend my negative energy. When I gave it legs this meant it is moving out of my system. So in this way, I personalized one of the ancient icons (see **color plate 16**).

Books have long been a part of my life. As a graduate student, I used medieval Arabic documents to study the history of Mamluk Jerusalem. I spent several years deciphering these documents, which were handwritten in a cursive, nearly illegible script. When I mastered the script, I loved it. Because my handwriting in Arabic is horrible, when I introduced calligraphy to my collages, I decided to photocopy these legal documents and cut and paste them in. After two years, I decided to use my own handwriting; I no longer cared whether it is beautiful or ugly. What encouraged me was the peaceful effect that calligraphy had on me.

I might use a Sufi text, which was often repeated for meditative effect, or invent my own text, combining other texts. The repetition of certain lines or verses became a totally absorbing experience, because the words resound in one's head. This is a very personal meditation, even though I might be using canonical authorities like Ibn 'Arabi, or Ibn Hazm. One internalizes the text as it corresponds to emotions experienced during the writing process. Sometimes the text corresponds closely with the images in a painting, and sometimes not. What is most important is that the writing process involves a deep level of concentration, or meditation.

Later, when I became more comfortable with my own calligraphic style, I reexamined the medieval documents, discovering that the artists had also subverted calligraphic rules—the *alif* and the *lam* might be joined, sometimes two words are joined together, truly straight lines might not exist, etc.

In more recent work, I started to etch on different layers of paint, so that the lower layer appears in a contrasting color and this must be done

very quickly (see **figure 44**). The technique pushed me to abstract the calligraphic icon, joining words, omitting dots, my pen had to move very quickly. I had little time to think. If the meaning is less apparent, well, I feel that I don't always want everyone to immediately understand my work.

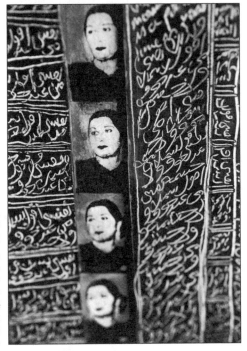

Figure 44. "I want to say... (Umm Kulthum)," by Huda Lutfi. Acrylic, engraving, calligraphy. Detail of diptych (24 cm X 19 cm each).

Samia Mehrez: *As a historian, you have written extensively on women's issues, sexuality, and gender relations. What is the nature of the relationship between your historical research and your artistic output? Does your art confirm, contest, or subvert your work as an historian?*

Huda Lutfi: History in the university seemed to omit women. I began to take history more seriously, when as a graduate student at McGill, I began to examine primary sources. This was in the early 1980s when very little was being written on women in Arabo-Muslim history. I started to ask, "where are the women?" In a course on Mamluk historical literature, I worked with a biographical dictionary that happened to include biographies of women. There they were! I had discovered that women were present in historical literature. I learned that women transmitted hadith and used to study and teach. They don't appear as frequently as men do, as historical literature has been written by men.

In many of my paintings, the female body is the expression of the feminine (see **figure 45**). In this sense it is closely related to and reinforces my historical research. Women need their historical presence. My painting also contests the fact that women are rarely present in the historical chronicles as if to say, well, here they are in image form.

More recently, I have been working on the meaning of birds in medieval Arabic dream texts. I found birds appearing in my paintings (see **color plate 17**). I used them as symbols that express freedom of

movement and spirit. I
always choose icons to
convey feelings and emo-
tions (see **figure** 43). For
example, I used the Coptic
paper doll which used to be
pricked with pins as a
magical practice to destroy
evil or bad energy. When I
saw one of these dolls in
the museum, I happened to
be undergoing some per-
sonal family problems
which had left me feeling
helpless. I felt that I was
that doll.

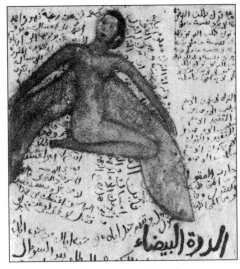

Figure 45.
"The White
Pearl," by
Huda Lutfi.
Acrylic,
calligraphy,
on wood.
Detail
(whole
work, 26
cm X 86
cm).

James Stone: *Arabic script anchors your work in a pervasive system of
variation and repetition, surcharging the work of art with a symbolism
that is both meaningful and full of imagery. How does the written text
affect your understanding of the human figures that it situates?*

Huda Lutfi: Yes, although in my later works, I use less of it. I still
return to the script as it is a favorite icon. Let's say I have an image
of a woman and a man holding hands and walking together. There is
an obvious bond of love connecting these figures. So I used Ibn
'Arabi's text on spiritual love so as to produce the idea that spiritual
love is not in conflict with sensual love. Ibn 'Arabi in particular has
dealt with that issue. I always return to Ibn 'Arabi, because he taught
me something that I was unable to resolve as a younger woman con-
cerning the conflict between the material and the spiritual. Ibn 'Arabi
holds that they coincide.

I discovered that Ibn 'Arabi writes that the creative process involves
the interaction between the feminine and masculine elements and that
interaction is love. As a mystic, not simply a theorist, he considered this
to be the highest form of mystical experience, which mirrors the reality
of the creative process. I continue to read Ibn 'Arabi, and inscribe his
texts in my paintings.

As for using texts written by men, well why not? I appropriate the
male text to say what I want, and by juxtaposing it along with feminine
icons, I am making a different use of it.

Samia Mehrez: *Your 1997 exhibit at the American University in Cairo was aptly entitled, "Women and Memory." Could you elucidate your understanding of this relationship as you have depicted it in several of your paintings?*

Huda Lutfi: In painting, you are not bound by a rigid methodology as in research. So, in my painting of Umm Kulthum, I gather feminine symbols together from different periods (see **figure 44**). Here they are! Here are the archetypal feminine icons, the fertility goddess, the goddess of love and life juxtaposed with modern goddesses, the singer, or the actress. By condensing these figures into one particular space you have a powerful sense of their presence, not only today, but also in the past, in memory. In art, you can go beyond boundaries, you are playing.

Women and memory refers not only to historical memory in the collective, it also acquires a personal sense. Through the images, I am telling my story. Painting is a form of recording memory. I am remembering certain experiences, I remember my dismemberment and recognize it. Women often have some inability to express their sexuality, their emotions, and energy, but here, I express myself in images.

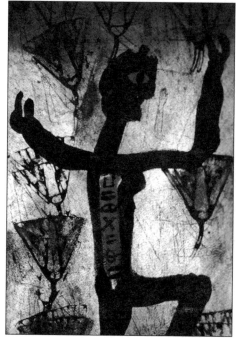

Figure 46. "In Search of the Lotus," by Huda Lutfi. Acrylic, handpainting, on leather. Triptych (11 cm X 30 cm each).

James Stone: *The gaze of one of your stock icons in particular allures me, the female figure in profile with a single enlarged eye. Why does this arresting image crop up frequently in your painting?*

Huda Lutfi: You chose one of my favorite icons that has been in my painting from the start. Whether in the form of a single eye or two eyes in a face, I always depict big eyes (see **figure 46**). The eye is the symbol of seeing, perception, becoming aware, knowing, wisdom. Reality is also the act of knowledge, because

one constantly looks and perceives. And I like eyes. They appear in the circle of time, or magical imagery in some of my paintings. The act of painting itself is an effort to see, to see oneself, the effort to understand oneself.

Samia Mehrez: *Many of the female figures in your paintings are framed, contained within cages, boxes, windows. Their posture within these frames seems to me ambiguous; often their arms are raised in an attempt to support/break through these frames. Could you comment on this ambiguity?*

Huda Lutfi: Yes, they are framed. The frame is a feeling. Women have been framed in boxes and windows. The posture in my paintings is both (see **color plate 18**). That is why it makes you wonder whether they are trying to escape their position or accepting it. Women go through both processes—they support being framed, but they also reject it. There are times when I feel that I am trapped in a box, or a cage, and I want to get out. There are other moments when one accepts reality. However, I do feel framed in the structure. That framing is not simply external, it is internal and can become very dangerous, or problematic. The cultural frame is so ingrained within us through a conditioning process that one frames oneself unconsciously. And seeing it, becoming aware of how it works is crucial in terms of self-knowledge.

I have asked myself, "Why do I choose the frame?" Is it simply due to my lack of training as a painter? Or is it connected to my own feeling of being framed? It can be both a technique, and an emotion. Superficially, I may seem less constrained, or framed. I am a university professor, I am very active and have many friends. But what about psychological framing? This is the question.

I don't think that being framed is a uniquely female experience. I think that all human beings who live within social structures, as we do, feel that they are framed. We support the social structure because we believe that this will help us to reproduce an orderly human society. Can we escape these frames? Who invented such structures, women or men? Most certainly *both*. We are all implicated in our frames and have framed ourselves.

In the paintings, women with raised hands reflect a state of acceptance, or resignation to reality. That posture of raised hands also reflects a spiritual state (see **figure 47**). For me, spirituality may be expressed in flow, in rhythm, or dance, but also in stillness and silence—a stillness of intense vision, and of being hypnotized. For me, stillness or silence is the absence of thought in the mind. It is a great relief to silence the chattering of the mind and experience stillness.

Figure 47. "Submission or Acceptance," by Huda Lutfi. Acrylic, calligraphy, on granite. Detail (complete work, 19 cm X 17 cm).

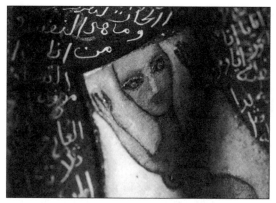

James Stone: *How should we gender your representations of the human form? Why are your few male figures almost always androgynous?*

Huda Lutfi: My representations are almost always of women (see figure 45). I'm not trying to stress the physical difference between the feminine and the masculine. That is why painting is important, because one is confronted with an image that one created unconsciously, and these images help you to understand yourself. Society reinforces and sharpens the opposition between the sexes, although sometimes men may be more "feminine" than women, and vice versa. The men I paint are not muscular or physically oppressive, they are not men who are oppressed by their physicality. Perhaps I have projected an aim to see men and women coming closer together, being less feminine, or less masculine. Maybe I would like to see this in my everyday relationships. I pose all of this as questions, because I am not certain of the answers.

James Stone: *Is your art jubilant or anguished? If art is a sublimation of painful experiences in one's life, then how do you respond to a viewer like myself, who primarily sees the richness of the impasto, the formal security of repeated symbols, the passionate earthiness of the making?*

Huda Lutfi: I can't say either way. I think it could be both. There are times when I feel like dancing and want to express movement, so that will be portrayed. And there are other times when I am experiencing pain, loneliness, anger, or jealousy. But I am also aware that these emotions are not permanent—they keep shifting all the time.

Samia Mehrez: *You have exhibited your paintings inside and outside of Egypt. Could you tell us about the reception of your work? Have you encountered any problems given the nature of the representation in your paintings?*

Huda Lutfi: The first time I exhibited was in Marseilles in 1996. I had been painting for four or five years. My work was well received; I was awarded second prize in the Biennial Exhibit for Mediterranean Women Artists. It gave me a push to continue.

My first exhibit in Egypt was at the Ewart Gallery at the American University in Cairo. There were mixed reactions. Some people were very enthusiastic and thought that it was different. It was successful in the sense that people liked the work and expressed an interest in buying it. And then there were reactions of complete indifference from the community of Egyptian artists who either said nothing about the exhibit or did not come to see it.

Then I participated in a collective exhibit at the Cairo Atélier. Some of the artists who organized the exhibit helped me select some of the paintings. I was a little disappointed when some rejected the pieces with female nudes because they thought that they wouldn't be appropriate to exhibit. For me, human nudity is a representation of a state of purity, it is without class, culture, or social inhibitions. It is a free and innocent state. Perhaps I feel less pressured by such constraints to avoid using the nude, because I am not in this for commercial reasons. I do not rely on my art to make a living, I do it for myself. At the same time, I would like to sell it, not only for the money, but to know that people enjoy it, and to lose some of my attachment to the work. So, sometimes, I like to give some pieces away as presents.

In an exhibit at the Mashrabiya, a commercial gallery, I had a wider audience; my work was well received. People appreciated the work and what it evoked. Perhaps we sometimes exaggerate our fears of what others think of us.

Samia Mehrez: *Your work has been described as not belonging to a particular school or trend of modern art. Does this affect you? Do you prefer to remain on the margin?*

Huda Lutfi: I believe I am on the margin anyway. Perhaps I like to be on the margin. The American University in Cairo is on the margin of Egyptian society at large; doing gender history is on the margin. I don't belong to a particular school or trend because I was not formally trained as a painter. I may like being a loner in this sense; I do not have to conform to fashionable trends, or follow certain rules. But I am fortunate in having friends who are artists. I love seeing their work and learning from them. I also try to go to exhibits, inside and outside of Egypt.

About being on the margin: some eight months ago, I began teaching children how to paint. This came about by accident. My friend Kamal Fahmy, who directs a center in Giza for street children, had repeatedly asked me to visit the center, and I did in June of 1998. When I arrived, I found the children sitting around a big table drawing. So I started painting with them, and we made fantastic paintings together. I decided to work with the kids once a week and discovered that I was learning a lot from them, even though initially, they did not know how to use paint. What I appreciated the most was their spontaneity in the use of lines and colors. When you come to painting with conceptual baggage, you cannot do that. Most of these street children are quite uninhibited because they have had little formal schooling. They are very sharp, however, and they learn quickly. It is quite gratifying for me to work with them, both as a teacher and as a painter. They have this amazing courage to harmonize such colors as bright red, yellow, pink, and mauve, whereas I never thought I could use these colors together. Working with the children constitutes a reciprocal learning process, and after six months, their work was so impressive that we were able to organize two exhibits.

Glossary

Abu Zayd al-Hilali: subject of Arab traditional song epics. An Egyptian version is known as the *Sira al-Hilaliyya*

al-Ahjur: a valley in rural highland Yemen

'alima/almeh/'awalim: a premodern term for dancer/singer in Egypt who perform for female or male audiences and was considered to be "learned" in her art (the term, literally, means "one who knows," a title used in all trades and their guilds

Antar and Abla: Hero-knight and heroine of an Arab traditional epic along the lines of Romeo and Juliet, for the black Antar was spurned by Abla's family

Alf Layla wa-Layla: *A Thousand and One Nights*, a classical text in which Shahrazad relates stories to Shahryar, her husband to distract him from murdering her

'aql: the intellect; in Sufi terms, intellectual knowledge

arabesk: contemporary Turkish popular musical form akin to Arabic "pop" music today

'ashiq: literally, the lover; a bard and storyteller, known as *ashlikar* in Turkey, a form of minstrel who may travel and perform epic or more modern songs in the eastern and northeastern Muslim world

'ataba: a Syro-Lebanese vocal improvisational form

'awda: literally, return, and signifying the return of the Palestinian refugees from exile

'Azbakiya: once a pond, this became a theater district in Cairo

Bairam: the *'Id al-Adha*, or Feast of the Sacrifice, commemorating the release of Isaac, and the sacrifice of the lamb in his stead, celebrated by Muslims at the end of the pilgrimage to Mekka

bala': a form of poetry performed as part of a competition at men's wedding parties in highland Yemen

bara': a dance form of highland Yemen marking tribal affiliation and performed by men out of doors, and more recently, by professional dance troupes

barbari: Nubian, from Nubia in Upper Egypt; possessing a distinct language and muscial style

bashraf: an Arabo-Ottoman instrumental piece (*peshrev* in Turkish) with the affect of a solemn march. Like the *sama'i* which may follow the playing of a *bashraf*, it has sections and a refrain (*taslim*)

buzuq: a soprano relative of the *'ud* but with a smaller body, longer neck, and metal peg. Played in historic Syria (Syria and Lebanon) and associated with rural highlands, and the gypsies (*nawar*)

dabka: folkloric line dance performed in Lebanon, Syria, Jordan, and Palestine. Staged and choreographed in contemporary times, it may be performed by men and/or women

daff: a frame drum or tambourine, with or without cymbals

danse du ventre: belly dance, more specifically referring to professional perform-
ances as compared with the Arabic term *raqs sharqi*, a style of solo dance
that can be performed by ordinary women at weddings, for example

darbukka: also known as *tabla*, the clay, metal, (or today, plastic) drum with fish
or synthetic skin, played with both hands. It is usually held under one arm
and is used throughout the Middle East as percussion. Its shape can be like
an upside-down vase with varying neck widths

dayr: village

dhikr: literally "remembrance," *dhikr* refers to the Sufi sessions involving chanti-
ng of particular phrases and verses or, for some orders, movement and song.
In the public Egyptian *dhikr* or *hadhra*, an *imam* leads (and sings) the partic-
ipants are called *dhakkira*, and they are guided by the *mustaftih* who indi-
cates the changes in tempo and meter

djoze: a four-stringed bowed violin played upright, used in Iraqi classical music

Druze: an indigenous Muslim sect, an offshoot of the Isma'ili Shi'a found today
in Syria, Lebanon, and Palestine with an esoteric dogma and belief in the
transmigration of souls

dulab: a short instrumental piece usually introducing the *maqam* in the Arabo-
Ottoman repertoire

effendim: literally, members of the *effendi* class, used to indicate the plural "you";
more recently in Egyptian conversation to mean "pardon me, good sir
(lady)," or "come again?" and in answering the telephone

fallahin: a term for peasants and farmers. More recently the tribal people of
Yemen have begun using the term, although historic categorization divided
them from sedentary peasants in the past

fannan: artist, actor, dancer, or musician; also used for performing stars

fasl mudhik: comedic sketches in which entertainers created brief "roasts" on
figures of authority, or servants, imitated animals, or told jokes

finjan: a coffee cup

funun jamila: fine arts

galabiya: traditional garment in Egypt, a long, long-sleeved robe comparable to
the *thob* (Lebanon) or the *thawb* (the Gulf), somewhat more full in cut, and
made in various subregional styles

al-gadid/al-jadid: literally, the new. In Egypt, refers to Arabic music from the
1920s or 1930s onward

Goha: or Joha Nasruddin, a comical protagonist of whom moralistic stories and
short sayings are told in Arabic and Turkish traditions

habit: decadent; referring to the commercial theater in Egypt

hafla: party, or festive gathering where music may be performed

ya hadhra: "O, sir," a term of respect

hakawati: a traditional story-teller. In some areas, the *hakawati* might serve as a public reader to his audience

hal/ahwal: a state of consciousness; Sufis aim to progress from one hal, or stage of understanding, to the next

harim: a harem, up to the early modern era, meaning the elite women of a household, and also to the area of the household where they lived

inshad: Sufi mystical songs with poetic and philosophical texts

intifadha: an uprising, usually referring the Palestinian Intifada of December 1987 or the Intifadha al-Aqsa, which refers to the Palestinian reaction to Israeli troops beginning in October of 2000

jalsa: literally, a sitting, or a small intimate gathering at home at which music may be performed

jinsiya: nationality

karagoz: shadow puppetry; also a specific comic Turkish character. The tradition of *karagoz* shadow puppetry spread throughout the former Ottoman land

la'ibiyya: an older form of lu'b; a line dance, performed in the past with tiny steps on a *mandil* (kerchief, headcloth), and more recently a complex form comprised of several subsections

lawn: literally, color, in Arabic music it means the affect, or style of a piece, or seg-ment of a piece as indicated by the melodic use of the *maqam*, or sometimes the rhythm. Hence, *lawn baladi* (rural, earthy folk music) *lawn gharbi* (suggest-ing Western music), *lawn badawi* (a Bedouinlike melody) or *lawn tarab* (invok-ing the tonalities of more traditional Arabic classical, or "art" music)

longa: like the *sama'i* and *dulab*, a form of the Arabo-Ottoman instrumental repertoire, the *longa* was more lively, and demanding technically. Like these forms it is identified by the *maqam* it features, and sometimes, the compos-er's name (hence Longa Riyadh for one composed by Riyadh Sunbati or Longa Kurd for one in the *maqam* Kurd)

lu'b: term for dance forms found in Yemen, also in Saudi Arabia. In Yemen it is a couple dance performed by two women, two men, or more rarely, a man and a woman

mada'ih nabawi: eulogies sung for the Prophet Muhammad or Muslim popular saints

mahabizzoun: all male actor/musician groups who performed comedic plays in Edward William Lane's era

maqam (s.), *maqamat* (pl.): The modal system of Arabic music comprised of groupings of eight tones, not necessarily identical in the ascending and descending of scales. Examples include Bayyati, Nahawand, Kurd, and varia-tions thereof, such as Muhayyar Kurd. *Maqam* also refers to a particular kind of vocal suite featuring improvisation performed in Iraq

masrahiya: a musical play corresponding to the Western "musical"

mawwal: a vocal improvisation based on the *maqamat* and lines of verse, or on

single words, and sometimes even syllables. Can be sung with or without rhythmic accompaniment or instrumental "shadowing"

mijana: a type of *mawwal*, or vocal improvisation, performed in Lebanon, usually as a section of a song on syllables of a phrase

milayya, milayya laff: a black outer wrap worn by urban lower-class Egyptian women

Minya: a town and province in Upper Egypt

mughanni/ya: a singer

mawlid (s.); *mawalid* (pl.): festival of a Muslim historical figure regarded as (moulid) "saintly," celebrated in the streets of cities and villages

munshid: a professional singer of Sufi mystical verse

musiqa: the Arabic term for secular vocal or instrumental music including Eastern as well as Western musical forms

musiqar: a musical master or composer in Western or Eastern music

mutrib: a master of Arabic music (literally, one who possesses the ability to enchant the listener) and can refer to a vocalist, instrumentalist, or a composer who also performs as the term measures the art of performance

muwashshah/at: reportedly a poetic form that was later set to music, originating in al-Andalus (Arab/Islamic Spain) and imported with refugees from Spain after the expulsion. The vocal form is performed by a chorus and soloist and there are Syro-Lebanese as well as North African versions

muzayyin/mazayina: a subgroup of lower status of the *Bani Khums* tribe who nevertheless have ritual knowledge. May serve as barbers, musicians, etc.

nay: a reed flute; in Egypt, the *salamiya* is a soprano version and the *kawala* has a deeper tone

naqqal: Farsi term for a storyteller, parallel to the *hakawati*, who may tell stories from the poet Ferdowsi's *Shahnameh* ("Book of Kings")

Orientalism: (1) A trend in visual and performing arts, and in some aspects of popular culture that began in the West in the nineteenth century (2) the formal study of Middle Eastern languages, literature, culture, and religion (3) a critique in the form of a book, *Orientalism*, written by Edward Said about the deeper intent of the Orientalists' canon which had combined intellectual study with imperialist and neoimperialist worldviews, racism, and antipathy to Islam. Other scholars have further explored the implications of this meaning of orientalism

pesteh: a light-toned song performed in the cycle of Iraqi *maqam*-singing. The instrumentalists may sing the pesteh, instead of or trading off with the featured soloist, as may the audience

qabil/qaba'il: a tribe/the tribal population. While many natives of Middle Eastern countries can trace their families back to tribal origins, the term usually refers to those who still live with their tribal group and adhere to customary (tribal) law

al-qadim: literally, "the old." In Egypt, refers to Arabic music of the Arabo-

Ottoman tradition which began to be replaced with modern compositions
and forms in the 1920s and 1930s

qafla: a musical phrase or cadence

qalb: literally, the heart; in Sufi terms, knowledge of the heart

qanun: a zither played on the lap (or on a table in Egypt) and plucked, shaped
like a large parallelogram; it has 144 strings that can be adjusted for micro-
tones by use of *'uraba*, small stops on the edge of each string

qaragoz: traditional shadow play with puppets, also spelled *karagoz*. In Turkey,
there is also a character with this name. In Egypt, the tradition also continues

qasida: In general, a strophic poetic form. In twentieth-century Arabic music, the
qasida remained the basis for full-length songs in *lawn tarab*. In Yemen,
qasida refers to a particular form of issue-oriented poem sent by the poet
and performed in a light song (*ghina*) by a messenger, and requires a poetic
response. Such poetry is available on audiocassettes

rababa: a one- or two-stringed, bowed spike fiddle traditionally played while
seated on the ground; it is a Bedouin instrument

rai: a contemporary popular musical form that developed in Algeria. The lyrics of
rai may mock or protest authority and social mores, and as it began as a
music of youth, the stars of rai are referred to with the title Chab (young
man) or Chabba (young woman) before their names, i.e. Chab Khaled

raqs: the Arabic term for dance, sometimes denoting professionalized dance
rather than other forms. *Raqs sharqi* (eastern) can mean belly dance or solo
dance in the style of belly dance, whereas *raqs baladi* means indigenous
dance and implies folkloric movement.

riqq: a tambourine with resonant fish skin. The skin and cymbals are played with
the fingers rather than simply shaking the instrument

sada: the elite of tribal groups (hence the honorary derivative, *sayid/sayida*)

sahra: an evening party where music may be performed

saltana: the state of ecstasy that a listener must reach and a performer must
achieve for *tarab* to exist

sama'i: an Arabo-Ottoman instrumental composition based on a *taslim* (refrain)
that precedes and follows a melodic segment called a *khanah* that may fea-
ture transpositions to a related *maqam*. The *sama'i* has three to four *khanahs*
set to a 10/8 rhythm (except for the final *khanah*, often in 6/8, 3/4, or 7/8).
The study of Arabic music traditionally began with the *sama'iat*

sammi'a: literally, a listener; this implies a true connoisseur and aficionado of
Arabic music. Performers of Arabic music enjoy the expressive vocal
responses of such listeners in their audiences

santur: a zither played in Persian and Iraqi music. Similar to the *qanun* but with-
out the *'uraba* (wooden stops allowing for changes in microtone), microtones
can be adjusted only by shifting a longer bar. It is played with mallets and

rests on a hollow table/stand

sha'ir al-rababa: a singer who accompanies himself with the stringed, long-necked, bowed upright instrument, the *rababa*, performing stories or poetic epic texts. The *rababa* could be made of a tortoise shell or of wood

simsimiya: instrument in the lyre family from the Egyptian Red Sea coast, the Sinai peninsula, and Yemen. Sometimes called the *tanbura*, which in its Nubian form has a neck made of goat-horn

siyahbaze: a comic traditional Persian play in which the central character performs in blackface, as a clown at weddings

Sufi: a Muslim member of a mystic order whose aim is to approach God and gain self-understanding

sulha: a reconciliation ceremony between the members of feuding families

sumud: literally, steadfastness, *sumud* also refers to the Palestinians who remained in their homeland despite hardship in retaining their property

tabarruj: illicit display, usually of the body

tabla: used interchangeably with the term *darbukka*; a clay, metal, or plastic drum with a fish-skin head (or today, also specially treated plastic) played under the arm, and across the lap if seated

tabl baladi: a larger drum played with sticks, also known as *tabla*. Essential to Lebanese rural and Sai'di music. The Lebanese *tabbal* may dance while playing

tahmilah: an instrumental form from the later Arabo-Ottoman tradition. A sectional piece, it builds on a theme that is introduced, and then elaborated on, and modulated by a single instrument, with the *takht*, or ensemble, echoing each new phrase

ta'iziye: a historical Persian "passion" play telling the story of Hussein, the grandson of the Prophet Muhammad, and his death at the hands of the 'Ummayads; also more generally, a ceremony for death

tajribi: experimental; also the title of the Experimental Theater Festival and competition held annually in Cairo

takht: literally, a stage or platform, it became the name for the small traditional Arabic orchestra that performed on a raised dais or stage. A traditional *takht* included an *'ud*, a violin (*kamanja*), a *riqq*, and a *qanun*, with the possible inclusion of a *nay*

taqasim: instrumental improvisation in Arabic music. An art form unto itself, the best musicians illustrate their knowledge of the *maqamat* in exploring the rhythmic and melodic possibilities of their instrument in the *taqasim*

tarab: the quality of enchantment possessed by the finest Arabic music, it is an aesthetic term expressing the power of the performer to capture her/his audience

tariqa/turuq: Sufi brotherhood, or "order." The leadership of such orders may go back to early periods in Islamic history

tchalgi Baghdadi: a typical Iraqi ensemble of Baghdad which might include the *qanun*, the *santur*, the *djoze*, the *nay*, the *naqqara*, the *darbukka*, the *riqq*, and possibly the *'ud*

'ud: a large-bodied, bent-neck lute, played in Arabic, Turkish, and Persian music, dating back to the eighth century, if not earlier

ughniya: a vocal composition, a song. The form began to be popular earlier in the twentieth century

'umda: in Egypt, a village headman

zaffa: entertainment at a wedding celebration, often performed as a procession

zajal: a form of rhymed verse in colloquial Arabic, or a category of folk song (and improvised sung verse) in Lebanon, Syria, and Palestine. Also a Moroccan oral poetic tradition (also in colloquial language) historically recited in outdoor performances, now written and published

zamil: a two-line composed poem, performed outdoors by ranks of marching men at festivities or conciliation ceremonies in Yemen. Often political in nature, addressing a particular grievance. The word's general meaning is a dear (male) friend, a best friend

zamr: a double-reed instrument played in Lebanon, and historically, a specialty of the Gypsies (*nawar*)

Bibliography

Compiled by Sherifa Zuhur

References below are listed alphabetically by author or by title (when no author's name is used). At the left of each reference is one or more one-letter codes to assist the reader in identifying items by topic. Topics include: **A** (art); **C** (cinema); **D** (dance); **M** (music); **P** (poetry); and **T** (theater). Those Arabic or Persian names previously published in Western languages appear in the various systems of transliteration that were used. All other Arabic names in the bibliography, except for those in Moroccan dialect, are included under the AUC Press' system of transliteration. The Farsi titles correspond to the Standard International Transliteration system employed by the *International Journal of Middle East Studies*. The names and terms in Iraqi, Moroccan, and Lebanese dialects are given with modifications that fit their pronunciation.

T 'Abd Allah, Ghassan. 1979. *Al-masrah al-filastini bayna al-tajriba wa al-'asala.* Jerusalem: [no publisher listed].
——————. 1990. *The Siege.* Jerusalem: Dar al-'Awda.

M 'Abdullah, Abdullah Ahmad. 1975. *Farid al-Atrash: Lahn al-Khulud.* Cairo: Dar al-Sha'b.

M 'Abd al-Wahhab, Muhammad. 1975. *Mudhakkirat Muhammad 'Abd al Wahhab.* Edited by Muhammad Rif'at al-Muhami. Beirut: Dar al-Thaqafa.

M ——————, et al. 1975. *Farid al-Atrash: Bayna al-fann wa al-hayat.* Cairo: Dar al-Ma'arif.

T Abdel Wahab, Farouk. 1974. *Modern Egyptian Drama: An Anthology.* Minneapolis: Bibliotheca Islamica.

M Abdul Halim Hafiz, Seven Feet Under Ground and Still Singing. [n.d.] *Al-Musiqa al-'Arabiyya*, issue no. 15. Kifah Fakhuri, ed. Amman: Noor al-Hussein Foundation.

T Abou Saif, Laila Nessim. 1969. The Theatre of Naguib al-Rihani: The Development of Comedy in Modern Egypt. Ph.D. Dissertation, University of Illinois at Urbana-Champaign.

T ——————. 1973. Najib al-Rihani: From Buffoonery to Social Comedy. *Journal of Arabic Literature*, 4, pp. 1–17.

A Abu al-'Aynayn, Sa'id. 1990. *Rakha...faris al-karikatir.* Cairo: Dar Akhbar al-Yawm.

C Abu Lughod, Lila. 1995. Movie Stars and Islamic Moralism in Egypt. *Social Text*, 42, Spring, pp. 53–68.

C Abu Sayf, Salah (ed.). 1994. *Mawsu'at al-aflam al-'arabiya.* Cairo: Bayt al Ma'arifa.

A Adams, Marie Jeanne. 1973. Structural Aspects of Village Art. *American Anthropologist*, 75, pp. 265–279.

P Adonis. 1990. *An Introduction to Arab Poetics.* Austin: University of Texas Press: Austin.

D Adra, Najwa. 1973. Style and Information in Balinese Dance. Unpublished ms.
——————. 1982. Qabyala: The Tribal Concept in the Central Highlands of the Yemen Arab Repubic. Ph.D. dissertation, Temple University.

D ——————. 1993. Tribal Dancing and Yemeni Nationalism: Steps to Unity. *Revue du monde musulman et da la méditeranée*, 67:1, pp. 161–168.

_____. 1996. The 'Other' as Viewer: Reception of Western and Arab Televised Representations in Rural Yemen. *The Construction of the Viewer: Media Ethnography and the Anthropology of Audiences*. Peter I. Crawford and Sigurjon Baldur Hafsteinsson (eds.), Højbjerg: Intervention Press.

D _____. 1998a. Middle East: Dance Research and Publication. In Selma Jeanne Cohen (ed.), *International Encyclopedia of Dance*. New York: Oxford University Press, vol. 4, pp. 414–417.

D _____. 1998b. Middle East. An Overview. In Cohen, Selma Jeanne (ed.), *International Encyclopedia of Dance*. New York: Oxford University Press, vol. 4, pp. 402–413.

D _____. 1998c. Dance and Glance: Visualizing Tribal Identity in Highland Yemen. *Visual Anthropology*, 11:1,2; pp. 55–102.

D Ahmad, Ibrahim Farhan. 1978. Al-darja. *Al-turath al-sha'bi*, 9:4, pp. 59–67.

T Akhundzadeh [Akhundzadah], Fath'ali. 1963. *Alefba-ye jadid va maktubat.* Baku: Azerbaidzhan SSR Elmler Akademijasy.

T 'Ali, Mahmud. [n.d.] *Saraqu al-sunduq, ya Muhammad: min silsila turath 'Ali al-Kassar.* Cairo: Al-Majlis al-'Ala l-il-Thaqafa.

A Ali, Wijdan (ed). 1989. *Contemporary Art from the Islamic World.* London: Scorpion.

A _____. 1994. Modern Arab Art: An Overview. In Salwa M. Nashashibi et al., *Forces of Change: Artists of the Arab World.* Lafayette, California: International Council for Women in the Arts; Washington DC: the National Museum of Women in the Arts.

A _____. 1997. *Modern Islamic Art: Development and Continuity.* Gainesville, Florida: University Press of Florida.

M Aliksan, Jan [Jean Alexian]. 1987. *Al-Rahbaniyun wa Fairuz: Alf 'amal fanni, khamsuna 'amman min al-'ata'.* Damascus: Dar Tlas.

T Allen, Roger. 1979. Egyptian Drama after the Revolution. *Edebiyat* 4:1, pp. 97–134.

T _____. 1981. The Artistry of Yusuf Idris. *World Literature Today*, 55:1.

T _____ (ed.). 1987. *Modern Arabic Literature.* New York: Ungar.

T _____ (ed.). 1994. *Critical Perspectives on Yusuf Idris.* Washington, D.C.: Three Continents Press.

T Alrawi, Karim. 1998. *A Gift of Glory.* Rochester, NY: MBPAC Press.

T Amin, Dina. 1998. Temporal and Spatial Reconstitution in Alfred Farag's Play *Al-Shakhs. Journal of Arabic Literature.* 19:3-4, October-December, pp. 167–184.

T _____. 2000. Women in the Arab Theater: Finding a Voice. *Al Jadid*, 30, Winter, pp. 8–10, 19.

T And, Metin. 1963-64. *A History of Theatre and Popular Entertainment in Turkey.* Ankara: Forum Yayinlari.

D _____. 1976. *A Pictorial History of Turkish Dancing: From Folk Dancing to Whirling Dervishes, Belly Dancing to Ballet.* Ankara: Dost Yayinlari.

M, T _____. 1984. Ataturk and the Arts, with Special Reference to Music and Theater. In Jacob M. Landau (ed.), *Ataturk and the Modernization of Turkey.* Boulder, Co.: Westview Press.

Anderson, Benedict R. O. 1983. *Imagined Communities: Reflections on the Origin and Spread of Nationalism.* London: Verso.

T Anis, Muhammad. 1979. *Al-Haraka al-masrahiya fi al-manatiq al-muhtalla.* Haifa: Dar Galileo.

C Arab Cinematics toward the New and the Alternative. 1995. *Alif: Journal of Contemporary Poetics* (full issue), 15.

C, M Arab Women and Cinema. 1999. *Al-Raida* (full issue), 16:86–87, Summer/Fall.

C Armbrust, Walter. 1996. *Mass Culture and Modernism in Egypt.* Cambridge:

Cambridge University Press.

C . 1998. Transgressing Patriarchy: Sex and Marriage in Egypt Film. *Middle East Report*, No. 206, Spring.

T 'Arsan, 'Ali 'Uqla. 1983. *Al-Zawahir al-masrahiya 'inda al-'Arab*. Tripoli: al Munsh'a al-'Amma li-l-Nashr wa-l-Tawqi' wa-l-i'lan.

T Artaud, Antonin. 1970. *The Theatre and its Double*. London: Calder & Boyars.

Asad, Talal. 1993. *Genealogies of Religion: Discipline and Reasons of Power in Christianity and Islam*. Baltimore: Johns Hopkins University Press.

C *Ashiklar*. 1995. David Grabias (director). Sinema Productions.

P, T Ashrawi, Hanan Mikhail. 1976. *Contemporary Palestinian Literature Under Occupation*. Birzeit: Birzeit University Publications.

M Asmar, Sami. 1998a. Remembering Farid al-Atrash: A Contender in the Age of Giants. *Al Jadid*. 4:22, pp. 34–35, 38.

M . 1998b. Three Musical Legacies Left by Sayyed Makkawi, Munir Bashir, and Walid Akel. *Al Jadid*, 4:23, pp. 20–21, 25.

M . 1998c. Over Two Decades After His Death, Musical Legacy of Abdul-Halim Hafez Revisited. *Al Jadid*, 4:24, pp. 20–21.

M . 1999. Fairouz: A Voice, a Star, a Mystery. *Al Jadid*, 5:27, pp. 14–16.

Atif, Nadia Izzeldin. 1974. *Awlad al Nokta*: Urban Egyptian Humor. Ph.D. dissertation. University of California, Berkeley.

A Atla, Tarek. 1996. Healing for Hearts. *Al-Ahram Weekly*. February 15–21, p. 9.

M Al-Atrash, Farid. [n.d.] *Mudhakkirat Farid al-Atrash*. Beirut: Maktabat al Jamahir.

T Audebert, Claude. 1978. Al-Hakim's *Ya tali' al-shajara* and Folk Art. *Journal of Arabic Literature*, 9, pp. 138–149.

T Awad, Louis. 1975. Problems of the Egyptian Theatre. In R. C. Ostle (ed.), *Studies in Modern Arabic Literature*. Warminster, England: Aris & Phillips.

M 'Awad, Mahmud. 1969. *Umm Kulthum allati la ya'rifuha ahad*. Cairo: Akhbar al-Yawm.

T 'Awad, Ramsis. 1979. *Ittijahat siyasiya fi al-masrah qabla al-thawrat 1919*. Cairo: Al-Hay'a al-Misriya al-'Amma li-l-Kitab.

D Awhan, Faruq. 1988. Al-ihtifal al-masrahi fi-taqalid al-raqs al-sha'bi: Raqsat al-'iyala fi-l-Imarat al-'Arabiya al-Muttahida. *Al-Ma'thurat al Sha'biya*, 3:9, pp. 41–61.

T A'zam, Hamid Reza. 1989. Shegerd-e Akhar. *Ketab-e Sobh*, Spring, 3, pp. 193–237.

T Aziz, Barbara. 1996. Tales in the 'hood: The Last Hakawati. *Aramco World*, 47:1, January/February; pp. 12–17.

T Aziza, Mohamed. 1970. *Regards sur le théâtre arabe contemporaine*. Tunis: Maison Tunisienne de l'édition.

M Azzam, Nabil Salim. 1990. Muhammad 'Abd al-Wahhab in Modern Egyptian Music. Ph.D. dissertation, University of California, Los Angeles.

T Badawi, M. H. 1987. *Modern Arabic Drama in Egypt*. Cambridge: Cambridge University Press.

T . 1988. *Early Arabic Drama*. Cambridge: Cambridge University Press.

T (ed.). 1992. *Modern Arabic Literature*. Cambridge: Cambridge University Press.

Badran, Margot. 1995. *Feminists, Islam and Nation: Gender and the Making of Modern Egypt*. Princeton University Press.

C Baecque, Antoine de. 1987. L'architecture des sens *Noce en Galilée*. *Cahiers du cinéma*. 401:77; November, pp. 45–47.

A Bahnassi, Afif. 1980. *Al-fann al-hadith fi al-bilad al-'arabiya*. Tunis: Dar al Janub li-l-Nashr.

A . 1985. *Ruwwad al-fann al-hadith fi al-bilad al-'arabiya*. Beirut: Dar al-Ra'id al-'Arabi.

A . 1973. Tatawwur al-fann al-Suri khilal mi'at 'amm ("Development of Syrian Art during One Hundred Years"). In *The Annual Arab Syrian Archeological and Historical Revue*, 23, nos 1 and 2.

C Baker, Raymond. 1995. Combative Cultural Politics: Film Art and Political
 Spaces in Egypt. *Alif: Journal of Comparative Poetics.* 15, pp. 6–38.
 Bakhtin, Mikhail M. 1981. *The Dialogic Imagination.* Austin: University of
 Texas Press.
 _____. 1984. *Rabelais and His World.* Bloomington: Indiana
 University Press.
 _____. 1986. *Speech Genres and Other Late Essays.* Austin: University
 of Texas Press.
 Baramki, Gabi. 1987. Building Palestinian Universities Under Occupation.
 Journal of Palestine Studies, 17:1, pp. 12–20.
T Basha, 'Abidu. 1995. *Bayt al-nar–al-zaman al-da'i' fi al-masrah al-Lubnani.*
 London: Riad El-Rayyes.
M Bashi, 'Abd al-Wahhab. 1978. Mulla Taha Karkuli: Qari'a al-maqamat al-
 'Iraqiya. *Al-Turath al-Sha'bi,* 9, pp. 73–78.
M Basilov, Vladimir N. 1989. Bowed Musical Instruments. In Basilov (ed.),
 Nomads of Eurasia. Los Angeles: National History Museum of Los Angeles.
A Bateson, Gregory. 1972. Style, Grace, and Information in Primitive Art. *Steps
 to an Ecology of Mind.* San Francisco: Chandler Publishing Co., pp. 128–152.
P Bauman, Richard. 1977. *Verbal Art as Performance.* Rowley, MA: Newbury
 House Publishers.
T, P Bayati, Shawkat Abd al-Karim. 1989. *Tatawwur fann al-hakawati fi al-
 turath al-'Arabi wa-atharuhu fi al-masrah al-'Arabi al-mu'asir.*
 Baghdad: Dar al-Shu'un al-Thaqafiya al-'Amma.
 Beattie, Kirk. 1994. *Egypt During the Nasser Years: Ideology, Politics and
 Civil Society.* Boulder, Co.: Westview Press.
 Bédoucha, Genevieve. 1987. Une tribu sédentaire: la tribu des hauts plateaux
 yéménites. *L'Homme.* 27:2, pp. 139–150.
 Beeman, William O. 1988. Affectivity in Persian Language Use. *Culture,
 Medicine and Psychiatry,* 12, pp. 9–30.
T, A Ben Amots, Dan. 1982. *Sipure Abu-Nimr.* Tel Aviv: Zemorah-Bitan, 1982.
 Benjamin, Walter. 1968. The Task of the Translator: An Introduction to the
 Translation of Baudelaire's *Tableaux parisiens.* In *Illuminations.* New
 York: Schocken Books, pp. 69–82.
 Bernstein, Basil B. 1975. *Class, Codes, and Control: Theoretical Studies
 Towards a Sociology of Language.* New York: Schocken Books.
C Berrah, Mouny, Levy, Jacques, and Cluny, Claude-Michel (special vol. eds.).
 1987. *Les cinémas arabes.* Paris: CinémAction et Grand Maghreb and
 Institut du monde arabe.
P Berrechid, Abelkrim [Birrashid, Abd al-Karim]. 1977. Alif ba: al-waqi'iya al-
 ihtifaliya. *Al-thaqafa al-jadida,* 7, Spring, p. 156.
 _____. 1993. *Al-ihtifaliya: mawaqif wa mawaqif mudadda.* Marrakech:
 Tansift.
 Besnier, Niko. 1990. Language and Affect. *Annual Review of Anthropology.*
 Betts, Robert Brenton. 1988. *The Druze.* New Haven and London: Yale
 University Press.
T Beyza'i [Bayza'i], Bahram. 1965. *Namayesh dar Iran.* Tehran: Kaviyani.
T _____. 1975. *Chahar Sanduq.* Tehran: Ruzbehan.
T _____. 1976. *Seh Namayeshnameh-ye Arusaki.* Teheran: Negah.
T _____. 1980. *Marg-e Yazdgerd.* Tehran: Ruzbehan.
M Blacking, John. 1982. The Structure of Musical Discourse: The Problem of the
 Song Text. *Yearbook for Traditional Music* Vol. 14, pp. 15–23. New
 York: International Council for Traditional Music.
C Blecher, Robert. 1997. History as Social Critique in Syrian Film: Muhammad
 Malas' *al-Leil* and Ryad Chaia's *al-Lajat. Middle East Report,* 204, July
 September, pp. 44–46.
M Blum, Stephen, and Amir Hassanpour. 1996. The Morning of Freedom Rose

Up: Kurdish Popular Song and the Exigencies of Cultural Survival. *Popular Music*, 15:3, pp. 325–343.

T Bogden, Robert. 1988. *Freak Show: Presenting Human Oddities for Amusement and Profit.* Chicago: University of Chicago Press.

P Bouhmid, Mohamed. 1995. Innahum yuriduna al-'aita ka dajijin li-jam'i al hushudi' as-sulta fi al-maghribi lam tafham 'anna ihtirama al-'aita fi-hi janibun min jawanibi al-hafidi 'ala shakhsiyatina. *Al-Ittihad al-Ishtiraki*, April 15, p. 6

M Boullata, Kamal and Sargon Boulus (eds.). 1981. *Fayrouz, Legend and Legacy.* Washington DC: Forum for International Arts and Culture.

Bourdieu, Pierre. 1990. *The Logic of Practice.* Stanford: Stanford University Press.

Bowen, Donna Lee and Evelyn A. Early, (eds.). 1993. *Everyday Life in the Muslim Middle East.* Bloomington: Indiana University Press.

T Brand, Hanita. 1990. Al-Farafir by Yusuf Idris: The Medium is the Message. *Journal of Arabic Literature.* 21:1, pp. 57–71.

Briggs, Charles L., and Richard Bauman. 1992. Genre, Intertextuality, and Social Power. *Journal of Linguistic Anthropology*, 2:2, pp. 131–172.

Brook, Peter. 1980. *The Empty Space.* New York: Atheneum.

Browne, J. Ross. 1874. In a Caravan with Gerome the Painter: Concluding Paper. *Harper's New Monthly Magazine*, 6:32, May, p. 534.

T Brumm, Ann-Marie. 1995. Three Interviews. *Edebiyat*, 6, p. 84.

T Bullard, George. 1999. Play Shows Detroit as an Art Sanctuary. *Detroit News*, March 6.

T Bu Sha'ir, Rashid. 1996. *Athar Birtuld Birikht fi masrah al-Mashriq al-'Arabi.* Damascus: al-Ahali li-l-Taba'a wa-l-Nashr wa-l-Tawzi'.

Bujra, Abdalla S. 1971. *Politics of Stratification. A Study of Political Change in a South Arabian Town.* Oxford: Clarendon Press.

M Cachia, Pierre. 1977. The Egyptian Mawwal: Its Ancestry, Its Development, and Its Present Forms. *Journal of Arabic Literature*, 8, pp. 77–103.

P ———. 1989. *Popular Narrative Ballads of Modern Egypt.* New York: Oxford University Press.

Campbell, Bartley. 1882. *The White Slave.* [No publisher listed, no date]. Produced at Haverty's 14th St. Theatre, New York, April 3.

M, P Campbell, Kay Hardy. 1996. Recent Recordings of Traditional Music from the Arabian Gulf and Saudi Arabia. *Middle East Studies Association Bulletin*, 30:1, July, pp. 37–40.

M ———. 1996. A Heritage without Boundaries (interview with Jihad Racy). Aramco World, 47:3, May/June, pp. 2–5.

Carapico, Sheila. 1998. *Civil Society in Yemen: The Political Economy of Activism in Modern Arabia.* Cambridge: Cambridge University Press.

T Carlson, Susan. 1993a. Collaboration, Identity, and Cultural Difference: Karim Alrawi's Theatre of Engagement. *Theatre Journal*, 45:2, pp. 155–173.

T ———. 1993b. Collaboration, Identity and Cultural Difference: Karim Alrawi's Theatre of Engagement. *American Theatre in Higher Education*, March.

A Carswell, J. 1989. The Lebanese View. In *Lebanon—The Artist's View—200 Years of Lebanese Art.* Exhibition catalogue. The Concourse Gallery, Barbican Center. London: The British Lebanese Association.

Casey, Edward S. 1987. *Remembering: A Phenomenological Study.* Bloomington: Indiana University Press.

M Caspi, Michael M., and Julia Ann Blessing. 1993. "O bride, light of my eyes": Bridal Songs of Arab Women in Galilee. *Oral Tradition*, 8:2, pp. 355–380.

Cataldi, Sue L. 1993. *Emotion, Depth, and Flesh, A Study of Sensitive Space: Reflections on Merleau-Ponty's Philosophy of Embodiment.* Albany: State University of New York Press.

P Caton, Steven C. 1990. *"Peaks of Yemen I Summon": Poetry as Cultural Practice in a North Yemeni Tribe.* Berkeley: University of California Press.

A Centre d'études et de documentation économiques juridiques et sociales (CEDEJ). 1991. *Images d'Égypte: de la fresque à la bande dessinée*, Cairo: CEDEJ.

T Chaikin, Joseph. 1972. *The Presence of the Actor.* New York: Atheneum.

M Chehabi, H. E. 2000. Voices Unveiled: Women Singers in Iran. In Rudi Matthee and Beth Baron (eds.), *Iran and Beyond: Essays in Honor of Nikki Keddie.* Costa Mesa: Mazda Press.

Chelebi, Evliya Effendi. 1968. *Narrative of Travels in Europe, Asia, and Africa in the Seventeenth Century* Vol. 1. New York: Johnson Reprint.

Chelhod, Joseph. 1970. L'organisation sociale au Yémen. *L'Ethnographie*, 13, pp. 61–86.

_____. 1973a. Les cérémonies du mariage au Yémen. *Objêts et Mondes*, 13, pp. 3–34.

_____. 1973b. La parenté et le mariage au Yémen. *L'Ethnographie*, 67, pp. 47–90.

_____. 1975. La société yéménite et le droit. *L'Homme.* 15:2, pp. 67–86.

_____ et al. 1984–85. *Arabie du sud, histoire et civilisation.* Paris: Maisonneuve et Larose.

T Chelkowski, Peter J. (ed.). 1979. *Ta'ziyeh: Ritual and Drama in Iran.* New York: New York University Press.

A Chorbachi, Wasma'a. 1989. Arab Art Twenty Years Later. *Arab Studies Quarterly.* 11: 2 and 3, pp. 143–154.

C CinemAction (full issue; Youssef Chahine l'Alexandrine).1985. 33.

T Cohen-Mor, Dalya. 1992. *Yusuf Idris: Changing Visions.* Potomac, MD: Sheba.

T Cole, Catherine. 1996. Reading Black-face in West Africa: Wonders Taken for Signs. *Critical Inquiry*, 23, Fall, pp. 183–215.

A Collingwood, R.G. 1958. *Principles of Art.* Oxford: Oxford University Press.

D *Columbian Gallery: A Portfolio of Photographs from the World's Fair.* 1894. Chicago: The Werner Co.

Commins, David. 1991. *Islamic Reform: Politics and Social Change in Late Ottoman Syria.* New York: Oxford University Press.

P Connelly, Bridget. 1986. *Arab Folk Epic and Identity.* Berkeley: University of California Press.

A *Contemporary Art in Kuwait/ al-Fann al-tashkili fi al-Kuwait.* 1983. Kuwait: al-Sharika al-Dawliya al-Kuwaytiya li-l-Istithmar.

D Cummings, C.F. Gordon. 1882. Egyptian Dervishes. *Littell's Living Age*, December 16, p. 669.

T Dabashi, Hamid. 1993. *Parviz Sayyad's Theater of Diaspora: Two Plays:* The Ass *and* The Rex Cinema Trial. Costa Mesa, Calif.: Mazda Publishers.

T _____ and M. R. Ghanoonparvar (eds.). 1993. *Theatre of the Diaspora* Costa Mesa, CA: Mazda Publishers.

A Dahesh Museum. 1997. *Picturing the Middle East: A Hundred Years of European Orientalism, A Symposium.* New York: Dahesh Museum.

M Danielson, Virginia. 1987. The Qur'an and the Qasidah: Aspects of the Popularity of the Repertory of Umm Kulthum. *Asian Music*, 19:1, Fall/Winter, pp. 26–45.

M _____. 1989. Cultural Authenticity in Egyptian Musical Expression: The Repertory of the Mashayikh. *Pacific Review of Ethnomusicology*, 5, pp. 48–60.

M _____. 1990–1991. Min al-Mashayikh: A View of Egyptian Musical Tradition. *Asian Music* 22:1, Fall/Winter, pp. 113–128.

M _____. 1991. Shaping Tradition in Arabic Song: The Career and Repertory of Umm Kulthum. Ph.D. dissertation, Department of Music, University of Illinois, 1991.

M _____. 1997. *The Voice of Egypt: Umm Kulthum, Arabic Song, and Egyptian Society in the Twentieth Century.* Cairo: American University

in Cairo Press.

M _____. 1996. New Nightingales of the Nile: Popular Music in Egypt since the 1970s. *Popular Music*, 15:3, pp. 229–312.

C Darwish, Mustafa. 1998. *Dream Makers on the Nile: A Portrait of Egyptian Cinema*. Cairo: The American University in Cairo Press.

M Davis, Ruth. 1996. The Art/Popular Music Paradigm and the Tunisian Ma'luf. *Popular Music*, 15:3, pp. 313–323.

M Dawkhi, Yusuf Farhan. 1984. *Al-Aghani al-Kuwaytiya*. Doha: Markaz al Turath al-Sha'b li-Duwal al-Khalij al-'Arabiya.

Derrida, Jacques. 1985. *The Ear of the Other: Otobiography, Transference, Translation*. Christie V. McDonald (ed.), New York: Schocken Books.

T Devlin, Joyce. 1992. Joint Stock: From Colorless Company to Company of Color. *Theatre Topics*. 2, March.

M al-Dissuqi, Muhammad. 1993. Farid al-Atrash: Rabi'a al-ughniya ala 'arabiya al-da'im. *Fann*, 204, 27 December.

T Ditmars, Hadani. 1994. The El-Hakawati Theater—Search for Identity on and off Stage. *The New Middle East*, 1:2, August-September, pp. 34–35.

Djikstra, Bram. 1986. *Idols of Perversity: Fantasies of Feminine Evil in Fin-de Siecle Culture*. New York: Oxford University Press.

Dostal, Walter. 1974. Sozio-ökonomische Aspekte der Stammesdemokratie in Nordost-Yemen. *Sociologus*. 24:1, pp. 1–15.

A Douglas, Alan, and Malti-Douglas, Fedwa. 1994. *Arab Comic Strips*. Indiana University Press.

Dresch, Paul. 1989. *Tribes, Government, and History in Yemen*. Oxford: Clarendon Press.

T, D Durant, John and Alice. 1957. *Pictorial History of the American Circus*. New York: A. S. Barnes.

A Dyer, Richard. 1993. *The Matter of Images: Essays on Representation*. New York: Routledge.

Eickelman, Dale F. 1992. Mass Higher Education and the Religious Imagination in Contemporary Arab Societies. *American Ethnologist*, 19: 4, pp. 643–655.

M Eliah, Elaine. 1999. Plucked from Obscurity. *Aramco World*, 50:2, March/April, pp. 38–39.

T Elias, Marie. 1996. Hiwar: Wannus ... 'an kitabatihi al-jadida. *Al-Tariq*, 55:1, January-February; pp. 96–104.

T _____. 1996. Ba'da al-qira'a wa-qabla al-tadribat: Madinat Sa'dallah Wannus 'ala Masrah al-Madina. *Al-Tariq*, 55:1, January-February, pp. 163–165.

T _____. 1997. Madha ya'ni al-masrah al-'an. *Al-Tariq*, 56:3, May-June, pp. 5–24.

T El-Enanay, Rashid. 1997. The Western Encounter in the Works of Yusuf Idris. *Research in African Literatures*, 28:3, Fall, pp. 33–55.

A Enany, Sarah. 1993. Waves of Passion. *Cairo Today*, October, p. 47.

Encyclopaedia Palestina/Al-mawsu'a al-filistiniya. 1990. Damascus: Hay'at al-Mawsu'a al-filistiniya (Encyclopaedia Palestina Corporation).

A Erkanat, Judy. 1997. Old Ways, New Warps. *Aramco World*, 47:1, January/February, pp. 28–31.

Ernst, Carl. W. 1985. *Words of Ecstasy in Sufism*. Albany: State University of New York Press.

T Eysselinck, Walter. 1994. Identity and Anxiety in the Plays of Karim Alrawi. Unpublished paper, Department of Performing and Visual Arts, The American University in Cairo.

D Fahmy, Farida Melda. 1987. The Creative Development of Mahmoud Reda: A Contemporary Egyptian Choreographer. Master's thesis. Department of Dance Ethnology, University of California, Los Angeles.

M Fakhuri, Kifah (ed.). [n.d.] *Al-musiqa al-'Arabiya*. Queen Nur Foundation, Jordan: Arab Academy of Music.

T Farabough, Laura. 1992. Al Warsha in Cairo. *Theater Forum*, Spring, pp. 4–11.

T Farag, Nadia. 1975. Yusuf Idris and Modern Egyptian Drama. Ph.D. dissertation, Columbia University.

T _____. 1976. *Yusuf Idris wa al-masrah al-Misri al-hadith*. Cairo: Dar al-Ma'arif bi-Misr.

T Farag-Badawi, Nadia. 1981. Ali Salem (Ali Salim): A Modern Egyptian Dramatist. *Journal of Arabic Literature*. 12, pp. 87–100.

M *Farid al-Atrash: Lahn al-khulud. Hayat fannan*. 1977. Beirut: Dar al-Mafaq al-Jadida.

M *Farid al-Atrash: Mudhakkirat majmu'at aghaniya*. [n.d.] Aleppo: Al-Maktab Hadithiya.

M Farmer, Henry George. 1929. *A History of Arabian Music to the XIII Century*. London: Luzac.

D al Faruqi, Lois Ibsen. 1976. Dances of the Muslim People. *Dance Scope*. 11:1, pp. 43–51.

M _____. 1978. Ornamentation in Arabian Improvisational Music: A Study in Interrelatedness in the Arts. *World of Music*, 20, pp. 17–32.

D _____. 1978. Dance as an Expression of Islamic Culture. *Dance Research Journal*, 10:2, Spring-Summer, pp. 6–13.

M _____. 1980. The Status of Music in Muslim Nations: Evidence from the Arab World. *Asian Music*, 12:1, pp. 56–85.

M _____. 1981. *An Annotated Glossary of Arabic Musical Terms*. Westport, Connecticut: Greenwood Press.

M _____. 1985. Music, Musicians, and Muslim Law. *Asian Music*, 17:1, pp. 3–36.

T Fathi, Ibrahim. 1991. *Kumidiya al-hukm al-shumuli*. Cairo: al-Hay'a al Misriya al-'Amma li-l-Kitab.

A Fathy, Hassan. 2000. *Architecture for the Poor*. Cairo: American University in Cairo Press, 2000.

T Feeney, John. 1999. Shadows of Fancy. *Aramco World*. 50:2, March/April; pp. 14–21.

Feld, Steven. 1990. Wept Thoughts: The Voice of Kaluli Memories. *Oral Tradition*, 5:2/3, pp. 241–266.

M _____ and Aaron A. Fox. 1994. Music and Language. *Annual Review of Anthropology*, 23, p. 42.

A Fernandez, James W. 1966. Principles of Opposition and Vitality in Fang Aesthetics. *Journal of Aesthetics and Art Criticism*, 25, pp. 53–64.

A _____. 1977. *Fang Architectonics*. Philadelphia: Institute for the Study of Human Issues.

_____. 1986. *Persuasions and Performances: The Play of Tropes in Culture*. Bloomington: Indiana University Press.

A Fethe, C. B. 1977. Craft and Art: A Phenomenological Distinction. British *Journal of Aesthetics* 17:2, pp. 129–137.

Fishman, Joshua A. 1968. Sociology of Language. *Readings in the Sociology of Language*. Joshua A. Fishman (ed.). The Hague: Mouton.

P Freyha, Anis. 1974. *A Dictionary of Modern Lebanese Proverbs*. Beirut: Librarie du Liban.

Friedman, Robert J. 1983. Israeli Censorship of the Palestinian Press. *Journal of Palestine Studies*, 13:1, pp. 98–108.

Friedrich, Paul. 1988. Multiplicity and Pluralism in Anthropological Construction/Synthesis. *Anthropological Quarterly*, 6, pp. 103–112.

M Frishkopf, Michael. Forthcoming. Al-Inshad al-dini ("Islamic Religious Singing") in Egypt. *Garland Encyclopedia of World Music* vol. 6. New York: Garland Publishing.

M Fu'ad, Ni'mat Ahmad. 1976. *Umm Kulthum: 'asr min al-fann.* Cairo: al-Hay'a al-Misriya al-'Amma li-l-Kitab.

T Gaffary, Farrokh. 1984. Evolution of Rituals and Theater in Iran. *Iranian Studies,* 17:4, pp. 361–389.

C Gaffney, Jane. 1987. The Egyptian Cinema: Industry and Art in a Changing Society. *Arab Studies Quarterly.* 9:1, Winter, pp. 53–75.

Gal, Susan. 1989. Language and Political Economy. *Annual Review of Anthropology,* 18, pp. 345–367.

A Gauche, Sarah. 1998. Lebanon's Renaissance of the Arts. *Aramco World,* 49:1, January/February; pp. 2–11.

Geertz, Clifford. 1973. *The Interpretation of Cultures.* New York: Basic Books, Inc.

_____. 1976. From the Native's Point of View: On the Nature of Anthropological Understanding. In *Meaning in Anthropology.* Albuquerque: University of New Mexico Press, pp. 221–238.

_____. 1983. Blurred Genres: The Refiguration of Social Thought. In *Local Knowledge.* New York: Basic Books.

Gell, Alfred. 1975. *Metamorphosis of the Cassowaries.* London: Athlone Press.

T Gella, Julius. 1977-78. *Al-Farafir:* A Problematic Experiment in the Search for the Egyptian National Dramatic Form. *Graecolatina et Orientalia,* 9/10.

Gerholm, Tomas. 1977. *Market, Mosque and Mafraj: Social Inequality in a Yemeni Town.* Stockholm: University of Stockholm.

T Ghanoonparvar, M. R., and Green, John (eds.). 1989. *Iranian Drama: An Anthology.* Costa Mesa, CA: Mazda Publishers.

A Gharib, Samir. 1988. *Le surrealisme en Égypte et les arts plastiques.* Cairo: Prism.

Ghoussoub, Mai, and Emma Sinclair Webb (eds.). *Imagined Masculinities: Male Identity and Culture in the Modern Middle East.* London: Saqi Books, 2000.

M, T Ghunayim, Mahmud. 1935. Al-Radiyu. *Al-Risala,* January 7, p. 7.

Gilman, Sander L. 1982. *On Blackness Without Blacks: Essays on the Image of the Black in Germany.* Boston: G. K. Hall.

Gilmore, David. 1990. *Manhood in the Making: Cultural Concepts of Masculinity.* New Haven and London: Yale University Press.

Gilsenan, Michael. 1973. *Saint and Sufi in Modern Egypt: An Essay in the Sociology of Religion.* Oxford: Clarendon Press.

_____. 1996. *Lords of the Lebanese Marches.* Berkeley: University of California.

Gingrich, André. 1989a. The Guest Meal among the Munebbih. Some Considerations on Tradition and Change in *'Aish wa mil* in Northwestern Yemen. *Peuples méditerranéens,* 46, pp. 129–149.

_____. 1989b. Les Munebbih du Yémen perçus par leurs voisins: Description d'une société par le corps et sa parure. *Téchniques et Culture,* 13, 127–139.

Glaser, Eduard. 1884. Meine Reise durch Arab und ashid. *Petermanns Mitteilungen.* Vol. 30, pp. 170–183 and 204–213.

A Göçek, Fatma Müge (ed.). 1997. *Political Cartoons: Cultural Representation in the Middle East.* Princeton, NJ: Markus Wiener Publishers.

A Goma'a, "Portraits of the Century." Twentieth-century special issue, *Al-Ahram Weekly,* December 30, 1999–January 5, 2000, p. 19.

T Guran, Hiva. 1981/2. *Kusheshha-ye Nafarjarn: Seyri dar Sad Sal Tiyatr-e Iran.* Tehran: Aqah.

T Habibian, Maryam. 1991. Iranian Theatre in Exile: An Examination of Iraj Jannatie Ataie's Plays in England. *BRISMES Proceedings of the 1991 International Conference on Middle Eastern Studies, SOAS, London.*

T _____. 1999. Under Wraps on the Stage: Women in the Performing Arts in Post-Revolutionary Iran. Paper presented at the Middle East Studies Association's annual meeting in Washington DC, Nov. 19–22.

Habiby, Emile [Habibi, Imil]. 1974. *Al-waqa'i al-ghariba fi ikhtifa' Sa'id abi*

al-nahs al-mutasha'il. Haifa: Dar al-Ittihad.
_____. 1985. *The Secret Life of Saeed the Ill-fated Pessoptimist.* London: Zed Books.

A Hale, Sondra. 1970. Arts in a Changing Society: Northern Sudan. *Ufahamu,* 1:1, pp. 64–79.

A _____. 1973. Musa Khalifa of Sudan. *African Arts,* 6:3.

A _____. 1981. Art and Dialectics. *Africa Today,* 28:2.

D Halman, Talât Sait, and Metin And. 1992. *Mevlana Çelal Eddin Rumi and the Whirling Dervishes.* Istanbul: Dost Yayinlari.

T Halman, Talât Sait (ed.). 1976. *Modern Turkish Drama: An Anthology of Plays in Translation.* Minneapolis: Biblioteca Islamica.

T Hamdan, Masud. 1996. The Theater Play as an Aesthetic Medium for Alternative Mass Communication: The Carnivalesque Satires of Durayd Lahham and Muhammad al-Maghut. Master's Thesis, University of Haifa.

Al-Hamdani, al-Hasan Ibn Ahmad. 1884. *Geographie der Arabischen Halbinsel [Sifat Jazirat al-'Arab].* D. H. Muller, ed. Leiden: Brill.

M Hammad, Muhammad 'Ali. *Sayyid Darwish: Hayat wa-naghm.* Cairo: al Hay'a al-Misriya al-'Amma li-l-Ta'lif wa-l-Nashr, 1970.

M Hammarlund, Anders, and Ozdalga, Elisabeth. 1998. *Sufism, Music and Society in Turkey and the Middle East.* Richmond, England: Curzon Press.

T Hammouda, AbdelAziz. 1979. Modern Egyptian Theater: Three Major Dramatists. *World Literature Today,* 33, Autumn.

Hanks, William F. 1987. Discourse Genres in a Theory of Practice. *American Ethnologist,* 14:4, pp. 668–692.

T Haring-Smith, Tori (ed.). 1998. *Scenes for Women by Women.* Portsmouth, N.H.: Heinemann.

P, D Hart, David M. 1976. The Cultural Role of Ay-aralla-buya: Poetry, Music and Dancing. In *The Aith Waryaghar of the Moroccan Rif: An Ethnology and History.* Tucson, Arizona: University of Arizona Press.

M Hasanayn, 'Adil. [n.d.] *'Abdul Halim Hafidh, ayyamuna il hilwa.* Cairo: AMADO.

M Hassan, Fayza. 2000a. The Word, The Tune, The Stone. *Al-Ahram Weekly.* February 24–March 1.

D _____. 2000b. Beauty and the Beat. *Al-Ahram Weekly,* July 6–12.

D Hawthorne, Julian. 1893. Foreign Folk at the Fair. *Cosmopolitan.* 15:5, September, p. 576.

M, P, A Hayes, J. R. (ed.). 1983. *The Genius of Arab Civilization: Source of Renaissance.* Cambridge: MIT Press.

C Hennebelle, Guy. 1976. Arab Cinema. *MERIP Report,* 52, November.

D Henni-Chebra, Djamila, and Pôche, Christian. 1996. *Les danses dans le monde arabe: ou, l'héritage des almées.* Paris: L'Harmattan.

Hoffman, Valerie J. 1995. *Sufism, Mystics, and Saints in Modern Egypt.* Columbia, S.C.: University of South Carolina Press.

Hoffman-Ladd, Valerie. 1992. Devotion to the Prophet and His Family in Egyptian Sufism. *International Journal of Middle East Studies.* 24:4, pp. 615–637.

P Homerin, Th. Emil. 1994. *From Arab Poet to Muslim Saint: Ibn al-Farid, His Verse, and His Shrine.* Columbia, S.C.: University of South Carolina Press.

A Howard, V.A. 1982. *Artistry: The Work of Artists.* Indianapolis: Hackett Publishing Company.

P, T Huart, Clément. 1966. *A History of Arabic Literature.* Beirut: Khayats.

D Husayn, Mustafa. 1963. Al-ghina wa al-raqs 'ind 'asha'ir al-'Iraq. *Jaridat al Balad,* 70, p. 3.

Hymes, Dell. 1972. Language in Society. *Language in Society,* Vol. 1. Cambridge: Cambridge University Press, pp. 1–14.

M Ibrahim, Mustafa Fathy, and Pignol, Armand. 1987. *L'éxtase et le transistor: aperçus sur la chanson égyptienne contemporaine de grande audience.*

Cairo: Centre d'études et de documentation économiques juridiques et sociales.

A The Ideas, Works, and Legacies of Architect Hassan Fathy. (Articles by S. Swan, J. Feeney, W. Facey, D. Doughty, et al.). 1999. *Aramco World*, 50:4, July/August, pp. 16–63.

T Idris, Yusuf. 1956. *Jumhuriyat farahat*. Cairo: Dar Ruz al-Yusuf.

T _____. 1957. *Malik al-qutn, jumhuriyat farahat: masrahiyyatani*. Cairo: al-Mu'assassa al-Qawmiyya li-l-Nashr wa-l-Tawzi'.

T _____. 1958. *Al-Lahza al-harija*. Cairo: Al-Sharika al-'Arabiyya li-l-Taba'a.

T _____. 1966. *Al-Farafir wa-al-mahzala al-ardiya*. Cairo: al-Ahram.

T _____. 1971. *Al-Jins al-thalith*. Cairo: 'Alam al-Kutub.

T _____. 1974. *Nahwa masrah 'Arabi ma'a al-nusus al-kamila li-l-masrahiyyat*. Cairo: al-Watan al-'Arabi.

T _____. 1977. *The Sinners*. Trans. Kristin Peterson-Ishaq. Washington, D.C.: Three Continents Press.

T _____. 1978a. *The Cheapest Nights and Other Stories*. Trans. Wadida Wassef. London: Owen.

T _____. 1978b. *In the Eye of the Beholder: Tales of Egyptian Life from the Writings of Yusuf Idris*. Minneapolis: Bibliotheca Islamica.

T _____. 1986. *Yusuf Idris bi-qalam kibar al-udaba'*. Cairo: Maktabat Misr.

T _____. 1990. *Rings of Burnished Brass*. Trans. Catherine Cobham. Cairo: American University in Cairo Press.

T _____. [n.d.] *Al-Bahlawan*. Cairo: Dar Misr li-l-Tiba'a.

T _____. [n.d.] *Al-Mukhattatin*. Cairo: Maktabat Misr.

A Iraqi Culture Center. 1975. *Iraqi Art of the 50s*. London.

A _____. 1979. *Seven Iraqi Artists*. London.

A _____. 1980. *The Influence of Calligraphy on Contemporary Arab Art*. London.

A _____. 1981. *Contemporary Arab Art*. London.

A Iskandar, Rushdi, al-Mallakh, Kamal, and al-Sharuni, Subhi. 1991. *80 sana min al-fann, 1908–1988*. Cairo: al-Hay'a al-Misriya li-l-Kitab.

T Isma'il, Sayyid 'Ali. 1998. *Tarikh al-masrah fi Misr fi al-qarn al-tas'i 'ashar*. Cairo: General Egyptian Book Organization.

M Al-Jabaqji, Sabr al-Rahman. 1993. *Al-qism al-awwal (wa-al-qism al-thani) min diwan al-musiqar Farid al-Atrash* (Collection des chants). Vol. 1 and Vol. 2. Beirut: Maktab Dar al-Sharq.

Al-Jabarti, 'Abd al-Rahman. 1986. *'Aja'ib al-athar fi al-tarajim wa al-akhbar*. Cairo: Al-Anwar al-Muhammadiya.

T Al-Jabir, Hayat M. 1978. Experimental Drama in Egypt 1960–1970 with Reference to Western Influence. Ph.D. dissertation. Indiana University.

A Jabra, J. I. 1983. *The Roots of Iraqi Art*. Wasti Graphic & Publishing Ltd., Jersey, Channel Islands.

Jankowski, James, and Gershoni, Israel (eds.). 1977. *Rethinking Nationalism in the Arab Middle East*. New York: Columbia University Press.

T Jannati-'Ata'i, Abolqasem. 1977. *Bonyad-e Namayesh dar Iran*. Tehran: Safi'alishah.

M Jargy, Simon. 1988. *La musique arabe*. Paris, Presses Universitaires de France.

M Jarkas, Riyad. 1989. *Fairuz: al-mutriba wa-al-mishwar*. Beirut: Sharikat 'Ashtarut li-l Taba'a wa-al-Nashr.

Javadi, Hasan. 1988. *Satire in Persian Literature*. Rutherford, NJ: Farleigh Dickinson University Press.

M Al-Jawadi, 'Abd al-Karim 'Abd al-'Aziz. 1992. *Farid al-Atrash*. Beirut: Dar al Kitab al-'Alami.

T Jayyusi, Salma Khadra, and Roger Allen (eds.). 1995. *Modern Arabic Drama*. Bloomington: Indiana University Press.

A El-Jesri, Manal. 1998. True Colors. *Egypt Today*, 19:10, October, pp. 72–79.

Johansen, Julian. 1996. *Sufism and Islamic Reform in Egypt: The Battle for Islamic Tradition*. Oxford: Clarendon Press.

Johnson, Robert A. 1986. *He: Understanding Male Psychology*. New York: Perennial Library, Harper & Row.

T Johnson-Davies, Denys (ed.). 1981. *Egyptian One-Act Plays*. London: Heinemann.

T Jones, Lura Jafran. 1977. The 'Isawiya of Tunisia and Their Music. Ph.D. dissertation, University of Washington, Seattle.

Jong, F. de. 1976–77. Cairene Ziyara Days: A Contribution to the Study of Saint Veneration in Islam. *Die Welt des Islams*, 17:1-4, pp. 26–43.

A Julian, Philippe. 1977. *The Orientalists: European Painters of Eastern Scenes*. Oxford: Phaidon.

M Al-Jundi, Adham. 1954–58. *A'lam al-adab wa-al-fann*. Damascus: Matba'at Majallat Sawt Suriya.

Jung, Karl. 1923. *Psychological Types*. New York: Harcourt, Brace and Co.

Kabbani, Rana. 1986. *Europe's Myths of Orient*. London: Macmillan.

P Kaeppler, Adrienne. 1993. Poetics and Politics of Tongan Laments and Eulogism. *American Ethnologist*, 20, p. 478.

T Kamil, 'Abd al-Hamid. 1923. Al-Hilal. Unpublished manuscript. Archives of the al-Masrah al-Qawmi.

M Kamil, Mahmud. 1971. *Muhammad al-Qasabji*. Cairo: al-Hay'a al-Misriya al-'Amma li-l-Kitab.

M _____. 1977. *Al-masrah al-ghina'i al-'arabi*. Cairo: Dar al-Ma'arif.

Kammen, Michael. 1991. *Mystic Chords of Memory: The Transformation of Tradition in American Culture*. New York: Knopf.

T Kapuscinski, Gisele (trans.). 1987. *Modern Persian Drama: An Anthology*. Lanham, MD: University Press of America.

A Karnouk, Liliane. 1988. *Modern Egyptian Art: The Emergence of a National Style*. Cairo: American University in Cairo Press.

A _____. 1995. *Contemporary Egyptian Art*. Cairo: American University in Cairo Press.

T Kassab-Hassan, Hanan and Elias, Marie. 1997. *Dictionary of Theater: Terms and Concepts of Drama* (French/English/Arabic contents/index). Beirut: Librarie du Liban.

T Al-Kassar, Majid. 1991. *'Ali al-Kassar: Barbari Misr al-wahid*. Cairo: Dar Akhbar al-Yawm.

Kassem, Hashem. Innovations for Oud: Charles Rouhana in a Music Revival. Interview of Rouhana with Kassem, translated by Sami Asmar. *Al Jadid*, 5:27, Spring.

Kelley, Robin. 1998. Playing for Keeps: Pleasure for Profit on the Postindustrial Playground. In Wahneema Lubiano (ed.), *The House That Race Built*. New York: Pantheon.

M Kendal, Nizan. 1979. Kurdish Music and Dance. *World of Music*, 21:1, pp. 19–28 (French and German abstracts, pp. 29–32).

D Kent, Carolee. 1989. Arab-American "Zaffat al-'arusah" in the Los Angeles Area. *UCLA Journal of Dance Ethnology*, 13.

M Kerbage, Toufic. [198-]. *The Rhythms of Pearl Diver Music in Qatar*. Doha: Culture and Art Directorate, Ministry of Information.

M Khalil, As'ad Abu. 1998. Fairuz. *Historical Dictionary of Lebanon*, Asian Historical Dictionaries, No. 30, Lanham, MD: The Scarecrow Press.

T Al-Khatib, Muhammad Kamil. 1994. *Nazariyat al-masrah*. Damascus: Wizarat al-Thaqafa.

P Khatibi, Abdelkebir. 1983. *Amour bilingue*. Paris: Fata Morgana.

P _____. 1990. *Love in Two Languages*. Minneapolis: University of Minnesota Press.

T Khatir, Mubarak. 1983. *Al-masrah al-tarikhi fi al-Bahrayn: muqaddima wa namudhaj, 1925-1953*. Bahrain: M. al-Khatir.

T El-Kholy, Samha, and Robison, John (eds.). 1993. *Festschrift for Gamal Abdel Rahim*. Cairo: Binational Fulbright Commission.

T Khurshid, Faruq. 1991. *Al-judhur al-sha'biya li-l-masrah al-'Arabi*. Cairo: al Hay'a al-Misriya al-'Amma li-l-Kitab.
T Kilani, Muhammad Sayyid. 1958. *Fi rubu' al-Azbakiya*. Cairo: Dar al-'Arab Bustany.
 Kishtainy, Khalid. 1985. *Arab Political Humour*. London: Quartet Books.
 Knipp, C. 1974. The Arabian Nights in England: Galland's Translation and its Successors. *Journal of Arabic Literature*, 5, pp. 44–54.
T Kramer, Annette. 1995. Creative Acts. *Aramco World*, 46:4, July/August; pp. 22–25.
A Krawit, Henry (ed.). 1997. Picturing the Middle East: A Hundred Years of European Orientalism, a Symposium. New York: Dahesh Museum.
M Labib Fumil. 1962. *Qissat Asmahan* [told by Fu'ad al-Atrash]. Beirut: [no publisher listed].
M _____. 1974. *Farid al-Atrash: Lahn al-khulud*. Cairo: Dar al-Sha'b.
M, P Lagrangé, Frederick. 1995. Poètes et musiciens en Égypte au temps de la Nahda. Dissertation, Université de Lille III.
A Lahoud, Édouard. 1974. *Contemporary Art in Lebanon*. Beirut: Dar el-Machreq.
M Lambert, Jean. 1990. La médecine de l'âme: musique et musiciens dans la société citadine à San'a, République du Yémen. Doctoral thesis, École des hautes études en sciences sociales, Paris.
M _____. 1993. Musiques régionales et identité nationale. *Revue du monde Musulman et de la Méditerranée*, 67:1, pp. 171–186.
T Landau, Jacob M. 1958. *Studies in the Arab Theater and Cinema*. Philadelphia: University of Pennsylvania Press.
D, M, T Lane, Edward William. 1836. *An Account of the Manners and Customs of the Modern Egyptians, written in Egypt during the years 1833, -34, and -35, partly from notes made during a former visit to that country in the years 1825, -26, -27, and -28*. London: C. Knight.
 Lavie, Smadar. 1990. The Poetics of Military Occupation: Mzeina Allegories of Bedouin Identity under Israeli and Egyptian Rule. Berkeley: University of California Press.
 Layne, Linda L. 1989. The Dialogics of Tribal Self-Representation in Jordan. *American Ethnologist*, 16:1, pp. 24–39.
A *Lebanon, The Artist's View: 200 Years of Lebanese Art*. 1989. Exhibition catalog, the Concourse Gallery, Barbican Centre for Arts and Conferences. London: The British Lebanese Association.
P Lemsyeh, Ahmed. 1992. 'Atbat as-salk. *Afaq*, 4/3, pp. 7-12.
P _____. 1992. *Shkun aterz l-ma?* Rabat.
 Lessing, Doris. 1980. *The Marriages between Zones Three, Four and Five*. New York: Random House.
M Lewis, Edwin [Adwin Luwis]. 1873. *Tatrib al-Adhan fi Sina'at al-Alhan*. Beirut: [no publisher listed].
A Lexington. 1994. The Ink of Human Kindness. *The Economist*, p. 34.
 Lomax, Alan, et al. 1977. A Stylistic Analysis of Speaking. *Language in Society*, 6:1.
T Lott, Eric. 1993. *Love and Theft: Blackface Minstrelsy and the American Working Class*. New York: Oxford University Press.
 Lukes, Steven and Itzhak Galnoor. 1985. *No Laughing Matter: A Collection of Political Jokes*. London: Routledge and Kegan Paul.
 Macdonald, Duncan Black. 1932. A Bibliographical and Literary Study of the First Appearance of the Arabian Nights in English. *Library Quarterly* 2, pp. 387-420.
M Macrae, Craig. 1998. A Guide to Central Asian Music. *Middle East Studies Association Bulletin*. 32:2, Winter, pp. 165-168.
M Al-Mahallawi, Hanafi. 1992. *'Abd al-Nasir wa Umm Kulthum: 'alaqa khassa jiddan*. Cairo: Markaz al-Qada li-l-Kitab wa-al-Nashr.
 Mahfouz, Naguib. [1947]. *Zuqaq al-Midaqq*. Cairo: Dar Misr.
 _____. 1975. *Midaq Alley*. Cairo: The American University in Cairo

Press, 1975.

T Mahmud, Fatima Musa (ed.). 1995–98. *Qamus al-masrah*. Cairo: Al-Hay'a al Misrya al-'Amma li-l-Kitab.

M Mainguy, Marc-Henri. 1969. *La musique au Liban*. Beirut: Éditions Dar al-Nahar.

P Al-Majdhub [Mejdoub], 'Abd al-Rahman. 1966. *Les quatrains de Mejdoub le Sarcastique, poète maghrébin du XVI siècle*. Paris: Maisonneuve et Larose.

A Makhoul, Bashir. 1995. *Contemporary Palestinian Art*. Unpublished doctoral dissertation, Department of Fine Arts, Faculty of Art and Design, Manchester Metropolitan University, England.

T Malekpur [Malikpur], Jamshid. 1985. *Adabiyyat-e Namayeshi dar Iran*. Tehran: Tus.

C Malkmus, Lizbeth. 1988. The 'New' Egyptian Cinema: Adapting Genre Conventions of a Changing Society. *Cinéaste*, 16:3, pp. 30–33.

C ———, and Armes, Roy. 1991. *Arab and African Film Making*. London: Zed Books.

C Malone, Michael. 1979. *Heroes of Eros: Male Sexuality in the Movies*. New York: E. P. Dutton.

T Manzalaoui, Mahmoud (ed.). 1977. *Arabic Writing Today: The Drama*. Cairo: American Research Center in Egypt.

M Marcus, Scott Lloyd. 1989. Arab Music Theory in the Modern Period. Ph.D. dissertation, University of California, Los Angeles.

M ———. 1989. The Periodization of Modern Arabic Music Theory: Continuity and Change in the Development of *Maqamat*. *Pacific Review of Ethnomusicology*, 5, pp. 33–48.

A Mardukh, Ibrahim. 1988. *Al-Haraka al-tashkiliya al-mu'asira bi-l-Jaza'ir*. Algiers: Mu'assasa al-Wataniya li-l-Kitab.

Al-Mas'udi (d. 956 CE). 1865. *Les prairies d'or [Muruj al-dhahab]*. Paris: Imprimerie Impériale.

T Al-Masri, Mai. 1996. Yawm al-masrah al-'alami, yum Sa'adallah Wannus. *Al-Tariq*, 2, March-April, pp. 123–124.

D Matthee, Rudi. 2000. Prostitutes, Courtesans, and Dancing Girls: Women Entertainers in Safavid Iran. In Rudi Matthee and Beth Baron (eds.), *Iran and Beyond: Essays in Middle Eastern History in Honor of Nikki R. Keddie*. Costa Mesa, Calif.: Mazda Publishers.

McPherson, J.W. 1941. *The Moulids of Egypt*. Cairo: Nile Mission Press.

A, C, P *Mediterraneans* (Méditerranéennes). Kenneth Brown, ed. Paris.

C Megherbi, Abdelghani. 1982. *Les algériens au miroir du cinéma colonial*. Algiers: Éditions S.N.E.D.

C ———. 1985. *Le miroir apprivoisé: Sociologie du cinéma Algérien*. Algiers: Enal.

Mehrez, Samia. 1992. Translation and the Postcolonial Experience: The Francophone North African Text. In Lawrence Venuti (ed.), *Rethinking Translation: Discourse, Subjectivity, Ideology*. New York: Routledge.

C Mellen, Joan. 1977. *Big Bad Wolves: Masculinity in the American Film*. New York: Pantheon.

C Menicucci, Garay. 1998. Unlocking the Arab Celluloid Closet: Homosexuality in Egyptian Film. *Middle East Report*, 206, Spring, pp. 32–37.

D Meri, La. 1961. Learning the Danse du Ventre. *Dance Perspectives*, 10, Spring.

P Mesnaoui, Driss. 1995. *L-Wauw*. Rabat.

Messick, Brinckley. 1996. *Calligraphic State*. New York: Columbia University Press.

A El-Messiri, Nur. 1986. Art and the Egyptian Environment. *Arts and the Islamic World*, Summer.

Metzger, Jan, Martin Orth and Christian Sterzing. 1983. *This Land is Our Land: The West Bank Under Israeli Occupation*. London: Zed Press.

M Miller, Lloyd Clifton. 1999. *Music and Song in Persia: The Art of Avaz*. Salt Lake City: University of Utah Press.

P Miller, W. Flagg. 1996a. Poetic Envisionings: Identities of Person and Place in

Yafi'i Cassette-poetry. Paper presented at the annual meeting of the Middle East Studies Association. Providence, RI.

_____. 1996b. Yafi' Has Only One Name: Shared Histories and Cultural Linkages Between Yafi' and Hadhramawt. Paper presented at the Hadhramawt Revisited Conference. St. Petersburg.

A Mitchell, Dolores. 1992. Images of Exotic Women in Turn of the Century Tobacco Art. *Feminist Studies*, 18:2, Summer, pp. 338–340.

M Moftah, Ragheb, Roy, Martha, and Toth, Margit (eds.). 1998. *The Coptic Orthodox Liturgy of St. Basil.* Cairo: American University in Cairo Press.

D Molé, Marijan. 1963. La danse extatique en Islam. In Jean Cazeneuve (ed.), *Les danses sacrées.* Paris: Éditions du Seuil.

D Monty, Paul Eugene. 1986. Serena, Ruth St. Denis, and the Evolution of Belly Dance in America (1876–1976). Ph.D. dissertation, New York University.

T Moosa, Matti. 1972. Naqqash and the Rise of the Native Arab Theater in Syria. *Journal of Arabic Literature*, 3, pp. 106–117.

T _____. 1974. Ya'qub Sanu' and the Rise of Arab Drama in Egypt. *International Journal of Middle East Studies*, 5:4, September, pp. 401–433.

T Moqaddam [Muqaddam], Hasan. 1922. *Ja'far Khan az Farang Amadah.* Tehran: Intisharat-e Iran-e Javan.

T Moreh, Shmuel. 1987. Ya'kub Sanu': His Religious Identity and Work in the Theater and Journalism, According to the Family Archive. In Shimon Shamir (ed.), *The Jews of Egypt: A Mediterranean Society in Modern Times.* Boulder, Co.: Westview.

T _____. 1992. *Live Theatre and Dramatic Literature in the Medieval Arab World.* Edinburgh: Edinburgh Press.

T _____ and Philip Sadgrove. 1996. *Jewish Contributions to Nineteenth Century Arabic Theatre: Plays from Algeria and Syria.* Oxford: Oxford University Press.

A Morris, Raymond N. 1995. *The Carnivalization of Politics: Quebec Cartoons on Relations with Canada, England, and France 1960–1979.* Montreal: McGill-Queen's University Press.

M Murruwah, Nizar. 1998. *Fi al-musiqa al-Lubnaniya al-'Arabiya wa-al-masrah al-ghina'i al Rahbani.* Beirut: Dar al-Farabi.

Mundy, Martha. 1983. San'a' Dress 1920-75. *San'a'. An Arabian Islamic City.* R. B. Serjeant and Ronald Lewcock (eds.). London: The World of Islam Festival Trust.

M Murad, Radwan. 1993. Farid al-Atrash wa Asmahan yaqaduman: *Intisar al-shabab. Hurriya*, 2:18, January 2.

M Mustafa, Zaki. 1975. *Umm Kulthum: Ma'had al-hubb.* Cairo: Dar al-Tab'a al Haditha, 1975.

Nader, Laura. 1970. A Note on Attitudes and the Use of Language. *Readings in the Sociology of Language.* Joshua A. Fishman (ed.). The Hague: Mouton.

Al-Nadim, Muhammad ibn Ishaq (fl. 987 CE). 1970. *Al-Fihrist.* New York: Columbia University Press.

_____. 1985. *Al-Fihrist.* Doha: Dar Qatri ibn al-Fuja'a.

C Naficy, Hamid. 1987. The Development of an Islamic Cinema in Iran. In *Third World Affairs*, 3.

C _____. 1992. Islamizing Film Culture in Iran. In Samih K. Farsoun and Medrdad Mashayekhi (eds.), *Iran: Political Culture in the Islamic Republic.* London: Routledge.

C _____. 1994. Veiled Visions/Powerful Presences: Women in Post-revolutionary Iranian Cinema. In Mahnaz Afkhami and Erika Friedl (eds.), *In the Eye of the Storm: Women in Post-revolutionary Iran.* Syracuse, NY: Syracuse University Press.

C _____, 1995. Shohat, Ella, and Friedlander, Jonathan. *The Cinema of Displacement: Middle Eastern Identities in Transition.* Los Angeles:

Grunebaum Center for Near Eastern Studies, UCLA.

T Nafisi, Sa'id. 1926/7 *Akherin Yadegar-e Nader Shah*. Tehran: Majallah-e Sharq.

A Nashashibi, Salwa M., et al. 1994. *Forces of Change: Artists of the Arab World*. Lafayette, California: International Council for Women in the Arts; Washington, DC: National Museum of Women in the Arts.

M Nelson, Kristina. 2001. *The Art of Reciting the Qur'an*. Cairo: American University in Cairo Press.

D Ness, Sally Ann. 1992. *Body, Movement, and Culture: Kinesthetic and Visual Symbolism in a Philippine Community*. Philadelphia: University of Pennsylvania Press.

M Nettl, Bruno. 1980. Musicial Values and Social Values: Symbols in Iran. *Asian Music*, 12:1, pp. 129–148.

D Nieuwkerk, Karin van. 1995. *A Trade Like Any Other: Female Singers and Dancers in Egypt*. Austin: University of Texas Press.

A Nochlin, Linda. 1983. The Imaginary Orient. *Art in America*, 71:5 May, pp. 119–191.

A _____. 1994. Why Have There Been No Great Women Artists? In Hermann, Anne C., and Stewart, Abigail J. (eds.), *Theorizing Feminism: Parallel Trends in the Humanities and Social Sciences*. Boulder: Westview Press.

P Norris, H. T. 1980. *The Adventures of Antar*. Warminster: Aris & Philips.

M El-Noshokaty, Amira. 2000. A Turban for a Lute. *Al-Ahram Weekly*. February 24–March 1.

C Nouri, Shakir. 1986. *À la recherche du cinéma irakien: histoire, infrastructure, filmographie (1945–1985)*. Paris: L'Harmattan.

D, T Odd Sights in Brooklyn: A Howling Dervish in Mr. Beecher's Pulpit. 1880. *New York Times*, December 11, p. 7.

T Odell, George Clinton Densmore. 1949. *Annals of the New York Stage*, Vol. 14. New York: Columbia University Press.

Osborne, Harold. 1977. The Aesthetic Concept of Craftsmanship. *British Journal of Aesthetics* 17:2, pp. 138–148.

T Osman, Etidal. 1979. Thematic Concerns in the Speeches and Dialogues of "Abdullah Nadim." MA Thesis, American University of Cairo.

T Oskoui [Usku'i], Mostafa [Mustafa]. 1991. *Studies in the History of the Theatre of Iran* ([*Pazhuhishi dar tarikh-ye ti'atr-ye Iran*] title page and contents only in English). Moscow: Anahita.

A Ostle, R. 1991. Literature and Art in Egypt (1914–1950): Form, Structure and Ideology. In *D'un orient l'autre: Les métamorphoses successives des perceptions et connaissances*. Cairo: CEDEJ.

Paglia, Camille. 1990. *Sexual Personae: Art and Decadence from Nefertiti to Emily Dickinson*. London: Penguin Books.

C Panayi, Panikos. 1993. *One Last Chance*: Masculinity, Ethnicity, and the Greek Cypriot Community of London. In Pat Kirkham and Janet Thumim (eds.), *You Tarzan, Masculinity, Movies and Men*. New York: St. Martin's Press.

A Parker, Ann, and Neal, Avon. 1995. *Hajj Paintings: Folk Art of the Great Pilgrimage*. Washington D.C.: Smithsonian Institution Press.

Passages of Eastern Travel. 1856. *Harper's New Monthly Magazine*, 12:69, February, p. 379.

T Peacock, James L. *Rites of Modernization: Symbolic and Social Aspects of Indonesian Proletarian Drama*. [1968]. Chicago: University of Chicago.

Peirce, Charles S. 1940. Logic as Semiotic: The Theory of Signs. In Justus Buchler (ed.), *The Philosophy of Peirce. Selected Writings*. London: Kegan Paul, Trench, Trubner and Co.

Penfield, Fredric Courtland. 1899. *Present Day Egypt*. New York: The Century Co.

A Perez, Nissan N. 1988. *Focus East: Early Photography in the Near East (1839–1885)*. New York: Abrams.

Phillips, Wendell. 1955. *Qataban and Sheba: Exploring the Ancient Kings on the Biblical Spice Routes of Arabia*. New York: Harcourt, Brace.

C Pines, Jim, and Willemen, Paul (eds.). 1989. *Questions of Third Cinema*. London: BFI.

M Pôche, Christian. 1969. Vers une musique libanaise de 1850 à 1950. *Les Cahiers de l'Oronte*, 7.

M _____. 1996. Les archives de la musique arabe. *Revue d'études palestiniennes*, 60:8, pp. 79–95.

T Provenzano, F. 1999. Meadow Brook Finds Its Role with Glory. *The Observer & Eccentric* (Birmingham, Michigan), March 18.

P. T. Barnum, Forty Years of Recollections. 1873. Buffalo, NY: Warren, Johnson.

Al-Qasimi, Muhammad. 1960. *Qamus al-sina'at al-shamiya. [Dictionnaire des métiers damascains]*. Paris: Mouton.

Raafat, Samir W. 1994. *Maadi 1904-1962: Society and History in a Cairo Suburb*. Cairo: Palm Press.

A Al-Rabi'a, Shawkat. 1988. *Al-Fann al-tashkili al-mu'asir fi al-watan al-'arabi*. Cairo: al-Hay'a al-Misriya al-'Amma li-l-Kitab.

M Racy, Ali Jihad. 1976. Record Industry and Egyptian Traditional Music 1904–1932. *Ethnomusicology*, 20:1, pp. 23–48.

M _____. 1977. Musical Change and Commercial Recording in Egypt, 1904–1932. Ph.D. dissertation, University of Illinois at Urbana-Champaign.

M _____. 1981a. Music in Contemporary Cairo: A Comparative Overview. *Asian Music*, 13:1, pp. 14–26.

M _____. 1981b. Legacy of a Star. In Kamal Boullatta and Sargon Boulus (eds.), *Fayrouz, Legend and Legacy*. Washington, D.C.: Forum for International Art and Culture.

M _____. 1982. Musical Aesthetics in Present-Day Cairo. *Ethnomusicology*, 26:3, pp. 391–406.

M _____. 1983a. Music. In J. R. Hayes (ed.), *The Genius of Arab Civilization: Source of Renaissance*. Cambridge, Mass.: M.I.T. Press.

M _____. 1983b. The Waslah: A Compound-Form Principle in Egyptian Music. *Arab Studies Quarterly*, 5:4, pp. 396–403.

M, P _____. 1985. Music and Dance in Lebanese Folk Proverbs. *Asian Music*, 17:1, pp. 83–97.

M _____. 1986. Words and Music in Beirut: a Study of Attitudes. *Ethnomusicology*, 30:3, Fall, pp. 413–427.

M _____. 1986. Lebanese Laments: Grief, Music, and Cultural Values. *World of Music*, 28, pp. 27–37.

M _____. 1991. Creativity and Ambience: An Ecstatic Feedback Model from Arab Music. *World of Music*, 33:3, pp. 7–28.

M _____. 1996. Heroes, Lovers, and Poet-Singers: The Bedouin Ethos in Music of the Arab Near East. *Journal of American Folklore*, 109:434, Fall, pp. 404–424.

T Radi, Akbar. 1989. *Ahesteh ba Gol-e Sorkh*. Tehran: Namayesh.

T Al-Ra'i, 'Ali. 1975. Some Aspects of Modern Arabic Drama. In R. C. Ostle (ed.), *Studies in Modern Arabic Literature*. Warminster, England: Aris & Phillips.

A Rakha, Youssef. 1999. Painting the Psyche. *Al-Ahram Weekly*, 444, August 26–September 1.

M Rasmussen, Anne Katharine. 1990. Individual and Social Change in the Music of Arab Americans. Ph.D. dissertation, University of California, Los Angeles.

M _____. 1992. An Evening in the Orient: A Middle Eastern Nightclub in America. *Asian Music*, 23:3, Spring/Summer, pp. 3–70.

M _____. 1996. Theory and Practise at the "Arabic org:" Digital Technology in Contemporary Arab Music Performance. *Popular Music*, 15:3, pp. 345–365.

M . 1997. The Music of Arab Detroit: A Musical Mecca in the Midwest. In Anne K. Rasmussen and Kip Lornell (eds.), *Musics of Multicultural America: A Study of Twelve Musical Communities*. New York: Schirmer Books.

M . 1997. Made in America: Historical and Contemporary Recordings of Middle Eastern Music in the United States. *Middle East Studies Association Bulletin*, 31:2, December, pp. 158–162.

Rejwan, Nissim. 1979. *Nasserist Ideology: Its Exponents and Critics*. New York: Wiley.

P Reynolds, Dwight Fletcher. 1991. Heroic Poets, Poetic Heroes: Composition and Performance in an Arabic Oral Epic Tradition of Northern Egypt. Ph.D. dissertation, University of Pennsylvania.

Reynolds-Ball, Eustace. 1987. *The City of Caliphs: A Popular Study of Cairo and its Environs and the Nile and its Antiquities*. Boston: Estes & Lauriat.

T, D Rezvani, Medjid K. 1962. *Le théâtre et la danse en Iran*. Paris: Maisonneuve et Larose.

T, P Ricks, Thomas M. (ed.). 1984. *Critical Perspectives on Modern Persian Literature*. Washington, D.C.: Three Continents Press.

A Rifaey, Tonia. 1997. An Illustration of the Transitional Period in Egypt, 1919–1924: Political Cartoons in Egypt's Revolutionary History. Master's Thesis. Department of Arabic Studies, American University in Cairo.

 . 1998."Visual Identity and Egyptian Cartoons, 1918–1924." Paper presented at the Middle East Studies Association's annual meeting, Washington, DC.

P Al-Rihani, Amin. 1989. *Al-qissa wa al-riwaya: al-muhalafa al-thulathiya*. Beirut: Dar al-Jil.

Al-Rihani, Najib. 1959. *Mudhakkirati*. Cairo: Dar al-Hilal.

M Rivers, Susan. 1995. Playing in Interesting Times. *Aramco World*, 46:5, September/October, pp. 12–15.

M Rizq, Qustandi. 1993. *Al-musiqa al-sharqiya wa-al-ghina' al-'arabi*. Cairo: Dar al-'Arabiya li-l-Kitab (reprint of 1934–38 edition).

Rorty, Amelie O. 1980. Introduction. *In Explaining Emotions*. Berkeley: University of California Press, pp. 1–8.

A Rosenthal, Donald A. 1982. *Orientalism: The Near East in French Painting 1800–1880*. Rochester, NY: Memorial Art Gallery of the University of Rochester.

T Rudnicka-Kassem, Dorota. 1993. *Egyptian Drama and Social Change: A Study of Thematic and Artistic Development in Yusuf Idris's Plays*. Cracow: Jagiellonian University.

T Ryberg, Birgitta. 1992. *Yusuf Idris (1927–1991): Identitätskrise und gesellschaftlicher Umbruch*. Stuttgart: Franz Steiner.

A Saad el-Din, Mursi (ed.). 1998. *Gazbia Sirry: Lust for Color*. Cairo: American University in Cairo Press.

T Sadgrove, Philip. 1996. *The Egyptian Theatre in the Nineteenth Century, 1799–1882*. Reading, Berkshire: Ithaca Press.

C Sadoul, Georges (ed.). 1966. *The Cinema in the Arab Countries: Anthology Prepared for UNESCO*. Beirut: InterArab Centre of Cinema and Television.

M Sahhab, Fiktur. 1987. *Al-saba'a al-kibar fi al-musiqa al-'arabiya al-mu'asira*. Beirut: Dar al-'Ilm li-l-Malayin.

M . 1998. *Wadi' al-Safi*. Beirut: Dar Kalimat li-l-Nashr, 1998.

M Saïah, Ysabel. 1985. *Oum Kalsoum: l'étoile de l'orient*. Paris: Denoël.

Said, Edward W. 1979. *Orientalism*. New York: Random House.

 . 1999. *Out of Place: A Memoir*. New York: Knopf.

M . 2000. Bonding Across Cultural Boundaries. *New York Times* Part 2, February 27, pp. 43, 56.

T Sa'id, Khalida. 1984. Firqat masrah al-hakawati min al-nass al-hayy ila al-nass al-muktamil aw masirat al-bahth 'an al-dhat. *Mawaqif*, 50,

Spring,
 pp. 135-164.
T Al-Sa'id, Shakir Hassan. 1983. *Fusul min tarikh al-haraka al-tashkiliya fi al 'Iraq*. Baghdad: Wizarat al-Thaqafa wa al-I'lam, Da'irat al-Shu'un al Thaqafiya wa-al-Nashr.
Sa'id Abu al-'Aynayn. 1990. *Rakha—faris al-karikatir*. Cairo: Akhbar al-Yawm.
T Sa'edi [Sa'idi], Gholamhoseyn. 1976. *Karbafakha dar Sangar*. Tehran: Sepehr.
T _____. 1976/7. *Mah-e 'Asal*, Tehran: Kitab-e Jibi.
T _____. 1986. *Pardehdaran-e A'inehafruz*. Paris: Ketab-Alefba.
T _____. 1986. *Otello dar Sarzamin-e Ajayeb*. Paris: Ketab-Alefba.
D Saleh, Magda Ahmed Abdel Ghaffar. 1979a. A Documentation of the Ethnic Dance Traditions of the Arab Republic of Egypt. Ph.D. dissertation, New York University.
D Saleh, Magda. 1979b. *Dance in Egypt: A Quest for Identity*. In Patricia A. Rowe and Ernestine Stodelle (eds.), *Dance Research Collage: A Variety of Subjects Embracing the Abstract and the Practical* (CORD Dance Research Annual no. 10). New York: CORD, pp. 215-218.
T Salehzehi, Salman Farsi. 1989. "Ab, Bad, Khak," in *Ketab-i Sobh*, 3, Spring, pp. 185-192.
D Salem, Lori Anne. 1995. "The Most Indecent Thing Imaginable:" Race, Sexuality and the Image of Arabs in American Entertainment, 1850-1990. Ph.D. dissertation, Temple University.
T Salim, 'Ali. 1976. *Masrahiyat Ali Salim*. Cairo: Maktabat Madbuli.
A Salim, Nizar. 1977. *L'art contemporain en Iraq*. Lausanne: Sartec.
A Salman, Abd al-Rasul. 1984. *Al-tashkil al-mu'asir fi duwwal Majlis al Ta'awwun al-Khaliji*. Kuwait: Sharikat al-Matba'a al-Asriya.
C Samak, Qussai. 1979. The Arab Cinema and the National Question: From the Trivial to the Sacrosanct. *Cineaste*, 9:3, Spring.
C _____. 1979a. *Cinéma du moyen orient et du Maghreb*. Montreal: Le Cercle de la Culture Arabe.
Saxon, A. H. 1989. *P. T. Barnum: The Legend and the Man*. New York: Columbia University Press.
A Al-Sayyid Marsot, Afaf Lutfi. 1971. The Cartoon in Egypt. *Comparative Studies in Society and History* 13, January, pp. 2-15.
_____. 1977. *Egypt's Liberal Experiment: 1922-1936*. Berkeley: University of California Press.
P, M Sbait, Dirgham H. 1986. Poetic and musical structure in the improvised sung colloquial qasidah of the Palestinian poet-singers. *Al-'Arabiyya*, 19:1 and 2, pp. 75-108.
Schacht, Joseph, and C. B. Bosworth (eds.). 1979. *The Legacy of Islam*. Oxford: Oxford University Press.
M Schade-Poulson, Marc. 1999. *Men and Popular Music in Algeria: The Social Significance of Rai*. Austin: University of Texas Press.
Schami, Rafik. 1996. *A Hand Full of Stars*. Tel Aviv: Schoken.
T Schechner, Richard. 1985. *Between Theater and Anthropology*. Philadelphia: University of Pennsylvania Press.
D Schieffelin, Edward L. 1976. *The Sorrow of the Lonely and the Burning of the Dancers*. New York: St. Martin's Press.
Schimmel, Annemarie. 1983. *Mystical Dimensions of Islam*. Chapel Hill: University of North Carolina Press.
P _____. 1982. *As Through a Veil: Mystical Poetry in Islam*. New York: Columbia University Press.
Schmidt, Jürgen. 1987. Die sabäische Wasserwirtschaft von Marib In Daum, Werner (ed.), *Jemen: 3000 Jahre Kunst und Kultur des glucklichen Arabien*. Frankfurt: Umschau-Verlag.
M Schuyler, Philip. 1990. Hearts and Minds: Three Attitudes toward Performance Practice and Music Theory in the Yemen Arab Republic.

Ethnomusicology, 34:1, pp. 1–18.

M _____. 1993. The Sheba River Dam: The Reconstruction of Architecture, History and Music in a Yemeni Operetta. *Revista de Musicologia*, 16:3, pp. 45–51.

M _____ 1990–92. Music and Tradition in Yemen. *Asian Music*, 22:1, Fall/Winter, pp. 51–72.

M _____ (ed.). 1998. *Asian Music*, 17:1, Fall/Winter, 1998. (Entire issue on music in the Middle East/Islamic world).

Searle, John R. 1983. *Intentionality: An Essay in the Philosophy of Mind.* Cambridge: Cambridge University Press.

T Semaan, Khalil I. 1979. Drama as a Vehicle of Protest in Nasir's Egypt. *International Journal of Middle Eastern Studies*, 10:1, February, pp. 49–53.

T Sepanlu [Sipanlu], Mohammad Ali. 1988. *Nevisandegan-e Peshraw-e Iran.* Tehran: Zaman.

Serjeant, R.B. 1967. Société et gouvernment en Arabie du Sud. *Arabica.* 14, pp. 284–297.

C Shafik, Viola. 1998. *Arab Cinema: History and Cultural Identity.* Cairo: American University in Cairo Press.

C _____[Shafiq]. 1999. Women, National Liberation and Melodrama in Arab Cinema: Some Considerations. *Al-Ra'ida*, 16:86–87, Summer/Fall, pp. 12–18.

C Shaheen, Jack. 1983. The Arab Image in the American Mass Media. In Edmund Ghareeb (ed.), *Split Vision: Arab Portrayal in the American Media.* Washington, D.C.: American-Arab Affairs Council.

M Shalaby, Karam. 1998. Qissat 'Abd al-Halim. *Al-Mushahid al-Siyasi*, April 11–25.

A Shammut, Isma'il. 1989. *Al-fann al-tashkili fi filistin.* Kuwait: I Shammut.

M Al-Sharif, Samim. 1981. *Al-ughniya al-'arabiya.* Damascus: Wizarat al Thaqafa wa al-Irshad.

M _____. 1991. *Al-musiqa fi Suriya: a'lam wa-tarikh.* Damascus: Wizarat al-Thaqafa.

M _____. 1992. *Al-Sunbati: wa-jil wa-'amalaqa.* Damascus: Dar al-Tlas.

M Al-Shawan, 'Aziz. 1986. *Al-musiqa ta'bir naghmi wa mantiq.* Cairo: General Book Organization.

M El-Shawan, Salwa Aziz. 1981. Al-musiqa al-'arabiyyah: A Category of Urban Music in Cairo, Egypt, 1927–1977. Ph.D. dissertation, Columbia University.

M El-Shawan Castelo-Branco, Salwa. 1987. Some Aspects of the Cassette Industry in Egypt. *World of Music*, 29, 1987.

D Shay, Anthony. 1976. Traditional Music and Dances of Lebanon. *Viltis*, 35:4, December, pp. 6–9.

D _____. 1995. Dance and Non-Dance: Patterned Movement in Iran and Islam. *Iranian Studies*, 28:1–2, pp. 61–78.

Shehadeh, Raja. 1982. *The Third Way: a Journal of Life in the West Bank.* London: Quartet Books.

T Al-Shetaiwi, Mahmoud Flayeh Ali Gemei'an. 1983. The Impact of Western Drama upon Modern Egyptian Drama. Ph.D. dissertation. University of Illinois at Urbana-Champaign.

T Shihada, Radi. 1989. Masrah al-hakawati al-filastini. *Al-Karmil*, 31, pp. 172–191.

M Shiloah, Amnon. 1980. Arab Folk Music. In Stanley Sadie (ed.), *The New Grove Dictionary of Music and Musicians.* London: Macmillan Publishers Limited, vol. 1, p. 529.

M _____. 1995. *Music in the World of Islam: A Socio-cultural Study.* Detroit: Wayne State University Press.

Shinar, Dov. 1987. *Palestinian Voices: Communication and Nation Building in the West Bank.* Boulder, CO: Lynne Rienner.

A Shinn, Earl. 1880. *The Art Treasures of America, being the choicest works of art in the public and private collections of North America.* Philadelphia:

Gebbie & Barrie.

C Shohat, Ella. 1989. *Israeli Cinema: East/West and the Politics of Representation*. Austin: University of Texas Press.

P Shryock, Andrew. 1997. *Nationalism and the Genealogical Imagination: Oral History and Textual Authority in Tribal Jordan*. Berkeley: University of California Press.

T Shukri, Ghali. 1992. *Yusuf Idris: Farfur kharij al-sur*. Cairo: Wizarat al-I'lam, al-Hay'a al-'Amma li-l-Isti'lamat.

M Shushah, Muhammad al-Sayyid. 1976. *Umm Kulthum*. Cairo: Maktabat Ruz al-Yusuf.

T Sidqi, Amin. 1920. *Al-barbari fi al-jaysh*. Unpublished manuscript. Archives of the Masrah al-Qawmi.

T Sleiha, Nehad. 1993. Taken at the Flood. *Al-Ahram Weekly*, 14–20 October, p. 10.

T Slyomovics, Susan. 1991. "To Put One's Finger in the Bleeding Wound" Palestinian Theater under Israeli Censorship. *The Drama Review*, 35:2, pp. 18–38.

Smith, Anthony D. (ed.). 1976. *Nationalist Movements*. London: Macmillan Press Ltd.

T Snir, Reuven. 1990. Petsa Ekhad mi-Pts'av–ha-Sifrut ha-'Aravit ha-Falastinit be-Yisrael. *Alpayim*, 2, pp. 244–268.

T _____. 1993a. The Beginnings of Political Palestinian Theater: Qaraqash by Samih al-Qasim. *The Near East*, 35, pp. 129–147.

T _____. 1993b. Al-'anasir al-masrahiya fi al-turath al-sha'bi al-'Arabi, al-qadim. *Al-Karmil*. 14, pp. 149–170.

T _____. 1995a. Hebrew as the Language of Grace: Arab-Palestinian Writers in Hebrew. *Prooftexts*, 15:2, pp. 163–183.

T _____. 1995b. Palestinian Theater: Historical Development and Contemporary Distinctive Identity. *Contemporary Theater Review*, 3:2, pp. 29–73.

T _____. 1996. Palestinian Theater as a Function of Cultures: The Case of Samih al-Qasim's Qaraqash. *Journal of Theater and Drama*, 2, pp. 101–120.

T Somekh, Sasson. 1981. *Mabna al-qissa wa-mabna al-masrahiya fi adab Yusuf Idris*. Tel Aviv: Maktabat wa Mataba'at al-Suruji.

M Spector, Johanna. 1989. Musical Tradition and Innovation. In Edward Allworth (ed.), *Central Asia: 120 Years of Russian Rule*. Durham, NC: Duke University Press.

Starkey, Paul. 1977. Philosophical Themes in Tawfiq al-Hakim's Drama. *Journal of Arabic Literature*, 8, pp. 136–152.

Stagh, Martina. 1993. *The Limits of Freedom of Speech: Prose Literature and Prose Writers in Egypt under Nasser and Sadat*. Stockholm: Almquist & Wiksell, 1993.

P Stallybrass, Peter and Allon White. 1986. *The Politics and Poetics of Transgression*. London: Methuen.

Steegmuller, Francis (ed). 1972. *Flaubert in Egypt: A Sensibility on Tour*. Boston: Little, Brown and Co.

M Stokes, Martin. 1992. *The Arabesk Debate: Music and Musicians in Modern Turkey*. New York: Oxford University Press.

_____. 1999. Turkish Urban Popular Music. *Middle East Studies Association Bulletin*, 33:1, Summer.

Stookey, Robert W. 1978. *Yemen: The Politics of the Yemen Arab Republic*. Boulder: Westview Press.

M Sugarman, Jane. 1989. The Nightingale and the Partridge: Singing and Gender among Prespa Albanians. *Ethnomusicology*, 33:2, pp. 191–215.

Sulayman, Muhammad. 1988. *Al-sihafa al-filastiniyya wa-qawanin al-intidab al-baritani*. Nicosia: Bisan Press.

M Sultan, Mahmud. 1986. *'Abd al-Wahhab: mu'jizat al-zaman fi al-fann al-musiqi wa-al-ghina'i*. Cairo: al-Hay'a al-Misriya al-'Amma li-l-Kitab.

Swagman, Charles F. 1988. Tribe and Politics: An Example from Highland Yemen. *Journal of Anthropological Research*, 44:3, pp. 251–261.

M Al-Taba'i, Muhammad. 1961. *Asmahan tarwi qissatha*. Beirut: Al-Maktaba al-Tujari li-l-Taba'a wa al-Tawzi' wa al-Nashr.

T Tabrizi, Mirza Aqa. 1976. *Mirza Aqa Tabrizi: Chahar Teyatr*. Tabriz, Iran: Nil.

Al-Tahtawi, Rifa'a. 1993. *Talkhis al-ibris fi talkhis Baris*. Cairo: General Egyptian Book Organization.

T Tamer, Zakaria. 1985. *Tigers on the Tenth Day*. London: Quartet Books.

T _____. 1979. *Al-numur fi al-yawm al-'ashir: qisas*. Jerusalem: Manshurat Salah al-Din.

C Tawfiq, Sa'd al-Din. 1960. *Qissat al-sinima fi Misr: dirasat naqdiya*. Cairo: Dar al-Hilal.

M Touma, Habib Hassan. 1996. *The Music of the Arabs*. Portland, Ore.: Amadeus Press.

Truman, Ben C. 1893. *History of the World's Fair*. Philadelphia: Mammoth Publishing.

M Turino, Thomas. 1989. The Coherence of Social Style and Musical Creation among the Aymara in Southern Peru. *Ethnomusicology*, 33:1, pp. 1–30.

M Ubaid, Joseph. 1974. *Al-salat fi aghani Fairuz*, Jounih, Lebanon: Al-Matba'a Al-Bulisiya.

Upadhyaya, Hari S. 1986. Attitude of Indian Proverbs Toward High Caste Hindus. *Proverbium*, 3, pp. 46–56.

T Urban, Greg. 1997. Culture: In and about the World. *Anthropology Newsletter*, 38:2, pp. 1, 7.

T Urian, Dan. 1996. Perspectives on Palestinian Drama and Theater: A Symposium. In Linda Ben-Zvi (ed.), *Theater in Israel*. Ann Arbor: University of Michigan Press.

A Veillion, Margo. 1994. *Nubia: Sketches, Notes, and Photographs*. London: Scorpion.

Vitalis Robert. 1995. *When Capitalists Collide: Business Conflict and the End of Empire in Egypt*. Berkeley: University of California Press.

Volosinov, V. N. 1973. *Marxism and the Philosophy of Language*. Cambridge: Harvard University Press.

M Wade, Bonnie. 1976. Fixity and Flexibility: From Musical Structure to Cultural Structure. *Anthropologica*, 18:1, pp. 15–26.

Walters, Delores M. 1987. Perceptions of Social Inequality in the Yemen Arab Republic. Ph. D. dissertation, New York University.

_____. 1998. Invisible Survivors: Women and Diversity in the Transitional Economy of Yemen. In Richard A. Lobban, Jr. (ed.), *Middle Eastern Women and the Invisible Economy*. Gainesville: University Press of Florida.

T Wannus, Sa'dallah. 1989. *Al-fil ya malik al-zaman; wa-Mughamarat ra's al-mamluk Jabir: masrahiyatan*. Beirut: Dar al-Adab.

_____. 1995. Al-jaw' ila al-hiwar. *Al-Tariq*, 2, March-April.

El-Warsha (Theater). 1987–97. El-Warsha's Progress. Private publication.

C Wassef, Magda (ed.). 1995. *Égypte: 100 ans de cinema*. Paris: Éditions Plume/ Institut du Monde Arabe.

M Waugh, Earle H. 1989. *The Munshidin of Egypt: Their World and Their Song*. Columbia, S.C.: University of South Carolina Press.

A Weir, Hilary. 1985. Ramses Wissa Wassef. *Arts in the Islamic World*, 2:2, Summer.

M *Whether Good or Bad: Arabesk is the Fad*. 1993. Video series in 4 parts. VHS Kerime Senyucel (Prod.) for Turkish Radio and Television.

A Wolff, Janet. 1992. Excess and Inhibition: Interdisciplinarity in the Study of Art. In J. Nelson Grossberg and P. Treicher (eds.), *Cultural Studies*. New York: Routledge.

C Woll, Allen L., and Miller, Randall M. 1987. Arabs. In *Ethnic and Racial Images in American Film and Television: Historical Essays and Bibliography*. New York: Garland Publishing.

D Wood, Leona, and Shay, Anthony V. 1976. Danse du Ventre: A Fresh
 Appraisal. *Dance Research Journal*, 8:2, Spring-Summer, pp. 18–30.
 Wright, Alan. 1993. Reviving the Spirit, Resisting Decay. *Al-Ahram Weekly*,
 October 21–27, p. 10.
T Yalfani, Muhsin. 1990. *Qavitar az shab: panj namayeshnameh*. Paris: Kitab-e
 Chashmandaz.
A Yarshater, Ehsan. 1979. Contemporary Persian Painting. In Richard
 Ettingrausen and Ehsan Yarshater (eds.), *Highlights of Persian Art*.
 Boulder: Westview Press.
D Yunus, 'Abd al-Hamid. 1983. Al-raqs al-sha'bi. In *Mu'jam al-fulklur: ma'a
 masrad inklizi-'arabi*. Beirut: Maktabat Lubnan.
T *Yusuf Idris bi qalam kibar al-'udaba'* [Taha Hussein et al.]. [1986]. Cairo:
 Maktabat Misr.
M Zaki, 'Abd al-Hamid Tawfiq. 1993. *A'lam al-musiqa al-misriya 'abra 150
 sana*. Cairo: al-Hay'a al-Misriya al-'Amma li-l-Kitab.
M _____. 1993. *Al-Mu'asirun min ruwwad al-musiqa al-'arabiya*. Al
 Hay'a al-Misriya al-'Amma li-l-Kitab.
M Zalzal, Zéna. Portrait: Béchara el-Khoury: de la musique avant toute chose.
 L'Orient-LeJour. http://www.dm.net.lb/orient/htdocs/1-14-17.html
P Al-Zayyat, Ahmad Hasan. 1934. Al-Radiu wa-l-Sha'ir. *Al-Risala*, December
 3, pp. 2121–2122.
T Zeidan, Joseph. 1997. Modern Arabic Theater: The Journey Back. In Issa J.
 Boullata and Terri DeYoung (eds.), *Tradition and Modernity in Arabic
 Literature*. Fayetteville: University of Arkansas Press.
M, D, C, A Zuhur, Sherifa (ed.). 1998. *Images of Enchantment: Visual and
 Performing Arts of the Middle East*. Cairo: American University in
 Cairo Press.
M, C _____. 2000a. An Arab Diva in Gendered Discourse. In Rudi Matthee
 and Beth Baron (eds.), *Iran and Beyond: Essays in Middle Eastern History
 in Honor of Nikki R. Keddie*. Costa Mesa, Calif.: Mazda Publishers.
M, C _____. 2000b. *Asmahan's Secrets: Woman, War, and Song*. London: Saqi.
M, C _____. 2000c. Asmahan's Secrets: Gender, Art, and Cultural
 Disputations. *Al-Ra'ida*, 18:86, Winter, pp. 41–44.
 _____. 2001. The Mixed Impact of Feminist Struggles in Egypt in the
 1990s. *Middle East Review of International Affairs*, 5:1, March.
 (url: <http://www.meria.biu.ac.il/>).
M, C _____. Forthcoming. Building a Man On-stage: Masculinity and
 Romance according to Farid al-Atrash. *Men and Masculinities*, 3:3.

Index